TECHNICAL ENGINEERING AND DESIGN GUIDES AS ADAPTED FROM THE US ARMY CORPS OF ENGINEERS, NO. 14

PHOTOGRAMMETRIC MAPPING

Published by
ASCE Press
American Society of Civil Engineers
345 East 47th Street
New York, New York 10017-2398

ABSTRACT

This manual, Photogrammetric Mapping, is adapted from the U.S. Army Corps of Engineers' Technical Engineering and Design Guides, No. 14. It provides procedures, minimum accuracy requirements, instrumentation and equipment requirements, and quality control criteria for photogrammetric mapping. This includes aerial photography and standard line mapping products, including digital spatial data for use in computer-aided design and drafting (CADD) systems. The manual should be used as a guide in planning mapping requirements, developing contract specifications, and preparing cost estimates for all phases of aerial photography and photogrammetric mapping. Throughout the manual, photogrammetric mapping criteria standards are in specific terms and are normally summarized in tables while methodologies are discussed in more general terms if they are described in readily available references.

Library of Congress Cataloging-in-Publication Data

Photogrammetric mapping
 p. cm. — (Technical engineering and design guides as adapted from the U.S. Army Corps of Engineers ; no. 14)
 Includes bibliographical references.
 ISBN 0-7844-0143-8
 1. Aerial photogrammetry—Handbooks, manuals, etc. I. Series.
 TA593.25.P56 1996 95-47824
 526.9'82—dc20 CIP

CONTENTS

DEPARTMENT OF THE ARMY
U.S. Army Corps of Engineers
WASHINGTON, D.C. 20314-1000

REPLY TO
ATTENTION OF:
Engineering Division

Mr. Charles A. Parthum
President, American Society
 of Civil Engineers
345 East 47th Street
New York, New York 10017

Dear Mr. Parthum:

 I am pleased to furnish the American Society of Civil
Engineers (ASCE) a copy of the U. S. Army Corps of Engineers
Engineering Manual, EM 1110-1-1000, Photogrammetric Mapping. The
Corps uses this manual to provide procedural guidance, technical
specifications, and quality control criteria for performing
aerial photogrammetric mapping activities.

 I understand that ASCE plans to publish this manual for
public distribution. I believe this will benefit the civil
engineering community by improving transfer of technology between
the Corps and other engineering professionals.

 Sincerely,

 Arthur E. Williams
 Lieutenant General, U. S. Army
 Commanding

CHAPTER 1

INTRODUCTION

1-1. PURPOSE.

This manual presents procedural guidance, technical specifications, and quality control (QC) criteria for performing aerial photogrammetric mapping activities.

1-2. APPLICABILITY.

This manual applies to all major subordinate commands, districts, and laboratories performing and/or contracting for aerial photography and photogrammetric mapping services in support of planning, engineering and design, construction, operation, maintenance, and/or regulation of civil works or military construction projects. This manual is also applicable to U.S. Army Corps of Engineers (USACE) functional areas having responsibility for environmental investigations and studies, archeological investigations, historical preservation studies, hazardous and toxic waste site restoration, structural deformation monitoring investigations, regulatory enforcement activities, and support to Army installation maintenance and repair programs and installation master planning functions. Waivers from applicability should be requested by written memorandum to Headquarters, USACE (ATTN: CECW-EP).

1-3. REFERENCES.

Required and related publications are listed in Appendix A.

1-4. EXPLANATION OF ABBREVIATIONS AND TERMS.

Photogrammetry terms and abbreviations used in this manual are defined in the Glossary (Appendix B).

1-5. SCOPE OF MANUAL.

This manual provides standard procedures, minimum accuracy requirements, instrumentation and equipment requirements, and QC criteria for photogrammetric mapping. This includes aerial photography and standard line mapping (topographic or planimetric) products, including digital spatial data for use in computer-aided design and drafting (CADD) systems. The manual is intended to be a primary reference specification for contracted photogrammetric services. It should be used as a guide in planning mapping requirements, developing contract specifications, and preparing cost estimates for all phases of aerial photography and photogrammetric mapping. It may also be used as general guidance in executing some phases of photogrammetric mapping with USACE-hired labor forces.

A. Throughout the manual, photogrammetric mapping criteria standards are in specific terms and are normally summarized in tables. Guidance is in more general terms where methodologies are described in readily available references or survey instrumentation operating manuals. Where procedural guidance is otherwise unavailable, it is provided herein.

B. Accuracy specifications, procedural criteria, and QC requirements contained in this manual shall be directly referenced in the scopes of work for Architect-Engineer (A-E) survey services or other third-party survey services. This is intended to assure that uniform and standardized procedures are followed by contract service sources throughout USACE.

C. This manual is intended to cover only those large-scale (i.e., greater than 400 ft per in.) photogrammetric mapping products that support typical USACE construction projects. These products include detailed site plan (or planimetry) feature mapping, topographic (vertical terrain) mapping, air photo enlargement plan drawings, and orthophotography mapping. The manual focuses primarily on the preparation of design drawings and other documents associated with these products, including related contracted construction performance activities.

D. Three distinct accuracy classes for USACE photogrammetric mapping products are defined in this manual, together with the detailed crite-

ria, instrumentation, and procedures necessary to meet these accuracy classifications. For each class of map, procedural specifications and limitations are defined, such as allowable types of photographic or mensuration instruments, QC criteria, limiting flight altitude and photo enlargement criteria, and recommended development scales based on project functional requirements.

E. Appendix C contains guidance for project engineers or project managers in developing cost estimates for negotiated qualification-based A-E contracts. This appendix contains an overview of general photogrammetric mapping procedures for those not requiring the detail found in the body of the manual. It therefore may be used independently of the manual for project managers requiring only general background knowledge but needing detailed cost estimating procedural guidance.

1-6. LIFE CYCLE PROJECT MANAGEMENT INTEGRATION OF PHOTOGRAMMETRIC MAPPING THROUGHOUT THE PROJECT LIFE.

Most engineering projects require some degree of surveying and mapping during each stage, i.e., planning, acquisition, design, construction, operation, and maintenance. Therefore, in the early phases of a project, a comprehensive plan should be developed to integrate the surveying and mapping requirements throughout the various stages of the project's life. This would eliminate duplicate surveys performed for different purposes, of different accuracies, for different organizations, and/or at different times.

1-7. METRICS.

Both metric (SI) and English (non-SI) systems of measurement are used in this manual due to the common use of both systems throughout the surveying, mapping, and photogrammetric professions. English units of measure are far more common in photogrammetric mapping, with photo and map scales measured in feet per inch (ft/in.), photo coverage usually measured in acres, or occasionally in square miles, flight altitudes in feet, and aerial film/photo dimensions in inches. Camera focal lengths are measured in either inches or millimeters (mm), with "6-in. camera" normally used rather than its 153-mm equivalent.

A. Metric scale ratios are rarely used in continental United States (CONUS) civil works or military construction; however, they may be pre-

scribed for some military operational mapping projects. Map scales and air photo plan scales used in engineering, construction, and real estate are normally expressed in mixed English units, or "1 in. = x ft" notation, or more commonly, "xft/in." An "x-scale" map, another common usage, implies "x ft/in." Unit ratio (i.e., 1:x) scale measures are less commonly used. For example, a 100-scale photo represents a 100 ft/in. scale photo, or 1 in. = 100 ft, or 1:1,200.

B. Minimum scale limitations given in the manual for either photography or mapping refer to the "inches per foot" ratio measure, meaning that a scale cannot be less (i.e., smaller ratio) than the prescribed scale—e.g., a 100 ft/in. scale is smaller than a 50 ft/in. scale. Due to the variety of mixed measurements, equivalent conversions are not shown in this manual—the most common measurement unit is used for example computations.

In all cases, metric conversions are based exclusively on the U.S. Survey Foot, which equals exactly 1,200/3,937 m. See Chapter 2 for details on the use of other metric conversions used in surveying and mapping.

1-8. TRADE NAME EXCLUSIONS.

The citation in this manual of trade names of commercial firms, commercially available mapping products, or photogrammetric instruments does not constitute their official endorsement or approval.

1-9. ACCOMPANYING GUIDE SPECIFICATIONS.

To facilitate contracting photogrammetric mapping services, Appendix F, Guide Specification for Photogrammetric Mapping and Aerial Photography Services, has been developed to accompany this manual. This manual is designed to be used in conjunction with the guide specification as a QC and quality assurance (QA) aid in administering contracts for photogrammetric mapping and surveying services.

1-10. MANUAL DEVELOPMENT AND PROPONENCY.

The Headquarters, USACE, proponent for this manual is the Surveying and Analysis Section, General Engineering Branch, Civil Works Directorate. The manual was developed by the U.S. Army Topographic Engineering Center (USATEC) during

the period 1990–1991 under the Civil Works Guidance Update Program, U.S. Army Engineer Waterways Experiment Station. Primary technical authorship and/or review were provided by Ohio State University, Columbus; Virginia Polytechnic Institute and State University, Blacksburg; U.S. Army Engineer Districts, St. Louis, Seattle, Detroit, Tulsa, and Albuquerque; and the Management Association for Private Photogrammetric Surveyors (MAPPS). Recommended corrections or modifications to this manual should be directed to Headquarters, USACE, ATTN:CECW-EP-S, 20 Massachusetts Avenue NW, Washington, DC 20324-1000.

1-11. DISTRIBUTION.

Copies of this manual may be obtained from the USACE Publications Depot, 2803 52nd Avenue, Hyattsville, MD 20781-1102.

CHAPTER 2

PHOTOGRAMMETRIC ACCURACY STANDARDS AND CLASSIFICATIONS

2-1. GENERAL.

This chapter presents USACE photogrammetric mapping standards that have been established to specify the quality of the spatial data product (i.e., map) to be produced. These standards are drawn largely from recognized industry standards.

A. Minimum Accuracy Standards. This chapter sets forth the accuracy standards to be used in USACE for photogrammetrically derived maps and related spatial data products. Minimum requirements to meet these accuracy standards are given for critical aspects of the photogrammetric mapping and mensuration process, such as maximum flight altitudes, maximum photo enlargement ratios, C-Factor ratio limitations, and aerotriangulation adjustment criteria.

B. Target Scales. Mapping accuracy standards are associated with the final development scale of the map—both the horizontal "target" scale and vertical relief components. The use of CADD equipment allows the ready separation of planimetric features and topographic elevations to various layers, and depiction at any scale. Problems arise when target scales are in creased beyond their original values, or when so-called "rubber sheeting" is performed. *It is therefore critical that these spatial data layers contain descriptor information identifying the original source target scale and designed accuracy.*

C. Mapping Requirements. The specified accuracy of a map product shall be sufficient to assure that the map can be reliably used for the purpose intended, whether this purpose is an immediate or a future use. However, the accuracy of a map shall not surpass that required for its intended functional use. Specifying map accuracies in excess of those required for project design, construction, or condition reports is all too often performed; results in increased costs to USACE, local sponsors, or installations; and may delay project completion. It is absolutely essential that mapping accuracy requirements originate from the functional and realistic accuracy requirements of the project. General guidance on project-specific accuracy requirements is contained in this and later chapters.

D. Chapter Precedence. The standards set forth in this chapter shall have precedence over numbers, figures, references, or guidance presented in other chapters of this manual.

2-2. PHOTOGRAMMETRIC MAPPING STANDARDS.

There are five generally recognized industry standards that can be used for specifying spatial mapping products and resultant accuracy compliance criteria:

A. Office of Management and Budget (OMB) "United States National Map Accuracy Standards" (Bureau of the Budget 1947).

B. Photogrammetry for Highways Committee "Reference Guide Outline: Specifications for Aerial Surveys and Mapping by Photogrammetric Methods for Highways" (Photogrammetry for Highways Committee 1968).

C. U.S. Department of Transportation (DOT) "Surveying and Mapping Manual" (Miller 1985).

D. American Society for Photogrammetry and Remote Sensing (ASPRS) "ASPRS Accuracy Standards for Large-Scale Maps" (ASPRS 1990).

E. U.S. National Cartographic Standards for Spatial Accuracy.

Each of these standards has application to different types of functional products, ranging from wide-area small-scale mapping (OMB National Map Accuracy Standards) to large-scale engineering design (ASPRS Accuracy Standards for Large-Scale Maps). Their resultant accuracy criteria (i.e., spatial errors in X-Y-Z), including QC compliance procedures, do not differ significantly from one another. In general, use of any of these standards for a photogrammetric mapping contract will result in a quality product.

2-3. USACE PHOTOGRAMMETRIC MAPPING STANDARD.

The recommended standard for USACE photogrammetric mapping is the ASPRS Accuracy Standards for Large-Scale Maps (ASPRS 1990). This standard was developed and is generally recognized by the photogrammetric industry, and is specifically concerned with definitions of spatial accuracies for engineering projects typical of those designed by USACE. This standard is intended for site plan development work involving mapping scales larger than 1:20,000, usually in the range of 1in.=20 ft to 1in.=100 ft. Its primary advantage over other standards is that it contains more definitive statistical map testing criteria, which, from a contract administration standpoint, is desirable. It also is applicable to conventional surveying topographic site development work. For small-scale general location mapping work (i.e., scales smaller than 1:20,000), any of the other mapping standards in paragraph 2-2 may be specified. The OMB National Map Accuracy Standards (Bureau of the Budget 1947) is perhaps the most widely used standard and is recommended for smaller scale mapping work.

A. Application of Standards. The objective of these photogrammetric standards is twofold:

(1) To help assure that the topographic map accuracy standards will be met during the production process.

(2) To help assure that contractual deliverables other than maps, such as aerial photographs, ground control, etc., will possess quality of the required degree.

USACE photogrammetric mapping criteria relating to the recommended ASPRS standards are presented in this chapter and throughout the manual. Other USACE-specific criteria required in addition to the ASPRS standards are also given.

B. Map Accuracy Subclassifications. Three map accuracy classifications are prescribed in the ASPRS standards. These classes are discussed in paragraph 2-4A. Lower classifications will be more economical. The project engineer/manager must determine the specific map accuracy requirement and class for a given project based on the functional requirements. This determination cannot be done by the USACE Command survey function or the photogrammetric mapping contractor. (Further guidance on selecting mapping target scales as a function of an engineering project is contained in later chapters

of this manual.) The accuracy class must be shown on all final drawings/design files.

C. Use of ASPRS Standards for Conventional Mapping. The ASPRS standards are also applicable to large-scale site plan mapping performed by plane table or electronic total station techniques. This work may either supplement the aerial mapping work (e.g., surface or subsurface utility details) or be of a scale too large for aerial mapping (generally larger than 1in. = 40 ft).

D. Compliance Tests. Tests for compliance with the ASPRS and other map accuracy standards are discussed in more detail in Chapter 3, Quality Control and Quality Assurance Standards. Maps found compliant with a particular standard shall have a statement indicating that standard. The compliance statement shall refer to the data of lowest accuracy depicted on the map. Published maps whose errors exceed those given in a standard shall omit from their legends all mention of standard accuracy.

2-4. ASPRS ACCURACY STANDARDS FOR LARGE-SCALE MAPS.

In March 1990, the Professional Practicing Division, ASPRS, approved a set of standards as guidelines for large-scale mapping (Appendix D). These standards have been designed for large-scale planimetric and topographic maps prepared for engineering applications and other special purposes. Emphasis is placed on the final spatial accuracies that can be derived from the map in terms most generally understood by users. These ASPRS standards, and recommended USACE standards, are synopsized below.

A. Map Classes. Three map accuracy classes are defined. Class 1 maps are the most accurate. Class 2 maps have twice the root mean square error (RMSE) of a Class 1 map; Class 3 maps have thrice the RMSE of a Class 1 map. Maps may be one class in horizontal accuracy and another in vertical.

B. Horizontal Accuracy Criteria. The planimetric standard makes use of the RMSE as being " . . . defined to be the square root of the average of the squared discrepancies." It goes on to state: " . . . the discrepancies are the differences in coordinate or elevation values as derived from the map and as determined by an independent survey of higher accuracy (check survey)." The RMSE is defined in terms of feet or meters at ground scale rather than in inches or millimeters at the target map scale. This results in a linear relationship between

TABLE 2-1. Planimetric Feature Coordinate Accuracy Requirement (Ground X or Y in Feet) for Well-Defined Points

Target Map Scale		Limiting RMSE in X or Y		
1 in. = x ft (1)	Ratio, ft/ft (2)	Class 1 (3)	Class 2 (4)	Class 3 (5)
5	1:60	0.05	0.1	0.15
10	1:120	0.1	0.2	0.3
20	1:240	0.2	0.4	0.6
30	1:360	0.3	0.6	0.9
40	1:480	0.4	0.8	1.2
50	1:600	0.5	1.0	1.5
60	1:720	0.6	1.2	1.8
100	1:1,200	1.0	2.0	3.0
200	1:2,400	2.0	4.0	6.0
400	1:4,800	4.0	8.0	12.0
500	1:6,000	5.0	10.0	15.0
800	1:9,600	8.0	16.0	24.0
1,000	1:12,000	10.0	20.0	30.0
1,667	1:20,000	16.7	33.3	50.0

RMSE and target map scale; as map scale decreases, the RMSE increases linearly. The RMSE is the cumulative result of all errors including those introduced by the processes of ground control surveys, map compilation, and final extraction of ground dimensions from the target map. The limiting RMSE's shown in Table 2-1 are the maximum permissible RMSE's established by this standard. These limits of accuracy apply to well-defined points only.

C. Vertical Accuracy Criteria. Vertical accuracy is defined relative to the required contour interval (CI) for a map. In cases where only digital elevation models are being generated, an equivalent CI must be specified, based on the required digital point (spot) elevation accuracy. (The contours themselves may be later generated using CADD software routines.) The vertical standard also uses the RMSE, but only for well-defined features between contours containing interpretative elevations, or spot elevation points. (Contours in themselves are not considered as well-defined feature points.) The RMSE for Class 1 contours is one-third of the CI. The RMSE for Class 1 spot heights is one-sixth of the CI. Class 2 and Class 3 accuracies are twice and thrice those of Class 1, respectively. Testing for vertical map compliance is also performed by independent, higher accuracy ground survey methods, such as differential leveling. Table 2-2 summarizes the limiting vertical RMSE's for well-defined points, as checked by independent surveys at the full (ground) scale of the map.

D. Map Accuracy Testing. Horizontal and vertical accuracy is to be checked by comparing measured coordinates or elevations from the map (at its intended target scale) with coordinates determined by a check survey of higher accuracy. Comparison survey accuracies are defined by relative distance accuracy ratios, as determined from the error propagation resulting within a minimally constrained, properly weighted, least squares adjustment. (This is not the same statistic as a simple traverse or level line misclosure.)

(1) For horizontal points, the check survey should produce a standard deviation equal to or less than one-third of the limiting RMSE selected for the map. This means that the relative distance accuracy ratio of the check survey must be less than one-third that of the limiting RMSE, expressed as a function of the distance measured across the map sheet (not overall project or design file) diagonal.

(2) For example, given a 1 in. = 50 ft target scale with a required horizontal feature accuracy of 0.5 ft (i.e., Table 2-1, Class 1 accuracy) and a typical diagonal distance of 40 in. across a standard sheet, the check survey should have a relative accuracy of 1:12,000, or Second-Order, Class II (50 ft/in. by 40 in./0.5 ft/3). This accuracy level is constant for all scales plotted on a standard drawing sheet with approximately a 40 in. dimension.

(3) Only the dimensions of a typical sheet, not the overall project or design file dimensions, are

TABLE 2-2. Topographic Elevation Accuracy Requirement for Well-Defined Points

| Target CI, ft | Limiting RMSE, ft | | | | | |
| | Topographic Feature Points for Class | | | Spot or Digital Terrain Model Elevation Points for Class | | |
	1	2	3	1	2	3
0.5[a]	0.17	0.33	0.5	0.08	0.16	0.25
1	0.33	0.66	1.0	0.17	0.33	0.5
2	0.67	1.33	2.0	0.33	0.67	1.0
4	1.33	2.67	4.0	0.67	1.33	2.0
5	1.67	3.33	5.0	0.83	1.67	2.5

[a]Obtaining differential elevation accuracies at or below the 0.5-ft contour level requires specialized aircraft/platforms and/or cameras—use conventional ground topo survey methods below the 0.2-ft level.

used to compute relative line accuracies. This is true regardless of whether the data are contained in an overall digital design file—the critical parameter for engineering and construction is relative accuracy of map features within the range of a drawing/sheet.

(4) Thus for a typical 40 in. plot on a standard F-size drawing sheet, the relative line accuracy check surveys in Table 2-3 must be run to check the map product. For smaller drawing/site sizes, the relative accuracies would be adjusted downward accordingly.

(5) For vertical points, the check survey (i.e., differential leveling or electronic total station trig elevations) should produce an RMSE not greater than 1/20th of the CI, expressed relative to the longest diagonal dimension of a standard drawing sheet (approximately 40 in.). The map position of the ground point may be shifted in any direction by an amount equal to twice the limiting RMSE in horizontal position. Conventional Third-Order leveling procedures and standards will be of sufficient accuracy to provide reliable check surveys for all photogram-

metric map classes with a CI of 1 ft or larger. Again, as with horizontal evaluation, vertical check survey accuracies are relative to the area on a given map sheet, not to the overall project dimension.

(6) The same survey datums must be used for both the mapping and check surveys.

(7) Refer to Chapter 3 for additional details on map testing criteria.

E. Checkpoints. As mentioned earlier, checkpoints should be confined to well-defined points, such as road intersections, etc. Depending upon map scale, certain features will be displaced for the sake of map clarity. These points should not be used unless the rules for displacement are well known and can be counteracted. A minimum of 20 checkpoints per map sheet are required. These should be well distributed over the map sheet. Any checkpoint whose discrepancy exceeds three times the limiting RMSE should be corrected before the map is considered to meet the standard.

F. Map Testing Requirements. Tests for compliance of a map sheet are optional. One or more sheets (or segments of a design file) may be tested for compliance. The decision on whether to check work on a particular project rests with the Contracting Officer or his designated representative, and is dependent on numerous factors, such as intended design work, available personnel, known contractor capabilities, and personnel resources available for the test. Map testing can be a significant percentage of the overall project cost in some cases. Procedures for rejecting unsatisfactory work based on unacceptable map tests are contained in USACE guide specifications for surveying service contracts.

TABLE 2-3. Horizontal Control Survey Standards for 40 in. Drawing

Map Class (1)	Relative Accuracy (2)	Survey Standard (3)
1	1:12,000	2nd, Class II
2	1:6,000	3rd, Class I
3	1:4,000	3rd, Class II

G. Compliance Statement. Maps (or the appropriate digital design file descriptor level) produced to meet the ASPRS standard shall include the following statement:

THIS MAP WAS COMPILED TO MEET THE ASPRS STANDARD FOR CLASS *[__] MAP ACCURACY.

If the map was field checked and found compliant, the following additional statement shall be added:

THIS MAP WAS CHECKED AND FOUND TO CONFORM TO THE ASPRS STANDARD FOR CLASS *[__] MAP ACCURACY.

For digital products, the descriptor level should also contain the original target mapping scale along with the absolute horizontal and vertical accuracies intended or checked.

2-5. UNITED STATES NATIONAL MAP ACCURACY STANDARDS.

In 1941, a U.S. Bureau of the Budget (now OMB) circular established guidelines for maps produced by Federal civilian agencies, the United States National Map Accuracy Standards (USNMAS). These standards were developed primarily for smaller scale topographic mapping, such as the U.S. Geological Survey (USGS) 1:24,000 quadrangle mapping program. In many cases, the USNMAS have also been adapted by several non-Federal and Department of Defense agencies to their specific requirements. These standards may be used for USACE mapping at scales smaller than 1:20,000. For scales larger than 1:20,000, use of the ASPRS standards is recommended.

A. US National Map Accuracy Standards. Reproduced below are the standards:

EXECUTIVE OFFICE OF THE PRESIDENT
Bureau of the Budget
Washington, D.C. 20503

June 10, 1941 Revised April 26, 1943
 Revised June 17, 1947

UNITED STATES NATIONAL MAP ACCURACY STANDARDS

With a view to the utmost economy and expedition in producing maps which fulfill not only the broad needs for standard or principal maps, but also the reasonable particular needs of individual agencies, standards of accuracy for published maps are defined as follows:

I. Horizontal Accuracy. For maps on publication scales larger than 1:20,000, not more than 10% of the points tested shall be in error by more than 1/30 inch, measured on the publication scale; for maps on publication scales of 1:20,000 or smaller, 1/50 inch. These limits of accuracy shall apply in all cases to positions of well defined points only. "Well defined" points are those that are easily visible or recoverable on the ground, such as the following: monuments or markers, such as bench marks or property boundary monuments; intersections of roads, railroads, etc.; corners of large buildings or structures (or center points of small buildings), etc. In general what is "well defined" will also be determined by what is plottable on the scale of the map within 1/100 in. Thus while the intersection of two road or property lines meeting at right angles would come within a sensible interpretation, identification of the intersection of such lines meeting at an acute angle would obviously not be practicable within 1/100 in. Similarly, features not identifiable upon the ground within close limits are not to be considered as test points within the limits quoted, even though their positions may be scaled closely upon the map. In this class would come timberlines, soil boundaries, etc.

II. Vertical accuracy, as applied to contour maps on all publication scales, shall be such that not more than 10% of the elevations tested shall be in error more than one-half the contour interval. In checking elevations taken from the map, the apparent vertical error may be decreased by assuming a horizontal displacement within the permissible horizontal error for a map of that scale.

III. The accuracy of any map may be tested by comparing the positions of points whose locations or elevations are shown upon it with corresponding positions as determined by surveys of a higher accuracy. Tests shall be made by the producing agency, which shall also determine which of its maps are to be tested and the extent of such testing.

IV. Published maps meeting these accuracy requirements shall note this fact on their legends, as follows: "This map complies with national map accuracy standards."

V. Published maps whose errors exceed those aforestated shall omit from their legends all mention of standard accuracy.

VI. When a published map is a considerable enlargement of a map drawing (manuscript) or of a

published map, that fact shall be stated in the legend. For example, "This map is an enlargement of a 1:20,000-scale map drawing," or "This map is an enlargement of a 1:24,000-scale published map."

VII. To facilitate ready interchange and use of basic information for map construction among all Federal map making agencies, manuscript maps and published maps, wherever economically feasible and consistent with the uses to which the map is to be put, shall conform to latitude and longitude boundaries, being 15 minutes of latitude and longitude, or 7-1/2 minutes, or 3-3/4 minutes in size.

B. Compliance Statement. Maps in compliance with the USNMAS shall include the following statement:

THIS MAP COMPLIES WITH NATIONAL MAP ACCURACY STANDARDS.

2-6. AMERICAN SOCIETY OF PHOTOGRAMMETRY SPECIFICATIONS FOR AERIAL SURVEYS AND MAPPING BY PHOTOGRAMMETRIC METHODS FOR HIGHWAYS.

These standards, developed in 1968 (Photogrammetry for Highways Committee 1968), are quite similar to the DOT standards contained in paragraph 2-7. Use of these standards is optional for USACE Commands.

A. Contours. Ninety percent of the elevations determined from the solid-line contours of the topographic maps shall have an accuracy with respect to true elevation of one-half CI or better and the remaining 10% of such elevations shall not be in error by more than one CI.

B. Coordinate Grid Lines. The plotted position of each plane coordinate grid line shall not vary by more than 1/100 in. from true grid value on each map manuscript.

C. Horizontal Control. Each horizontal control point shall be plotted on the map manuscript within the coordinate grid in which it should lie to an accuracy of 1/100 in. of its true position as expressed by the plane coordinates computed for the point.

D. Planimetric Features. Ninety percent of all planimetric features that are well-defined on the photographs shall be plotted so that their position on the finished maps shall be accurate to within at least 1/40 in. of their true coordinate position, as determined by the test surveys, and none of the features tested shall be misplaced on the finished maps by

more than 1/20 in. from their true coordinate position.

E. Special Requirements. When stipulated in the contract or delivery order scope of work, all specified features shall be delineated on the maps, regardless of whether they can be seen on the aerial photographs and on stereoscopic models formed therefrom. The contractor shall complete compilation by conventional field surveys on the ground to comply with all accuracy and completeness stipulations.

F. Spot Elevations. Ninety percent of all spot elevations placed on the maps shall have an accuracy of at least one-fourth the CI, and the remaining 10% shall not be in error by more than one-half the CI.

2-7. DOT MAP STANDARDS.

In 1985, DOT published its "Surveying and Mapping Manual" (Miller 1985). Section 3-80-01 of this manual defines five types of maps: planimetric maps, whose only indication of relief is by spot heights; topographic maps, which show contours and additional spot heights as needed; cadastral maps, which show property ownership; planimetric-cadastral maps; and topographic-cadastral maps. The standards for these maps are abstracted in paragraphs A–D below. Use of these standards is optional for USACE Commands.

A. Cadastral Data. Coordinates of property boundary points must be plotted so that their distance from the nearest grid lines are not in error by more than 1/100in. The map shall show all property boundary lines connecting property boundary points. Coordinates of property boundary points may have been determined by field traverse or by analytical aerial triangulation. Owners' names or designations, coordinates, and property boundary point symbols shall be shown on the map.

B. Contours. At least 90% of all tested contours shall be in error by no more than one-half of the CI. This applies only to the contours that appear on the map, regardless of the stated CI. Contours cannot be shifted horizontally in an attempt to meet the criterion. All representable topographic features visible on the aerial photographs must be depicted on the map.

C. Spot Heights. For topographic maps, the labeled elevation of at least 90% of the spot elevations tested shall not differ from the true elevation by more than one-fourth of the CI, and none by more than one-half of the CI, or for maps produced photogrammetrically, the RMSE of the elevations of all of the spot elevations tested shall not exceed

1/5,000th of the flight height of the photography (H/5,000), whichever is less restrictive. For planimetric maps, the RMSE of the elevation in feet of all the spot elevations tested shall not exceed 1/60th of the map scale expressed in feet to 1 in., or for maps produced photogrammetrically, 1/4,000th of the flight height of the photography (H/4,000), whichever is less restrictive.

D. Coordinate Grid Lines. On the finished map, no measurement of 3 ft or less between coordinate grid lines shall differ from the correct distance by more than 1/100 in. No two measured distances of 3 ft or less, with diagonals of a rectangle bounded by coordinate grid lines, shall differ from each other by more than 1/100 in. No horizontal control point tested may be located on the finished map so that its position in relation to the adjacent coordinate grid lines differs from its true coordinate position by more than 1/100 in. The location of a control point is the center of the plotted symbol representing the control point or the center of the image of the target placed over the control point.

2-8. UNITED STATES NATIONAL CARTOGRAPHIC STANDARDS FOR SPATIAL ACCURACY.

The USNMAS is in the process of being revised. A draft for review has been prepared by USGS. These standards appear more applicable to small-scale mapping work such as that performed by the USGS. Like the ASPRS (1990) standards, this standard allows for three accuracy classifications based on RMS positional errors. The ASPRS standards may be used in lieu of the USNMAS for small-scale mapping if desired. The draft is reproduced verbatim as follows:

UNITED STATES NATIONAL CARTOGRAPHIC STANDARDS FOR SPATIAL ACCURACY

These standards concern the definitions of spatial accuracy as they pertain to cartographic data, both digital and graphic, prepared or utilized by federal agencies.

I. Horizontal Accuracy. For cartographic data intended for publication at 1:250,000 scale and larger, the root mean square (rms) error in either the x or y coordinates will not exceed 0.25 mm, measured on the intended publication scale. These limits of accuracy shall apply in all cases to positions of well-defined points.

II. Vertical Accuracy. For elevation data, the rms error will not exceed one-third of the publish-ed or planned contour interval. For purposes of checking elevations, the apparent vertical error at each test point may be reduced by shifting the position in any direction by 0.50 mm. Spot elevations shall be given within a limiting rms error of one-sixth of the published contour interval.

III. Accuracy Test. The accuracy of any cartographic product may be tested by comparing the positions or elevations of points with corresponding positions or elevations as determined by surveys of a higher accuracy. The rms error will be calculated separately for each coordinate tested using all of the test point discrepancies. Tests for compliance of a product are optional. Products may be tested for either horizontal or vertical accuracy or both.

IV. Cartographic Products. Those products meeting both horizontal and vertical accuracy requirements shall carry the note:

COMPLIES WITH NATIONAL CARTOGRAPHIC STANDARDS FOR SPATIAL ACCURACY

Products failing either horizontal or vertical accuracy requirements, or both, will display "Complies with National Cartographic Standards for Spatial Accuracy - Class ___". The rms errors for Class 2 products will not exceed 0.50 mm in the x or y coordinates and two-thirds of the contour interval in the vertical. All products that exceed those limits will be Class 3.

V. Product Series. Sample testing is permitted for determining the class level of a series of one hundred or more cartographic products that were made using similar instruments, procedures, and materials. At least 3% (but not less than 30) of the series will be tested and the call of the whole series will be based on the results. If 90% or more of the products tested meet the class intended, then the whole production group will be certified as meeting that class.

VI. Nonstandard Products. Those products produced in areas where it is impractical to meet or test for compliance with these standards (e.g. due to dense timber or foliage) will not carry an accuracy statement.

2-9. TYPICAL MAPPING SCALES, CONTOUR INTERVALS, AND ACCURACY CLASSIFICATIONS FOR USACE FUNCTIONAL APPLICATIONS.

Table 2-4 depicts typical mapping parameters for various USACE engineering, construction,

TABLE 2-4. Typical USACE Surveying and Mapping Requirements for Military Construction, Civil Works, Operations, Maintenance, Real Estate, and HTW Projects

Project or Activity (1)	Typical Target (Plot) Map Scale 1 in = x ft (2)	Feature Location Tolerance[2] ft-RMS (3)	USACE Control Survey[3] Accuracy (4)	Feature Elevation Tolerance[4] ft-RMS (5)	USACE Control Survey[3] Accuracy (6)	Typical Contour Interval, ft (7)	ASPRS Map Accuracy Class (8)
Military Construction (MCA, MCAF, OMA, OMAF):							
Design and Construction of New Facilities: Site Plan Data for Direct Input into CADD 2-D/3-D Design Files							
General Site Plan Feature and Topo Detail	30–50	0.1–0.5	3rd - I	0.1–0.3	3rd	1	1 or 2
Surface/Subsurface Utility Detail	30–50	0.2–0.5	3rd - I	0.1–0.2	3rd	N/A	1
Building or Structure Design	20–50	0.05–0.2	3rd - I	0.1–0.3	3rd	1	1
Airfield Pavement Design Detail	20–40	0.05–0.1	3rd - I	0.05–0.1	2nd	0.5–1	1
Grading and Excavation Plans (Roads, Drainage, etc.)	30–100	0.5–2	3rd - I or II	0.2–1	3rd	1–2	2
Maintenance and Repair (M&R), or Renovation of Existing Structures, Roadways, Utilities, etc., for Design/Construction Plans and Specifications (P&S)	30–50	0.1–0.5	3rd - I	0.1–0.5	3rd	1	1
Recreational Site P&S (Golf Courses, Athletic Fields, etc.)	100	1–2	3rd - II	0.2–2	3rd	2–5	2
Training Sites, Ranges, Cantonment Areas, etc.	100–200	1–5	3rd - II	1–5	3rd	2	2 or 3
Installation Master Planning and Facilities Management Activities (Including AM/FM and GIS Feature Applications)							
General Location Maps for Master Planning Purposes	100–400	2–10	3rd - II	1–10	3rd	2–10	2 or 3

(Continued)

TABLE 2-4. (Continued)

Project or Activity (1)	Typical Target (Plot) Map Scale 1 in = x ft (2)	Feature Location Tolerance[2] ft-RMS (3)	USACE Control Survey[3] Accuracy (4)	Feature Elevation Tolerance[4] ft-RMS (5)	USACE Control Survey[3] Accuracy (6)	Typical Contour Interval, ft (7)	ASPRS Map Accuracy Class (8)
Space Management (Interior Design/Layout)	10–50	0.05–1	Relative to Structure	N/A	N/A	N/A	N/A
Installation Surface/Subsurface Utility Maps (As-builts; Fuel, Gas, Electricity, Communications, Cable, Storm Water, Sanitary, Water Supply, Treatment Facilities, Meters, etc.)	50–100 (DA) 50 (USAF)	0.2–1	3rd - I	0.2	3rd	1	1
Architectural Drawings (Reference ER 1110-345-710):							
Floor Plans, Roof Plans, Exterior Elevations, Cross Sections	1/16" to 1/4" per ft	—	—	—	—	—	—
Wall Sections	1/2" per ft	—	—	—	—	—	—
Stair Details	3/4" per ft	—	—	—	—	—	—
Detail Plans	3/4" to 3" per ft	—	—	—	—	—	—
Area-/Installation-/Base-Wide Mapping Control Network to Support Overall GIS and AM/FM Development[5]	N/A	Varies 1–200	3rd - I or 2nd - II	Varies 1–10	2nd or 3rd	1–10	2 or 3
Housing Management (Family Housing, Schools, Boundaries, and Other Installation Community Services)	100–400	10–50	4th	N/A	4th	N/A	3
Environmental Mapping and Assessments	200–400	10–50	4th	N/A	4th	N/A	3

(Continued)

TABLE 2-4. (Continued)

Project or Activity (1)	Typical Target (Plot) Map Scale 1 in = x ft (2)	Feature Location[2] Tolerance ft-RMS (3)	USACE Control Survey[3] Accuracy (4)	Feature Elevation[4] Tolerance ft-RMS (5)	USACE Control Survey[3] Accuracy (6)	Typical Contour Interval, ft (7)	ASPRS Map Accuracy Class (8)
Emergency Services (Military Police, Crime/Accident Locations, Emergency Transport Routes, Post Security Zoning, etc.)	400–2,000	50–100	4th	N/A	4th	N/A	3
Cultural, Social, Historical (Other Natural Resources)	400	20–100	4th	N/A	4th	N/A	3
Runway Approach and Transition Zones; General Plans/Sections[6]	100–200	5–10	3rd - II	2–5	3rd	5	2 or 3
Civil Works Design, Construction, Operations and Maintenance Activities							
Site Plan Mapping for Design Memoranda, Contract Plans and Specifications, etc.—for Input to CADD 2-D/3-D Design Files							
Locks, Dams, Flood Control Structures; Detail Design Plans	20–50	0.05–1	2nd - II	0.01–0.5	2nd or 3rd	0.5–1	1
Grading/Excavation Plans	100	0.5–2	3rd - I	0.2–1	3rd	1–5	1
Spillways, Concrete Channels, Upland Disposal Areas	50–100	0.1–2	2nd - II	0.2–2	3rd	1–5	1
Construction In-place Volume Measurement	40–100	0.5–2	3rd - I	0.5–1	3rd	N/A	1
River and Harbor Navigation Projects: Site Plan Mapping Design, Operation, or Maintenance of Flood Control Structures, Canals, Channels, etc.—for Contract Plans or Reports							
Levees and Groins (New Work or Maintenance Design Drawings)	100	1–2	3rd - II	0.5–1	3rd	1–2	2

(Continued)

TABLE 2-4. (Continued)

Project or Activity (1)	Typical Target (Plot) Map Scale 1 in = x ft (2)	Feature Location Tolerance[2] ft-RMS (3)	USACE Control Survey[3] Accuracy (4)	Feature Elevation Tolerance[4] ft-RMS (5)	USACE Control Survey[3] Accuracy (6)	Typical Contour Interval, ft (7)	ASPRS Map Accuracy Class (8)
Canals and Waterway Dredging (New Work Base Mapping)[7]	100	2	3rd - II	0.5	3rd	1	3
Canals and Waterway Dredging (Maintenance Drawings)	200	2	3rd - II	0.5	3rd	1	3
Beach Renourishment/Hurricane Protection Projects	100–200	2	3rd - II	0.5–1	3rd	1	2
Project Condition Reports (Base Mapping for Plotting Hydrographic Surveys: Line Maps or Air Photo Plans)	200–1,000	5–50	3rd - II	0.5–1	3rd	1–2	3
Revetment Clearing, Grading, and As-Built Protection	100–400	2–10	3rd - II	0.5–1	3rd	1–2	3
Geotechnical and Hydrographic Site Investigation Surveying Accuracies							
Hydrographic Contract Payment and P&S Surveys	—	10	N/A	0.5	N/A	1	N/A
Hydrographic Project Condition Surveys	—	20	N/A	1.0	N/A	1	N/A
Hydrographic Reconnaissance Surveys	—	300	N/A	1.5	N/A	1	N/A
Geotechnical Investigative Core Borings	—	5–10	4th	0.1–0.5	3rd or 4th	1–5	N/A
General Planning and Feasibility Studies, Reconnaissance Reports, Permit Applications, etc.	100–400	2–10	3rd - II	0.5–2	3rd	2–10	3
Civil Works Projects—GIS Feature Mapping							
Area/Project-Wide Mapping Control Network to Support Overall GIS Development	N/A	Varies 1–100	2nd - I or 2nd - II	Varies 1–10	2nd	1–10	2 or 3

(Continued)

TABLE 2-4. (Continued)

Project or Activity (1)	Typical Target (Plot) Map Scale 1 in = x ft (2)	Feature Location Tolerance[2] ft-RMS (3)	USACE Control Survey[3] Accuracy (4)	Feature Elevation Tolerance[4] ft-RMS (5)	USACE Control Survey[3] Accuracy (6)	Typical Contour Interval, ft (7)	ASPRS Map Accuracy Class (8)
Soil and Geologic Classification Maps, Well Points	400	20–100	4th	N/A	4th	N/A	3
Cultural and Economic Resources, Historic Preservation	1,000	50 -100	4th	N/A	4th	N/A	3
Land Utilization GIS Classifications; Regulatory Permit General Locations	400–1,000	50–100	4th	N/A	4th	N/A	3
Socio-economic GIS Classifications	1,000	100	4th	N/A	4th	N/A	3
Land Cover Classification Maps	400–1,000	50–200	4th	N/A	4th	N/A	3
Archeological or Structure Site Detail Mapping (Including Nontopographic, Close Range, Photogrammetric Mapping)	0.5–10	0.01–0.5	2nd - I or II	0.01–0.5	2nd	0.1–1	1
Structural Deformation Monitoring Studies/Surveys[8]	Large-scale vector movement diagrams or tabulations					(Long-Term Movement)	
Reinforced Concrete Structures (Locks, Dams, Gates, Intake Structures, Tunnels, Penstocks, Spillways, Bridges, etc.)		0.001	N/A[9]	0.001	N/A[9]	0.01–0.1	N/A
Earth/Rock Fill Structures (Dams, Floodwalls, Levees, etc.)		0.01–0.2	N/A	0.01–0.1	N/A	0.1	N/A
Flood Control and Multipurpose Project Planning, Floodplain Mapping, Water Quality Analysis, and Flood Control Studies	400–1,000	20–100	3rd - I	0.2–2	2nd or 3rd	2–5	3
Federal Emergency Management Agency Flood Insurance Studies	400	20	3rd - I	0.5	3rd	4	3

(Continued)

TABLE 2-4. (Continued)

Project or Activity (1)	Typical Target (Plot) Map Scale 1 in = x ft (2)	Feature Location Tolerance[2] ft-RMS (3)	USACE Control Survey[3] Accuracy (4)	Feature Elevation Tolerance[4] ft-RMS (5)	USACE Control Survey[3] Accuracy (6)	Typical Contour Interval, ft (7)	ASPRS Map Accuracy Class (8)
Real Estate Activities (Acquisition, Disposal, Management, Audit)[10]							
Tract Maps, Individual, Detailing Installation or Reservation Boundaries, Lots, Parcels, Adjoining Parcels, and Record Plats, Utilities, etc.	50–400[11]	0.05–2	3rd - I or II	0.1–2	3rd	1–5	1
Condemnation Exhibit Maps	50–400	0.05–2	3rd - I or II	0.1–2	3rd	1–5	1
Guide Taking Lines (for Fee and Easement Acquisition) **Boundary Encroachment Maps**	20–100	0.1–1	3rd - I or II	0.1–1	3rd	1	1
Real Estate GIS or LIS General Feature Mapping Land Utilization and Management Forestry Management Mineral Acquisition	200–1,000	50–100	4th	N/A	4th	N/A	3
General Location or Planning Maps	1:24,000 (USGS)	50–100	N/A	5–10	3rd	5–10	—
Easement Areas and Easement Delineation Lines	100	0.1–0.5	3rd-I or II	0.1–0.5	3rd	—	2
Hazardous and Toxic Waste (HTW) Site Investigation, Modeling, and Cleanup Activities							
General Detailed Site Plan Mapping (HTW Sites, Asbestos, etc.)	5–50	0.2–1	2nd - II	0.1–0.5	2nd or 3rd	0.5–1	1
Subsurface Geotoxic Data Mapping (Modeling)	20–100	1–5	3rd - II	1–2	3rd	1–2	1

(Continued)

TABLE 2-4. (Continued)

Project or Activity (1)	Typical Target (Plot) Map Scale[1] 1 in = x ft (2)	Feature Location[2] Tolerance ft-RMS (3)	USACE Control Survey[3] Accuracy (4)	Feature Elevation[4] Tolerance ft-RMS (5)	USACE Control Survey[3] Accuracy (6)	Typical Contour Interval, ft (7)	ASPRS Map Accuracy Class (8)
Contaminated Ground Water Plume Mapping (Modeling)	20–100	2–10	3rd - II	1–5	3rd	1–2	2
General HTW Site Planning, Reconnaissance Mapping, etc.	50–400	2–20	3rd - II	2–20	3rd	2–5	2
Emergency Operation Management Activities							
(Use basic GIS data base requirements defined above)							

[1] Target map scale is that contained in CADD, GIS, and/or AM/FM layer, and/or to which ground topo or aerial photography accuracy specifications are developed. This scale may not always be compatible with the feature location/elevation tolerances required. In many instances, design or real property features are located to a far greater relative accuracy than that which can be scaled at the target (plot) scale, such as property corners, utility alignments, first-floor or invert elevations, etc. Coordinates/elevations for such items are usually directly input into a CADD or AM/FM data base.

[2] The map location tolerance (or precision) of a planimetric feature is defined relative to two adjacent points within the confines of a structure or map sheet, not to the overall project or installation boundaries. Relative accuracies are determined between two points that must functionally maintain a given accuracy tolerance between themselves, such as adjacent property corners; adjacent utility lines; adjoining buildings, bridge piers, approaches, or abutments; overall building or structure site construction limits; runway ends; catch basins; levee baseline sections; etc. The tolerances between the two points are determined from the end functional requirements of the project/structure (e.g., field construction/fabrication, field stakeout or layout, alignment, locationing, etc.). Few engineering, construction, or real estate projects require that relative accuracies be rigidly maintained beyond a 5,000-ft range, and usually only within the range of the detailed design drawing for a project/structure (or its equivalent CADD design file limit). For example, two catch basins 200 ft apart should be located to 0.1 ft relative to each other, but need only be known to ±100 ft relative to another catch basin 5 miles away. Likewise, relative accuracy tolerances are far less critical for small-scale GIS, LIS, and AM/FM data elements. Actual construction alignment and grade stakeout will generally be performed to the 0.1- or 0.01-ft levels, depending on the type of construction.

[3] USACE control survey accuracy refers to the procedural and closure specifications needed to obtain/maintain the relative accuracy tolerances needed between two functionally adjacent points on the map or structure, for construction or layout. Usually Third-Order control procedures (horizontal and vertical) will provide sufficient accuracy for most work, and in many instances of small-scale mapping or GIS rasters, Third-Order, Class II methods and Fourth-Order topo/construction control methods may be used. Base- or area-wide mapping control procedures shall be designed and specified to meet functional accuracy tolerances within the limits of the structure, building, or utility distance involved for design, construction, or real estate surveys. Higher order control surveys shall not be specified for area-wide mapping or GIS definition unless a definitive functional requirement exists (e.g., military operational targeting or some low-gradient flood control projects).

(Continued)

TABLE 2-4. (Continued)

[4] (See note 2.) Some flood control projects may require better relative accuracy tolerances than those shown.

[5] GIS raster or vector features generally can be scaled or digitized from any existing map of the installation. Typically, a standard USGS 1 in. = 2,000 ft scale quadrangle map is adequate given the low relative accuracies needed between GIS data features, elements, or classifications. Relative or absolute GPS positioning (10 to 300 ft) may be adequate to tie GIS features where no maps exist. In general, a basic area- or installation-wide Second- or Third-Order control network is adequate for all subsequent engineering, construction, real estate, GIS, and/or AM/FM control.

[6] Typical requirements for general approach maps are 1:50,000 (H) and 1:1,000 (V); detail maps at 1:5,000 (H) and 1:250 (V).

[7] Table refers to base maps upon which subsurface hydrographic surveys are plotted, not to hydrographic survey control.

[8] Long-term structural movements measured from points external to the structure may be tabulated or plotted in either X-Y-Z or by single vector movement normal to a potential failure plane. Reference EM 1110-2-4300 and EM 1110-2-1908 for stress-strain, pressure, seismic, and other precise structural deflection measurement methods within/between structural members, monoliths, cells, embankments, etc.

[9] Accuracy standards and procedures for structural deformation surveys are contained in EM 1110-1-1004. Horizontal and vertical deformation monitoring survey procedures are performed relative to a control network established for the structure. Ties to the National Geodetic Reference System or National Geodetic Vertical Datum of 1929 are not necessary other than for general reference, and then need only USACE Third-Order connection.

[10] Real property surveys shall conform to local/state minimum technical standards, where prescribed by law or code.

[11] A 1 in. = 100 ft scale is recommended by ER 405-1-12. Smaller scales should be on even 100-ft increments.

19

TABLE 2-5. Selection of CI

CI, ft (1)	General Purpose (2)
1	Final design, excavation and grading plans, earthwork computations for bid estimates, and contract measurement and payment.
2	Route location, preliminary alignment and design.
4-5	Preliminary project planning, hydraulic sections, rough earthwork estimating.
10-20	High-gradient terrain, low unit cost earthwork excavation estimates, scaled/digitized directly from existing USGS quad maps.

and real estate mapping applications. The table is intended to be a general guide in selecting a target scale for a specific project; numerous other project-specific factors may dictate variations from these general values. The table does not apply exclusively to photogrammetric mapping activities—some of the required surveying and mapping accuracies identified exceed those obtainable from photogrammetry and may need to be obtained using conventional surveying techniques. Selection of an appropriate CI is extremely site-dependent, and will directly impact the mapping costs since the photo negative scale (and resultant model coverage and ground survey control) is determined as a function of this parameter. Table 2-5 may be used as general guidance in selecting a CI (or Digital Terrain Mapping (DTM) elevation accuracy, as applicable). See also additional guidance in subsequent chapters dealing with photo mapping planning and cost estimating.

2-10. SUPPLEMENTAL USACE PHOTOGRAMMETRIC MAPPING CRITERIA.

The following criteria shall be followed (and/or referenced) in preparing contract specifications or delivery order scopes of work for photogrammetric mapping services.

A. Non-SI/SI Conversion. Conversions between non-SI units and SI units of measure shall be as follows:

(1) 1 in. = 25.4 mm exactly

(2) 1 International Foot = 0.3048 m exactly

(3) 1 U.S. Survey Foot = 1,200/3,937 m exactly

B. Maximum Enlargement for Map Compilation From Negative to Map Scale. The maximum enlargement from original negative scale to final map scale shall conform to Table 2-6.

C. Maximum Allowable C-Factor Ratios. The C-factor ratios in Table 2-7 shall not be exceeded for any class of photogrammetric mapping used for engineering and design.

D. Minimum Negative Scales for Planimetry. Table 2-8 depicts the minimum allowable negative scale (and related flight altitude for a 6 in. focal length camera) for a given target mapping scale. These minimum scales are based on prescribed enlargement limitations given in Table 2-6, and are intended for large-scale engineering and design site plan mapping work. The negative scale shown in the table is simply computed by multiplying the target scale times the maximum allowable enlargement ratio prescribed in Table 2-6.

E. Minimum Negative Scale for Topographic Development. The minimum negative scales in Table 2-9 shall be used relative to the vertical contour accuracy intended for the product. These limiting negative scales, along with limitations based on the planimetric component, will be used in determining the optimum negative scale for a project. The limiting negative scales are computed based on the prescribed C-factor ratio limits given in Table 2-7 (multiplied by the CI and divided by 6). In some instances, a different scale will be flown for the horizontal planimetry and for the vertical topography. This most often occurs when a 1 ft CI is required at a relatively small mapping scale, say 1 in. = 100 to 200 ft.

F. Photo Control Survey Standards and Specifications. In general, Third-Order control surveys will be adequate for controlling most large-scale photogrammetric mapping projects.

TABLE 2-6. Maximum Enlargement Ratios from Photographic Scale to Map Scale

Instrument Type	Measurement Accuracy at Photo Scale mm	Maximum Enlargement Photo to Map		
		Map Class	Planimetric Map	Topographic Map
Analytical Stereoplotter	0.003–0.005	1	7	—[1]
		2	8	
		3	9	
Analog Stereoplotter (Mechanical First-Order)	0.010–0.015	1	6	—[1]
		2	7	
		3	8	
Air Photo Plan Sheets (Optimum)	N/A	N/A	4	—
	N/A	N/A	1.5	—
Ortho Photos	—	1	4	—
	—	2	6	—
	—	3	8	—
Second-Order Mechanical Stereoplotter[2]	0.015–0.025	1	5	4
		2	6	5
		3	7	6
Third-Order Direct-Optical Stereoplotter[2]	0.030–0.050	1	N/A	N/A
		2	5	N/A
		3	5	5

[1] Topographic enlargement limitations are a function of the CI and C-factor (Table 2-9).

[2] These older, near-obsolete types of plotters should not be specified in a USACE photogrammetric mapping service contract.

USACE survey standards and specifications for engineering and construction surveying are in the process of being developed. These standards will be based on relative loop closure criteria rather than Federal Geodetic Control Committee (FGCC) relative line accuracy criteria. The FGCC standards (1984) may be used pending development of USACE survey standards.

G. Aerotriangulation Accuracy Standards. Aerotriangulation accuracy for each class of map and orthophotograph shall conform to Table 2-10.

2-11. USACE ORTHOPHOTO AND ORTHOPHOTO MAP ACCURACY STANDARDS.

This section sets forth the standards for orthophotos and orthophoto maps. Each orthophoto shall meet the quality and precision specified in the contract. USACE standards for orthophoto mapping will conform to the USNMAS. A USACE Class 1 ortho-

TABLE 2-7. Maximum C-Factor Ratios (Denominator)

Stereoplotter (1)	Class 1 (2)	Class 2 (3)	Class 3 (4)
Analytical	2000	2200	2500
First-Order Analog/ Mechanical	1600	1800	2000

TABLE 2-8. Minimum Negative Scales and Maximum Flight Altitudes for Planimetric Mapping

Target Scale 1 in. = x ft (1)	First-Order Analog/Mechanical			Analytical		
	Class 1 (2)	Class 2 (3)	Class 3 (4)	Class 1 (5)	Class 2 (6)	Class 3 (7)
5	—	—	—	—	—	—
10	—	—	—	—	—	—
20	—	—	—	140 [840]	160 [960]	180 [1,080]
30[a]	—	—	—	210 [1,260]	240 [1,440]	270 [1,620]
40	240 [1,440]	280 [1,680]	320 [1,920]	280 [1,680]	320 [1,920]	360 [2,160]
50	300 [1,800]	350 [2,100]	400 [2,400]	350 [2,100]	400 [2,400]	450 [2,700]
60	360 [2,160]	420 [2,520]	480 [2,880]	420 [2,520]	480 [2,880]	540 [3,240]
100	600 [3,600]	700 [4,200]	800 [4,800]	700 [4,200]	800 [4,800]	900 [5,400]
200	1,200 [7,200]	1,400 [8,400]	1,600 [9,600]	1,400 [8,400]	1,600 [9,600]	1,800 [10,800]
400	2,400 [14,400]	2,800 [16,800]	3,200 [19,200]	2,800 [16,800]	3,200 [19,200]	3,600 [21,600]
>400[b]						

Notes:

1. Minimum negative scale in feet per inch shown above maximum flight altitude in feet shown in brackets.

[a] Mapping scales larger than 1 in. = 30 ft require nonstandard aircraft, special cameras and mounts, close-range photogrammetry, and/or ground survey methods. These large scales are difficult to obtain from fixed-wing aircraft due to low-altitude restrictions and image motion.

[b] Scales above 1 in. = 400 ft are not generally applicable to detailed design work, but are for general location or feasibility planning mapping. Specially equipped aircraft will be required at the higher altitudes. Twelve-inch (or longer) focal length cameras may also be used for these small-scale maps.

photo map is equivalent to the USNMAS. Two lower-order USACE orthophoto map classes are added to the USNMAS. Use the guidance shown in Table 2-11 to determine if simple or differential rectification is required. Differentially rectified (controlled) orthophotos or orthophoto maps should not be specified when less costly semicontrolled or uncontrolled air photo enlargement plans would suffice. Additional orthophoto mapping criteria are found in Chapter 9.

A. Photographic Detail. The ground surface, vegetation, culture, and all other details shall be clearly discernable.

**TABLE 2-9. Minimum Negative Scale and Maximum Flight Altitudes
for Topographic Development**

| CI, ft (1) | First-Order Analog/Mechanical | | | Analytical | | |
	Class 1 (2)	Class 2 (3)	Class 3 (4)	Class 1 (5)	Class 2 (6)	Class 3 (7)
1/2	133 [800]	150 [900]	167 [1,000]	167 [1,000]	183 [1,100]	208 [1,250]
1	267 [1,600]	300 [1,800]	333 [2,000]	333 [2,000]	367 [2,200]	417 [2,500]
2	533 [3,200]	600 [3,600]	667 [4,000]	667 [4,000]	733 [4,400]	833 [5,000]
4	1,067 [6,400]	1,200 [7,200]	1,333 [8,000]	1,333 [8,000]	1,467 [8,800]	1,667 [10,000]
5	1,333 [8,000]	1,500 [9,000]	1,667 [10,000]	1,667 [10,000]	1,833 [11,000]	2,083 [12,500]
10	2,667 [16,000]	3,000 [18,000]	3,333 [20,000]	3,333 [20,000]	3,667 [22,000]	4,167 [25,000]

Note:
1. For each CI, the minimum negative scale in feet per inches is shown above the maximum flight altitude in feet in brackets; based on a standard 6-in. focal length camera.

B. Accuracy. Orthophotos shall depict all visible image features in the correct planimetric position to the accuracy specified in subparagraph C below. Image displacements caused by ground relief and by tilt shall be removed. Topographic line and point data shall meet the topographic map standards previously set forth in this chapter.

C. Orthophoto Accuracy Classes. For Class 1 orthophotos, 90% of all photographic details on the orthophotograph shall be accurate to within at least 1/40 in. of true position, as determined by test surveys, and none of the photographic details shall be displaced by more than 1/20 in. from true coordinate position. Class 2 and Class 3 accuracy standards shall be two and three times Class 1 standards, respectively. Table 2-12 summarizes these standards. Class 1 orthophotos will generally be required only when de-

TABLE 2-10. Aerotriangulation Accuracy Criteria

| Map Class (1) | Aerotriangulation Method (2) | Allowable Error at Control and Test Points | | | |
| | | Horizontal | | Vertical | |
		RMSE (3)	Maximum (4)	RMSE (5)	Maximum (6)
1	Fully Analytical	H/10,000	3 RMSE	H/9,000	3 RMSE
2	Fully Analytical	H/8,000	3 RMSE	H/6,000	3 RMSE
3	Fully Analytical or Semianalytical	H/6,000	3 RMSE	H/4,500	3 RMSE

TABLE 2-11. Requirements for Differential Rectification Based on Project Relief

Scale ft/in. (1)	Differential Rectification Required if Relief Exceeds Amount Shown (in feet)—Otherwise Use Simple Rectification		
	Class 1 (2)	Class 2 (3)	Class 3 (4)
50	1.5	3	4.5
100	3	6	9
200	6	12	18
400ᵃ	12	24	36
1,000ᵃ	30	60	90

ᵃAt scales smaller than 400 ft/in., which are used only for general site reference, simple air photo enlargements should be used in lieu of costly orthophoto differential rectification. Simple air photo plans may be controlled (rectified to photo identifiable ground control), semicontrolled (rectified to USGS 1:24,000 maps), or uncontrolled (no rectification).

tailed design is superimposed on the print, usually at scales greater than 100 ft/in. Since the orthophoto process rectifies images at the ground elevation of a DTM scan, accuracy standards must exclude objects above and below the scan elevation, such as tops of buildings, poles, trees, and other like objects.

D. Compliance Statement. Orthophoto maps in compliance with the USNMAS shall include the following statement:

THIS ORTHOPHOTO MAP COMPLIES WITH NATIONAL MAP ACCURACY STANDARDS.

(1) Maps found compliant with a USACE Class 2 or Class 3 orthophoto map accuracy standard will include the following statement:

TABLE 2-12. Summary of Orthophoto and Orthophoto Map Accuracy at Publication Scale

Class (1)	Accuracy	
	Percent (2)	In. (3)
1	90	1/4
	100	1/20
2	90	1/20
	100	1/10
3	90	1/13
	100	1/6

THIS ORTHOPHOTO COMPLIES WITH USACE STANDARD FOR CLASS *[__] ACCURACY.

(2) The compliance statement shall refer to the data of lowest accuracy depicted on the orthophoto.

(3) Published maps whose errors exceed those aforestated shall omit from their legends all mention of standard accuracy.

E. Scan Lines. The final orthophoto (map) shall not contain scan lines and mismatched imagery that interfere with the interpretability of ground features or that are aesthetically objectionable. Mismatches exceeding 1/20 in. are generally unacceptable and may be cause for rejection.

F. Photographic Tone. The photographic negative of the orthophotograph shall have uniform color tone, and shall have the appropriate degree of contrast that will cause all details to show clearly in the dark-tone areas and in the highlight areas as well as in the halftones between the dark and highlight. Negatives having excessive contrast or low contrast may be rejected. Exposure scan lines shall not be noticeable or detracting from the photographic details.

G. Artifacts. The orthophoto (map) shall not contain out-of-focus imagery, dust marks, scratches, and inconsistencies in tone and density between individual orthophotos and/or adjacent map sheets.

H. Enlargement Ratio. The enlargement from the aerial negative to orthophoto publication scale shall not exceed four times for Class 1, six times for Class 2, and eight times for Class 3.

I. Obscured Cultural and Other Topographic Data. Data obscured on the aerial photographs shall be added to the orthophoto map in conventional graphical form. If a building or other nonlinear feature is partly obscured, its entire outline or other representation shall be graphical. These data shall be from field surveys on the ground, previously compiled line data (separates, etc.), or photogrammetric stereocompilation.

J. Photographic Film. Only fine-grain photographic film on a dimensionally stable base shall be used for exposing the initial negative of each orthophotograph as it is compiled. Outdated film shall not be used.

K. Sample Orthophotos. Image quality and exposure shall not be less than that provided to USACE by the Contractor as sample orthophotography if this is a required submittal item during contract negotiations.

L. Digital Resampling. Orthophotographs that have been created by digital processing shall have been resampled by bilinear, cubic convolution, or equivalent algorithm. Nearest neighbor resampling shall not be acceptable.

M. Screening. Final reproducible sheets shall be halftone-screened positives on a polyester base with a minimum thickness of 0.004 in. Screening shall be 120 lines per inch, unless otherwise specified by contract. For composite orthophoto and contour reproducibles, only the photographic image shall be halftone screened.

2-12. USACE DIGITAL DATA PRODUCT ACCURACY STANDARDS.

A. General. A DTM shall consist of three-dimensional coordinates of points taken in a specified pattern and recorded on a computer-compatible media.

B. Coordinate Systems. A DTM shall consist of three coordinates for each point measured, recorded on the specified media. Coordinates shall be in the system authorized for the project. Elevations and horizontal coordinates shall be recorded to the nearest 1/10 ft or better at ground scale. For small-scale mapping, elevations may be recorded to the nearest foot.

C. Grid. The horizontal coordinate system for a grid DTM shall have its axes parallel to the axes of the grid.

D. Cross Sections. Horizontal coordinates for cross sections shall be center-line or baseline stationing, and offset from center line or baseline. All offsets left of center line shall be negative and all offsets right of center line must be positive, unless otherwise approved by the USACE Contracting Officer.

E. Remeasurement. The coordinate system for remeasurement shall be the same as was used for the original measuring. Elevations shall be taken at the same points on the grid or along the same cross sections that were measured for original data. In addition, measurements shall be taken along the grid lines or cross-section lines at the change from original ground to earthwork and at significant breaks in the earthwork surface.

F. Critical Points. Coordinates shall be measured and recorded for enough points to define the topography completely and accurately. Break (hinge) lines (along crests, valleys, etc.) shall be defined by points at all breaks, and all points making up the same break line shall be so identified. In addition, other points shall be measured and recorded to define the shape of the terrain between break lines. The maximum spacing of points shall be as specified by USACE.

G. Obscured Areas. When the DTM model is produced photogrammetrically, and there are areas where structures, brush, or tree cover obscure the ground so that the DTM cannot be measured completely and accurately from the photographs, the data necessary to complete the work shall be secured by ground surveys.

H. Accuracy. The RMSE in feet of the elevations of all points tested shall not exceed the limit specified in the contract or delivery order. No individual error shall exceed three times the specified limit for RMSE. The average error (the algebraic sum of the individual test point errors, taking into consideration their signs, divided by the number of test points) shall not exceed 0.3 times the specified limit for the RMSE. The RMSE and the average error for any individual cross section or any individual group of grid points shall not exceed twice the limits established for the entire DTM.

I. Recordation of Data. Stereoplotters used to measure coordinates photogrammetrically shall be equipped with encoders that sense the instrument settings and transmit them in digital form. The coordinates shall be recorded by the stereoplotter directly onto the media.

2-13. PHOTOGRAMMETRIC MAPPING COVERAGE.

Table 2-13 depicts various aerial photo mapping parameters that may be used for mission planning purposes.

TABLE 2-13. Standard Photogrammetric Mapping Coverage Parameters

Photo Negative Scale, ft/in. (1)	9 by 9 in. Full Photo Width ft sq (2)	9 by 9 in. Full Photo Coverage acres (3)	Flight Line Spacing, ft (4)	Lineal Gain Per Exposure, ft (5)	Net Model Gain acres (6)
166	1,500	52	1,050	600	15
200	1,800	74	1,260	720	20
250	2,250	116	1,575	900	32
300	2,700	167	1,890	1,080	46
400	3,600	297	2,520	1,440	83
500	4,500	465	3,150	1,800	130
600	5,400	669	3,780	2,160	187
1,000	9,000	1,860	6,300	3,600	520
1,200	10,800	2,678	7,560	4,320	750
1,667	15,000	5,165	10,500	6,000	1,446
2,000	18,000	7,438	12,600	7,200	2,082

Notes:

1. Coverage parameters based on standard 6-in. camera, 9- by 9-in. negative size, 60% end lap, and 30% side lap. Net Model Gain = 28% (i.e., 0.4 by 0.7) of full photo coverage.

2. 1 acre = 43,560 sq ft

3. 1 square mile (or section) = 640 acres

CHAPTER 3

QUALITY CONTROL AND QUALITY ASSURANCE STANDARDS

3-1. GENERAL.

If good QC procedures are designed and adhered to, then a quality mapping product is assured. Overall QC is the responsibility of the mapping contractor, and is exercised at specific stages of the map production process. The Government's role during data acquisition and map/data base compilation should generally be limited to performing QA, which may involve only cursory spot-checking of the maps, or to performing formal field map testing using Government or third-party forces. The scope of contractor QC and Government QA effort is driven by the functional uses of the end product, acceptable omissions, and accuracy tolerances. Since there is no perfect map product, the magnitude of QC and QA performed must be economically commensurate with the mapping and/or engineering project.

A. Minimizing Rework. Proper QC does not increase the cost of the product. The earlier in the production process a mistake, blunder, or carelessness is caught, the less rework and the less the final cost (whether the cost of rework is borne by the Government or by the contractor). When defects must be reworked, increased cost through lowered productivity results. By reducing waste, cost will also be reduced.

B. Categories of Quality Control. Quality control on photo mapping work may be divided into two categories: process control and product assurance.

(1) Process quality control. Process QC is primarily the responsibility of the contractor. This includes contractor QC reviews of flight alignments, photographic quality, stereocompilation, map accuracy, and map completeness. The degree of QC required of the contractor will be governed by the contract specifications, and should be developed based on the end functional use of the map product. On projects involving utility relocations, contractor field map classification and edit would be critical, and labor for this work must be scheduled in the contract or delivery order. For a small-scale Geographic Information System (GIS) developing land use classifications, extensive field edit would not be necessary. Because of limited USACE resources, QC responsibility is usually fully placed on the contractor. Some Federal agencies maintain QC; however, this is usually due to their use of low-bid mapping procurement rather than qualification-based methods used in USACE. For example, the Government may require its inspection of the photographs prior to the contractor's beginning to triangulate or to compile; submission of field survey data for its review and approval; a printout of the aerotriangulation adjustment prior to continuation; or a phased delivery and inspection of a percentage of the mapping or other products before authorizing the remainder. However, this type of control by the Government of the contractor's interim work phases may prove counterproductive, and should not be exercised except on large and critical mapping projects. In addition, the Government must possess the in-house technical expertise to reliably assess interim submittals by the contractor.

(2) Product quality assurance. The Government's primary role is that of product QA. Product quality will be assured by the Government using a variety of inspection and testing techniques on the final deliverables. The Government may perform product QA using Government employees or third-party contractors, or through agreement with, and oversight by, the photogrammetric mapping contractor. Product assurance checks, tests, or field inspections are called for in the contract; however, the Government has the option to waive any or all tests and accept the delivered product without formal field testing/checking.

3-2. CONTRACTOR QUALITY CONTROL.

The contractor will be responsible for internal QC functions involved with field surveying, photogra-

phy and laboratory processing, stereocompilation, drafting, and field checking and editing of the photogrammetrically made measurements and compiled maps to ascertain their completeness and accuracy. Also, the contractor will make the additions and corrections that are required to complete the maps and photogrammetrically made measurements.

3-3. QUALITY ASSURANCE OF MAPS.

The mapping contractor is responsible for assuring, through QC efforts, that deliverables meet the required accuracy and content specifications. The Government may perform such QA checks as necessary to verify the quality of maps by final inspection and/or testing of the delivered products. Because of Government resource and economic limitations, formal QA checking or testing described in paragraph C below is optional, even though it may be called for in the contract. On many projects, the contractor's QC program may be deemed sufficient to assure the adequacy of the product. Cursory field spot checks by the Government may be adequate on other projects. If excessive errors or omissions are suspected or uncovered, then formal field testing may have to be performed unless the contractor willingly corrects any such deficiencies.

A. Applicable Standards. The USACE standards delineated in Chapter 2 will be the applicable standards for quality control and subsequent quality assurance map testing of all map or spatial data products delivered. These standards are necessary for contract enforcement should the contractor not willingly correct deficiencies at his own time and expense.

B. Timeliness. The Government will complete all QA checks or tests as quickly as practical. Each map sheet will, within 30 days after receipt of the finished map sheets, be accepted, be returned for correction, or be rejected for recompilation. The contractor will correct returned map sheets and/or replace rejected map sheets within 30 days after receipt of the returned sheet or notice of rejection.

C. Testing. All tests for accuracy will be made on the map manuscript, the finished map, or a copy of the map on scale-stable material at the target scale specified in the contract. All maps compiled may be subject to map testing by the Government, by independent third-party forces, or by contractor forces working under direct Government review to ensure that they comply with the applicable accuracy requirements. Map test results will be statistically evaluated relative to the contract-defined

accuracy criteria (e.g., ASPRS), and a pass/fail determination will be made accordingly. The decision of whether or not to perform rigid map testing on any project, delivery order, or portion of a project rests with the Contracting Officer. In all cases, the contractor will be advised in writing when such action will be taken.

D. Office and Field Checks. The party responsible for map testing may, during the course of the project, inspect map compilation in the contractor's facility by comparing them with aerial photographs. However, the final map compilation will normally be checked by field inspection. Horizontal and vertical accuracy checks, using traverse, triangulation, and differential leveling methods will be made to test selected points or features on the completed drawings.

E. Plotting of Nonphotogrammetric Data. The Government or its designee will make appropriate measurements to verify that the coordinate grid is square and correctly spaced; that the positions of control points and property corners agree with their surveyed coordinates; and that labeling of designation, horizontal coordinates, and elevation is correct.

F. Methods of Testing. Preliminary checking of map content for completeness may be done by comparing the map with photographs taken from the air or from the ground. The final check will be a field check comparing the map with conditions on the ground. The geometrical accuracy of map features may be evaluated by comparison to ground surveys, aerotriangulation, or the stereoplotter. Comparative procedures and evaluation methods must be in conformance with the requirements of the contract or the referenced specification (e.g., ASPRS).

(1) Ground surveys. Traverses and level circuits for testing the accuracy of planimetry, spot elevations, contours, and cadastral points will start and close on monuments of the National Geodetic Reference System (NGRS), on a state or local network designated by the contract, or on station markers and benchmarks of the basic control survey for the project. The surveys will be made to the standards of accuracy required for the basic control survey for the mapping project and conform to the referenced specification accuracy requirement.

(2) Aerotriangulation. If the supplemental control survey for the project is by aerotriangulation, coordinates of points to be used for testing may be produced as part of the supplemental control survey. Point data can be produced for testing planimetry, spot elevations, or stereoplotter setup for testing. The aerotriangulation used to produce test data will meet

all specification requirements for controlling the plotting of the map features to be tested.

(3) Stereoplotter. Maps may be tested for completeness and for accuracy of planimetry, spot elevations, and contours by setting the map and transparencies of photographs of the mapping area in a stereoplotter, orienting the photographs to the control plotted on the map, and making appropriate measurements.

a. Operator. Testing by stereoplotter will be done by a competent, experienced Government operator using a properly calibrated stereoplotter, which, with the original photographs or diapositives, is capable of making measurements of comparable accuracy to that of the instrument used by the contractor.

b. Contour factor. When a topographic map is being tested, the contouring factor, or the ratio of flight height to the smallest CI accurately plottable, of the stereoplotter used by the Government will be comparable to that used by the contractor during original compilation.

c. Verification. The Government may also verify the accuracy of stereoplotter map testing performed by the contractor by requiring the contractor's operator to report the horizontal and vertical coordinates of specified readily identified points. The Government will have measured the coordinates of these points by ground surveys or by aerotriangulation.

G. Testing of Features. Map features will be tested as set forth below:

(1) Planimetry. The accuracy of the planimetric map feature compilation will be tested by comparing the ground coordinates (x and y) of at least 20 well-defined map features per test per map sheet, as determined from measurements on the map at publication scale, to those for the same points provided by a check survey of higher accuracy. The check survey will have an order of accuracy and procedures as specified for establishing the mapping control. Maps will also be examined for errors and/or omissions in defining features, structures, utilities, and other nomenclature, or for total gaps in compilation/coverage. The minimum of 20 points will be distributed throughout the sheet or concentrated in critical areas. Tests will be made on well-defined points only. Well-defined points are those that are easily visible or recoverable on the ground, such as intersections of roads or railroads and corners of buildings or structures. In general, what is well-defined will also be determined by what is plottable at the scale of the map within 1/100 in. Thus, while the intersection of two property lines meeting at right angles would come within a sensible interpretation, identification of the intersection of such lines meeting at an acute angle would obviously not be practical. Points that are not well defined are excluded from the accuracy test. The selection of well-defined points will be made through agreement between Government and the contractor. Generally, it may be more desirable to distribute the points more densely in the vicinity of important structures or drainage features and more sparsely in areas that are of lesser interest. Further definitions and requirements for selection of well-defined photo/map points are typically found in the map accuracy standard used. The locations and numbers of map test points and/or test profiles will be mutually agreed to by the contractor and Contracting Officer's Representative (COR).

(2) Coordinates. Coordinates of planimetric features as measured on the map will be compared with coordinates of the same features as determined by ground surveys or by aerotriangulation. Planimetric features may also be checked by stereoplotter.

(3) Spot elevations. A minimum of 20 points will be checked. These points will either be distributed throughout the sheet or concentrated in critical areas. Spot elevations will be compared with elevations determined by field or photogrammetric methods. The test for vertical accuracy will be performed by comparing the elevations at well-defined points determined from the map to corresponding elevations determined by a survey of higher accuracy.

(4) Contours. The accuracy of contouring will be tested by comparison of a profile measured on the map with a profile measured by ground surveys, or with a profile measured with a stereoplotter or analytical plotter. The location of each test traverse will be designated by the Government. The elevation and station will be recorded for each break in the terrain and for each contour elevation. Ground-surveyed profiles will be at least 6in. long at final map scale, with an elevation measured at least every 100 ft on the ground, and should cross at least 10 contour lines when possible. Profiles measured by stereoplotter will be at least 10 in. long at finished map scale, and the true elevation will be recorded where each plotted contour crosses the profile line. Profiles should start and close upon map features or previously established control points. In flat areas and at principal road and rail intersections, spot elevations will be checked. In general, one profile per map sheet is sufficient.

H. Acceptance. A map sheet or a mapping project will be accepted when the Government or its designee has performed sufficient testing to

assure that each phase of the mapping meets the Government standards and specifications.

I. Rejection. When a series of sheets are involved in a mapping project, the existence of errors (i.e., map test failure) on any individual sheet will constitute prima facie evidence of deficiencies throughout the project (i.e., all other sheets are assumed to have similar deficiencies); and field map testing will cease. After correction of the work, the contractor will be responsible for payment of the cost of map testing required on the corrected drawings. When such efforts are performed by Government survey employees, these costs will be deducted from contract/delivery order payment estimates. There are two reasons for which a map sheet is unacceptable.

(1) Returned for correction. If testing shows that the map is incomplete or has a few isolated errors, the map sheet will be returned for correction. The corrected map will be subject to the same extent of testing as for a new sheet.

(2) Rejected for recompiling. A map sheet may be rejected if it fails to meet specifications in any one phase of the mapping. If testing shows extensive errors or general inaccuracy, the map sheet will be rejected and a new sheet compiled. The new sheet will be subject to the same extent of testing as was the original (rejected) sheet. If a map or a map sheet is found to be incomplete, it will be returned for completion. This may be for addition of specific items found missing, or if missing items are numerous, for general completion.

J. Criteria. The following criteria will be used for the acceptance, return for correction, or rejection for recompilation of a map:

(1) Coordinate grid. Any error beyond specification tolerances (1/100 in.) in spacing or orthogonality of the coordinate grid may be cause to reject the map sheet for recompiling.

(2) Control points. Any error beyond specification tolerance (1/100 in.) in plotting or any error in labeling the elevation of control points may be cause to reject the map sheet for recompiling, unless the photogrammetric contractor can demonstrate that the erroneous data were not used in setting up the photogrammetric instrument or as a basis for ground mapping measurements.

(3) Cadastral points. Any error beyond specification tolerance (1/100 in.) in plotting of cadastral points may because for return of the map sheet for correction.

(4) Horizontal positions. A map sheet will not be rejected for recompiling because of error in the horizontal position of planimetric or topographic features or spot elevations (not control points) unless at least 20 points were tested. If fewer than 20 points were tested and excessive errors were found, the map sheet may be returned for correction of the errors.

(5) Elevation rejection. A map sheet will not be rejected for recompiling because of errors in labeling the elevations of spot elevations (not control points) but will be returned for correction.

(6) Test profile for contours. The contours of a section of a map may be accepted on the basis of a single test profile, performed either by ground surveying or by stereoplotter.

(7) Additional test profiles. When the first ground surveyed test profile indicates that a map sheet fails to comply with accuracy requirements, an additional test profile will be made. This profile will generally be parallel to the first profile at a distance from the first as specified by the Government. No map sheet will be rejected unless the sum of the lengths of the test profiles completed is 12 in. or more at finished map scale. To determine acceptability of the contouring, the data from all the profiles will be combined and treated as a unit.

(8) Stereoplotter test. When the profile measured by stereoplotter indicates that a map sheet fails to comply with accuracy requirements, a test traverse may be surveyed on the ground to determine conclusively whether the map will be rejected.

K. Intensity of Testing. The standards set forth in Chapter 2 do not state the intensity of the tests to be made. This subsection provides additional guidance. It is applicable only should the Government exercise its option to perform full field map testing on a given contract or delivery order.

(1) Mapping project. At least one map will be tested for each mapping project or mapping contract.

(2) Area mapping. Test points will average at least one for every 10 sq ft of map at finished map scale, with a minimum of 20 points.

(3) Linear mapping. Test points will average at least one for every 50 lin ft at finished map scale.

(4) Additional tests. Additional tests will be made when there is reason to suspect the quality of the mapping in general or at any specific location.

(5) New contractors. When the Government has no previous experience with a contractor's products, a more extensive inspection may be performed than for the products of established contractors.

CHAPTER 4

AERIAL PHOTOGRAPHY

4.1. GENERAL.

This chapter is subdivided into three sections specifying flight, camera, and film requirements for USACE aerial photography. Excepting references to Chapter 2 specifying permissible scale ratios between negative and map scales, this chapter is self-contained and may be directly referenced in aerial photography contracts. Many of the criteria contained in this chapter involve normal contractor QC functions, which the Government may or may not review as part of its QA effort. Some of the criteria were developed for older stereoplotters and are not applicable to newer analytical plotter use, or are applicable only to contracts for aerial photography (i.e., non-mapping) procured by low-bid methods.

4-2. SUBCONTRACTED PHOTOGRAPHY.

Before commencement of any aerial photography by a subcontractor, the contractor shall furnish the Government Contracting Officer, in writing, the name of such subcontractor, together with a statement as to the extent and character of the work to be done under the subcontract, including applicable camera certifications.

SECTION I
AIRCRAFT FLIGHT SPECIFICATIONS

4-3. GENERAL.

The contractor shall be responsible for operating and maintaining all aircraft used in conformance with all governing Federal Aviation Administration and Civil Aeronautics Board regulations over such aircraft. Any inspection or maintenance of the aircraft resulting in missing favorable weather will not be considered as an excusable cause for delay.

A. Crew Experience. The flight crew and cameraman shall have had a minimum of 400 hours experience in flying precise photogrammetric mapping missions.

B. Acquisition Delays. The contractor shall inspect and constantly monitor the photographic coverage and film quality, and shall undertake immediate reflights of areas wherein coverage does not meet specifications. The reason for any photography that does not meet the standard specifications shall be legibly handwritten using a grease pencil on the inspection prints. Rejection of photography by the contractor or the Contracting Officer shall not in itself be a reason for granting of delay or of another photo season. Failure to undertake reflights or delays in forwarding materials for preliminary inspection (if required) that result in a lost season may be reason to invoke default of contract.

4-4. OPERATIONAL PROCEDURES.

The camera and its mount shall be checked for proper installation prior to each mission. Particular attention shall be given to vacuum supply. Except on short flight lines, a minimum of two runoff or blank exposures is required between usable frames immediately prior to the start of the photography for each flight line or part of a flight line. Any exposures within the project area with a color balance shift compared to the remainder of the roll will result in unacceptable exposures. Some unexposed film must be retained at the beginning or end of each roll for a step wedge, which is required for controlled processing.

A. Aircraft. The aircraft furnished shall be capable of stable performance and shall be equipped with essential navigation and photographic instruments and accessories, all of which shall be maintained in operational condition during the period of the contract. No windows shall be interposed between the camera lens system and the terrain, unless high-altitude photography is involved. Also, the camera lens system shall not be in the direct path of any exhaust gasses or oil from aircraft engines. A typical aerial mapping aircraft is shown in Fig. 4-1.

FIG. 4-1. Cessna 206 Turbo-Charged Mapping Aircraft (Courtesy of Southern Resource Mapping Corporation)

B. Aircraft Utilization. Total aircraft utilization to, from, between, and over project sites is based on the provisions contained in the contract. For the purposes of estimating aircraft operational time, any day containing two or more consecutive hours of suitable flying conditions, in any sizable portion of the area not yet photographed, will be considered a suitable day for aerial photography. Additional crew costs will accrue during deployment at or near the project site, where applicable. Aircraft and flight crew standby at the home base shall be considered as an overhead expense.

C. Emergency Aircraft Standby. Detailed requirements, conditions, notification procedures, and compensation provisions for emergency dedication of an aircraft to a USACE Command shall be specified. Direct and indirect costs shall be clearly identified in establishing the crew-day rate for such an item.

D. Flight Line Design. The ground distance *W* between adjacent flight lines and the air distance *B* between consecutive exposure stations shall be expressed as decimal parts of the flight height above mean ground height *H*. Negative scales for map compilation shall be as stated in the applicable contract section.

E. Weather Conditions (Flying Conditions). Unless otherwise specified, aerial photographs shall be taken between the hours of 10 a.m. and 2 p.m., local solar time, on days when well-defined images can be obtained. Photographing shall not be attempted when the ground is obscured by haze, smoke, dust, or snow or when the clouds or cloud shadows will appear on more than 5% of the

area of any one photograph without permission of the Contracting Officer. Photographs shall not contain shadows caused by topographic relief or sun angle, whenever such shadows can be avoided during the time of year the photography must be taken. As stated in paragraph B above, any day containing two or more consecutive hours of suitable flying conditions, in any sizable portion of the area not yet photographed, will be considered a suitable day for aerial photography.

(1) Sun angle. Photographing shall be undertaken when the sun angle is 30 degrees or greater, there is no atmospheric haze, and the lighting and weather conditions are suitable for obtaining acceptable film. Special care must be taken to minimize shadows in mountainous and canyon areas since shadows on color infrared positive film are black and contain little or no detail. Exceptions to the stated sun angle requirement may be made if additional shadow detail will enhance ground images or if reflections or hot spots will mar the imagery on the aerial film.

(2) Cloud cover. Photographs shall not be obtained during poor weather conditions. Excessive wind conditions that will not permit maintaining the allowable flight line tolerances shall be avoided. Photographs that contain clouds, haze, or smoke so that critical ground areas are obscured shall be rejected.

(3) Ground conditions. The season and any special requirements concerning foliage, snow, or other conditions will be specified in the contract. Conditions that might obscure ground detail shall be the responsibility of the contractor. However, if questions or concerns about conditions exist, consultation with the Contracting Officer or the COR before undertaking or continuing the work is advisable. Photographic operations shall be limited to the season specified in the contract unless otherwise authorized by the Contracting Officer.

F. Allowable Flight Line Tolerances. The centers of the first two and last two exposures of each flight line shall fall beyond the project boundaries.

(1) Flight lines. The minimum area(s) to be photographed will be indicated on maps provided for each photographic assignment. The contractor shall design the flight lines to obtain proper side lap to assure full stereoscopic photographic coverage. Generally, the flight lines shall be parallel to each other and to the longest boundary lines of the area to be photographed. For single strip photography, the actual flight line shall not vary from the line plotted on the flight map by more than the scale of the photography expressed in feet. For example, the

allowable tolerance for photography flown at a scale of 1 in. equals 1,000 ft is more or less 1,000 ft. Any proposed variation in either the camera focal length or negative scale constitutes a major change in scope and therefore must be effected by formal contract modification.

(2) Flight height. Departures from specified flight height shall not exceed 2% low or 5% high for all flight heights up to 12,000 ft above ground elevation. Above 12,000 ft, departures from specified flight height shall not exceed 2% low or 600 ft high. During inspection for acceptance, the flight height will be verified by multiplying the focal length of the camera (in feet) by the denominator of the calculated scale of the aerial film. The photography scale is calculated by dividing the distance between two identifiable points as measured on one of the photographs (as near as possible at the mean ground elevation) by the actual ground distance as measured from the best available map.

(3) Stereoscopic coverage. Stereoscopic coverage shall be treated as follows:

a. *Full project coverage.* The entire area of the project shall be stereoscopically covered by successive and adjacent overlaps of photographs within the usable portion of the field of the lens. This is an essential requirement for photomapping work.

b. *Reflights.* Lack of acceptable stereoscopic coverage caused by the contractor's failure to adhere to the specified flight design shall be corrected by reflights at the contractor's own expense.

c. *Reimbursable reflights.* Lack of acceptable stereoscopic coverage caused by conditions that could not be avoided by the exercise of reasonable diligence and care on the part of the contractor will be corrected by reflights at the Government's expense, when authorized by the Contracting Officer.

4-5. FLIGHT LINE MAPS.

Flight line maps may be prepared by the contractor. The maps will be current (up-to-date) standard topographic maps and of the largest scale compatible with the project scale. The project boundaries shall be clearly marked.

A. Substitute Photography. In flight lines rephoto-graphed to obtain substitute photography for rejected photography, all negatives shall be exposed to comply with flight specifications, including scale and overlap requirements. The joining end negatives in the replacement strip shall result in complete stereoscopic coverage of the contiguous area on the portion or portions not rejected.

B. Flight Log. For each flight day, the pilot or cameraman shall prepare a flight log containing the date, project name, aircraft used, and names of crew members. In addition, the following shall be prepared for each flight line: altitude, camera, magazine serial number, f-stop, shutter speed, beginning and ending exposure numbers and times, and any other comments relative to the flight conditions. The flight logs shall be delivered to the Contracting Officer as specified in the work order.

C. Scale of Photography. The flight height above the average elevation of the ground shall be such that the negatives have an average scale suitable for attaining required photogrammetric measurement, map scale, CI, and accuracy. Negatives having a departure from the specified scale of more than 5% because of tilt or any changes in the flying height may be rejected.

D. Overlap. Unless otherwise directed by the Contracting Officer, the overlap shall be sufficient to provide full stereoscopic coverage of the area to photographed, as follows:

(1) Project boundaries. All of the area appearing on the first and last negative in each flight line that crosses a project boundary shall be outside the boundary. Each strip of photographs along a project boundary shall extend over the boundary not less than 15% or more than 55% of the width of the strip.

(2) Strip overlap. Where the ends of strips of photography join the ends of other strips, or blocks flow in the same general direction, there shall be a sufficient overlap of stereoscopic models. If the scales of photography are different, they shall be at the smaller photo scale. In flight lines rephotographed to obtain substitute photography for rejected photography, all negatives shall be exposed to comply with original flight specifications, including scale and overlap requirements. The joining end negatives in the replacement strip shall have complete stereoscopic coverage of the contiguous area on the portion or portions not rejected.

(3) Shoreline coverage. Strips running parallel to a shoreline may be repositioned to reduce the proportion of water covered provided the coverage extends beyond the limit of any land feature by at least 10% of the strip width.

(4) End lap. Unless otherwise specified in the contract, the end lap shall average not less than 57% or more than 62%. End lap of less than 55% or more than 68% in one or more negatives may be cause

for rejection of the negative or negatives in which such deficiency or excess of end lap occurs.

(5) Side lap. Unless otherwise specified in the contract, the side lap shall average 25%. Any negative having side lap less than 15% or more than 50% may be rejected. The foregoing requirement can be modified, subject to the Contracting Officer's approval, in cases where the strip area to be mapped is slightly wider than the area that can be covered by one strip of photographs; where increase in side lap is required for control densification; or where increase or decrease in side lap is required to reach established ground control.

(6) Terrain elevation variances. When ground heights within the area of overlap vary by more than 10% of the flying height, a reasonable variation in the stated overlaps shall be permitted provided that the fore and aft overlap does not fall below 55% and the lateral side lap does not fall below 10% or exceed 40%. In extreme terrain relief where the foregoing overlap conditions are impossible to maintain in straight and parallel flight lines, the gaps created by excessive relief shall be filled by short strips flown between the main flight lines and parallel to them.

E. Crab. Any series of two or more consecutive photographs crabbed in excess of 10 degrees as measured from the mean flight path of the airplane, as indicated by the principal points of the consecutive photographs, may be considered cause for rejection of the photographs. Average crab for any flight line shall not exceed 5 degrees. Relative crab in excess of 10 degrees between two successive exposures shall be rejected. For aerotriangulation, no photograph shall be crabbed in excess of 5 degrees as measured from the line of flight.

F. Tilt. Negatives exposed with the optical axis of the aerial camera in a vertical position are desired. Tilt (angular departure of the aerial camera axis from a vertical line at the instant of exposure) in any negative of more than 3 degrees, an average tilt of more than 1 degree for the entire project, an average of more than 2 degrees for any 10 consecutive frames, or relative tilt between any two successive negatives exceeding 5 degrees shall be cause for rejection.

SECTION II
AERIAL CAMERAS

4-6. GENERAL.

The photographs to be used in precise photogrammetric work must be obtained using a fully

calibrated precision camera with a single high-resolution low-distortion lens. Cameras used for photogrammetric mapping must meet the requirements outlined below. The cost for calibration and other compliance will be borne by the contractor. The aerial camera used shall be of similar quality to a Wild Model RG10, Wild RC-8, Jena MRB, Carl Zeiss Jena LMK, Zeiss RMK-A 15/23, Carl Zeiss Jena LMK 1000/2000, Carl Zeiss RMK TOP, or Wild RC-20 (Figure 4-2). A shutter speed shall be chosen that

a. Mounting in Cessna 206

b. Video Exposure Control System

FIG. 4-2. Zeiss RMK-A 15/23 6 in. Focal Length Camera (Courtesy of Southern Resource Mapping Corporation)

meets the combined requirements of minimal image movement and optimum lens aperture for the prevailing illumination conditions.

4-7. CAMERA CLASSIFICATIONS.

There are two classes of cameras. The first is the precision mapping camera that shall have been calibrated by USGS. The second is the substitute camera.

4-8. USES.

The precision mapping camera shall be used for all photogrammetric mapping projects. A substitute camera may be used for taking special-purpose photographs provided prior approval is obtained from the Contracting Officer.

4-9. CAMERA MOUNTING REQUIREMENTS.

The camera mount shall be regularly serviced and maintained, and shall be insulated against aircraft vibration.

A. Camera Opening. The camera opening in the aircraft shall provide an unobstructed field of view when a camera is mounted with all its parts above the outer structure. The field of view shall, so far as practicable, be shielded from air turbulence and any effluence such as gasses and oil. The camera port glass (if required) shall be free of scratches and shall not degrade the resolution or the accuracy of the camera.

B. Exposure Control. An automatic exposure control device is permitted and recommended for all photography, but a manual override capability is required for some types of terrain to achieve proper exposure.

4-10. CAMERA CRITERIA/ REPORTING.

The camera shall meet the following criteria:

A. Type of Camera. A single-lens precise aerial mapping camera equipped with a high-resolution, distortion-free lens shall be used on all assignments. The camera shall function properly at the necessary altitude and under expected climatic conditions, and shall expose a 9 in.-square negative. The lens cone shall be so constructed that the lens, focal plane at calibrated focal length, fiducial mark-

ers, and marginal data markers comprise an integral unit or are otherwise fixed in rigid orientation with one another. Variations of temperature or other conditions shall not cause deviation from the calibrated focal length in excess of ± 0.05 mm or preclude determination of the principal point location to within ± 0.003 mm.

B. Calibration. The aerial camera(s) furnished by the contractor shall have been calibrated by the USGS within three years of award of a contract. The calibration report shall be presented to the Contracting Officer prior to use of the camera. Certification shall also be provided indicating that preventive maintenance has been performed within the last two years. Camera features and acceptable tolerances are as follows:

(1) Focal length. The calibrated focal length of the lens shall be 153 mm, ± 3 mm, and measured to the nearest 0.001 mm.

(2) Platen. The focal plane surface of the platen shall be flat to within 0.013 mm and shall be truly normal to the optical axis of the lens. The camera shall be equipped with means of holding the film motionless and flat against the platen at the instant of exposure.

(3) Fiducial marks. The camera shall be equipped with a minimum of four fiducial marks, with eight preferable, for accurately locating the principal point of the photograph. The lines joining opposite pairs of fiducial marks shall intersect at an angle within one minute of 90 degrees.

(4) Lens distortion. The absolute value of radial distortion measured at maximum aperture, as stated in the calibration report, shall not exceed 0.01 mm.

(5) Lens resolving power. With appropriate filter mounted in place, the Area Weighted Average Resolution (AWAR) shall be at least 60 lines/millimeter when measured on type V-F spectroscopic plates at maximum aperture stated on calibration report. The lens shall be fully corrected for color photography.

(6) Filter. An appropriate light filter with an anti-vignetting metallic coating shall be used. The two surfaces of the filter shall be parallel to within ten seconds of arc. The optical characteristics of the filter shall be such that its addition and use shall not cause any undesirable reduction in image resolution and shall not harmfully alter the optical characteristics of the camera lens.

(7) Shutter. The camera shall be equipped with a between-the-lens shutter of the variable speed type, whose efficiency shall be at least 70% at the fastest rated speed.

FIG. 4-3. Wild P-31 Terrestrial Photogrammetric Camera (Courtesy of Southern Resource Mapping Corporation)

(8) Stereomodel flatness. The deviation from flatness of the average data from two models (elevation discrepancy at photography scale) at measured points may not exceed ±1/8000 of the focal length of a nominal 6 in. (153 mm) focal length camera. If elevation discrepancies exceed this value, the camera will not be acceptable.

(9) Substitute cameras. Substitute cameras may be used for taking photography provided prior approval is obtained from the Contracting Officer or is provided for in the contract. Substitute cameras shall meet the minimum requirements for resolution as specified for precision mapping cameras. For close-range photogrammetry, terrestrial cameras may be employed (Fig.4-3).

SECTION III
PHOTOGRAPHIC FILM

4-11. GENERAL.

Only unexpired film of the type specified in paragraph 4-14 shall be used. All film shall be purchased by the contractor, unless specifically stated otherwise. All aerial film shall be of archival quality. The film exposed and processed shall not be spliced. The processed negatives shall be free of stains, discoloration, or brittleness that can be attributed to ageing.

4-12. TYPES OF AERIAL FILM.

The contractor shall furnish aerial film of a quality that is equal to or superior to 4 mil Kodak

Double-X Aerographic 2405 (Estar Base) panchromatic film; 4 mil Kodak Plus-X Aerographic 2402 panchromatic (Estar Base) film; 4 mil Kodak Infrared Aerographic 2424 film; 4 mil Kodak Aerocolor Negative film 2445 (Estar Base); or 4 mil Kodak Aerochrome Infrared 2443 film (Estar Base). Only fresh, fine-grain, dimensionally stable, and safety base aerial film shall be used.

A. Color Infrared Film. Color infrared emulsion shall be sensitive to the visible and near-infrared spectrum from 400 to 900 nanometers. The film shall be a polyester base material with a nominal thickness of 4.8 mils (0.12 mm) and shall have three gelatine layers containing silver halide, one layer to be sensitive to infrared light, one to be sensitive to green light, and one to be sensitive to red light.

B. Black-and-White Film. Black-and-white emulsion shall be sensitive to red, green, and blue wavelengths.

4-13. ALLOWABLE FILM EMULSION TYPES.

Black-and-white panchromatic, black-and-white infrared, color, and color infrared are the allowable film emulsion types. Each specific mapping requirement will dictate which emulsion type to be used. Table 4-1 provides guidance on the type of emulsion to use for particular applications.

4-14. FILM CHARACTERISTICS.

A. Panchromatic Film. Panchromatic film is the most popular for aerial photography. Its sensitivity extends from the blue through the red portions of the spectrum. It is usually desirable to use a minus blue (yellow) or bright red filter to reduce the effects of haze and smog. There is a greater latitude in exposure and processing of black-and-white panchromatic films than there is with color films, which assures a greater chance of success in every photo mission.

B. Color. Color aerial photography entails the taking of photographs in natural color. Both color negative and color positive film types are available. Color photography requires above-average weather conditions, meticulous care in exposure and processing, and color-corrected lenses. For these reasons, color photography and color prints are more expensive than panchromatic.

C. Infrared. Infrared emulsions have greater sensitivity to red and the near-infrared. They

TABLE 4-1. Film Emulsions Allowable for Image Interpretation (or Mapping)

Technique (1)	Applications (2)	Emulsion type		
		Black & White (3)	Color (4)	Color Infrared (5)
Mapping	Topographic Maps: Map or Digital Form	all	all	all
Interpretation of Mosaics	Route Corridor Studies; Area-wide Planning Studies	all	all	all
Visual Inspection of Landsat or SPOT Imagery	Regional Planning Studies; Environmental Analysis	all	all	all
Digital Analysis of Landsat or SPOT Imagery	Image Classification; Image Enhancement; Studies in the Plant Sciences	all	n/a	all
Monoscopic Visual Inspection of 9×9 Aerial Photos	Vegetation Analysis and Classification; Land Use Classification	all	all	all
Stereoscopic Visual Inspection of 9×9 Photo Pairs	Drainage Pattern Identification; Approximate Height Measurements; Land Use and Vegetation Analysis	all	all	all
Visual Inspection of Enlarged Photo Plan Sheets	Facility Identifications; Analysis of Street or Lot-level Features	all	all	all
Visual Mono or Stereo Inspection of Small Format (70-35 mm) Aerial Photographs	Vegetation Analysis	all	all	all

Note:
1. all = allowable.

2. n/a = not allowable.

record the longer red light waves, which penetrate haze and smoke. Thus, infrared film can be used on days that would be unsuitable for ordinary panchromatic films. It is also useful for the delineation of water and wet areas, and for certain types of forestry and land use studies. Its chief disadvantage is a greatly increased contrast, which may tend to cause a loss of image information.

D. Color Infrared. Color infrared has many of the same uses as black-and-white infrared, but in addition, the nuances of color help in photo interpretation. Because greens are recorded as reds on this emulsion, it is often termed "false color film." It is used in the detection of diseased plants and

trees, identification and differentiation of a variety of fresh and salt water growths for wetland studies, and many water pollution and environmental impact studies. A color-corrected camera lens is required. The cost of obtaining infrared color is greater than that for black and white. Because of the cost of making infrared color prints, color transparencies are used and viewed on a light table.

4-15. TYPE OF DIAPOSITIVES.

All black-and-white diapositive transparencies used for photogrammetric measurements, in-

cluding map compilation, shall be equal or superior in quality to 0.130 in.-thick Kodak Aerial Plotting Plates or 0.007 in.-thick Dupont Diapositive Film, No. CT-7. All color diapositive transparencies shall be equal or superior to Kodak Color Diapositive Film, No. 4109.

4-16. DIAPOSITIVE PROCESSING AND QUALITY.

All diapositives shall comply with the specifications for contact prints in paragraph 4-22.

4-17. FILM PROCESSING AND HANDLING SPECIFICATIONS AND CRITERIA.

All aerial film shall be processed under controlled conditions in automatic, continuous film processors. The film shall be processed in accordance with the manufacturer's instruction. The processing, including development and fixation and washing and drying of all exposed photographic film, shall result in negatives free from chemical or other stains, containing normal and uniform density and fine-grain quality. Before, during, and after processing, the film shall not be rolled tightly on drums or in any way stretched, distorted, scratched, or marked, and shall be free from finger marks, dirt, or blemishes of any kind.

A. Storage and Handling. Storage and handling of all photographic material shall be in accordance with the manufacturer's recommendation. Adverse storage conditions affect the color-emulsion layers and subsequently the color balance of the film, and possibly overall film speed and contrast. All aerial film shall be stored in the original containers to prevent any exchange in moisture between the rolls and their surroundings up to the time they are to be exposed. Photographic film containers shall not be exposed to direct sunlight or other sources of heat. Unexposed color infrared film that is to be stored for several months shall be stored at 0 to −10°Fahrenheit (°F) (−18 to −23° Celsius (°C). Color infrared film stored in the field by the photographic flight crew shall be refrigerated at about 40 °F (4 °C) or lower until 2 to 6 hours prior to exposure, at which time the film shall be maintained at a temperature of approximately 70 °F (21 °C). Exposed but unprocessed color infrared film shall be sealed and refrigerated at about 40 °F (4 °C) or lower. Exposed film shall be processed as soon as possible to avoid undesirable color balance

changes. All color infrared film shall be shipped from the contractor's storage facility to the photographic flight crew and from the photographic flight crew to the photographic laboratory by 24-hour express delivery service.

B. Image Quality. The imagery on the aerial film shall be clear and sharp and evenly exposed across the format. The film shall be free from clouds and cloud shadows, smoke, haze, light streaks, snow, flooding, excessive soil moisture, static marks, shadows, tears, crimps, scratches, and any other blemishes that interfere with the intended purpose of the photography. If, in the opinion of the Contracting Officer, the contractor has adhered to the specifications and has exercised reasonable care to meet density requirements, allowance will be made for unavoidable shadows, permanent snow fields, or reflectance from water bodies. It must be possible to produce black-and-white internegatives and duplicate positives from original color infrared films and duplicate negatives from original black-and-white films with no significant loss of image detail.

C. Image Resolution. When there is doubt concerning the resolution of images obtained, a comparison will be made of well-defined edges of man-made structures and other features in the film with previous imagery of acceptable quality, similar scale, and contrast. If the imagery is obviously degraded when compared to previously accepted like images, the film shall be rejected for poor image quality. The film will be evaluated by the following criteria:

(1) A 3X enlargement on film.

(2) Comparison to a calibrated matrix in a visual edge-match comparator.

(3) Edge traces in a microdensitometer.

(4) A combination of these methods.

D. Characteristic Curve and Color Balance. A twenty-one-step gray sensitometric wedge (0.15 density increments) shall be exposed on one end of each roll of film before processing. The contractor shall make appropriate density measurements on the step wedge and plot the characteristic curves and determine color balance for each roll of color infrared film and gamma for each roll of black-and-white film. The plotting shall be on Kodak curve-plotting graph paper E-64 or equivalent. The plot shall be delivered with each roll of film.

E. Density Measurements. The density units defined below are for those measured on a transmission densitometer with a scale range of at

least 0.0 to 3.0 and a 1-mm aperture probe. Readings shall not be made closer than 25 mm (1 in.) to an exposure edge nor closer than 40 mm (1.5 in.) to an exposure corner. Specular reflectors (such as water surfaces) or small, isolated density anomalies within a scene shall not be used for determining the maximum or minimum densities or density range of a roll of film.

F. Test Exposures. For black-and-white photography, additional black-and-white exposures over the project area may be made that are representative of the area, for use as test strips in determining the processing required to achieve the desired density spread. The final product may be an image map; therefore, the density and physical quality of the film are critical to the image map quality.

G. Density Values. The maximum density in useful areas of the negative shall not exceed D 1.5 above base, other than in areas of high reflectance where a maximum density of D 2.0 shall be permissible. The net value of fog shall not exceed D 0.2 or D 0.4 above the density of the support when processed in full strength D-19 developer at 20 °C for 10 minutes with continuous agitation. The density of 0.4 applies only with film nominally rated at a speed in excess of 250 ASA (American Standards Association) effective aerial film speed. The density, contrast, and freedom from fog of all negatives shall be such that commercially available grades of paper (covering log E ranges of 0.6-1.6) can be used in printing to give detail in significant areas of highlight and shadow. Useful minimum shadow detail shall be not normally less than a net density of D 0.2 above the base fog value. In no circumstances shall the minimum density fall below $D = 0.1$ above the base plus fog value. Contrast limits shall be kept within $\pm 20\%$ in the case of rewind spool-tank processing ($\pm 12\%$ in the case of continuous processing) of the average gradient g of the $D/\log E$ characteristic curve when measured over a log E range 1.0 from a density of 0.4 above base plus fog.

H. Black-and-White Film. Black-and-white panchromatic film shall be exposed and processed to obtain a minimum density $D\text{-}min$ of not less than 0.30 density units above base plus fog, and a maximum $D\text{-}max$ not in excess of 1.50 density units above base plus fog. The aim point for density range is 1.0 density unit for the average scene (a brightness range of approximately 10:1) processed to a 1.0 gamma. The aerial film shall be exposed for and processed to a high gamma when the terrain photographed is lacking in contrast and to a low gamma when the terrain has extreme contrast. If this practice

FIG. 4-4. Editing a Roll of 9 in. Color Infrared Film (Courtesy of Southern Resource Mapping Corporation)

is followed, film that does not achieve a 1.0 density range may be acceptable, provided the required sensitometric wedge is properly affixed and the achieved density range is not less than 0.60 nor more than 1.20 density units.

I. Color Infrared Film. All color infrared film shall be exposed and processed to the manufacturer's specifications, where reasonable and practicable. Modified or nonstandard processing is not permitted. All color infrared $D\text{-}min$ and $D\text{-}max$ densities as measured on the original aerial film positives with the film emulsion up and using status A filters shall be no lower nor higher than the values provided in Table 4-2. All color infrared density values include the Base + Stain value. Upon receipt from the manufacturer of the year's supply of color infrared film, the contractor shall determine the color balance of the

TABLE 4-2. Color Infrared Densities

Filter (1)	D-min (2)	D-max (3)
Red	75 ± 0.10	1.65 ± 0.10
Green	0.55 ± 0.10	2.25 ± 0.10
Blue	0.55 ± 0.10	2.25 ± 0.10

rolls. The color infrared balance shall be conducted by removing approximately 3 ft of unexposed film from the outside wrap of the film, exposing a twenty-one-step sensitometric wedge (0.15 density increments) on the removed film strip, and processing it in an automatic continuous-film processor (Figure 4-4). The color balance shall be established by obtaining two points on the characteristic curve at $D = 1.0$, one point being at the midpoint of the two visible-light curves and the second at the point of intersection of $D = 1.0$ with the infrared curve. The processed twenty-one-step wedges shall be assigned a control number to reference them to the roll from which they were removed. The step wedges will be maintained on file and used as a criterion for acceptable color balance of the exposed and processed film.

J. Dimensional Stability of Film. Equipment used for processing shall be either rewind spool-tank or continuous processing machine and must be capable of achieving consistent negative quality without causing distortion of the film. The film shall be dried without affecting its dimensional stability. The dimensional stability of the base shall be such that in any negative the length and width between fiducials shall not vary by more than 0.3% from the same measurements taken on the camera, and the differential between these measurements shall not exceed 0.04%.

K. Film Roll Specifications. A roll of aerial film shall consist only of exposures made with the same camera system (lens, cone, and magazine). No more than one project may be placed on a roll. Film spools having a flange diameter of approximately 13.3 cm (5-3/16 in.) shall be used, and only that length of film which can be wound on a spool without strain, leaving at least 3 mm (1/8in.) of flange exposed, shall be placed on each spool. All film on any one roll shall have the same roll number.

L. Leader and Trailer. Three feet of blank or unused film shall be left beyond the first and last used exposure on each roll to serve as a leader and trailer. If 3 ft of blank or unused film is not left on the original film roll, 3 ft of leader or trailer must be spliced onto the roll. Splicing shall be accomplished with 3/4 in. pressure-sensitive, polyester-base tape. The splices shall be of the butt-joint type with tape placed on both sides of the splice. Particular care shall be given to the alignment of the film when splicing, with care taken to trim all excess binding tape so the film will be perfectly straight after splicing. A splice shall not be closer than 5in. from the image edge of any edited frame. There shall be no splices within the 3ft of leader or trailer.

4-18. CAMERA PANEL.

The camera panel of instruments should be clearly legible on all processed negatives. Failure of instrument illumination during a sortie may be cause for rejection of the photography. All fiducial marks shall be clearly visible on every negative.

4-19. FILM REPORT.

A report shall be included with each project giving the following information:

A. Film number.

B. Camera type and number, lens number, and filter type and number.

C. Magazine number or cassette and cassette holder unit numbers.

D. Film type and manufacturer's emulsion number.

E. Lens aperture and shutter speed.

F. Date of photography.

G. Start and end time for each run in local time.

H. Negative numbers of all offered photography.

I. Indicated flying height.

J. Computed flying height above sea level.

K. Scale of photography.

L. Outside air temperature.

M. Weather conditions—cloud, visibility, turbulence.

N. Date of processing.

O. Method of developing.

P. Developer used and dilution.

Q. Time and temperature of development or film transport speed.

R. Length of film processed.

S. General comment on quality.

4-20. FILM DOCUMENTATION, LABELING, AND ANNOTATION.

A. Labeling of Film Strip. The following information shall be supplied as leaders at the start and the end of each film strip:

(1) Contract number and/or delivery order designation, as applicable.

(2) Film number.

(3) Flight line identification(s).

(4) Dates/times of photography.

(5) Effective negative numbers and run numbers.

(6) Approximate scale(s) of photography.

(7) The calibrated focal length of the lens unit.

(8) Contractor's name.

B. Negative Annotations. Each negative shall be labeled clearly with the identification symbol and numbering convention furnished herein. The numbers shall be sequential within each flight line and shall be in the upper right corner of the negative image edge to be read as one looks northerly along the flight line (or westerly when lines are east-west). All lettering and numbering of negatives shall be 1/5 in. high and shall result in easily read, sharp, and uniform letters and numbers. Negatives shall be numbered using heat-foil or indelible ink. The date of the photography shall be in the upper left corner of each frame followed with the USACE project number and photo scale ratio. The frame number will be in the upper right corner of each frame with the roll number printed 2 in. to the left of the frame number. Each negative shall be provided with the following annotation, which shall also appear on the prints:

(1) Year, month, and day of flight.

(2) USACE project identification number.

(3) Photo scale (ratio).

(4) Film roll number.

(5) Negative number.

C. Container Labels. The contractor-furnished container and spool for each roll of film shall become the property of the Government. Container labels shall be typed or neatly lettered by the contractor with the required data and securely affixed to each container. All rolls of aerial film shall be shipped in sturdy, cylindrical plastic containers with each container labeled as indicated below:

(1) Name and address of the contracting agency.

(2) Name of the project.

(3) Designated roll number.

(4) Numbers of the first and last numbered negatives of each strip.

(5) Date of each strip.

(6) Approximate scale.

(7) Focal length of lens in millimeters.

(8) Name and address of the contractor performing the photography.

(9) Contract number.

D. Manufacturer's Identification Number. Each roll of film contains the manufacturer's identification number. This number shall be provided on the photography supplement report for and with each roll of film submitted.

4-21. PHOTO INDEX MAP REQUIREMENTS.

Negatives and prints of an assembly of aerial photographs that form an index of a project's aerial photography may be prepared if called for in the specifications.

A. Assembly. The photo index shall include photographic prints made from all negatives of the photography taken and accepted for the project. The prints shall be trimmed to a neat and uniform edge along the photographic image without removing the fiducial marks. The photographs shall be overlap-matched by conjugate images on the flight line with each photograph identification number clearly shown. The photographs for each adjacent flight line strip shall overlap in the same direction. Air base lengths shall be averaged in the image matching of successive pairs of photographs on flight lines, and adjoining flight line assemblies shall be adjusted in length by incremental movement along the flight line, as necessary.

B. Labeling and Titling. For geographic orientation, appropriate notations shall appear on the index, naming or otherwise identifying important and prominent geographic and land use features. All overlay lettering and numbering shall be drafting quality. In addition, a north arrow, sheet index, if applicable, and a title block shall appear on each index. The title block shall contain project name, contractor's name, contract agency name, date of photography, and average scale of photography.

C. Scale and Size. The stapled or taped assembly of photography shall be photo-reduced to a scale of about one-third of the original negative scale. A larger photo index scale can be used if all exposures for one project fit the required format on a single sheet.

D. Photographic Copying and Printing. The photo index shall be copied on photographic film so that prints can be made by contact or projection method. The method used shall be the option of the contractor. Whenever the index cannot

be copied on one negative, it shall be copied on two or more negatives, as necessary.

4-22. CONTACT PRINTS.

All contact prints shall be made on medium-weight, semimatte paper stock approved by the Contracting Officer. Contact prints shall be delivered flat and trimmed and contain all highlight and shadow detail. The following shall be stamped on the back of each contact print:

Project _____
USACE Contract No. DAXXXX _____
Date of Photography _____
Flight Length _____
Calibration of Camera Date _____
Contractor _____
Address _____
Telephone _____

A. Photographic Print Quality. The processing shall result in finished photographic prints having fine-grain quality, normal uniform density, and such color tone and degree of contrast that all photographic details of the negative from which they are printed show clearly in the dark-tone areas and highlight areas as well as in the halftones between the dark and the highlight. Excessive variance in color tone or contrast between individual prints will be cause for their rejection. All prints shall be clear

FIG. 4-5. LOG-E-TRONICS Contact Printer and Processor (Courtesy of Southern Resource Mapping Corporation)

and free of stains, blemishes, uneven spots, air bells, light fog or streaks, creases, scratches, and other defects that would interfere with their use or in any way decrease their usefulness. A typical contact printer is shown in Fig. 4-5.

B. Trimming. All contact prints shall be trimmed to neat and uniform dimensional lines along edges (without loss of image) distinctly leaving the camera fiducial marks. Prints lacking fiducial marks shall be rejected. The Contracting Officer may waive the fiducial mark requirement for prints from substitute cameras.

C. Print Condition. All prints shall be delivered to the Government Contracting Officer in a smooth, flat, usable condition.

4-23. CONTRACT DELIVERABLES.

All the required film and contact print materials shipped shall conform to the requirements stated in the contract specifications and shall become the property of the Government. Requirements for contract deliverables are specified below:

A. All film exposed on the project.

B. One set of positive black-and-white prints (from black-and-white film) or one set of negative black-and-white prints (from color infrared film) of all photography.

C. The flight log.

D. One photo index including photographic prints made from all negatives of the photography for the project.

E. Camera Calibration Report (see sample report in Fig. 4-6).

The following additional items shall be delivered if specified in the contract:

A. One set of clear film positives of the flight maps used by the contractor. These positives, in flight line strips, shall be the same scale as the inspection prints submitted.

B. The photography supplement report, which identifies all photography flown as part of the contract.

C. Color infrared color balance test strips and graphs.

D. Black-and-white processing test exposures and graphs.

E. Weekly progress reports.

F. Monthly progress reports.

G. Camera log (Fig. 4-7).

H. Film edit log (Fig. 4-8).

USGS Report No. OSL/1609

United States Department of the Interior

GEOLOGICAL SURVEY
RESTON, VA 22092

REPORT OF CALIBRATION March 7, 1991
of Aerial Mapping Camera

Camera type:	Zeiss RMK A 15/23*	Camera serial no.:	140241
Lens type:	Zeiss Pleogon A2/4	Lens serial no.:	134668
Nominal focal length:	153 mm	Maximum aperture:	f/4
		Test aperture:	f/4

These measurements were made on Kodak Micro-flat glass plates, 0.25 inch thick, with spectroscopic emulsion type 157-01 Panchromatic, developed in D-19 at 68° F for 3 minutes with continuous agitation. These photographic plates were exposed on a multicollimator camera calibrator using a white light source rated at approximately 5200K.

I. Calibrated Focal Length: 153.747 mm

This measurement is considered accurate within 0.005 mm

II. Radial Distortion

Field angle	\bar{D}_c	D_c for azimuth angle			
		0° A-C	90° A-D	180° B-D	270° B-C
degrees	um	um	um	um	um
7.5	-2	-1	-3	-2	-1
15	-3	-3	-5	-3	-1
22.7	-5	-6	-7	-3	-3
30	-3	-3	-4	-2	-3
35	-1	0	-2	0	-1
40	6	6	9	5	6

The radial distortion is measured for each of four radii of the focal plane separated by 90° in azimuth. To minimize plotting error due to distortion, a full least-squares solution is used to determine the calibrated focal length. \bar{D}_c is the average distortion for a given field angle. Values of distortion D_c based on the calibrated focal length referred to the calibrated principal point (point of symmetry) are listed for azimuths 0°, 90°, 180° and 270°. The radial distortion is given in micrometers and indicates the radial displacement away from the center of the field. These measurements are considered accurate within 5 um.

* Equipped with Forward Motion Compensation

FIG. 4-6. USGS Camera Calibration Report (From U.S. Army Engineer District, Seattle) (Sheet 1 of 5)

USGS Report No. OSL/1609

III. Resolving Power in cycles/mm

Area-weighted average resolution: 83

Field angle:	0°	7.5°	15°	22.7°	30°	35°	40°
Radial lines	134	134	113	95	95	80	67
Tangential lines	134	113	95	80	80	67	48

The resolving power is obtained by photographing a series of test bars and examining the resultant image with appropriate magnification to find the spatial frequency of the finest pattern in which the bars can be counted with reasonable confidence. The series of patterns has spatial frequencies from 5 to 268 cycles/mm in a geometric series having a ratio of the 4th root of 2. Radial lines are parallel to a radius from the center of the field, and tangential lines are perpendicular to a radius.

IV. Filter Parallelism

The two surfaces of the B No. 137586, the C-F No. 140221, and the KL No. 137546 filters accompanying this camera are within 10 seconds of being parallel. The B filter was used for the calibration.

V. Shutter Calibration

Indicated shutter speed	Effective shutter speed	Efficiency
1/200	3.67 ms = 1/270 s	74%
1/400	1.87 ms = 1/535 s	74%
1/600	1.25 ms = 1/800 s	74%
1/800	0.94 ms = 1/1060 s	74%
1/1000	0.74 ms = 1/1350 s	74%

The effective shutter speeds were determined with the lens at aperture f/4. The method is considered accurate within 3 percent. The technique used is Method I described in American National Standard PH3.48-1972(R1978).

VI. Magazine Platen

The platens mounted in FK 24/120 film magazine No. 117911 and CC24 film magazine No. 136388 do not depart from a true plane by more than 13 um (0.0005 in).

The platens for these film magazines are equipped with identification markers that will register "CZ284" for magazine No. 117911, and "CZ277" for magazine No. 136388 in the data strip area for each exposure.

FIG. 4-6. (Sheet 2 of 5)

USGS Report No. OSL/1609

VII. Principal Points and Fiducial Coordinates

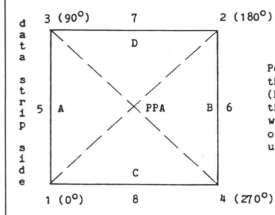

Positions of all points are referenced to the principal point of autocollimation (PPA) as origin. The diagram indicates the orientation of the reference points when the camera is viewed from the back, or a contact positive with the emulsion up. The data strip is to the left.

	X coordinate	Y coordinate
Indicated principal point, corner fiducials	0.002 mm	-0.001 mm
Indicated principal point, midside fiducials	-0.007	0.000
Principal point of autocollimation	0.0	0.0
Calibrated principal point (point of symmetry)	0.007	-0.008

Fiducial Marks

	X	Y
1	-103.954 mm	-103.925 mm
2	103.955	103.921
3	-103.932	103.946
4	103.914	-103.925
5	-113.005	0.011
6	112.988	-0.011
7	0.006	113.000
8	-0.021	-112.990

VIII. Distances Between Fiducial Marks

Corner fiducials (diagonals)
 1-2: 293.983 mm 3-4: 293.956 mm
Lines joining these markers intersect at an angle of 90° 00' 19"

Midside fiducials
 5-6: 225.994 mm 7-8: 225.990 mm
Lines joining these markers intersect at an angle of 89° 59' 55"

Corner fiducials (perimeter)
 1-3: 207.871 mm 2-3: 207.887 mm
 1-4: 207.868 mm 2-4: 207.846 mm

The method of measuring these distances is considered accurate within 0.005 mm.

FIG. 4-6. (Sheet 3 of 5)

USGS Report No. OSL/1609

IX. Stereomodel Flatness

Magazine No.: 117911 Base/Height ratio: 0.6
Platen ID: CZ284 Maximum angle of field tested: 40°

Stereomodel
Test point array
(values in micrometers)

The values shown on the diagram are the average departures from flatness (at
negative scale) for two computer-simulated stereomodels based on comparator
measurements on contact glass (Kodak Micro-flat) diapositives made from Kodak
2405 film exposures. These measurements are considered accurate within 5 um.

X. Resolving Power in cycles/mm

Area-weighted average resolution: 44 Film: Type 2405

Field angle:	0°	7.5°	15°	22.7°	30°	35°	40°
Radial lines	67	57	57	48	48	40	40
Tangential lines	67	57	57	48	40	40	28

FIG. 4-6. (Sheet 4 of 5)

USGS Report No. OSL/1609

IX. Stereomodel Flatness

Magazine No.: 136388 Base/Height ratio: 0.6

Platen ID: CZ277 Maximum angle of field tested: 40°

```
d  ┌─────────────────────────┐
a  │    ┌ ─ ─ ─ ─ ─ ─ ─ ┐     │
t  │        7        -4       │
a  │    │                │    │
   │             -3          │
s  │    │                │    │
t  │                          │
r  │    │ -3      -1     6│    │
i  │                          │
p  │    │        -4      │    │
   │                          │
s  │    │                │    │
i  │                          │
d  │    │ 1       2      │    │
e  │    └ ─ ─ ─ ─ ─ ─ ─ ┘     │
   └─────────────────────────┘
```

Stereomodel
Test point array
(values in micrometers)

The values shown on the diagram are the average departures from flatness (at negative scale) for two computer-simulated stereomodels based on comparator measurements on contact glass (Kodak Micro-flat) diapositives made from Kodak 2405 film exposures. These measurements are considered accurate within 5 um.

X. Resolving Power in cycles/mm

Area-weighted average resolution: 46 Film: Type 2405

Field angle:	0°	7.5°	15°	22.7°	30°	35°	40°
Radial lines	67	67	57	57	48	40	40
Tangential lines	67	57	57	48	48	40	28

This aerial mapping camera calibration report supersedes the previously issued USGS Report No. OSL/1356, dated June 7, 1988.

Bradish F. Johnson

Bradish F. Johnson
Acting Chief, Optical Science Laboratory
National Mapping Division

FIG. 4-6. (Sheet 5 of 5)

CAMERA LOG

DATE 7/09/88 AREA MADIGAN HOSPITAL, FORT LEWIS, WA JOB NO.

SCALE 1/5400, 1/4200 ALT. - A.M.T.

PLANE N713MA PILOT PUGSLEY CAMERA MAN LINFORD

CAMERA 116202 MAGAZINE 939 FILM TYPE B/W XX ROLL NO.

ATMOSPHERE CLEAR

DATE	AREA & STRIP NO.	f-STOP	TIME FLOWN Start	Finish	DIRECTION	EXPOSURES From	To	ALT.—MSL.
7/9/88	MADIGAN HOSPITAL 1	5.6 800	1030		S	10	13	3000
	1				S	14	20	
	2				E	21	27	
	2				E	28	31	
	2				E	32	35	2400
	2				E	36	43	
	2				E	44	50	
	1				S	51	60	
	1				S	61	65	
	OBL			1100		66		

REMARKS _____

FIG. 4-7. Camera Log (From U.S. Army Engineer District, Seattle)

FILM EDIT LOG

PROJECT: _MADIGAN HOSPITAL, FT LEWIS_ AVG. ENDLAP: _60% & 80%_

IDENT. #: _S88058_ AVG. SIDELAP: _32%_

DATE FLOWN: _7/9/88_ PARALLAX CHECK: _____

LINE	2	3	4	5	6	7	8	9	10	11	12	13	14	15	REMARKS
1	62	62	60												2700 AMT
1	82	81	81	81	80										
2	60	62	60												
2	60	60	60												2100 AMT
2	77	82	82	82	79	82	80								
2	80	81	80	79	80	79	81								
1	80	80	79	80	80	79	80	79							
1	58	61	60	61											

1) Check line against flight map and mark every 5th exposure on map.
2) Endlap shall not be less than 55% nor more than 65%.
3) Sidelap shall not be less than 20% nor more than 40%.
4) Crab shall not exceed 3%.
5) Tilt shall not exceed 3% nor shall it exceed 5% between successive exposures.
 Average tilt over the project shall not exceed 1%.
6) Identify strip and exposure with grease pencil. X-out excess exposures.
7) Annotate each line and exposure in ink on North or West edge.

RECORDED BY: _EGGER 7/12/1988_
REVIEWED BY: _HANSEL 7/12/1988_

FIG. 4-8. Film Edit Log (From U.S. Army Engineer District, Seattle)

CHAPTER 5

GROUND CONTROL REQUIREMENTS FOR PHOTOGRAMMETRIC MAPPING

5-1. GENERAL.

This chapter covers ground control requirements for photogrammetric mapping projects. The fundamental requirements for control network configuration, point location, and image characteristics are discussed. However, the overview presented here is not intended to be used for field survey design or survey procedural instruction. The USACE specification writer or photogrammetric engineer should refer to appropriate survey standards and specifications for guidance in designing the project control surveys.

5-2. COORDINATE REFERENCE SYSTEMS.

The coordinate reference system is the backbone of a mapping project. It provides the framework to tie together all field survey and map data. The coordinate reference system must be specified for the final map product. Typically, the State Plane Coordinate zone or the universal transverse Mercator (UTM) zone in which the project is located is used to define a mapping coordinate system. The photogrammetric engineer must be familiar with the reference datum, the coordinate system definition, and the methods required to transform all data into the final map coordinate system. Chapter 10 reviews the definitions of the datums and coordinate systems typically encountered in mapping. Several sources in Appendix A provide detailed information on datums, coordinate systems, and map projections.

5-3. GROUND CONTROL REQUIREMENTS FOR PHOTOGRAMMETRIC MAPPING

Field surveying for photogrammetric control is generally a two-step process. The first step consists of establishing a network of *basic control* in the project area. This basic control consists of horizontal control monuments and benchmarks of vertical control that will serve as a reference framework for subsequent surveys. The second step involves establishing *photo control* by means of surveys originating from the basic control network. Photo control points are the actual points appearing in the photos that are used to control photogrammetric operations. The accuracy of basic control surveys is generally of higher order than subsequent photo control surveys.

A. Basic Control. A basic control survey provides a fundamental framework of control for all project-related surveys, such as property surveys, photo control surveys, location and design surveys, and construction layout. The accuracy, location, and density of the basic control must be designed to satisfy all the project tasks that will be referenced to the control. Horizontal basic control typically consists of linear traverse lines or trilaterated networks connecting horizontal points. Vertical basic control is typically a separate survey of level routes and route networks connecting vertical points.

(1) Horizontal basic control points should be angle points in traverses or vertices of network triangles. Vertical basic control points should be turning points in level routes. Side shots or open traverses should not be used to locate basic control. Second- or Third-Order plane surveys will generally be of sufficient accuracy to establish basic control for most, if not all, USACE projects. See also the guidance in Table 2-4.

(2) In planning the basic control survey, maximum advantage should be taken of existing, or project, control established in the area by the USACE Command. In remote areas, basic control may have been established by the National Geodetic Survey (NGS) or USGS. In many locations, local control points exist such as those established for State agency and urban area networks. Care should be exercised before using any control points to verify that they are adequately interconnected or are adequately connected to the national network (i.e., NGRS).

(3) Basic control survey stations should be located and monumented to be permanent, at least for the life-time of the project. All stations should be fully described and referenced to permanent field reference points. The station descriptions should be included in the control survey report.

B. Photo Control. Photo control points are photoidentifiable points that can be measured on the photograph and stereomodel. Photo control points are connected to the basic control framework by short spur traverses, intersections, and short level loops. Lengthy side shots and open traverses should be avoided. Photo control surveys are local surveys of limited extent. Photo control points are surveyed to the accuracy required to control the photogrammetric solution. Typically, Third-Order, Class II type plane surveys are sufficient to establish photo control points.

(1) Characteristics. Photo control points should be designed by considering the following characteristics: location of the control point on the photograph; positive identification of the image point; and measurement characteristics of the image point.

a. Location. Of the characteristics listed in paragraph (1) above, location is always the overriding factor. Photo control points must be in the proper geometric location to accurately reference the photogrammetric solution to the ground coordinate system. Horizontal photo control points should define a long line across the photographic coverage. The horizontal control accurately fixes the scale and azimuth of the solution. Vertical photo control should define a geometrically strong horizontal triangle spanning the photographic coverage. The vertical control accurately fixes the elevation datum of the solution.

b. Identification. The identification of the photo control points on the aerial photographs is critical. Extreme care should be exercised to make this identification accurate. The surveyor should examine the photo control point in the field using a small pocket stereoscope with the aerial photographs. Once a photo control point is identified, its position on the photograph should be pricked using a sharp needle. A brief description and sketch of each point should be made on the reverse side of the photograph. Each photo control point should be given a unique name or number.

c. Measurement. Subject to the constraints imposed by location considerations, photo control points should be designed to provide accurate pointing characteristics during photogrammetric measurements. Furthermore, control points should not be located at the edge of the image format since image resolution and distortion are both degraded at the edge of the format. Photo control points falling in the outside 10 to 15% of the image format should be rejected.

(2) Horizontal photo control. Images for horizontal control have slightly different requirements from images for vertical control. Because their horizontal positions on the photographs must be pre-

TABLE 5-1. Photo Control Required for Photogrammetric Products

Product (1)	Minimum Control Required		Per Unit (4)
	Horizontal (2)	Vertical (3)	
Photo Enlargement	0	0	Photo
Rectified Photo (Controlled or Semicontrolled)	3 Total Control	0	Photo
Photo Plans and Mosaics	3	0	Sheet
Planimetric and Topographic Mapping	3	4	Stereomodel
Orthophoto Mapping	3	4	Stereomodel

cisely measured, images of horizontal control points must be very sharp and well defined horizontally. Care should be exercised to ensure that control points do not fall in shadowed areas.

(3) Vertical photo control. Images for vertical control need not be so sharp and well defined horizontally. Points selected should, however, be well defined vertically. Since measurements are typically made stereoscopically, good vertical control points should have characteristics that make it easy for the operator to put accurately the floating mark at the correct elevation. Vertical control points are best located in small, flat or slightly crowned areas with some natural features nearby that assist with stereoscopic depth perception.

C. Control Point Distribution. The number of control points required and their optimum locations depend upon the use that will be made of them. For example, a semicontrolled mosaic may require only a sparse uniformly distributed network of horizontal control. The most demanding requirements for photo control are encountered when spatially resecting a photo or scaling and leveling a stereomodel.

(1) If photo control is being established for the purpose of orienting stereomodels in a plotting instrument for topographic map compilation, the absolute geometric minimum amount of photo control needed in each stereomodel is three vertical and two horizontal control points. However, some amount of redundant control should be used as a check. Thus, as a practical minimum, each stereomodel oriented in a plotter should have three horizontal and four vertical control points. The horizontal points should be widely spaced. Horizontal points in opposite diagonal corners of the neat model are optimum. Vertical control points should be in the corners of the neat model. Vertical control should never be along a single line in the neat model. A fifth vertical control point in the center of each stereomodel is useful as a quality control check for stereomodel deformation.

(2) Table 5-1 summarizes the number of photo control points required for typical photogrammetric products.

5-4. MARKING PHOTO CONTROL.

Photoidentifiable control points can be established by marking points with targets before the flight or by selecting identifiable image points after the flight.

A. Premarking. Premarking photo control points is recommended for Class 1 and Class 2

a. **Typical cross design**

b. **Y-shaped design**

c. **T-shaped design**

FIG. 5-1. Typical Ground Control Target Designs

mapping. Marking control points with targets before the flight is the most reliable and accurate way to establish photo control points. Survey points in the basic control network can also be targeted to make them photoidentifiable. When the terrain is relatively featureless, targeting will always produce a well-defined image in the proper location. However, premarking is also a significant expense in the project because target materials must be purchased, and targets must be placed in the field and maintained until flying is com-

pleted. The target itself should be designed to produce the best possible photo control image point. The main elements in target design are good color contrast, a symmetrical target that can be centered over the control point, and a target size that yields a satisfactory image on the resulting photographs.

(1) Location. Target location should be designed according to the characteristics for photo control points discussed in paragraph 5-3B. The optimum location for photo control points is in the triple overlap area; however, when control is premarked, it is difficult to ensure that the target will fall in the center of the triple overlap area when the photography is flown. Care should be taken that targets are not located too near the edge of the strip coverage so that the target does not fall outside of the neat model.

(2) Material. Targets may be made of cloth or plastic or may be painted on plywood, fiberboard, or similar sheet material or on pavement or flat rock outcrops. Flexible targets may be made by assembling pieces of the material to form the pattern or by printing the pattern on sheet material. Cloth, paint, and other material used for targets should have a non-glossy matte surface. Targets should be held in place by spikes, stakes, small sandbags, or any other means necessary to keep them in position and maintain flatness.

(3) Shape. Targets should be symmetrical in design to aid the operator in pointing on the control point. A typical cross design suggested by Wolf (1983) is illustrated in Fig. 5-1. Similar leg and center panel designs can be developed in Y, T, and V shapes if field conditions require alternate shapes. The center panel should be centered over the control point, since this is the image point at which measurements will be taken. The legs help in identifying the targets on the photos and also in determining the exact center of the target should the image of the center panel be unclear.

(4) Size. Target sizes should be designed on the basis of intended photo scale so that the target images are the optimum size for pointing on the photos. Target size is related to the size of the measuring mark in the comparator and stereoplotter instruments used. An image size of about 0.050 mm square for the central panel is a typical design value. As shown in Figure 5-1, if the ground dimension of the central panel of the target is D, then the leg width should also be D, leg length should be $5D$, and the open space between the central panel and the leg should be D. Target sizes are readily calculated once photo scale and optimum target image size are selected. If, for example, a central

panel size of 0.050 mm is desired and photography at a scale of 1:12,000 is planned, then D should be 2.0 ft.

(5) Maintenance. All targets should be maintained in place and protected from or restored after damage by man, animals, or weather until photography has been taken. As soon as feasible after photography has been taken, each target should be inspected. If the inspection reveals that the target has been moved from its proper position or otherwise disturbed in any way, this fact should be reported in the photo control survey report. Damaged or lost targets will require that the photography on which the targets should appear be replaced with a new flight if the lost targets will jeopardize meeting the accuracy requirement for the photogrammetric product. As an alternative to replacing or relocating lost targets and replacing the deficient photography, unless the photography will be used for Class 1 mapping aerotriangulation, it may be permissible to substitute natural images for the lost targets when acceptable natural images are present and suitably located to replace all lost targets.

B. Postmarking Photo Identifiable Control. Postmarking photo control after the photography is flown is a method that may be used for Class 3 mapping. The postmarking method consists of examining the photography after it is flown and choosing natural image features that most closely meet the characteristics for horizontal or vertical photo control points. The selected features are then located in the field and surveyed from the basic control monuments. One advantage of postmarking photo control points is that the control point can be chosen in the optimum location—the corners of neat models and in the triple overlap area. The principal disadvantage of postmarking is that the natural feature is not as well defined as a targeted survey monument either in the field or on the image.

TABLE 5-2. FGCC Horizontal Distance Accuracy Standards

Survey Classification (1)	Minimum Distance Accuracy (2)
First-Order	1:100,000
Second-Order, Class I	1:50,000
Second-Order, Class II	1:20,000
Third-Order, Class I	1:10,000
Third-Order, Class II	1:5,000

TABLE 5-3. FGCC Elevation Accuracy Standards

Survey Classification (1)	Maximum Elevation Difference Accuracy, mm/km (2)
First-Order, Class I	0.5
First-Order, Class II	0.7
Second-Order, Class I	1.0
Second-Order, Class II	1.3
Third-Order	2.0

5-5. SURVEY ACCURACY STANDARDS.

Ground control should be established to a level of accuracy commensurate with that specified for the final map product (see Chapter 2). Careful planning and analysis of the basic control and photo control ground surveys should be performed by the contractor to ensure that sufficient accuracy will be obtained throughout the project area to meet map compilation and aerotriangulation criteria.

A. Accuracy Required. Field surveys to establish project control should ideally originate from higher order control established by USACE, NGS, USGS, or local agencies. Field surveys should be designed for the lowest order survey that will meet project requirements, as specified in Table 2-4. As the accuracy standard increases, the cost of the survey will increase significantly. As a rule of thumb, the accuracy of the horizontal photo control should be twice the horizontal map accuracy to be produced, and the vertical photo control accuracy should be as accurate as the spot elevation accuracy to be produced. The accuracy of a given photo control point is the propagated error in the basic control survey points combined with the error contributed by the survey to connect to the photo control point.

B. USACE Standards. USACE standards and guidelines for control surveys are presently under development. Until the USACE standards are available, the FGCC standards discussed in paragraph C below should be used to plan and execute the basic and photo control surveys for photogrammetric aerotriangulation and mapping.

C. FGCC Standards. Standards and Specifications for Geodetic Control Networks (FGCC 1984) may be used to plan and execute the basic and photo control surveys for photogrammetric aerotriangulation and mapping. FGCC relative ac-

curacy standards for horizontal and vertical control are shown in Tables 5-2 and 5-3. The FGCC document also gives procedural specifications for triangulation, trilateration, traversing, Global Positioning System (GPS) and Doppler positioning, photogrammetry, and leveling field survey methods. These specifications should be followed to ensure that the accuracy standard will be met.

The distance accuracy $1:a$ is defined to be

$$a = \frac{d}{s} \qquad (5\text{-}1)$$

where a = distance accuracy denominator; d = distance between survey points; and s = propagated standard deviation of distance between survey points obtained from a weighted and minimally constrained least squares adjustment.

The elevation difference accuracy b is a ratio defined as

$$b = \frac{s}{\sqrt{d}} \qquad (5\text{-}2)$$

where b = elevation difference accuracy ratio; s = propagated standard deviation of elevation difference in millimeters between survey points obtained from a weighted and minimally constrained least squares adjustment; and d = distance between control points in kilometers measured along the level route.

5-6. DELIVERABLES.

Unless otherwise modified by the contract specifications, the following materials will be delivered to the Government upon completion of the control surveys:

A. General report describing the project and survey procedures used including description of the project area, location, and existing control found; description of the basic and photo control survey network geometry; description of the survey instruments and field methods used; description of the survey adjustment method and results such as closures and precision of adjusted positions; justification for any survey points omitted from the final adjusted network.

B. One set of paper prints showing all control points. The points should be symbolized and named on the image side, and the exact point location should be pinpricked through the print.

C. A list of the adjusted coordinates of all horizontal and vertical basic and photo control points.

CHAPTER 6

ANALYTICAL AEROTRIANGULATION

6-1. GENERAL.

Since ground control is a significant expense in any mapping project, aerotriangulation bridging or control extension methods are often used to reduce the amount of field surveying required by extending control to each stereomodel photogrammetrically. The number of control points required to scale and level each stereomodel does not change; on small projects of a few stereomodels, it may be cost-effective to establish all the stereomodel control by field survey methods. However, as the areal extent of a project increases, and thereby the number of stereomodels, aerotriangulation becomes an efficient method of extending a sparse field survey control network. This chapter emphasizes fully analytical aerotriangulation methods since these methods are most appropriate for modern instruments and large-scale mapping requirements.

6-2. AEROTRIANGULATION PRINCIPLES.

A. Definition. Aerotriangulation is the simultaneous space resection and space intersection of image rays recorded by an aerial mapping camera. Conjugate image rays projected from two or more overlapping photographs intersect at the common ground points to define the three-dimensional space coordinates of each point. The entire assembly of image rays is fit to known ground control points in an adjustment process. Thus, when the adjustment is complete, ground coordinates of unknown ground points are determined by the intersection of adjusted image rays. An overview of aerotriangulation principles and methods is included in Chapter 10.

B. Purpose. The purpose of aerotriangulation is to extend horizontal and vertical control from relatively few ground survey control points to each unknown ground point included in the solution. The supplemental control points are called pass points, and they are used to control subsequent photogrammetric mapping. Each stereomodel is scaled and leveled using the adjusted co-ordinate values of the pass points located in the stereomodel.

C. Relationship to Ground Control. Aerotriangulation is essentially an interpolation tool, capable of extending control to areas between ground survey control using several contiguous uncontrolled stereomodels. An aerotriangulation solution should never be extended or cantilevered beyond the ground control. Ground control should be located at the ends of single strips and along the perimeter of block configurations. Within a strip or block, ground control is added at intervals of several stereomodels to limit error propagation in the adjusted pass point coordinates. Extending control by aerotriangulation methods is often referred to as *bridging* since the spatial image ray triangulation spans the gap between ground control.

6-3. PASS POINTS.

Pass point requirements are related to type of point used, location, and point transfer and marking requirements.

A. Type of Points. Pass points may be artificially marked points, targeted points, or natural images. However, since pass points must lie at or very near the center line of the triple overlap area, artificially marked points designed from the photography taken should be used. Premarked targets are too expensive and too difficult to align with the triple overlap areas. Natural images are not suitable for precise pointing.

B. Marking Artificial Points. Artificially marked pass points must be well-defined symmetrical patterns drilled, punched, or otherwise marked in the emulsion using a suitable marking instrument such as a Wild PUG or equivalent. Only the aerotriangulation/compilation positives should be marked. Normally, the original negatives should not be marked.

C. Location. A minimum of three pass points must be marked along the center line of each triple overlap area. One pass point must lie near the photo principal point, and one point must lie near

each of the corners of the neat model. Pass point locations must be selected by examining the photographic prints with a stereoscope. Pass points must be located on unobscured level ground in accordance with the characteristics for vertical photo control. All pass point locations must be symbolized and labeled on the control photographs.

D. Point Transfer for Monoscopic Measurements. Artificial pass points are typically marked in stereoscopic correspondence on all photographs showing the site of the point, using a stereoscopic transfer and point marking device such as a Wild PUG or equivalent. For the minimum three pass points in each triple overlap area, this operation will result in a minimum nine pass points on each photo. This method is required when photo coordinates are to be measured on a monocomparator. This method may be used when pass points are to be measured stereoscopically, either as photo coordinates on a stereocomparator or analytical stereoplotter or as model coordinates on any stereoplotter. Stereoscopic point transfer and marking should be done by a highly experienced operator using utmost care in choosing the site and in the marking of each pass point.

E. Point Transfer for Stereoscopic Measurements. When pass points are to be measured stereoscopically, either as photo coordinates on a stereocomparator or analytical stereoplotter or as model coordinates on any stereoplotter, artificial pass points need be marked on the center photograph only using a suitable point marking device. Viewing the marked point stereoscopically with adjacent photographs will accomplish the point transfer of the pass point location to the overlapping photo as part of the measurement process. When parallel flight lines of photography are used, tie points should be transferred from one flight line to each adjacent flight line using a stereoscopic transfer and point marking device such as a Wild PUG or equivalent. Artificial points are typically not superimposed on images of targets.

6-4. GROUND CONTROL POINTS.

Ground control requirements are related to targeting, control location, and survey accuracy requirements.

A. Targeting. Aerotriangulation for Class 1 and Class 2 mapping should require ground photo control points to be targeted prior to the flight. Targeting should be in accordance with paragraph 5-4A. Aerotriangulation for Class 3 mapping may use post-

flight natural photo control points if approved by the Government.

B. Control Location. Final control location and bridging distances used should be the decision of the contractor, but the following guidelines should be applied:

(1) Single strips

a. Along a single flight line of photography (Fig.6-1), horizontal control points should be in pairs at the strip ends within the terminal stereomodel, one on each side of the flight line approximately opposite each other. For each single flight line, additional horizontal control points should be located at intervals along the strip that do not exceed the maximum allowable bridging distance. Horizontal basic control points should be no more than one-third of the width of coverage of a photograph from the flight line.

b. Along a single flight line of photography, vertical control points should be in pairs, one on each side of the flight line approximately opposite each other and at a distance from the flight line of between one-fourth and one-third of the width of coverage of a photograph. For each single flight line, the pairs of vertical control points should be

a. Single strip configuration

△ Total Control Point

☐ Vertical Control Point

b. Block configuration

FIG. 6-1. Typical Strip and Block Control Configurations

located at the strip ends within the terminal stereo-model and at intervals along the strip that do not exceed the allowable bridging distance for the class of mapping.

(2) Blocks. A block of photography, consisting of two or more flight lines of photography (Fig. 6-1), should have control points spaced approximately equally around the periphery following the same spacing and location guidelines as for strips in paragraph 6-4B(1). There should be at least one horizontal control point and two vertical control points near the center of any block.

a. Additional horizontal control should be located in the center of the block such that horizontal control falls in alternating strips at an interval not to exceed two times the allowable horizontal bridging distance. There should be at least one horizontal control point and two vertical control points near the center of any block.

b. Additional vertical control should be located in the center of the block such that vertical control falls in each strip at an interval not to exceed two times the allowable vertical bridging distance.

C. Bridging Distance. Table 6-1 lists typical allowable bridging distances that may be used as a guide in estimating control requirements for a project. These are minimum guidelines, and many contractors will design a more dense control pattern, for example, a horizontal control point every five stereomodels regardless of block size.

D. Ground Control Accuracy. Ground control accuracy for aerotriangulation should be more stringent than for a project fully controlled by field survey points.

The aerotriangulation solution will contribute to the propagated error in the pass point ground control values. Since the pass point coordinates should meet the accuracy required for photo control, the photoidentifiable ground control

TABLE 6-1. Allowable Bridging Distances

| Map Class (1) | Allowable Bridging Distance (Stereomodel Bases) | |
	Maximum Horizontal Control Spacing (2)	Maximum Vertical Control Spacing (3)
1	4	2
2	5	3
3	6	3

points used to control the aerotriangulation should be more typical of the accuracy of the basic control survey.

E. GPS Control. The GPS is an effective method of establishing basic project control and photo control. GPS is an especially effective way to connect the project area surveys to existing national network stations outside the project region. Kinematic GPS methods are also being used to position the camera at the time of exposure. If the camera position is known, ground control points used to resect for the camera position can be eliminated. The use of kinematic GPS methods should be evaluated carefully. Unless the terrain is inaccessible for ground targeting, terrestrial GPS surveys to establish control points and normal flying procedures may be more cost-effective and accurate for large-scale mapping. GPS theory and applications are more fully discussed in Leick (1990).

6-5. OTHER POINTS.

Coordinates can be established by aerotriangulation for additional points located on the photography by targets or artificially marked as pass points. For example, these points may be aerotriangulation checkpoints, stereoplotter test points, or cadastral points to be located on the map. The Government should specify all points required to be included in the aerotriangulation in addition to the control points and standard pass point pattern. If a supplemental pass point is required for checking stereomodel flatness at compilation time, it should be located near the center of the stereomodel within a circle whose diameter is the central third of the air base.

6-6. INSTRUMENTATION.

Precise photo coordinate measurements are required for fully analytical aerotriangulation. An analytical stereoplotter or a monocomparator must be used. When semianalytical aerotriangulation serves as a preadjustment for fully analytical aerotriangulation, instrumentation and measurement procedures are controlled by the requirements for fully analytical aerotriangulation. When semianalytical aerotriangulation is to be the final adjustment for pass point coordinates, coordinates of independent stereomodels must be measured on a Second-Order analog instrument or better as defined in Table 7-1.

6-7. ACCURACY AND QUALITY CONTROL CRITERIA.

The contractor is responsible for designing the aerotriangulation scheme that will meet the requirements of the photogrammetric product. Table 6-2 summarizes the guidelines for evaluating aerotriangulation methods. However, since meeting required pass point accuracies is dependent on the photogrammetric system, the contractor should be allowed some latitude in meeting criteria for these intermediate results.

A. Photo Coordinate Measurements. Photo coordinate measurement is the most critical factor contributing to the accuracy of aerotriangulation results. The contractor should be especially careful to control the quality of point transfer, point marking, and point measurement. The measurement stage(s) of the stereoplotter or the monocomparator should have a least count of 0.001 mm or less. The viewing, pointing, and digitizing components of these instruments should enable the operator to group multiple readings on any well-defined target or marked pass point within a maximum spread of 0.004 mm. Multiple readings are of more value if they are not consecutive;

TABLE 6-2. Guidelines for Evaluating Analytical Aerotriangulation

Analytical Aerotriangulation Procedures (1)	Criteria (2)
Photo Coordinate Measurements: Monocomparator or Analytical Stereoplotter	
Least Count of Stage Coordinate	0.001 mm
Interior Orientation: Transformation to Fiducial Coordinates	
Minimum Number of Fiducials	4
Maximum Residual (After Affine Transformation)	0.020 mm
Preliminary Sequential Strip Formation and Adjustment	
Stereomodel Relative Orientation	
Minimum Number of Points, y-parallax Residuals	6
RMSE	0.005 mm
Maximum	0.015 mm
Stereomodel Joins	
Minimum Number of Points	3
x,y Pass Point Coordinate Discrepancy	
RMSE	H/12,000 ft
Maximum	H/6,000 ft
z Pass Point Coordinate Discrepancy	
RMSE	H/10,000 ft
Maximum	H/5,000 ft
Polynomial Strip Adjustment	
X,Y Control Point Coordinate Residual	
RMSE	H/10,000 ft
Maximum	H/6,000 ft
Z Control Point Coordinate Residual	
RMSE	H/7,000 ft
Maximum	H/5,000 ft
Simultaneous Bundle Adjustment	0.004 mm
RMSE of Photo Coordinate Residual	1.5
Maximum Variance Factor Ratio	
(See also Table 6-3)	

however, this reading scheme is often not practical. If multiple readings are made consecutively, the operator must move off the image and re-point between each reading. The instrument used should be capable of measuring a photo coordinate with an RMSE not greater than 0.003 mm. It is mandatory to end the measuring of a photograph with a reading on the first point measured (usually a fiducial mark) to assure that the instrument encoders have not drifted or skipped counts.

B. Interior Orientation. Interior orientation refers to the geometric relationship between the image plane and the perspective center of the lens.

(1) The initial step is to transform the measured stage coordinates into the photo coordinate system defined by the calibrated fiducial coordinates. An affine transformation, which accounts for differential image scale and shear, is typically used to establish the photo coordinate system. The transformation parameters are determined by a least squares adjustment using at least the four midside or four corner fiducials. If both types of fiducials are present in the camera, eight fiducial points can be used to increase the redundancy of the adjustment.

(2) After the photo coordinate system is established, the image measurements must be corrected for systematic errors. This procedure is called photo coordinate refinement. Corrections are applied for principal point offset, radial lens distortion, tangential lens distortion, and atmospheric refraction. Procedures for making these corrections may be found in Wolf (1983) and Moffitt and Mikhail (1980). Correction for tangential lens distortion may be neglected if it is found to be insignificant in the camera calibration report. Photo coordinate refinement may be performed by the analytical stereoplotter software or the aerotriangulation software. Typically, the interior orientation and refinement parameters are considered known based on the calibration report. Then the photo coordinate refinement is performed before the photo coordinates are used for the aerotriangulation adjustment. If self-calibration aerotriangulation software is used, the camera interior orientation parameters are considered to be approximations, and they are adjusted as a parameter in the aerotriangulation solution.

C. Preliminary Sequential Aerotriangulation. This process (Table 6-2) refers to the sequential assembly of independent stereomodels to form a strip unit and the polynomial strip adjustment into the ground coordinate system. The sequential procedure is a preliminary adjustment that develops initial approximations for the final simultaneous bundle adjustment. The sequential procedure also serves

as a quality control check of the photo and ground coordinate data. The guidelines listed in Table 6-2 are not rigorously enforced, but they are used to evaluate the building blocks of a larger strip or block configuration.

(1) Relative orientation of each stereo pair is performed by a least squares adjustment using the collinearity equations. The stereomodel is created in an arbitrary coordinate system, and the adjustment is unconstrained by ground coordinate values. Therefore, the photo coordinate residuals should be representative of the point transfer and measuring precision. The photo coordinate residuals should be examined to detect misidentified or poorly measured points. The minimum number of points that will uniquely determine a relative orientation is five, and the photo coordinate residuals will be zero. The six-point minimum recommended in Table 6-2 results if the standard nine pass points per photo configuration is used. With only one redundant pass point, the photo coordinate residuals will still be quite small unless a large blunder is present. Typically, more than the minimum six pass points are used. The RMSE and maximum residual values listed will more likely be reached when larger numbers of pass points are used.

(2) When stereomodels are joined to form a strip, the pass points shared between models will have two coordinate values, one value in the strip coordinate system and one value in the transformed model coordinate system. The coordinate differences or discrepancies between the two values can be examined to evaluate how well the models fit to one another. Horizontal coordinate discrepancies will typically be smaller than vertical discrepancies since the image ray intersection geometry is weaker in the vertical direction. As the stereomodels are transformed into the strip, one after the other, the pass point coordinate discrepancies should be uniform and no outliers should be observed. The coordinate discrepancy criterion is expressed as a fraction of the flying height above terrain because the magnitude of the discrepancy in ground units is dependent on the photo scale.

(3) Polynomial strip adjustment is a preliminary adjustment that produces initial ground coordinate values for all the pass points in a strip. The pass point coordinate values will be adjusted again by the final bundle adjustment. The polynomial correction curve is fit to the coordinate errors at the control point locations using a least squares adjustment. The residuals of the least squares curve fit can be examined to evaluate the adequacy of the polynomial adjustment. The residual criterion is expressed as a fraction of the flying height above terrain because the magnitude of the discrepancy in ground units is dependent on the

photo scale. The evaluation of the polynomial residuals is the least critical check in the aerotriangulation process, and a great deal of latitude can be allowed in meeting these criteria. From project to project, large variations in the residuals may occur because of the number of stereomodels in the strip, the polynomial function used, and the distribution of the control points. It is more important to check the X, Y, and Z error curves after the linear transformation of the strip into the ground coordinate system and before the polynomial correction. These error curves should be smooth Second- or Third-Order curves. Outliers from a smooth continuous curve are an indication of a blunder in the photogrammetric value or the ground survey value at a control point.

D. Simultaneous Bundle Adjustment.

Fully analytical aerotriangulation must be adjusted by a weighted least squares adjustment method. The adjustment software must form the collinearity condition equations for all the photo coordinate observations in the block and solve for all photo orientation and ground point coordinates in each iteration until the solution converges.

(1) The exterior coordinate system used for the adjustment should be a local rectangular coordinate system as defined in Chapter 10. This coordinate system contains no earth curvature or map projection distortions. These effects may be judged to be negligible for small project areas and low flying heights, but they are significant factors for large project areas and high flying heights.

(2) The least squares adjustment results should be examined to check the consistency of the photo coordinate measurements and the ground control fit. Residuals on the photo coordinates should be examined to see that they are representative of the random error expected from the instrument used to measure them. Residuals should be randomly plus or minus and have a uniform magnitude. The residuals should be checked carefully for outliers and systematic trends. The standard deviation of unit weight computed from the weighted adjusted residuals should not be more than 1.5 times the reference standard deviation used to compute the weights for the adjustment. A large computed reference variance indicates inflated residuals and possible systematic errors affecting the adjustment. For example, if photo coordinates were judged to have an overall measurement standard deviation of 0.005 mm and this value was used to compute observation weights, the standard deviation of unit weight computed by the adjustment should not exceed 0.0075 mm. A complete discussion of least squares adjustment methods and analysis of adjustment results can be found in Mikhail (1976).

(3) Accuracy of aerial analytical triangulation should be measured by the RMSE and the maximum error in each coordinate (X, Y, and Z) direction for the combined checkpoints. The maximum allowable error should be checked at the midpoint of the bridging distance between ground control points using checkpoints or test drop points surveyed for this purpose. Table 6-3 lists the accuracy criteria suggested for each class of mapping. These criteria are the final and most important check of the aerotriangulation results.

E. Semianalytical Aerotriangulation.

When semianalytical aerotriangulation is to be the final adjustment for pass point coordinates, final adjustment of strips or blocks must be performed using numerical polynomial strip adjustment or simultaneous stereomodel block adjustment. Analog or graphical adjustment methods must not be used. This criterion includes analytically computed independent stereomodels using monocomparator photo coordi-

TABLE 6-3. Aerotriangulation Accuracy Criteria (for 6-in. Focal Length Photography)

Map Class (1)	Aerotriangulation Method (2)	Allowable RMSE at Test Points[1]	
		Horizontal[2] (3)	Vertical[2] (4)
1	Fully Analytical	H/10,000	H/9,000
2	Fully Analytical	H/8,000	H/6,000
3	Fully Analytical or Semianalytical	H/6,000	H/4,500

Notes:
[1]The maximum allowable error is 3 RMSE.
[2]One-sigma level.

DIRECT GEODETIC CONSTRAINT ANALYTICAL AEROTRIANGULATION PROGRAM K658 FOR MULTIPLE CAMERA BLOCKS - JUNE 1979 PAGE NO. 61

FAIRCHILD RAIL GARRISON 90008 2-5 1 APR 90 1/4200 ZEISS 153.755 MK2 31 MAY 1990

POINT NO.	EASTING	NORTHING	ELEVATION	D-EAST	D-NORTH	D-ELEV	
556	2786827.385	250839.112	2412.14	-0.165	-0.028	0.28	H & V
3521	2788659.065	251320.650	2411.14				
3522	2787483.426	251227.729	2408.32				
3523	2786402.842	250902.489	2414.15				
4621	2787457.352	232749.686	2392.55				
4622	2786331.083	232803.281	2401.21				
4623	2785144.380	232809.955	2422.71				
580	2786204.833	233229.089	2405.01	0.053	0.169	0.09	H & V
558	2785370.182	233994.918	2422.22	0.082	-0.092	0.09	H & V
4631	2787471.758	234229.074	2400.87				
4632	2786396.453	234204.204	2406.73				
4633	2785372.762	234188.906	2424.67				
4641	2787462.665	235694.789	2406.46				
4642	2786362.539	235646.811	2418.74				
4643	2785324.200	235526.918	2429.87				
559	2785316.662	235848.956	2429.34	0.222	0.026	0.06	H & V

ROOT MEAN SQUARE ERRORS

		HORIZONTAL			VERTICAL	
	NO. POINTS	X	Y	RESULTANT	NO. POINTS	Z
HELD	27	0.14	0.17	0.22	62	0.17
KNOWN, BUT NOT HELD	3	1.54	0.82	1.75	0	0.0
ALL KNOWN POINTS	30	0.50	0.30	0.59	62	0.17

FIG. 6-2. Portion of Output From Analytical Aerotriangulation Adjustment (From U.S. Army Engineer District, Seattle)

nates. Strips must be assembled by numerical coordinate transformations of successive stereomodels. Strips of stereomodels may be assembled using base-in/base-out capabilities on analytical or universal analog stereoplotters.

6-8. STEREOPLOTTER SETTINGS.

Fully analytical aerotriangulation determines the six camera exterior orientation parameters for each photograph, camera position (X_L, Y_L, and Z_L), and angular orientation (the omega-phi-kappa system described in paragraph 10-6). By relating these parameters to the flight line between each two successive camera stations and scaling to the stereomodel, data are obtained for setting up the stereoscopic model in the stereoplotter. For a specific analog stereoplotter, orientation settings can be derived that will enable the operator to set up the stereomodel for compilation much faster than the manual empirical method, thereby saving expensive stereoplotter time during the compilation phase of the project.

6-9. DELIVERABLES.

Unless otherwise modified by the contract specifications, the following materials will be delivered to the Government upon completion of the aerotriangulation:

A. General report about the project and procedures used including description of the project area, location, and extent; description of the instrumentation used for pass point transfer and marking, and photo coordinate measurement; and description of the aerotriangulation methods and software used including version numbers.

B. One set of paper prints showing all control points and pass points used. The points should be symbolized and named on the image side, and the exact point location should be pinpricked through the print.

C. A list of the computed coordinates of all points specified by the Government.

D. A report of the accuracies attained and listing discrepancies in each coordinate direction at control points and checkpoints separately, a justification for any control points or pass points omitted from the final adjustment, and the RMSE and maximum error (in relation to ground surveyed coordinates) in each coordinate direction (X, Y, and Z) for the control points and checkpoints as a group.

E. Complete copies of all computer printouts (Figure 6-2).

F. A list of stereoplotter orientation settings, if specified.

CHAPTER 7

STEREOCOMPILATION PROCEDURES

7-1. GENERAL.

This chapter reviews stereoplotter map compilation procedures and discusses the instruments and procedures employed in compiling line and digital map products. The primary focus is on modern analytical plotters that can directly translate photographic images to digital files for use in CADD, GIS, Land Information System (LIS), and Automated Mapping/Facilities Management (AM/FM) data bases.

7-2. PREPARATION.

Preparation for stereo map compilation begins with gathering the materials required to perform the compilation and then setting up the stereoplotter.

A. Materials Required. Materials required to begin stereoplotter setup and compilation include the following:

(1) Positive transparencies. Positive transparencies for the stereoplotter must be printed from the original negatives and prepared to proper size. Positives are made by contact printing from the original film negative of a standard 9 by 9 in. format camera. Positives must be printed on a dimensionally stable film base (termed film positives) or on glass.

(2) Camera calibration parameters. The camera calibration parameters define the interior orientation of the imaged bundle of rays. If an analog stereoplotter is used, the fundamental parameter required is the calibrated focal length so that the proper principal distance can be set on each projector. If an analytical stereoplotter is used, the complete camera calibration report (Fig. 4-6) is required. The camera calibration parameters may be stored in the analytical stereoplotter's computer data files.

(3) Ground control data. A file of ground coordinate values for all the photo control points surveyed on the ground and the pass points located by aerotriangulation is required to perform absolute orientation of each stereomodel. The coordinate file must be accompanied by a set of photo prints showing all photo control and pass points clearly symbolized on the image and identified on the back of the print.

(4) Photographic prints. A set of photographic prints should be available to the stereoplotter operator. These prints are used with a stereoscope to familiarize the operator with the terrain prior to compilation of a stereomodel. The prints can also be used by the operator during compilation for notations concerning interpretation of features and difficult areas to contour. In topographic mapping, the desired mapworthy detail is frequently interpreted from observations in the field in advance of stereocompilation. This information should be annotated on the contact prints given to the operator for incorporation into the map.

(5) Base map. A base map showing the coordinate grid of the horizontal datum and all ground control points is required for absolute orientation of each model. If a hard copy map manuscript is to be compiled, the base map must be carefully plotted to map specifications for grid lines and control points on stable drafting film. The base map for a computer graphics compilation system will be in the form of a computer file, but it must contain the same grid and control information as a hard copy base map.

B. Stereomodel Setup. Stereomodel setup proceeds through the three orientation steps—interior orientation, relative orientation, and absolute orientation. These orientation procedures are discussed in paragraph 10-14. The stereoplotter operator must use care in performing each orientation step and check each completed stereomodel for accuracy.

(1) Stereomodel deformations. Model setups should be checked for systematic model deformations by examining control coordinate discrepancies and image residuals or y-parallaxes. Stereomodels can be uniformly tilted in any direction, twisted (opposite diagonals systematically high or low), bowed (center systematically high or low), or incorrectly scaled. Redundant horizontal control, vertical control in the model corners, and, whenever practical, a fifth vertical control point at the model center will catch these deformations. The center test point can be a supplemental photo control point established by fully analytical aerotriangulation.

(2) Stereomodel setup sheets. Model setup sheets should be prepared for each stereomodel oriented for compilation. Model setup sheets and model orientation histories should be made a part of the permanent file for the project and are a mandatory contract submittal item. Example setup sheets are shown in Figs. 7-1 through 7-3.

a. If an analog stereoplotter is used, all

Job ID _____ Project ID _____ Model ID _____

Setup:

Model Base _____ Model Scale _____

Left Projector: Right Projector:

 Photo No. _____ Photo No. _____

 Omega _____ Omega _____

 Phi _____ Phi _____

 Kappa _____ Kappa _____

 bx _____ bx _____

 by _____ by _____

 bz _____ bz _____

Stereomodel:

Note parallax on sketch at orientation points.

Label control points on sketch and note coordinate discrepancies.

Remarks:

Operator _____ Date _____

FIG. 7-1. Typical Stereomodel Setup Sheet

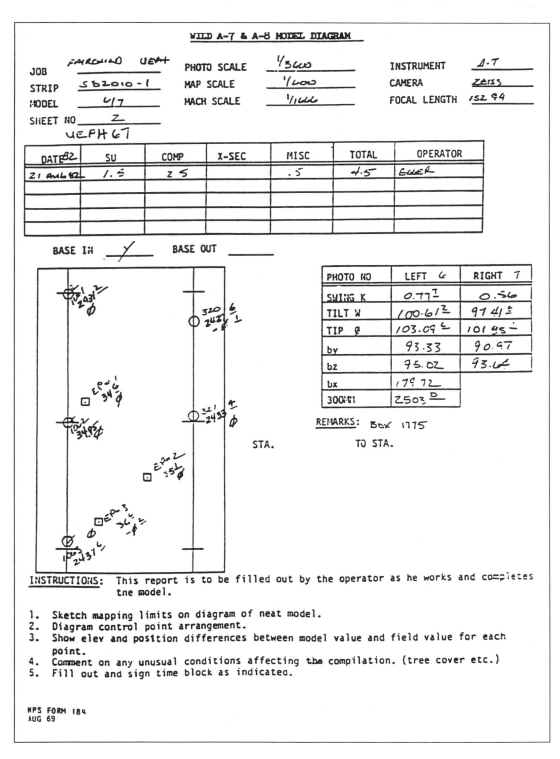

FIG. 7-2. Wild A-7 and A-8 Model Diagram (From U.S. Army Engineer District, Seattle)

horizontal and vertical control points and pass points should be measured after the model is absolutely oriented. The horizontal and vertical coordinate differences between the model measurement and the ground control file value should be recorded on a graphic diagram of the model showing location of the control point and the coordinate discrepancy values. The operator may also make notations concerning the interior orientation and the relative orientation residual y-parallax.

```
GOWEN FIELD, IDAHO
MPRC
------------------------
ALIGNMENT FILE: GOWENC
ORIENT FILE: #159
DATA FILE: FIL 206,221,222
FLIGHT DATE:  17 OCT 90
CAMERA:  KARR2  151.56 mm
SHEETS:  N/A
HOURS:     START: 8:00AM 3-26  FINISH: 11:00AM 3-27
  SU-1.0   DIGITAL COLLECTION-8.5    MISC-2.5(S.L.)  TOTAL- 9.5

MODEL GO90023-1015/1014 O   OPERATOR SIMMONS       DATE 1991. 3.26. 8.13
-----------------------------------------------------------------------

   MODEL SCALE 1:   4800   TABLE SCALE 1:    600   PHOTO SCALE 1:   4915

   ORIENTATION DATA  LEFT PHOTO  RIGHT PHOTO                      MODEL
   ----------------
               F      151.563     151.563   FLIGHT HEIGHT          2430
           OMEGA       -.743       -.282    ABOVE GROUND
             PHI       -.002       -.191
           KAPPA        .001      -2.215        AZIMUT          -62.934
              BX      -44.061      44.061   MODEL   ( XG0     2505956.48
              BY        1.494      -1.494   CENTER  ( YG0      581298.17
              BZ         .257       -.257   POSITION( ZG0        5734.92

MODEL BASE: B =     88.173 (ORTHO)    EARTH CURV.CORR.: R =   20898952

ORIENTATION REPORT
------------------

ABSOLUTE ORIENT.  USED CONTROL POINTS  PLANIMETRY  8 ELEVATION  8
                  POINT NO.            1141        1142         1143
                  POINT NO.            1154        2173         1151
                  POINT NO.            1152        1153
                  RESIDUAL COORDINATE ERRORS         MEAN          MAX
                                               X     .131        -.281
                                               Y     .108         .212
                                               Z     .076        -.171

RELATIVE ORIENT.  USED PARALLAX POINTS    8
                  RESIDUAL PARALLAXES      MEAN    .001  MAX   -.001

INTERIOR ORIENT.  USED FIDUCIALS  1234              LEFT       RIGHT
                                    X-SHRINKAGE   .999292     .999387
                                    Y-SHRINKAGE   .999412     .999616
                                    RECTANGUL.    -.00043     -.00011

REMARKS:
--------

EOF..
```

FIG. 7-3. Kern MAPS-200 Absolute Orientation Output (From U.S. Army Engineer District, Seattle)

b. In the analog setup sheet shown in Fig. 7-1, ground control and pass point locations are plotted in their approximate location by eye. Each point is plotted with the appropriate symbol and labeled with point identification. The coordinate discrepancies between the control value and the measured model value are computed and labeled near each point. The RMSE and the allowable maximum of the horizontal coordinate discrepancies should meet the planimetric accuracy criteria for the map class that is to be compiled. The RMSE and the allowable maximum of the vertical coordinate discrepancies should meet the spot elevation accuracy criteria for the map class to be compiled. If the model setup fails these accuracy criteria, the setup is rejected and the problem resolved.

c. If an analytical stereoplotter is used, a model setup history will be produced as a consequence of the mathematical solution. The results of the interior orientation, relative orientation, and absolute orientation will be output to a monitor and saved as a file. The results will include the observation residuals and the standard deviation of unit weight for each adjustment solution, as shown in Fig. 7-3.

d. Model setup reports are generated by the orientation software adjustments of an analytical stereoplotter. The interior orientation comparator stage coordinate to fiducial coordinate transformation should be reported for both stages. The exterior orientation collinearity adjustment should then be reported with coordinate discrepancies at each control point and pass point. Since these orientations are determined by least squares adjustment, the residuals should be examined carefully for outliers and systematic trends. The maximum photo coordinate residual in the interior orientation transformation should not exceed 0.015 mm. The RMSE and the allowable maximum of the horizontal coordinate discrepancies should meet the planimetric accuracy criteria for the map class that is to be compiled. The RMSE and the allowable maximum of the vertical coordinate discrepancies should meet the spot elevation accuracy criteria for the map class to be compiled. If the model setup fails these accuracy criteria, the setup is rejected and the problem resolved. Review of these statistical reports is a vital Government QA function.

7-3. STEREOPLOTTER ACCURACIES.

Stereoplotter accuracies are best expressed in terms of observation error at diapositive scale. In this way, instruments can be compared based on the fundamental measurement of image position on the positive. Measurement error on the positive can be projected to the model space so that expected horizontal and vertical error in the map compilation can be estimated.

A. Enlargement From Photograph to Target Map Scale. The enlargement ratio from photograph to the target map scale refers primarily to the projection system of the stereoplotter. A contact positive of the original negative and a compilation of the stereomodel at final map scale are assumed. If reductions or enlargements are performed in the negative to positive printing or the stereomodel to map manuscript printing, they must be included when evaluating the photograph to map enlargement ratio. Criteria for maximum enlargement from photograph to map scale are guidelines for determining the smallest photographic scale that should be used to compile a given map scale on a given stereoplotter. If the focal length of the camera is specified (e.g., 6 in.), then the maximum flying height can be determined. Specific USACE criteria for maximum photo enlargement and flight altitude were provided in the tables in Chapter 2.

B. C-Factor. The C-factor is a traditional expression of vertical compilation accuracy. It is defined as the ratio of the flying height above terrain to the minimum CI that should be compiled on the stereoplotter. The C-factor is an empirical rating scale that depends not only on the stereoplotter instrument but also on the camera, the film, and the skill of the operator. An exact C-factor is not to be specified for a specific instrument. It is a "calibration" factor of the entire photogrammetric system, and each production unit should be aware of its own limitations. When a photogrammetric project is planned, the C-factor may be used as a rule of thumb to evaluate the relationship between photo scale and CI. If a ratio is indicated that is far outside the typical range, it may serve as a warning to evaluate the project plan more carefully. Few instrument manufacturers of photo mapping firms can quantify a specific C-factor, and many tend to be overoptimistic in their ratings. The C-factor is used to derive the negative scale and flight altitude to achieve the vertical accuracy based on the specified CI. Assuming too optimistic (high) a C-factor will adversely affect the resultant accuracy of the map product. The maximum C-factor values given in Chapter 2 are based on practical experience, and are recommended for USACE engineering and design mapping work. They should not be exceeded regardless of manufacturer/contractor claims that they are too conservative. Table 7-1 lists typical C-factor ranges.

TABLE 7-1. Typical C-Factor Ranges (6 in. Focal Length Photography)

Instrument Type (1)	Map Class (2)	C-Factor Range (3)
Analytical Stereoplotter	1	1800–2000
	2	2000–2200
	3	2200–2500
First-Order Mechanical Stereoplotter	1	1400–1600
	2	1600–1800
	3	1800–2000
Second-Order Mechanical Stereoplotter	1	1200–1400
	2	1400–1600
	3	1600–1800
Third-Order Direct-Optical Stereoplotter	1	N/A
	2	800–1000
	3	1000–1200

7-4. STEREOPLOTTER OUTPUT DEVICES.

Stereoplotters are connected to a variety of devices for plotting or recording line work and digital data. Although the direct tracing of map manu-

scripts on a stereoplotter is a form of output, it is expected that modern stereoplotters will be encoded and interfaced to a graphical or digital output device. Fig. 7-4 depicts an analog plotter driving a digital recording device. Fig. 7-5 shows two types of modern, fully automated analytical stereoplotter configurations. (Typical output devices are further discussed in Chapter 10.)

a. Wild BC-1

FIG. 7-4. Wild B8S Digital Analog Stereoplotter (Courtesy of Southern Resource Mapping Corporation)

b. Zeiss P2

FIG. 7-5. Analytical Stereoplotters (Courtesy of Southern Resource Mapping Corporation)

7-5. LINE MAP COMPILATION PROCEDURES.

All planimetric features and contours are delineated by following the feature with the floating mark, adjusting the elevation so that the floating mark is always in contact with the apparent model surface as the compilation proceeds. The particular map details to be compiled depend on the type of map being prepared and the land use characteristics of the project area (Appendix E).

A. Compilation of Planimetry. As a general rule, those features whose accurate positioning or alignment is most important should be compiled first. The relationship of the model to the datum should be checked at frequent intervals during the compilation process. Each feature should be completed before proceeding to the next feature. It is preferable to compile all the features of a kind at one time; in this way, the chances of overlooking and omitting any detail are minimized.

(1) Care should be taken when plotting objects having height, such as buildings and trees, to avoid tracing their shadows instead of their true positions. Buildings may have to be plotted by their roof lines, as the photograph perspective may cause their bases to be partially obscured.

(2) Planimetry should not be compiled beyond the limits of the neat model.

(3) For compilation of planimetric detail only, an absolute level is not required.

B. Planimetric Features. All planimetric features identifiable on or interpretable from the aerial photographs should be shown on the final maps. The following feature lists may be modified by the Government in the contract scope of work to add or delete features in accordance with the purpose of the map (CADD, GIS, LIS, AM/FM, etc.) and the site-specific characteristics of the area to be compiled:

(1) Land use features. Land use features include parks, golf courses, and other recreational areas; historic areas; archeological sites; buildings; fences and walls; canals; ditches; reservoirs; trails; streets; roads; railroads; quarries, borrow pits; cemeteries; orchards; boundaries of logged-off areas and wooded areas; individual lone large trees; the trace of cross-country telephone, telegraph, and electric power transmission lines and their poles and towers; fence lines; billboards; rock and other walls; and similar details.

(2) Structural features. Structural features include bridges; trestles; tunnels; piers; retaining walls; dams; power plants; transformer and other substations; transportation terminals and airfields; oil, water, and other storage tanks; and similar detail. Structural features shall be plotted to scale at all map scales. Minor irregularities in outlines not representable by the limiting RMSE of the map standard may be ignored. Features smaller than 1/20 in. at map scale should be symbolized at 1/20 -in. size.

(3) Hydrographic features. Hydrographic features include rivers, streams, lakes, ponds, marshes, springs, falls and rapids, glaciers, water wells, and similar detail. Wherever they exist, such features as the drainageways of draws, creeks, and tributary streams longer than 1 in. at map scale should be delineated on the maps.

(4) Scale-dependent features. On maps at scales of 50 ft to the inch or larger, there should be shown, in addition to the other required land use features, curbs, sidewalks, parking strips, driveways, hydrants, manholes, lampposts, and similar features dependent on the functional application.

(5) Ground completion surveys. Areas that are obscured on the photography by buildings, shadows, or trees should be completed by ground survey methods that meet the accuracy class of the mapping. Ground surveys are also used to map features that cannot be seen on the photography such as underground utilities, easements and property boundaries, and political boundaries. A stereoplotter operator cannot be expected to pick up all objects on a given site—even if visible in the photography. (This is no different from conventional plane table surveying—a certain percentage of omissions is probable.) Requirements for surface and subsurface utilities or other critical features must be specifically and explicitly outlined in the contract scope, including requirements for ground verification, editing, etc. The contractor cannot be held liable for normal or expected omissions if the Government fails to detail critical portions of the work, and program contract funds therefor. Failure by either the Government or the mapping contractor to adequately depict critical feature requirements is usually caught during construction, and the cost of construction change orders for "differing site conditions" due to these deficiencies will usually far exceed the original field mapping effort.

(6) Sample planimetric feature data. Figs. 7-6 and 7-7 depict portions of planimetric layers developed for general planning (1 in. = 200 ft) and AM/FM or design (1 in. = 50 ft) purposes.

C. Compilation of Topography. Topographic contours are delineated by setting the stereoplotter's floating mark at the appropriate contour

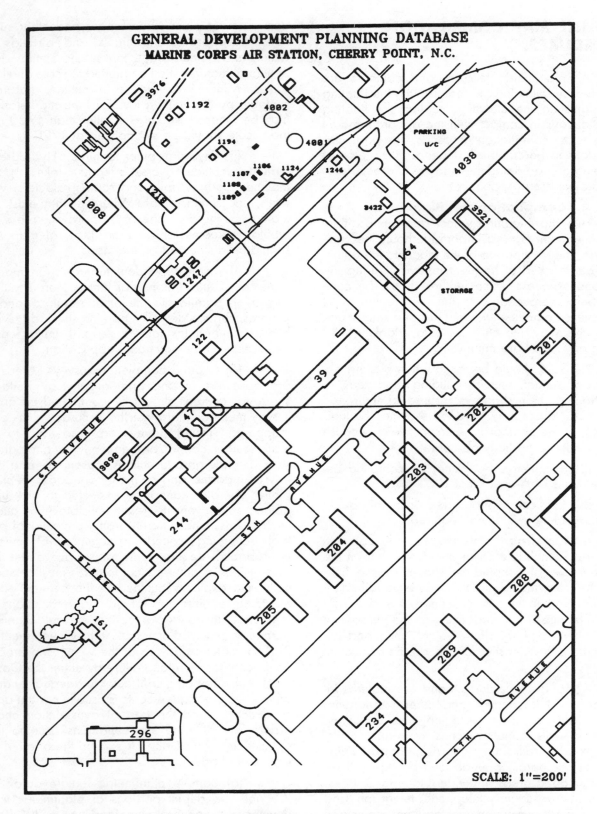

FIG. 7-6. General Development Planning Data Base (Courtesy of Southern Resource Mapping Corporation)

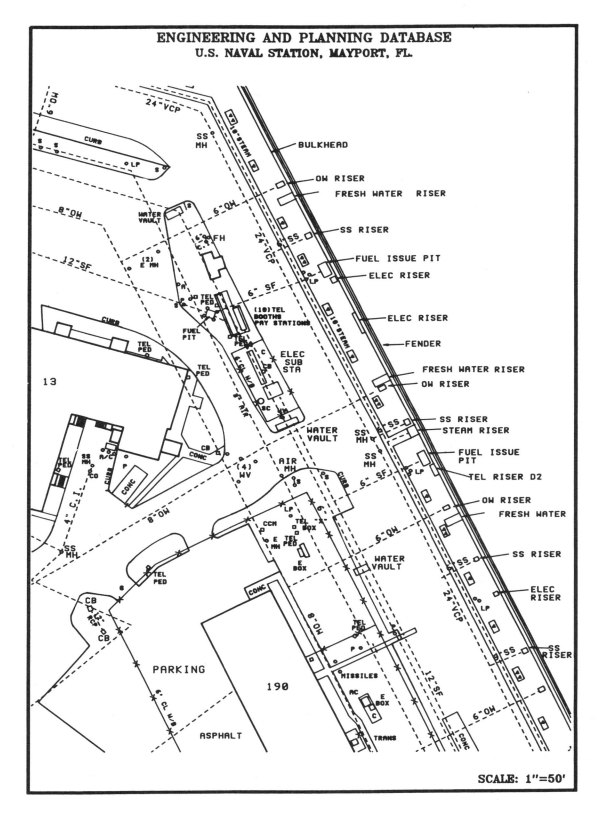

FIG. 7-7. Design and/or AM/FM Data Base (Courtesy of Southern Resource Mapping Corporation)

elevation, and tracing the contour while the floating mark is maintained in constant visual contact with the apparent terrain surface in the stereomodel. When making any stereoscopic measurement with a floating mark, and especially when contouring, the observer must strive for an awareness of the model around, above, and below the mark itself. Depending on the character of the topography, it is usually preferable to compile the contours associated with topographic features or small groups of features, rather than to thread one contour across a whole model before starting to trace the next contour.

(1) Contouring requires that the model be both positioned and leveled as accurately as possible. During the compilation of contours, the stereocompiler should frequently check both the position and level of the model. He should also check the consistency of this elevation reading on a given point (index reading) frequently, as his personal "index" may be subject to a variation, especially during the first minutes of stereoscopic observation. This varying index must be corrected, until such time as it becomes stable. The error in the index check should not exceed the spot height accuracy for the class of map being compiled.

(2) Drainage lines, large and small, should be lightly drawn prior to compiling the contours. Drainage is of great importance in obtaining the proper contour expression of landforms since most landforms have developed to some extent through the effects of erosion. The drain lines should be carried in the map manuscript as an aid in map editing and final drafting. Using paper prints and a stereoscope is also very helpful in interpreting the landforms since the vertical dimension is exaggerated and the drainage is accentuated.

(3) Spot readings of terrain elevation may be needed in areas where it is difficult to follow the terrain by direct tracing of the contours. Such areas include very flat terrain, large monotone areas such as fields of grass, areas in shadow, and areas covered by trees. If a sufficient number and distribution of accurate spot readings can be made, then the contours can be interpolated from the spot readings. If there is doubt that the interpolated contours will meet the accuracy class of the mapping, then the contours should be shown by dashed lines and the area marked for possible field completion. Where the terrain surface is completely obscured by vegetation, the contours should be omitted and the area marked for field survey completion if the terrain in this area is critical to subsequent design and construction. Contours should not be estimated by tracing the tops of the vegetation and making a height adjustment.

D. Spot Elevations. Spot elevations are elevations of certain topographic and cultural features that are required to furnish the map users with more specific elevations of these features than may be interpolated from the contours.

(1) Spot elevations should be recorded by the stereocompiler whenever needed to supplement spot elevations that may have been obtained in the course of field surveys. Spot elevations are typically shown in their proper position at the water level of lakes, reservoirs, and ponds; on hilltops; in saddles; at the bottom of depressions; at the intersection of well-traveled roads, principal streets in cities, railroads, and highways; and similar locations.

(2) When the terrain is flat and the contours are widely spaced, spot elevations are added to better define the topographic surface. This is exhibited in Fig. 7-8. If contours are more than 2 in. apart at map scale, spot elevations should be added at an approximately uniform spacing of 1 to 2 in. at map scale.

(3) Spot elevations must meet the map class accuracy standard. Each spot elevation should be determined by averaging repeated readings in the stereomodel.

7-6. DIGITAL TERRAIN MODEL COMPILATION PROCEDURES.

A DTM is a numerical representation of the ground surface that may be used as a substitute for a contour line map. The DTM is easily stored and manipulated by a computer and may be used to generate a number of useful products. A DTM may be used to interpolate and plot a topographic contour map, to determine earthwork quantities, or to produce an orthophotograph from an orthorectifier. It is normally translated into a three-dimensional CADD design file for these subsequent applications.

A. Types of Digital Terrain Models. The DTM may be grid, cross section, remeasurement, or critical point type, or as specified by the contract.

(1) Grid. Grid DTMs consist of elevations taken at regularly spaced intervals in two horizontal coordinate directions. These two horizontal directions may coincide with the northing and easting of the authorized project coordinate system or they may be skewed to it. Grid models are used for borrow pit determination, input for orthorectification, and numerous other applications. From gridded DTM data, triangulated irregular networks (TIN) may

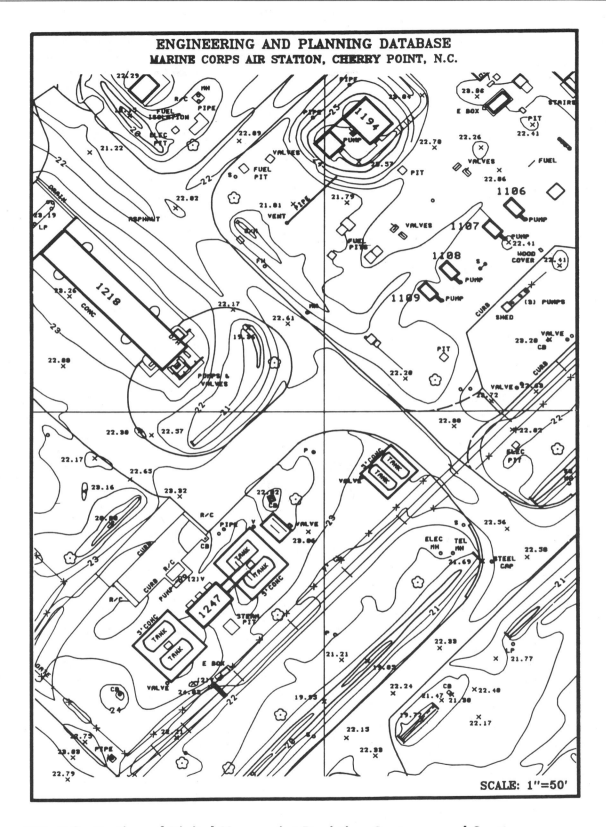

FIG. 7-8. Portion of Digital Manuscript Depicting Contours and Spot Elevations (Courtesy of Southern Resource Mapping Corporation)

be derived for use in standard design analysis software.

(2) Cross sections. Cross sections are measured perpendicular to and at regular intervals along a center line or a baseline. Each cross section consists of elevations and offset distances from the center line or baseline, measured for each significant break in the terrain. Cross sections are typically used for defining the original terrain along the proposed line for a highway.

(3) Remeasurement. Remeasurement defines the terrain after earthwork is completed. Original measurement may have been in grid or cross-section pattern; remeasurement extends only as far as construction operations changed the terrain, and it includes measurement of the same grid points or along the same cross-section lines, plus significant breaks in the surface as altered by construction.

(4) Critical points. The three coordinates of critical points define the topography of an area similar to sideshots in a stadia field survey. Critical points recorded along terrain break lines can be combined with grid type data to form a very accurate DTM. From such data, other descriptions of the topography can be derived such as contours or cross sections along any chosen alignment.

B. Contract Requirements. USACE commands will provide in each contract statement of work at least the following:

(1) Area. For design applications, USACE will provide a map of the area to be included in the DTM model, by outlining it or by drawing a center line or baseline and specifying the width of coverage. Written description may further define the area. For grid, cross section, or remeasurement DTMs, USACE will also provide the topographic engineer a scaled map of the area required for the DTM product.

(2) Stereomodel setup data. If the original data were compiled by another contractor, USACE will furnish the contractor the Ground Control Survey Report and the Aerotriangulation Report, which includes the X, Y, and Z ground coordinates of points for orienting the stereoplotter, and the stereoplotter orientation settings if available from the aerotriangulation report. For remeasurement, it shall be the map used for the original measurements.

(3) Point location and spacing.

a. For grid DTMs USACE will specify the spacing of points and outline on the map the area or areas of the DTM.

b. For cross sections, USACE will specify the maximum spacing of points and the maximum spacing of sections along the center line or baseline, and

the points required along each section. USACE will provide the necessary baseline alignment data, including the center line to be cross sectioned, all points of beginning and end of spirals and/or circular curves, and, unless they are off of the map sheet, points of intersection of highway tangents, and centers of circular curves. If plotted on a map at the target scale, these points will be indicated by circles 1/16 in. in diameter, centered on each point and labeled as to point type and (except points of intersection and curve centers) stationing. The center line will be shown by a line 1/200 in. wide, and section stations will be indicated by a line 1/16 in. long transverse to the center line, with each even hundred-foot line 1/8 in. long and labeled with its stationing.

c. For critical points, USACE will specify the maximum spacing of points.

(4) Digital data media. The Government will specify the media on which the DTM data shall be recorded and its arrangement and format, unless the data will be used exclusively by the contractor's organization in his design operations. The media may be magnetic tape or magnetic disc.

7-7. MAP MANUSCRIPT.

Unless a CADD system (or similar software package developed for stereoplotters with translation capabilities to any CADD package) is interfaced directly to the stereoplotter, graphical maps and overlays for orthophotomaps are prepared on the stereoplotter as map manuscripts. (Most modern photomapping firms have direct CADD-compatible stereoplotter output to video monitors, so the traditional paper or mylar "manuscript" is becoming obsolete (Fig. 7-9). The map manuscript base shall have the horizontal coordinate grid and the ground control points plotted on it in waterproof durable ink. Map manuscripts shall be drawn on dimensionally stable, matte-surface, polyester-type plastic drafting film at least 4 mils thick.

A. All map detail plotted on the manuscripts shall be to the clarity and accuracy that will result in finished maps fulfilling the map class accuracy standard.

B. Each map manuscript shall be compiled at a scale equal to or larger than the target scale specified for the finished map. When the compilation is made at a scale larger than required in the finished map, each manuscript shall be subsequently reduced photographically to produce the final map.

C. When a CADD system is interfaced directly to the stereoplotter, the map is compiled directly

a. Miami International Airport Terminal (1in. = 15 ft.)

b. Broward County, FL, school (1in. = 44.2 ft.)

FIG. 7-9. Direct Stereoplotter Screen Displays (Courtesy of CADMAP Software)

into its final form on the graphic display and stored in a digital data base. Preliminary digital map plots or map manuscripts may be plotted on translucent drafting vellum when requested for inspection purposes. The digital data base shall include the horizontal coordinate grid and the ground control points.

D. Map manuscripts shall show in the sheet margin the identification of map area, map scale expressed as both a representative fraction and a graphical bar scale, and flight number and photo numbers of the stereomodels contained in the map. Match notes of adjacent maps shall be shown on all sides of the plot. The original map manuscripts are a deliverable item and shall be maintained in a reasonably clean and legible condition. Lines must be of a clarity and density to provide clear, sharp, and legible paper prints from any standard reproduction equipment. Lettering on the manuscript shall be neat and legible.

7-8. MAP EDIT.

Map manuscripts must be edited carefully before or immediately after the stereomodel compilation phase of the project is completed. The map editor should be someone other than the stereoplotter operator who compiled the original map manuscript.

A. Each map must be checked for

(1) Compliance with the required map accuracy standards.

(2) Completeness of planimetric and topographic detail, as called for in the contract specifications.

(3) Correctness of symbolization and naming of features.

(4) Agreement of edge-matched planimetric and topographic line work with adjacent maps.

B. When a CADD system is interfaced directly to the stereoplotter, preliminary digital maps may be plotted on translucent drafting vellum for subsequent editing. Stereoplotters equipped with graphic superimposition in the viewing system can be used to assist the editor in checking the digital data base; however, this procedure will use time on the stereoplotter and increase the cost of editing. A typical independent CADD editing workstation is shown in Fig. 7-10.

7-9. FINAL MAP.

Final map sheets can be prepared by hand inking and scribing methods from map manuscripts,

FIG. 7-10. Typical Graphic Edit Workstation (Courtesy of Southern Resource Mapping Corporation)

or by computer-driven plotters from a graphic data base file. Final sheets should be on dimensionally stable, matte-surface, polyester-type plastic film at least 4 mils thick and of American National Standards Institute (1980) (ANSI) F-Size, unless otherwise specified. Upon completion, each map sheet should be reviewed and edited to ensure completeness and uniformity of the maps.

A. Drafting or Plotting.

(1) Final maps may be traced from the stereoplotter manuscripts by drafting in ink or scribing methods. When ink is used, a durable waterproof ink that will not flake or chip with normal use is required. All drafting must be clear and legible. Lettering and numbers should not obscure map features, and should be done using mechanical lettering guides. The Government contract will specify appropriate line weights, lettering sizes, and symbols to be used for the map scale and CI of the final map. See EM 1110-1-1807 for USACE CADD standards.

(2) Final maps may be produced from digital graphic data files by a computer-driven plotter capable of meeting the map class standard of accuracy (Fig.7-11). Digital graphic data files shall meet the requirements for layers, symbols, line weights, etc., as specified in EM1110-1-1807. The finished map shall be a drawing of the manuscript data stored in the digital data base.

FIG. 7-11. Hewlett Packard Draft Master I Pen Plotter Plotting Selected Layers of Newark International Airport Data Base (Courtesy of Southern Resource Mapping Corporation)

(3) Final maps may be produced directly at compilation time by stereoplotters interfaced to a computer-assisted digital plotting table if drafting standards and accuracy standards for the class of mapping can be met. The Government must approve this method of producing final maps.

B. Layout. USACE will specify the final map sheet size, border line dimensions, and map neat line dimensions and placement. A map sheet layout plan should be prepared for advance approval by USACE. Sheets should be laid out to cover the project area in an orderly, uniform, and logical fashion. The size and location of the stereomodels are dictated by the aerial photographs. The stereomodels may or may not coincide with the size, format, and positioning of the final map sheets.

C. Content.

(1) Legend and drawing notes. The final drawings should show, at minimum, the following information:

a. Project title.

b. Scale and scale bar.

c. North arrow and magnetic north.

d. Legend of symbols used (if different from standards).

e. Credit/Certification/Logo of the mapper.

f. Adjoining sheet numbers or a sheet layout plan for large projects (i.e., index map).

g. Grid projection or geographic coordinate datum.

h. Date of photography.

i. Date of mapping.

The drawing layout and content may be specified by USACE, or it may be proposed by the contractor for approval by USACE.

(2) Coordinate grid. The horizontal datum coordinate grid shall be shown on the map manuscript and on the final map. Spacing between grid intersections shall be 5 in. at finished map scale. Each coordinate grid line shall be numerically labeled at its ending on the edges of each map sheet.

(3) Ground control. Monumented horizontal control shall be shown by the appropriate symbol on the final map. The location of the control point is the center of the plotted symbol. Monumented vertical control shall be shown by the appropriate symbol on the final map.

(4) Map detail. All planimetric, topographic, and spot elevation map detail shall be drawn or scribed using professional standards of draftsmanship or plotted directly from a digital data base by high-resolution, high-accuracy, computer-driven plotters. Each line shall be uniform in width for its entire length. Symbols, letters, and numbers shall be clear and legible. All names and numbers shall be legible and clear in meaning and shall not interfere with map features.

7-10. REPRODUCTION.

The final map shall be ready for reproduction by any of the standard printing processes so that all lines, images, and other map detail as well as descriptive material will be clear, sharp, and legible.

A. The final map shall be drafted, scribed, or plotted at the target scale specified for the mapping project or larger. Larger scale maps can be reduced to a specified scale by photographic reproduction using a high-quality copy camera. Final maps may not be produced by enlarging manuscript maps.

B. When a photographic reproduction is used, a master sheet format showing all standard margin information can be prepared and registered with each drafted or scribed sheet during the photographic reproduction of the final positive map

sheets. This is accomplished by contact printing in a vacuum frame.

7-11. DELIVERABLES.

The following materials will be delivered to the Government upon completion of the project:

A. Stereomodel setup sheets or computer printouts.

B. Reproducible positives of each final map.

C. Paper prints of each final map.

D. Computer digital data base files. The Government shall specify the media, either magnetic disk or magnetic tape.

E. Computer DTM Files. The Government shall specify the media, either magnetic disk or magnetic tape.

CHAPTER 8

AERIAL MOSAICS, INDEXES, AND PHOTO PLANS

8-1. GENERAL.

The other chapters of this manual will be used in preparing for the construction of aerial mosaics, indexes, and photo plans. The sections of this chapter are supplemental to these chapters, but will take precedence, except for Chapter 2, in case of contradiction.

8-2. SOURCE PHOTOGRAPHS.

A photo mosaic or photo index will be made from vertical aerial photography taken for USACE as part of the contract or will be made from vertical aerial photography supplied by USACE.

8-3. UNCONTROLLED MOSAICS AND PHOTO INDEXES.

The mosaic or index will be prepared by stapling onto a backing board an assembly of prints of the photography.

A. Overlap Matching. The photographs will be overlap-matched by corresponding images along the flight line. The photographs for each adjacent flight line strip will overlap in the same direction. Air base lengths will be averaged in the image matching of pairs of photographs on the flight line. Parallel, adjoining flight line assemblies will be adjusted in length by incremental movement of the photographs along the flight line until corresponding image matching of adjacent flight line strips can be accomplished insofar as practical for the entire project.

B. Labeling. The frames of an uncontrolled photographic mosaic will be overlapped such that the labeling of each frame of photography is hidden. Each strip of a photographic index will be overlapped such that the labeling is visible, and the overlapping of strips will be such that the exposure numbers are visible.

C. Scale. The approximate scale of an uncontrolled mosaic will be at the original negative scale unless otherwise specified by contract. The scale of an index of aerial photography will be one-fourth the scale of the photography from which it was made.

D. Tone Matching. All prints will have similar density and contrast.

E. Trim. All prints for indexes will be trimmed with the fiducial marks showing.

8-4. SEMICONTROLLED MOSAICS.

Semicontrolled mosaics will be constructed from rectified paper prints or from digital imagery, and registered to existing maps of the area.

A. Ground Control Requirements. For most applications, redundant registration to 1:24,000-scale USGS map features will provide sufficient accuracy.

B. Tone Matching. Adjacent images will be tone and contrast matched to give the appearance of a continuous image.

C. Feathering. If the mosaics are constructed from paper prints, the edges of the mosaicked images will be feathered to minimize the ability to perceive the edges.

8-5. CONTROLLED MOSAICS.

Controlled mosaics will be constructed from differentially rectified orthophotos by using either photomechanical mosaicking or digital imagery methods.

A. Ground Control Requirements. Controlled mosaics will have ground control density and accuracy equivalent to the comparable Class 3 map.

B. Aerotriangulation Requirements. Controlled mosaics will have aerotriangulation and

model setup accuracies equivalent to the comparable Class 3 map.

C. Tone Matching. Adjacent images will be tone and contrast matched to give a continuous appearance to the image.

8-6. AIR PHOTO PLANS.

Air photo plan enlargements may be uncontrolled, semicontrolled, or controlled, as required by contract. They will meet the requirements for accuracy and image quality of the mosaic of corresponding accuracy.

8-7. ACCURACY SPECIFICATIONS AND COST CONSIDERATIONS.

The accuracy specification for controlled and semicontrolled mosaics, indexes, and photo plans will be that used for topographic maps. Table 8-1 lists the classification of these products.

8-8. LABELING AND TITLING.

For geographic orientation, appropriate notations will appear on the mosaic, index, or photo plan, naming several important and prominent geographic and land-use features. For an index, the film roll number and exposure number on every tenth photograph will be accentuated with a narrow, short-strip overlay of white paper on which the appropriate numbers have been written. The flight line number will be lettered and accentuated at the end of each flight line strip of photographs in the index.

A. Annotation. All overlay lettering and numbering will be neat and readable on both the index assembly and its photographic copies, and will not interfere with the principal land use and topographic features or with the symbols and numbers not accentuated on the individual intermediate photographs. For each mosaic or index, a graphic scale bar will be shown representing the average scale of the vertical photography assembled to form the index.

B. Title Block. A title block will be placed on the margin and photographically copied as part

TABLE 8-1. Classification of Photomap Products

Description (1)	Controlled Mosaic or Photo Plan (2)	Semicontrolled Mosaic or Photo Plan (3)	Uncontrolled Mosaic (4)	Uncontrolled Photo Plan (5)
USACE Map Accuracy Class	3 or As Specified	N/A	N/A	N/A
Maximum Enlargement Factor From Negative	4 (Maximum) Prefer Negative Scale	5 (Maximum) Prefer Negative Scale	6 (Maximum) Prefer Negative Scale	4 (Maximum)
Degree of Ground Control Required	As for Topographic Mapping	Existing Map Control	Minimum Control to Scale Photos	Minimum Control to Scale Photos
National Map Accuracy Class Vertical Information	Contours Generated from Digital File Required to Rectify Photographs	N/A	N/A	N/A
Rectified Photographs Required	Yes (Orthorectified)	Yes	No	No
Tone and Contrast Matched Prints Required	Yes	Yes	Yes	No

of the assembly or segments thereof. This title block will have the name of USACE at the head, followed by the project name and number; the photography scale, focal length, flight height, and date; the engineer's name; and a north arrow and the graphic scale bar—all in a format approved by USACE. The lettering for the title will be of such size that when photographic prints of the index are made to the size and scale required, individual letters will be not less than 1/10 in. in height and will be clearly legible.

8-9. PHOTOGRAPHIC COPYING AND PRINTING.

The assembly of photographs will be copied on black-and-white or color-negative photographic film so that prints can be made by the contact or projection method of printing.

A. Projection Method Requirements. If the projection method is selected, the scale of the copy negative will be not less than one-third the scale specified for the photographic prints of the index. Whenever the index cannot be copied photographically on one negative, it will be copied segmentally on two or more negatives as necessary. Each negative of a segment of the index will have photographic image overlap of the portion of the index photographed on the preceding negative, which will result in not less than 2 in. overlap at the scale required in photographic prints of the index.

B. Paper Print Requirements. Prints of the assembly will be on double-weight semimatte or resin-coated photographic paper.

8-10. DELIVERABLES.

The negative or negatives of the photographic index and the required photographic prints thereof will be furnished to and become the property of USACE. The paper prints of the photography that were assembled to form the mosaic or index will also become the property of USACE.

CHAPTER 9

ORTHOPHOTOGRAPHS AND ORTHOPHOTO MAPS

9-1. GENERAL.

Orthophotographs can be used as a substitute for a topographic line map for certain smaller scale, nondesign applications, such as LIS. If terrain relief is slight, simple rectification of an aerial photograph is sufficient. In areas of medium to high relief, an orthophoto must be made by means of differential rectification. Orthophotos should not be specified when removal of relief distortion is not critical to the functional application, as is the case in most GIS data elements or USACE river and harbor navigation maps. Orthophotos are of no value when digital CADD planimetric data files are required. Including orthophotos with conventional planimetric line maps is a waste of resources—simple (and more economical) semicontrolled, rectified air photo plans should

be used instead. An orthophoto should not be considered as a substitute for a detailed line map since feature details are not as accurate or discernable on an orthophotograph as in a stereoplotter.

9-2. METHODS OF RECTIFICATION.

Orthophotographs may be prepared by either simple rectification or differential rectification, depending on the relief difference in each aerial photograph. Simple rectification is adequate for photographs containing no more relief in feet than the scale in feet to the inch multiplied by the factor 0.03. This assures that the displacement due to relief of any photographic image will not exceed the specification limit for planimetry. For example, differen-

TABLE 9-1. Orthophotograph Preparation Guidelines

Description (1)	Orthophotgraph (2)	Orthophotograph (3)	Orthophotgraph (4)
USACE Map Accuracy Class	1	2	3
Maximum Enlargement Factor from Negative	4 times	6 times	8 times
Ground Control Required	Yes	Yes	Yes
Mismatch of Features Across Join Lines	Not to Exceed 1/50 in.	Not to Exceed 1/40 in.	Not to Exceed 1/20 in.
USACE Map Accuracy Class Vertical Information	Contours generated from digital file required to rectify photographs	N/A	N/A
Recommended Minimum Equipment	Wild OR-1, Gigas-Zeiss, or equivalent	Wild OR-1, Gigas-Zeiss, or equivalent	K320 Orthoscan, or T-64 Ortho-photoscope or equivalent

tial rectification is required for any photograph at a scale of 200 ft to the inch in an orthophoto map project made from photographs taken with a 6 in. focal length camera lens if the relief in that photograph exceeds 6 ft.

9-3. ORTHOPHOTO QUALITY.

The final orthophoto is a true map portraying planimetric information by photographic imagery. The orthophoto should be free of visible scan lines and mismatched imagery, as well as dust, scratch marks, and inconsistencies in tone and density between individual orthophotos.

9-4. CONTOURS.

Contours can be added to (or superimposed onto) the orthophotographs through the plotting system provided in the analytical orthoplotters or by resetting the original stereomodels and compiling the contours onto a transparent overlay registered to the orthophotographs. The contours may be photographically combined into the orthophoto map, and may be shown as either white or black lines. The selection is made to effect the greatest contrast, considering the predominant tone of the work area. Cartographic symbolization, contour numbers, spot elevations, and border and title information can be compiled and reproduced in the photo laboratory.

9-5. ENLARGEMENT FACTOR.

In making orthophoto maps, the enlargement from the aerial photo scale to the final orthophoto map is critical. The enlargement will not exceed 4 to 8 times as shown in Table 9-1.

9-6. POSITION ACCURACY.

In order to meet position accuracy requirements, special considerations may be necessary at locations where the ground elevation changes abruptly, as at vertical cliffs, retaining walls, and bridges. If the equipment used cannot accommodate such a sudden vertical change, it will be necessary to prepare two orthophotographs of such areas, one that depicts faithfully the upper level of the terrain and another that depicts faithfully the lower level of the terrain. The two shall then be combined by special photographic printing techniques or by removing a portion from one orthophotograph and inserting it into the other. The resulting montage shall meet all dimensional and aesthetic specifications. No attempt shall be made to place the tops of buildings, tanks, towers, trees, etc., in map position; rectification shall be at a ground level.

9-7. ORTHOPHOTOGRAPH PREPARATION GUIDELINES.

Table 9-1 presents guidelines for the preparation of orthophotos.

9-8. DELIVERABLES.

All materials including the orthophotograph negatives, the control prints, and the diapositives will be furnished to the Contracting Officer as stipulated in the contract specifications.

9-9. EQUIPMENT.

The orthophotograph shall be compiled on an instrument capable of making direct enlargements up to eight diameters between original negative scale and compilation scale.

CHAPTER 10

PRINCIPLES OF PHOTOGRAMMETRY

10-1. GENERAL.

The purpose of this chapter is to review the principles of photogrammetry. The chapter contains background information and references that support the standards and guidelines found in the previous chapters. Section I reviews the basic elements of photogrammetry with an emphasis on obtaining quantitative information from aerial photographs. Section II discusses basic operational principles of stereoplotters. Section III summarizes the datums and reference coordinate systems commonly encountered in photogrammetric mapping. Section IV discusses the principles of aerotriangulation. Section V provides background information for mosaics and orthophotographs. A more generalized nontechnical overview of photogrammetry may be found in Appendix C.

SECTION I
ELEMENTS OF PHOTOGRAMMETRY

10-2. GENERAL.

The purpose of this section is to review the basic geometry of aerial photography and the elements of photogrammetry that form the foundation of photogrammetric solutions.

10-3. DEFINITION.

Photogrammetry can be defined as the science and art of determining qualitative and quantitative characteristics of objects from the images recorded on photo graphic emulsions. Objects are identified and qualitatively described by observing photographic image characteristics such as shape, pattern, tone, and texture. Identification of deciduous versus coniferous trees, delineation of geologic landforms, and inventories of existing land use are examples of qualitative observations obtained from photography. The quantitative characteristics of objects such as size, orientation, and position are determined from measured image positions in the image plane of the camera taking the photography. Tree heights, stockpile volumes, topographic maps, and horizontal and vertical coordinates of unknown points are examples of quantitative measurements obtained from photography.

10-4. GEOMETRY OF AERIAL PHOTOGRAPHY.

The geometry of a single vertical photograph is shown in Fig. 10-1. The photographic negative is shown for completeness, but in practice it is typical to work with the photographic positive printed on paper, film, or glass. The front nodal point of the camera lens is defined as the exposure station of the photograph. The nodal points are those points in the camera lens system such that any light ray entering the lens and passing through the front nodal point will emerge from the rear nodal point travelling parallel to the incident light ray. Therefore, the positive photograph can be shown on the object side of the camera lens, positioned such that the object

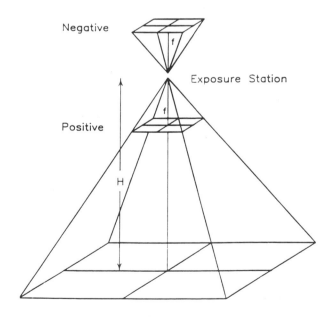

FIG. 10-1. Single Vertical Photograph Geometry

point, the image point, and the exposure station all lie on the same straight line. The line through the lens nodal points and perpendicular to the image plane intersects the image plane at the principal point. The distance measured from the rear nodal point to the negative principal point or from the front nodal point to the positive principal point is equal to the focal length f of the camera lens.

10-5. SINGLE VERTICAL AERIAL PHOTOGRAPHY.

Vertical photographs, exposed with the optical axis vertical or as nearly vertical as possible, are the principal kind of photographs used for mapping. If the axis is perfectly vertical, the resulting photograph is termed a "truly vertical" photograph. In spite of the precautions taken to maintain the vertical camera axis, small tilts are invariably present; but these tilts are usually less than 1 degree and they rarely exceed 3 degrees. Photographs containing these small, unintentional tilts are called "near vertical" or "tilted" photographs. Many of the equations developed in this chapter are for truly vertical photographs, but for certain work, they may be applied to near vertical photos without serious error. Photogrammetric principles and practices have been developed to account for tilted photographs, and no accuracy whatsoever need be lost in using tilted photographs.

A. Photographic Scale. The scale of an aerial photograph can be defined as the ratio between an image distance on the photograph and the corresponding horizontal ground distance. Note that if a correct photo graphic scale ratio is to be computed using this definition, the image distance and the ground distance must be measured in parallel horizontal planes. This condition rarely occurs in practice since the photograph is likely to be tilted and the ground surface is seldom a flat horizontal plane. Therefore, scale will vary throughout the format of a photograph, and photographic scale can be defined only at a point.

(1) The scale at a point on a truly vertical photograph is given by

$$S = \frac{f}{H - h} \qquad (10\text{-}1)$$

where S = photographic scale at a point; f = camera focal length; H = flying height above datum; and h = elevation above datum of the point.

Equation 10-1 is exact for truly vertical photographs and is typically used to calculate scale on nearly vertical photographs.

(2) In some instances, such as flight planning calculations, approximate scaled distances are adequate. If all ground points are assumed to lie at an average elevation, an average photographic scale can be adopted for direct measurements of ground distances. Average scale is calculated by

$$S_{ave} = \frac{f}{(H - h_{ave})} \qquad (10\text{-}2)$$

where h_{ave} is the average ground elevation in the photo. Then referring to the vertical photograph shown in Fig. 10-2, the approximate horizontal length of the line AB is

$$D \cong \frac{d(H - h_{ave})}{f} \qquad (10\text{-}3)$$

where D = horizontal ground distance; and d = photograph image distance.

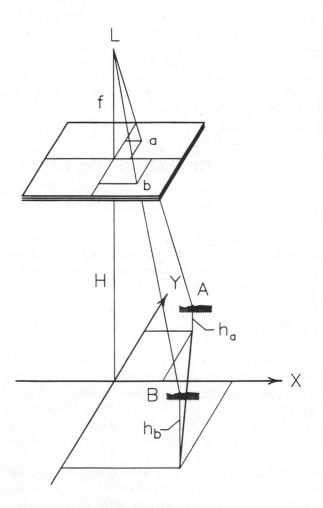

FIG. 10-2. Horizontal Ground Coordinates From Single Vertical Photograph

The flat terrain assumption, however, introduces scale variation errors. For accurate determinations of horizontal distances and angles, the scale variation caused by elevation differences between points must be accounted for in the photogrammetric solution.

B. Horizontal Coordinates. Horizontal ground distances and angles can be computed using coordinate geometry if the horizontal coordinates of the ground points are known. Fig. 10-2 illustrates the photogrammetric solution to determine horizontal ground coordinates.

(1) Horizontal ground coordinates can be calculated by dividing each photocoordinate by the true photographic scale at the image point. In equation form, the horizontal ground coordinates of any point are given by

$$X_p = \frac{x_p(H - h_p)}{f}$$

$$Y_p = \frac{y_p(H - h_p)}{f} \qquad (10\text{-}4)$$

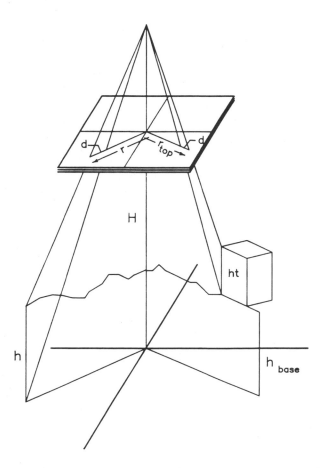

FIG. 10-3. Relief Displacement On a Vertical Photograph

where X_p, Y_p = ground coordinates of point p; x_p, y_p = photocoordinates of point p; and h_p = ground elevation of point p.

Note that these equations use a coordinate system defined by the photocoordinate axes having an origin at the photo principal point and the x-axis typically through the midside fiducial in the direction of flight. Then the local ground coordinate axes are placed parallel to the photocoordinate axes with an origin at the ground principal point.

(2) The equations for horizontal ground coordinates are exact for truly vertical photographs and typically used for near vertical photographs.

(3) After the horizontal ground coordinates of points A and B in Fig. 10-2 are computed, the horizontal distance is given by

$$D_{AB} = \sqrt{(X_a - X_b)^2 + (Y_a - Y_b)^2} \qquad (10\text{-}5)$$

This solution is not an approximation because the effect of scale variation caused by unequal elevations is included in the computation of the ground coordinates. It is important to note, however, that the elevations h_a and h_b must be known before the horizontal ground coordinates can be computed. The need to know elevation can be overcome if a stereo solution is used.

C. Relief Displacement. Relief displacement is another characteristic of the perspective geometry recorded by an aerial photograph. The displacement of an image point caused by changes in ground elevation is closely related to photographic scale variation. Relief displacement is evaluated when analyzing or planning mosaic or orthophoto projects. Relief displacement is also a tool that can be used in photo interpretation to determine heights of vertical objects.

(1) The displacement of photographic images caused by differences in elevation is illustrated in Fig. 10-3. The image displacement is always along radial lines from the principal point of a truly vertical photograph or the nadir of a tilted photograph. The magnitude of relief displacement is given by the formula

$$d = \frac{rh}{H} \qquad (10\text{-}6)$$

where d = image displacement; r = radial distance from the principal point to the image point; and H = flying height above ground.

(2) Since the image displacement of a vertical object can be measured on the photograph,

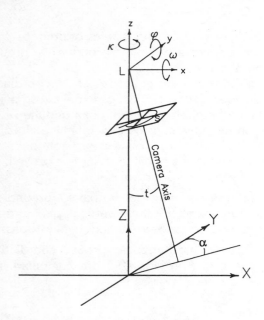

FIG. 10-4. Exterior Orientation of an Aerial Photograph

Equation 10-6 can be solved for the height of the object to obtain

$$ht = \frac{d(H - h_{base})}{r_{top}} \qquad (10\text{-}7)$$

where ht = vertical height of the object; and h_{base} = elevation at the object base above datum.

Remember, heights of vertical objects can be determined on a single photograph, but elevation above datum cannot be determined.

10-6. EXTERIOR ORIENTATION OF TILTED PHOTOGRAPHS.

Unavoidable aircraft tilts cause aerial photographs to be exposed with the camera axis tilted slightly from vertical, and the resulting pictures are called tilted photographs. The equations given above are exact for truly vertical photographs, and they are used with near vertical photography for planning, estimating, and photo interpretation. However, an accurate photogrammetric solution using aerial photographs must account for the camera position and tilt at the instant of exposure.

A. The exterior orientation of a photograph is its spatial position and angular orientation with respect to the ground coordinate system. Six independent parameters are required to define exterior orientation. The space position is normally given by three-dimensional coordinates of the exposure sta-

tion in a ground coordinate system. The vertical coordinate corresponds to the flying height above datum. Angular orientation is the amount and direction of tilt in the photo. Three angles are sufficient to define angular orientation, and two different systems are commonly used: the tilt-swing-azimuth system (t-s-α) and the omega-phi-kappa system (ω, φ, κ). The omega-phi-kappa system possesses certain computational advantages over the tilt-swing-azimuth system, but the tilt-swing-azimuth system is perhaps more easily understood. Figure 10-4 illustrates the parameters used to express exterior orientation of an aerial photograph.

B. The tilt-swing-azimuth system is appropriate for hand calculations. An auxiliary photocoordinate system is defined with an origin at the photo nadir and y' axis along the direction of tilt. The expression for scale on a tilted photograph is

$$S = \frac{\dfrac{f}{\cos t} - (y' \sin t)}{H - h} \qquad (10\text{-}8)$$

where y' = auxiliary photocoordinate; and t = photo tilt angle.

C. The tilt of aerial mapping photography is seldom large enough to require using tilted photograph equations for hand calculations when planning and estimating projects. However, Equation 10-8 does show that scale is a function of tilt, and scale variation occurs on a tilted photo even over flat terrain.

D. Since the swing angle s of a truly vertical photograph is undefined, the omega-phi-kappa angular orientation system is preferred when expressing exterior orientation of any photograph. In the omega-phi-kappa system, the angular orientation of a tilted photograph is given in terms of three *sequential* rotation angles, omega, phi, and kappa. These angles, also shown in Fig. 10-4, uniquely define the angular relationships between the three image coordinate system axes of a tilted photo and the three axes of the ground coordinate system. Omega is a rotation about the x photographic axis, phi is about the y-axis, and kappa is about the z-axis.

E. The angular orientation of a truly vertical photograph taken with the flight line in the ground X or east direction is

$$\omega = 0$$
$$\phi = 0$$
$$\kappa = 0$$

The omega-phi-kappa angular orientation system is used in analogic and analytical solutions to

express the exterior orientation of a photograph and produce accurate map information from aerial photographs.

10-7. STEREOSCOPIC VISION.

Stereoscopic vision determines the distance to an object by intersecting two lines of sight. In the human vision system, the brain senses the parallactic angle between the converging lines of sight and unconsciously associates the angle with a distance. Overlapping aerial photographs can be viewed stereoscopically with the aid of a stereoscope. The stereoscope forces the left eye to view the left photograph and the right eye to view the right photograph. Since the right photograph images the same terrain as the left photograph, but from a different exposure station, the brain perceives a parallactic angle when the two images are fused into one. As the viewer scans the entire overlap area of the two photographs, a continuous stereomodel of the ground surface can be seen. The stereomodel can be measured in three dimensions, yielding the elevation and horizontal position of unknown points. The limitation that elevation cannot be determined in a single photograph solution is overcome by the use of stereophotography.

A. Lens Stereoscope. A lens or pocket stereoscope is a low-cost instrument that is very useful in the field as well as the office. It offers a fixed magnification, typically 2.5X. The lens stereoscope is useful for photo interpretation, control point design, and verification of mapped planimetric and topographic features.

B. Mirror Stereoscope. A mirror stereoscope can be used for the same functions as a lens, but is not appropriate for field use. The mirror stereoscope has a wider field of view at the nominal magnification ratio. Since photographs can be held fixed for stereo viewing under a mirror stereoscope, the instrument is useful for simple stereoscopic measurements. Mirror stereoscopes can be equipped with binocular eyepieces that yield 6X and 9X magnification. The high magnification helps to identify, interpret, and measure photographed features.

C. Floating Mark. Stereoscopic measurements are possible if a floating mark is introduced in the viewing system. Identical halfmarks, such as a small filled circle or a small cross, are put in the field of view of each eye. As the stereomodel surface is viewed, the two halfmarks are viewed against the photographed scene by each eye. If the halfmark positions are properly adjusted, the brain will fuse their images into a single floating mark that appears in three-dimensional space relative to the stereo-

model. By moving the halfmarks parallel to the viewer's eye base, the floating mark can be adjusted until it is perceived to lie on the stereomodel surface. At this point, the two halfmarks are on the identical or conjugate image points of two different photographs. The horizontal position and elevation of the mark can be determined and plotted on a map. The importance of the floating mark is that all points in a stereomodel can be measured and mapped. Thus, indistinct points, such as hilltops, centers of road intersections, and contours can be mapped in three dimensions from the stereomodel.

10-8. GEOMETRY OF AERIAL STEREOPHOTOGRAPHS.

The basic unit of photogrammetric mapping is the stereomodel formed in the overlapping ground coverage of successive photographs along a flight line. Fig. 10-5 illustrates the ground coverage along three contiguous flight lines in a block of aerial photographs. Along each flight line, the overlap of photographs, termed end lap, is typically designed to be 60%. End lap must be at least 55% to ensure continuous stereoscopic coverage and provide a minimum triple overlap area where stereomodels can be matched together. Between adjacent flight lines, the overlap of strips, termed side lap, is typically designed to be 30%. Side lap must be at least 20% to ensure continuous stereoscopic coverage.

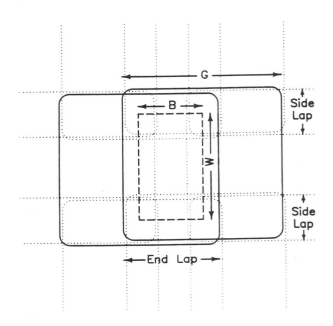

FIG. 10-5. Aerial Photography Stereomodel and Neat Model

A. Stereomodel Dimensions. For project planning and estimating, photograph and stereomodel ground dimensions are computed by assuming truly vertical photography and flat terrain at average ground elevation.

(1) Using average photographic scale, the ground coverage G of one side of a square format photograph is

$$G = \frac{d}{S_{ave}} \qquad (10\text{-}9)$$

where d is the negative format dimension. The flying height above datum is also found using average scale and average ground elevation.

$$H = h_{ave} + \frac{f}{S_{ave}} \qquad (10\text{-}10)$$

(2) Let B represent the air base between exposures in the strip. Then from the required photo end lap E_{lap}

$$B = G\left(1 - \frac{E_{lap}}{100}\right) \qquad (10\text{-}11)$$

(3) Let W represent the distance between adjacent flight lines. Then from the required side lap S_{lap}

$$W = G\left(1 - \frac{S_{lap}}{100}\right) \qquad (10\text{-}12)$$

(4) Match lines between contiguous stereomodels pass through the center of the triple overlap area and the center of the side lap area. These match lines bound the neat model area, the net area to be mapped within each stereomodel. The neat model has width equal to B and length equal to W.

B. Parallax Equations. The parallax equations may be used for simple stereo analysis of vertical aerial photographs taken from equal flying heights—that is, the camera axes are parallel to one another and perpendicular to the air base. Conjugate image points in the overlap area of two truly vertical aerial photographs may be projected as shown in Fig. 10-6. When the photographs are properly oriented with respect to one another, the conjugate image rays recorded by the camera will intersect at the true spatial location of the object point. Images of an object point A appear on the left and right photos at a and a', respectively. The planimetric position of point A on the ground is given in

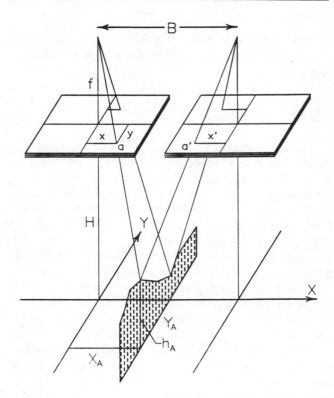

FIG. 10-6. Stereopair of Vertical Aerial Photographs

terms of ground coordinates X_A and Y_A. The XY ground axis system has its origin at the datum principal point O of the left photograph; the X-axis is in the same vertical plane as the photographic x and x′ flight axes; and the Y-axis passes through the datum principal point of the left photograph and is perpendicular to the X-axis.

(1) Photographic parallax is defined as the apparent movement of the image point across the image plane of the camera as the camera exposure station moves along the flight line. The parallax of the image point in Fig. 10-6 is

$$P_a = x_a - x_a' \qquad (10\text{-}13)$$

where x_a and $x'a$ are coordinate distances on the left and right photographs, respectively. Since parallactic image motion is parallel to the movement of the camera, the parallax coordinate system must be parallel to the direction of flight. All parallax occurs along the x-axis in the axis of flight photocoordinate system. The y and y′ coordinates are equal.

(2) Given truly vertical aerial photographs and photocoordinates measured in the axis of flight system, the following parallax equations can be derived:

$$X = \frac{xB}{p}$$

$$Y = \frac{yB}{p}$$

$$h = H - \frac{fB}{p} \qquad (10\text{-}14)$$

where X, Y = horizontal ground coordinates; x, y = photocoordinates on the left photograph; and p = parallax

Note that the origin of the ground coordinate system is at the ground principal point of the left photograph, and the X-axis is parallel to the flight line.

C. Parallax Difference Equation.

The parallax equations given in b above assume that the photographs are truly vertical and exposed from equal flying heights; thus, the camera axes are parallel to one another and perpendicular to the air base. Scale variation and relief displacement are not regarded as errors in the parallax method since these effects are measured as image parallax and used to compute elevations; however, tilted photographs, unequal flying heights, and image distortions seriously affect the accuracy of the parallax method. Absolute elevations are difficult to determine using the parallax equations given in b above because small errors in parallax will cause large errors in the vertical distance $H\text{-}h$. More precise results are obtained if differences in elevation are determined using the parallax difference formula

$$h_A = h_C + \frac{\Delta p(H - h_C)}{P_a} \qquad (10\text{-}15)$$

where h_A = elevation of point A above datum; h_C = elevation of point C above datum; P_a = parallax of image point a; P_c = parallax of image point c; and Δp = difference in parallax $(P_c - P_a)$.

The formula should be applied to points that are close to one another on the photo format. The differencing technique cancels out the systematic errors affecting the parallax of each point. If C is a vertical control point, the absolute elevation of A can be determined by this method.

10-9. FUNDAMENTAL PHOTOGRAMMETRIC PROBLEMS.

The fundamental photogrammetric problems are resection and intersection. All photogrammetric procedures are composed of these two basic problems.

A. Resection.

Resection is the process of recovering the exterior orientation of a single photograph from image measurements of ground control points. In a spatial resection, the image rays from total ground control points (horizontal position and elevation known) are made to resect through the lens nodal point (exposure station) to their image position on the photograph. The resection process forces the photograph to the same spatial position and angular orientation it had when the exposure was taken. The solution requires at least three total control points that do not lie in a straight line, and the interior orientation parameters, focal length, and principal point location. In aerial photogrammetric mapping, the exact camera position and orientation are generally unknown. The exterior orientation must be determined from known ground control points by the resection principle.

B. Intersection.

Intersection is the process of photogrammetrically determining the spatial position of ground points by intersecting image rays from two or more photographs. If the interior and exterior orientation parameters of the photographs are known, then conjugate image rays can be projected from the photograph through the lens nodal point (exposure station) to the ground space. Two or more image rays intersecting at a common point will determine the horizontal position and elevation of the point. Map positions of points are determined by the intersection principle from correctly oriented photographs.

10-10. PHOTOGRAMMETRIC SOLUTION METHODS.

Correct and accurate photogrammetric solutions must include all interior and exterior orientation parameters. Each orientation parameter must be modeled if the recorded image ray is to be correctly projected and an accurate photogrammetric product obtained. Interior orientation parameters include the camera focal length and the position of the photo principal point. Typically, the interior orientation is known from camera calibration. Exterior orientation parameters include the camera position coordinates and the three orientation angles. Typically, the exterior orientation is determined by resection principles as part of the photogrammetric solution. The remaining parameters are the ground coordinates of the point to be mapped. Planimetric and topographic details are mapped by intersecting conjugate image rays from two correctly oriented photographs. Methods of solving the fundamental photogrammetric

problems may be classified as analog or analytical solutions.

A. Analog Solutions. Analog photogrammetric solutions use optical or mechanical instruments to form a scale model of the image rays recorded by the camera. An optical analog instrument projects a transparency of the image through a lens such that the camera bundle of image rays is accurately reproduced and the projected image is brought to focus at some finite distance from the lens. A mechanical analog instrument uses a straight metal rod, a space rod, to represent the image ray from the image point, through the lens perspective center, to the modelled ground point. Analog instruments are limited in function (focal length, model scale enlargement, flight geometry) by the physical constraints of the analog mechanism. They are limited in accuracy by the calibration of the analog mechanism and by unmodelled systematic errors. Analog instruments cannot effectively compensate for differential or nonlinear image and film deformation errors.

B. Analytical Solutions. An analytical photogrammetric solution uses a mathematical model to represent the image rays recorded by the camera. The image ray is assumed to be a straight line through the image point, the exposure station, and the ground point. The following collinearity equation expresses this condition:

$$x = x_o - f \frac{[m_{11}(X - X_L) + m_{12}(Y - Y_L) + m_{13}(Z - Z_L)]}{[m_{31}(X - X_L) + m_{32}(Y - Y_L) + m_{33}(Z - Z_L)]}$$

$$y = y_o - f \frac{[m_{21}(X - X_L) + m_{22}(Y - Y_L) + m_{23}(Z - Z_L)]}{[m_{31}(X - X_L) + m_{32}(Y - Y_L) + m_{33}(Z - Z_L)]}$$

$$(10\text{-}16)$$

where x,y = measured photocoordinates; x_o, y_o = principal point photocoordinates; m_{ij} = nine direction cosines expressing the angular orientation; X, Y, Z = ground point coordinates; and X_L, Y_L, Z_L = exposure station coordinates.

The collinearity condition equations include all interior and exterior orientation parameters required to solve the resection and intersection problems accurately. Analytical solutions consist of systems of collinearity equations relating measured image photocoordinates to known and unknown parameters or the photogrammetric problem. The equations are solved simultaneously to determine the unknown parameters. However, since there are usually redundant measurements producing more equations than there are unknowns in the problem,

a least squares adjustment is used to estimate the unknown parameters. The least squares adjustment algorithm includes residuals v_x and v_y on the measured photocoordinates that estimate random measurement error.

10-11. TERRESTRIAL PHOTOGRAMMETRY.

A. Definition. Terrestrial photogrammetry refers to applications where the camera is supported on the surface of the earth. Typically, the camera is mounted on a tripod and the camera axis is oriented in or near the horizontal plane. When the distance to the object is less than approximately 300 m, the method is often referred to as close-range photogrammetry.

B. Applications. Terrestrial photogrammetry techniques can be applied to measuring and mapping large vertical surfaces. These applications include topographic mapping of rugged terrain and vertical cliffs, deformation measurement of structures, and architectural mapping of buildings. Close-range applications include measuring and calibrating irregular surfaces such as antenna reflectors and industrial assembly jigs, and three-dimensional mapping of industrial installations and construction sites.

C. Instrumentation.

(1) Cameras. Cameras for engineering applications of terrestrial photogrammetry should be stable, calibrated metric cameras similar to aerial cameras. For highest accuracy, some cameras expose the image directly on glass planes to ensure image plane flatness. Film type cameras should have a film-flattening device. Terrestrial cameras are available in a range of focal lengths and format size. If the camera is combined with angle measuring capability for orienting the camera axis in a known direction, the instrument is referred to as a phototheodolite. Stereometric cameras are two cameras rigidly fixed to a base bar. Since the base is usually short, stereometric cameras fall into the close-range category.

(2) Stereoplotters. Some specialized stereoplotters have been developed specifically for terrestrial applications; however, these instruments are not typically available in the United States photogrammetric industry. Some analog stereoplotters can accommodate some terrestrial and close-range cameras; but often incompatible focal lengths, format sizes, and depth of field constraints make analog stereoplotters unusable for this work. Analytical stereoplotters can accommodate terrestrial and close-range cameras because no mechanical constraints

are placed on the mathematical projection. Of course, monocomparators and analytical software work equally well for precise applications of point mapping.

D. Methods. The photogrammetric principles discussed in this chapter apply also to the terrestrial solutions. Terrestrial photogrammetry differs from aerial photogrammetry in the fact that the camera is accessible. Thus, the camera position and orientation can be measured. Theoretically this eliminates the need for control points and resection to orient the camera. When considering a terrestrial or close-range application, additional consideration must be given to optimum camera location geometry, focusing requirements of the camera, and depth of field requirements to capture the object to be measured.

SECTION II
STEREOSCOPIC PLOTTING INSTRUMENTS

10-12. GENERAL.

A general overview of existing stereoplotter designs and general operating procedures is presented in this chapter. For the purposes of this chapter, only instruments that perform a complete restitution of the interior and exterior orientation of the photography taken will be considered. Although all types of stereoplotters are discussed, it is expected that analytical stereoplotters will become the industry standard because of accuracy, efficiency, and capability.

10-13. TYPES OF STEREOPLOTTERS.

The three main component systems in all stereoplotters are the projection system, the viewing system, and the measuring and tracing system. Stereoplotters are most often grouped according to the type of projection system used in the instrument.

A. Direct-Optical Projection Stereoplotters. Direct-optical projection stereoplotters project a transparent positive of the original negative optically through a lens to recreate the bundle of image rays recorded by the cameras. This type of stereoplotter was the precursor of modern mechanical projection and analytical stereoplotters. Briefly, these stereoplotters use a fixed focal length lens for projection so that the principal distance and the projection distance of the instrument are fixed. Thus, the enlargement ratio from positive to stereomodel is also fixed. For a typical "Kelsh-type" instrument, the

enlargement ratio of the stereomodel is five times the contact positive scale. The stereomodel is viewed directly on a reflecting platen in the model space. The floating mark is on the platen, and as the mark is moved through the model, its position is traced directly onto a map manuscript below the mark. The vertical movement of the platen is read out at model scale as the elevation of the floating mark. Direct-optical projection stereoplotters are classified as the least accurate instrument type. They have been replaced in practice by mechanical projection and analytical stereoplotters.

B. Mechanical Projection Stereoplotters. Mechanical projection stereoplotters are analog instruments that recreate the image ray using a metal space rod. The space rod pivots in a fixed gimbal joint representing the lens nodal point. Two space rods from adjacent diapositives intersect in the model space to define the terrain point. Since no lens is included in the projection system, the principal distance and projection distance along the space rod can be varied. Usually a small range of camera focal lengths can be accommodated, and model scale can be varied within the mechanical limits of the instrument.

(1) The viewing system of a mechanical projection stereoplotter is an optical train system of lenses and prisms similar in principle to a mirror stereoscope. The operator perceives the stereomodel by looking directly at the positive image. Image magnification is included to increase the precision of the floating mark placement in the stereomodel.

(2) The floating mark is included in the optical train. Its position in the model space corresponds to the intersection of the space rods representing the two conjugate image rays. The model carriage where the space rods intersect may be free moving. The model carriage may include a pencil mount, and the carriage is hand-driven to trace out a map manuscript. The model carriage may be connected to a mechanical drive that can be digitally encoded. Thus, the movement of the floating mark is converted to digital x-y-z model coordinates in three dimensions.

(3) The accuracy of mechanical projection stereoplotters will typically be in the medium to high range. Plotters designed for map compilation are in the medium range. These plotters typically have free-moving model carriages that are hand-driven during map compilation. The Kern PG2, Galileo G6, and Wild B8 are some examples of medium-accuracy mechanical projection stereoplotters used for map compilation. Mechanical projection stereoplotters in the high-accuracy range warrant more precise measurement of the stereomodel space. In these instru-

ments, the model carriage is mechanically driven and controlled by operator hand wheels and foot disk or similar control devices. These stereoplotters are also more massive and stable instruments than the medium-accuracy compilation instruments, and typically they are universal instruments capable of analog aerotriangulation. The Wild A8, Zeiss C8, and Jena Stereometrograph are some examples of these instrument types.

C. Analytical Stereoplotters. Analytical stereoplotters use a mathematical image ray projection based on the collinearity equation model. The mechanical component of the instrument consists of a precise computer-controlled stereocomparator. Since the photo stages must move only in the x and y image directions, the measurement system can be built to produce a highly accurate and precise image measurement. The x and y photocoordinates are encoded, and all interior and exterior orientation parameters are included in the mathematical projection model. Except for the positive format size that will fit on the photo stage, the analytical stereoplotter has no physical constraints on the camera focal length or model scale that can be accommodated.

(1) The viewing system is an optical train system typically equipped with zoom optics. The measuring mark included in the viewing system may be changeable in style, size, and color. The illumination system should have an adjustable intensity for each eye.

(2) The measuring system consists of an input device for the operator to move the model point in three dimensions. The input device is encoded, and the digital measure of the model point movement is sent to the computer. The software then drives the stages to the proper location accounting for interior and exterior orientation parameters. These operations occur in real time so that the operator, looking in the eyepieces, sees the fused image of the floating mark moving in three dimensions relative to the stereomodel surface. The operator's input device for model position may be a hand-driven free-moving digitizer cursor on instruments designed primarily for compilation, or it may be a hand wheel/foot disk control or similar device on instruments supporting fine pointing for aerotriangulation.

(3) Analytical stereoplotters are more accurate than analogic stereoplotters because the interior orientation parameters of the camera are included in the projection software. Therefore, any systematic error in the photography can be corrected in the photocoordinates before the photogrammetric projection is performed. Correcting for differential film deformations, lens distortions, and atmospheric re-

fraction justifies measuring the photocoordinates to accuracies of 0.003 mm and smaller in analytical stereoplotters. To achieve this accuracy, the analytical stereoplotter must have the capability to perform a stage calibration using measurements of reference grid lines etched on the photo stage.

(4) Analytical stereoplotters capable of precise map compilation and aerotriangulation measurements include (but are not limited to) the Zeiss Planicomp P series, the Wild (now Leica) AC and BC series, the Kern (now Leica) DSR series, the Intergraph Intermap, and the Galileo Digicart (Fig. 7-5).

D. Digital Stereoplotters. The next generation of stereoplotters will be digital (or soft copy) stereoplotters. These instruments will display a digital image on a workstation screen in place of a film or glass diapositive. The instrument will operate as an analytical stereoplotter except that the digital image will be viewed and measured. The accuracy of digital stereoplotters is governed by the pixel size of the digital image. The pixel size directly influences the resolution of the photocoordinate measurement. A digital stereoplotter can be classified according to the photocoordinate observation error at image scale. Then it should be comparable to an analog or analytical stereoplotter having the same observation error, and the standards and guidelines in this manual should be equally as applicable. See also paragraph 10-15.

10-14. STEREOPLOTTER OPERATIONS.

All stereoplotters, whether analog or analytical, must be set up for measuring or mapping in three consecutive steps: interior orientation, relative orientation, and absolute orientation.

A. Interior Orientation. Interior orientation involves placing the photographs in proper relation to the perspective center of the stereoplotter by matching the fiducial marks to corresponding marks on the photography holders and by setting the principal distances of the stereoplotter to correspond to the focal length of the camera (adjusted for overall film shrinkage).

B. Relative Orientation. Relative orientation involves reproducing in the stereoplotter the relative angular relationship that existed between the camera orientations in space when the photographs were taken. This is an iterative process and should result in a stereoscopic model easily viewed, in every part, without "y parallax"—the separation of the two images so they do not fuse into a stereoscopic model. When this step is complete, there

exists in the stereoplotter a stereoscopic model for which three-dimensional coordinates may be measured at any point; but it may not be exactly the desired scale, and it may not be level—water surfaces may be tipped.

C. Absolute Orientation. Absolute orientation uses the known ground coordinates of points identifiable in the stereoscopic model to scale and to level the model. When this step is completed, the X, Y, and Z ground coordinates of any point on the stereoscopic model may be measured and/or mapped.

10-15. STEREOPLOTTER ACCURACIES.

Stereoplotter accuracies are best expressed in terms of observation error at diapositive scale. In this way, instruments can be compared based on the fundamental measurement of image position on the positive. Measurement error on the positive can be projected to the model space so that expected horizontal and vertical error in the map compilation can be estimated. Stereoplotter accuracy affects the maximum allowable enlargement from photo scale to map scale and the minimum CI that can be plotted from given photo scale. The enlargement ratio and the empirical C-factor are discussed in Chapter 7, and maximum values for these two factors are specified in Chapter 2.

10-16. STEREOPLOTTER OUTPUT DEVICES.

Stereoplotters are connected to a variety of devices for plotting or recording line work and digital data. Although the direct tracing of map manuscripts on a stereoplotter is a form of output, it is expected that modern stereoplotters will be encoded and interfaced to a graphical or digital output device. Examples of these output devices are shown in Chapter 7.

A. Stereoplotters may be computer assisted. The movement of the measuring mark of these stereoplotters is digitally encoded. The digital signal is sent directly to a computer-controlled coordinatograph. The operator can include feature codes in the digital signal that the computer can interpret to connect points with the proper line weight and type, plot symbols at point locations, label features with text, etc. The final map product can be produced at the manuscript stage by an experienced operator.

B. A digitally encoded stereoplotter may also be interfaced to a digital compilation software system in which the compiled line work and annotations appear on a workstation screen. Similar to the computer-assisted stereoplotter and coordinatograph, the compilation on the workstation screen can be displayed with proper line weights (or colors and layers), line types, symbols, and feature labels. In addition, since the map exists in a digital computer file, basic map editing can be done as the manuscript progresses. Typically, the digital compilation file is converted (or translated) to a full CADD design file where it can be merged with adjacent compiled stereomodels and final map editing performed. The deliverable product from these systems is often in digital form on computer tape or disk.

SECTION III
GROUND CONTROL DATUMS AND COORDINATE REFERENCE SYSTEMS

10-17. GENERAL.

Photogrammetric ground control consists of any points whose positions are known in a ground reference coordinate system, and whose images can be positively identified in the photographs. Ground control provides the means for orienting or relating aerial photographs and stereomodels to the ground. Almost every phase of photogrammetric work requires some ground control. Photogrammetric control is generally classified as either *horizontal control* (the position of the point is known with respect to a horizontal datum), or *vertical control* (the elevation of the point is known with respect to a vertical datum). Sometimes both horizontal and vertical object space positions of points are known so that these points serve a dual control purpose. Such points may be referred to as *total control*.

10-18. COORDINATE DATUMS AND REFERENCE SYSTEMS.

A datum is a reference surface on which a coordinate system is defined. In surveying and mapping, many datums and many coordinate systems can be defined that will express the position of points on the earth's surface. It is of utmost importance to know the coordinate system used to reference any control survey or map. Control survey or map data sets referenced to different coordinate systems cannot be combined unless a transformation of one coordinate system into the other is performed. A detailed discussion of coordinate datums and trans-

formations is given by Soler and Hothem (1988, 1989).

A. Horizontal Geodetic Datum.

Datums are often separated into horizontal and vertical datums. A horizontal geodetic datum uses an ellipsoid as the reference surface. The size and shape of the ellipsoid are chosen to give the best fit to the earth on a global basis or on a regional or continental basis. Many different ellipsoids have been proposed. The datum definition is completed by orienting a specific ellipsoid to the earth and defining a coordinate system.

(1) Curvilinear coordinates. Geodetic longitude and latitude are curvilinear coordinates that define the position of a point on the curved ellipsoid surface. The coordinates are expressed in angular units. (Longitude is the angle measured in the plane of the equator from the reference meridian through Greenwich, England, to the meridian through the point. Latitude is the angle in the plane of the meridian through the point from the equator to the normal through the point.) A geodetic height can also be defined as the distance along the normal from the surface of the ellipsoid to the point.

(2) Geocentric coordinates. Geocentric coordinates are defined for a given datum by placing the origin of a right-handed spatial rectangular coordinate system at the center of the reference ellipsoid. The z-axis coincides with the semiminor axis of the ellipsoid. The x- and y-axes are in the plane of the equator with the x-axis through 0-degree longitude. Simple Cartesian coordinate computations can be performed in the geocentric system. The ellipsoid parameters and curved reference surface are eliminated from the computations (Fig. 10-7).

(3) Local rectangular coordinates. A local rectangular coordinate system can be defined for a given project area. The geocentric coordinate axes are translated to a convenient point in or near the project area. Then the x-y-z geocentric axes are rotated to align with local east, north, and up (along the normal), respectively, at the point. Local rectangular coordinates will appear more natural with respect to the terrain, and the coordinate magnitudes will be smaller for computations. Photogrammetric aerotriangulation should be computed in a local rectangular system (especially for large project areas) since earth curvature and map projection distortion are not present in Cartesian coordinates.

(4) North American Datum of 1927. In the United States, two horizontal datums are commonly encountered in engineering surveying and mapping: the North American Datum of 1927 (NAD27) and

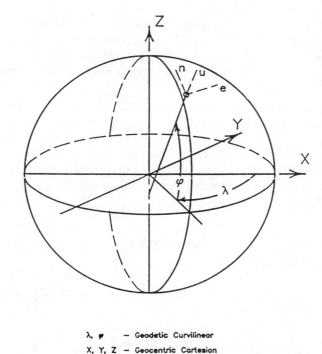

λ, φ — Geodetic Curvilinear
X, Y, Z — Geocentric Cartesian
e, n, u — Local Rectangular

FIG. 10-7. Coordinate Reference Systems

the North American Datum of 1983 (NAD83) (Table 10-1). NAD27, a datum defined by an adjustment begun in 1927 of the national control point network, is a continental datum referenced to the Clarke 1866 ellipsoid. The ellipsoid is positioned and oriented to closely fit the geoid throughout the North American continent. Since the NAD27 adjustment, new control surveys were added to the network by holding the original framework fixed and adjusting the new survey to fit the original. As the network grew without readjustment, distortions were found that demanded a readjustment of the network to meet modern surveying requirements.

(5) North American Datum of 1983. NAD83 is a rigorous least squares adjustment of the entire national control network incorporating modern high-precision traverse and satellite measurements. NAD83 is a global datum referenced to the Geodetic Reference System of 1980 ellipsoid. The ellipsoid is earth-centered and designed to be a best fit to the global geoid. Thus, the NAD83 datum will have a larger geoid-to-ellipsoid separation than the NAD27 datum in the United States. Since NAD83 is a readjustment of the original observations in the control network, it is not possible to directly transform coordinates from one datum to the other. Interpolation methods using control points adjusted in both datums have been programmed by the NGS for the purpose of estimating

TABLE 10-1. Comparison of NAD27 and NAD83 Datum Elements

Datum Element (1)	NAD27 (2)	NAD83 (3)
Reference Ellipse	Clarke 1866 a = 6,378,206.4 m b = 6,356,583.8 m	GRS 80 a = 6,378,137 m f = 1/298.2572221
Datum Point	Meades Ranch Station	Earth's Mass Center
Best Fitting	North America	Global
Adjustment	Terrestrial data for 25,000 stations and piecewise fits	Terrestrial and satellite data for 250,000+ stations

Note:
1. a = length of semimajor axis of ellipsoid.
 b = length of semiminor axis of ellipsoid.
 f = flattening of ellipsoid.

the NAD83 coordinates of points surveyed in the NAD27 datum. Although the NAD27 datum is still used, it should gradually be replaced by the NAD83 datum.

B. Vertical Geodetic Datum. A vertical geodetic datum is a reference system for measuring vertical position or elevation. The reference surface is the geoid, which is an equipotential gravity surface that best approximates mean sea level. Elevation above mean sea level (the geoid) is measured along the direction of gravity, perpendicular to the equipotential surfaces. In the United States, the vertical geodetic datum is the National Geodetic Vertical Datum of 1929. The elevation of a point can be combined with the horizontal position on the ellipsoid to define a three-dimensional coordinate, latitude, longitude, and height (ϕ, λ, h), by the relationship

$$h = H + N \qquad (10\text{-}17)$$

where h = height above the ellipsoid; H = elevation above the geoid; and N = geoid separation above the ellipsoid.

C. Map Projections. A map projection is a mathematical function that defines a relationship of coordinates between the ellipsoid and a plane. The purpose of a map projection is to display the curved earth surface on a flat plane that can be printed on a sheet of paper. If field survey observations are reduced to the plane, the computation and adjustment of horizontal control positions can be carried out in two-dimensional Cartesian coordi-

nates. The need for more involved geodetic survey computations can be eliminated.

(1) The final map reference system is a plane developed from a regular mathematical surface. Developable surfaces that can be rolled out into a plane include a plane, a cone, and a cylinder. The ideal map projection would display all distances and directions correctly, all areas would retain their correct shape and relative size, meridians and parallels would intersect at right angles, and great circles and rhumb lines would be represented as straight lines. Obviously, the earth's surface, being spherical, cannot be developed upon a plane without distortion of some of these quantities.

(2) In engineering surveying and mapping, correct depiction of shapes is important. Thus, the characteristic of conformality is enforced in projections used for large-scale mapping. This is accomplished by mathematically constraining the projection scale factor at a point, whatever it may be, such that it is the same in all directions from that point. This characteristic of a projection preserves angles between infinitesimal lines. That is, all lines on the grid cut each other at the same angles as do the corresponding lines on the ellipsoid for very short lines. Hence, for a small area, there is no local distortion of shape. But since the scale must change from point to point, distortion of shape can exist over large areas. Remember that the distortion present in any map projection is not an "error" since it is a mathematically defined function. The distortion must simply be accounted for in transforming data from map to ground.

(3) The most commonly encountered map projections in engineering surveying and mapping are the State Plane Coordinate Systems (SPCS). NGS has developed SPCS's for each state, and many states have formally adopted the systems by legislative action. The SPCS's are based on the Lambert Conformal Conic Projection or the transverse Mercator projection. For complete discussion of the SPCS's refer to Stem (1989).

(4) State Plane Coordinate Systems are defined for both the NAD27 and NAD83 datums. For the NAD27 SPCS definition, the unit of length is the USSurvey Foot. For the NAD83 SPCS definition, the unit of length is variable among the states. Care must be exercised when using NAD83 SPCS values in feet since either the U.S. Survey Foot or the International Foot may be used in a specific state or locality. The conversion factors are given in paragraph 2-10A.

(5) Another commonly used plane coordinate projection system is the UTM projection. Since this is the standard military reference system, operational support mapping work may need to be compiled using this system. The UTM system uses a Mercator cylindrical projection with the axis of the cylinder oriented perpendicular to the earth's polar axis. The UTM coordinate zones are uniformly spaced around the equator at 6-degree intervals and extend north and south from the equator. A useful reference for the UTM system and other map projections is Snyder (1982).

SECTION IV
PRINCIPLES OF AEROTRIANGULATION

10-19. GENERAL.

The principles of aerotriangulation are reviewed in this section. The basic procedures for sequential and simultaneous aerotriangulation adjustment methods are discussed as background for Chapter 6. Emphasis is placed on fully analytical aerotriangulation procedures.

10-20. AEROTRIANGULATION PRINCIPLES.

A. Definition. Aerotriangulation is the simultaneous space resection and space intersection of image rays recorded by an aerial mapping camera. The spatial direction of each image ray is determined by projecting the ray from the front nodal point of the camera lens through the image on the positive photograph. Conjugate image rays projected from two or more overlapping photographs intersect at the common ground points to define the three-dimensional space coordinates of each point. The entire assembly of image rays is fit to known ground control points in an adjustment process. Thus, when the adjustment is complete, ground coordinates of unknown ground points are determined by

△ Control Point
○ Pass Point

FIG. 10-8. Aerotriangulation Geometry

the intersection of adjusted image rays. Simultaneously with the ground point intersections, the exterior orientation of each photograph is determined by image ray resection through the camera.

B. Purpose. The purpose of aerotriangulation is to extend horizontal and vertical control from relatively few ground survey control points to each unknown ground point included in the solution. The supplemental control points are called pass points, and they are used to control subsequent photogrammetric mapping.

C. Geometric Principles. The aerotriangulation geometry along a strip of photography is illustrated in Fig. 10-8. Photogrammetric control extension requires that a group of photographs be oriented with respect to one another in a continuous strip or block configuration. The exterior orientation of any photograph that does not contain ground control is determined entirely by the orientation of the adjacent photographs. In a given aerotriangulation configuration, each photograph contributes to the exterior orientation of the adjacent photographs through the pass points located in the *triple overlap* areas. The term triple overlap refers to the ground area shared by two adjacent stereomodels along the strip. The triple overlap area is imaged on three consecutive photographs. Thus, when end lap is specified to be 60%, the alternate photographs will overlap each other by 20% at average terrain elevation.

D. Pass Points. A pass point is an image point that is shared by three consecutive photographs (two consecutive stereomodels) along a strip. As the pass point is positioned by one stereomodel, it can be used as control to orient the adjacent stereomodel. Thus, the point "passes" control along the strip. Only three-ray points in the triple overlap area serve this pass point function. A two-ray point in the stereomodel is an intersection point only and does not contribute to the aerotriangulation function unless it is also a ground control point. A pass point that is shared between two adjacent strips is called a tie point.

10-21. AEROTRIANGULATION METHODS.

Aerotriangulation methods can be characterized in several ways:

A. Photogrammetric projection method (analogic or analytical).

B. Strip or block formation and adjustment method (sequential or simultaneous).

C. Basic unit of adjustment (strip, stereomodel, or image rays).

Modern instruments and adjustment methods dictate that an analytical adjustment of stereomodels or image rays be emphasized.

A. Semianalytical Aerotriangulation. Semianalytical methods use the stereomodel as the basic unit of the aerotriangulation process. Stereomodels may be formed by either analogical or analytical methods. After interior and relative orientation of each stereopair of photographs, stereomodel coordinates are measured in an arbitrary coordinate system defined in the model space. For aerotriangulation purposes, the spatial coordinates of the two exposure stations and each pass point in the stereomodel are required.

(1) Sequential strip formation. A strip unit is formed sequentially from the stereomodels by joining them at the exposure station and pass points shared by the new stereomodel and the previous stereomodel already in the strip coordinate system. Each stereomodel added to the strip provides the necessary points to bring the succeeding stereomodel into the strip unit. The sequential nature of the strip formation procedure allows systematic errors to accumulate as the strip unit is assembled from the individual stereomodels. Residual systematic errors in the interior orientation, the relative orientation, and the measurement system are propagated down the strip causing the horizontal and vertical strip coordinate datums to bow and twist. Although it is difficult to measure and completely remove individual systematic errors in each stereomodel, the total effect of all the errors acting on a strip unit is readily apparent after initially leveling and scaling the assembled strip unit. Discrepancies at the horizontal and vertical control coordinates are calculated by taking the coordinate differences between the known position of each control point and its position in the assembled strip unit.

(2) Strip adjustment. The sequential strip formation causes the X, Y, and Z coordinate discrepancies at the control points to form smooth error curves. The error curves can be approximated by second- or third-order polynomial functions. Corrections to the strip pass point coordinates are derived by evaluating the polynomial functions at the strip location of each pass point. The corrections are applied to the original strip coordinates to complete the strip adjustment process.

a. The polynomial functions model the error propagation in a single strip unit. Block configurations may be adjusted by using separate polynomials for each strip. The unique strip units in a block are joined together at tie points in the overlap area

between strips. The polynomial functions adjusting adjacent strips are constrained to yield the same adjusted coordinates at each tie point in the block.

b. The polynomial adjustment of aerotriangulation is an approximate method that is less accurate than the simultaneous adjustment of stereomodels or photographs. The purpose of polynomial strip adjustment in modern aerotriangulation systems is to perform a preliminary adjustment of all the photogrammetric and ground survey measurements. The sequential strip formation and polynomial adjustment is an excellent way to detect blunders in the data and provide initial approximations for use in simultaneous adjustments.

B. Simultaneous Adjustment of Stereomodels. The adjustment of independent stereomodels as individual units is the logical extension of the strip unit adjustment discussed in the previous paragraph. Sequentially formed strip units are not used, but rather all stereomodels in an entire strip or block are simultaneously transformed into the ground coordinate system. Stereomodels without ground control points are carried into the ground coordinate system by the pass points and exposure stations shared with adjacent stereomodels. The simultaneous adjustment of stereomodels can rival the simultaneous adjustment of photographs if the individual stereomodels are corrected for all systematic deformations. However, the development of analytical stereoplotters that measure precise photocoordinates warrants that the more rigorous fully analytical aerotriangulation be required for all large-scale and high-accuracy mapping.

C. Fully Analytical Aerotriangulation. Fully analytical aerotriangulation is a simultaneous adjustment solution of collinearity equations representing all the image rays in a strip or block of photography. The adjustment is often referred to as the "bundle" method. Although the basic unit of adjustment is actually the individual image ray, the solution determines the exterior orientation parameters of the bundle of image rays recorded by each photograph, and the adjusted ground coordinates of each ground intersection point in the ground coordinate system.

SECTION V
MAP SUBSTITUTES—MOSAICS, PHOTO MAPS, AND ORTHOPHOTOGRAPHS

10-22. GENERAL.

Map substitute refers to those products where the compiled planimetric line map is replaced or augmented by the aerial photographic images.

Since the photographic image will have scale variation caused by the perspective view of the camera, photo tilt, and unequal flying heights, each product must be evaluated according to how the scale variation problem is treated. Scale variation may be ignored, as in an index mosaic, and an approximate map substitute is obtained; or the scale variation can be compensated, as in an orthophoto process, and a nearly true map substitute can be obtained.

10-23. AERIAL MOSAICS.

Aerial mosaics are constructed from sets of individual adjoining aerial photographs. Typically, the outer edge of the photo coverage of each print is trimmed back to a selected match line, and the photos assembled by carefully matching ground detail along the match line. A photo index mosaic is a rough composite of a number of individual photographs of a flight line or set of flight lines overlaid one on top of the other without trimming the photo prints. This composite may itself be photographed onto a single piece of film. Mosaic and index assemblies form a continuous representation of the terrain covered by the photography. Photo maps are maps using a photograph (or mosaic) as the base to which limited cartographic detail such as names, route numbers, etc., are added. Generally, a photo map is constructed from an orthophoto, or from several orthophotos mosaicked together.

10-24. USES OF MOSAICS.

The increased need for presenting a pictorial view of the earth's surface has led to the aerial mosaic as a means of showing a complete view of large areas. Because a single photo is limited in area, groups of photos are combined into mosaics to provide the aerial picture. Mosaics are of principal use for presenting synoptic views of a relatively large area, and as indexes of individual photographs. The features are usually labeled or "annotated" to facilitate the recognition of critical areas, or overlays may be prepared to show planning developments or contemplated changes in an area. For example, a mosaic can show the location of a proposed highway. Using this technique, laypersons, and particularly property owners adjacent to the proposed highway, can visualize its effect on their holdings. Photo indexes are used as a visual record of the photographs of a project and as a reference of availability of photographs over a particular area of terrain. Photo maps are particularly useful for land use, land cover delineation, land planning, zoning, tax maps, and preliminary engineering design.

10-25. METHODS OF MOSAIC CONSTRUCTION.

There are three principal construction methods for the making of mosaics:

A. From Paper Prints. This is the simplest method. The paper prints that are to be joined are laid one on top of the other so that commonly imaged terrain is matched. Then the paper prints are cut, along a feature if possible, so that the edge joins will be as inconspicuous as possible. The photographs are matched and pasted to a base. As necessary, the photographs are stretched to assure a good match of features across the join line. The completed mosaic may be photographed if a reduced scale mosaic, such as an index mosaic, is desired.

B. From Negatives or Diapositives. This method is called photomechanical mosaicking. The negatives to be used for the construction are overlaid and stud registered. After the join lines are selected, a mask is made that is opaque on one side of the join line and clear on the other. A negative of the mask is made for the other photo of the pair to be joined. These masks are also stud registered. After all negatives and masks have been stud registered, a piece of unexposed film is put down (in the darkroom) over the studs and the first photo negative and its corresponding mask are registered and an exposure made. The mask permits only that portion of the unexposed film under the negative to be exposed. Successive portions of the film are exposed as this process is repeated for each negative and mask until the whole film is exposed as a single mosaic.

C. From Digital Imagery. Digital (or digitized) imagery can be used to create a mosaic. This method has been used most commonly with small-scale satellite photographs. The method is very computer intensive. Either by human or automated correlation, common points on the two images to be joined are selected. The computer can then match each pixel of the one image with the corresponding pixel of the second image. A join line is decided upon and the two images digitally "sheared" along the join line. The two sheared images are then brought together into a single file having a common pixel coordinate system.

10-26. TYPES OF MOSAICS AND AIR PHOTO PLAN MAPS.

Mosaics or air photo plans may be uncontrolled, semi-uncontrolled, or controlled. They may be constructed from unrectified, rectified, or differentially rectified photographs. A controlled mosaic or air photo plan is prepared using photographs that have been rectified to an equal scale, while an uncontrolled mosaic is prepared by a "best fit" match of a series of individual photographs.

10-27. ORTHOPHOTOGRAPHS.

Orthophotographs are photographs constructed from vertical or near-vertical aerial photographs, such that the effects of central perspective, relief displacement, and tilt are (practically) removed. The resulting orthophotograph is an orthographic project.

A. Orthophotomaps. Orthophoto maps are orthophotographs with overlaid line map data. The common line data overlays include grids, property lines, political boundaries, geographic names, and other selected cultural features.

B. Limitation of Orthophotographs. The original aerial negative from which the orthophotograph is made is a central projection and, as such, displays relief displacement and obscuration of features. For example, a building will obscure the terrain that lies behind it. This obscuration results in gaps of information that can be gotten only from other sources of information, such as field survey or separate photograph. Also, optical orthorectifying devices have a finite width and length slot width that can "rectify" only to an average elevation within that slot. Thus, small objects, such as trees, buildings, etc., are not rectified at all. Normally, only a "smoothed" approximation to the actual terrain is rectified. Digital rectifiers with spot diameters as small as 5 to 25 μm can, to a much greater degree, overcome this latter shortcoming.

10-28. USES OF ORTHOPHOTOGRAPHS.

Orthophotos and orthophoto maps are widely used for general planning purposes. The complete and accurate display of all features in a project area is an ideal medium for demonstrating terrain features to laypersons. Proposed designs of engineering projects can be superimposed on the orthophoto map for a vivid understanding of work to be accomplished. Many factors must be considered before deciding on a photomap product instead of a topographical map product. The intended use of the product needs to be classified exactly, together with the accuracy required and whether height informa-

tion is required or not. For many USACE engineering, operations, and maintenance activities, rectified air photo plan sheets may be used in lieu of fully rectified orthophotographs.

10-29. METHODS OF ORTHOPHOTOGRAPH PREPARATION.

Orthophotographs are prepared from pairs of overlapping aerial photographs using specially designed orthoplotting instruments. The photographs are oriented in the instrument in the conventional manner for standard stereo photogrammetric mapping. The requirements for ground control or control to be established by aerotriangulation are the same as for photogrammetric mapping. The instrument provides the means of scanning the stereomodel to effect corrections for the varying scales caused by topographic relief. The tilt and other distortions are corrected in the orientation of the stereomodel.

CHAPTER 11

PLANNING, EXECUTION, COST ESTIMATING, AND CONTRACTING PHOTOGRAMMETRIC MAPPING PROJECTS

11-1. GENERAL.

This chapter presents an overview of the planning, execution, and cost estimation required for a photogrammetric mapping project. Each project, because it has unique characteristics, requires careful study and planning to assure that effective methods, techniques, equipment, and personnel are employed to provide a low-risk, cost-effective solution. A professional photogrammetrist should be used in designing and prescribing photogrammetric operations. Details on standards, QC, and operational guidance are found in the respective chapters of this manual. Procedures for preparing detailed cost estimates are contained in Appendix C. All contract actions discussed in this chapter assume PL 92-582 (i.e., Brooks Act) qualification-based selection procedures were employed in obtaining the photogrammetric mapping contractor.

11-2. PROJECT PLANNING.

There are three aspects to project planning: planning by the Government in preparation of solicitation or delivery order issuance, planning by the contractor in preparation of the response, and planning between contractor and Government upon award of contract or issuance of a delivery order. To be effective in the planning and organization of a mapping project, the contracted photogrammetrist must become familiar with the specific needs and requirements for the project. This detail should have been fully described in the contract or delivery order scope of work, and should convey critical items such as the target map scale (i.e., horizontal accuracy), the CI (i.e., vertical accuracy), map details required, the need for ground control and its location for future use, specific engineering and construction applications intended (including critical utility locations), ground survey or verification requirements, the final

products and their style and format, and the time schedule for the completion of the various phases of the work. The contracted photogrammetrist must decide that the needs and requirements of USACE can be met through the use of photogrammetric procedures and to what extent conventional topographic surveying must be employed, what equipment and personnel are needed to do the work, and what is a realistic estimate of time and cost to complete the project.

A. Risk Assessment. One of the principal objectives of planning is the assessment of risk that may be inherent in the project. There are several types of risk: programmatic, technical, schedule, and cost. Risks should be identified whenever possible and the plan should include actions to mitigate their possible impact.

B. Determination of Map Target Scale and Accuracies. The most critical planning phase involves the Government's determination of the required target scale and related horizontal (planimetric feature) and vertical relief accuracies. The target scale is determined by the engineering or planning application of the map or data base product (GIS, LIS, AM/FM, etc.). The cost of mapping will vary exponentially with the selected target scale and required vertical relief accuracy, since these two factors will determine the flying height, and thus, subsequent photo coverage, model setups, etc. Therefore, it is essential that the USACE project manager exercise solid engineering judgment in arriving at the optimal map scale for the project.

(1) The map target scale, required CI, and general accuracy standard are established according to intended usage. Table 2-4 offers guidance for selecting map scales and CI's, including related survey control requirements. The nominal values shown in this table have been found to be of use in support of most USACE civil and military engineering, planning, and real estate activities.

(2) The horizontal and vertical accuracy requirements of a map or spatial data base must be commensurate with one another since the maximum flying height will be governed by that factor which is limiting. This is clearly exhibited by the negative scale and flight altitude criteria in Tables 2-8 and 2-9. Having an inordinate disparity between horizontal target scale and vertical CI (e.g., 0.5 ft contours at a 400 ft/in. target scale) can significantly drive up the cost of the map product, and may require two different flight altitudes to accommodate each parameter.

(3) Accuracy requirements, as is true for control surveys, have a great impact on cost. They define the methods and equipment that must be used. Applications requiring the highest accuracy include route location design, site development, facility location design, and determination of pay quantities. Applications requiring lesser accuracy include regional planning studies, reconnaissance surveys, route location studies, and facility planning studies. The least amount of accuracy is required on some GIS data elements (Table 2-4). The highest intended use must govern the selected accuracy because lower accuracy applications can always make use of higher accuracy maps. However, the reverse is not true; a map that does not meet the required accuracy for a given application cannot be used for that application. The accuracy of a map (and the data used in producing the map) cannot, in general, be efficiently increased. Thus, during the planning process, consideration should be given to the "highest and best" use to which the map will be put. At times it may be advantageous to collect part of the data at a higher accuracy in anticipation of future uses. Terrain cover, such as dense forest, will make meeting accuracy requirements for contours through aerial photogrammetric methods practically impossible. More expensive transit, plane table, or terrestrial photogrammetric methods will need to be employed.

(4) Present practice indicates that maps be produced in the non-SI system of measure. However, if a map is to be made to the metric (SI) system, as may be required for military operations or projects outside the continental United States (OCONUS), it is recommended that the scale take advantage of the decimal nature of the system. Table 11-1 gives typical relationships between non-SI and SI map scales.

C. Sample Photo and Map Target Scale Applications. Figs. 11-1 through 11-8 are intended to supplement the guidance provided in Table 2-4. They may be used as an aid in selecting optimum photo negative scales and map target

TABLE 11-1. Non-SI/SI Map Scale Relationships

Non-SI Scale (1)	Comparable SI Scale (2)
1:240	1:250
1:480	1:500
1:960	1:1,000
1:1,200	1:1,000
1:2,400	1:2,500
1:4,800	1:5,000

scales based on specific engineering and planning applications. Figs. 11-1 through Figure 11-7 depict typical planning, engineering, and real estate mapping applications, showing a portion of the manuscript (digital data base) at various target scales. The aerial negatives in Fig. 11-8 show the varying detail available at different flying heights. The guidance provided in (1)–(11) corresponds to the limiting criteria given in Chapter 2. Recommended target scales and CI's are based on Class 1 mapping using an analytical plotter.

(1) Fig. 11-8a

Negative Scale	1:2,000, 1 in. = 166.6 ft
Altitude above ground level (AGL)	1,000 ft
Optimum Target Scale	1 in. = 20 ft
Optimum CI	0.5 ft

Use: Extremely detailed site plan mapping for facility/structure design, detailed utility mapping for relocation, etc., where accuracy, relief, and feature detailing are critical.

(2) Fig. 11-8b

Negative Scale	1:2,400, 1 in. = 200 ft
Altitude AGL	1,200 ft
Optimum Target Scale	1 in. = 30 ft
Optimum CI	1 ft

Use: Same as above, except 1-ft CI; 0.5-ft CI for lower map classes.

(3) Fig. 11-8c

Negative Scale	1:3,000, 1 in. = 250 ft
Altitude AGL	1,500 ft
Optimum Target Scale	1 in. = 40 ft
Optimum CI	1 ft

Use: Standard 40-scale site plan mapping.

FIG. 11-1. General Planimetric Feature Mapping, 1 in. = 1,000 ft Scale, With Small-Scale Index Map (Courtesy of Southern Resource Mapping Corporation)

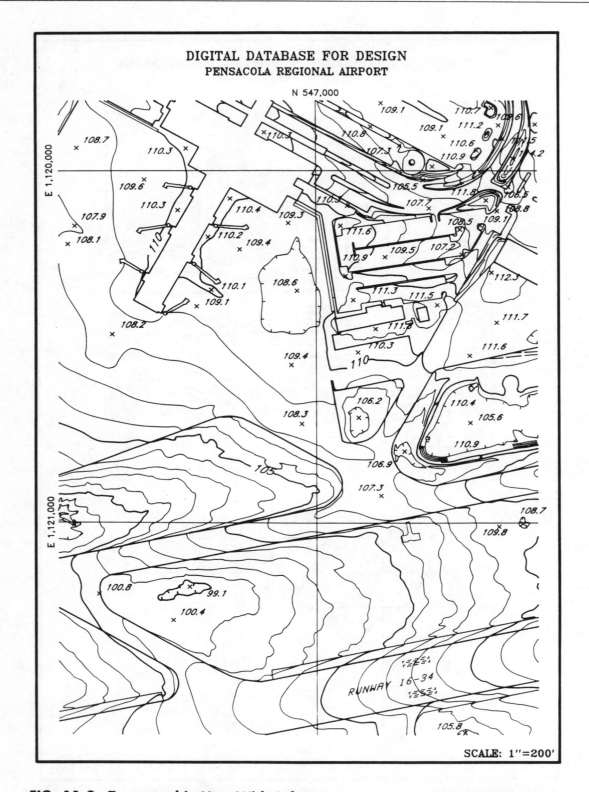

FIG. 11-2. Topographic Map With 1-ft Contours, 1 in. = 200 ft Scale, for General Airfield Drainage Study/Design Uses (Courtesy of Southern Resource Mapping Corporation)

FIG. 11-3. Planimetric Map of Residential Area, 1 in. = 200 ft Scale, for General Planning Purposes (Courtesy of Southern Resource Mapping Corporation)

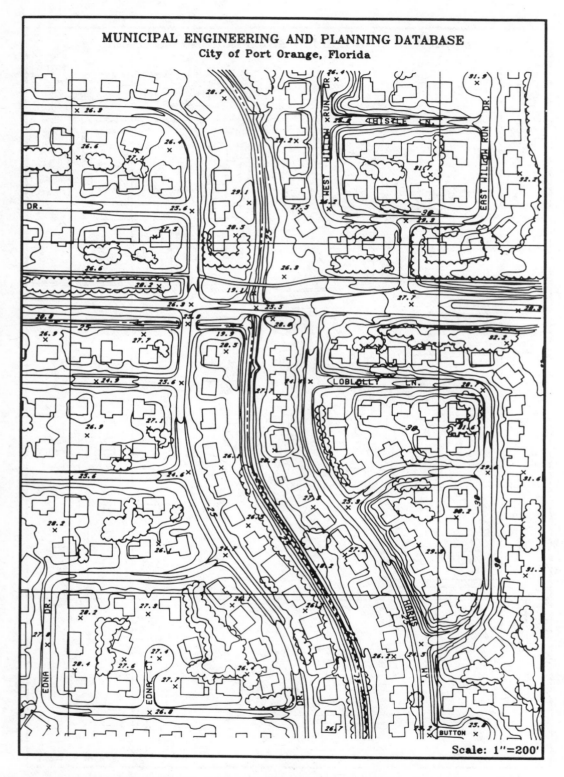

FIG. 11-4. Topographic and Vegetation Layers Added to Fig. 11-3, 1in. = 200 ft Scale (Courtesy of Southern Resource Mapping Corporation)

FIG. 11-5. Planimetric Feature and Selected Utilities, 1in. = 40 ft Scale, for Detailed Design of Typical Civil Works Project (U.S. Army Engineer District, Jacksonville) (Courtesy of Southern Resource Mapping Corporation)

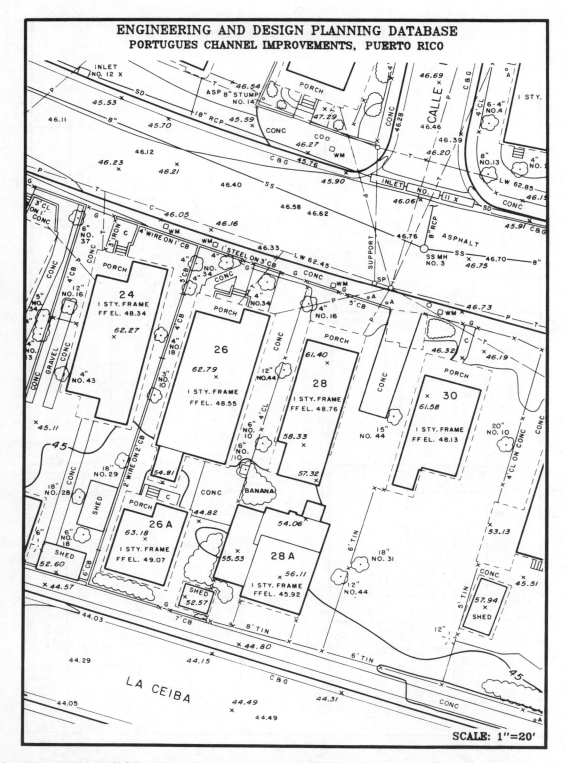

FIG. 11-6. Full Planimetric and Topographic Map, 1 in. = 20 ft scale, for Detailed Design Use (Courtesy of Southern Resource Mapping Corporation)

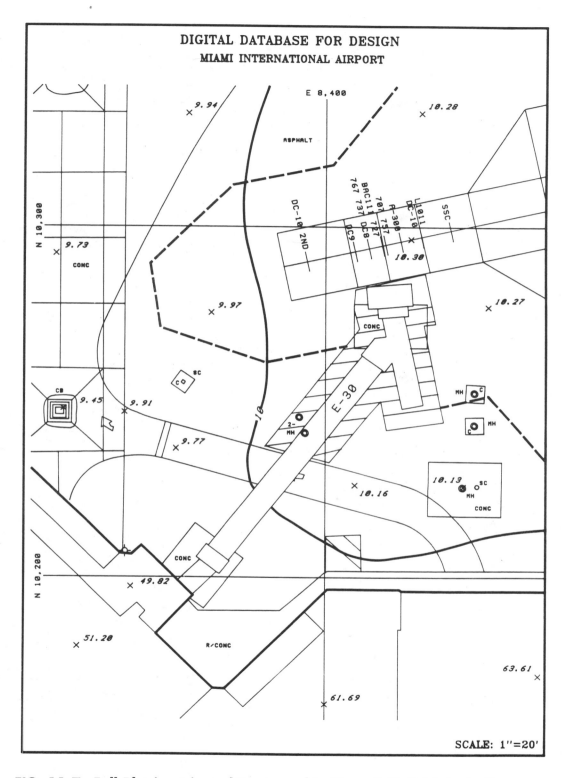

FIG. 11-7. Full Planimetric and Topographic Map of Airfield, Including Drainage, 1 in. = 20 ft Scale, for Detailed Design Use (Courtesy of Southern Resource Mapping Corporation)

FIG. 11-8. Photographic Negative Scales for Various Engineering Applications (Courtesy of Southern Resource Mapping Corporation) (Sheet 1 of 11) a. 1 in. = 166.6 ft

FIG. 11-8. (Sheet 2 of 11) b. 1 in. = 200 ft

FIG. 11-8. (Sheet 3 of 11) c.

FIG. 11-8. (Sheet 4 of 11) d. 1 in. = 300 ft

FIG. 11-8. (Sheet 5 of 11) e. 1 in. = 400 ft

FIG. 11-8. (Sheet 6 of 11) f. 1 in. = 500 ft

FIG. 11-8. (Sheet 7 of 11) g. 1 in = 600 ft

FIG. 11-8. (Sheet 8 of 11) h. 1 in. = 1,000 ft

FIG. 11-8. (Sheet 9 of 11) i. 1 in. = 1,200 ft

FIG. 11-8. (Sheet 10 of 11) j. 1 in. = 1,666 ft

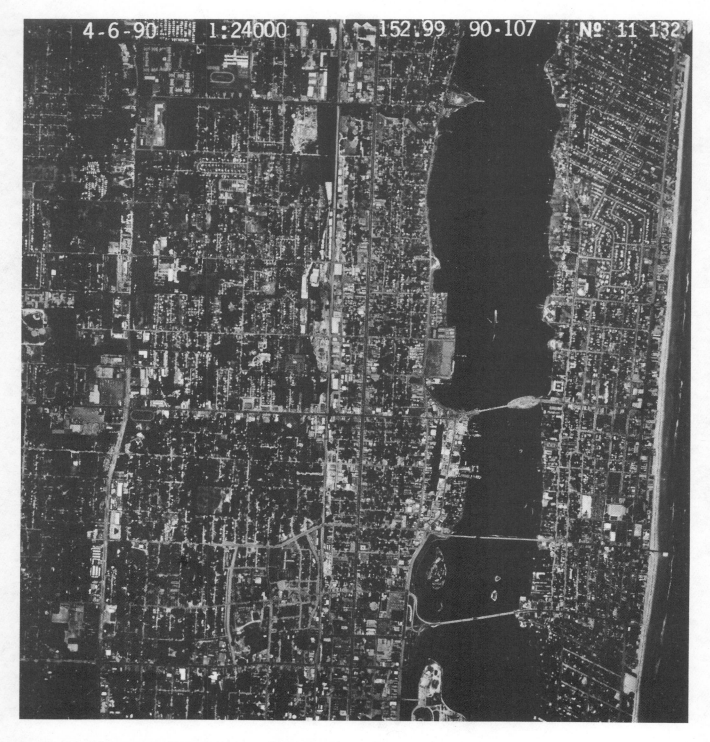

FIG. 11-8. (Sheet 11 of 11) k. 1 in. = 2,000 ft

(4) Fig. 11-8d

Negative Scale	1:3,600, 1 in. = 300 ft
Altitude AGL	1,800 ft
Optimum Target Scale	1 in. = 40 to 50 ft
Optimum CI	1 ft

Use: Standard 50-scale site plan mapping; facility structure and utility detailing for operations and maintenance or AM/FM applications; 1 in. = 50ft air photo plans.

(5) Fig. 11-e

Negative Scale (Nominal)	1:4,800, 1 in. = 400 ft
Altitude AGL	2,400 ft
Optimum Target Scale	1 in. = 60 ft
Optimum CI	1 to 2 ft

Use: Standard 60-scale site plan mapping; 1-ft contour drainage mapping for 1 in. = 200 ft scale areas; base for 1 in. = 100 ft air photo plan sheets.

(6) Fig. 11-8f

Negative Scale	1:6,000, 1 in. = 500 ft
Altitude AGL	3,000 ft
Optimum Target Scale	1 in. = 80 to 100 ft
Optimum CI	2 ft

Use: Typical 1 in. = 100 ft scale mapping for design applications, grading and excavating plans, real estate, etc.

(7) Fig. 11-8g

Negative Scale	1:7,200, 1 in. = 600 ft
Altitude AGL	3,600 ft
Optimum Target Scale	1 in. = 100 ft
Optimum CI	4 ft

Use: Target 4 ft contour applications, 100-scale planimetric mapping, selected utility features, planning maps (AM/FM), 1 in. = 100 ft air photo plan sheets.

(8) Fig. 11-8h

Negative Scale	1:12,000, 1 in. = 1,000 ft
Altitude AGL	6,000 ft
Optimum Target Scale	1 in. = 150 to 200 ft
Optimum CI	4 to 5 ft

Use: 5 ft CI and 1 in. = 200 ft scale mapping, major surface utility features, 1 in. = 200 ft air photo plan sheets.

(9) Fig. 11-8i

Negative Scale	1:14,400, 1 in. = 1,200 ft
Altitude AGL	7,200 ft
Optimum Target Scale	1 in. = 200 ft
Optimum CI	4 to 5 ft (1 m)

Use: Standard 1 in. = 200 ft general planning maps, with either 5 ft or 1-m CI, 1 in. = 200 ft air photo plan sheets.

(10) Fig. 11-8j

Negative Scale	1:20,000, 1 in. = 1,666 ft
Altitude AGL	10,000 ft
Optimum Target Scale	1 in. = 300 to 400 ft
Optimum CI	5 ft

Use: Scale match to 1:20,000 scale OCONUS quads, 1in.= 400 ft line maps or air photo plans.

(11) Fig. 11-8k

Negative Scale	1:24,000, 1 in. = 2,000 ft
Altitude AGL	12,000 ft
Optimum Target Scale	1 in. = 200 ft
Optimum CI	10 ft

Use: Scale match to 1:24,000 USGS quad, small-scale (1in. = 400 ft to 1 in. = 1,000 ft) photo screens, planimetry for general transportation corridors, creation of regional large-area GIS data bases, 1 in. = 1,000 or 2,000 ft scale air photo plan drawings.

D. Plan Subelements. The overall photogrammetric mapping project plan can be subdivided into eight sub-elements that are performed primarily by the contracted professional photogrammetrist:

(1) Identification of project area, data requirements, and map scale. During the initial planning discussions with the functional map user, the target map scale and related accuracy (and flying height) requirements are determined, using the above guidance and that in Chapter 2. When the contract scope of work is prepared, the project boundaries for both aerial photography and mapping should be clearly marked on the most current available map. Once the needs and requirements of a project are delineated (during or after contract award), a detailed operation plan should be prepared by the contracted photogrammetrist. This plan should be developed to best use the equipment, personnel, and facilities that are available and the basic knowledge, experience, and professional judgment of the photogrammetrist. Some operations may be best done in-house by the contractor; others are best performed by subcontractors who have a demonstrated competence in equipment, knowledge, and experience, and who use qualified pro-

fessional managers. The Operation Plan must meet the specifications and provide surveys and maps at a fair and reasonable cost to the map user. Many elements of the work depend on the project. Decisions regarding the amount and location of ground control, the use of bridging or analytical methods for control extension, the stereoplotting instruments to be used, and personnel to be assigned to the various phases of the work are critical; and each operation must be planned carefully. During the actual work on a project, each segment should be monitored as part of the contractor's QC effort; and when unforeseen events occur, the operation plan must be amended to meet such contingencies without a sacrifice of map quality and, it is hoped, without substantial additional costs.

(2) Collection of source material. Source material refers to the existing (extant) data that can be used to support the project. In order to review the physical conditions of the location to be mapped, the best available maps and/or recent photographs of the area should be obtained. The USGS quadrangle maps, which cover almost all of the United States, are invaluable for preliminary planning and review. Sources of pre-existing horizontal and vertical control should be sought from Federal, state, and private agencies unless project control was provided by the USACE Command. Whenever possible, a site visit should be made to the area, particularly when large-scale mapping is requested that may be used for subsequent utility relocation, grading and excavation, building siting or renovation, or any other like project where potential errors or omission can be critical during construction. Material from any adjoining (abutting) projects, either completed or in progress, should be used.

(3) Development of specifications. As definitive and clear a set of specifications as possible should be prepared for the project through the joint efforts of the functional map user and the USACE COR in charge of the mapping phase of the project. The specifications should attempt to minimize the likelihood of misunderstanding of the requirements by the contractor. Because the USACE COR cannot maintain constant supervision over photogrammetric operations, he must rely upon the integrity and reliability of the professional photogrammetrists employed on the project. Regardless, well thought out and written specifications will minimize the risk of misinterpretation. The most successful mapping projects are those accomplished when specifications are prepared for the specific project at hand, and there is a clear understanding of the requirements and specifications between USACE and the contractor.

(4) Flight map design. Flight maps are best prepared by the contractor, not the Government specification writer. The map on which the flight lines are drawn should be the best available map of the project area. USGS quadrangle maps at scales of 1:24,000 or 1:62,500 are particularly valuable for this purpose. Previously flown aerial photographs can be used especially when reflights of this photography are ordered. In general, it is best to plan flight lines parallel to the longest dimension of the project area. For areas having irregular boundaries or for meandering streams, block flying, that is, two or more parallel flight lines to cover the area, is preferable to having many short lines whose directions follow the irregular directions of the area. Also, consideration should be given to roads and trails adjacent to the project area. Incorporating these access routes into the photography frequently will facilitate the necessary ground surveys for photo control. Flight lines must recognize potential flight hazards. For example, lines should be parallel to the ridge lines of mountains rather than leading into them. The scale of the photograph should be determined by the focal length of the camera to be used and by the CI of the topographic maps. In remote and inaccessible areas, additional consideration should be given to existing horizontal and vertical control, and to places within or adjacent to the mapping area where photo control points may be found. Unusual conditions may dictate special (usually higher altitude photography) flights be flown.

(5) Project equipment and materials requirements. Specifications should be prepared to dictate the use of certain equipment, materials, and technical procedures and to stipulate the meeting of certain accuracy limits. The type of camera, focal length, film emulsion type, etc., must be specified. However, the type of field or compilation equipment should be specified only if absolutely necessary to assure proper performance. Maximum use of existing USACE guide specifications and references to the criteria in this manual should be made.

(6) Methodology and equipment. Photogrammetric firms are, in accordance with PL 92-582 qualification-based procedures, selected upon the basis of their professional reputation, their equipment, personnel, and demonstrated technical ability to perform a specific project or phase of photogrammetric work. Unless there is an overriding need, the contractor should not be required to adopt particular production methods. However, if specific methods are required to meet accuracy, deliverables, or other requirements, they should be spelled out and made part of the contract. Table 11-2 provides guidance

TABLE 11-2. Allowable Photo Mapping Techniques

Mapping Technique (1)	Accuracy Classification		
	Class 1 (2)	Class 2 (3)	Class 3 (4)
Direct Digital Data by Stereoplotter From Overlapping 9×9 Aerial Photos	Horizontal and Vertical	Horizontal and Vertical	Horizontal and Vertical
Digitizing Maps Made by Stereoplotter From Overlapping 9×9 Aerial Photos	Horizontal and Vertical	Horizontal and Vertical	Horizontal and Vertical
Digitizing/Scaling Orthophotographs	Horizontal Only	Horizontal Only	Horizontal Only
Digitizing/Scaling Orthophotographs With Superimposed Contours/Elevations	Horizontal and Vertical	Horizontal and Vertical	Horizontal and Vertical
Digitizing/Scaling Controlled Mosaics	Not Allowed	Not Allowed	Horizontal Only
Digitizing/Scaling Landsat Imagery	Not Allowed	Not Allowed	Horizontal Only
Digitizing/Scaling SPOT Imagery	Not Allowed	Not Allowed	Horizontal Only
Digitizing/Scaling Maps Made by Transferscopes from 9×9 Photos	Not Allowed	Not Allowed	Horizontal Only
Digitizing/Scaling Enlarged Aerial Plan Sheets	Not Allowed	Not Allowed	Horizontal Only

as to which mapping techniques are appropriate for each of the three map classes.

(7) Schedule. A schedule for the completion of the various phases of the project should be prepared. The complexity of this schedule will obviously vary with the scope of the work. A bar chart showing time along the top and work breakdown along the left side (Fig. 11-9) is extremely helpful during early planning stages to assure a realistic schedule. For more detailed planning, the critical path method is more informative for determining the earliest and latest start dates of the various phases and for defining the set of operations that are time-critical (critical path) in meeting the schedule. Unanticipated delays in the critical path will cause delay in the overall schedule and may have unfavorable cost impacts. It is recommended that any one of a number of desktop computer software packages be purchased to aid in the production of these charts. For extensive, long-term mapping projects (i.e., full photo coverage on an entire state or region), the Government may require periodic submittals of these progress schedules.

(8) Deliverables. A precise list of deliverables should be clearly identified in the contract. Each of the deliverables must be adequately defined and the applicable standards and specifications identified. A submittal schedule must also be developed.

11-3. PHOTOGRAPHY.

This phase consists of developing a detailed flight plan, flying and photography, developing the negatives, and producing contact prints and diapositives.

A. Detailed Flight Plan. Flight maps should be prepared by the contracted photogrammetric engineer to provide instructions to the flight crew on the location and position of the flight lines, the overlap between successive photographs, the location of adjacent flight lines, the side lap between flight lines, and the camera and film to be used. Special instructions include conditions to be observed, such as when the photographs are to be taken, i.e. when the ground is free of snow, or when the leaves are off the trees, or "photograph between the hours of . . . and . . . ," or "photographs of the . . . Bay are to be taken at high tide," etc.

	WEEKS→ OPERATIONS	1	2	3	4	5	6	7	8	9	10	11	12	13	14	15	16	17	18	19	20	21	22	23	24	25	26	27	28	29	30	31	32	33	34	35	36	37	38	39	40
Project Planning	Identify Area	▨																																							
	Collect Source		▨																																						
	Develop Specs.		▨																																						
	Flight Map			▨																																					
	Equip. Requirements			▨																																					
	Methodology			▨																																					
	Schedule	▨	▨	▨																																					
	Cost Estimate			▨																																					
Contract	Solicitation Prep.	▨	▨	▨	▨	▨																																			
	Solicitation							▨	▨	▨																															
	Negotiation									▨																															
	Contract Award									▨																															
Aerial Photography	Flight Plan										▨																														
	Photo Collection											▨	▨	▨																											
	Film Processing													▨																											
	Contact Prints														▨	▨																									
	Photo Indexes															▨	▨	▨																							
	Orthophotos																											▨	▨	▨	▨	▨	▨	▨	▨						
	Mosaics Controlled																												▨	▨	▨	▨	▨	▨	▨	▨					
Control Surveys	Preparation											▨	▨	▨																											
	Photo Control													▨																											
	Targeting													▨																											
	Field Survey														▨	▨	▨	▨	▨	▨	▨	▨	▨	▨																	
	Comps., Adjustment																						▨	▨	▨	▨	▨														
	Report																								▨	▨															
Stereo Compilation	Aerotriangulation																									▨	▨														
	Map Compilation																													▨	▨	▨	▨	▨							
	Digital Compilation																													▨	▨	▨	▨	▨							
	Compilation Edit																																▨	▨	▨						
Field Edit	Field Identification																																▨	▨	▨						
	Location																																▨	▨	▨						
Final Drafting	Drafting																																	▨	▨	▨					
	Final Edit																																		▨	▨	▨				
Delivery	Delivery																																			▨	▨	▨			
Quality Control; Assurance	Contractor									▨	▨	▨	▨	▨	▨	▨	▨	▨	▨	▨	▨	▨	▨	▨	▨	▨	▨	▨	▨	▨	▨	▨	▨	▨	▨	▨	▨	▨	▨	▨	▨
	Government			A	A	A						A				A		A								A	A							A	A	A			A	A	

A = Quality Assurance Event

FIG. 11-9. Work Breakdown Structure and Schedule

B. Flying for Photographic Collection. An air crew experienced in photographic collection for photogrammetric mapping is essential. The crew must be aware of the need to conform to flight design and must have the ability to do so. The aircraft should be appropriate for the specific project and must conform to Federal Aviation Administration (FAA) regulations. The modifications made to accommodate the aerial camera must be FAA approved.

C. Film Processing and Inspection. Film must be processed in conformance with the standards and specifications written in the contract, or as referenced to this manual from the contract. Care is required to meet the required density values. Film must be handled to minimize scratches, marks, discoloration, and dimensional instability. Annotations should be placed on each frame.

D. Contact Prints and Diapositives. Contact prints and diapositives must be free of scratches, marks, and discolorations, and otherwise conform to standards set forth in the contract. Diapositives are required to be dimensionally stable.

E. Photo Indexes, Air Photo Plan Enlargements, Mosaics, Orthophotographs. The accuracy of these photographic products depends upon their intended use. Orthophotographs may be map "substitutes" and therefore warrant sufficient care in production to meet map accuracy requirements. Mosaics and air photo plan sheets may be controlled, semicontrolled, or uncontrolled, depending upon requirements.

11-4. GROUND CONTROL AND TARGETING REQUIREMENTS.

Accurate, well-distributed, photoidentifiable control points are essential for a successful project.

A. Preparation. In preparing for the control survey for a photogrammetric mapping project, the accuracy and reliability of the existing survey data should be ascertained.

B. Photo Control. Photo control points are points on the ground whose images can be identified on the aerial photographs to be used for photogrammetric mapping. Based upon the photo control requirements, some photo control points will require horizontal (X-Y) coordinates, others will need elevations only, and some will require both horizontal and vertical values. The identification of the photo control points on the aerial photographs is critical. Extreme care must be exercised by the contractor's surveyor to make certain of this identification. The surveyor should examine the photo control point in the field using a small pocket stereoscope with the aerial photographs. Once a photo control point is identified, its position on the photograph should be pricked using a sharp needle. A brief description and sketch of each point should be made on the reverse side (without photo images) of the photograph. The photographs used in the field provide the means of communication between the surveyor and the photogrammetrist who will be using the survey data in mapping. If the surveyor can see clearly the points that he has selected in his stereoscope, it is almost certain that the photogrammetrist in the office will be certain of the point. Good photo control points include relatively flat areas at the intersection of fence lines, sidewalk corners, prominent road markings or spots, etc. Road center-line intersections are poor for horizontal points, but if the area is reasonably flat, they may be good for vertical points. Points on steep slopes are poor.

C. Targeting. While most photo control points are selected after the photographs have been made, there are times when marking points on the ground prior to obtaining the photographs is advantageous. Premarking or panelling points is particularly valuable when bridging and analytical aerotriangulation methods are to be used in the mapping process. Panels are made using colored fabric (unbleached muslin), plastic, or in some instances, paint on roads. The color to be used should be in sharp contrast to the background area, i.e., black on a white background, etc. Panels are in the form of crosses, Ts, or Vs. The long dimension of the panel should be a minimum of 0.01 of the negative scale in feet. For photographs at a scale of 1 in. = 500 ft, this would be 5 ft. The minimum width should be 0.01 of the photo scale in inches. Larger targets will be more easily visible, while anything smaller may not be seen on the photographs. The control point is located directly under the center of the cross or the intersection of the lines of the T or V. The panels should be secured to the ground. Rocks or forked sticks driven through the material do a good job.

D. Location of Photo Control. The location of the photo control points on the photography should be selected by the photogrammetrist, either by designation of an area in which a specific control point should be obtained or by actually identifying the point on the photograph. The former method is to be preferred since the surveyor should be required to make the most reliable selection in the field. The points are numbered to facilitate their use and further identification. For small mapping projects, or where good judgment and economy dictate, photo control should be obtained for each of the stereomodels to be used in the mapping. (A stereomodel is the area included in

the overlap between two photographs.) An ideal situation requires at least three horizontal and four vertical photo control points for each stereomodel. The vertical controls should not be in a straight line. They should be in each of the four corners of the model and generally be immediately adjacent to the mapping boundaries. The horizontal control may use the same points used for vertical control or may be located along an easily accessible survey route within or just outside the mapping limits. Additional adjacent models should be controlled, using a similar configuration, making sure that traverses and bench level lines are on closed adjusted loops.

E. Ground Control Surveys. Ground control surveys must have sufficient accuracy to assure that the compilation will meet the contracted map accuracy. Refer to Table 2-4 for guidance on recommended base control accuracy requirements. If targeting has already been completed, the survey must include the targeted points unless they are for aerotriangulation. Any method of survey is permissible provided accuracy and other criteria are met.

F. Computation and Adjustment. Survey data should be adjusted by the method of least squares or equivalent. Any outliers (points whose residuals generally exceed three times the normalized standard error) should be analyzed and corrected. Coordinates are to be reduced to the appropriate projection and datum.

G. Control Report. A control report including sketches with witnesses of the control points, statistical results of the adjustment, and geographic coordinates in the appropriate projection and datum should be furnished. A qualitative assessment of the control along with noteworthy observations should be included in this report.

11-5. STEREO COMPILATION AND AEROTRIANGULATION.

A. Aerotriangulation. Aerotriangulation is normally a cost-effective method of extending and increasing the density of photo control. Aerotriangulation is used most successfully on relatively large mapping projects, on jobs where existing basic control is found at each end of a mapping area, or when the requirements of the job do not include the establishment of ground control points within the mapping area. When two or more adjacent flight lines are involved, a block system of aerotriangulation should be used.

B. Map Compilation. The target scale, CI, map details, and the accuracy of the final map are the primary factors that drive the production and QC performance of the photogrammetric contractor. The map compilation phase of the work ties these requirements together to produce the manuscript map or equivalent spatial/digital design file. The plotting ratio (the optimum enlargement or reduction factor between the scale of the aerial photography and the plotting scale) varies with the accuracy requirements of the project. There are four relevant scale relationships to be considered: the scale of the aerial negative, the scale of the stereomodel (viewing scale), the scale of the map compilation, and the final map publication scale. Each of these scales impinges upon the final accuracy of the map.

C. Digital Compilation. There are several types of DTM's: grid, cross section, remeasurement, and critical point. During the project planning phase, it must be decided what the purpose of the compilation is and then specify which type of DTM is needed. Such elements as standard point spacing, maximum point spacing, type of media, and data structure must be clearly specified in the contract or delivery order scope of work.

D. Compilation Edit. Upon completion of the map compilation by the stereoplotter operator, a thorough review and edit must be made before final drafting. This element of QC is designed to check for discernible errors (unusual topographic features can be checked by examining the contact prints stereoscopically), to ensure that the manuscript map is conventional and consistent in expression, that the user's specifications have been followed (designated mapping limits, symbols, amount and type of details shown, names, format and content, etc.), that ties have been made and referenced to adjacent sheets, that control has been labeled, and that the manuscript is complete with respect to content and appearance.

11-6. FIELD EDIT AND COMPLETION.

Field inspection of manuscripts is usually necessary to fill in details required by the specifications that may have been obscured on the aerial photography or that are too small to be recognized on the photographs. For map scales of 100 ft/in. and smaller, the field edit takes the form of classification of data. This might include names of landmark buildings, highways, trails, cemeteries, identification of major features, and similar general data. Classification surveys can be made before the maps are compiled, for which it is desirable to use enlarged photographs. For maps of larger scales, particularly those larger than 100 ft/in., the field edit becomes an essential part of the mapping process. Largescale

maps are used for the design of engineering projects; and complete map details are critical, especially if structure or utility relocations are involved. In urban areas, parked cars may hide manholes and catch basins, utility poles and outlets should be checked and identified, property corners and the names of owners verified, trees and landscape plans identified, invert of first-floor elevations obtained, and such other details acquired as may be needed by the functional map. For this purpose, prints of the manuscript map should be used in the field. The field notations must be neat and legible, with any supplemental ground survey data properly recorded.

11-7. FINAL DRAFTING AND REPRODUCTION.

The manuscript map is the initial medium in the preparation of the final map. In some instances, it is the final product delivered to the map user. Content and accuracy of the final maps must be in compliance with the specifications. Final sheets should be uniform in size (unless specified otherwise), format symbolization, line weights, and accuracy. To preserve the accuracy standards of the photogrammetric process, the manuscript (the original) map must be drawn on a stable base material (polyester sheets, Dupont Mylar, or equal are recommended). Experience indicates that the manuscript sheets should be cut from the manufacturer's rolls and allowed to "season" in the atmosphere of the map compilation area. If the horizontal photo control has been computed on the SPCS, this grid, or a local grid, should be plotted on the manuscript sheets. Best results are obtained by using a coordinatograph, or programmed drafting instruments. Precise grids can be laid out using a beam compass. The horizontal control points should be plotted, preferably through the use of automated plotting equipment.

11-8. QUALITY CONTROL ACTIONS.

The photogrammetric mapping process entails the use of many separate operations, each of which has the possibility of introducing systematic and random errors. Each step must be carefully monitored by the contractor to ensure that allowable limits are not exceeded. The following is a summary of the QC, and Government quality assurance as applicable, needed for a reliable photogrammetric mapping project:

A. Aerial Camera. Calibration certificate to check distortion, resolution, and camera configuration.

B. Original Negatives. Check image quality, coverage, and forward and side overlaps. Set up random models in a stereoplotter to check for residual y-parallax.

C. Photo Control. Check closures for traverses and levels. Closed loops should always be run on primary mapping control networks.

D. Stereo Orientation. Review and check setup reports for each stereomodel. Investigate photo control points that are inconsistent with other points or that do not produce a "flat" model. Insist upon operator and/or field survey checks on erroneous or inconsistent control points.

E. Office Edit. Experienced topographers should examine each manuscript map.

F. Field Edit. Large-scale maps for critical engineering projects should be examined and, if necessary, tested in the field. Unusual topographic features or conditions should be noted, visited, and checked.

G. Drafting Edit. Final sheets should be checked for accuracy of content and clarity of presentation.

11-9. FACTORS IN ESTIMATING COSTS OF PHOTOGRAMMETRIC PROJECTS.

A. General. Cost estimation enters at two places in the project cycle:

(1) During planning (budget estimates). If the project or any part of the project is to be contracted, an estimate of the contracted phases must be made in order to budget the cost either in the current or the out years. Those parts of the project to be done by another Government agency will need to be estimated to program the amount that will need to be transferred. Those parts to be done by the agency itself will need to be estimated to forecast the in-house resources needed; at a minimum, this includes management time for the COR. Guidance for developing rough budget estimates is given in Appendix C.

(2) During proposal evaluation. Prior to contract negotiations, a detailed Independent Government Estimate (IGE) must be prepared. Appendix C contains guidance and samples of detailed IGE's for typical USACE mapping projects. One of the elements in evaluating a contractor's proposal relative to the IGE is cost realism. Unrealistically low (or high) estimates should be questioned. Often, unrealistic estimates are a result of oversight, excessive precaution, or lack of clear understanding of the contract requirements, not only by the prospective

contractor but also by the preparer of the IGE. These disparities are resolved during negotiations with appropriate adjustments made to the IGE.

B. Fixed and Variable Costs. Project costs can be divided into fixed and variable costs. Fixed costs are those, once the project has been defined, that are incurred regardless of unforeseen contingencies and modifications. For example, the cost of moving the aircraft and crew from the home base to the project base is a fixed cost. Variable costs are those that change as contingencies change. For example, the number of days that an aircraft is grounded at the project base because of inclement weather is a variable cost.

C. Contract Type. The usual contract for photogrammetric mapping projects is a firm fixed price, as derived from PL 92-582 selection and negotiation procedures. Consequently, the contractor is contractually committed to producing the deliverables for the agreed-upon price. The Government, when negotiating, should assess whether it is priced realistically.

D. Cost Breakdown. A rule of thumb for estimating the breakdown of costs between the various phases of a typical urban mapping project is as follows:

(1) Aerial Photography: 5 to 10%

(2) Geodetic (Field) Control: 30 to 50%

(3) Map Production: 45 to 60%

E. Cost Breakdown Example. Table 11-3 is a cost breakdown adapted from an example in the "Manual of Photogrammetry" (American Society of Photogrammetry 1980).

F. Cost Drivers. Each operation of the photogrammetric mapping project has its cost drivers, i.e., those items that have the greatest impact on the project cost. Map production, which usually contributes the greatest cost to the overall project, is the first place to look for savings; the next is geodetic control; and the last, aerial photography. Aerial photography, being generally less than 10% of the total project cost, offers the least potential for cost savings. Likewise, the effort spent preparing cost estimates should be proportionate to the relative costs shown in the above example. Many estimators spend more time counting the number of photographs required to cover the project (3% of overall cost) than in estimating stereoplotter compilation time (a 22% cost item).

(1) Aerial photography. Photographic scale enters into cost generally in two ways. First is its effect on the number of photographs required to cover a unit area of the terrain. Second is its effect

TABLE 11-3. Example Cost Breakdown for a Photogrammetric Mapping Project

Operation (1)	Percent of Operation (2)
Aerial Photography	3
Geodetic (Field) Control	15
Map Production	82
Layout	3
Stereocompilation	22
Aerotriangulation	2
Model Orientation	2
Planimetry	12
Contours	6
Drafting/scribing	46
Planimetry	22
Contours	24
Editing (15% of Drafting)	7
Mosaics, Index Map	2
Printing	2

Note: For modern digital mapping operations, the relative percentages of stereocompilation and Drafting/Scribing can easily reverse.

on the required flying height and, therefore, on the type of aircraft and equipment; very high flown photography will require a more expensive aircraft. Emulsion type affects principally the developing and handling requirements. Color film requires a more expensive process than does black and white. The location of the project area and its accessibility to a project airfield is a consideration. If each day's collection requires a several-hundred-mile flight to reach the project area, considerable extra expense will be incurred. If the airspace above the project is restricted in any way, extra expense may be incurred. Naturally, the size of the project area is a consideration. Each additional flight line necessitates an additional turn of the aircraft, which adds to total "unproductive" flight time. Fewer but longer flight lines are generally preferable. Unpredictable and inhospitable weather conditions such as rain, fog, cloud cover, snow, snow cover, etc., may cause the air crew to remain at the project base for an inordinately long period of time waiting for proper flying conditions. In particularly unfortunate circumstances, the project may have to be aborted altogether for that flying season. High winds may make it impossible to meet flight design, tilt, crab, and other constraints. Mountainous terrain will have the

effect of obscuring features, necessitating additional coverage to fill in the gaps.

(2) Geodetic (field) control. Terrain type and cover have a great impact on cost; mountainous and brush-choked terrain make maneuvering for the ground control party difficult. The GPS can greatly speed up the establishment of control. Placing control close to roads and trails facilitates its establishment; therefore, the density of the transportation network is critical to cost. Control should be no denser than required to meet accuracy requirements. Minimizing project-specific control through the use of preexisting control is very cost-effective. Aerotriangulation should be used, wherever possible, to densify control.

(3) Map production. The density and comprehensiveness of feature detail are perhaps the most vigorous drivers of cost. The compilation of planimetric detail generally absorbs the greatest percentage of time during the compilation phase. Field completion, because of the travel time and per diem required, is also expensive. Nonphotographic information such as cartographic names, underground utilities, and political boundaries can be time-consuming to obtain and render.

(4) Other cost drivers. There are a number of other cost drivers that can be scrutinized. Contract direct labor rates, overhead charges, general and administrative charges, and fees should all be carefully reviewed. These are contractual matters and fall under the responsibility of the Contracting Officer. However, the assessment of the qualifications of the project personnel and of the amount and level of management and supervision, and estimates of the time required to perform each specific task should be thoroughly assessed by the technical personnel. Schedule can have a great impact on cost. If an operation can be coordinated with other ongoing projects, considerable savings may be possible. This is especially true if the project area is remote and thus is subject to high fixed costs of mobilization that may be allocated across several projects. Also, if the schedule can coincide with the "best" flying season and if overtime rates can be avoided, cost savings can be realized; priority projects generally cost more. The number and extent of briefings, meetings, and reports should be sufficient to assure proper monitoring of the performance on the project, but they should not interfere with its progress. The deliverables should be well defined, actually needed and used for Government QA checks, and not beyond the requirements of the project.

G. Industry Cost Terms. Below is a short description of several cost terms used by the commercial mapping industry in their cost analysis processes. These may not correspond directly to Government cost item terminology, or "seven-item breakdown," and any differences are usually resolved during the field audit process.

(1) Direct labor. Includes the labor of those operational personnel that are directly assigned to perform work on the deliverables.

(2) Overhead on direct labor. This includes fringe benefits such as vacation, holidays, sick leave, pensions, bonuses, downtime and marketing; work and office space, utilities, and equipment; and items such as pens and pencils that may be too small (de minimus) to keep accurate accounting of. Overhead is calculated as a percentage of direct labor and usually ranges from 60% to 175% depending upon the nature of the business.

(3) Other direct charges (ODC). These are nonlabor costs and include travel, per diem, and other miscellaneous special costs such as rental, lease, or purchase of computers, software, and supplies such as film obtained specifically for the contract.

(4) General and administrative overhead (G&A). This category includes salaries and fringe benefits of indirect personnel, such as officers of the company, accounting, administrative, purchasing, and contracts personnel along with their office space, utilities, equipment, and supplies. Bid and proposal and investigations, research, and development costs are allocated to G&A. G&A usually ranges from 5% to 25% of the total of direct labor, overhead, and ODCs, depending upon the nature of the business and precisely how costs are allocated between direct overhead and G&A.

(5) Fee (profit). This is an amount added to the cost of the contract as "consideration" to the business. The method of calculating fee varies depending upon the type of contract, and may not represent the actual profit received by the company (which may be higher or lower). Fee generally ranges from 5 to 15% and should be a function of the quality of the contractor's performance on the project and on the degree of risk assumed by the contractor. On Government contracts, profits are computed using weighted guidelines.

11-10. CONTRACTED PHOTOGRAMMETRIC MAPPING SERVICES.

Most USACE photogrammetric mapping requirements are obtained by contract. This paragraph briefly describes the general procedures used in contracting for these services. The companion Civil

Works Construction Guide Specification, CW 01335, should be consulted for specific contract formats. Appendix C to this manual provides guidance in preparing cost estimates. For detailed guidance on procurement policies and practices, refer to the appropriate procurement regulations.

11-11. PL 92-582 QUALIFICATION-BASED SELECTION.

In accordance with current laws and regulations, photogrammetric mapping and surveying services must be procured using qualification-based selection procedures in accordance with PL 92-582 (Brooks Act). These services may be included as part of a fixed-price (single-project scope) A-E design contract or included as a line item on an indefinite delivery type (IDT) surveying and mapping services contract. In some instances, a fixed-scope photo mapping contract may be issued. In almost all cases, photogrammetric mapping and related surveying services will be negotiated as part of the A-E selection process; therefore, a Government cost estimate for these services must be prepared in advance of formal negotiations with the contractor. Exceptions are noted in CW 01335.

11-12. CONTRACT TYPES.

Fixed-scope photo mapping service contracts are not common; in most cases, USACE Commands obtain photo mapping services via IDT contracting methods. One or more delivery orders may be placed against the IDT contract for specific projects. An overall contract threshold is established—currently $400,000 per year per contract; thus, the accumulation of individual orders cannot exceed this limit. Individual orders placed against the basic contract are normally limited to $75,000. The term of an IDT contract is usually set at 1 year; however, option year extensions may be authorized. Separate project scopes are written and negotiated for each order. The unit prices established in the basic IDT contract are used as a basis for estimating and negotiating each delivery order. The basic unit prices in an IDT contract are established as part of the A-E acquisition and negotiation process; therefore, a Government cost estimate for these services must be prepared in advance of formal negotiations with the contractor. These basic unit prices must adequately represent the anticipated work over the course of the IDT contract—typically a one-year period. (Separate rates are negotiated for additional option years.) Deficiencies in these unit rates will impact subsequent delivery order negotiations.

TABLE 11-4. Factors for Estimating Costs

Item (1)	Description (2)
I	Direct labor or salary costs of pilots, photo mapping technicians, etc.: includes applicable overtime or other differentials necessitated by the observing schedule.
II	Overhead on Direct Labor.
III	G&A Overhead Costs (on Direct Labor).
IV	Material Costs.[1]
V	Travel and Transportation Costs: crew travel, per diem, etc. Includes all associated costs of vehicles.[1]
VI	Other Costs: includes survey equipment and photogrammetric instrumentation. Major equipment costs should be amortized down to a daily rate, based on average utilization rates, expected life, etc. Excludes all instrumentation and plant costs covered under G&A, such as interest.[1]
VII	Profit (To be computed/negotiated on individual delivery orders per Engineer Federal Acquisition Regulation Supplement 15).

Note:
[1] Government audit must confirm if any of these direct costs are included in overhead.

11-13. UNIT PRICE BASIS.

The unit prices scheduled for each scheduled photo mapping service in a contract must be estimated using the following USACE-directed detailed analysis method. The seven-item breakdown for estimating costs is given in Table 11-4. A typical contract price schedule is shown in CW 01335.

11-14. VERIFICATION OF CONTRACTOR COST OR PRICING DATA.

It is essential (but not always required) that a cost analysis, price analysis, and field pricing support audit be employed to verify all cost or pricing data submitted by a contractor, in particular, for actual aircraft, instrumentation utilization rates, and reduced costs per day. Some aircraft operation and maintenance costs may be direct or portions may be indirectly included in a firm's G&A overhead account. In some instances, a firm may lease/rent aircraft, instruments, or equipment in lieu of pur-

chase. Rental would be economically justified only on limited-scope projects and if the equipment is deployed on a full-time basis. Whether the equipment is rented or purchased, the primary (and most variable) factor is the GPS equipment's actual utilization rate, or number of actual billing days to clients over a year. Only a detailed audit and cost analysis can establish such rates, and justify modifications to the usually rough assumptions used in the IGE. In addition, an audit will establish any nonproductive labor/costs, which are transferred to a contractor's G&A. Costs and overhead percentages are subject to considerable geographic, project, and contractor-dependent variation. Associated costs for insurance, maintenance contracts, interest, etc., are presumed to be indirectly factored into a firm's G&A overhead account. If not, then such costs must be directly added to the basic equipment depreciation rates.

August 31, 1989

Survey Branch

Gentleman:

 You are invited to submit a written proposal for surveying and mapping services under Contract No. , entitled Fort Lewis Master Plan Automation, Fort Lewis, Washington. The statement of work is attached as enclosure 1.

 NPS Form 107 and 1180-1 (enclosures 2 and 3) are attached for your use in preparation of your proposal, as is a profit factor determination sheet (encl 4). Use labor and overhead rates already negotiated for the basic contract.

 Please submit your confirmed quotation for accomplishing this work by September 8, 1989.

 If you have any questions, please call Mr. Ken Graybeal at (206) 764-3535.

 Sincerely,

Enclosures John P. Erlandson
 Contracting Officer's
 Representative

 GRAYBEAL EN-SY

 ERLANDSON EN-SY /s/

 EN-SY FILE

FIG. 11-10. Letter Request for Proposal

CENPS-EN-SY 30 August 1989

DETAILED SPECIFICATIONS
WORK ORDER NO.
CONTRACT NO.

1. <u>Project</u>: Fort Lewis Master Plan Automation.

2. <u>Location</u>: Fort Lewis, Washington.

3 <u>General</u>: The Contractor shall prepare topographic and planimetric digital
data files from fully controlled aerial photography provided by the
Government.

4. <u>Detailed Specifications</u>: The following specifications are in addition to
the applicable Technical Requirements described in Appendix "A" of the basic
contract:

a. Target Computer Graphic System. The Contractor shall provide
interactive graphic and non-graphic data files that are fully compatible with
and fully operational on an Intergraph computer system running Intergraph
Software version 8.8 and VAX/VMS version 5.0. The files shall be Intergraph
Design files.

(1) File Format:
Intergraph design file shall utilize design plan working units of
FT:10TF:100 (Master Units: Subunits: Positions Units) to insure capability to
use the state plane coordinate system and be compatible with Seattle District
mapping procedures and standards. Design file coordinates shall be the same
as Washington State Plane Coordinate, South Zone, as provided by the
Government.

(2) File Size:
Intergraph design files shall not exceed 2340 blocks (1.2 Mega Bytes)
of information per file. Each data file shall be as large as possible, but
not to the point of being too large for transfer using 1.2 mb floppies to the
Intergraph system described in paragraph 4a.

(3) File Layout:
All information for Fort Lewis 1"=40' mapping will reside on one file
with a file generated for each individual model. File name will be referenced
to the photograph number, i.e., FL87215 MP, whereas FL = Fort Lewis, 87 = year
flown, 215 = photo number and MP = master planning. All files shall be edge
matched.

b. File Development From Aerial Photograph. The Contractor shall develop
data files from Government furnished aerial photography (24 stereo models)
using accepted photogrammetric standards, procedures and equipment. Mapping
limits shall be as shown on the Government furnished project map. Digital
data will be used to produce 1"=40' maps with a 1' contour interval. Each
data file shall contain the following levels, line code, weight, and colors
with appropriate name or annotation:

FIG. 11-11. Scope of Work (Sheet 1 of 4)

Item	Level	Color	Weight	Line Code	TX	FT
Spot Elevations	4	4	1	0	2.4	127
Intermediate contour	5	6	0	0		
Guide Contours	6	6	3	0		
Contour Annotation	7	6	1	0	3.2	127
Coordinate Grid &						
Annotation	8	2	0	0	4.8	127
Monuments	9	3	1	0	4.0	24
Control Points	10	4	0	0		
Fence Lines	13	1	0	0		
Sidewalks	14	0	0	0		
Misc Outlines	15	1	0	3		
Road, Bridges	19	3	1	0		
Airfields	21	3	1	0		
Railroads, RR						
Bridges	23	4	0	0		
Building	27	4	2	0		
Object (pads)	29	3	0	0		
Structure	31	6	1	0		
Vegetation	33	2	0	0		
Water, Lakes,						
Streams	35	1	1	0		
Parking Lots	37	6	1	0		
Flumes	39	4	1	0		
Storm, Sewer						
(Catch Basins)	41	2	0	0		
Electrical (P.P.,						
S.L., T.L.)	47	3	0	0		
Water (Fire						
Hydrant)	49	1	0	0		
Steam-HTHW	51	4	0	0		
Gas	53	3	2	0		
Fuel	55	3	0	0		
Culverts	57	4	1	3		
Drainage Ditch	59	1	1	0		

c. File Development From Existing Files. Using accepted data entry techniques and procedures, the Contractor shall develop data files for the 1"=40' mapping. This will be accomplished by referencing the Government furnished 1"=400' data file miscellaneous mp and copying the Approach/Clear Zone limits and the outline for Landfills. Level and element symbology are as follows:

Item	Level	Color	Weight	Line Code	TX	FT
Approach/Clear						
Zone	12	6	1	0		
Landfill Outline	15	1	0			

d. Text Development. Using accepted data entry techniques and procedures, the Contractor shall develop text data for the 1"=40' mapping. This will be accomplished by referencing the Government furnished 1"=400' mapping files for the following:

FIG. 11-11. (Sheet 2 of 4)

Item	Level	Color	WT	Line Code	TX	FT
Approach/Clear Zone	12	6	1	0	7.0	24
Landfills	15	1	0	3	7.0	24
Street Names	20	3	0	0	7.0	24
Airfield	22	4	0	0	7.0	24
Railroad	24	4	0	0	7.0	24
Bldg. Descriptive Text	26	4	0	0	7.0	24
Building Numbers	28	4	0	0	4.8	24
Object/Recreation	30	3	0	0	7.0	24
Bus Stop/Facility Numbers	32	6	0	0	4.8	24
Geographic Names/ Water	36	1	1	0	7.0	24
Parking Lots	38	6	0	0	5.6	24
Water Wells	50	1	0	0	4.8	24

e. Map Symbol: All symbols, line type and line weights shall conform with Government furnished menu and cell files.

5. Government Furnished Material:

a. Photo prints and diapositives for the following (diapositives under separate cover):

S87013-5, exposure 57 thru 60 and exposure 62 thru 67
S89004-5, exposure 60 thru 62
S87013-6, exposure 84 thru 92
S87013-7, exposure 111 thru 117

b. Control listing (separate cover).

c. Project map with mapping limits (1"=800').

d. Seattle District mapping matrix menu (separate cover).

e. Files on 1.2 mb floppy disks for the following (separate cover):

(1) MAP01.UCM-MAP65.UCM (Matrix Menu User Commands).

(2) G3MAPMM.DGN (Matrix Menu Design File).

(3) 1"=400' mapping files of the following:
 o WATREC.MP (Water and Recreation).
 o MISC.MP (Geographic Names, Landfills, etc.).
 o SHTxBLDG.MP (Building No., Description, Structures, Bus Stops).

 o SHTxROAD.MP (Road Names, Parking, etc.).

FIG. 11-11. (Sheet 3 of 4)

6. <u>Submittals:</u>

a. Prefinal submittal

(1) The prefinal submittal shall consist of one (1) set of check prints 1"=50' for each model. Also, data files on 1.2 mb floppy disks for all models submitted.

(2) Government review period shall be 10 days from receipt of each submittal.

b. Final submittal: The final data files shall contain all the revisions required as a result of the Government review comments from previous submittal. The final submittal will consist of:

(1) Diskets 1.2 mb for all files with tabulation.

(2) All Government furnished material.

7. <u>Schedule and Delivery:</u> The submission schedule will commence on the day notice-to-proceed is issued and will run consecutively for the number of days shown. All submissions under this work order shall be accompanied by a letter of transmittal:

Submittal	Days After Notice to Proceed
Prefinal Submittal	90
Review Comments	105
Final Submittal	125

8. <u>Conference Record:</u> The Contractor shall prepare the minutes of all conferences and meetings and shall distribute copies to all attendees within 10 calendar days.

FIG. 11-11. (Sheet 4 of 4)

Other accounting methods for developing daily costs of equipment may be used. Equipment utilization estimates in an IGE must be subsequently revised (during negotiations) based on actual rates as determined from a detailed cost analysis and field price support audits.

11-15. IDT ORDERING.

Since unit prices have been established in the basic contract, each such delivery order is negotiated strictly for effort. The negotiated fee on a delivery order is then a straight mathematical procedure of multiplying the agreed-upon effort (time or unit of measure quantity) against the unit prices, plus an allowance for profit. Thus, an IGE is required for each order placed, along with a detailed profit computation, documented records of negotiations, etc. The scope is attached to a DD1155 order placed against the basic contract. The process for estimating the time to perform any particular photo mapping or survey function in a given project is totally dependent upon the knowledge and personal field experience of the Government estimator. Figs.11-10 through 11-15 depict the flow of a typical ordering action for photogrammetric mapping services. These figures, furnished by the U.S. Army Engineer District, Seattle, show the IDT contract delivery order process as a part of the Fort Lewis Master Plan. Figure11-16 represents a Government cost estimate for in-house photogrammetric mapping services.

~~DETAILED ANALYSIS (A-E PROPOSAL)~~ (GOVERNMENT ESTIMATE)	DATE 7 SEP 1989	PAGE 1 OF 2

JOB TITLE AND LOCATION *FORT LEWIS, MASTER PLAN AUTO*
☐ CONCEPT ☐ PRELIMINARY ☒ FINAL ☐ REVISION

REMARKS (PLANS & SPECS;REPORT;OTHER: EXPLAIN) (ECC _____)
W.O. # *CONTRACT* *(PRIME CONTRACTOR)*

DIRECT LABOR COSTS

PRODUCTION ELEMENT	ENGINEERING			DRAFTING			TYPING (IF NOT INDIRECT)		
	HOURS	RATE	TOTAL	HOURS	RATE	TOTAL	HOURS	RATE	TOTAL
Project Manager	56	16.67	933.52						
Supervisor Land Surveyor									
Party Chief									
Survey Tech (instrumentan)									
Survey Aid (Rod/Chainman)									
Office Supervisor									
Computer Technician									
Photogrammetrist/CADD									
Stereo Plotter Operator									
Computer Editor									
Carto Tech (Drafting)									
TOTAL			933.52						

FEE ESTIMATE

1. DIRECT LABOR COSTS (DLC)		$ 933.52
2. SALARY O.M. (VACATION, SICK LEAVE, ETC.	(_____ $ DLC) $ _____ 121%	
3. GENERAL & ADMIN (office equip., bldg. rental, etc)	(_____ $ DLC) $ _____	$ 1129.56
	SUB-TOTAL	$ 2063.08
4. PROFIT (10% $ OF SUB-TOTAL) (WEIGHTED)		$ 206.31

5. TRAVEL
 AIR FARE $ _____
 AUTO MILEAGE $ _____ $ 0
 PER DIEM $ _____

6. REPRODUCTION
 DRAWINGS $ _____
 SPECS & CALS $ _____
 MATERIALS - SUPPLIES $ _____ $ 0

7. UNUSUAL EXPENSES - EXPLAIN
 SUB CONTRACTOR 45 580.28
 $ ~~44000.27~~

ESTIMATE BY: *KENNETH D. GRAYBEAL*	APPROVED:	TOTAL FEE $ 47,849.67 ~~46,275.00~~ 9/12/5?
DATE: 7 SEPT 1989	DATE:	

NPS Form 1180-1
May 90 (Rev) (Replaces NPS Form 110)

FIG. 11-12. Independent Government Estimate With Back-Up Data (Sheet 1 of 5)

DETAILED ANALYSIS (A-E PROPOSAL)	(GOVERNMENT ESTIMATE)	DATE 7 SEPT 1989	PAGE 2 OF 2

JOB TITLE AND LOCATION *FORT LEWIS MASTER PLAN AUTO* ☐ CONCEPT ☐ PRELIMINARY ☒ FINAL ☐ REVISION

REMARKS (PLANS & SPECS;REPORT;OTHER: EXPLAIN) (ECC _____) *(SUB CONTRACTOR)*
W.O. # CONTRACT

DIRECT LABOR COSTS

PRODUCTION ELEMENT	ENGINEERING			DRAFTING			TYPING (IF NOT INDIRECT)		
	HOURS	RATE	TOTAL	HOURS	RATE	TOTAL	HOURS	RATE	TOTAL
Project Manager	18	16.67	300.06						
Supervisor Land Surveyor									
Party Chief									
Survey Tech (instrumentan)									
Survey Aid (Rod/Chainman)									
Office Supervisor	70	14.37	1005.90						
Computer Technician									
Photogrammetrist/CADD	420 ~~395~~	10.95	4599.00 ~~4325.25~~						
Stereo Plotter Operator	560 ~~550~~	12.40	6944.00 ~~6820.00~~						
Computer Editor	58 ~~52~~	13.74	796.92 ~~714.48~~						
Carto Tech (Drafting)	12	9.51	114.12						
TOTAL			13,279.81						

FEE ESTIMATE 13760.00

1. DIRECT LABOR COSTS (DLC)		S ~~13279.81~~
2. SALARY O.M. (VACATION, SICK LEAVE, ETC.) (____ $ DLC) $ ____ } 198%		27244.80
3. GENERAL & ADMIN (office equip., bldg. rental, etc) (____ $ DLC) $ ____ }		S ~~26294.02~~
	SUB-TOTAL	S ~~34573.83~~ 41004.80
4. PROFIT (10% $ OF SUB-TOTAL) (WEIGHTED)		S ~~3457.38~~ 4100.48
5. TRAVEL AIR FARE $ ____ AUTO MILEAGE $ ____ PER DIEM $ ____		S ____ 0
6. REPRODUCTION DRAWINGS $ ____ SPECS & CALS $ ____ MATERIALS - SUPPLIES $ 475.00		S ____ 475.00
7. UNUSUAL EXPENSES - EXPLAIN		S ____ 0

ESTIMATE BY:	APPROVED:	TOTAL FEE $ 45,580.28 ~~44,006.21~~ 9/12/89
DATE:	DATE:	

NPS Form 1180-1
May 90 (Rev) (Replaces NPS Form 110)

FIG. 11-12. (Sheet 2 of 5)

BACK-UP DATA TO (A-E PROPOSAL) (GOVERNMENT ESTIMATE)

DATE: 5 SEP 89 PAGE: 1 OF 2

JOB TITLE: FORT LEWIS, MASTER PLAN AUTO (BACK UP)

SPECIFY: ☐ CONCEPT ☐ FINAL ☐ PRELIMINARY ☐ REPORT

REMARKS: W.O. # CONTRACT (SUB)

LIST OF DRAWINGS/ACTIVITIES (MANHOURS) (MAN DAYS)

NO.	DESCRIPTION	PROJECT MANG	OFFICE SUP.	COMP EDITOR	CARTO STEREO	CARTO CADD	CARTO DRAFT	
1.	REVIEW/PLAN	4	4	2				
2.	FILE DEVELOPMENT FROM AERIAL PHOTOGRAPH							
	COMPILE	6	28	6	560 ~~550~~			
	CHECK PLOTS					21		
	EDIT (CADD)					232		
	FILE DEV. CADD SYSTEM			16				
3.	FILE DEVELOPMENT FROM EXISTING COE FILES							
	TEXT	2	6	2		59		
	APPROACH LINES		2	2		14		
	SYMBOLS			2		2		
	FILE DEV. CADD SYSTEM			12				
ESTIMATE BY:								
DATE:								

NPS Form 107
APR 79 (Rev)

FIG. 11-12. (Sheet 3 of 5)

	BACK-UP DATA TO (A-E PROPOSAL) (GOVERNMENT ESTIMATE)		DATE		PAGE 2 OF 2	

JOB TITLE:

REMARKS:

SPECIFY
☐ CONCEPT ☐ FINAL
☐ PRELIMINARY ☐ REPORT

LIST OF DRAWINGS/ACTIVITIES (MANHOURS) (MAN DAYS)

NO.	DESCRIPTION	PROJECT MANG	OFFICE SUP.	COMP EDITOR	CARTO STEREO	CARTO CADD	CARTO DRAFT	
4.	PREFINAL SUBMITTAL							
	PLOTS					21		
	REVIEW	2	2	2		8	8	
	BLUELINES						4	
	DISK FILES			2				
5.	FINAL SUBMITTAL							
	EDIT (CADD)	2	8			40		
	CHECK PLOTS			2		21		
	REVIEW	2	8	4		6		
	FINAL DISK COPY			4				
ESTIMATE BY:		18	70	58	~~550~~ 560	~~845~~ 420	12	
DATE:								

NPS Form 107
APR 79 (Rev)

FIG. 11-12. (Sheet 4 of 5)

ARCHITECT–ENGINEER
PROFIT FACTOR DETERMINATION
EFARS 15.902(b) 88FEB04

PROJECT _FORT LEWIS MASTERPLAN AUTOMATION_

RFP No. _____ PREPARATION DATE: _7 SEPT 89_

A/E FIRM _____ PREPARED BY: _GRAYBEAL_

FACTOR	RATE	X	WEIGHT	=	VALUE
DEGREE OF RISK (no risk .07 to high risk .15)	25		0.08		2.00
RELATIVE DIFFICULTY OF WORK (simple work .07 to most complex .15)	20		0.07		1.60
SIZE OF JOB $50K——$500K——$1MIL .15———.09———.07	15		0.14		2.10
PERIOD OF PERFORMANCE DAYS 60 / 90 / 120 / 150 / 180 .07——.90——.11——.13——.15 (NOTE: On modifications, apply <u>no</u> weight where additional time is not required)	20		0.10		2.00
ARCHITECT-ENGINEER'S INVESTMENT (below avg .07 to above avg .15)	5		0.10		0.50
ASSISTANCE BY GOVERNMENT (much assist .07 to little assist .15)	5		0.08		0.40
SUBCONTRACTING % of subcontracting 0% / 20% / 40% / 60% / 80% .15——.13——.11——.09——.07	10		0.14		1.40

<u>100%</u>

PROFIT ALLOWANCE – – – – – – – – – _10.0_ %

Based on the circumstances of this procurement action, each of the above
factors shall be weighted from .07 to .15 as indicated on reverse. The value
shall be obtained by multiplying the rate by the weight. The value column
when totalled indicates the fair and reasonable profit percentage under the
circumstances of this particular procurement.

9230s

FIG. 11-12. (Sheet 5 of 5)

Department of the Army
Seattle District Corps of Engineers
P.O. Box C-3755
Seattle, WA 98124-2255

ATTENTION: MR. JOHN P. ERLANDSON, COR *9/11/89 1345 hrs / Grapeal*

SUBJECT: PROPOSAL FOR WORK ORDER NO.
 CONTRACT FORT
 LEWIS MASTER PLAN AUTOMATION,
 FT. LEWIS, WASHINGTON

Dear Mr. Erlandson:

 We are very pleased to respond to your RFP letter dated August 31, 1989 for another block of
the Fort Lewis MPA digital mapping program. However, we must advise you that our present work load,
including Ft. Lewis MPA Work Orders No. and , may not allow us to begin Work Order No.
until January 1, 1990. This is a safe estimate of time that also considers delays due to the ownership
changes in the organization. When the new management arrives, we may be more optimistic
about the current and future production schedules for all of our photogrammetric services. Until then,
the following proposal is offered with a modified delivery schedule for your consideration.

Scope of Services

Provide topographic and planimetric digital data files from fully controlled aerial photography provided
by the government as outlined in the "Detailed Specifications", Work Order No.
 dated 30 August 1989; except items not to be shown according to the party agreement list
defined in Enclosure No. 1. Said agreement being the changes negotiated between and the
Government under Work Order No.

Fee Quotation

The above services shall be accomplished for a lump sum of $47,706.83. Details of the cost breakdown
are shown on the attached NPS Forms 107, 100 and Profit Factor Determination 9230 for both and

FIG. 11-13. Contractor's Letter Proposal With Cost Estimate (Sheet 1 of 7)

Mr. John P. Erlandson, COR
Department of the Army
September 8, 1989
Page Two

Time Schedule

 request that Item 7 of Work Order No. , "Schedule and Delivery", be modified to commence work following notice-to-proceed on or about January 1, 1990. We also request that the submittal schedule be revised as follows:

Submittal	Days After Notice-To-Proceed
Prefinal Submittal	105 Days
Review Comments	120 Days
Final Submittal	135 Days

Thank you and until further notice, we remain at your service.

 Sincerely,

Enclosures
 Estimate Forms - 7
 Enclosure No. 1 - 1

FIG. 11-13. (Sheet 2 of 7)

| DETAILED ANALYSIS (A-E PROPOSAL) (GOVERNMENT ESTIMATE) | | | | | | DATE 9/8/89 | | PAGE 1 OF 5 | |

JOB TITLE AND LOCATION FORT LEWIS MASTER PLAN AUTOMATION
☐ CONCEPT ☐ PRELIMINARY ☒ FINAL ☐ REVISION

REMARKS (PLANS & SPECS;REPORT;OTHER: EXPLAIN) (ECC _____)
WORK ORDER NO. CONTRACT PRIME

DIRECT LABOR COSTS

PRODUCTION ELEMENT	ENGINEERING			DRAFTING			TYPING (IF NOT INDIRECT)		
	HOURS	RATE	TOTAL	HOURS	RATE	TOTAL	HOURS	RATE	TOTAL
Project Manager	56	16.67	933.52						
Supervisor Land Surveyor									
Party Chief									
Survey Tech (instrumentan)									
Survey Aid (Rod/Chainman)									
Office-Supervisor									
Computer Technician									
Photogrammetrist/CADD									
Stereo Plotter Operator									
Computer Editor									
Carto Tech (Drafting)									
TOTAL			933.52						

FEE ESTIMATE

1. DIRECT LABOR COSTS (DLC)		$ 933.52
2. SALARY O.M. (VACATION, SICK LEAVE, ETC.) (30% $ DLC) $ 280.06		
3. GENERAL & ADMIN (office equip., bldg. rental, etc) (91% $ DLC) $ 849.50		$ 1129.56
SUB-TOTAL		$ 2063.08
4. PROFIT (10.2 % $ OF SUB-TOTAL) (WEIGHTED)		$ 210.43
5. TRAVEL AIR FARE $_____ AUTO MILEAGE $_____ PER DIEM $_____		$ -0-
6. REPRODUCTION DRAWINGS $_____ SPECS & CALS $_____ MATERIALS - SUPPLIES $_____		$ -0-
7. UNUSUAL EXPENSES - EXPLAIN SUB CONTRACTOR		$ 45,433.32
ESTIMATE BY:	APPROVED:	TOTAL FEE $ 47,706.83
DATE: 9/8/89	DATE: 9/8/89	

NPS Form 1180-1
May 90 (Rev) (Replaces NPS Form 110)

FIG. 11-13. (Sheet 3 of 7)

DETAILED ANALYSIS (A-E PROPOSAL) (GOVERNMENT ESTIMATE)							DATE 9/8/89		PAGE 2 OF 5

JOB TITLE AND LOCATION
FORT LEWIS MASTER PLAN AUTOMATION ☐ CONCEPT ☐ PRELIMINARY ☐ FINAL ☐ REVISION

REMARKS (PLANS & SPECS;REPORT;OTHER: EXPLAIN) (ECC _____)
WORK ORDER NO. CONTRACT SUB

DIRECT LABOR COSTS

PRODUCTION ELEMENT	ENGINEERING			DRAFTING			TYPING (IF NOT INDIRECT)		
	HOURS	RATE	TOTAL	HOURS	RATE	TOTAL	HOURS	RATE	TOTAL
Project Manager	73	14.73	1049.01						
Supervisor Land Surveyor									
Party Chief									
Survey Tech (instrumentan)									
Survey Aid (Rod/Chainman)									
Office Supervisor	15	16.67	250.05						
Computer Technician	-								
Photogrammetrist/CADD	420	10.95	4599.00						
Stereo Plotter Operator	560	12.40	6944.00						
Computer Editor	58	13.74	796.92						
Carto Tech (Drafting)	10	9.51	95.10						
TOTAL			13734.08						

FEE ESTIMATE

1. DIRECT LABOR COSTS (DLC)		$ 13734.08
2. SALARY O.M. (VACATION, SICK LEAVE, ETC. (28% $ DLC) $ 13734.08		3845.54
3. GENERAL & ADMIN (office equip., bldg. rental, etc) (170% $ DLC) $ 13734.08		$ 23347.94
	SUB-TOTAL	$ 40,927.56
4. PROFIT (10 $ OF SUB-TOTAL) (WEIGHTED)		$ 4092.76
5. TRAVEL AIR FARE $_____ AUTO MILEAGE $_____ PER DIEM $_____		$ -0-
6. REPRODUCTION DRAWINGS $_____ SPECS & CALS $_____ MATERIALS - SUPPLIES $_____		$ 413.00
7. UNUSUAL EXPENSES - EXPLAIN		$_____

ESTIMATE BY:	APPROVED:	TOTAL FEE $ 45,433.32
DATE: 9/8/89	DATE: 9/8/89	

NPS Form 1180-1
May 90 (Rev)

(Replaces NPS Form 110)

FIG. 11-13. (Sheet 4 of 7)

BACK-UP DATA TO (A-E PROPOSAL) ~~(GOVERNMENT ESTIMATE)~~		DATE 9/8/89	PAGE 3 of 5

JOB TITLE: FORT LEWIS MASTER PLAN

REMARKS:

SPECIFY
☐ CONCEPT ☐ FINAL
☐ PRELIMINARY ☐ REPORT

LIST OF DRAWINGS/ACTIVITIES (MANHOURS) (MAN DAYS)

NO.	DESCRIPTION	PROJECT MANG	OFFICE SUP.	COMP EDITOR	CARTO STEREO	CARTO CADD	CARTO DRAFT	
1	PROJECT SURVEYOR	56						
ESTIMATE BY:		56						
DATE: 9/8/89								

NPS Form 107
APR 79 (Rev)

FIG. 11-13. (Sheet 5 of 7)

BACK-UP DATA TO (A-E PROPOSAL) (GOVERNMENT ESTIMATE)					DATE 9/8/89		PAGE 4 OF 5	

JOB TITLE:	SPECIFY
	☐ CONCEPT ☐ FINAL
REMARKS:	☐ PRELIMINARY ☐ REPORT

LIST OF DRAWINGS/ACTIVITIES (MANHOURS) (MAN DAYS)

NO.	DESCRIPTION	PROJECT MANG	OFFICE SUP.	COMP EDITOR	CARTO STEREO	CARTO CADD	CARTO DRAFT	
	REVIEW & PLAN	2	5	3				
	FILE DEV. FROM AERIAL PHOTO							
	SET UP MACROS							
	COMPILE	7	35		560			
	CHECK PLOTS		2	2		21		
	EDIT		18			230		
	TRANSLATE			15				
	FILE DEV FROM EXISTING FILES							
	SET UP							
	APPROACH ZONE		2	4		16		
	TEXT DEV.		2	4		68		
	MAP SYMBOLS							
	TRANSFER & MERGE			8				

ESTIMATE BY:	
DATE:	

NPS Form 107
APR 79 (Rev)

FIG. 11-13. (Sheet 6 of 7)

| | BACK-UP DATA TO (A-E PROPOSAL) (GOVERNMENT ESTIMATE) | DATE | | PAGE 5 OF 5 |

					SPECIFY			
JOB TITLE:					☐ CONCEPT		☐ FINAL	
REMARKS:					☐ PRELIMINARY		☐ REPORT	

LIST OF DRAWINGS/ACTIVITIES (MANHOURS) (MAN DAYS)

NO.	DESCRIPTION	PROJECT MANG	OFFICE SUP.	COMP EDITOR	CARTO STEREO	CARTO CADD	CARTO DRAFT	
	PRE FINAL SUB							
	PLOTS		2	2		21		
	REVIEW		1				7	
	BLUELINES						3	
	COPY TO DISK			3				
	FINAL SUB							
	EDIT	3	7	8		43		
	CHECK PLOTS		2	2		21		
	COPY TO DISK			4				
	DOCUMENTATION			3				
ESTIMATE BY:								
DATE:								

NPS Form 107
APR 79 (Rev)

FIG. 11-13. (Sheet 7 of 7)

ARCHITECT-ENGINEER
PROFIT FACTOR DETERMINATION
EFARS 15.902(b) 88FEB04

PROJECT _FORT LEWIS MASTER PLAN AUTOMATION_

RFP No. _____ PREPARATION DATE: _8/8/89_

A/E FIRM _____ PREPARED BY: _D HART_

FACTOR	RATE	X	WEIGHT	=	VALUE
DEGREE OF RISK (no risk .07 to high risk .15)	25		0.07		1.75
RELATIVE DIFFICULTY OF WORK (simple work .07 to most complex .15)	20		0.11		2.20
SIZE OF JOB $50K———$500K———$1MIL .15————.09————.07	15		0.15		2.25
PERIOD OF PERFORMANCE DAYS 60 / 90 / 120 / 150 / 180 .07——.90——.11——.13——.15 (NOTE: On modifications, apply <u>no</u> weight where additional time is not required)	20		0.13		2.60
ARCHITECT-ENGINEER'S INVESTMENT (below avg .07 to above avg .15)	5		0.07		0.35
ASSISTANCE BY GOVERNMENT (much assist .07 to little assist .15)	5		0.07		0.35
SUBCONTRACTING % of subcontracting 0% / 20% / 40% / 60% / 80% .15——.13——.11——.09——.07	10		0.07		0.70

<div align="center">

100%

PROFIT ALLOWANCE - - - - - - - - - - 10.20

</div>

Based on the circumstances of this procurement action, each of the above
factors shall be weighted from .07 to .15 as indicated on reverse. The value
shall be obtained by multiplying the rate by the weight. The value column
when totalled indicates the fair and reasonable profit percentage under the
circumstances of this particular procurement.

9230s

FIG. 11-14. Weighted Guideline Profit Computation

CENPS-EN-SY (117-2-4a) 12 September 1989

MEMO FOR: RECORD

SUBJECT: Record of Negotiation for Work Order , Contract
 Surveying and Mapping Support Services in Washington and Oregon

1. Request for proposal was issued August 31, 1989, to the firm
 , to submit a proposal for Work Order . Work Order is
for Master Plan Automation, 1"=40' Mapping, Fort Lewis, Washington.

2. The Government estimate in the amount of $46,275.60, was approved on
September 7, 1989.

3. , proposal dated September 8, 1989, in the
amount of $47,706.83, was 3% above the Government estimate.

4. The following is a comparison of the Contractor's proposal and the
Government estimate:

DISCIPLINE	CONTRACTOR	GOVERNMENT	DIFFERENCE
Project Manager	56 Hrs	56 Hrs	0 Hrs
Project Manager	15 Hrs	18 Hrs	-3 Hrs
Office Supervisor	73 Hrs	70 Hrs	+3 Hrs
CADD Operator	420 Hrs	395 Hrs	+25 Hrs
Stereoplotter Operator	560 Hrs	550 Hrs	+10 Hrs
Computer Editor	58 Hrs	52 Hrs	+6 Hrs
Draftsman	10 Hrs	12 Hrs	-2 Hrs
Overhead	121%	121%	0
Overhead	198%	198%	0
Profit	10.2%	10%	+0.2%
Profit	10%	10%	0
Material & Supplies	$413	$475	-$62

 5. Telephone negotiations were held on September 11, 1989, between Kenneth
Graybeal, Project Manager, representing the Government and
Project Manager, representing the firm
The following areas were discussed:

 a. The Government questioned the number of hours proposed for the
stereoplotter and the CADD operators. The Contractor stated that the required
mapping will be tying into existing mapping performed by the Corps of
Engineers (COE). This will require the Contractor to convert COE data files
to reside on his computer. Also, the stereoplotter operator will require more
time to match existing buildings, roads, contours, etc. The Government agrees
and the hours as proposed are acceptable. The Government will revise its
estimate.

FIG. 11-15. Record of Negotiation (Continued)

b. The hours as proposed for the project manager , office supervisor, computer editor and draftsman are acceptable.

c. Contractor's overhead rates , 121%) and , 198%) are as negotiated in the basic contract.

d. The Government calculated profit at 10% for and calculated profit at 10.2% and calculated profit at 10%. This is acceptable.

e. The Contractor's proposal for materials and supplies is acceptable.

f. Due to the Contractor's present workload, which includes COE Work Order No. 3, 4, and 6, the Contractor has asked for what amounts to an extension of the schedule and delivery dates. The Contractor's anticipated start date would be 1 January 1990, with an extension of the prefinal submittal from 90 days to 105 days, review comments from 105 days to 120 days and the final submittal from 125 days to 135 days. The Government agrees that the Contractor is saturated with work and has no option but to grant an extension.

6. The Contractor's proposal of $47,706.83 compares favorably with the revised Government estimate of $47,849.67.

9. Based on the above evaluation and discussions with the Contractor, his proposal is considered fair and reasonable and recommended for approval.

KENNETH D. GRAYBEAL

FIG. 11-15. (Concluded)

CENPS-EN-SY 16 May 1990

MEMORANDUM FOR Commander, Little Rock District, ATTN: CESWL-ED-PM (Mike Marlow)

SUBJECT: Pine Bluff Arsenal Master Planning, Production of Base Maps

Transmitting herewith are project specifications and the final cost estimate for subject project. Please call me on FTS 446-3535 if you have any questions.

FOR THE COMMANDER:

JOHN P. ERLANDSON
Chief, Survey Branch

CF w/encl:
CESWF-ED-GS (Anderson)

FIG. 11-16. USACE In-House Cost Proposal, Pine Bluff Arsenal Master Planning (Courtesy of U.S. Army Engineer District, Seattle) (Sheet 1 of 5)

CENPS-EN-SY 16 May 1990

PROJECT SPECIFICATIONS

1. **PROJECT**: Pine Bluff Arsenal

2. **LOCATION**: Pine Bluff, Arkansas

3. **GENERAL**: Prepare nine (9) general site maps in digital format from aerial photography provided by the Little Rock District. Work includes aerotriangulation, stereo compilation, stereoplotter to CADD data conversion and final map preparation on CADD.

4. **DETAILED SPECIFICATIONS**:

 a. Graphic System; All work will be collected in graphic or nongraphic data files that are fully compatible and operational on an Intergraph computer system. Standards including format, size, layout, level assignments and symbology will be as described in the CADD Master Planning Data Base Plan and Users Manual developed by Mid States Engineering, Inc., for EUD unless otherwise modified by the Little Rock District.

 b. Sheet Configuration; The sheet layout will be identical to existing general site maps.

 c. Grid; All mapping will be performed in the Arkansas State Plane Coordinate System, South Zone, NAD 83.

 d. Map Scale and Contour Interval; Map data will be collected from 103 stereomodels using accepted standards, procedures and equipment. This data will be used to produce nine (9) general site maps at 1'=400' having a 2-foot contour interval. The contours will be solid in open areas and dashed in areas of uncertainty or heavy canopy. Density of spot elevations will be somewhat greater than shown on existing maps. No spots will be placed on roads or road intersections.

 e. Map Limits; Mapping limits will be the same as the limits shown on the existing general site maps provided by the Little Rock District.

 f. Map Planimetry; Maps will include all paved and unpaved roads, bridges, railroads, buildings and other structures, drainage, visible fence lines, power poles, culverts and manholes, and groups of trees or vegetation. In addition, maps will include the project boundary, building numbers, street/road/railroad names, and other appropriate text shown on existing maps.

 g. Border and Margin Data; This data which includes title block, legend, sheet index, scale, north arrow, notes, etc. will be prepared and shown on each sheet in accordance with guidance in TB ENG 353, 'Installation Master Planning Preparation' and examples provided by the Little Rock District.

5. **RESPONSIBILITIES**: Responsibility/assignment for each participant are as

FIG. 11-16. (Sheet 2 of 5)

follows:

 a. Little Rock District; Program and project management, funding, field surveys, aerial photography, diapositives, Seed files, file structure and product review.

 b. Fort Worth District; Aerotriangulation and stereo compilation.

 c. Seattle District; Project execution, coordination, stereo compilation, contract support, map data assembly and preparation of final map products.

6. <u>SUBMITTALS</u>:

 a. Prefinal Submittal, This will consist of one (1) set of check prints.

 b. Final Submittal, Final maps and data files will contain all revisions resulting from Little Rock District review comments on the prefinal submittal. Final submittal will consist of one (1) set of prints and data tapes and all other material furnished by the Little Rock District.

7. <u>SCHEDULE AND DELIVERY</u>: Assuming aerotriangulation is successfully completed no later than 15 June 1990 and there are no unforseen problems during compilation the prefinal and final submittal dates will be as follows:

Submittal	Schedule
Prefinal Submittal	1 Sept 1990
Review Comments	15 Sept 1990
Final Submittal	1 Oct 1990

FIG. 11-16. (Sheet 3 of 5)

CENPS-EN-SY 16 May 1990

PINE BLUFF ARSENAL, AR

WORK ITEM DESCRIPTION

1. PLANNING AND COORDINATION:

Participate with SWL and SWF, as necessary, in the preparation of scope of work, cost estimate, progress reports, etc.

2. AEROTRIANGULATION:

Using fully analytical methods, establish sufficient photo control to perform stereo compilation. Includes pugging and measuring about 125 photographs and the final adjustment.

3. STEREO COMPILATION:

Compile from 103 stereo models all planimetry and topography within the boundaries of the installation. All data will be digitized into appropriate layers per EUD Standards or SWL substitute.

4. DATA CONVERSION:

Convert stereoplotter data files to Intergraph Design files.

5. CADD:

Work includes cartographic editing, annotation, edge matching, blocking-out sheets, adding borders, grid, title block data and all other information required by SWL.

6. FINAL EDIT:

Work includes final corrections to maps following NPS and SWL review.

7. SR&A:

Supervision, review and administration of A-E contract.

FIG. 11-16. (Sheet 4 of 5)

PROJECT WORK ITEM ESTIMATE

FY: 90

Section: LD PHOTO/MAPPING Work Item: COST ESTIMATE FY91
BRANCH: SURVEY

pg 1 of 1 pgs

Project No.
Project Title: PINE BLUFF ARSENAL, PHOTOGRAMMETRIC UTILITY TIES

```
 (1)          (2) |  (3)  |  (4)  |  (5) |  (6)   | (7)   | (8)   | (9)   | (10)  | (11)  | (12)  | (13)  | (14)  | (15)   | (16)    | (17)
              *         Direct Labor  $    Subtotal  Sect   Branch  Total   Other  Contract Indirect Total  Overhead LINE ITEM          LINE ITEM
Phase/Task    * Act    STEREO COMP/EDT CADD Direct  Sect   Branch  Direct  Direct  2544s   *        Dir&Ind  *       *SUBTOTAL Contingency *TOTAL*
              * No.    $176   $196   $154  Labor   S&A %  S&A %   Labor   Expense POs             *Dir&Ind* 24%                           *
                                                   10%    12%                       73%                            *
-----------------------------------------------------------------------------------------------------------------------------------------------------
SECTION TOTAL * |M-Days|136.00|35.00 |32.00|203.00 |20.30 |26.57 |249.87 |*******|*******|*******|*******|*******|249.87  |********* |249.87 *
              * | $    |23936 |6860  |4928 |35724  |3572  |4676  |43973  | 2000  | 0    *|32188 *|78161 *|10465 *|88626   |$$$    0 *|88626  *
              *                                                                                                                                *
PAGE TOTAL    * |M-Days|136.00|35.00 |32.00|203.00 |20.30 |26.57 |249.87 |*******|*******|*******|*******|*******|249.87  |********* |249.87 *
              * | $    |23936 |6860  |4928 |35724  |3572  |4676  |43973  | 2000  | 0    *|32188 *|78161 *|10465 *|88626   |$$$    0 *|88626  *
=====================================================================================================================================================
STEREO COMPLIE* |M-Days|136.00|0.00  |0.00 |136.00 |13.60 |17.80 |167.40 |*******|*******|*******|*******|*******|167.40  |0%  0.00 *|167.40 *
172 MODELS    * | $    |23936 |0     |0    |23936  |2394  |3133  |29463  | 0     | 0    *|21567 *|51030 *|7012  *|58042   |$$$    0 *|58042  *
              *                                                                                                                                *
COMPUTER EDITOR |M-Days|0.00  |35.00 |0.00 |35.00  |3.50  |4.58  |43.08  |*******|*******|*******|*******|*******|43.08   |0%  0.00 *|43.08  *
ADJ A.T./FILES/EDIT| $ |0     |6860  |0    |6860   |686   |898   |8444   | 0     | 0    *|6181  *|14625 *|2010  *|16635   |$$$    0 *|16635  *
              *                                                                                                                                *
CADD OPERATOR * |M-Days|0.00  |0.00  |32.00|32.00  |3.20  |4.19  |39.39  |*******|*******|*******|*******|*******|39.39   |0%  0.00 *|39.39  *
FINAL FILES   * | $    |0     |0     |4928 |4928   |492.80|645   |6066   | 0     | 0    *|4440  *|10506 *|1444  *|11950   |$$$    0 *|11950  *
              *                                                                                                                                *
DIAPOSITIVES  * |M-Days|0.00  |0.00  |0.00 |0.00   |0.00  |0.00  |0.00   |*******|*******|*******|*******|*******|0.00    |0%  0.00 *|0.00   *
COLOR         * | $    |0     |0     |0    |0      |0.00  |0.00  |0.00   | 2000  | 0    *|0     *|2000  *|0     *|0       |$$$    0 *|2000   *
              *                                                                                                                                *
              * |M-Days|0.00  |0.00  |0.00 |0.00   |0.00  |0.00  |0.00   |*******|*******|*******|*******|*******|0.00    |0%  0.00 *|0.00   *
              * | $    |0     |0     |0    |0      |0.00  |0.00  |0.00   | 0     | 0    *|0     *|0     *|0     *|0       |$$$    0 *|0      *
              *                                                                                                                                *
              * |M-Days|0.00  |0.00  |0.00 |0.00   |0.00  |0.00  |0.00   |*******|*******|*******|*******|*******|0.00    |0%  0.00 *|0.00   *
              * | $    |0     |0     |0    |0      |0.00  |0.00  |0.00   | 0     | 0    *|0     *|0     *|0     *|0       |$$$    0 *|0      *
              *                                                                                                                                *
              * |M-Days|0.00  |0.00  |0.00 |0.00   |0.00  |0.00  |0.00   |*******|*******|*******|*******|*******|0.00    |0%  0.00 *|0.00   *
              * | $    |0     |0     |0    |0      |0.00  |0.00  |0.00   | 0     | 0    *|0     *|0     *|0     *|0       |$$$    0 *|0      *
              *                                                                                                                                *
              * |M-Days|0.00  |0.00  |0.00 |0.00   |0.00  |0.00  |0.00   |*******|*******|*******|*******|*******|0.00    |0%  0.00 *|0.00   *
              * | $    |0     |0     |0    |0      |0.00  |0.00  |0.00   | 0     | 0    *|0     *|0     *|0     *|0       |$$$    0 *|0      *
              *                                                                                                                                *
              * |M-Days|0.00  |0.00  |0.00 |0.00   |0.00  |0.00  |0.00   |*******|*******|*******|*******|*******|0.00    |0%  0.00 *|0.00   *
              * | $    |0     |0     |0    |0      |0.00  |0.00  |0.00   | 0     | 0    *|0     *|0     *|0     *|0       |$$$    0 *|0      *
              *                                                                                                                                *
              * |M-Days|0.00  |0.00  |0.00 |0.00   |0.00  |0.00  |0.00   |*******|*******|*******|*******|*******|0.00    |0%  0.00 *|0.00   *
              * | $    |0     |0     |0    |0      |0.00  |0.00  |0.00   | 0     | 0    *|0     *|0     *|0     *|0       |$$$    0 *|0      *
```

FIG. 11-16. (Sheet 5 of 5)

APPENDIX A

REFERENCES

A-1. REQUIRED PUBLICATIONS.

Note: References used in this EM are available on interlibrary loan from the Research Library, ATTN: CEWES-IM-MI-R, U.S. Army Engineer Waterways Experiment Station, 3909 Halls Ferry Road, Vicksburg, MS 39180-6199.

Public Law 92-582 Public Law 92-582 (86 STAT 1278), "Public Buildings—Selection of Architects and Engineers"

Engineer Federal Acquisition Regulation Supplement 15 Engineer Federal Acquisition Regulation Supplement 15

ER 405-1-12 Real Estate Handbook

ER 1110-345-710 Drawings

EM 1110-1-1002 Survey Markers and Monumentation

EM 1110-1-1003 NAVSTAR GPS Surveying

EM 1110-1-1807 Standards Manual for U.S. Army Corps of Engineers Computer-Aided Design and Drafting (CADD) Systems.

EM 1110-2-1908 Instrumentation of Earth and Rock Fill Dams (Earth-Movement and Pressure Measuring Devices) (Part 2)

EM 1110-2-4300 Instrumentation for Concrete Structures

American National Standards Institute 1980 American National Standards Institute. 1980. "American National Standard Engineering Drawing and Related Documentation Practices; *Drawing Sheet Size and Format*," ANSI Y14.1, New York.

American Society for Photogrammetry and Remote Sensing 1990 American Society for Photogrammetry and Remote Sensing. 1990. "ASPRS Accuracy Standards for Large-Scale Maps," *Photogrammetric Engineering and Remote Sensing*, Vol 56, No. 7, pp 1068–1070.

American Society of Photogrammetry 1980 American Society of Photogrammetry. 1980. "Manual of Photogrammetry," 4th ed., Chester C. Slama, ed., Falls Church, VA.

Bureau of the Budget 1947 Bureau of the Budget. 1947 (17 June). "United States National Map Accuracy Standards," Office of Management and Budget, Washington, DC.

Federal Geodetic Control Committee 1984 Federal Geodetic Control Committee. 1984. "Standards and Specifications for Geodetic Control Networks," National Oceanic and Atmospheric Administration, Rockville, MD.

Miller 1985 Miller, A. E. 1985. "Surveying and Mapping Manual," U.S. Department of Transportation, Federal Highway Administration, Washington, DC.

Photogrammetry for Highways Committee 1968 Photogrammetry for Highways Committee. 1968. "Reference Guide Outline: Specifications for Aerial Surveys and Mapping by Photogrammetric Methods for Highways," U.S. Department of Transportation, Washington, DC.

U.S. National Cartographic Standards for Spatial Accuracy U.S. National Cartographic Standards for Spatial Accuracy. U.S. Department of Interior, U.S. Geological Survey, Washington, DC.

A-2. RELATED PUBLICATIONS.

Blank 1980 Blank, Leland. 1980. *Statistical Procedures for Engineering, Management, and Science.* McGraw-Hill, New York.

Federal Emergency Management Agency 1991 Federal Emergency Management Agency. 1991. "Guidelines and Specifications for Study Contractors, Flood Insurance Study," FEMA 37, Washington, DC.

Graham and Read 1986 Graham, Ron, and Read, Roger E. 1986. "Manual of Aerial Photography," Focal Press, London and Boston.

Headquarters, Department of the Army 1958 Headquarters, Department of the Army. 1958. "Universal Transverse Mercator Grid," Technical Manual 5-241-8, U.S. Government Printing Office, Washington, DC.

Karara 1979 Karara, H. M., ed. 1979. "Handbook of Non-Topographic Photogrammetry," 2d ed.,

American Society of Photogrammetry, Falls Church, VA.

Large-Scale Mapping Guidelines 1986
Large-Scale Mapping Guidelines. 1986. USGS Open-File Report 86-005, United States Department of the Interior, U.S. Geological Survey, National Mapping Division, Reston, VA.

Leick 1990 Leick, Alfred. 1990. *GPS Satellite Surveying.* John Wiley and Sons, New York.

Mikhail 1976 Mikhail, E. M. 1976. *Observations and Least Squares.* IEP-Dun-Donnelley Publisher, New York.

Moffitt and Mikhail 1980 Moffitt, F. H., and Mikhail, E. M. 1980. *Photogrammetry,* 3d ed., Harper and Row, New York.

Schwarz 1989 Schwarz, Charles R., ed. 1989. *North American Datum of 1983.* NOAA Professional Paper NOS 2, U.S. Department of Commerce, Rockville, MD.

Snyder 1982 Snyder, J. P. 1982. "Map Projections Used by the U.S. Geological Survey," U.S. Geological Survey Bulletin 1532, U.S. Government Printing Office, Washington, DC.

Soler and Hothem 1988 Soler, T., and Hothem, L. D. 1988. "Coordinate Systems Used in Geodesy: Basic Definitions and Concepts," *Journal of Surveying Engineering, American Society of Civil Engineers,* Vol 114, No.2, pp 84-97.

Soler and Hothem 1989 Soler, T., and Hothem, L. D. 1989. "Important Parameters Used in Geodetic Transformations," *Journal of Surveying Engineering, American Society of Civil Engineers,* Vol 115, No. 4, pp 414–417.

Stem 1989 Stem, J. E. 1989. "The State Plane Coordinate System of 1983," NOAA Manual NOS NGS 5, National Oceanic and Atmospheric Administration, Rockville, MD.

Wolf 1983 Wolf, P. R. 1983. *Elements of Photogrammetry.* 2d ed., McGraw-Hill, Inc., New York.

APPENDIX B

GLOSSARY

B-1. NOTATION.

a = Distance accuracy denominator

b = Elevation difference accuracy ratio

B = The air distance between consecutive exposure stations; air base between exposures in a strip of photographs

d = Distance between survey points; distance between control points in kilometers measured along the level route; photograph image distance; image displacement; negative format dimension

D = Density; ground dimension of a central panel of a target; horizontal ground distance

$D\text{-}min$ = Minimum density

$D\text{-}max$ = Maximum density

E_{lap} = Required photo end lap

f = Camera focal length

g = Gradient

G = Ground coverage of one side of a square format photograph

h = Elevation above datum of the point

h_{ave} = Average ground elevation in a photograph

h_{base} = Elevation at the object base above datum

h_p = Ground elevation of point p

ht = Vertical height of an object

H = The flight height above mean ground height

m_{ij} = Nine direction cosines expressing the angular orientation

N = Geoid separation above an ellipsoid

p = Parallax; photo width

P_a = Parallax of the image point

r = Radial distance from the principal point to the image point

s = Propagated standard deviation of distance between survey points obtained from a weighted and minimally constrained least squares adjustment

S = Photographic scale at a point

S_{ave} = Average photographic scale

S_{lap} = Required side lap

t = Photo tilt angle

W = The ground distance between adjacent flight lines

y' = Auxiliary photocoordinate

x,y = Photocoordinates

x_o,y_o = Principal point photocoordinates

x_p,y_p = Photocoordinates of point p

X,Y = Horizontal ground coordinates

X,Y,Z = Ground point coordinates

X_L,Y_L,Z_L = Exposure station coordinates

X_p,Y_p = Ground coordinates of point p

ω,ϕ,κ = System defining angular rotation in a photograph in which ω is a rotation about the x photographic axis, ϕ is about the y-axis and κ is about the z-axis

B-2. ABBREVIATIONS.

A-E = Architect-Engineer

AM/FM = Automated Mapping/Facility Management

ANSI = American National Standards Institute

ASP = American Society of Photogrammetry

ASPRS = American Society for Photogrammetry and Remote Sensing

AWAR = Area Weighted Average Resolution

CADD = Computer-aided design and drafting

CF = Contour factor

CI = Contour interval

CONUS = Continental United States

COR = Contracting Officer's Representative

CRT = Cathode-ray tube

CW = Civil Works

DEM = Digital Elevation Modeling

DOT = US Department of Transportation

DTM = Digital Terrain Model

EDM = Electronic distance measurement

F-hgt = Flight height

FAA = Federal Aviation Administration

FGCC = Federal Geodetic Control Committee

G&A = General and Administrative Overhead

GIS = Geographic Information System

GPS = Global Positioning System

IDT = Indefinite delivery type

IGE = Independent Government Estimate

JTR = Jcount Travel Regulations

LIS = Land Information System

MGE = Mean ground elevation

NAD 27 = North American Datum of 1927 (for additional information, see *Datum* in paragraph B-3)

NAD 83 = North American Datum of 1983 (for additional information, see *Datum* in paragraph B-3)

NDVD 88 = North American Vertical Datum of 1988 (for additional information, see *Datum* in paragraph B-3)

NGRS = National Geodetic Reference System

NGVD 29 = National Geodetic Vertical Datum of 1929 (for additional information, see *Datum* in paragraph B-3)

NGS = National Geodetic Survey

OCONUS = Outside the continental United States

ODC = Other Direct Charges

OMB = Office of Management and Budget

QA = Quality assurance

QC = Quality control

QUAN = Quantity

RMSE = Root mean square error

SI = International System of Units

SPCS = State Plane Coordinate System

TIN = Triangulated irregular network

U/M = Unit measure

U/P = Unit price

USACE = U.S. Army Corps of Engineers

USGS = U.S. Geological Survey

USNMAS = U.S. National Map Accuracy Standards

UTM = Universal Transverse Mercator

B-3. TERMS.

Accuracy Degree of conformity with a standard. Accuracy relates to the quality of a result and is distinguished from precision, which relates to the quality of the operation by which the result is obtained.

Adjustment Process designed to minimize inconsistencies in measured or computed quantities by applying derived corrections to compensate for random or accidental errors.

Aerotriangulation (or Bridging) The process of developing a network of horizontal and/or vertical positions from a group of known positions using direct or indirect measurements from aerial photographs and mathematical computations.

Air Base The line segment, or length of the line segment, joining two adjacent camera stations.

Analytical Stereoplotter A stereoplotter in which the three-dimensional model is formed mathematically by a computer or a microprocessor.

Antivignetting Filter A filter used with wide-angle photography to produce uniform lighting over the whole photograph.

Azimuth Horizontal direction reckoned clockwise from the meridian plane.

Basic Control A survey over the entire extent of a project that establishes monumented points of

known horizontal position and monumented points of known elevation.

Bench Mark Relatively permanent material object, natural or artificial, bearing a marked point whose elevation above or below an adopted datum is known.

Between-the-Lens Shutter A shutter located between the elements of a camera lens.

Cadastral Pertaining to extent, value, and ownership of land. Cadastral maps show property corners and property lines.

Calibration Plate A glass photographic plate exposed in the aerial camera and developed to give a record of the relative positions of the fiducial marks (also called flash plate).

Camera Axis A line through the camera rear nodal point, perpendicular to the film plane.

Camera Station The point in space where the forward node of the camera lens was located at the instant the photographic exposure was made.

cartography Science and art of making maps and charts. The term may be taken broadly as comprising all the steps needed to produce a map: planning, aerial photography, field surveys, photogrammetry, editing, color separation, and multicolor printing.

C-factor Empirical ratio between flight height and contour interval used to indicate the capability of photogrammetric systems. (C-factor multiplied by contour interval desired equals flight height of aerial photography.) C-factor, unless otherwise indicated, is based on the use of 6-in. focal length lenses with a 9- by 9-in. film format.

Color Separation Process of preparing a separate drawing, engraving, or negative for each color required in the printing production of a map or chart.

Comparator A precise instrument that measures two-dimensional coordinates on a plane (usually a photograph).

Compilation Process of drafting a new or revised map or chart, or portion thereof, from existing maps, aerial photographs, field surveys, and other sources.

Contact A method of making copies of photography in which the photography is placed in contact with the photosensitive material during exposure, producing a copy of exactly the same size as the original.

Contour Imaginary line on the ground, all points of which are at the same elevation above or below a specified datum.

Contour Interval (CI) Difference in elevation between two adjacent contours.

Contouring Factor The ratio of the flight height to the smallest contour interval that a photogrammetric system can consistently map to specification accuracy (also called C-factor).

Contrast The difference between the densities of the lightest and the darkest areas of a photograph.

Control, Mapping Points of established position or elevation, or both, used as fixed references in positioning and correlating map features. Fundamental control is provided by stations in the national networks of triangulation and traverse (horizontal control) and leveling (vertical control). Usually it is necessary to extend geodetic surveys, based on the fundamental stations, over the area to be mapped to provide a suitable density and distribution of control points.

Supplemental control points are those needed to relate the aerial photographs used for mapping with the system of ground control. These points must be positively photoidentified; that is, the points on the ground must be positively correlated with their images on the photographs.

Control Station Point on the ground whose position (horizontal or vertical) is known and can be used as a base for additional survey work.

Coordinates Linear and/or angular quantities that designate the position of a point relative to a given reference frame.

Coordinates, Origin of Point in a system of coordinates that serves as a zero point in computing the system elements or in prescribing its use.

Cover In mapping, vegetation over the terrain.

Crab (Aerial Photography) The condition caused by failure to orient the camera with respect to the track of the airplane. In vertical photography, crab is indicated by the edges of the photographs not being parallel to the ground track of the aircraft.

Culture Features constructed by man under, on, or above the ground that are delineated on a map. These include roads, trails, buildings, canals, and sewer systems. In a broad sense, the term also applies to all names, other identification, and legends on a map.

Datum (Plural Datums) In surveying, a reference system for computing or correlating the results of surveys. There are two principal types of datums: vertical and horizontal. A vertical datum is a level surface to which heights are referred. In the United States, the generally adopted vertical datum for leveling operations is the National Geodetic Vertical Datum of 1929. The horizontal datum, used as a

reference for position, is defined by the latitude and longitude of an initial point, the direction of a line between this point and a specified second point, and two dimensions that define the spheroid.

Datum, National Geodetic Vertical See National Geodetic Vertical Datum of 1929.

Deflection of the Vertical At any point, the deviation of the vertical (plumb line) from the normal to the spheroid.

Develop Subject an exposed photographic material to proper chemical solutions to change the latent image to a visible image.

Diapositive A positive transparency for use in a precision photogrammetric instrument.

Diazo Process Rapid and inexpensive method for reproducing documents.

Displacement Any shift in the position of an image on a photograph due to tilt during photography, scale changes in the photographs, and relief of the area photographed.

Displacement Due to Relief An essential characteristic of vertical aerial photography that causes high terrain points to appear farther from the center and low points to appear closer to the center of the photograph than would the map positions of the points.

Distortion A lens aberration that causes a difference between the position of any part of the image and its theoretically correct position.

Dodging Selectively shading or masking a portion of a photograph while making a copy, to reduce extremes of contrast. Automatic dodging selectively varies illumination over the photograph in proportion to the average density of each area on the photography.

Doppler Effect An apparent change in frequency of a signal due to relative motion between the source and the point of observation.

Double Projection Stereoplotter A stereoplotter in which the three-dimensional model is formed optically by projecting portions of the two photographs into the model space.

Easting In a plane coordinate system, the coordinate that varies in a general east-west direction, increasing to the east.

Electronic Distance Measuring (EDM) Devices Instruments that measure the phase difference between transmitted and reflected or retransmitted electromagnetic waves of known frequency, or that measure the round-trip transit time of a pulsed signal, from which distance is computed.

Elevation Vertical distance of a point above or below a reference surface or datum.

Emulsion Suspension of a light-sensitive silver salt (especially silver chloride or silver bromide) in a colloidal medium (usually gelatin), which is used for coating photographic films, plates, and papers. Types of photographic emulsions commonly used are panchromatic (black and white), color negative, color positive, color infrared, and black-and-white infrared.

End Lap Overlap of any two successive photographs in the direction of the flight line. Also called forward overlap.

Extraterrestrial Surveying System A surveying system using radio signals from satellites that are received by receivers on monumented points and processed by computers to determine geodetic coordinates (longitude, latitude, and height above spheroid) of the occupied point. The two extraterrestrial surveying systems discussed in this manual are the Satellite Doppler System and the Global Positioning System.

Feature Separation Process of preparing a separate drawing, engraving, or negative for selected types of data in the preparation of a map or chart.

Fiducial Marks Reference marks formed on photography by marks held in a fixed relationship to the camera lens. The intersection of the lines connecting opposite fiducial marks usually defines the principal point of the photograph.

Fix Render a developed photographic image permanent by chemical solutions that remove unaffected light-sensitive material.

Flash Plate See *Calibration Plate*.

Flight Altitude The vertical distance of the aircraft above mean sea level.

Flight Height The vertical distance from average terrain elevation to the point from which an aerial photograph is taken.

Flight Line A line on the ground, on a map, or on vertical aerial photography designating the path along which the aircraft is to fly when photographing.

Flight Plan All factors related to aircraft and camera operation contributing to producing suitable photography. A flight plan includes flight altitude, flight lines, and photograph spacing.

Focal Length The distance from the rear nodal point of a lens to the plane on which the lens causes parallel rays of light to converge.

Fog (Photographic) The visual reduction in light transmission caused by the base material (usually

polyester) of the film plus the unexposed emulsion of the photographic medium.

Geodesy Science concerned with the measurement and mathematical description of the size and shape of the earth and its gravitational field. Geodesy also includes the large-scale extended surveys for determining positions and elevations of points, in which the size and shape of the earth must be taken into account.

Geodetic Coordinates The position of a point described by latitude, longitude, and height above the ellipsoid.

Geodetic Survey A survey that considers the surface of the earth to be curved.

Geoid An equipotential surface coinciding with mean sea level for the oceans and extended in land areas so the surface is always perpendicular to the direction of gravity.

Graticule Network of parallels and meridians on a map or chart.

Grid Network of uniformly spaced parallel straight lines intersecting at right angles. When superimposed on a map, it usually carries the name of the projection used for the map—that is, Lambert grid, transverse Mercator grid, universal transverse Mercator grid. However, care must be taken not to confuse a projection grid with the underlying network of geographic meridians and parallels (i.e., graticule) generated by the projection.

Halftone A picture in which the gradation of light is obtained by the relative darkness and density of tiny dots produced by photographing the subject through a fine screen.

Imagery Visible representation of objects and/or phenomena as sensed or detected by cameras, infrared and multispectral scanners, radar, and photometers. Recording may be on photographic emulsion (directly as in a camera or indirectly after being first recorded on magnetic tape as an electrical signal) or on magnetic tape for subsequent conversion and display on a cathode-ray tube.

Inertial Surveying A total surveying instrumentation package using accelerometers, gyroscopes, and a computer to sense, compute, and record the three-dimensional position of the instrument as it is moved from point to point.

Interpretation The result of stereoscopic examination of aerial photography augmented by other imagery to obtain qualitative information about the terrain, cover, and culture that might influence the location of a highway.

Intervalometer A device that operates the camera shutter at a selected interval of time.

Latitude Angular distance, in degrees, minutes, and seconds, of a point north or south of the equator.

Lens Distortion Lens aberration shifting the position of images off the axis causing objects at different angular distances from the axis to undergo different magnifications.

Leveling Surveying operation in which elevations of objects and points are determined relative to a specified datum.

Line Copy (Line Drawing) Map copy suitable for reproduction without the use of a screen; a drawing composed of lines as distinguished from continuous-tone copy.

Longitude Angular distance, in degrees, minutes, and seconds, of a point east or west of the Greenwich meridian.

Magazine The part of an aerial camera that holds the film and includes the mechanism for advancing the film.

Map Graphic representation of the physical features (natural, artificial, or both) of a part or the whole of the earth's surface, by means of signs and symbols or photographic imagery, at an established scale, on a specified projection, and with the means of orientation indicated.

Map, Engineering Map showing information that is essential for planning an engineering project or development and for estimating its cost. It usually is a large-scale map of a small area or of a route. It may be entirely the product of an engineering survey, or reliable information may be collected from various sources for the purpose, and assembled on a base map.

Map, Flood Control Map designed for studying and planning flood control projects in areas subject to flooding.

Map, Hypsographic Map showing relief with elevations referred to a geodetic vertical datum.

Map, Land Use Map showing the various purposes for which parcels of land are being used.

Map, Line Map composed of lines as distinguished from photographic imagery maps.

Map, Orthophotographic Map produced by assembling orthophotographs at a specified uniform scale in a map format.

Map, Planimetric Map that presents only the horizontal positions for features represented; distinguished from a topographic map by the omission of relief in measurable form. The features usually shown on a planimetric map include rivers, lakes, and seas; mountains, valleys, and plains; forest and prairies; cities, farms, transportation routes, and public utility

facilities; and political and private boundary lines. A planimetric map intended for special use may present only those features essential to the purpose to be served.

Map, Thematic Map designed to provide information on a single topic, such as geology, rainfall, population.

Map, Topographic Map that presents the horizontal and vertical positions of the features represented; distinguished from a planimetric map by the addition of relief in measurable form.

Map Projection Orderly system of lines on a plane representing a corresponding system of imaginary lines on an adopted terrestrial or celestial datum surface. Also, the mathematical concept of such a system. For maps of the earth, a projection consists of a graticule of lines representing parallels of latitude and meridians of longitude or a grid.

Map Series Family of maps conforming generally to the same specifications and designed to cover an area or a country in a systematic pattern.

Mean Sea Level The average of the heights of the surface of the sea at all stages of tide.

Meridian A plane curve on the surface of the earth passing through the axis of rotation and any given point on the earth's surface. All points on a given meridian have the same longitude.

Monocomparator A comparator that measures on a single photograph (see *comparator*).

Monument (Surveying) Permanent physical structure marking the location of a survey point. Common types of monuments are inscribed metal tablets set in concrete posts, solid rock, or parts of buildings; distinctive stone posts; and metal rods driven in the ground.

Mosaic An assembly of vertical aerial photographs to form a continuous representation of the terrain covered by the photography.

National Geodetic Vertical Datum of 1929 Reference surface established by the U.S. Coast and Geodetic Survey in 1929 as the datum to which relief features and elevation data are referenced in the conterminous United States; formerly called "mean sea level of 1929."

Nodal Point One of two intangible points in a camera lens that have the characteristic that any ray of light directed to the front nodal point will exit parallel to itself through the rear nodal point.

Northing In a plane coordinate system, the coordinate in a general north-south direction, increasing to the north.

Oblique Photograph A photograph taken with the axis of the camera intentionally directed between vertical and horizontal.

Optical Train Stereoplotter A stereoplotter in which the three-dimensional model is formed mechanically.

Origin of Coordinates Point in a system of coordinates that serves as a zero point in computing the system's elements or in prescribing its use.

Orthophotograph Photograph having the properties of an orthographic projection. It is derived from a conventional perspective photograph by simple or differential rectification so that image displacements and scale differences caused by camera tilt and terrain relief are removed.

Orthophotomap An orthophotograph to which has been added a grid, contour lines, names, and/or other information characteristic of a map but missing on the orthophotograph.

Orthophotomosaic Assembly of orthophotographs forming a uniform-scale mosaic.

Overlap The amount by which one photograph overlaps another, customarily expressed as a percentage. The overlap between aerial photographs in the same flight line is called the end lap, and the overlap between photographs in adjacent parallel flight lines is called the side lap.

Overlay A printing or drawing on a transparent or translucent medium intended to be placed in a register on a base map or other graphic. The overlay depicts information that does not appear on the base or require special emphasis.

Panchromatic A photographic emulsion for black-and-white photography that is sensitive to all colors of the visible spectrum.

Parallax An apparent change in the position of one object with respect to another due to a change in the position of observation.

Pass Point A point whose horizontal and/or vertical position is determined from photographs by photogrammetric methods and is intended for use as a control point in the orientation of the photographs.

Photogrammetry Science or art of obtaining reliable measurements or information from photographs or other sensing systems.

Photography Photographic film, exposed and processed.

Photoindex An assembly of photographs in their proper relative positions, generally annotated and copied at a reduced scale.

Photomap (Photographic Map) Map made by adding marginal information, descriptive data,

and a reference system to a photograph or assembly of photographs.

Plane Coordinate System A system of usually perpendicular lines on a plane surface. Distances from the system to points on the surface represent coordinates.

Plane Survey A survey that treats the surface of the earth as though it were a plane.

Planimetry Plan details of a map—those having no indications of relief or contour.

Platen The flat surface of an aerial camera against which the film is pressed while exposure is made.

Precision The variance of repeated measurements from their average; the degree of refinement with which an operation is performed.

Principal Point The foot of a perpendicular from the rear nodal point of the camera lens to the plane of a photograph.

Print A copy made from a transparency by photographic means.

Process Develop and fix exposed photographic material.

Quadrangle Four-sided area, bounded by parallels of latitude or meridians of longitude used as an area unit in mapping (dimensions are not necessarily the same in both directions).

Rectification, Differential The process of scanning and reprojecting small areas of a photograph onto a plane from different perspectives to remove displacements due to tilt and relief. The process may be accomplished by any one of a number of instruments developed specifically for the purpose.

Rectification, Simple The process of projecting a photograph onto a horizontal plane by means of a rectifier to remove displacements due to tilt of the camera.

Relief Elevation variations of the land or sea bottom.

Representative Fraction Scale of a map or chart expressed as a fraction or ratio that relates unit distance on the map to distance measured in the same unit on the ground.

Root Mean Square Error (RMSE) The square root of the quotient of the sum of the squares of the errors divided by the number of measurements, or

$$RMSE = \sqrt{(\Sigma e^2)}/n$$

in which e is the error at each point (the difference between the value used as a standard and the value being tested), and n is the total number of points tested.

Scale The ratio of the size of the image or representation of an object on a photograph or map to its true size. Scale may be expressed as a representative fraction (as 1/10,000) or ratio (as 1:10,000) or it may be expressed as the number of feet to an inch. Scales are referred to as "large" if the ratio is large (the denominator is small) and as "small" if the ratio is small (the denominator is large).

Scribing Removal of portions of a photographically opaque coating from a transparent base with engraving tools.

Side Lap Overlap of photographs in adjacent (parallel) flight strips.

Spheroid A surface easily defined mathematically that closely represents the geoid. It is produced by rotating an ellipse on its minor axis.

Spot Elevation Point on a map or chart whose height above a specified datum is noted, usually by a dot or a small sawbuck and elevation value. Elevations are shown, on a selective basis, for road forks and intersections, grade crossings, summits of hills, mountains and mountain passes, water surfaces of lakes and ponds, stream forks, bottom elevations in depressions, and large flat areas.

State Plane Coordinate System Coordinate systems established by the U.S. Coast and Geodetic Survey (now the National Ocean Survey), at least one for each State.

Stereocomparator A comparator using the binocular vision of the operator that measures the two photographs on a stereoscopic pair simultaneously (see *comparator*).

Stereocompilation Drafting of a map or chart manuscript from aerial photographs and geodetic control data by means of photogrammetric instruments.

Stereoplotter Instrument for plotting a map by observation of stereomodels formed by pairs of photographs.

Stereoscopic Pertaining to the use of binocular vision for observation of a pair of overlapping photographs or other perspective views, giving the impression of depth.

Supplemental Control Surveys between basic control points to establish the additional points necessary to control the detailed mapping.

Target A contrasting symmetrical pattern placed around a point on the ground to facilitate locating and measuring the image of the point in a photograph.

Target Map Scale The intended design scale of the map or digital data file element.

Tilt For vertical aerial photography, the angular deviation of the camera axis from a vertical line.

Topography Configuration (relief) of the land surface; the graphic delineation or portrayal of that configuration in map form, as by contour lines; in oceanography the term is applied to a surface such as the sea bottom or a surface of given characteristics within the water mass.

Transparency A photograph on a transparent (glass or plastic) base, which can be viewed by transmitted light.

Traverse Sequence of lengths and directions of line segments connecting a series of stations, obtained from field measurements, and used in determining positions of the stations.

Triangulation Method of extending horizontal position of the surface of the earth by measuring the angles of triangles and the included sides of selected triangles.

Trilateration Method of surveying wherein the lengths of the triangle sides are measured, usually by electronic methods, and the angles are computed from the measured lengths.

Universal Transverse Mercator (UTM) Grid Military grid system based on the transverse Mercator projection, applied to maps of the earth's surface extending from the equator to the 84-degree latitudes.

Vertical Photograph A photograph taken with the camera axis directed downward along (or nearly along) a vertical line.

APPENDIX C

COST ESTIMATING PRINCIPLES

C-1. GENERAL

This appendix contains guidance for U.S. Army Corps of Engineers (USACE) project engineers, project managers, or project engineering technicians who are required to develop cost estimates for negotiated qualification-based Architect-Engineer (A-E) contracts.

A. Section I is an overview of basic principles of production-oriented photogrammetry. Although it intentionally duplicates some of the material in the manual, it is presented in a simpler form for those who do not require an in-depth knowledge of photogrammetry. It is also designed for direct use in Proponent-Sponsored Engineer Corps Training (PROSPECT) courses.

B. Section II provides guidance on the elements of estimating costs for all phases of a photogrammetric mapping project. Methods for computing budgetary and detailed cost estimates are presented.

C. Section III presents a series of cost estimate examples for specific military and civil works projects.

D. Section IV provides background on the use of software that can be used to automate the entire estimating process.

SECTION I
OVERVIEW OF PHOTOGRAMMETRY PRINCIPLES

C-2. PHOTOGRAMMETRIC COST ESTIMATING

A. There are two complementary specialties that may require cost estimating when contracted from the private mapping industry: "photogrammetry" and "photo image analysis" (air photo interpretation). Photogrammetric cost estimating is the major concern of this reference, but image analysis also requires aerial photography and, in some situations, photogrammetric mapping. These terms are further defined as follows:

(1) Photogrammetry is the process of creating maps using photographic images. Individuals performing this function are termed photogrammetrists.

(2) Image analysis is the art of interpreting specific criteria from a remotely sensed image. Individuals performing this function are often termed photo analysts.

B. A photogrammetrist must develop a capability to interpret photo image features and relate them to ground culture so that these features can be correctly symbolized by recognizable map features. Also, the photogrammetrist must have some recognition of landforms so that the contours can correctly depict the terrain configuration. Photogrammetrists gain this expertise by translating the photo image into what has been previously observed on the ground during daily routine pursuits. A photogrammetrist produces mapping directly from the photographs by identifying, symbolizing, and compiling cultural features that are visible on the imagery. In addition, contours are drawn in true terrain position. A limited effort is directed toward field checks to determine the quality of the work.

C. Photo analysts also develop the capability to interpret photo image features and relate them to ground culture and landforms so that these features can be studied, inventoried, and related to specific nonphotogrammetric disciplines. For example, a soils specialist may be looking for erodible soils on a proposed highway route; a forester may be estimating the volume of standing trees on a timber tract; an entomologist may be attempting to discern the prevalence of insect infestation in a specific township; an agronomist may be searching for plant disease in specific croplands; an hydrologist may be comparing the degree of suspended matter in several close-grouped lakes; or an engineer may be searching for erosion cuts in levees or breaks in dikes.

D. There is a major difference between the photogrammetrist and the photo analyst. The former uses photos to directly create an end product. The latter uses photos and photo interpretation techniques only as one implement in his toolbox of

procedures to arrive at a product. In comparison, the major portion of a photogrammetrist's efforts is direct use of the photos. Conversely, the analyst's use of the photos may not be his major effort.

E. Photogrammetric job costing is a process that should address several duties or missions:

(1) Project design.

(2) Item costing.

(3) Project scheduling.

In order to estimate photogrammetric costs for a digital mapping or image analysis venture, it is necessary to visualize production procedures that must be accomplished. For that reason, the estimator should design a specific procedural scheme before a cost estimate can be formulated. With a logical project plan in mind, it is possible to estimate man-hour and material needs and apply cost factors. Since hourly labor rates, direct cost rates, overhead, and profit margins vary widely, it is necessary to estimate costs based on a specific production system.

F. Digital mapping projects require three basic operations:

(1) Aerial photography.

(2) Field control surveys.

(3) Collection and editing of digital data.

Projects often demand supplementary functions such as aerotriangulation, orthophotomapping, photographic reproduction products, and supplementary field surveys (outboundaries, cross sections, drill hole locations, utilities information).

G. Some costs are rather straightforward to determine. Once a photo scale is selected to be used in a project, it is relatively easy to calculate the number of photos and apply unit rates for the total cost. Other costs may be rather difficult to determine and will vary from one project site to another, often depending on the ground conditions of the specific project. Many unit item time frames can be estimated only with a fairly thorough understanding of the equipment and production procedures, generally termed "experience." Unfortunately, these difficult items usually form the bulk of the project costs. This is coupled with the fact that most USACE commands cannot afford the time and effort to train experienced photogrammetrists to estimate mapping costs.

H. When estimating a project, it is essential to include every item that could be required. The estimator must include overhead expenses and, when working through a private contractor, a reasonable profit for the contractor.

I. USACE Commands contract most of their photogrammetric work to private contractors. The relationship between the USACE cost estimator and the private contractor should not be adversarial but a cooperative effort to produce a product of legitimate quality for a reasonable price. Both the USACE representative and the private contractor should cooperate toward this end. USACE cost estimators should make a positive effort to visit the map production facilities of private contractors in order to enhance familiarity with state-of-the-art equipment and procedures. Private mapping contractors are deservedly proud to display their facilities and share their technical expertise, especially if it contributes to the collective understanding of project requirements. It is recognized that the USACE cost estimator and a private contractor will not necessarily approach cost estimating on a specific project from a singular perspective. However, if both have a similar understanding of the specifications and a common knowledge of production procedures, their independent cost estimates should provide a basis for negotiating a reasonable fee that will provide a quality product.

J. Before specific cost estimating can be addressed, some practical aerial survey procedures should be examined to provide the less technically experienced cost estimator with the proper level of technical knowledge with regard to issues of practical photogrammetric production. Some of the more basic principles of photogrammetry are outlined in this section.

C-3. RADIANT ENERGY

In order to understand the rudiments of aerial mapping or photo analysis, a basic concept of radiant energy (flux) should be recognized. All forms of radiant energy composing the electromagnetic spectrum travel in waves as illustrated in Fig. C-1. A major characteristic that separates one form of radiance from any other is the wavelength, which is simply the distance traced by the wave during one period of oscillation.

A. Fig. C-2 represents the electromagnetic spectrum showing component energies utilized by

FIG. C-1. Radiant Energy Wave

FIG. C-2. Electromagnetic Spectrum

remote sensing in their relative wavelength range. Note that the human eye sees only that portion denoted as visible light. Keep in mind that this rendition is not in true logarithmic format, so the amount that the eye detects is a very small portion of the flux that is bouncing around the sky at any point in time.

B. Aerial photo projects do not span more than the limited amount of the electromagnetic spectrum shown in Table C-1. Collection of data outside of these wavelengths must be done with some sensor other than a camera.

The portions of the electromagnetic spectrum that interest the aerial mapper and photo analyst are visible light and infrared light.

(1) Visible light. The sun emits solar energy, which beats down upon the earth. Objects on the earth's surface absorb and/or reflect varying amounts of this radiation. A white light source, such as the sun, includes the primary visible colors of blue, green, and red. The visible spectrum spans the 0.4-0.7-μm range. Various colors of the rainbow are blends of the primary physical colors of red, green, and blue. Equal parts of blue, green, and red appear as white light. Absence of all three results in black. A radiant wave will be deflected by colliding with any foreign particle of matter larger than that wavelength. The shorter the wavelength, the more it is scattered by particulate matter in the air. Blue wavelengths are shortest and they ricochet off the most minute particles (gases, dust, and vapor) causing them to skitter all over the sky, while the longer green and red plow on through. This prolific scattering of the shorter waves dominates the sense of vision and compels humans to see blue. But, as the size of the particulate matter increases—caused by smoke, moisture, or dust storms—the longer waves then are deflected. Thus, more of the greens and reds fill the sky.

(2) Infrared. Infrared implies heat radiation.

a. There are two types of heat that will be detectable by specific sensors: thermal and reflected. Refer again to the electromagnetic diagram (Figure C-2) to grasp the relationship of the infrared categories.

b. Thermal. Longer infrared wavelengths are actual temperature radiations emitted from an object. Emitted heat images must be sensed with a thermal scanner, which breaks this information into variable intensity light pulses used to create the photographic image. Since mid-infrared and thermal infrared are not captured by film, these will not be further discussed.

TABLE C-1. Portion of Electromagnetic Spectrum Pertinent to Aerial Photography

Band (1)	Wavelength micrometers (2)
Visible Light	0.4–0.6
Blue	0.5–0.6
Green	0.6–0.7
Near-infrared (Reflected Heat)	0.7–1.0

c. Near-Infrared. Reflected heat refers to the shorter wavelengths and indicates the relative amounts of solar heat that reflect off the molecular composition of the surface of an object. It does not indicate the actual temperature of the mass.

d. Healthy vegetation (whether leaves on trees or bushes, blades of grass, stalks of corn, foliage of soybeans) produces sugar through the photosynthetic process. When this chemical function breaks down, and photosynthesis decreases or stops, the leaf surface takes on a different molecular structure. The amount of infrared reflection differs at these various stages and is seen as different hues, especially with color infrared imagery where healthy vegetation is red and various stages of less vigor result in more subdued pinks.

e. Clean water absorbs infrared waves, so this feature tends to be very dark on infrared images. As the amount of suspended particles increases, the infrared waves hit this foreign material and are reflected, resulting in a lighter image tone.

f. A portion of the near-infrared images (0.7-1.0 μm) can be exposed directly on aerial film and produce an image just as with visible light photography.

g. Essentially the photogrammetrist is concerned only with aerial photography covering 0.4-0.7 μm, whereas the image analyst must be familiar with a wider portion of the spectrum both shorter (ultraviolet) and longer (infrared) than visible radiation.

C-4. AERIAL FILMS.

Although there are a number of aerial films in use, some are rather specialized. Basically there are four film types that are most commonly used in aerial photography.

A. Panchromatic. Usually called black and white, this emulsion is sensitive to the visible spectrum (0.4-0.7 μm). The image is presented as various shades of gray tones to represent color hues. Fig. C-3 shows the film, seen in cross section. The sensitive layer consists of silver salt (bromide, chlo-

ride, halide) crystals suspended in a pure gelatin coating on a plastic base sheet. Visible light rays react with the silver particles causing a chemical process that creates a gray-scale image.

B. Natural Color (True Color). This emulsion is sensitive to the visible spectrum (0.4-0.7 μm). Image is presented in the natural colors as seen by the eye. Fig. C-4 shows the film, seen in cross section. There are three layers of gelatin containing sensitized dyes, one each for blue, green, and red light. Bear in mind that green- and red-sensitive layers are also affected by blue wavelengths. Light waves pass through and react with the blue layer. They then pass through a filter that absorbs most of the blue waves. Continuing on, they pass through the green and red layers, thus completing the exposure.

C. Infrared. This film is sensitive to green, red and part of near-infrared (0.5-1.0 μm) and renders a black-and-white image. The image looks quite like panchromatic, except that water and some vegetation appear as darker gray to black. Film structure resembles panchromatic with the exception that the sensitivity range is shifted to eliminate most of the blue and pick up some of the near-infrared.

D. Color Infrared ("False Color"). When used with a yellow filter, this film is sensitive to green, red, and part of near-infrared (0.5-1.0 μm). The image contains a lot of red/pink hues in vegetative areas, the color depending upon the degree to which the photosynthetic process is active. It also images water in blue/black hues depending on the amount of particulates suspended in the water body. Film structure resembles that of natural color, except that the blue-sensitive layer is replaced by a layer that reacts to a portion of near-infrared.

E. Films also have an antihalation layer on the underside of the base. This layer absorbs the rays that pass through the sensitized layers and prevents them from rebounding. This eliminates double exposure. Photogrammetry normally employs panchro-

FIG. C-3. Cross Section of Panchromatic Film

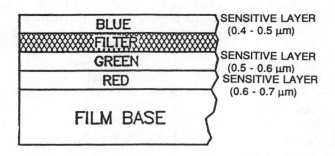

FIG. C-4. Cross Section of Natural Color Film

matic and to a limited extent natural color photography. Image analysis uses all of those discussed above plus, to a lesser degree, some of the more specialized films. Fig. C-5 points out the emulsion sensitivity and image colors for natural color and false color films.

F. Uses of Aerial Film. Aerial photography can be used in both mapping and photo interpretation for various disciplines. Sometimes a single type of film is best for a particular use. For some uses, several types can be used in combination. Color films are more expensive than black and white, especially if reproduction products are required; however, there can be situations where the additional cost may be overshadowed by the amount of extra detail that can be extracted from one film type as opposed to another. Table C-2 lists some uses of various film types. There are many applications for time-lapse air photo comparison, whereby aerial photos can be exposed over the same features periodically to see changes during the interim period.

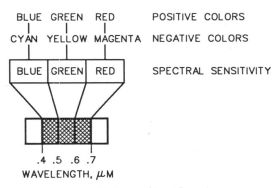

a. Natural (true) color

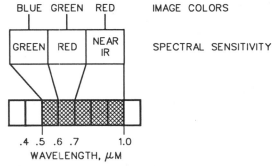

b. False color (color infrared)

FIG. C-5. Emulsion Sensitivity and Image Colors for Natural Color and False Color Films

TABLE C-2. Uses of Film Types

Use (1)	Type (2)
Accident Scenes	Pan, Color
Archeological Features	Pan, IR
Crop Disease Detection	CIR
Earthwork Computations	Pan, Color
Flooding Studies	Pan, IR
Forest Inventory	IR, CIR
Franchise Siting	Pan, Color
Game Habitat	Pan, IR, CIR, Color
Geological Landforms	Pan, Color
Ice Flow	Pan, Color
Jetty Damage	Pan, Color
Land Use	Pan, Color
Land/Water Separation	IR, CIR
Levee Erosion	Pan, Color
Planimetric Mapping	Pan, Color
Quarry Extraction Volumes	Pan, Color
Route Location	Pan, Color
Soil Moisture Location	IR, CIR
Soils Delineation	Pan, IR, CIR, Color
Stockpile Volumes	Pan, Color
Topographic Mapping	Pan, Color
Vegetation Identification	IR, CIR
Vegetation Vigor	IR, CIR
Water Purity (particulate)	CIR
Wetlands	CIR, Color
Wildlife Census	Pan, Color

Note:
1. Pan = panchromatic; IR = infrared; CIR = color infrared.

C-5. PHOTO MAPPING AIRCRAFT

Historically, photogrammetry has relied upon aerial photography as a basic tool. Aerial photography, as the name suggests, requires an airborne platform from which to expose the film. The common platform is an airplane. Of course, the type of aircraft may vary greatly, depending upon the needs and facilities of the aerial photographer.

A. In obtaining photography where the altitude of the aircraft remains below about 18,000 ft above mean sea level, a single-engine craft can be employed. Above this altitude, a more powerful dual-engine airplane is needed. That is not to say that twin-engine aircraft are not commonly used at lower altitudes. Dual engines are normally faster, but they are also more expensive to amortize, operate,

and maintain. Higher cost of these aircraft must be redeemed by capabilities of greater speed or higher operating ceilings.

B. In order for an aircraft to operate as a photo platform, it is necessary to cut a hole in the belly of the aircraft. A camera mount is attached to the floor centered over the hole. The camera then slips into this mount, which rotates through a 360-degree horizontal plane and can be tilted several degrees in two directions. This compensates for the inconsistencies in the flight attitude. Most photo mapping firms use a two-man flight crew comprised of a pilot and photographer. In some operations, the pilot performs both functions.

C-6. AERIAL CAMERAS.

There are a number of aerial camera systems on the market, all of which are very expensive (in the $200,000 range) because of precision construction and meticulous lens polishing. These cameras are finely adjusted, and most are sent to the U.S. Geological Survey (USGS) every 3 years for a calibration test to ensure their continued accuracy. A cross-sectional representation of the working components of a typical aerial camera is shown in Fig. C-6 and briefly described below.

A. A vacuum is applied to the film at the instant of exposure so that the film is held flat. Otherwise there could be air bubbles beneath the film, causing uncontrollable distortions on the photographic image.

B. The camera lens system is compound, meaning that there are several elements of polished glass.

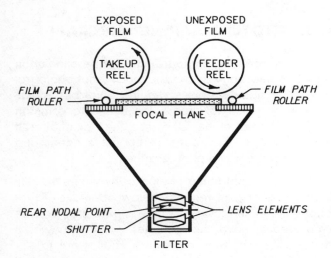

FIG. C-6. Components of an Aerial Camera

C. Focal length of a given camera is the distance from the rear nodal point of the lens system to the focal plane. There are several focal lengths available: narrow angle (12 in.), normal angle (8.25 in.), wide angle (6 in.), and superwide angle (3.5 in.). Image analysis projects may use all of these various focal lengths, whereas photogrammetric line mapping projects use the 6 in. predominantly, and 3.5 in. to a lesser extent.

D. Several compensatory devices used to adjust for flight irregularities are being integrated into the flight system to a greater extent than in the past:

(1) Forward image motion compensation. This system stops the motion that is caused by the forward distance covered by the aircraft during the time period that the shutter is open.

(2) Gyroscopic stabilization. This system reduces the amount of camera tilt by constantly adjusting for the movement of the aircraft from a level flight.

(3) Flight guidance. This system allows the pilot to input flight path information that automatically directs the aircraft heading to adhere to the intended flight path.

(4) Intervalometer. An electrical apparatus that automatically triggers the shutter on a specific time sequence.

(5) Viewfinder. An optical attachment that allows the photographer to view the ground area seen by the camera. It has an electromechanical rheostatic feature that permits the photographer to alter the timed exposure to compensate for the variable speed of the aircraft, which is required to maintain the proper forward overlap (FOL).

(6) Vacuum. This system works off the aircraft vacuum system to hold the film flat on the platen at the time of exposure.

(7) Electric cables. These pull current from the aircraft's electronic system to supply power to the electrical components of the camera system.

C-7. CAMERA FILTERS.

Aerial photography is usually exposed through a glass or gelatin filter attached beneath the lens. There are a variety of filters depending upon the type of film used and the purpose of the imagery. Most common filters are as follows.

A. Minus Blue Filter. This so-called haze filter is a yellow-colored filter that passes some of the blue rays and all of the red and green while

absorbing much of the haze-scattered visible blue light. This filter is used with panchromatic (black-and-white) photography.

B. Antivignette Filter. This clear filter absorbs various gradations of light in different areas of the lens so that the total image has a more even tonal grade. This filter is used with color film.

C. Deep Red Filter. This dark red filter, absorbing all but the longer wavelengths, can be used with infrared film to enhance the image.

C-8. FLIGHT CONDITIONS.

Several conditions should be considered in aerial photo flight planning since they influence the amount of flying time, project cost, delivery schedule, quality of photography, or accuracy of the mapping data.

A. Time of Day. Normally flights are limited to the time period that falls between 3 hours after sunrise to 3 hours before sunset. This causes the number of daily available photography hours to fluctuate by both latitude and season. In the middle latitudes of the United States, this may equate to 3 hours or so in December and perhaps up to almost triple that in June.

B. Season. In areas of deciduous vegetation, flights are normally made in the leaf-free season (late November through early April). In evergreen vegetation areas, the leaves are retained year-round and the ground is obscured on the photos during all seasons. This limits mapping to non-vegetated areas. During summertime photography, there is a greater reflectance variance than in other seasons. This tends to range from almost white (fields, paved surfaces) to almost black (vegetation, shadows), which may result in unacceptable contrasting imagery.

C. Site Restrictions. Airports and military reservations may have restrictions on overflights. These could be total exclusions or restrictions limited only to certain time slots.

D. Film Limits. Normally, color film requires more favorable weather conditions than black and white. On the other hand, infrared has better haze-penetrating capability than panchromatic.

E. Clouds. Most contracts call for images that are essentially free of clouds and cloud shadows. In warm weather, even if early morning is clear, clouds usually begin building up before the flying day ends. When a cold front moves through, a period (from a few hours to a few days) of good flying weather tends to follow. In winter, there are cold days when the sky is clear and sharp, sometimes lasting from one to several days. In certain situations, when it is advantageous to have a minimum of shadows, photos may be exposed under an overcast. However, in order to enhance the photography, the overcast must be solid, high, thin, and bright. The negative aspect of this situation is that image viewers rely on shadows to locate and identify certain image features.

F. Height Restrictions. In order to ensure the safety of both the flight crew and general public, Federal flight regulations decree that an aircraft must not fly lower than that altitude from which the plane can, if it were to lose its power source, glide far enough to clear populated areas. This generally equates to a minimum altitude of 1,000 ft above the ground. Also, at altitudes in excess of 18,000 ft, the flight crew is infringing upon the airspace of commercial airways. The pilot must then file a flight plan prior to commencing a mission.

G. Turbulence. Wind and thermal currents, assuming otherwise favorable conditions, can create sufficient adverse conditions to prohibit a photo flight. This situation may cause excess tilt, crab, or drift in the photography. Although turbulence can be a problem at any flight height, it is especially troublesome at low altitudes.

H. Haze. There is usually some haze present near urban areas that can diminish image resolution. This urban haze can spread a considerable distance from the source. The degree of haze tends to rise along with temperature.

I. Sun Angle. The sun angle lessens during the winter to the point where it not only shortens the flying day but it also creates long dark shadows, especially on wooded north-facing slopes. When the sun angle drops below 30 degrees, flying should be terminated. This condition should be a problem for only a few days in the southern two-thirds of the country. In the northern third this condition could be more restrictive. Of course, during that time frame these latitudes could also be snow covered, which may also a deterrent for photography.

J. Snow Cover. Some snow might be tolerated on aerial photos, especially thin, spotty patches. Snow cover can have several adverse effects on aerial photography:

(1) The surface of the snow causes a high light reflection, creating high-density light flares on the image.

(2) There is little surface contrast on a high-reflective material, which tends to flatten the terrain image.

(3) Depending upon the snow depth, a certain amount of ground cover is obliterated on the image.

(4) Snow has a depth that affects the measurement of terrain contours.

C-9. PHOTO SCALE.

Since photo scale is the major factor influencing cost on a photo mapping project, it is important to fully understand the interrelationships between photo scale, flight altitude, camera focal length, and the ground (map) target scale. Fig. C-7 shows congruent triangles A and B. Since similar parts of congruent triangles are proportional, the photo width p is proportional to g (ground distance covered) in the same magnitude as f (camera focal length) is to H (flight altitude above mean ground level). This is a situation analogous to the geometry of an aerial photograph. Hence, if triangle B represents a camera, the ratio of p to g is the scale of the photo.

A. The scale of an aerial photograph or a map can be stated basically in one of two ways:

(1) 1:2,400, where one unit on the photo represents 2,400 "similar" units on the ground as:

1 in. on the photo = 2,400 in. on the ground
1 ft on the photo = 2,400 ft on the ground
1 m on the photo = 2,400 m on the ground

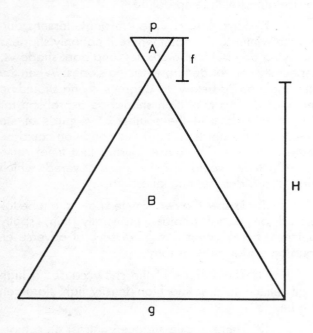

FIG. C-7. Photo/Ground Geometric Relationship

(2) 1 in. = 200 ft, where one unit on the photo represents "different" units on the ground.

Both of the scales cited above mean the same thing. In order to convert from 1:2,400, assume that both are inches, then 2,400 in. divided by 12 in. per foot equals 200 ft. So the resultant scale is 1 in. = 200 ft or 1 in. on the photo is equal to 200 ft on the ground.

B. This may lead to the obvious question: how is the scale of an aerial photograph controlled? Refer to triangles A and B in Figure C-7 and let:

f = focal length of camera, inches
H = altitude of aircraft above ground level, feet

Then,

$$\text{Photo Scale} = \frac{(1)}{(X)} = \frac{\text{focal length}}{\text{altitude}} = \frac{f, \text{inches}}{H, \text{feet}}$$

For example, given a camera with a 6 in. focal length flying at a height of 1,200 ft above mean ground elevation, the photo scale would be computed as:

$$\frac{1}{X} = \frac{6}{1,200}$$

which cross-multiplies to $6X = 1200$, and $X = 200$, which translates to a negative scale of 1 in. = 200 ft. Factoring the above formula results in a simplified version to determine photo scale in inches/feet:

1 in. = (flight height in feet/focal length in inches)

C. The altitude of the aircraft can be determined if the photo scale and the focal length are known. In the same example, and using a 6 in. focal length, it is desirable to produce a photo scale of 1 in. = 200 in.

$$\frac{1}{200} = \frac{6}{H}$$

then $H = 1,200$ ft, which equates to:

flight height, feet = focal length, inches, X photo scale denominator, feet

D. It is often necessary to know the scale of an existing photo. Some photos contain the scale in the photo title. If not, find a reliable map of the same area. Using the indicated scale of the map, measure the distance between two distinct map features in feet. Then measure the distance on the photo, in inches. Divide the map distance by the photo dis-

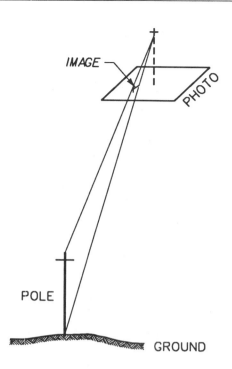

FIG. C-8. Image Displacement

tance, which gives the number of feet that is equal to 1 in. on the photo.

E. There can be some confusion when thinking about relative photo or map scales. Just remember:

(1) Large scale means that image or map detail is relatively large.

(2) Small scale means that image or map detail is relatively small.

F. Aerial cameras most commonly in use present a photographic format with an image area which is 9 by 9 in. plus a 1/2 in. border on all four sides. Within this strip, on one side of the photo, there are several pieces of information that are imprinted onto the negative at the time of exposure. These include a clock to show time of exposure, an altimeter showing height of the aircraft, a bubble target whose position indicates whether the camera is level, and a blank square on which the date of exposure is usually written. Along the edge of one side of the image are stamped certain data, which can include photo scale, project symbol, negative roll number, date, exposure number, and any other information specified by the photo contractor. Precision mapping cameras have eight fiducial (collimation) marks, one in the center of each edge and one in each corner, which are used primarily for extracting camera measurements for insertion in photo control bridging (aerotriangulation) procedures. By

connecting fiducials on opposite sides, the photo principal point can be located. On truly vertical photography, the nadir and principal point are one and the same.

C-10. IMAGE DISPLACEMENT.

Except over very limited areas, the surface of the world is not smooth. Consequently, the effect of natural relief will affect the photo scale.

A. An aerial photo is a three-dimensional image transferred onto a two-dimensional plane. Hence, the photographic process literally squashes a three-dimensional feature onto a plane that lacks the vertical dimension. Image features above or below mean ground level must be displaced from their true horizontal location. Fig. C-8 graphically demonstrates this phenomenon.

B. Assuming that the pole in the figure rises truly vertically from the ground, the pole's top and base have the same horizontal X-Y placement. This diagram belies that fact, because the base and the top are in displaced positions on the image. This separation will not necessarily be the same on successive photos. Just as images of fast-rising features are displaced, so are the changes in ground elevations, though not as visibly apparent. With this in mind, it follows that if several scale sets are calculated from an individual photograph, each may vary from the others. The more diverse the terrain character, the more the scale variance.

C. Displacement is a normal inherent condition and should not be confused with distortion, the latter being caused by discrepancies in the photograph, processing, and reproduction systems.

D. When measurements are extracted directly from the photos on an image analysis project, there will be horizontal discrepancies that, depending upon relief slope and flight height variance, may be detrimental to data accuracy. Since stereoplotters work with a three-dimensional "spatial" image

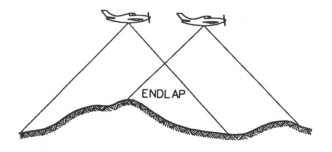

FIG. C-9. Endlap

formed by a pair of overlapping two-dimensional photos, normal displacement can be compensated for in the mapping process. Distortion cannot.

C-11. PHOTO OVERLAP.

Most aerial photo projects, whether intended for mapping or image analysis, require that a series of exposures be made along each of several flight lines. These photos overlap in two directions.

A. Endlap. Endlap (also known as forward overlap) is the overlapping of successive photographs along a flight strip. This overlapping area of two successive aerial photos, which creates the three-dimensional effect necessary for mapping, is known as a stereomodel, or more commonly model. Fig. C-9 shows an endlap between a single pair of consecutive photos on a flight line.

(1) Practically all projects require more than a single pair of photographs. Usually the aircraft follows a predetermined flight path as the camera exposes consecutive overlapping images. The degree of endlap normally ranges between 55 and 65% of the length of a photo, with a nominal average of 60% for most mapping and image analysis. Occasionally it may be advantageous to fly with 80% endlap.

a. This is especially true in rectified image and orthophoto projects. In this instance, the best stereo pair to fit on a specific sheet format can be selected, thus avoiding the necessity of splicing the orthoimage.

b. Some photogrammetrists advocate using 80% endlap for aerotriangulation procedures. The reasoning is that analytical data can be extracted from more photos for individual photo control points, and the mathematical solution of additional ray bundles will strengthen the accuracy of the analytical control bridge.

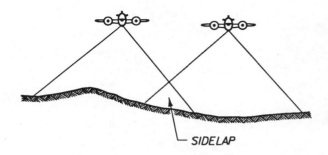

FIG. C-10. Sidelap

(2) There are situations where three-dimensional capabilities may not be required on a flight. This allows a 20% endlap and results in full two-dimensional coverage.

B. Sidelap. This sidelap denotes the overlapping areas of photographs between adjacent flight lines. It is designed so that there are no gaps in the three-dimensional coverage of a multiline project. Fig. C-10 shows the relative head-on position of the aircraft in adjacent flight lines and the resultant area of exposure coverage.

The amount of sidelap normally ranges between 20 and 40% of the width of a photo, with a nominal average of 30% typically specified. The area covered by three flight lines, as well as the sidelap between adjacent lines, is shown in Fig. C-11.

C-12. PHOTOGRAPHIC STEREOMODEL.

From the foregoing discussion of overlap, it is evident that consecutive photos in a flight strip overlap. This situation allows a viewer, when using appropriate stereoscopic instruments, to look at a pair of two-dimensional photos and see a single three-dimensional image. When focusing each eye

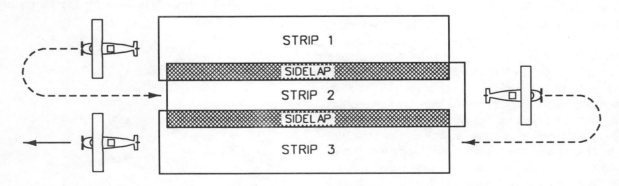

FIG. C-11. Sidelap Areas in Adjacent Flight Lines

FIG. C-12. Endlap in a Stereopair

FIG. C-13. Stereomodel

on a particular image point that was seen by the camera from two different aspects (parallax effect), the mind is convinced that it is seeing a lone image point with three dimensions. This is called an optical illusion.

A. The overlapping portion of two consecutive aerial photos is shown as the hatched area in Fig. C-12. The number of stereomodels required to cover a given project area also directly relates to the overall cost of a mapping project.

B. In practice, the photogrammetrist thinks of a model as the neat area that a single stereopair contributes to the total project. This allows for the endlap and sidelap with surrounding photos. A mapping model is shown as the crosshatched area in Fig. C-13.

C-13. FLIGHT INCONSISTENCIES.

The aircraft is neither a stable platform nor are all vertical photographs truly vertical. This platform is affected by wind currents and turbulence, which prevent the camera from always maintaining a straight and level orientation. Several inconsistencies may be encountered during an aerial photo mission, all of which need to be compensated for during subsequent compilation phases.

A. Drift. Fig. C-14 depicts the situation where wind can push (i.e., "drift") the aircraft off the designated center line to a position that is parallel to the intended flight path. This can result in diminished or excessive sidelap with adjacent flight lines and

FIG. C-14. Drift

possibly cause gaps in photo coverage if drift is severe.

B. Crab. Fig. C-15 illustrates the situation where the pilot adjusts the attitude of the aircraft to compensate for a quartering wind but the photographer fails to adjust the camera attitude to the same angle. This condition (i.e., "crab") can result in diminished or excessive sidelap or endlap, and possibly cause gaps in photo coverage.

C. Tilt. Tilt is the condition in which the attitude of the aircraft rotates around either its X- or Y-axis:

(1) X-tilt. The airplane is rotated on the axis in line with the flight path so that the wings are not level.

(2) Y-tilt. The airplane is rotated on the axis perpendicular to the flight path so that the nose is pitched up or down.

The tilt shown in Fig. C-16 could be either X-tilt or Y-tilt depending upon whether the aircraft is viewed head-on or in profile, respectively. Both tilts have the same effect on the imagery. They increase the range of scale differences within the image and between images on adjacent photos. If tilt is excessive, it may even introduce distortion, especially in rugged terrain.

D. A single exposure may contain any or a combination of all of these inconsistencies.

C-14. STEREOPLOTTERS.

Historically, photogrammetric and image analysis information was extracted from aerial photographs through a process combining visual perception, mental adroitness, and manual dexterity. *End products* of these procedures were hard-copy maps and data tabulations compiled mechanically and used piecemeal to formulate decisions. The field of photogrammetry is undergoing a transition from graphic (analog) to digital (analytical) mapping. Maps and data tabulations have become *byproducts* in this age of increasing technological sophistication. Currently, significant amounts of photographic imagery data that are collected go directly into automated data bases, such as Computer-Aided Design and Drafting (CADD), Geographic Information Systems (GIS), Land Information Systems (LIS), and Automated Mapping/Facility Management (AM/FM). This information is integrated with data from diverse sources to propagate various information systems products. Presently, there are two general classes of stereoplotters used to encode this spatial data: analog and analytical. These are described below.

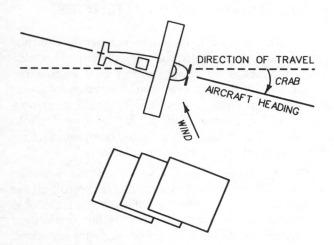

FIG. C-15. Crab

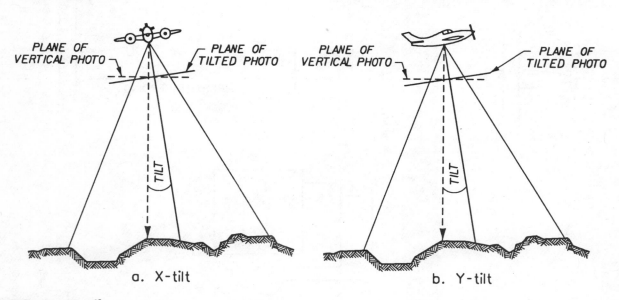

a. X-tilt

b. Y-tilt

FIG. C-16. Tilt

A. Analog Stereoplotters. Graphic mapping allows the use of analog instrumentation, which is essentially a manual process. In the past this type of instrumentation involved the following:

(1) Orienting photos by manipulating appropriate instrument rotations to introduce flight inconsistencies (drift, crab, tilts) into the machine as they were observed in the camera at the instant of exposure.

(2) Referencing photos in the stereoplotter to coincide with horizontal and vertical field survey data by mechanically manipulating appropriate stereoplotter movements.

(3) Drawing planimetric and topographic features with a cursor that activated a pantograph or automatic tracing table, which in turn, traced the movements of the cursor at a different scale.

(4) Manually cleaning and tracing the hardcopy map as inked line drawings for presentation as a final graphic product.

Analog systems can now be interfaced with appropriate software and data collection hardware to perform digital data generating functions. In these systems, the stereocompiler still orients the model by physically adjusting the control knobs on the analog stereoplotter upon direction of the computer controller. The schematic in Fig. C-17 represents a generalized concept of a manual analog system that is partially controlled by an interface with an electronic driver and a data collector.

B. Analytical Stereoplotters. Over the past decade or so, stereoplotters have been equipped with internal computers that perform the mathematical image orientation solution, allowing the computer to perform a portion of the map production. These systems are termed analytical. Analytical machines are inherently more accurate than analog systems. The schematic diagram in Figure C-18 illustrates the generalized conception of an analytical system. Note the higher level of sophistication over the previous figure. Computer control, viewing screen, and data collector are an integral part of the system rather than the peripheral interfaces in the analog system. Some contractors operate a combination of analog and analytical instruments, although some have converted completely to analytical. The trend is towards fully analytical compilation.

C. Spatial Models. Stereoplotters work with a "spatial" stereomodel in both analog and analytical instruments. The stereocompiler inserts diapositives (film plates produced by contacting a positive image onto a clear film base) of two successive aerial photo exposures into the machine. Even though the operator is actually viewing two separate images, proper relative alignment of the photos allows the operator's mind to fuse the dual images into a reduced three-dimensional model of the terrain floating in its relative spatial position. Once the photos are aligned for three-dimensional viewing, the operator (after inputting the photo control information) orients the photos to the terrain. The computer outputs a summary of the residual error at each control point. A spatial reference mark inside the machine is maneuvered horizontally by handwheels

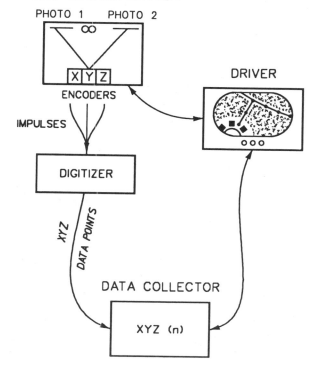

FIG. C-17. Schematic of an Analog Stereoplotter

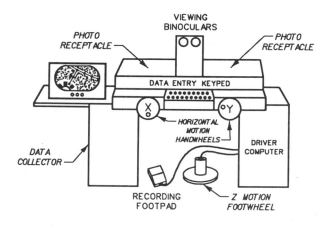

FIG. C-18. Schematic of an Analytical Stereoplotter

or cursor and is controlled vertically by footwheel or cursor. When the photos are properly oriented, this reference can read the true X-Y-Z (east/north/elevation) geographic position of any point on the stereomodel.

D. Digital Software Interface. Both analog and analytical systems can be interfaced with appropriate software and peripheral hardware to generate map data in digital form. Depending upon the configuration of the digital interfaces, data may be read in one of several formats (e.g., ASCII, binary, AutoCAD, Intergraph). Data can also be shuttled through appropriate transformation software to convert data design files for use between diverse CADD environments.

C-15. MAP ACCURACIES.

Most mapping organizations, whether Government or private, use procedures enabling them to adhere to some stated accuracy specifications. Refer to Chapter 2 for specifications on USACE mapping accuracy standards for large-scale mapping. The mapper may also have occasion to use Government small-scale mapping data, especially when working with Information System data bases. These data will conform to U.S. National Map Accuracy Standards. These specifications are also described in Chapter 2.

C-16. PHOTO SCALE, CONTOUR INTERVAL, AND TARGET MAP SCALE DETERMINATION.

Photo scale, contour interval (CI), and the target mapping scale are integrally related and directly affect the cost of a spatial data product.

A. Photo Scale Selection. Planimetric and topographic detailing are the two main factors that must be considered in selecting a photo scale for digital mapping. One (or occasionally both) of them will govern the final photo scale.

(1) Planimetric (cultural) features. Normally, on larger scale mapping projects, a great deal of finite features (poles, street signs, inlets, traffic signs, sidewalks, manholes, etc.) are drawn. As map scale gets smaller, progressively more of this finite detail is omitted (by reason that it may not be visible and/or identifiable on the photos or to reduce map clutter), and some of the larger features may be symbolized due to minimum size limitations. This dictates that large-scale planimetric mapping requires large-scale photos. In order to preserve horizontal validity of planimetric detail, the enlargement factor from photo

TABLE C-3. Enlargement Factors

	Map Class		
Plotter (1)	1 (2)	2 (3)	3 (4)
Analog	6	7	8
Analytical	7	8	9

to map for USACE mapping should not exceed the *maximum* factors in Table C-3. Refer to Table 2-6 in Chapter 2 for determining maximum enlargement ratios for a specific stereoplotter/map class. There are situations where, once the appropriate map scale is calculated based upon drawing a specific CI (refer to the following paragraph), a larger map scale is dictated by the planimetric detailing. It would then be wise to calculate a larger photo scale based on the horizontal requirements. This would require the aircraft to fly at a lower altitude than would normally be required in maintaining the vertical accuracy.

(2) Topographic (terrain) features. Usually, except for situations discussed in (1) above, photo scale is determined to maintain accuracy of the selected CI (i.e., vertical accuracy limitations normally govern the photo scale selection). Photo scale limitations based on topographic compilation accuracy are dependent on two parameters: the C-factor and the CI.

B. C-Factor. There is an empirical geometric relationship between height of the aircraft above mean ground elevation (MGE) and the smallest accurate CI that can be generated at that specific flight height. This correlation is referred to as C-factor or CF. This contour factor is a fraction in which the numerator is reduced to the unit one.

$$\frac{1}{factor} = \frac{C \ (CI \ in \ feet)}{H \ (flight \ height \ in \ feet)}$$

or

$$CF = \frac{CI}{H}$$

Assuming that it is required to draw contours at 2-ft vertical intervals with a C-factor that is 1/1,500th of the flight height:

$$\frac{1}{1500} = \frac{2}{H} \ ; \ then \ H = 3,000 \ ft \ above \ MGE$$

In practice, C-factor is not referred to as a ratio, but rather as the denominator of the C-factor fraction. The C-factor formula can also be converted to a simplified version in order to directly determine flight height:

flight height = C-factor × contour interval,

or

$$H = CF \times CI$$

Assuming that it is required to draw contours at 2-ft vertical intervals with a C-factor of 1,500, the flight height:

$$H = CF \times CI = 1500 \times 2$$
$$= 3{,}000 \text{ ft above MGE}$$

As noted elsewhere, some stereoplotters are more accurate than others, by reason of mechanical construction or optics, so it stands to reason that C-factors of various instruments are dissimilar. Acceptable C-factors vary from one stereocompilation instrument make and model to another.

(1) In actual application the C-factor for various instrumentation is considered as a range, rather than a discrete integer. This range is influenced by several factors:

a. Camera. Amount of radial distortion in the camera lens.

b. Stereoplotter. Caliber of the optical and mechanical structure, as well as attention to periodic calibration and maintenance, of the stereoplotting instrument.

c. Control data. Veracity and sufficiency of field control information, as well as aerotriangulation solution. These factors impact the accuracy of collected digital data.

d. Stereocompiler. Visual acuity and production experience of the stereoplotter operator.

e. Image quality. Resolution/definition of the photo image. This factor is an unknown quantity until photography is exposed. Since inconstant atmospheric conditions alter terrain reflection intensities diversely, the visual quality of the negatives may lack the anticipated resolution/definition.

f. Aerotriangulation. This analytical photo control procedure is discussed in paragraph C-19. Errors are introduced into the photo control by this process.

The degradation of any, or the combined effect of several, of these elements will adversely affect the C-factor.

(2) In production application, this C-factor

TABLE C-4. Maximum C-Factors

Plotter (1)	Class		
	1 (2)	2 (3)	3 (4)
Analog	1600	1800	2000
Analytical	2000	2200	2500

may diverge significantly from one production system to another, subject to the qualitative philosophy of the organization providing the mapping product. Given the wide range of C-factor claims for the same instruments, and in order to provide consistency in photomapping specifications, estimates, and accuracies, the C-factors in Table C-4 are the *maximum* that may be used for USACE mapping work.

(3) It is wiser to be conservative in the application of C-factors, since the production cost differential may be of less consequence than potential future construction claim expenditures that may incur from stretching the accuracy limits of the imagery.

C. Correlating C-Factor, Flight Height, and Photo Scale. In order to solidify comprehension of the relationship between CI, flight height, and photo scale, a few situations are presented.

(1) Given a Class 1 mapping project requiring contours at 1-ft intervals using an analytical stereoplotter with an estimated C-factor of 1750, determine the maximum flight height and smallest photo scale:

flight height = C-factor × contour interval

or

$$\text{F-hgt} = CF \times CI$$
$$= 1750 \times 1 = 1{,}750 \text{ ft MGE}$$

(less than 2,000 ft allowed per Table 2-9)

This would result in a photo negative scale of

$$1 \text{ in.} = \frac{\text{F-hgt}}{\text{focal length}} = \frac{1750}{6} = 292 \text{ ft}$$

(Use 1 in. = 300 ft)

(2) Given a Class 1 mapping project requiring contours at 2 ft intervals with an analog stereoplotter with an estimated C-factor of 1500, deter-

mine the maximum flight height and smallest photo scale:

$$F\text{-hgt} = CF \times CI$$
$$= 1500 \times 2 = 3,000 \text{ ft MGE}$$

(less than 3,200 ft allowed per Table 2-9)

This would result in a photo negative scale of:

$$1 \text{ in.} = \frac{F\text{-hgt}}{\text{focal length}} = \frac{3000}{6} = 500 \text{ ft}$$

(3) Given a Class 2 mapping project requiring con tours at 5 ft intervals with an analog stereoplotter assigned a C-factor of 1800, determine the maximum flight height and smallest photo scale:

$$F\text{-hgt} = CF \times CI$$
$$= 1800 \times 5 = 9,000 \text{ ft MGE}$$

(same as 9,000 ft allowed per Table 2-9)

This would result in a photo negative scale of:

$$1 \text{ in.} = \frac{F\text{-hgt}}{\text{focal length}} = \frac{9000}{6} = 1,500 \text{ ft}$$

D. Correlating Planimetric and Topographic Requirements. Both planimetric and topographic specifications must be considered prior to selecting a photo scale. There are situations where, once the appropriate map scale is calculated based on drawing a specific CI, a larger map scale is dictated by planimetric enlargement limitations. In such cases, it would be necessary to calculate a larger photo scale based on the horizontal requirements, as in the following example:

(1) A project has a specified target mapping scale of 1 in. = 50 ft and a 2 ft CI. Assume a C-factor of 1650.

(2) Photo scale computations (exposed with a 6 in. focal length camera):

a. Contours will require a flight height of:

$$CF \times CI = 1650 \times 2$$
$$= 3,300 \text{ ft above MGE}$$

This results in a photo scale of:

$$1 \text{ in.} = \frac{F\text{-hgt}}{\text{focal length}} = \frac{3300}{6} = 550 \text{ ft}$$

b. Planimetric culture limits a 6-9× enlargement factor (depending upon which stereoplotter/map class is used) from photo scale to map scale. Assuming a 6× enlargement factor (Class 1 mapping with an analog stereoplotter (Table 2-6)), the photo scale will be:

1 in. = map scale × enlargement factor = 50 × 6

or

1 in. = 300 ft

which requires a flight height of:

photo scale × focal length = 300 × 6
= 1,800 ft above MGE

(equals limit prescribed in Table 2-8)

(3) In this situation, the computed photo scale based on planimetric detail will govern; thus, the selected photo scale will be 1 in. = 300 ft to assure planimetric accuracy. The back-computed C-factor will be:

$$\frac{F\text{-hgt}}{CI} = \frac{1800}{2} = 900$$

This more than satisfies the required 2 ft contour accuracy given the instrument's estimated C-factor of 1650.

C-17. PHOTO CONTROL POINTS.

Before maps are prepared from aerial photos, ground survey information is required on specific terrain features to relate the spatial model to its true geographical location. These terrain features may be identified in two ways: photo image and photo targets (or panels).

On some projects, local conditions may dictate that a combination of image points and targets be used. (Future developments in NAVSTAR Global Positioning System (GPS) technology will significantly reduce the amount of photo control required for a mapping project since each camera position will have an accurate X-Y-Z location.)

A. Photo Image Points. These are readily identifiable pictorial image features. Horizontal control points should be relatively small and sharply defined (fence corners, poles, signposts, etc.). Vertical control points do not have to be as small or sharply defined but should be fairly flat on unobstructed ground (road intersections, sidewalk intersections, manholes, railroad grade crossings, etc.). Of course, the photo scale determines finiteness of image points. A road intersection would not

be suitable as a horizontal control point on 1in. = 200 ft photos, whereas it may be suitable on 1in.= 2,000 ft photos.

B. Ground Targets. These are targeted panel points that are placed on unobstructed ground prior to photography. Targets can be a variety of shapes (+, X, L, V, square, or round) or materials (plastic, butcher paper, cloth, lime, paint). To be effective, panels must:

(1) Contrast with terrain background.

(2) Be of material that will withstand exposure to wind and rain until photos are exposed.

(3) Sometimes be removed after photography, perhaps because it is obligatory or is in the best interests of public relations.

(4) Not be placed in areas where overhead obstructions (trees, buildings, overpasses) will hide the target.

Targets must be of sufficient size to be recognized on the image. Fig. C-19 defines size of ground targets for any photo scale.

C. Example of Target Size. The calculated dimensions for targets to be used with 1 in. = 500 ft photos:

W (WIDTH OF PANEL IN FEET) = PHOTO SCALE DENOMINATOR (FEET) / 25.4 X 0.05

L (LENGTH OF PANEL LEGS IN FEET) = 10 X W

FIG. C-19. Size of Ground Targets

$$W = \frac{500}{25.4} \times 0.05 = 0.98 \text{ ft or 1 ft}$$

$$L = 10 \times 1 = 10 \text{ ft}$$

D. Advantages of Ground Targets. There are advantages to placing ground targets in advance of photography.

(1) They can be a finite image point, perhaps leading to better map accuracy.

(2) There should be less chance of misidentification of a control point, either by surveyor or stereocompiler.

E. Disadvantages of Ground Targets. There are disadvantages to using ground targets, for example, given a project to map a rural setting with limited image-identifiable features (dense woods, fallow fields, croplands). In this situation, it may be necessary to revert to ground targeting simply to take the place of nonexistent photoidentifiable points. This situation would also require the placement of a significantly greater number of panel points than would have been required for photo image point selection if conventional control had been used. In some situations targets must be placed where animals and humans cannot destroy them.

C-18. FIELD CONTROL SURVEYS.

To accomplish mapping from stereomodels, the aerial photo image must be scaled and levelled. To do this, it is necessary to accurately relate the photos to the ground, both horizontally and vertically. This is done by gathering field survey data on specific horizontal (scale) and vertical (level) points at the mapping site. Some points may contain both horizontal and vertical information and can be used for scaling and leveling. Chapter 5 discusses field survey control procedures and accuracies. Various instrumentation can be used for collecting ground control information such as theodolite, electronic distance measurement (EDM), spirit level, total-station, and differential NAVSTAR GPS.

A. Horizontal. Horizontal control involves running traverses through selected horizontal photo control points. Coordinates are then derived for whatever grid system to which the mapping is to be referenced. Initially, the project control is referenced to an existing station for which appropriate coordinates have been established. This may require the surveyor to run a traverse from a point outside of the mapping area. Then, a closed traverse is run through the photo control points. Horizontal control

may be accomplished with GPS surveying procedures. It is not always possible to occupy ground control points. If sideshots are necessary, they should be limited to very short distances. Much grief can result from erroneous extended sideshots!

B. Vertical. Vertical control involves running closed level circuits through the selected vertical photo control points. Most mapping projects require that these elevations be referenced to the National Geodetic Vertical Datum of 1929 (NGVD 29) by starting and closing on established benchmarks, which may be some distance from the mapping site. Until there are more global positioning satellites in orbit, elevations derived from GPS are not sufficiently accurate for large-scale mapping.

C. Control Point Density. A minimum of three horizontal and four vertical photo control points per stereomodel, in patterns similar to those shown in Fig. C-20, should be selected to assure mapping quality.

D. Ground Control Methods. There are two approaches to gathering this terrain information: conventional and skeletal.

(1) Conventional control surveys. Conventional surveys require that information at every photo control point to be used for mapping must be gathered onsite. Each stereomodel requires a minimum of three horizontal photo control points—two points for determining scale, and the third to verify the integrity of the scale. Each stereomodel also requires a minimum of four vertical control points—three to determine a spatial plane that is parallel to the reference datum and the fourth to verify that this solution is correct. Note that in Fig. C-21 each stereomodel contains the required number of horizontal and vertical field control points to assure a reliable spatial solution. In conventional control surveys, the photography is exposed first, then each required field control point is selected as an identifi-

■ HORIZONTAL CONTROL POINTS
● VERTICAL CONTROL POINTS

**FIG. C-21. Photo Control
Point Patterns**

able photo image point. The surveyor then locates these points on the ground and gathers the appropriate field information. Individual points may be selected as both horizontal and vertical.

(2) Skeletal control surveys. Skeletal surveys are run only when it is intended that aerotriangulation procedures be used to generate mapping photo control. See the following paragraph for a discussion of aerotriangulation.

C-19. AEROTRIANGULATION.

Aerotriangulation (also termed control triangulation or photo control bridging) is the analytical procedure that allows a mapper to use a skeletal pattern of ground control points, less than that required for conventional control, to analytically generate sufficient photo control points for mapping.

A. Ground Control. Refer again to the conventional ground control point requirements des-

■ HORIZONTAL CONTROL POINT
● VERTICAL CONTROL POINT

**FIG. C-20. Photo Control Point
Requirements Per Model**

ignated in Fig. C-21. The amount of skeletal ground control required to fulfill ground control requisites on the same site is diagrammed in Fig. C-22.

(1) Note that the pattern suggested in Fig. C-22 requires horizontal control points only on the periphery of the project. The reasoning for this is that mathematical horizontal bridging strength works from the interior outward. There are situations that may require interior horizontal control points, such as in breaking a large project into more than a single analytical run.

(2) Also shown is the vertical control point diagram. Note that interior vertical control points are required in addition to those on the periphery.

(3) In either situation, analytical photo control points that fall outside of the field control pattern are subject to potentially significant errors. In this situation the analytical bridge is actually extrapolating a solution, and the further outside the control pattern that the point falls, the greater the error.

■ HORIZONTAL CONTROL POINTS
● VERTICAL CONTROL POINTS

**FIG. C-22. Ground Control
Pattern for
Skeletal Control**

Therefore, it is desirable to locate peripheral control points outside the mapping area.

B. Photo Control Extension. There are several methods of accomplishing aerotriangulation, but generally it proceeds as follows:

(1) Photo point selection. A pattern of at least six photo image point locations per stereomodel is selected on the control photos. These are transferred to the diapositives.

(2) Point pugging. Using a point transfer device, a small hole is drilled through the film emulsion to act as an artificial control point.

(3) Comparator coordinates. Plate coordinates are read for all of the photo control points that appear on each film plate using either a monoscopic (X-Y) or stereoscopic (X-Y-Z) comparator.

(4) Analytical solution. These raw plate coordinates are input into the computer, which establishes (by polynomial computational procedures) a spatial network of raw photo coordinates loosely related to one another but not referenced to anything outside the computer matrix. If coordinates were gathered on a monocomparator, only X and Y were read. The software then manufactures Z from the horizontal coordinates. If coordinates were gathered on a stereocomparator, X, Y, and Z were read.

(5) Real coordinates. Ground control point data are introduced, and the computer generates (by least squares or some similar adjustment) comparable X-Y-Z (easting/northing/elevation) terrain coordinate sets for each photo control point. It also reports the residual error introduced at each field control point and the final root mean square error (RMSE) of all of the field control points. Accuracy (RMSE/flight height) of the field survey points resulting from this procedure should adhere to that listed in Table C-5. In no case should the residual error at a single acceptable field control point exceed three times the aggregate RMSE.

(6) Accuracy check. Generally there is only one way to check the validity of the analytical bridge—by comparison of the residual errors introduced at the field control point locations. There are at least three items contained in the bridging printout that are valuable in analyzing the reliability of the aerotriangulation:

a. Does the accuracy of the RMSE agree with Table C-5? If it is significantly less, there may be areas of intolerable inaccuracies in the field survey or aerotriangulation process.

b. What is the magnitude of the residual error at individual field control points? If these exceed triple the RMSE, there may be areas of intoler-

TABLE C-5. Accuracy of Aerotriangulation

Map Class (1)	Bridging Method (2)	Allowable Relative RMSE at Field Control Points	
		Horizontal (3)	Vertical (4)
1	Full Analytic	1/10,000	1/9,000
2	Full Analytic	1/8,000	1/6,000
3	Full Analytic or Semianalytic	1/6,000	1/4,500

able inaccuracies in the field survey or aerotriangulation process.

c. Which of the field control points were eliminated from the final aerotriangulation run? If several points, or points in critical locations, are excluded, there may be an adverse field control solution. If the analytical solution is the product of bare minimum control, the solution may appear sound while actually being faulty.

C. Models Spanned. Aerotriangulation allows some models to contain no field survey information, but certain maximum uncontrolled model spans should be limited.

(1) Vertical. No more than the uncontrolled number of models shown in Table C-6 should be spanned between field survey elevations.

(2) Horizontal. No more than the uncontrolled number of models shown in Table C-7 should be spanned between field survey coordinates.

D. Effects of Analytical Error. Since the aerotriangulation process generates an RMSE, this procedure will introduce more error into individual photo control points than if data for these same points had been accumulated by field surveys. This

TABLE C-6. Vertical Models Spanned

Map Class (1)	Model Spacing (2)
1	2
2	3
3	3

TABLE C-7. Horizontal Models Spanned

Map Class (1)	Model Spacing (2)
1	4
2	5
3	6

could have an effect in choosing a photo scale, and it may be advisable to consider reducing the C-factor by 5percent for each model spanned vertically on projects employing aerotriangulation. It is good practice to target field control points prior to the photo flight on projects using analytical photo control bridging. Use of ground targets adds better definition to field control points and can help lessen aerotriangulation network residuals.

C-20. DIGITAL MAPPING.

A significant proportion of digital data that are generated by aerial surveys will eventually find its way into automated data bases (i.e., GIS, CADD). Also, data derived from remote sensors are also incorporated into automated GIS data bases. Data from these sources can be mixed and matched in various GIS/CADD projects. Therefore, it is prudent to know the source and accuracy of each set of information contained in a data base.

A. Digital Mapping Data. Digital information that generates a map resides in a data base matrix composed of a multitude of individual points. Each point is spatial, having a coordinate triplet value for X (easting), Y be referenced to any desired geographic coordinate system. Since increasingly more digital data are being interjected into data bases for GIS and CADD systems, it is best to consider using standard coordinate systems for collecting data. Normally the local State Plane Coordinate System is used for most Continental United States (CONUS) military and civil works projects. CONUS elevations are usually referenced to NGVD 29.

(1) Digital data generation requires three basic components: feature code identifier, symbol macro, and data strings.

(2) The computer cannot distinguish between a contour and a building. It recaptures points and draws lines. Therefore, in order to plot a map that is intelligible for human viewing, individual data strings composing a feature must be attached to an identifier. This feature code identifier relates to a

symbol macro system command that instructs the computer to symbolize lines by weight, color, style, and symbology so that various features can be differentiated when the graphics screen or data plot is viewed. The "eyes" of the computer "see" digital data as:

$$FC, XYZ(1), \ldots , XYZ(n)$$

B. Digital Map Compilation. Digital mapping with a stereoplotter requires three operations: stereomodel orientation, map compilation, and data edit.

(1) Stereomodel orientation. This procedure involves "leveling" and "scaling" the stereomodel to photo control information previously input into the computer.

(2) Map compilation. This procedure is accomplished in two steps:

a. *Planimetry*. Planimetric data are generated by drawing cultural features that are visible and identifiable on the image. Within the stereoplotter there is a visible reference mark. In order to draw an object, the operator must position this reference mark on the apparent elevation of that feature. Since mapping is accomplished using a spatial image, the mark must be at its true elevation for the observed point to be in its true horizontal position. Normally, on large-scale mapping projects, a great number of finite features (poles, street signs, inlets, traffic signs, sidewalks, manholes, etc.) are drawn. As the map scale gets smaller on a given series of projects, progressively more of this finite detail is omitted since it may not be visible and/or identifiable on the photos or to reduce map clutter. Hence, some of the larger features may be symbolized due to minimum size limitations.

b. *Topography*. Contouring data collection requires that the operator must set the reference mark to the prescribed elevation of a specific contour, then visually push the reference mark along that level of the terrain. The compilation system interjects an X-Y-Z point periodically to form a series of tangents. The operator can also manually record supplemental points at significant terrain breaks. Additionally, the compiler pinpoints spot elevations in a pattern sufficient to supplement the contours in presenting a true rendering of the ground character. Spot elevations should be more accurate than contours. Contours are digitized "on the fly," in that the operator causes the reference mark to lose contact with the surface of the spatial image, thereby "digging" and "floating" as the contour strings are traced. Spot elevations are stereoscopically read while the reference mark is resting idly on the spatial surface of the ground.

(3) Data edit. In this operation, the data edit technician transfers compilation data to the editing system, which comprises a control monitor, data collector, graphic viewing screen, and digitizing tablet. After making a preliminary plot of the raw mapping data, the editor orients this plot to the digitizer. He then adds, deletes, and corrects information as necessary. Contour data can be processed through a line splining routine to smooth the shape. Also, the editor can insert annotative information such as feature names. Upon completion of the editing, a final hard copy data plot is generated. The data are passed through translation software to present the mapping information in a compatible design file format to be recognized by the user's CADD system. Some data collecting systems are interfaced directly with the user CADD, such as Intergraph or Auto-CAD, so data translation in this situation would be unnecessary.

C. Data Layering. Digital data are usually separated into layers with each data layer containing specific information for related features. Individual layers could contain transportation, hydrography, contours, photo control point locations, outboundaries, vegetation, transmission lines, buildings, text annotations, and such.

C-21. DIGITAL TERRAIN MODELS.

It has been pointed out that accurate contours can be drawn from aerial photographs with the aid of a stereoplotter. An alternative to digital data contour strings is a procedure known as Digital Terrain Modelling (DTM) or Digital Elevation Modelling (DEM). Essentially, this is an analytical process that inputs a random point data base and creates contours by interpolation, similar in principle to plane table mapping on the ground.

A. Procedure

(1) Digital data collection. The stereocompiler reads a pattern of X-Y-Z coordinate points (fixed grid or random) plus strings of data points along break features (stream bottom, ridge top, edge of road, etc.).

(2) Triangulated Irregular Network. The computer then creates an optimized triangular network of interpolated X-Y-Z points called a Triangulated Irregular Network (TIN). The algorithms used to optimize the TIN are critical to the reliability of the final product.

(3) Contour interpolation. From the TIN matrix, the computer traces the course of the contours, by mathematical interpolation, between appropriate data points.

B. Advantages and Disadvantages of DTM. Both conventional contouring and DTM procedures have some advantages as well as shortcomings.

(1) The main advantage of conventional contour strings is that the stereocompiler visually traces contours, so all of the terrain features are accurately and truly depicted.

(2) Primary disadvantages of contour strings are as follows:

a. Contour strings generate a tremendous amount of data.

b. There may be no capability for cross-section and earthwork functions.

(3) Main advantages of DTM are as follows:

a. A DTM requires that significantly lesser amounts of data are generated than by conventional contour strings.

b. A DTM can readily perform cross-section and earthwork functions.

c. Elevations of individual data points are more accurate than those generated on contour strings.

(4) A primary disadvantage of DTM is that interpolated contours may not truly depict the terrain surface due to an insufficient amount of collected DTM data.

C-22. DATA COMPATIBILITY.

The advent of digital data bases and expanded microstation capabilities has been a boon to mapping and GIS/CADD applications; however, there are photogrammetric pitfalls. Perhaps the greatest hazard, though seemingly an apparent strong suit, stems from the ability of a computer, driven by proper software, to accept almost any block of X-Y-Z data and create a map to any scale or CI. A primary advantage of automated information systems is not simply aggregating various themes to draw a composite map. More important is the capability of the user to reach into the data base, select particular portions of information, and formulate alternative solutions to given situations. Automated information systems will generate hard copy maps, data tabulations, and reports.

A. Information from a multitude of diverse sources can be integrated into a single data base, since these systems are capable of comparing various blocks of dissimilar data and presenting the viewer with a composite scenario based on given situation parameters. This allows the manager to manipulate variable parameters to compare multiple solutions with limited time expenditure.

B. Collected data for various themes are placed on specific data layers for convenience in accessing the data base. For this reason individual layers must be georeferenced to a common ground reference (state plane, Universal Transverse Mercator, latitude/longitude) so that data from various layers geographically match one another when composited. Digital data for many layers will have been collected from various existing map and aerial photo sources.

C. All features go into a data base as a group of individual coordinate points that are relational to each other through a common geographic positioning grid. However, not all information is collected to the same degree of accuracy! A map is as reliable only as its most inaccurate information layer. Serious thought must be given to the compatibility of information that resides in an integrated data base.

D. As was stated previously in paragraph C-20, there are two accuracy factors to be considered, each as an autonomous parameter.

(1) Horizontal scale. Assume that digital line graphics (DLG) information is purchased economically from the USGS. This would include transportation, hydrographics, political boundaries, and land lines digitized from 1:24,000 quadrangles. These data conform to U.S. National Map Accuracy Standards, which translates to allowable inaccuracy tolerance of 50 ground feet on 1:24,000 quads. If these data are merged with other data to create a map to scale 1 in. = 100 ft, some features can be realistically misplaced by 0.5 in. at the map scale.

(2) Topographic relief. Assume that DEM information is purchased economically from the USGS. This would include 10 or 20 ft contour information, depending on which is available for the project site, digitized from 1:24,000 quadrangles. These data conform to U.S. National Map Accuracy Standards, which states that 9/10ths of contours should be accurate to within half a CI. This translates to ±5 ft for 10 ft contours and ±10 ft for 20 ft contours. If these data were to be used to create contours at 2 ft vertical intervals, which DTM software can readily accomplish, each 2 ft contour could realistically vary by as much as ±5 to 10 ft.

C-23. VOLUME AND EARTHWORK COMPUTATIONS.

A. Volume. Photogrammetry can be used to calculate volumes of stockpiled material (stone,

coal, coke, aggregates, wood chips, etc.) or volumes extracted from quarries or borrow pits. This can be accomplished by at least two methods:

(1) Cross sections. Digital data are read, directly from the stereoplotter, on profiles run at periodic intervals across a stockpile (fill) or excavation (cut) area. Volume is then computed by average end area method. In this procedure the average end area of successive pairs of profiles is calculated. This average end area is then multiplied by the interval between the pairs, and a cumulative total volume is retained.

(2) Digital Terrain Model. Random DTM data are read directly from the stereoplotter. Volume is then computed by comparing this information with a DTM from the original ground.

B. Ground Reference. In both of the situations in *a* above, information must be available for the original preconstruction terrain. If these data are not accessible, assumptions must be made as to how the terrain appeared before the excavation or piling was accomplished. For example, it may be necessary to know the volume of a stone stockpile sitting atop natural ground (which is actually the base of the pile), and there is no information with which to construct the original ground grade configuration. In this situation, there are several alternatives:

(1) Find the average ground elevation where the stockpile meets the ground's natural grade.

(2) Drill a number of holes down through the pile to determine how deep it is to natural grade (if soft material is involved).

(3) While reading cross sections on the stereoplotter, connect the extremities (natural grade) of each cross section with a straight line.

C. Earthwork. Standard cut/fill calculations can be made directly from an analytical stereoplotter. It is necessary initially to input the proposed route center-line information into the system, then select the interval between cross sections. The stereoplotter then drives the internal reference mark to the appropriate profile and the operator reads the terrain elevations. Once the data set is complete, the computer then balances the quantities of earthwork.

C-24. TOLERABLE ERRORS.

Photogrammetry is not a perfect discipline. Discounting blunders that could impact each phase of a photomapping project, the project will contain legitimate, but tolerable, inaccuracies.

A. Photography Errors.

(1) No aerial camera focal plane is absolutely flat. There are certain areas of high and low spots. When using a camera that is calibrated periodically, this is normally not a significant problem area.

(2) Due to undulating character of the ground and the varying aircraft height, scale fluctuates within a single photo as well as between adjacent photos. This situation is adjusted during stereocompilation orientation.

B. Field Control Surveys. Chapter 5 discusses maximum allowable horizontal and vertical field survey errors.

C. Aerotriangulation. Chapter 6 discusses allowable aerotriangulation errors using state-of-the-art photo control bridging procedures. If RMSE's do not meet specifications, an investigation of the aerotriangulation procedure and field survey information is indicated. It should be remembered that residual errors on individual points can very well be up to triple the magnitude of the RMS. Such errors can be "averaged out" and hidden from the user.

D. Stereocompilation.

(1) Digital mapping models are scaled and leveled to photo control mathematically, and the computer solution specifies the amount of misclosure at each control point.

(2) Visual acuity varies with each stereoplotter operator. In some situations this may affect the vertical map accuracy by an amount approaching one-fifth to one-fourth of a CI.

(3) Resolution of the photo image may affect the operator's ability to place the reference mark on the true elevation of the image object. This could be a function of weather, film processing, or diapositive processing. Usually clear, crisp days produce a "hard" or distinct image, and warm humid days result in a "soft" or hazy image. Hard models allow the reference mark to be placed more precisely in contact with the terrain than soft models.

E. Error Concept. Engineering doctrine hypothesizes that errors tend to compensate. However, the collective weight of these various inconsistencies influences the total quality. Pushing the individual phases (photography, field survey, aerotriangulation, stereocompilation) to the maximum limits can create unwelcome problems.

C-25. ORTHOPHOTOGRAPHY.

Orthophotography is a procedure that segments a raw photo image and reconstructs an or-

thogonal image that appears similar to the original. This principle can be used by inserting the aerial photos into appropriate instrumentation and generating an orthophoto image. Various systems use different techniques, but all produce similar results. There are also systems that will collect the scanned image data in digital data form, and the orthophoto negatives can be generated off-line. Only one on-line approach is presented.

A. The photos are placed into a stereoplotter-type instrument and the model is oriented to photo control.

B. The machine causes a variable-width slit to track a scan line while the operator constantly maintains the reference mark on the surface of the spatial terrain. While the slit device is in motion, the photo negative is exposed on a film base. When the scanner reaches the end of a line, it moves over to scan each successive line in turn until the entire image is created.

C. The exposed film, containing the scanned image, is processed into a negative.

D. The negative is then processed into a positive image sheet to the desired sheet format. The resultant image appears similar to the original exposure, but the inherent image feature displacement has been removed.

E. Chapter 9 discusses orthophotography.

C-26. PHOTOGRAPHIC REPRODUCTION.

Once the aerial photo negatives have been exposed, various items can be reproduced.

A. Contact Prints. These are positive prints at the same size as the negative (9 by 9in.) on paper (usually resin-coated, semimatte finish), reproducible Mylar (clear plastic), or cronapaque (opaque plastic). For best tonal quality, contact prints should be exposed on an automatic dodging printer. This equipment softens areas of high reflection and brightens dense grey areas to give the total print a more pleasing graduated gray scale. Contact prints are the same scale as the negatives.

B. Diapositives. These are positive images contact printed onto transparent Mylar at negative size and are used mostly in the stereoplotters for mapping. For best tonal quality, film plates should be exposed on an automatic dodging printer. Film plates are the same scale as the negatives.

C. Enlargements. These are photo image sheets on paper, Mylar, or cronapaque on a larger scale and sheet size than the original negative.

(1) Types of enlargements. Enlargements can be scaled or rectified.

a. Scaled. Two distant points are selected on the photo image and by some method (field measurement or scaling from existing maps) a distance is obtained between these features. Then an enlargement factor is computed, and the negative image is enlarged to that factor.

b. Rectified. More than two points are selected on the photo image and coordinates are obtained, either by measurement from field survey or from an existing map. These coordinated positions are plotted on a sheet to the desired enlargement scale. Then the enlargement is rectified to a best-fit solution on these points by tilting the enlarger easel. Some enlarging equipment is computer controlled, where coordinate data are input and the rectifying procedure is done automatically.

(2) Accuracy limitations. It should be realized that in neither of these solutions is the image truly scaled. Because of displacement inherent in the two-dimensional image, there can be objectionable measurement errors throughout the enlargement. If design measurements are to be extracted directly from the photo image on a frequent basis, serious consideration must be given to an orthophoto, or better yet, standard line mapping. Since orthophoto images are labor intensive to generate, they are significantly more costly than enlargements. But the added cost may be necessary in instances where the photo image must be accurate in its entirety.

(3) Size restrictions. There are maximum size restrictions based on the capabilities of the enlarger, base stock size, and resolution of the projected image. For best tonal quality, enlargements should be exposed on an enlarger with a quartz halogen type of light projection with an maximum enlargement factor between 12 and 20 times.

(4) Enlargement factors. Following are examples of calculation of enlargement factors and scales.

a. To obtain an enlargement at a scale of 1in. = 100 ft from an aerial photo negative that scales 1in. = 850 ft, divide the negative scale (850) by the desired enlargement scale (100), which results in an enlargement factor of 8.5X. When the entire negative (9 × 9 in.) is enlarged by 8.5 times, the enlargement would cover 9 in. × 8.5 = 76.5 in. square. Since this is larger than available material, only a portion of the negative can be placed on the sheet at that scale.

b. If an enlargement is made to fit the entire image from a 1 in. = 850 ft negative onto a sheet size of 24 × 24 in., what is the scale of the enlargement? The entire image of a negative covers an area 9 × 9 in. To fit this square onto 24 × 24 in. format, divide the enlargement dimension (24 in.) by the negative dimension (9 in.) which results in an enlargement factor of 2.67X. Since the negative scale is 1 in. = 850 ft, divide 850 by the enlargement factor (2.67), which results in an enlargement scale of 1 in. = 318 ft.

D. Image Sheets. Single- or multiple-image panels can be placed on a sheet for route studies or "plan and profile." These panels can be photo image or line work or a combination of both. They require more than a single photographic exposure on one base sheet, which becomes labor intensive.

E. Duplication Films. Either negatives or positive transparencies can be duplicated. In some cases an internegative may be required, which could increase costs and reduce image quality.

F. Photo Index. A set of contact prints is laid out on a flat surface with each full photo placed in its relative flight line position with the titling information visible. A photograph is then exposed of this assemblage, usually at a scale reduction.

G. Copies. Copies of existing line drawings and continuous tone enlargements, mosaics, and image sheets can be reproduced (enlarged or reduced) on a copy camera.

H. Mosaics. A set of contact prints or enlargements is made. Selected portions of these reproductions are cut out and glued together with the image detail of each matched with its neighbors. This assembly is then usually reproduced on a copy camera to a smaller scale. This forms a large composite of multiple exposures, which appears as a single photograph.

SECTION II
ELEMENTS OF COST ESTIMATING

C-27. PHOTOMAPPING PRODUCTION FLOW.

In order to bring the various photogrammetric mapping procedures together in a logical sequence, Fig. C-23 depicts a typical photogrammetric production flow. This should present the project elements that need to be addressed when planning, specifying, and estimating costs for a digital mapping project. Solid lines indicate primary production

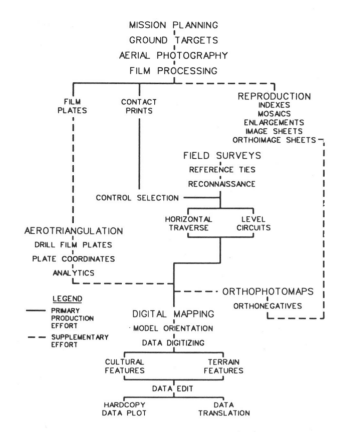

FIG. C-23. Photomapping Production Flow Diagram

effort, and dashed lines represent supplementary effort that may be required. Extensive facilities and equipment are required for a basic full-purpose production shop to handle a continuous workload of small to medium-sized digital mapping projects. The list in Table C-8 represents those average requirements.

Photogrammetric work tends to be seasonal, especially in some parts of the country. In a small production unit, to even out the workload, personnel tend to be versatile in more than one operational duty. Hence, it may not be necessary to include each and every worker to maintain production continuity. As can be seen, just a basic production unit could require as many as 20 people and perhaps a million dollars to establish. More complex mapping demands would necessitate additional equipment and personnel.

C-28. PROJECT DESIGN.

Prior to cost estimating a mapping project, there must be a concept, mental or written, as to what is required to complete that project. Writing the general job specifications and outlining the project

TABLE C-8. Requirements for Mapping Projects

Equipment (1)	Personnel (2)
Management	1 General Manager 1 Photogrammetrist 1-2 Project Managers 1-2 Clerical
Aerial Photography 1 Single-Engine Aircraft (Modified for Camera Mount) 1 Precision Aerial Mapping Camera (6-in. Focal Length)	1 Pilot 1 Photographer
Photo Lab 1 Film Processing Unit (Manual or Automatic) 1 Enlarger 1 Automatic Dodging Contact Printer 1 Copy Camera	2 Lab Technicians 1 Drafter
Field Survey 1 Field Truck 1 Theodolite 1 Electronic Distance Measurer 1 Compensating Spirit Level 1 Computer (COGO Software)	1 Crew Chief 1 Instrument Man 1 Rod Person
Aerotriangulation (If digital mapping shop includes analytical stereoplotter) 1 Point Transfer Device (If digital mapping shop includes analog stereoplotter) 1 Point Transfer Device 1 Comparator (Mono or Stereo) 1 Computer (With Analytics Software)	1 Analytical Technician 1 Analytical Technician
Digital Mapping 1 Analytical Stereoplotter (Preferable) or 1 Optical Train Stereoplotter (Acceptable) (With Digital Mapping Software Interface) 1 Edit Station (With Digitizing Tablet) 1 Computer	3 Stereocompilers 1 Data Editor 1 Computer Technician
Orthophotography 1 Orthoplotter	1 Plotter Operator

design can be helpful. The following factors must be considered in performing this effort.

A. Parameters.

(1) Project site. It is usually best to outline the site on a USGS quadrangle or another equally suitable map of the site.

(2) CI. This must be determined by the user based upon the function for which mapping is in-

tended. A general consideration is that smaller contour intervals are for design purposes, while larger intervals are for planning studies. See Chapter 2 for additional guidance in determining CI's for typical USACE projects.

(3) Mapping scale. This is also dependent upon the user's functional requirements (see Table 2-4 for guidance). It must be kept in mind that after the information resides in the data base, a map can

be generated to any scale—which can be advantageous or disastrous.

B. Photography.

(1) Photo flight parameters. Determine photo scale, film type, flight altitude, number of flight lines, and number of photographs based on the guidance in Chapter 2 and other chapters in this manual. It is good practice, once these items are calculated, to make a preliminary photo mission flight map, preferably on a USGS quadrangle map.

(2) Aircrew en route. Determine the distance from the photographer's base airport to the project site. This influences en route time for the craft and crew.

(3) Special considerations. Make some assumptions as to whether there may be any special considerations to this flight. Is the project in an area where overflights will be restricted to specific time slots? Are there any chronic adverse atmospheric (lingering haze, consistent cloud cover) or ground (snow, vegetation) conditions that will interfere with or prolong the flight?

C. Field Surveys.

(1) Travel time. Determine how far it is from surveyor's office to project site. This will influence labor travel costs and per diem expectations.

(2) Control reference. Collect information regarding nearest existing benchmarks and triangulation stations that must be used as geographic reference ties. Reference to distant established control is labor intensive and costly.

(3) Photo control density. Determine the pattern of horizontal and vertical field control points that will be needed. If a project requires preflight ground targets, it is helpful to arrange the layout on a USGS quadrangle. Ground control point selection should be done with some thought toward amenable survey routing.

D. Digital Mapping.

(1) Map detail density. Get some perception for the density of cultural features and terrain character on the site. This is normally a great variable between sites. It is probably the biggest labor-intensive item in the whole project. It takes a much longer time to digitize all of the congested cultural detail in an urban area than the few items in a rural setting. It also takes a much longer time to digitize numerous contours in rough, steep hills than a few in a flat river valley.

(2) Data edit. Once the data digitizing is complete, an edit of these data must be performed.

(3) Data translation. After data are compiled and edited, they must be translated into whatever format that is compatible with the user's CADD system.

(4) Data plot. A line plot of the digital data must be generated to assure that the data are complete and valid.

E. Miscellaneous.
Determine what other auxiliary items may be specifically required to complete this project.

(1) Does the project require any accessory photo reproduction items (contact prints, indexes, enlargements, mosaics)?

(2) Is aerotriangulation indicated?

(3) Will orthophoto image sheets be required?

(4) Are there any supplementary field surveys (bridge surveys, cross sections, well or boring location) required?

(5) Are there any supplementary digital mapping items (cross sections, boring locations, volumetrics) required?

(6) What hidden utility data text attributes will the mapper be required to integrate into the mapping data base? This can be extremely labor intensive depending on the quantity and complexity of information.

C-29. APPROACHES TO ESTIMATING PHOTOGRAMMETRIC MAPPING COSTS.

Cost estimating for photogrammetric services can be approached as follows.

A. Budgetary costs, where a realistic estimate will suffice to be included in a total cost package for seeking funds for future projects. A sample estimate of an hypothetical project is discussed in paragraph C-31.

B. Specific site costs, where the estimator wants a more specific item-oriented cost for negotiating fees with aerial photographers, field surveyors, and photomappers. Sample cost estimates for four projects are reviewed in paragraphs C-43 through C-46. Each of these examples provides a different type of finished product, and alternate approaches to estimate the various functions are presented.

C-30. BUDGETARY COST ESTIMATING.

Budgetary cost estimating can be accomplished in a number of ways, depending upon the degree of photogrammetric expertise of the estimator. Experienced technicians can call upon personal

experience or historical production records to formulate realistic cost estimates. The inexperienced estimator is disadvantaged because this background knowledge is not available to shape decisions. In this situation the estimator should consider at least three major items—aerial photography, field control surveys, and digital mapping—each appraised as a separate unit. The example budget estimate presented in paragraph C-31 will demonstrate a relatively uncomplicated procedure to develop a realistic estimate with the aid of a few graphs and tables. The estimator is encouraged to visit at least one, and preferably more, photogrammetric mapping firms and field survey operations to become acquainted with equipment, personnel duties, and procedures. Also, the estimator should make every effort to collect pertinent local labor rates, direct item costs, overhead, profit margins, and production times for field survey and mapping operations. The 1991 cost factors cited herein should be used only as examples for the estimator to become familiar with general cost estimating procedures. Finally, the estimator should select and use only those cost estimating procedures covered in this appendix that best fit the needs of the estimator's locale.

C-31. EXAMPLE PHOTOMAPPING BUDGET ESTIMATE.

A. Project Site. The scope of this sample project is to provide preliminary design mapping for an installation community development project covering the area shown on the map in Fig. C-24.

B. Major Functions.

(1) Acquire aerial photography.

(2) Accomplish field control surveys.

(3) Collect and edit digital mapping data.

C. Aids for Budgetary Costing. Tables C-9 and C-10 and Fig. C-25 will be used for budgetary cost estimating.

D. Budgetary Cost Estimating Format. Table C-9 is suggested as a format for learning to do a budgetary cost estimate only. A step-by-step discussion of this format follows. Once the estimator is familiar with the procedure, a format more suitable to a specific region can be developed.

(1) Step 1: Project Dimensions. For the purpose of this type of estimate, the project extremities should be measured from the site map. This measurement results in a square or rectangle. Acreage can be computed two ways:

a. Length (feet) × width (feet) / 43,560 (square feet per acre)

b. Length (miles) × (width (miles) × 640 (acres per square mile))

(2) Step 2: Area Expansion Factor. Project production hours for field surveys and digital mapping are to be calculated from information found in Figure C-25, which is predicated upon production hours for field surveys and production mapping per 100-acre segments. In order to expand appropriate acreage to the total site, a factor must be introduced. Hence, the number of 100-acre blocks in a project = total acreage/100 acres.

(3) Step 3: Function Ratio. The ratio of time expended by field surveys and digital mapping varies on any given project. A normal ratio would be about 35% for field surveys and 65% for digital data mapping.

(4) Step 4: Effort Hours per 100 Acres. The production time required for field control surveys and digital mapping will be estimated from Fig. C-25. This graph indicates the total hours required to control and map 100 acres on an "average" site (rolling terrain with scattered cultural development). For sites other than average, the estimator should calculate a total average cost and multiple by a factor of 1.5 for sites that are predominantly steep or culturally developed or 0.6 for sites that are flat and rural. For sites falling between these categories, the estimator must then interpolate project costs within these ranges. This sample site is heavily developed only in a limited area. The area represents three terrain slopes—flat in the east third, steep in the middle third, and rolling in the west third—which, when combined, can be considered as the equivalent of rolling on the total site. Considering both culture and terrain as "average," the production hours will be based on reading directly off the graph.

(5) Step 5: Total Effort Hours. After the appropriate production hours per each 100-acre blocks are selected, the total extrapolated number of production hours = area expansion factor × 100 acres.

(6) Step 6: Function Hours. The number of production hours by function will be:

a. Field survey hours = total effort hours × survey function ratio (35%)

b. Digital mapping hours = total effort hours × mapping function ratio (65%)

(7) Step 7: Hourly Labor Rates. When costs are calculated on an hourly rate basis, appropriate extension rates must be ascertained. In order to develop reasonable cost estimates, hourly labor rates and overhead percentage on labor must be

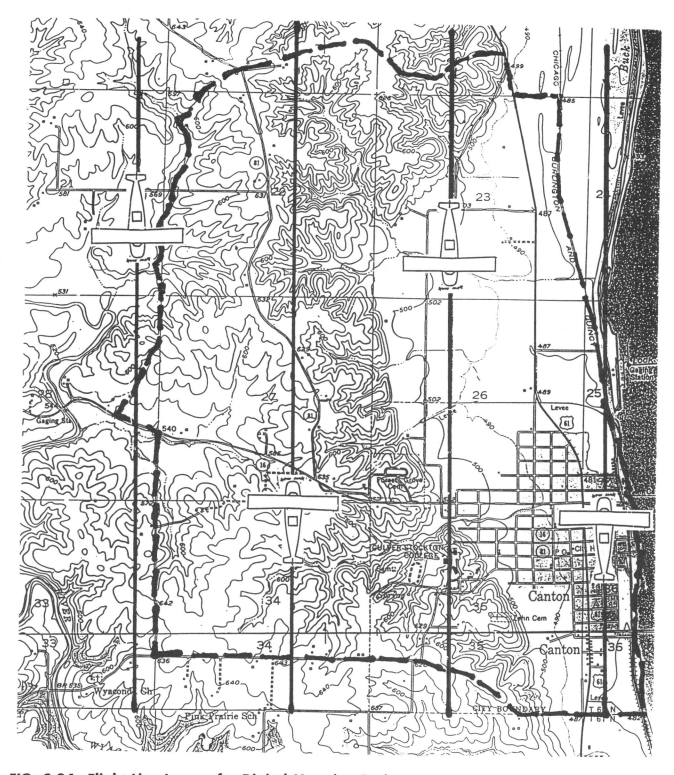

FIG. C-24. Flight Line Layout for Digital Mapping Project

TABLE C-9. Format for Budgetary Cost Estimating

Step 1. Project Dimensions

Step 2. Area Expansion Factor

Step 3. Function Ratio

Step 4. Effort Hours per 100 Acres

Step 5. Total Effort Hours

Step 6. Function Hours
 • Field Survey Hours
 • Digital Mapping Hours

Step 7. Hourly Labor Rates

Step 8. Direct Cost

Step 9. Total Estimated Project Cost

gathered. The estimator must attempt to use rates pertinent to the region in which the project site is located, using one of the following sources:

a. Negotiated contractor rates.

b. Regional wage rates as determined by Department of Labor.

c. Hired labor rates for those Districts with in-house capabilities.

Hourly labor rates are listed in Tables C-11 and C-12.

(8) Step 8: Direct Cost. Many of the direct cost items are relatively minimal as a single cost item. However, in the aggregate, these costs do impact the total cost. In budgetary cost estimating, a single lump sum percentage can be applied to cover these direct costs. Two items of mapping costs are significant:

a. Hourly rental on stereoplotter instruments, which are used to collect the digital mapping data.

b. Hourly rental on CADD systems, which may be used in the digital data editing process.

For budgetary estimating, it is realistic to presume that half of the mapping hours will be expended

TABLE C-10. Estimated Budgetary Costs for Aerial Photography

Area, Acres (1)	Cost, dollars, for Distance to Site, miles			
	100 (2)	200 (3)	300 (4)	400 (5)
Use for Maps to Scale 1 in. 5 50 ft with 1-ft CI Only				
1,000	1,700	2,100	2,900	6,600
3,000	2,100	2,500	3,300	7,000
5,000	2,700	3,100	3,900	7,600
Use for Maps to Scale 1 in. = 100 ft with 2-ft CI Only				
1,000	1,500	1,900	2,700	3,100
3,000	1,600	2,000	2,800	3,200
5,000	1,700	2,100	2,900	3,300
Use for Maps to Scale 1ft = 200 ft with 5-ft CI Only				
1,000	1,400	1,800	2,600	3,000
3,000	1,500	1,900	2,700	3,100
5,000	1,500	1,900	2,700	3,100
Use for Maps to Scale 1 ft = 400 ft with 10-ft CI Only				
1,000	1,300	1,700	2,400	2,800
3,000	1,300	1,700	2,500	2,900
5,000	1,400	1,800	2,600	3,100

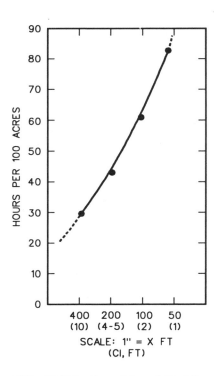

FIG. C-25. Combined Field Survey and Digital Mapping Hours Per 100-Acre Block

TABLE C-11. Hourly Labor Rates, Overhead, and Profit Margin for Photo Control Surveying

Function (1)	Maximum (2)	Average (3)	Minimum (4)
Hourly Rate, $			
Supervisory Surveyor	33.25	21.48	15.37
Party Chief	16.91	14.36	12.08
Instrumentman	13.40	11.44	9.62
Rodman	10.70	9.12	8.27
Draftsman	14.12	11.97	10.13
Computer Operator	17.80	15.75	12.24
Overhead, %	142	134	130
Profit, %	12.50	11.10	12.00

on each of the systems. The estimator must make an effort to attach a reasonable fee for these factors:

a. Negotiated contractor amortization rates.

b. Suggested rates from equipment manufacturers.

Direct cost rates are listed in Table C-13.

(9) Step 9: Total Estimated Project Cost.

a. *Aerial photography.* Table C-10 indicates the estimated costs for aerial photography. Using this table requires three parameters: map scale/CI combination (in this example, the project is to be mapped at 1 in. = 100 ft with 2 ft contours); photography area (in this example, 5,400 acres); distance from aircraft base to project site (simulated to be 150 miles for this project). Referring to the 1 in. = 100 ft/2 ft contour portion of Table C-10, the cost for flying 100 miles to photograph 5,000 acres is $1,700 and for 200 miles is $2,100, so a flight of 150 miles is interpolated to be $1,900.

TABLE C-12. Hourly Labor Rates, Overhead, and Profit Margin for Photogrammetric Digital Data Collection

Function (1)	Maximum (2)	Average (3)	Minimum (4)
Hourly Rate, $			
Chief Photogrammetrist	28.80	19.43	16.00
Photogrammetrist	21.70	16.42	13.00
Stereocompiler	15.00	11.26	8.25
Computer Operator	20.60	15.78	11.91
CADD Draftsman	13.00	10.48	8.01
Overhead, %	194	164	104
Profit, %	12.00	11.29	10.00

TABLE C-13. Direct Cost Rates

Function (1)	Rates, $ per U/M Indicated		
	Maximum (2)	Average (3)	Minimum (4)
Aircraft	375.00/hr	254.71	170.00
CADD Workstation	20.00/hr	11.65	5.77
Analytical Stereoplotter	22.47/hr	15.54	8.60
Computer Rental	15.00/hr	9.94	6.70
B&W Contact Prints	3.00/ea	3.24	1.56
Color Contact Prints	5.10/ea	3.93	1.84
B&W Diapositives	8.00/ea	3.58	1.60
Color Diapositives	12.00/plate	5.24	2.70
CADD Data Plots	22.00/sheet	20.07	13.30
	Average		
Vehicle Mileage	0.25/mile		
Field Survey Books	9.00/each		
Stakes/Lath	11.00/bundle		
Monuments	5.00/ea		
Per Diem	(per Joint Travel Regulations (JTR) rate)		
Aerial Film Processing Costs	Average Cost per Foot, $		
	Film	Processing	
Panchromatic	1.20	0.60	
B&W Infrared	2.10	0.60	
Color Infrared	4.20	1.60	
Natural Color	3.75	1.60	

Notes:
1. Assume 1 photo exposure = 1 ft of film.
2. On small jobs, minimum film charges usually apply.

b. *Lump sum factors.* Two factors should be applied to the total production costs in order to cover costs of technical supervision and aggregate of minor peripheral operations and items. Technical supervision covers the periodic effort of nonproductive managers, such as Supervisory Surveyors, Photogrammetrists, and Project Managers. A factor of 10 percent should be realistic for budgetary estimating. Minor peripheral items and operations would be survey vehicle rental, per diem, computer rental, aerotriangulation, computer operators, drafters, lab technicians, etc. These factors can vary greatly; for this project a 10 percent factor will be used.

c. *Profit.* The estimator can use negotiated contractor rates for profit margin. If these are not available, profit usually amounts to 10% to 12% of the production costs.

E. Estimating Project Costs.

(1) Defined Parameters.

a. *Contour interval.* Table C-14 indicates appropriate CI for preliminary design is 2 ft.

b. *Map scale.* Fig. C-25 indicates that the appropriate map scale for 2 ft contours is 1 in. = 100 ft.

(2) Using Table C-9 as a guide and referring to d above, the budgetary costs for this sample project are computed as follows:

a. *Step 1.* Project Dimensions:

13,000 ft long × 18,000 ft wide/43,560 ft/acre = 5,400 acres

TABLE C-14. Selection of Contour Interval

CI, ft (1)	Purpose (2)
1	Final Design and Earthwork Computations
2	Preliminary Design and Route Location
4-5	Preliminary Project Planning Phases

b. Step 2. Area Expansion Factor:

5,400 site acres/100 acres = 54

c. Step 3. Function Ratio: surveys 35%, mapping 65%.

d. Step 4. Effort hours per 100 Acres (taken from Fig. C-25) = 60 hr.

e. Step 5. Total effort hours (area expansion factor × effort hours per 100 acres) = 54 × 60 = 3,240 hr.

f. Step 6. Function hours (total effort hours × function ratio):

Surveys = 3,240 × 35%
= 1,134 hr

Mapping = 3,240 × 65%
= 2,106 hr

g. Step 7. Hourly labor rates (use mean rates from Tables C-11 and C-12):

	Surveys		Mapping
Party Chief	$14.36	Compiler	$11.26
Instrument Worker	$11.44	CADD Draftsman	$10.48
Rod Person	$ 9.12		
Avg Hrly Rates	$11.64		$10.87

h. Step 8. Direct cost (CADD system and analytical stereoplotter rental rates from Table C-13.)

CADD: 50% × 2,106 mapping hours
× $11.65 hourly rental = $12,267

Analytical Plotter:
50% × 2,106 mapping hours
× $15.54 hourly rental = $16,364

i. Step 9. Total Estimated Project Cost.

Photography:	$ 1,900
Labor:	
Surveys (1,134 hr × $11.64)	$ 13,200
Mapping (2,106 hr × $10.87)	$ 22,892
Overhead:	
(mean rates from Tables C-11 and C-12)	
Surveys ($13,200 × 133.87%)	$ 17,671
Mapping ($22,892 × 163.87%)	$ 37,513
Direct Costs:	
CADD System	$ 12,267
Analytical Stereoplotter	$ 16,364
Total Production Costs	$121,807
Supervision (@ 10%):	$ 12,181
Peripheral (@ 10%):	$ 12,181
Subtotal	$146,169
Profit (12% × $146,169)	$ 17,540
Total Project Cost (Budgetary)	$163,709

C-32. APPROACHES TO ESTIMATING DETAILED PROJECT COSTS.

Detailed cost estimates are required for contract negotiation purposes. Unlike the rough budgetary estimates described in paragraph C-31, detailed estimates must specifically account for all significant cost phases of a photogrammetric mapping operation. This is necessary since these estimates (both the Government's and the contractor's) may be subject to detailed field audits and/or other scrutiny. Also, contract modifications must be able to relate to the original estimate. Initially, it is important to specify which of the activities involved in making a map will be completed by the contractor and which may be done by the Government. USACE and other agencies may do some portion of the work. Most USACE Commands, however, contract all the mapping work and do not participate in any of the actual production activities associated with the generation of digital mapping products.

A. General Estimating Procedure. The cost estimating procedures presented here can be used to estimate all or only certain parts of a mapping project. An "add/subtract" approach was also included to maximize the applicability of this method. This approach allows each user to develop a cost estimating method that incorporates information needed in a specific locale. It is responsive to existing expertise and equipment found within USACE commands, and it allows for exclusion of

portions of a mapping project to be conducted by USACE-hired labor forces.

(1) Those using the following procedures should indicate which of these activities need to be cost estimated. Work to be omitted from the contract and performed by the Government can be excluded from this method and ignored for given project calculation of contractor costs. As stated earlier, those steps in a mapping project and in a cost estimating procedure for mapping include aerial photography, photo control surveying requirements, and map production (aerotriangulation, stereocompilation, conversion to CADD format). For each of these activities, the cost estimates have been further stratified into categories or cost elements that make up the second level of the hierarchy. Elements are grouped into costs that are based on Direct Labor, Hours, and Direct Costs. Under each second-level heading are the individual cost elements. This last "breakdown" presents a third level of detail.

(2) Paragraphs C-33 through C-42 present the cost estimating procedure in its entirety. It provides the individual cost elements or entries as a quantity (QUAN), unit measure (U/M, e.g., hours), unit price (U/P, e.g, $/hour), and/or amount (AMOUNT) or total for item. These elements can then be summed under the appropriate cost headings (e.g., Direct Labor, Hours, or Material Costs). These cost element headings can be summed for the total, and indirect costs and profit can be calculated to arrive at estimated cost for the project at hand.

B. Labor. Amount of work and cost of work that personnel will conduct is characterized as "Direct Labor, Hours" or other unit cost. This has been done for a number of reasons:

(1) It is convenient to express work in hours because it provides a per unit cost basis for estimating purposes.

(2) Salary figures are difficult to work with as an end product, but they can be unitized by division of the annual hours of work and made useful as a "unit hourly cost" for a given activity.

(3) Surveying and mapping services often have an hourly component in cost estimating, and this hourly approach is suitable to conditions under which contracting will be conducted.

(4) Hourly costs may be obtained from prequalified contractors or from wage rate determinations.

C. Direct Costs. Following the cost associated with Direct Labor or Hourly activities are costs that are direct in nature. Direct costs such as Material Costs can be easily calculated and are fixed by the number of units of a direct cost item that are required to complete the project. Typical direct cost items in large-scale aerial mapping would be the number of sheet-equivalents or feet of film that are necessary to provide photo coverage of the site.

(1) These direct costs may also be made on a per hour basis. This is the case for aircraft rental time. Therefore, it is important to realize that a number of cost items listed as either Direct or Material may be reported in hours.

(2) Direct costs may also be characterized as costs that do not have additional costs associated with their use. For example, labor costs often are associated with personnel who have benefit packages that may be charged in proportion to the time these individuals are used on the project. Direct costs may also be characterized by the fact that certain direct cost items may not be charged with additional indirect costs.

C-33. PROJECT SPECIFICATIONS.

A. Variables. It is desirable to specify a number of variables to help best characterize the mapping project and to assure that an accurate and precise cost estimate can be completed. Exact numbers and types of variables can be different for alternate approaches to cost estimating. However, a complete list of possible needs can be provided, and the required specifications can be selected from the list to customize the content for each cost estimate. It is desirable to specify a set of variables that describes the project before a cost estimate is made. Such a list or set of variables is provided herein. It includes most required items, and they should be known along with other information deemed to be useful. This would include information from this manual or in the Civil Works Construction Guide Specifications 01335. The list of specifications presents a good example of what information needs to be supplied before a cost estimation is made. This list is not exhaustive and any effort may include other variables as determined by the Command employing this method.

B. Assumptions. In developing the cost estimating method used herein, certain assumptions were employed. These are important because a variety of approaches to large-scale mapping are used in Government and industry. Some approaches make use of the latest technology and mathematical solutions. Others use older technology and methods. Here, several assumptions are made about approaches and technologies to provide uniform conditions for cost estimation. The following assumptions are made:

(1) Analytical stereoplotters will be used. For calculations the maximum C-factors for these instruments are noted in Table 2-7.

(2) Aerotriangulation spans the number of stereomodels in accordance with Table 6-1. Hence, "skeletal" field control survey procedures will be in effect.

(3) Cost per hour of personnel can be obtained from wage rates or from negotiated information supplied by the contractor.

C-34. CONTRACT PARAMETERS.

It is necessary to have information for the following items to best specify a project. Many of the items listed below are inputs to the cost estimating procedure and are used in calculations of parameters.

A. Area to be Mapped. It is desirable to provide a firm definition of the area to be mapped. This may be shown on large-scale topographic maps or 1:24,000 USGS quadrangles. Other descriptive and measurement information should be provided if available. Information may include details from surveys, deeds or whatever other documents are available. Descriptions may also include gross north-south and east-west dimensions of project.

B. Parameters. Other mapping parameters should be specified and may include the following:

(1) Final map scale.

(2) CI.

(3) Photo scale.

(4) Flight height above mean ground level.

(5) Film type.

(6) Calibrated focal length of camera.

(7) C-factor of stereoplotter.

(8) Nominal endlap.

(9) Nominal sidelap.

(10) Distance from aircraft base to project site.

(11) Flight line distance.

(12) Distance from site to nearest established horizontal control reference.

(13) Distance from site to nearest established vertical control reference.

(14) Cruising speed of aircraft.

(15) Estimate of terrain slope variability.

(16) Estimate of cultural development variability.

C. Deliverables. A list of delivery items should be supplied. This is necessary to clearly define the end products, which should ensure an accurate estimate of cost. The list below consists of a number of possible products that may be requested. Products should be specified by including them in the list. Also state the number of copies or sets to be furnished.

(1) Contact prints.

(2) Map sheets.

(3) Digital data in CADD or GIS/LIS format.

(4) Photo enlargements.

(5) Photo index.

(6) Photo mosaics.

(7) Field surveys.

(8) Orthophotos.

C-35. CALCULATED PARAMETERS.

There are several project-specific parameters that must be determined prior to cost estimating. This information is necessary to characterize the project and to supply input for the solution of individual line items.

A. Photo scale.

B. Number of flight lines.

C. Location of flight lines.

D. Number of flight line miles.

E. Number of photo exposures.

F. Flight height.

G. Acres of area to be mapped.

C-36. COST ESTIMATING ELEMENTS.

The elements of the cost estimating procedure described in this appendix are outlined in paragraphs C-37 through C-39 below. These three categories cover aerial photography, control surveys, and digital map compilation. The format used begins with detailed specifications for the individual contract effort. "Direct Labor, Hours" cost elements are provided as subheadings. "Material Costs" are addressed to complete the list of items that are to be used in costing photogrammetric mapping and aerial photographic services.

C-37. AERIAL PHOTOGRAPHY COST ITEMS.

Planning an aerial photo mission is important, because the resultant imagery impacts the accuracy of the final products. The following items are to be specified to assist in the calculations of costs associated with aerial photography.

A. Aircraft transport distance to site and return.

B. Aircraft speed.

C. Aircraft cost (charge per flight-hour).

D. Number of flight line miles.

E. Flight height above mean ground level.

F. Nominal photo scale.

G. Project size:

(1) Acres to be mapped.

(2) Gross dimensions to be photographed.

H. Contractor costs or wage rates (cost per hour). When using the formats in paragraphs C-37 through C-39, the estimator should enter the hourly labor rate for a specific technician in the "$/hour" slot. The estimator should make every effort to ensure that these rates are regional wage rates or actual contractor negotiated rates, as would be the case for work orders placed against an IDT contract. The following types of technicians would be used on a photomapping contract:

(1) Pilot and photographer on flight crew.

(2) Photo lab technician to check and title film as well as produce photo reproductions, and lay mosaics and photo indexes.

(3) Party chief, instrument worker, and rod person on field control survey crew.

(4) Drafter to make traverse diagrams, sketches, and references.

(5) Survey computer to balance traverses and level loops.

(6) Photogrammetrist to directly supervise mapping effort.

(7) Stereocompiler to collect digital mapping data.

(8) Editor/Drafter to edit digital mapping data.

(9) Computer operator to translate and manipulate digital mapping data for delivery products.

I. Itemization of labor cost items for aerial photography.

ITEM/DESCRIPTION	QUAN	U/P	AMOUNT
Labor required for flight planning (Pilot):	___ hr	$___/hr	$___
Labor for ground crew preparations prior to flight (U/M = Crew Hours (C-hr))	___ C-hr	$___/C-hr	$___
Inroad flight crew time (airfield to site)	___ C-hr	$___/C-hr	$___
Time of photography (Flight crew)	___ C-hr	$___/C-hr	$___
Film checking labor (quality check and titling) Lab technician	___ hr	$___hr	$___
Labor: Project Manager	___ hr	$___/hr	$___
Total Labor (Aerial Photography):			$___

J. Itemization of direct costs for aerial photography:

ITEM/DESCRIPTION	QUAN	U/P	AMOUNT
Aircraft Operation: Flight time to site (flight hours = miles to site times 2/average aircraft speed in mph) (U/M = Flight Hours (F-hr))	___ F-hr	$___/F-hr	$___
Photography time	___ F-hr	$___/F-hr	$___
Total aircraft rental/charge			$___
Film	___ exp	$___/exp	$___
Film Processing	___ exp	$___/exp	$___
Contact Prints (___ exp × ___ sets)	___ prints	$___/print	$___
Total Direct Costs (Aerial Photography):			$___

C-38. PHOTO CONTROL SURVEYING COST ITEMS.

A. Offsite Information. The following items are to be specified to assist in the calculations of costs associated with photo control surveying.

(1) Distance from survey office to site.

(2) Distance to horizontal reference.

(3) Distance to vertical reference.

(4) Time to complete horizontal photo control or number of points required.

(5) Time to complete vertical photo control or number of points required.

B. Itemization of Labor Costs for Photo Control Surveys.

ITEM/DESCRIPTION	QUAN	U/P	AMOUNT
Survey party labor (party chief, instrument worker, rod person):			
Inroad travel: __hr/trip × __trips = __C-hr (U/M)			
	__ C-hr	$___/C-hr	$___
Reconnaissance	__ C-hr	$___/C-hr	$___
Transfer referenced control to site:			
Horizontal ties	__ C-hrs	$___/C-hr	$___
Vertical ties	__ C-hr	$___/C-hr	$___
Horizontal control	__ C-hr	$___/C-hr	$___
Vertical control	__ C-hr	$___/C-hr	$___
Set photo targets	__ C-hr	$___/C-hr	$___
Office computations	__ hr	$___/hr	$___
Sketches & references	__ hr	$___/hr	$___
Project manager labor	__ hr	$___/hr	$___
Total Labor Costs (Surveys):			$___

C. Itemization of Direct Costs for Photo Control Surveys.

ITEM/DESCRIPTION	QUAN	U/P	AMOUNT
Target material	___targets	$___/ea	$___
Per Diem (__crewmen × ___survey days = ___days)			
	___days	$___/day	$___
Vehicle mileage			
(Inroad: ___ miles round-trip × __ trips = ___miles)			
	___miles	$___/mile	$___
Local	___miles	$___/mile	$___
Total Direct Costs (Photo Surveys)			$___

C-39. PHOTOGRAMMETRIC COMPILATION AND DIGITAL MAPPING COST ITEMS.

A. Site Specific Information. The following items are to be calculated, estimated, or measured to assist in the computing costs associated with digital mapping.

(1) Number of stereomodels to orient.

(2) Number of acres to map.

(3) Complexity of terrain character.

(4) Complexity of planimetric culture.

(5) Format translations of digital data.

B. Itemization of Labor Costs for Digital Mapping.

ITEM/DESCRIPTION	QUAN	U/P	AMOUNT
Photo control planning	__ hr	$___/hr	$___
Photo control input	__ hr	$___/hr	$___
Stereomodel orientation	__ hr	$___/hr	$___
Stereocompilation Labor			
Planimetric (___ models (or acres) × ____ hours per model (or acre) = ___ hours)			
	__ hr	$___/hr	$___
Topographic (___ models (or acres) × ____ hours per model (or acre) = ___ hours)			
	__ hr	$___/hr	$___
Digital data editing (__% of ___ total hours stereocompilation = ___ hours)			
	__ hr	$___/hr	$___
Digital data transformation or translation			
	__ hr	$___/hr	$___
Project manager labor	__ hr	$___/hr	$___
Total Labor Costs (Digital Mapping)			$___

C. Itemization of Direct Costs for Digital Mapping

ITEM/DESCRIPTION	QUAN	U/P	AMOUNT
Contact prints (control photos)	__ prints	$___/print	$___
Diapositives	__ plates	$___/plate	$___
CADD System Usage	__ hr (min)	$___/hr (min)	$___
Analytical Stereoplotter System Utilization	__ hr (min)	$___/hr (min)	$___
Data Plots:			
Preliminary (2 sets)	__sheets	$___/sheet	$___
Final	__ sheets	$___/sheet	$___
Aerotriangulation	__models	__$/model (photo)	$___
Total Direct Costs (Digital Mapping)			$___

C-40. SUMMARY OF PHOTOMAPPING COSTS.

Listed below is a summary of the costs itemized in paragraphs C-37 through C-39 with applied

overhead and profit margins to accumulate a total project cost.

Labor Costs:

Aerial Photography	$_____
Photo Control Surveying	$_____
Digital Mapping	$_____
Total Labor Costs	$_____

General and Administration
(G&A) Overhead

(Total Labor × Overhead Rate)	$_____

Direct Costs

Aerial Photography	$_____
Photo Control	$_____
Digital Mapping	$_____
Total Direct Costs	$_____

Total Project Costs

(Hourly Labor + Overhead + Direct)	$_____

Profit

(Total Project Costs × Profit Margin)	$_____
Total Estimated Project Cost	$_____
(Total Project Costs + Profit)	

C-41. COST ESTIMATING AIDS.

To support the process of estimating hours and direct costs of various photomapping phases, several estimating guidelines are included. These estimating guidelines are based on 1991 production measures and average labor costs. Maximum, average, and minimum direct labor charges are provided for each position function, based on the sample of firms indicated. Likewise, maximum, average, and minimum overhead rates and profits are shown. The overhead rate indicated includes direct fringes and G&A. It must be emphasized that these rates are taken from a relatively small sample of firms spread over CONUS, which accounts for their wide ranges. The estimator, when costing an authentic project, is urged to seek current labor rates more applicable to a project or geographical area, perhaps using regional wage rates or actual negotiated contractor rates from recent or current contracts. Although all of these estimating tools may not be suitable for every project, some may fit particular sites, or perhaps may be a catalyst to develop regional estimating tools tailored to a particular USACE Command.

A. Contour Interval. Table C-14 indicates appropriate CI's for various types of projects.

Refer also to Tables 2-4 and 2-5 for additional functional applications.

B. Aerial Photography Hourly Labor Rates. Table C-15 is a recap of 1991 labor rates for seven geographically distributed private sector aerial photographers. These wage rates may be used for general estimating purposes when specific local rates are not available.

C. Photo Control Surveying Hourly Labor Rates. Table C-11 is a recap of 1991 rates of five geographically scattered private sector surveying firms covering typical field survey services.

D. Digital Mapping Hourly Labor Rates. Table C-12 is a recap of 1991 rates of seven geographically scattered private sector aerial mappers, covering various compilation and mapping services. Functions of these individuals will include the following:

(1) Chief Photogrammetrist: concerned primarily with administrative duties, project management, client liaison.

(2) Photogrammetrist: involved in production management and technical trouble shooting.

(3) Stereocompiler: operates stereoplotter in digital mapping production. He may also do some portion of aerotriangulation such as control planning, point pugging, and plate coordinate collection.

(4) CADD Drafter: does digital data editing on a type of CADD system. He does not necessarily need to be as experienced as a stereocompiler.

(5) Computer Operator: does digital data translation, transforming, and massaging, as well as computer operation relative to aerotriangulation.

E. Aerotriangulation Rates. Rather than itemize cost for aerotriangulation operations,

TABLE C-15. Hourly Labor Rates, Overhead, and Profit Margin for Aerial Photography

Function (1)	Maximum (2)	Average (3)	Minimum (4)
Hourly Rate, $			
Project Manager	33.18	24.08	18.20
Pilot	18.20	15.42	12.07
Photographer	15.50	13.00	8.84
Lab Technician	14.00	10.84	8.84
Overhead, %	194	164	104
Profit, %	12.00	11.29	10.00

TABLE C-16. Breakdown of Operations to Calculate Aerotriangulation Time Requirements

Function (1)	Hours per Model (2)
Planning, Point Selection, and Labeling	0.50
Photo Point Pugging	0.50
Comparator Plate Coordinate Reading	0.35
Computer Input, Preparation, and Check	0.25
Computer Computations	0.35

most mappers charge a flat fee for this function—usually $70-$80 per photo at 1991 rates. In the event that it is necessary to devise a cost breakdown for control bridging, Table C-16 may be used for guidance.

F. Direct Cost Rates. Table C-13 recaps primary direct cost items.

Fig. C-26 indicates the cruising speed of aircraft relative to hourly rental fee. Once speed is determined, aircraft flight hours can be calculated.

G. Stereocompilation Hours.

(1) Model setup. Stereomodel orientation times normally run about half-hour per stereomodel.

(2) Data digitizing. Fig. C-32 through C-35 (paragraph 44*l*) may be used as aids in estimating planimetric and topographic digitizing effort.

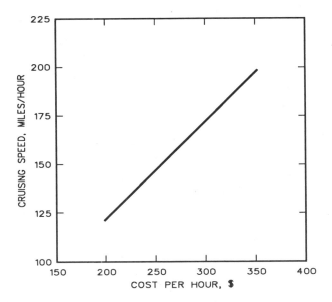

FIG. C-26. Estimating Aircraft Cruising Speed Costs

H. Digital Data Edit. Digital data editing time can range between 50–100% of digital data collection time depending upon the production routine of specific mapping units and quantity and complexity of mapping information.

C-42. PLANNING AND COSTING PHOTOGRAMMETRIC DIGITAL MAPPING PROJECTS.

Procedural planning and item costing on several example projects will follow. In these examples, the formula approach is emulated such that every item that is required to accomplish the production goal will be considered and costed. These examples are designed so that the potential estimator will become familiar with the entire estimating procedure and format.

A. The estimator, on actual projects, need not follow these formats by rote. He may pick and choose those functions that match specific project or locale requirements, and discard or revise those that are not appropriate. As discussed earlier, hourly labor rates, direct cost item rates, overheads, and profit margins used in these examples vary significantly between individual production organizations.

B. Production costs can vary significantly between geographical regions. When estimating costs for authentic projects, the estimator should seek specific procedures, historical production time estimates, hourly rates, overhead, profit margin, and direct item costs in order to tailor the costing to local experience and specific needs.

SECTION III
SAMPLE PHOTOMAPPING COST ESTIMATES

C-43. EXERCISE NUMBER 1: AERIAL PHOTO MISSION FOR PHOTO ANALYSIS PURPOSES.

A. Project. This mapping project is designed to assess stressed areas of crops in midgrowing season. The site is outlined on the map in Fig. C-27, which is taken from a portion of a 1:250,000 USGS quadrangle.

B. Requirements and Procedures.

(1) Obtain aerial photography that assures image discrimination between healthy and possibly distressed areas of crops.

FIG. C-27. Site Map for Photo Analysis Project

(2) Analysts will use the imagery to locate areas of dead or unhealthy crops, and distinguish between corn and beans.

(3) Analysts will go to the field to sample a number of areas to ascertain the veracity of the image interpretations.

(4) Using existing base map sheets, analysts will transfer photo delineations to this mapping.

(5) Analysts will than measure areas from the map and compile a report of their findings.

Items (2) through (5) are not pertinent to cost estimating the mapping work. They are included only to show how the aerial photography fits into the overall project.

C. Film. It is decided to fly color infrared (false color) aerial photography because it allows interpreters to differentiate between healthy and distressed areas of vegetation. Color infrared has at least three processing options:

(1) Film can be processed to a negative. The user may then order contact prints or transparencies to use in the interpretive work.

(2) Film can be processed directly to a color transparency. The user may then work with the image on a film positive over a light table. This is the least expensive option.

(3) Film can be processed to a transparency. The user can work with the film for image analysis. Also, paper prints can be made by going through an internegative.

Although the most expensive of the three procedures, option (3) is chosen for this example. The film positives can be used in the office for interpretive work, and the paper prints are more convenient to take to the field for ground truth verification.

D. Camera. Standard 6-in. focal length camera.

E. Photo Scale. Fly for a photo scale of 1 in. = 840 ft, which will allow discrimination between crops and other vegetation.

F. Season. Mid-June to early July would be the most advantageous time to expose photography for this particular purpose.

G. Overlap. Normal endlap (60%) and sidelap (30%) will be used.

H. Relevant Parameters.

(1) Flight height. The altitude of the aircraft (above mean ground level) will be:

$$\frac{1 \text{ in.}}{\text{scale}} = \frac{\text{focal length}}{\text{flight height}}$$

then

$$\frac{1 \text{ in.}}{840 \text{ ft}} = \frac{6 \text{ in.}}{\text{flight height}}$$

then, flight height = 6 × 840 = 5,040 ft above mean ground.

(2) Overlap gains. Image area of an aerial photograph measures 9 × 9 in. With a photo scale of 1 in. = 840 ft, the total image would be 7,560 ft square. Then:

a. Assuming normal 60percent endlap, the length of gain between photo centers along the line of flight would be:

(100% − 60%) × 7,560 = 3,024 ft

b. Assuming normal 30percent sidelap, the length of gain between flight strip centers would be:

(100% − 30%) × 7,560 = 5,292 ft

I. Flight Lines.

(1) Fly lines in north/south direction.

(2) Note that the flight lines will be a mile apart. The nature of this project places the site in a rural setting where the Public Land Subdivision System lines will be apparent for pilot to steer on section or quarter-section land lines.

(3) Measurements from the project map define that the area to be photographed covers a maximum area measuring 32 miles north-south by 25 miles east-west. The number of flight lines will be:

$$\frac{\text{total width}}{\text{sidelap gain}} = \frac{25 \text{ miles}}{1 \text{ mile}} = 25 \text{ flight lines}$$

J. Number of Photos. All of the flight lines are essentially the same length, and each flight line will require the following number of photos:

$$\frac{\text{length of line}}{\text{endlap gain}} + 1 \text{ end exposure}$$
$$= \frac{32 \text{ miles}}{0.57 \text{ mile per photo}} + 1 = 58 \text{ photos}$$

Total exposures:

number of lines × number of photos per line
= 25 lines × 58 photos = 1,450 exposures

K. Cross-Country. In order to estimate costs of an aerial photo mission, two elements must be determined:

(1) Distance from the site where the aircraft and crew are based to the project site. This can be measured from a road atlas.

(2) Speed of aircraft. Fig. C-26 indicates that the anticipated aircraft speed is relative to the hourly rental of the aircraft once hourly aircraft rental rate is known.

L. Costing Photo Mission. For this project the mean values depicted in Tables C-13 and C-15 will be employed.

(1) Ground Preparation. Prior to each day's flight the pilot and photographer must prepare the aircraft and camera for flying. This amounts to about one hour per day.

(2) Photo mission time. Table C-13 indicates an aircraft rental rate of about $255. Inserting this value into the line graph in Fig. C-26 results in a cruising speed of 150 miles per hour.

a. Photography:

$$\text{Flight lines} = \frac{25 \text{ lines} \times 32 \text{ miles per line}}{150 \text{ mph}}$$
$$= 5.3 \text{ hr}$$

$$\text{End turns} = \frac{25 \text{ lines} \times 3 \text{ min}}{60 \text{ min}} = 1.3 \text{ hr}$$

$$\text{Total photography} = \text{flight lines} + \text{end turns}$$
$$= 6.6 \text{ hr}$$

The flight is scheduled for the middle of June, which is the time of highest sun angle (the time of the solstice), which should allow for long flying days. This implies that the project could be flown in a single day. On the other hand, this site is located in the Midwest where, at this time of year, clouds tend to accumulate during the day. Also there are extended periods that are not conducive to flying, especially to photograph a color image. It is judged that it may take parts of two flying days of 3.3 hours each to complete the project.

b. En route (assume for this project that the aircraft is hangared 150 miles from the project):

$$\frac{150 \text{ miles} \times 2 \text{ ways}}{150 \text{ mph}} = 2.0 \text{ hr}$$

c. Daily flying time:

5.3 hr for each of 2 days

d. Refueling. Since the aircraft must refuel periodically (a variable item that must be adjusted for a specific aircraft used), set the aloft time limit to 4 hr, as it would be in the interest of crew safety to allow for a refueling stop.

Refuel Stop = 1 hr each of 2 days

e. Adjusted Flying Time =

6.3 hr × 2 days = 12.6 hr

(3) Photo lab work.

a. Film handling. Since false color comes on 200 ft rolls, this project will require at least seven rolls of film. Once film is exposed and processed, the accuracy of the flight line alignment, degree of crab, quality of image, and overlaps are checked by the contractor. Also the appropriate titling is stamped onto the film. Four hours per roll of film are allowed for this project.

b. Photo reference/index map. On a project requiring this magnitude of photography, a systematic reference index of the photo coverage is in order. This can be either a flight line index or a photo index.

c. Flight line index. The flight line centers are drawn on an existing map source (124,000, 1:50,000, 1:100,000, 1:250,000 USGS quadrangles can be used). Centers and identification numbers of the end photos, plus an appropriate scattering along the line, are spotted directly on the map. This is a relatively inexpensive procedure requiring a limited amount of labor-intensive activity. In many situations this product will suffice in locating specific photos covering selected areas. The following procedure will be used in this example: procure a set of 1:50,000 USGS quadrangles covering the area, draw each flight center on quad, and spot approximate center of every fifth photo on the flight lines. Estimated time for preparing this type of index is 16 hours.

d. Photo index. A set of contact prints is laid out on a flat surface with each full photo manually placed and secured in its relative position with the titling information visible. A photograph is then exposed of this assemblage, usually at a scale reduction. This method is quite labor intensive and significantly more expensive than the flight line index discussed in c above. It will not be used or estimated in this example.

M. Production Hours for Aerial Photography.

Phase	Pilot	Photographer	Lab Tech	Aircraft
Flight Plan	4.0			
Ground Prep	2.0	2.0		
En Route	4.0	4.0		4.0
Photography	6.6	6.6		6.6
Refuel	2.0	2.0		2.0
Check/Title				
Film			28.0	
Line Index			16.0	
Total	18.6	14.6	44.0	12.5

N. Cost of Aerial Photography.

(1) Salaries. Use mean hourly rates from TableC-15.

Personnel	Hours	Rate	Cost
Pilot	18.6	$15.42	$ 287
Photographer	14.6	$13.00	$ 199
Lab Tech	44.0	$10.84	$ 477
Supervision			
(10% of Others' Hours)	8.0	$24.08	$ 193
Hourly Rate Costs			$1,156
Overhead on Labor (163.87%)			$1,894
		Total Labor Cost	$3,050

(2) Direct costs. Use mean item rates from TableC-13.

Direct Cost Item	Units	Unit Cost	Cost
Aircraft	12.5	$255.00	$ 3,600
Contact Prints	1,450.0	$ 6.00	$ 8,700
Aerial Film	1,450.0	$ 4.20	$ 6,090
Film Processing	1,450.0	$ 1.60	$ 2,320
		Total Direct Cost	$20,710

(3) Total estimated costs.

Labor	$ 3.050
Direct	$20,710
Subtotal	$23,760
Profit (11.29%)	$ 2,682
Total Cost	$26,450

C-44. EXERCISE NUMBER 2: DIGITAL MAPPING PROJECT COST ESTIMATE.

A. Project. The scope of this project involves Class 2 mapping for preliminary site plan design mapping on a community development pro-ject. The site covers the area shown on the map in Fig. C-28, which is taken from a portion of a 1:24,000 USGS quadrangle.

B. Procedure. As the estimating process for this project progresses, it will become evident that the following functions will be required.

(1) Acquire aerial photography.

(2) Accomplish skeletal field control surveys.

(3) Generate photo control with aerotriangulation.

(4) Collect and edit digital mapping data.

C. Defined Parameters. At this point, a number of parameters can be defined:

(1) Contour interval. Table C-14 (or Table 2-5) indicates appropriate CI for preliminary design is 2ft.

(2) Camera. A 6 in. focal length camera will be used.

(3) Photo control. The mapping area is predominantly undeveloped so identification of sufficient photo control points that could be selected on the image is limited. Hence, aerotriangulation is indicated. Class 2 mapping limits analytical photo control bridging spans (Table 6-1) to three models for vertical and five models for horizontal.

(4) C-factor. The mapper has access to an analytical stereoplotter. Class 2 mapping limits the C-factor for an analytical stereoplotter to a maximum of 2200 (Table 7-1). Since aerotriangulation will be performed, a deformation in the vertical accuracy of the bridged photo control points can be expected. Allow for a 5percent accuracy degradation for each of the three models spanned. The revised C-factor ratio will then be 2200 × (100% − 15%) = 1870.

(5) Photo scale. This project requires a photo scale no smaller than:

$$\text{Flight Height} = \text{C-factor} \times \text{CI}$$
$$= 1870 \times 2 = 3{,}740 \text{ ft}$$

$$\text{Photo Scale} = \frac{\text{flight height}}{\text{focal length}} = \frac{3740}{6} = 623$$

$$\text{or } 1 \text{ in.} = 623 \text{ ft}$$

(6) Mapping scale. Class 2 mapping allows for a maximum image enlargement factor, from photo negative scale to target map scale, of 8 times (Table 2-6) for planimetric features. Hence, the largest map scale allowable from the 1 in. = 623 ft photos will be:

FIG. C-28. Site Map for Digital Mapping Project

$$\frac{\text{map scale denominator}}{\text{enlargement factor}} = \frac{623}{8} = 77$$

$$\text{or } \underline{1 \text{ in.} = 77 \text{ ft}}$$

Since this is an odd scale, the nearest smaller common mapping scale suitable for this project will be 1 in. = 100 ft.

(7) Overlap. The image area on a standard aerial photograph measures 9 × 9 in. With a photo scale of 1 in. = 623 ft, the total image will measure 5,607 ft square. Then:

a. Assuming normal 60percent endlap, the length of gain between photo centers along the line of flight would be:

$$(100\% - 60\%) \times 5{,}607 \text{ ft} = 2{,}243 \text{ ft}$$

b. Assuming normal 30percent sidelap, the length of gain between flight strip centers would be:

$$(100\% - 30\%) \times 5{,}607 \text{ ft} = 3{,}925 \text{ ft}$$

(8) Flight lines. Measurements from the project site map (Fig. C-28) define an area to be photographed that covers a maximum area 18,000 ft north-south by 13,000 ft east/west. The number of flight lines are then computed:

$$\frac{\text{total width}}{\text{sidelap gain}} = \frac{13{,}000}{3{,}925}$$
$$= 3.3 \text{ flight lines (use 4)}$$

Three flight lines would not sufficiently cover this project. Since four flight lines are required, the estimator can elect to recalculate a larger photo scale to better accommodate four lines. This would allow for a larger photo scale, which would increase the accuracy safety factor. On many projects, this is an option that the estimator should seriously consider. This computation involves working backward to determine the photo scale, as shown below:

a. Distance between flight line centers:

$$\frac{\text{total project width}}{\text{number of flight lines}} = \frac{13{,}000 \text{ ft}}{4}$$
$$= 3{,}250 \text{ ft}$$

β. Total ground coverage per photo width:

$$\frac{3{,}250 \text{ ft}}{(100\% - 30\%)} = 4{,}643 \text{ ft}$$

c. Photo scale:

$$\underline{\frac{4{,}643 \text{ ft}}{9 \text{ in.}} = 516 \text{ or } 1 \text{ in.} = 516 \text{ ft}}$$

d. Flight height:

photo scale denominator × focal length
$$= 516 \times 6$$
$$= 3{,}096 \text{ ft above mean ground elevation}$$

e. C-factor:

$$\frac{\text{flight height}}{\text{CI}} = \frac{3.096 \text{ ft}}{2 \text{ ft}} = 1548$$

(which would allow a greater vertical accuracy than a C-factor of 1870)

f. Enlargement factor:

$$\frac{\text{photo scale denominator}}{\text{map scale denominator}} = \frac{516}{100 \text{ ft}} = 5.16$$

(which would allow a greater horizontal accuracy than an enlargement factor of 6.23)

Conversely, the larger photo scale will create some additional labor in performing field surveys, aerotriangulation, and model orientation. Alone, none of these items is a major cost factor, but lumped together they may be an economical consideration that should be evaluated by the estimator. In order to maintain continuity in this example cost estimate, the parameters already calculated above will be used. Fig. C-24 shows the flight line layout for 1 in. = 623 ft scale photography.

(9) Number of models and photos. To calculate the number of models per flight line, simply divide total length of flight line by endlap gain:

$$\text{total models} = \text{flight lines} \times \frac{(\text{line length})}{\text{endcap}}$$
$$= 4 \times \left(\frac{18{,}00}{2{,}243}\right) = 32 \text{ models}$$

Allowing one additional photo for each line to assure stereoscopic coverage results in a total of 36 photo exposures required for the project. Often, two additional photos at the end of each flight line are specified; however, in practice, only one is necessary.

D. Estimating Photo Mission Time.

(1) Ground preparation. Prior to each day's flight the pilot and photographer must prepare the aircraft and camera for flying. This amounts to about one hour per day.

(2) Flying time. Table C-13 indicates an aircraft rental/charge rate of about $255. Inserting this value into the line graph in Fig. C-26 results in a cruising speed of 150 miles per hour.

a. Photography. It should take no more than half an hour to fly the four flight lines in this project.

b. En route flight time. Assume for this project that the aircraft is hangared 150 miles from the project:

$$\frac{150 \text{ miles} \times 2 \text{ ways}}{150 \text{ mph}} = 2.0 \text{ hr}$$

c. Project flight time = 2.5 hr
This flight can be completed in one day and its duration would not require refueling.

(3) Photo laboratory work. Checking and titling film should not exceed about 2hr for this project.

E. Production Hours for Aerial Photography.

Phase	Pilot	Photographer	Lab Tech	Aircraft
Flight Plan	1.0			
Ground Prep	1.0	1.0		
En Route	2.0	2.0		2.0
Photography	0.5	0.5		0.5
Processing			2.0	
Total	4.5	3.5	2.0	2.5

F. Cost of Aerial Photography.

(1) Salaries. Use mean hourly rates from Table C-15.

Personnel	Hours	Rate	Cost
Pilot	4.5	$15.42	$ 69
Photographer	3.5	$13.00	$ 45
Lab Tech	2.0	$10.84	$ 22
Supervision (10% of Others' Hours)	1.0	$24.08	$ 24
Hourly Rate Costs			$160
Overhead on Labor (163.87%)			$262
		Total Labor Cost	$422

(2) Direct costs. Use mean item rates from Table C-13.

Direct Cost Item	Units	Unit Cost	Cost
Aircraft	2.5	$255.00	$638
Contact Prints (2 sets)	52.0	$ 3.00	$156
Aerial Film (Panchromatic)	26.0	$ 1.20	$ 31
Film Processing	26.0	$ 0.60	$ 16
Total Direct Cost			$841

(3) Aerial photography costs.

Labor	$ 442
Direct	$ 841
Subtotal	$1,283
Profit (11.29%)	$ 145
Cost of Aerial Photography	$1,428

G. Field Control Surveys.
Costing field surveys is an individual concept. The estimator must draw upon some personal knowledge of survey procedures. Lacking that, it would be well for the estimator to sketch a diagram of anticipated control points, then confer with an experienced surveyor to estimate the expected survey hours. Defined parameters for control surveys are as follows.

(1) En route travel. Assume for this project that the office of the field surveyor is located 100 miles from the project. This equates to about half a day per crew member for each roundtrip. Crews return to the office periodically, as dictated by the policy of the surveyor. This project will require that the crew return to the home base at least once during the performance of the survey.

(2) Site reconnaissance: 8 hr per crew member

(3) Set targets. After control point locations are established and referenced, the survey crew will lay targets over the control points. It is estimated that half an hour per target per crew member will be necessary for a target time of 10hr per crew member. On the map in Fig. C-29 are designated proposed locations of preflight ground targets. Horizontal coordinates are required on the points symbolized with a triangle, and elevations are needed on points symbolized by circles. Refer to Fig. C-24 to visualize how targets relate to flight lines.

(4) Offsite control references. For this project it is assumed that there is an established triangulation station within 2 miles of the project site. A closed traverse should be run from the station to the site, then closed back on the station. The time required for a horizontal survey would be:

2 miles × 8 hr = 16 hr per crew member

The quadrangle notes a benchmark near the northeast corner of the project and another in the town near the southeast corner. A check of the Government control records verifies the existence of these stations, so there is no need to go further to tie into the vertical datum. Had these reference points not been there, the next closest benchmark is located on Highway 61 about 3 miles to the north. It would have been necessary to run a closed level circuit from this station to the project, then close back on the same benchmark, requiring about 3 days to establish this reference. Vertical surveys should be accomplished by differential leveling to third-order standards. No time needs to be allowed for a vertical survey.

FIG. C-29. Target Layout for Digital Mapping Project

(5) Horizontal traverses. The triangles shown on the target diagram in Fig. C-29 indicate that there are 11 peripheral points for which co-ordinates will be established. Each must be included in a closed horizontal traverse initiated and closed on known monuments. The time required would be:

11 targets × 8 hr = 88 hr per crew member

(6) Vertical circuits. For each of the horizontal points in the preceding paragraph, an elevation must also be obtained. The circles shown on the target diagram in Fig. C-29 indicate that there are 10 additional points for which elevations will be

established. Each of the 21 vertical points must be included in a closed level circuit initiated and closed on known benchmarks. Given measurements of the distances from target to target and closing back the circuit yields a requirement for vertical loops totaling an equivalent of at least 21 miles. The time required would be:

$$\frac{21 \text{ miles}}{2 \text{ miles daily}} \times 8 \text{ hr} = 84 \text{ hr per crew member}$$

H. Production Hours for Field Control Surveys.

Phase	Party Chief	Instr Worker	Rod/ Chain	Comp Oper	Drafts-person
Travel	16	16	16		
References					
Horizontal	16	16	16		
Vertical	—	—	—		
Reconnaissance	8	8	8		
Control Surveys					
Horizontal	88	88	88		
Vertical	84	84	84		
Targets	10	10	10		
Computations				16	
Sketches					16
Total	222	222	222	16	16

I. Cost of Field Control Surveys.

(1) Salaries. Use mean hourly rates from Table C-11.

Personnel	Hours	Rate	Cost
Party Chief	222	$14.36	$ 3,188
Instrument Worker	222	$11.44	$ 2,540
Rod/Chain Person	222	$ 9.12	$ 2,025
Computer Operator	16	$15.75	$ 252
Drafter	16	$11.97	$ 192
(10% of Others' Hours)	70	$21.48	$ 1,504
Hourly Rate Costs			$ 9,449
Overhead on Labor (133.77%)			$12,640
Total Labor Cost			$22,089

(2) Adjustments to field survey. There are at least two factors to be considered that may impact the field survey effort:

a. *Inclement weather*. This project is located in the Midwest, where the normal weather patterns can be expected to include about one day per two weeks of adverse weather conditions.

b. *Limiting field conditions*. A number of situations in the field can cause time extensions to the

field work, such as woods, dense culture, steep terrain, and limited access.

(3) Direct cost. In this example, the main direct costs include vehicle mileage and per diem for field survey crew members. Mileage normally costs about $0.25 per mile. Per diem allowances vary, depending upon cost of housing and meals in specific areas. Typically, established Federal JTR rates are used for these estimates.

Direct Cost Item	Units	Unit Cost	Cost
Mileage	2,000	$ 0.25	$ 500
Per Diem	90	$60.00	$5,400
Total Direct Cost			$5,900

J. Cost of Field Control Surveys.

Labor	$22,089
Direct	$ 5,900
Production Costs	$27,989
Inclement Weather (10%)	$ 2,799
Adverse Conditions (7%)	$ 1,959
Subtotal	$32,747
Profit (12.1%)	$ 3,962
Cost of Field Control Surveys	$36,709

K. Costing Aerotriangulation.

(1) Rather than itemize costs for aerotriangulation operations, most mappers charge a flat fee (usually $70 to $80 per photo) for this procedure.

(2) Aerotriangulation costs:

36 photos @ $75 = $2,700

L. Costing Digital Mapping.
Compilation of digital mapping data, in most situations, is the single most costly function in a mapping project. Estimating production hours is very subjective depending upon the density of planimetric culture and complexity of terrain character. Subsequent figures in this appendix may be used as aids in estimating compilation rates.

(1) Precompilation. Prior to commencing field surveys, field control points must be selected on the control photos. In this situation, targets were set rather than selecting photoidentifiable image points. This time would be used to plan a preflight target pattern. The time needed for photo control planning:

No. models × 0.25 hr ea = 32 × 0.25 = 8 hr

(2) Control data entry. Once field surveys and aerotriangulation have been accomplished, photo control data must be entered into the data

base. This can be typed in manually or entered via a data disk. The time needed for photo control input:

No. models × 0.25 hr = 32 × 0.25 = 8 hr

(3) Model orientation. Prior to collection of digital mapping data, the stereomodels must be oriented to the photo control data. Aerotriangulation should locate and correct errors in field surveys, so for stereomodels that have been analytically bridged, 0.5 hr should be sufficient to orient stereomodels in analytical plotters. In cases of conventional control problems and analog plotters, up to one full hour may be in order. The time needed for stereomodel orientation:

No. models × (0.5 to 1.0 hr) = 32 × 0.5 = 16 hr

(4) Photogrammetric digital data collection. Two major items are considered in estimating times to compile mapping data: planimetric features and terrain character. Because of varying intricacy from site to site, they should be considered and estimated separately.

(5) Planimetric Density:

a. Make a copy of the portion of the USGS quadrangle containing the mapping area.

b. Outline major areas of comparably developed cultural features similar to those shown in Fig. C-30.

c. Using the Culture Density Classification Template shown in Fig. C-31, estimate the percentage of cultural buildup at each level. The relative percentages are shown in Fig. C-30 (i.e., 10 and 80% levels).

d. With the aid of a polar planimeter, digitizing tablet, or a systematic/random pattern dot grid, measure the acreage of each density level as depicted in Fig. C-30.

e. Referring to Fig. C-32, use the 1 in. = 100 ft line to interpolate the number of tenths of hours of compilation time required for planimetric density levels selected above.

f. Enter pertinent information from items above into the tabular summary below. Multiply Acres/Type by Hours/Acre to complete summary.

Mapping Planimetric Features

Density	Acres/Type	Hours/Acre	Hours/Type
10	3,750	0.05	187
80	250	0.37	92
Total Planimetric Data Hours			279

(6) Terrain Slope.

a. Make a copy of the portion of the USGS quadrangle containing the mapping area.

b. Outline major areas of comparable terrain slope as shown in Fig. C-33.

c. Using the Terrain Slope Density Classification Template shown in Fig. C-34, estimate the slope factor of terrain for each area outlined in Fig. C-33 (i.e., 15, 35, and 55% estimates of relative gradient).

d. With the aid of a polar planimeter, digitizing tablet, or systematic/random pattern dot grid, measure the acreage of each slope level (i.e., the area of the 35 and 55% relative gradients shown in Fig. C-33).

e. Referring to the 2 ft contour line in Fig. C-35, interpolate the number of tenths of hours required for each slope density level selected above.

f. Enter pertinent information from items above into the tabular summary below. Multiply Acres/Type by Hours/Acre to complete summary.

Mapping Topography

Slope	Acres/Class	Hours/Acre	Hours/Type
15	1,500	0.08	120
35	1,350	0.17	230
55	1,150	0.25	289
Total Topographic Data Hours			639

(7) Digital data editing. After the digital data are compiled, it is then necessary to perform an edit operation on the mapping data base. The amount of editing time can vary considerably, depending on production system and application, but it normally runs between 60 to 100% of stereocompilation time. Estimators should consult with contractors or other mapping agencies to determine what editing surcharge will best fit specific operations. In this situation, the mapping data appear to be relatively clean and straightforward, so an edit percent surcharge of 70% is used in the estimate. The time needed for editing stereomapping digital data:

(plan hours + topo hours) × 70% edit
= (279 + 639) × 70% = 643 hr

(8) Data format translation. Configurations of photogrammetric mapping systems vary widely. For example, if the stereoplotter collects data in ASCII format and the user CADD is AutoCAD, then data must be translated into Drawing Interchange

FIG. C-30. Major Areas of Cultural Density Classification

File (DXF) format before entering the user system. In this case, data must be translated, and this operation is a cost item that must be included. Some systems may be interfaced to the specific CADD system (AutoCAD, Intergraph) of the data user; thus, the data coming from the stereoplotter to the CADD may need no further processing. Also during this operation, the editor may configure the data base into specific sheet data. Hours for this function can vary. Here again, the estimator should consult

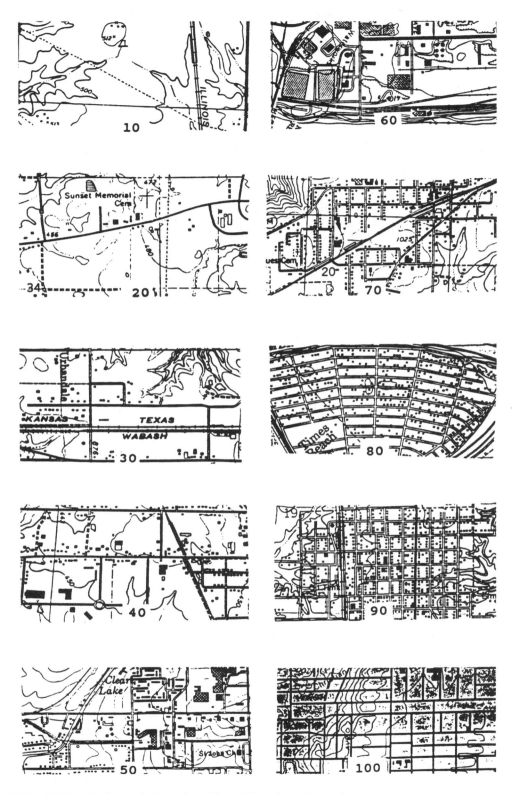

FIG. C-31. Cultural Density Classification Template

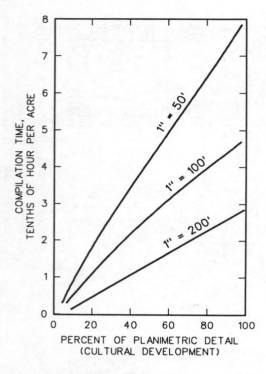

FIG. C-32. Planimetric Compilation Mapping Hours Per Acre Given Varying Cultural Densities

with contractors or other mapping agencies to determine percentage surcharges required for this phase of the work. In this example, a 5% surcharge is employed for data translation. The time needed for digital data translation: 5% × mapping hours = 46 hr.

(9) Hard copy data plots. As part of the data collection package, at least three sets of hard copy map sheets should be plotted:

a. Preliminary edit.

b. Final edit

c. Delivery data plot.

In this example, a 28 × 40 in. ANSI F-Size sheet with a 25 × 37 in. neat mapping area will be used. The estimator should measure gross dimensions and divide by 2,500 ft north-south and 3,700 ft east/west. To calculate the number of map sheets:

$$\left(\frac{\text{NS length}}{2,500}\right)\left(\frac{\text{EW length}}{3,700}\right) = \left(\frac{17,00}{2,500}\right)\left(\frac{13,00}{3,00}\right)$$
$$= 28 \text{ sheets}$$

M. Production Hours for Digital Mapping.

Phase	Stereo Compiler	Data Editor	Computer Operator
Control Planning	8		
Survey Input	8		
Model Setup	16		
Digital Data			
Planimetric	279		
Topographic	639		
Data Edit		643	
Translation			46
Total Hours	950	643	46

N. Cost of Digital Mapping. Use mean hourly rates from Table C-12.

Personnel	Hours	Rate	Cost
Stereocompiler	950	$11.26	$10,697
Data Editor	643	$10.48	$ 6,739
Computer Operator	46	$15.78	$ 726
Supervision:			
Chief Photogrammetrist (3% of Production Hours)	49	$19.43	$ 952
Photogrammetrist (7% of Production Hours)	115	$16.42	$ 1,888
	Hourly Rate Costs		$21,002
	Overhead on Labor (163.87%)		$34,416
	Total Labor Costs		$55,418

O. Direct Cost. Use mean direct cost item rates from Table C-13.

Direct Cost Item	Units	Cost/Unit	Cost
Diapositives	36	$ 4.00	$ 144
Prelim Data Plot	56	$20.00	$ 1,120
Delivery Data Plot	28	$20.00	$ 560
Analytical Plotter (Data Collection)	918	$15.54	$14,266
CADD (Data Editing)	729	$11.65	$ 8,493
Computer (Data Translation)	47	$10.00	$ 470
	Direct costs		$25,053
	Labor + Direct		$80,471
	Profit (11.29%)		$ 9,085
	Cost of Digital Mapping		$89,556

P. Total Estimated Project Cost.

Aerial Photos	$ 1,428.00
Field Control Survey	$ 36,709.00
Aerotriangulation	$ 2,700.00
Digital Mapping	$ 89,556.00
Total Project Cost	$130,393.00

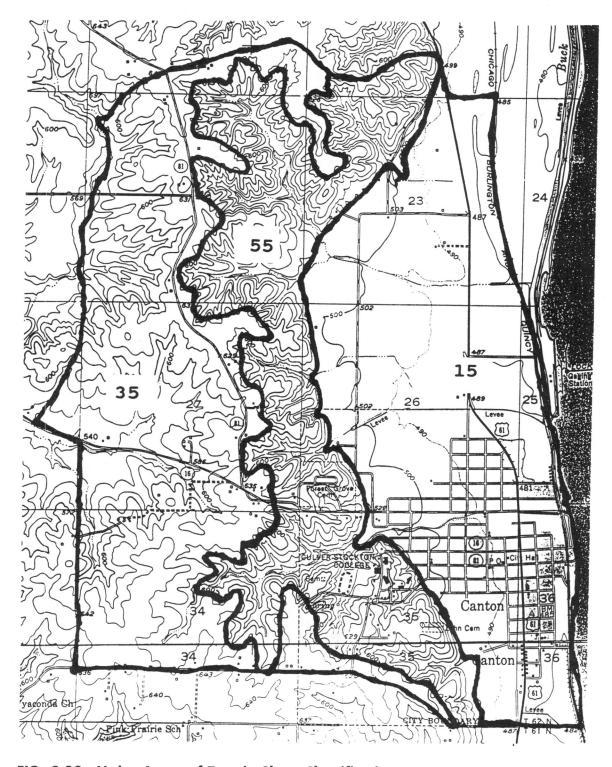

FIG. C-33. Major Areas of Terrain Slope Classification

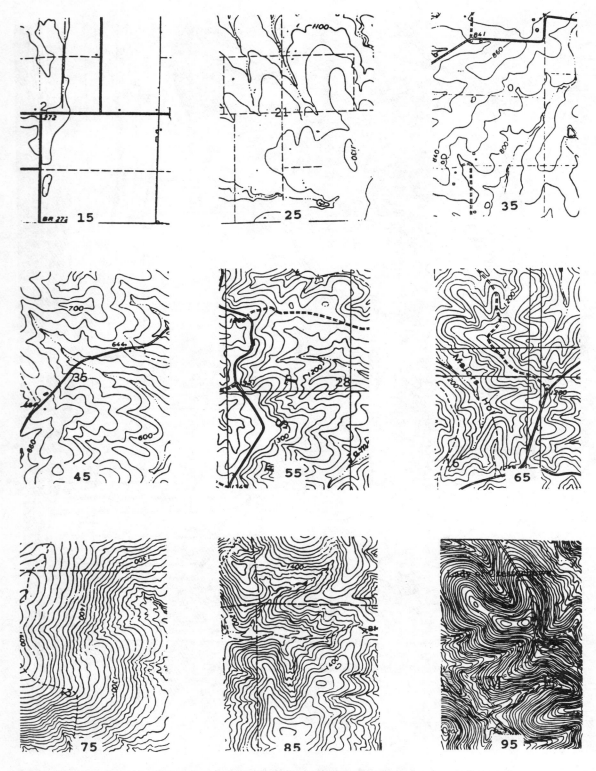

FIG. C-34. Terrain Slope Density Classification Template

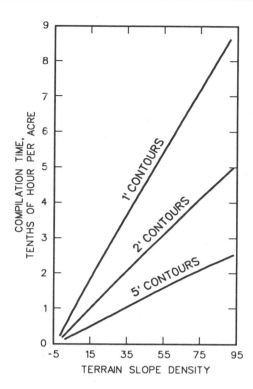

FIG. C-35. Topographic Compilation Mapping Hours Per Acre Given Varying Terrain Character Classifications

FIG. C-36. Site Map for Design Mapping and Orthophoto Project

Q. Comparison to Budgetary Cost. It is noted that a budgetary cost was estimated for this same project in paragraph C-30.

C-45. EXERCISE NUMBER 3: COST ESTIMATE FOR DESIGN MAPPING WITH ORTHOPHOTO IMAGE.

A. Project. In this example it is desired to obtain Class 1 mapping to collect digital data for earthwork excavation and placement for road construction. The digital data will also be used for utility design on a park site fronting a proposed lake. Also, Class 2 orthophoto image sheets will be produced to scale 1 in. = 100 ft for facilities layout use. The project area is shown on the map in Fig. C-36, which is copied from a portion of a 1:24,000 USGS quadrangle.

B. Procedure. As the estimating process progresses, it will become evident that the following functions will be required in this effort:

(1) Acquire aerial photography.

(2) Accomplish skeletal field control surveys.

(3) Generate photo control with aerotriangulation.

(4) Collect digital mapping data in DTM format and produce a hard copy line drawing to a scale of 1 in. = 50ft; planimetric and topographic digital data to USACE Class 1 accuracy standards (see Chapter 2).

(5) Generate orthophoto negatives and produce Class 2 orthophoto image sheets to a scale of 1 in. = 100 ft.

C. Defined Parameters. At this point a number of parameters can be defined:

(1) Contour interval. Tables C-14, 2-4, and 2-5 indicate appropriate CI for earthwork computations and final design is 1 ft.

(2) Camera. A 6 in. focal length camera will be used.

(3) Photo control. Mapping area is predominantly undeveloped, so identification of sufficient photo control points that could be selected on the image is limited. Hence, aerotriangulation is indicated. Class 1 mapping limits bridging spans (Table 6-1) to:

a. Two models for vertical.

b. Four models for horizontal.

(4) Photo scale. In this situation, two considerations are important: vertical accuracy of topographic data and horizontal accuracy of orthophoto imagery.

a. Topographic. USACE Class 1 mapping standards limit C-factor for analytical stereoplotter to

a maximum value of 2000 (Table 2-7). Aerotriangulation will be performed, so a deformation in the vertical accuracy of the bridged photo control points can be expected. Allow a 5percent accuracy degradation for each of the two models spanned.

$$\text{Revised C-factor} = 2000 \times (100\% - 10\%)$$
$$= 1800$$

$$\text{Flight height} = \text{C-factor} \times \text{CI}$$
$$= 1800 \times 1 = 1,800 \text{ ft}$$

$$\text{Photo scale} = \frac{\text{flight height}}{\text{focal length}} = \frac{1800}{6}$$

b. Orthophoto image. Class 2 orthophoto imagery limits maximum enlargement factor, from photo scale to orthophoto image sheet scale, to six times (Table 9-1). Hence, photo scale is computed as:

map scale denominator × enlargement factor
=100 × 6 = 600 or 1 in. = 600 ft

c. This project should be flown at both scales.

(5) Overlap. Image area of a standard aerial photograph measures 9 × 9 in.

Scale	1 in. = 300 ft	1 in. = 600 ft
Gross Image Coverage	2,700 ft × 2,700 ft	5,400 ft × 5,400 ft
Endlap (30% Forward Overlap) (Between Consecutive Exposures)	1,080 ft	2,160 ft
Sidelap (70%) (Between Adjacent Flight Lines)	1,890	3,780

(6) Flight lines.

a. Mapping flight:

$$\text{Number of flight lines} = \frac{\text{project width}}{\text{sidelap gain}} = \frac{3200}{1890}$$
$$= 1.69 \text{ lines}$$

which necessitates two lines as shown in Fig. C-37a.

b. Orthophoto flight

$$\text{Number of flight lines} = \frac{\text{project width}}{\text{sidelap gain}}$$
$$= \frac{3200}{3700} = 0.85 \text{ line}$$

which necessitates one line as shown in Fig. C-37b.

(7) Number of photos.

a. Mapping flight:

Line	Length, ft	Photos
1	3,600	4
2	3,600	4

Allow an additional photo for each line to assure stereoscopic coverage, which results in a total of 10 photos.

b. Orthophoto flight:

Line	Length, ft	Photos
1	3,600	4

a. Digital Mapping

b. Orthophotos

FIG. C-37. Flight Line Layouts

Allow an additional photo for the one flight line to assure stereoscopic coverage, which results in a total of three photos.

D. Estimating Photo Mission Time.

(1) Ground preparation. Allow 1hr per day.

(2) Flying time. Table C-13 indicates an aircraft rental rate of about $255. Inserting this value into the line graph in Figure C-26 results in a cruising speed of 150 miles per hour.

a. En route time, assuming for this project that the aircraft is hangared 100 miles from the project:

$$\frac{100 \text{ miles} \times 2 \text{ ways}}{150 \text{ mph}} = 1.3 \text{ hr}$$

b. Photography. The following times are estimated:

Mapping Flight for Lines	0.2 hr
Changing Altitude	0.2 hr
Ortho Flight	0.1 hr
Total	0.5 hr

c. Total flying time:

En route + photography = 1.3 + 0.5 = 1.8 hr

E. Production Hours for Aerial Photography.

Phase	Pilot	Photographer	Lab Tech	Aircraft
Flight Plan	1.0			
Ground Prep	1.0	1.0		
En Route	1.3	1.3		1.3
Photography	0.5	0.5		0.5
Processing			2.0	
Total	3.8	2.8	2.0	1.8

F. Cost of Aerial Photography. Use mean labor rates from Table C-15.

Personnel	Hours	Rate	Cost
Pilot	3.8	$15.42	$ 59
Photographer	2.8	$13.00	$ 36
Lab Tech	2.0	$10.84	$ 22
Supervision (10% of Others' Hours)	1.0	$24.08	$ 24
Hourly Rate Costs			$141
Overhead on Labor (163.87%)			$231
Total Labor Cost			$372

Use mean direct costs from Table C-13.

Function	Units	Unit Cost	Cost
Aircraft	1.8	$255.00	$459
Contact Prints (2 sets)	30.0	$ 3.00	$ 90
Aerial Film (panchromatic)	15.0	$ 1.20	$ 18
Film Processing	15.0	$ 0.60	$ 9
Total Direct Cost			$576

Labor + Direct		$ 948
Profit (11.29%)		$ 107
Cost of Aerial Photography		$1,055

G. Field Control Surveys.
Costing field surveys is an individual concept. The estimator must draw on some personal knowledge of survey procedures. Lacking that, it would be well to confer with an experienced surveyor.

H. Estimating Field Control Hours.

(1) En route travel: Assume that the office of the field surveyor is local to the project, so no en route travel is indicated.

(2) Offsite control references:

a. For this project, it is assumed that there is an established triangulation station within 2 miles of the project site. A closed traverse should be run from the station to the site then tied back on the station. The time needed for horizontal control:

2 miles × 8 hr = 16 hr per crew member

b. The quadrangle notes two benchmarks within 2miles of the site. A level circuit is run from this station to the project, then closed back to either one of the two benchmarks. Vertical surveys should be accomplished by differential leveling to third-order standards. The time needed for vertical control:

2 miles × 8 hr = 16 hr per crew member

(3) Site reconnaissance: On a small open site such as this, 2hr per crew member would be sufficient.

(4) Set targets. Refer to target diagram in Fig. C-38 for proposed target pattern. The time needed to set targets:

9 targets × 0.5 hr = 4 hr per crew member

(5) Establish control points:

a. Horizontal. The target diagram in Fig. C-38 indicates that there are seven points, symbolized with triangles, for which coordinates will be established. It is critical that each of these coordinates be accurately surveyed. Each must be included

FIG. C-38. Proposed Target Layout Diagram

in a closed horizontal traverse initiated and closed on known coordinates. The time needed to establish coordinates:

7 points × 2 hr = 14 hr per crew member

b. The target diagram also indicates that there are nine points, symbolized with triangles and circles, for which elevations will be established. Since the project is set up to bridge photo control with a three-model span, it is critical that each of these elevations is correct. Each must be included in a closed level circuit initiated and closed on known benchmarks. The time needed to establish elevations:

9 targets × 2 hr = 18 hr per crew member

c. Adjustments to survey time. A few items should be considered for adjusting field survey production. Since the crew will work out of the home office, there will be no need to consider inclement weather costs. Several situations could increase horizontal and vertical survey time—cultural development, woods (especially when foliage is present), and adverse terrain slopes. Individually, or in combination, these could increase survey time constraints. On this project example, there should be minimal culture and limited slopes and/or tree cover to interfere with control procedures; therefore, no additional control time is in order.

I. Production Hours for Field Control Surveys.

Phase	Party Chief	Instr Worker	Rod/ Chain	Comp Oper.	Drafts-person
Travel	0	0	0		
References					
Horizontal	14	14	14		
Vertical	16	16	16		
Reconnaissance	4	4	4		
Control Surveys					
Horizontal	16	16	16		
Vertical	18	18	18		
Targets	4	4	4		
Computations				8	
Sketches					8
Totals	72	72	72	8	8

J. Cost of Field Control Surveys.

(1) Salaries. Use mean hourly rates from Table C-11.

Personnel	Hours	Rate	Cost
Party Chief	72	$14.36	$1,034
Instrument Worker	72	$11.44	$ 824
Rod/Chain Person	72	$ 9.12	$ 657
Computer Operator	8	$15.75	$ 126
Draftsperson	8	$11.97	$ 96
Supervision (10% of Others' Hours)	23	$21.48	$ 494
Hourly Rate Costs			$3,231
Overhead on Labor (133.77%)			$4,322
Total Labor Costs			$7,553

(2) Direct cost. In this example the main direct cost would be vehicle mileage at about $0.25 per mile.

Direct Cost Item	Units	Cost/Unit	Cost
Vehicle Mileage	250	$0.25	$63
Total Direct Cost			$63

(3) Total estimated field control survey costs.

Labor + Direct	$7,553
Direct	$ 63
Survey Costs	$7,616
Profit (12.1%)	$ 922
Cost of Field Control Surveys	$8,538

K. Costing Aerotriangulation. In this example, rather than costing control bridging at a

FIG. C-39. Cultural Density Classification

lump sum per model, the operation breakdown in Table C-16 will be utilized.

(1) Estimated hours: Use Table C-16 for function breakdown.

Function	Hours/Model	Models	Total Hours
Plans	0.50	8	4.0
Pugging	0.50	8	4.0
Comparator	0.35	8	2.8
Input	0.25	8	2.0
Computer	0.35	8	2.8
		Total	15.6

(2) Estimated cost. Use mean rates in Table C-12.

Personnel	Hours	Rate	Cost
Stereocompiler	10.8	$11.26	$122
Computer Operator	4.8	$15.78	$ 76
Hourly Cost			$198
Overhead (163.87%)			$324
Total Hourly Cost			$522
Profit (11.29%)			$ 59
Total Cost			$581

L. Calculating Digital Mapping Hours.

(1) Precompilation.

a. Control planning. Prior to commencing field surveys, field control points must be selected on the control photos.

models × 0.25 hr = 8 × 0.25 = 2 hr

b. Control input. Once field surveys and aerotriangulation have been accomplished, photo control data must be entered into the data base.

models × 0.25 hr = 8 × 0.25 = 2 hr

c. Model orientation. Prior to collection of digital mapping data, the stereomodels must be oriented to the photo control data. Aerotriangulation should locate and correct errors in field surveys, so for stereomodels which have been analytically bridged, 0.5 hr should be sufficient to orient stereomodels in analytical plotters. In cases of conventional control problems or when using analog plotters, up to one full hour may be in order.

models × (0.5 to 1.0 hr) = 8 × 0.5 = 4 hr

(2) Digital data stereomapping.

a. Planimetric density. Refer to Fig. C-39. Since this project is essentially rural, there would be only a single low-density cultural development class. Using Fig. C-31, estimate the percentage of cultural buildup for this class. With the aid of a polar planimeter, digitizing tablet, or systematic/random pattern dot grid, measure the acreage of each density level. Referring to the 1 in. = 50 ft line in Fig. C-32, interpolate the number of tenths of hours required for planimetric density levels. Enter pertinent information into the tabular summary below. Multiply Acres/Type by Hours/Acre to complete summary.

Density	Acres/Type	Hours/Acre	Hours/Type
10	175	0.07	12

b. Terrain slope. Make a copy of the portion of the USGS quadrangle containing the mapping area. Outline major areas of comparable terrain slope similar to that shown in Fig. C-40. Using Fig. C-34, estimate the terrain slope factor at each level. With the aid of a polar planimeter, digitizing tablet, or systematic/random pattern dot grid, measure the acreage of each slope level. Referring to the 1-ft contour line in Fig. C-35, interpolate the number of tenths of hours required for slope density levels selected. Enter pertinent information into the tabular summary below. Multiply Acres/Type by Hours/Acre to complete summary.

Slope	Acres/Class	Hours/Acre	Hours/Type
15	60	0.15	9
25	75	0.25	19
65	40	0.55	22
Total Topographic Data Hours			50

FIG. C-40. Terrain Slope Classification

(3) Digital data editing. (See discussion under Example 2, paragraph C-44*l*(7)).

(plan hours + topo hours) × 70% edit
= (12 + 50) × 70% = 43 hr

(4) Data format translation. (See discussion under Example 2, paragraph C-44*l*(8)).

5% × mapping hours = 3 hr

(5) Production hours for digital mapping.

Phase	Stereo Compiler	Data Editor	Computer Operator
Control Planning	2		
Survey Input		2	
Model Setup		4	
Digital Data			
Planimetric		9	
Topographic		50	
Data Edit		43	
Translation			2
Total Hours	67	43	2

M. Costing Digital Mapping. Use mean hourly rates from Table C-12.

(1) Labor costs.

Personnel	Hours	Rate	Cost
Stereocompiler	67	$11.26	$ 754
Data Editor			
(CADD Draftsman)	43	$10.48	$ 451
Computer Operator	2	$15.78	$ 32

Supervision:			
Chief Photogrammetrist (3% of Production Hours)	3	$19.43	$ 58
Photogrammetrist	7	$16.42	$ 115

(7% of Production Hours)

Hourly Rate Costs		$1,410
Overhead on Labor (163.87%)		$2,311
Total Labor Costs		$3,721

(2) Direct cost. Use mean direct cost item rates from Table C-13. In this example the stereoplotter will be analog. Hence, there will be no hourly rental of an analytical plotter. On the other hand, the analog plotter is also being used as a CADD system. Hence, hourly stereocompilation and editing time will be charged as CADD usage hours.

Direct Cost Item	Units	Cost/Unit	Cost
Diapositives	10	$ 4.00	$ 40
Preliminary Data Plot	4	$20.00	$ 80
Delivery Data Plot	2	$20.00	$ 40
CADD System (Data Collection)	62	$11.65	$ 722
CADD (Data Editing)	41	$11.65	$ 448
Computer (Data Translation)	2	$10.00	$ 20
Direct Costs			$1,400
Labor + Direct			$5,121
Profit (11.29%)			$ 578
Cost of Digital Mapping			$5,699

N. Producing Ortho Image Sheets. Ortho negatives will be produced from the higher altitude photography.

(1) A double model (two consecutive ortho negatives without a visible seam in the match area) will be produced.

(2) A negative will be produced of the border sheet.

(3) A negative will be produced of the contour data plot.

(4) A positive copy will be produced by compositing the border and contour data plot, and overlaying the orthophoto image. This will require exposing each of three negative images onto each of the final sheets.

O. Costing Orthophoto Sheets.

(1) Orthophoto negatives. Some sources charge lump sum per model while some charge hourly rates for personnel and equipment. A cost in the neighborhood of $200-$250 per single model is realistic.

2 models × $225 = $450

(2) Orthophoto image sheets.

a. Sheet border negative: $50

b. Orthophoto image sheet positives (this will require multiple exposures):

2 sheets @ $150 = $300

(3) Orthophoto image sheet costs.

Orthophoto Negatives	$ 450
Sheet Border Negative	$ 50
Hard Copy Contour Data Plot	$ 40
Contour Plot Negatives	$ 64
Orthophoto Image Sheet Positives	$ 300
Production Cost	$ 904
Profit (11.29%)	$ 102
Total Cost	$1,006

P. Total Estimated Project Cost.

Aerial Photos	$ 1,055
Field Control Survey	$ 8,538
Aerotriangulation	$ 581
Digital Mapping	$ 5,699
Ortho Image Sheets	$ 1,006
Total Project Cost	$16,879

C-46. EXERCISE NUMBER 4: COST ESTIMATE FOR PHOTO IMAGE PLAN SHEETS.

A. Project. This project entails producing photo image plan sheets at a scale of 1 in. = 500 ft for general planning and land use/cover applications. The site requires bluff-to-bluff coverage bordering the stretch of the river indicated in Fig. C-41, which is copied from a portion of a 1:250,000 USGS quadrangle.

B. Requirements and Procedures. The following functions will be required:

(1) Obtain aerial photography suitable to fit on a 28× 40 in. sheet with 25 × 37 in. neat image area.

(2) Gather appropriate control information to scale the photo image.

(3) Produce photo image sheets with appropriate border information.

C. Film. The image sheets are intended for reproduction as needed on a black-and-white copy machine. Fly panchromatic aerial photography.

D. Camera. Use a 6-in. focal length camera.

E. Photo Scale. The image area width on a sheet is 25 in. × 500 ft = 12,500 ft, which, by measurement of maximum floodplain width on Fig. C-41, allows all of the area of interest to fit on a single sheet width. A 5× enlargement factor will produce good quality image, so it is decided to fly at a photo scale of 1 in. = 2,500 ft.

F. Season. It would probably be best to fly this project in a foliage-free condition, which would allow for imagery with a pleasing range in gray scale. It would also permit visibility of the ground under vegetative cover. If flown in foliage seasons, image would exhibit more striking contrast and some ground features would be obscured.

G. Overlap. It would be advantageous to fly with 80% endlap. Each sheet could then be produced from the single photo best fitting that particular image area.

H. Relevant Parameters.

(1) Flight height. The altitude of the aircraft (above mean ground level) will be:

$$\frac{1 \text{ in.}}{\text{scale}} = \frac{\text{focal length}}{\text{flight height}}$$

then

$$\frac{1 \text{ in.}}{2,500 \text{ ft}} = \frac{6 \text{ in.}}{\text{flight height}}$$

and the flight height = 6 × 2,500 = 15,000 ft above mean ground elevation.

(2) Overlap Gains. Image area of an aerial photograph measures 9 × 9 in. With a photo scale of 1 in. = 2,500 ft, the total image would be 22,500 ft square. Then assuming nominal 80percent endlap the length of gain between photo centers along the line of flight would be:

(100% − 80%) × 22,550 = 4,500 ft

I. Flight Lines. Flight line layout is shown in Fig. C-42.

J. Number of Photos.

Line	Length, ft	Photos
1	14,600	3
2	70,800	16
3	29,200	7
4	62,500	14
5	50,000	12
6	79,200	18
7	66,700	15
8	25,000	6
Total		91

FIG. C-41. Site Map of Photo Image Plan Sheet Project

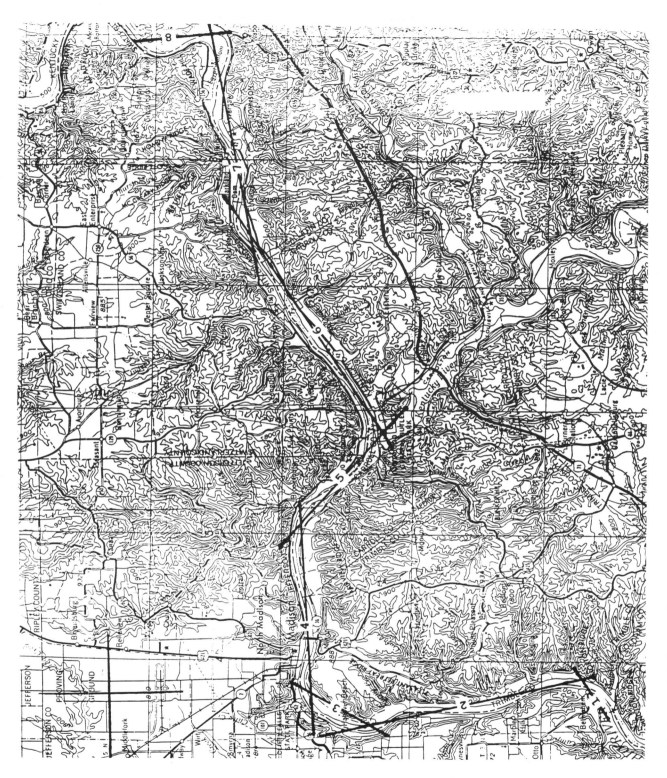

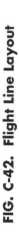

FIG. C-42. Flight Line Layout

K. Cross-Country. In order to estimate costs of an aerial photo mission, two elements must be determined:

(1) Distance from the site where the aircraft and crew are based to the project site. This can be measured from a road atlas.

(2) Speed of aircraft. Fig. C-26 can be used to determine anticipated speed relative to the hourly rental of the aircraft once hourly aircraft rental rate is known.

L. Costing Photo Mission. For this project the mean values in Tables C-13 and C-15 will be employed.

(1) Ground preparation for pilot and photographer to prepare the aircraft and camera for flying. Use 1 hour per day.

(2) Photo mission time. Table C-13 indicates an aircraft rental rate of about $255. Inserting this value into the line graph in Fig. C-26 results in a cruising speed of 150 miles per hour.

a. Photography. Flight lines average about 9.5 miles in length. Aircraft speed on short lines is significantly less than cruising speed.

$$\text{Flight lines} = \frac{9.5 \text{ miles}}{100 \text{ mph}} \times 8 \text{ lines} = 0.76 \text{ hr}$$

$$\text{End turns} = \frac{8 \text{ lines} \times 3 \text{ minutes}}{60} = 0.4 \text{ hr}$$

Total photography:

flight lines + end turns = 1.16 hr

b. En route time, assuming for this project that the aircraft is hangared 250 miles from the project:

$$\frac{250 \text{ miles} \times 2 \text{ ways}}{150 \text{ mph}} = 3.3 \text{ hr}$$

c. Total flying time = 4.46 hr

d. Refueling Stop. Allow 1 hr.

e. Photo lab work. Once film is exposed and processed, the accuracy of the flight line alignment, degree of crab, quality of image, and overlaps are checked. Also the appropriate titling is stamped onto the film. It is estimated that 4 hours should cover this.

M. Production Hours for Aerial Photography.

Phase	Pilot	Photographer	Lab Tech	Aircraft
Flight Plan	2.0			
Ground Prep	1.0	1.0		
En Route	3.3	3.3		3.3
Photography	1.2	1.2		1.2
Refuel	1.0	1.0		1.0
Processing			4.0	
Totals	8.5	6.5	4.0	5.5

N. Cost of Aerial Photography.

(1) Salaries. Use mean hourly rates from Table C-15.

Personnel	Hours	Rate	Cost
Pilot	8.5	$15.42	$131
Photographer	6.5	$13.00	$ 85
Lab Tech	4.0	$10.84	$ 43
Supervision (10% of Others' Hours)	2.0	$24.08	$ 48
Hourly Rate Costs			$307
Overhead on Labor (163.87%)			$503
Total Labor Cost			$810

(2) Direct costs. Use mean item rates from Table C-13.

Direct Cost Item	Units	Unit Cost	Cost
Aircraft	5.5	$255.00	$1,402
Contact Prints (2 sets)	182.0	$ 3.00	$ 546
Aerial Film	91.0	$ 1.20	$ 109
Film Processing	91.0	$ 0.60	$ 55
Total Direct Cost			$2,112

(3) Total estimated costs.

Labor	$ 810
Direct	$2,112
Subtotal	$2,922
Profit (11.29%)	$ 330
Total Cost	$3,352

O. Photo Control. Photo image sheets can be controlled in any of several ways. Choice of control is dependent upon the accuracy to be ingrained into the final product. Remember that these sheets will contain inherent horizontal displacement throughout the image no matter which control procedure is selected.

FIG. C-43. Photo Image Sheet Layout Diagram

(1) Scale enlargements with ground control. This method should be employed on larger scale image sheets and would be the most costly procedure.

 a. Set targets periodically, at 1-mile intervals, along the floodplain route.

 b. Establish ground coordinates for targets by ground surveys.

 c. Calculate photo scale from target coordinates and scale photos to an enlargement factor.

(2) Rectify enlargements with ground control and aerotriangulation. This method should be employed on larger scale image sheets, and cost could approach that in (1) above.

 a. Establish ground coordinates of straddle points (a point on each side of a river about a mile from the stream) about every four models.

 b. Generate photo control points with aerotriangulation.

 c. Rectify photo enlargements to photo control.

(3) Scale enlargements to map. This method should be employed on smaller scale image sheets and would be the least costly procedure.

 a. Select photoidentifiable control points on the image.

 b. Find same points on map, probably a USGS 1:24,000 quadrangle in this situation, and measure distance between pairs of points.

 c. Calculate photo scale and enlarge image sheets to the resultant factor.

(4) Rectify photo enlargements to map. This method should be employed on smaller scale image sheets, and it will be the method utilized for this project.

 a. Enlarge appropriate portions of USGS 1:24,000 quadrangles to scale 1 in. = 500 ft.

 b. Best fit rectification of photo image enlargements to enlarged quadrangle detail. Fig. C-43 depicts a layout arrangement of the final photo image sheets.

P. Costs to Produce Photo Image Sheets. Estimator should contact the source of production and discuss specific methods, then estimate costs based upon those procedures. Several of the photographic processing procedures that follow are labor intensive. It would be to the estimator's advantage to calculate size of intermediate and final products. Then seek a rate per square foot from the production source to apply these to the amount of product needed.

(1) Border data negative = $100

(2) USGS quadrangle enlargements (1 in. = 2,000 ft to 1 in. = 500 ft). Enlarge those portions of quadrangles that cover each of the 18 sheets. Produce a negative of the portion of quadrangle that covers the image sheet area, then produce an enlarged paper image to scale 1 in. = 500 ft.

 a. Layout time:

$$\frac{0.25 \text{ hr per sheet} \times 18 \text{ sheets}}{60 \text{ min}} = 4.5 \text{ hr}$$

 b. Layout cost:

 Salary = 4.5 hr @ $10.84 (lab tech) per hour
 = $ 49.

 c. Overhead (163.87%) = $ 80
thus total labor cost = $129.

 d. Quad enlargements ($4 to $5 per square foot) = 18 sheets × 6.25 sq ft per sheet @ $5 per square foot = $563.

(3) Photo image sheets ($80 to $100 per sheet) or 18 sheets @ $100 per sheet = $1,800.

Q. Total Project Costs.

Aerial Photography (Including Profit)	$3,352
Rectified Photo Image Sheets	
Border Negative	$ 100
Layout	$ 129
Quad Enlargements	$ 563
Image Sheets	$1,800
Production Costs	$2,592
Profit (11.29%)	$ †293
Total Production Costs For Image Sheets	$2,885
Total Project Cost	$6,237

C-47. PRODUCTION SCHEDULING.

When estimating project costs step by step as cited in the previous examples, production time for most labor-intensive items is calculated before costs can be derived. To illustrate production scheduling, the project in Example 2 (paragraph C-44) will be used.

A. Aerial Photography. Total flying time for the project is 2.5 hours. Assuming selective flying weather, this would be less than a full flying day. However, how many days of inclement weather often pass before the right day comes along? Probably at least a week could pass in this Midwest locale. In some regions this period would be less and

some more, depending on seasonal weather variables.

B. Field Control. Survey time is 222 crew hours plus 16 for the drafter and 16 for the computer, totalling 254 hr or the better part of 6.5 weeks. There may be some lag time to fit the surveyor's schedule or inclement weather. Assume at least 8 weeks to complete field surveys.

C. Aerotriangulation. Photo control bridging cannot proceed until field surveys are complete, at least on a project of this size. The bridging can progress at a rate of about four photos per day. Since there are 36 photos in this project, aerotriangulation would require about 9 days, assuming no significant field control inconsistencies.

D. Digital Mapping and Data Edit. Stereocompiler, data editor, and computer operator time totals 1,726 hours or almost 43 man-weeks. Most mapping shops run a daily double shift, but they usually have some backlogged workload. Realistically, this may cancel out the double-shifting. Some operations can overlap to an extent. After a reasonable segment of digital data has been collected from the plotters, data edit can progress. Considering these production factors, about 30 weeks can be allotted to do the digital data mapping.

E. Total Estimated Project Production Time.

Aerial Photography	1 week
Field Control	8 weeks
Aerotriangulation	2 weeks
Digital Mapping	30 weeks
Total	41 weeks (10 months)

F. Negotiated Project Schedule. Chances are, these lapsed times will not fit the desired completion schedule. Normally there is some room for the USACE Contracting Officer (or his authorized representative) and the field surveyor/mapping contractor to negotiate a completion schedule that is mutually reasonable to all parties. Scheduling of aerial photography is more dependent upon regional and seasonal vagaries of weather.

C-48. FIELD VERIFICATION OF MAPPING.

Not totally, but to a great extent, the validity of photogrammetric mapping relies upon the mapper to institute judicious procedural operations. In order to ascertain that the mapping is, in fact, reli-

able, there are field survey checks that may be applied, either by the contractor or the Government. Mapping standards require that certain percentages of items checked should fall within restricted error limits (see Chapters 2 and 3). A significant number of points must be sampled in the test. Otherwise, only a relatively few points can perhaps cast doubts upon an acceptable map, even though some of the samples may be questionable (i.e., some tested points may be in dense shadows, obscured by confined patches of vegetation, or fall on areas of little image contrast such as high-intensity reflections off pavement).

A. Horizontal. Only finite cultural features should be tested such as poles, fence corners, inlets, street sign posts, and manholes. Features should be tested by referencing to an authenticated coordinate station and running a closed traverse through the tested item. A ground coordinate can be calculated and compared to the coordinate of that feature residing in the data base.

B. Vertical. The field surveyor must use a credible survey routine to determine the precision of the contours generated by the photogrammetric digital data. Those listed below are intended as examples and do not exclude other equally viable options.

(1) Several dispersed lengthy survey profiles should be established on the ground and referenced to the grid system of the map. These profiles can be superimposed on the map by one of several ways, and agreement between the profile elevation points and the map contours can be compared.

(2) Several dispersed limited areas can be selected on the ground. The surveyor collects a sufficient number of points to create a contour map of these tracts. A hard copy contour plot of the ground contours overlaid on the photomapping will test agreement of contour placement.

SECTION IV
AUTOMATED COST ESTIMATING

Several USACE Districts have developed, to some degree, computer-aided photogrammetric project cost estimating. One such software package used by the USArmy Engineer District, St.Louis, will be briefly presented below. The intent is to demonstrate that it is feasible to let the computer, with only a limited amount of technical input from the estimator, perform the same cost estimating processes described in the previous examples.

C-49. PHOTOGRAMMETRIC COST ESTIMATING USING COMPUTER SPREADSHEET SOFTWARE.

A. General. As with any software package, the estimator must learn to operate the spreadsheet routine, then comply with the guidelines of the estimating documentation. The following paragraphs list the instructions for using this particular spreadsheet package. Fig. C-44, at the end of this appendix, contains a sample output of an automated photogrammetric mapping project cost calculation, which may be compared with the cost estimate for the digital data project that was cited in paragraph C-30 (budgetary) and paragraph C-44 (detailed).

B. Instructions for Using Cost Estimate Spreadsheet Program (SuperCalc5).

(1) Basic functions. The following basic production functions can be estimated with this spreadsheet:

a. Aerial photography

b. Photo control surveys (conventional and skeletal)

c. Aerotriangulation

d. Photogrammetric mapping

e. Orthophotomaps

(2) Rates. Before costing items, it is recommended that the applicable contractor rates for LABOR COSTS and DIRECT COSTS be entered into

```
                 PHOTOGRAMMETRIC PROJECT COST ESTIMATE
/////////////////////////////////////////////////////////////////////////////
PROJECT IDENTIFICATION                                          14 JAN 1992
=======================
Agency:    US ARMY ENGINEER DISTRICT, ST. LOUIS
Site:      SAMPLE DIGITAL MAPPING PROJECT
-----------------------------------------------------------------------------
At this point jump down to the CONTRACTOR RATE SCHEDULE section and
fill in the appropriate rates for Labor and Direct Cost items. Once
that is done, return to this point and continue with the estimate.
-----------------------------------------------------------------------------
                    PROJECT PARAMETERS
                    ^^^^^^^^^^^^^^^^^^^
GENERAL
=======
Mapping Area      4000 acres,        6.25 square miles

Site Limits      18000 feet N/S
                 13000 feet E/W
                  5372 acres,        8.39 square miles

Work Scope           1 Photos    (No=0,Yes=1)
                     2 Surveys   (No=0,Conventional=1,Skeletal=2)
                     1 Analytics (No=0,Yes=1)
                     1 Mapping   (No=0,Yes=1)
                     0 Ortho     (No=0,Yes=1)

Risk Factor          0 % - Photography
                     0 % - Field Surveys
                     0 % - Mapping

Recommended C-factor:
  Contour Interval          2 foot
  Map Plot Scale, 1" =    100 feet
  Stereoplotter             1 (analog=0,analytical=1)
  Government C-factor     2200
  Analytic Bridge Span      3 models vertically
  Vertical Deformation    .85
  Focal Length           1.00 (6"=1,3.5"=1.1)
  Revised C-factor       1870

Photo Scale:
  Suggested Photo Scale - recommend no smaller than:
    Topography          1"=     623 feet      or 1:    7480
    Planimetry          1"=     700 feet      or 1:    8400
  Selected Photo Scale is  1"=  623 feet      or 1:    7476

AERIAL PHOTOGRAPHY
==================
Contractor:  FLYERS, INC                     DACW43-A-91-010
```

FIG. C-44. Super Calc5 Computer Printout of Automated Photomapping Cost Estimate (Sheet 1 of 7)

Camera focal length has been defaulted for wide angle lens, which is
normal practice. Under certain conditions (i.e. very flat terrain),
superwide angle may be considered.

```
Change Focal Length?        0 (No=0,Yes=1)
Film Type                   0 (B&W=0,Color=1,IR=2,False Color=3)
Focal Length             6.00 inches  (152 mm)
Flight Height            3738 feet above mean ground
Actual C-factor          1869
Contour Error  (+/-)     1.00 feet
```
* C-factor is based on selected photo scale and contour interval.
If contour error is excessive, go back and select a larger photo
scale in order to maintain normal one-half contour maximum.

Photographic overlaps are defaulted to standard mapping requirements.
On specific photo projects you may want to change forward overlap
to 20% or 80%. If so, which? 60 *
* Mapping can be compiled with 60% or 80% FOL but not with 20% FOL.

```
Endlap (FOL)         60 %   =        2243 ft gain/model
Sidelap              30 %   =        3925 ft gain/line
Flight Lines          4 (actual value =      3.31), each    3.41 miles long
Stereo Pairs         32 with 60% FOL          20 minimum full models
Photos               36 FOL=60%                9 per line
Photo Index?          0 (No=0,Yes=1)
Distance            100 miles from aircraft base to job site
Plane Speed         178 miles per hour
Photography Time:
Flight Prep        1.00 hour / each of          1 trips
Enroute            1.12 hours / each of         1 trips
Photography        1.00 hours requiring         1 trips
Refuel              .00 hours
Mission Time       3.12 hours requiring         1 trip
```
Project will require 1 trips to complete photography. Is this
sufficient? If not, how many trips are required? 1

*** TABLE 3A ***
(PRODUCTION HOURS FOR AERIAL PHOTOGRAPHY)

	PILOT	PHOTO GRAPHER	LAB TECH	AIR CRAFT
PHOTOGRAPHY				
Flight Plan	1.00			
Ground Prep	1.00	1.00		
Enroute	1.12	1.12		1.12
Photography	1.00	1.00		1.00
Refuel	.00	.00		.00
PHOTO PREP				
Processing			3.00	
TOTAL HOURS	4.12	3.12	3.00	2.12

FIELD SURVEYS
==============

```
Contractor: GROUND CONTROL, LTD              DACW43-A-91-002

Distance          100 miles from contractor's office to site
References-
 Horizontal       2.00 miles to nearest triangulation station
 Vertical          .00 miles to nearest bench mark
Photo Control-
 Inclement Factor is       10 %
 Cultural Factor is       1.00
 Terrain Factor is        1.12
 Appropriate stereocompilation scale is 1" =     100'.
 Sheets            7 N/S and        4 E/W, or      28 total.
 Points            0 horizontal and        0 vertical(conventional)
 Points *         11 horizontal and       20 vertical(skeletal)
 (* For skeletal control, make target diagram and enter info.)
 Set Targets      10 hours/crew member(3)
```

FIG. C-44. (Sheet 2 of 7)

```
    Horizontal            0 hours(conventional)       75 hours(skeletal)
    Vertical              0 hours(conventional)       94 hours(skeletal)
    Recon                 0 hours(conventional)       17 hours(skeletal)
  Ties to References-
    Horizontal           16 hours/crew member(3)
    Vertical              0 hours/crew member(3)
    Inclement             0 hours(conventional)       21 hours(skeletal)
  Permanent Monuments-
    Establish             3 points, each requiring     0 hours/crew member(3)
  Supplemental Surveys-
    Item                  0 hours/crew member(3)
    Item                  0 hours/crew member(3)
    Item                  0 hours/crew member(3)
Crew Travel (roundtrip from contractor's office to site)-
  Travel mileage per roundtrip will be       200 miles.
  Onsite contractor vehicle mileage is      1221 miles.
  Driving time will be        4 hours per roundtrip.
  Project will require        2 trips
```

```
                *** TABLE 3B ***
           (PRODUCTION HOURS FOR PHOTO CONTROL SURVEYS)
                    PARTY   INSTRU   ROD/    COMP
                    CHIEF   WORKER   CHAIN   OPER   DRAFT
                  -------------------------------------------
CONTROL SURVEYS
  Travel-
    Ground          10      10       10
  References-
    Horizontal      16      16       16
    Vertical         0       0        0
  Controls-
    Targets         10      10       10
    Horizontal      75      75       75
    Vertical        94      94       94
    Recon           17      17       17
  Monuments          0       0        0
  Inclement         21      21       21
  Supplemental       0       0        0
  Computations                               24
  Sketches                                           37
                  -------------------------------------------
TOTAL HOURS        243     243      243      24     37
                  -------------------------------------------
```

AEROTRIANGULATION
==================

Contractor: MAPPERS CORP. DACW43-A-91-005

Analytical photo control bridging on 36 photo exposures will
be performed with Root Mean Square errors ranging from about .37
feet to about .53 feet depending upon accuracy of field control
surveys, proficiency of analytical software, and procedural care.
Maximum errors on specific points can be up to double the RMS, and
in some instances even more.

Calculate Hours? 1 (1=Yes,2=No)

```
                *** TABLE 3D ***
           (PRODUCTION HOURS FOR AEROTRIANGULATION)
                          STEREO-        COMPUTER
                          COMPILER       OPERATOR
                          --------       --------
Point selection             16
Point pugging               16
Comparator reading          11
Computer input                              8
Computations                               11
                          ---------------------------
Total hours                 43             19
                          ---------------------------
```

Control bridging hours per stereomodel:
 Stereocompiler 1.33

FIG. C-44. (Sheet 3 of 7)

```
      Computer Operator        .58

STEREOMAPPING
============
Contractor:  MAPPERS CORP.                    DACW43-A-91-005
Digital Data-
 Planimetry:
 Plan Factor       2
 a) Make copy of mapping area quad.
 b) Using CULTURE DENSITY TEMPLATE, outline areas in each
    DENSITY TYPE in the following tabulation.
 c) Calculate acreage in each category using ACREAGE TEMPLATE.
 d) Enter PLAN DENSITY and ACRES/TYPE in tabulation.
     DENSITY   % OF   PLAN    HOURS   ACRES   HOURS   WGHTD
      TYPE    AREA  DENSITY  /ACRE   /TYPE   /TYPE   DENSE
       A       94     10     .05     3750     188     .09
       B        6     80     .40      250     100     .05
       C        0      0     .00        0       0     .00
       D        0      0     .00        0       0     .00
       E        0      0     .00        0       0     .00
              100 * area is 100 %
 Full Plan       .50 estimated maximum hours/acre to compile culture
 Av. Density      14 weighted factor
 Plan Hours      288 total hours to compile cultural features

 Topography:
 a) Make copy of mapping area quad.
 b) Using SLOPE TEMPLATE as a guide, outline areas by
    whatever categories seem appropriate. Remember that
    Disturbed (mines, spoils, quarries) are separate.
 c) Calculate acreage of each category using ACREAGE TEMPLATE.
 d) Enter SLOPE FACTOR and ACRES/TYPE in tabulation.
     TERRAIN   % of   SLOPE   HOURS   ACRES   HOURS   WGHTD
      TYPE    AREA  FACTOR   /ACRE   /TYPE   /TYPE   SLOPE
       A       38     15     .08     1500     113     .06
       B       34     35     .18     1350     236     .12
       C       29     55     .28     1150     316     .16
       D        0      0     .00        0       0     .00
       E        0      0     .00        0       0     .00
    Disturbed   0      0     .00        0       0     .00
              100 * area is 100 %
 Max. Topo       .50 maximum hours/acre on natural ground
 Aver. Slope      33 weighted factor
 Topo Hours      665 total hours to compile topography

Delivery Map Sheets to Scale 1 inch =      100 feet -
 Plan/Topo        1 sets of      28 sheets
 Ortho/Topo       0 sets of       0 sheets
```

```
                      *** TABLE 3C ***
               (PRODUCTION HOURS FOR DIGITAL MAPPING)
                         HOURS        STEREO           COMPTR
                 UNITS   /UNIT        OPER    EDITOR   OPER
------------------------------------------------------------------
DIGITAL MAPPING
----------------
 Plan Control     32      .25          8
 Survey Input     32      .50         16
 Model Setup      32     2.00         64
 Digital Data
  Planimetric                        288
  Topographic                        665
 Data Edit                                   762
 Translation                                          76
 Analytics
  Prep            32     1.33         43
  Computing       32      .58                          19
------------------------------------------------------------------
TOTAL HOURS                         1083     762       95
------------------------------------------------------------------
```

FIG. C-44. (Sheet 4 of 7)

```
              TOTAL DIRECT LABOR TIME
              ==========================
                          Manhours
            Photos            10
            Surveys          791
            Analytics         61
            Mapping         1879
                          --------
            Total           2741

                *** TABLE 4 ***
        (LABOR COSTS USING APPROPRIATE CONTRACT RATES)

    LABOR COSTS
    ===========
        DISCIPLINE        HOURS        RATE                COST
    Map Project Manager       0         .00                 .00
    Chf. Photogrammetrist    94       19.43             1825.16
    Photogrammetrist        141       16.42             2313.62
    Stereocompiler         1041       11.26            11716.03
    Map Computer Operator    95       15.78             1495.31
    Photo Project Manager     4       24.08               49.33
    Aerial Photo Pilot        4       15.42               63.56
    Aerial Photographer       3       13.00               40.58
    Photo Lab Technician      3       10.84               32.52
    Map Drafter             762       10.40             7924.80
    Analytics Technician     61       11.26              688.21
    Field Survey Manager     49       21.48             1045.10
    Party Chief             243       14.36             3493.41
    Instrument Worker       243       11.44             2783.05
    Rod/Chain Person        243        9.12             2218.65
    Surveys Drafter          37       11.97              438.43
    Survey Comp. Operator    24       15.75              384.58

                *** TABLE 5 ***
        (DIRECT COSTS USING ITEMIZED CONTRACT RATES)

    DIRECT COSTS
    ============
        ITEM              UNITS        RATE                COST
    Aircraft                  3      254.71 /hour         764.13
    Final Sheets-
      Plan/Topo (mylar)      28       20.07 /sheet        561.96
      Ortho/Topo (mylar)      0         .00 /sheet           .00
      Ortho/Topo (cronpaq)    0         .00 /sheet           .00
      Ortho. Negatives        0         .00 /model           .00
    Contact Prints-
      Black & White          72 (2sets) 3.24 /contact     233.28
      Color                   0 (1 set)  .00 /contact        .00
      Control Photos         36 (1 set) 3.24 /contact     116.64
    Magnetic Tapes            7       11.44 /each           80.08
    Diapositives             36        2.60 /each           93.60
    Computer
      Mapping                76        9.94 /hour          755.44
      Analytics              19        9.94 /hour          188.86
    CADD System             762       11.65 /station/hour 8877.30
    Analytical Plotter     1041       15.54 /hour        16169.37
    Preliminary Plots        56       20.07 /sheet        1123.92
    Aerotriangulation        32       69.72 /plate        2231.19
    Aerial Film              36        1.18 /exposure        42.48
    Film Processing          36         .60 /exposure        21.60
    Base Material            32        5.00 /model          160.00
    Survey Mileage         1709         .25 /mile          427.25
    Field Survey Books        3        8.00 /each           24.00
    Laths                     6       25.00 /bundle        150.00
    Stakes                    6       14.00 /bundle         84.00
    Temporary Monuments      10        2.00 /each           20.00
    Permanent Monuments       3         .00 /each            .00
    Targets                  20        8.00 /each          160.00
    Per Diem                 90       60.00 /person/day   5400.00
    Protection - Level #     99         .00 /person/day      .00
    Photo Index
```

FIG. C-44. (Sheet 5 of 7)

```
     Original                    0          .00 set of      0each        .00
     Additional Copies           1          .00 set of      0each        .00
  Unique Items (identity, # of units, cost/unit, function ID)
     IDENTITY                 UNITS       UNITCOST       FUNCTION
     item                        0          .00 /each      0            .00
     item                        0          .00 /each      0            .00
     item                        0          .00 /each      0            .00
   * Function ID (0=none,1=photography,2=surveys,3=mapping)

                        PROJECT COST SUMMARY
                        ^^^^^^^^^^^^^^^^^^^^
  LABOR COSTS
  -----------
    Photography                                                     185.99
    Surveys                                                       10363.22
    Aerotriangulation                                               688.21
    Mapping                                                       25274.92
                                                                 ---------
  Total Labor Costs-                                              36512.34

  COMBINED OVERHEAD ON LABOR AND G&A
  ----------------------------------
    Photography    163.87 %                                         304.78
    Surveys        133.77 %                                       13862.88
    Analytics      163.87 %                                        1127.77
    Mapping        163.87 %                                       41418.01
                                                                 ---------
  Total Overhead on Labor and G&A-                                56713.45

  DIRECT COSTS
  ------------
    Photography                                                    1061.49
    Field Surveys                                                  6265.25
    Aerotriangulation                                               188.86
    Mapping                                                       27938.31
    Unique                                                             .00
                                                                 ---------
  Total Direct Costs-                                             35453.91

  LABOR, OVERHEAD, AND DIRECT COSTS
  ---------------------------------
    Photography                                                    1552.27
    Field Surveys                                                 30491.35
    Aerotriangulation                                              2004.84
    Mapping                                                       94631.24
    Unique                                                             .00
                                                                 ---------
  Total Labor, Overhead, and Direct Costs-                       128679.70

  PROFIT MARGIN
  -------------
    Photography       11.29 %                                       175.25
    Field Survey      12.10 %                                      3689.45
    Aerotriangulation 11.29 %                                       226.35
    Mapping           11.29 %                                     10683.87
    Unique              .00 %                                          .00
                                                                 ---------
  Total Profit-                                                   14774.92

  PROJECT COST ESTIMATE
  ---------------------
    Photography                                                    1727.52
    Field Surveys                                                 34180.80
    Aerotriangulation                                              2231.19
    Mapping                                                      105315.11
    Unique                                                             .00
                                                                 ---------
  Total Project Cost is Estimated at $    143455.
                                        --------
  PER ACRE COSTS
  --------------
                    Acres      $ Cost      $/Acre              %
    Photography     5372        1728         .32             1.20
    Surveys         4000       34181        8.55            23.83
```

FIG. C-44. (Sheet 6 of 7)

```
Analytics         4000           2231            .56                   1.56
Mapping           4000         105315          26.33                  73.41
Unique            4000              0            .00                    .00
                 ------       --------        -------               ------
Total                          143455          35.75                 100.00
```

DISCLAIMER
=========
This cost estimate was designed for mapping to scale 1 inch= 100
feet with a contour interval of two feet. Digital mapping data
should not be used to generate maps to a larger scale or a
smaller contour interval.

SCHEDULE INFO
=============
Photography should be available within about two weeks depending
on weather, foliage, and snow cover conditions.

Field control surveys should require approximately 30 crewdays
to complete barring adverse weather.

Photo control bridging should require about 9 mandays to complete.

Mapping should require approximately 242 mandays to complete.

///

Estimator _____ Date 14 JAN 1992
 EDGAR FALKNER
 CELMS-ED-HG
```

**FIG. C-44. (Sheet 7 of 7)**

Tables 4 and 5 of the program (Fig. C-44). These should be regional rates pertinent to the site. If the contractor rates are appropriate in all estimates, this is a one-time entry. Once entered, they can be protected and become fixed costs. If various contractors are used, this information must be changed for each estimate. Specific Unique Items should be entered as appropriate to the task, number of units, and rate per unit for items that are not listed elsewhere.

(3) Project parameters.

*a. Mapping area.* Enter the number of acres to be mapped. This may differ from the area to be photographed. This figure should be as reliable as is possible to determine it. It would be best to outline mapping area on a 1 in. = 2,000 ft scale USGS quadrangle.

*b. Site limits.* Enter the maximum north-south and east-west dimensions required to cover the outside limits of the total project. Since there are only two measurements, this area will be square or rectangular.

*c. Work scope.* Enter the appropriate number for those functions that will be accomplished on this project.

*d. Risk factor.* Enter an appropriate factor to compensate for additional costing that could be incurred due to conditions encountered on this specific site. Example: If mapping is to be done in a forested area, season could be a production time factor for

field surveys. In summer, foliage could require shorter lines-of-sight than in winter when trees are bare. This would demand additional field survey time.

*e. Contour interval.* Enter required CI.

*f. Map plot scale.* Enter required data check plot scale.

*g. Stereoplotter.* Choose analog or analytical. Computer will select and display Government C-factor.

*h. Bridged model span.* Enter maximum number of models planned to span between vertical points in field control for aerotriangulation. The computer will calculate and display a revised C-factor.

*i. Photo scale.* Computer will suggest photo scales in keeping with horizontal and vertical mapping accuracy.

*j. Selected photo scale.* Choose desired photo scale.

(4) Aerial photography.

*a. Focal length.* Normally, but not always, an aerial camera with wide-angle lens is used, so the focal length is defaulted to 6 in. If a superwide angle lens is selected, enter the number 1 and the subsequent calculations will reflect a 3.5 in. focal length.

*b. Film type.* Choose any one from those selections listed by entering the appropriate code number.

*c. Actual C-factor.* Computer will calculate and display the adjusted C-factor, based on the selected photo scale.

*d. Contour accuracy.* Computer will calculate the anticipated maximum vertical error in contours. If this exceeds half a CI, reselect a more amenable photo scale.

*e. Forward overlap.* Normal forward overlap is 60%, so that value is defaulted to handle the mapping function. In certain situations, it may be desirable to use 20% (which results in photos not suitable for mapping because they are essentially monoscopic) or 80% (which may have an advantage in orthophoto selection or aerotriangulation). If it is indicated that forward overlap be other than 60%, enter either 20 or 80. This will be reflected in the number of exposures to be required.

*f. Photo index.* Make choice as to whether a photo index is required.

*g. Cross-country distance.* Enter the number of miles, one-way, between the aircraft base and the project site. Computer will calculate and display speed of aircraft, en route time, site mission time, and total hours for the photographic mission.

*h. Number of trips.* Computer will calculate the number of trips that this mission would normally require.

(5) Field surveys.

*a. Distance.* Enter the number of miles, one way, from the contractor's base to the project site.

*b. References (horizontal).* Enter the number of miles, one way, to nearest established triangulation station.

*c. References (vertical).* Enter the number of miles, one-way, to the nearest recoverable benchmark.

*d. Inclement factor.* Enter appropriate factor for potential inclement weather that would deter field survey activities. This will vary by geographic area and season.

*e. Permanent monuments.* Enter number of hours per crew member that it should take to set permanent monuments. This will vary depending upon the type of soil that the monuments will be set into.

*f. Supplemental surveys.* Enter an identifier to describe any additional items of survey not covered in tying to existing control and collecting data for photo control points. Enter the number of hours that this item will require to complete.

(6) Aerotriangulation. Computer automatically calculates cost for aerotriangulation. Note that approximate anticipated errors are displayed. If these are intolerable, consider a larger map scale or eliminate this function.

(7) Stereomapping.

*a. Planimetric density.* Outline areas of comparable developed cultural features on map. The spreadsheet allows classification of up to five categories. Using the template given in Figure C-31, estimate the percentage of cultural buildup at each level. Enter measured acreage in each density level. Computer will calculate and display the estimated number of planimetric compilation hours.

*b. Topographic slope factor.* Outline areas of comparable terrain slope on map. Using the template given in Fig. C-34, estimate the appropriate slope factor for each of the terrain character classes. Enter measured area of each slope class. Computer will calculate and display the estimated number of topographic compilation hours.

*c. Final map sheets (plan/topo).* Enter the number of delivery sets of map sheets that are required.

(8) Labor production hours. Computer will calculate and display an itemized tabulation of labor hours required for:

*a.* Aerial photography

*b.* Field control surveys

*c.* Digital data collection and editing

Computer will assign production hours by personnel title and display an extension of labor costs for each title required in production.

(9) Direct costs. Computer will assign hours or units to required direct cost items and display an extension of direct costs involved.

(10) Overhead. Enter the appropriate contractor overhead percent for the selected functions.

(11) Profit margin. Enter the appropriate contractor profit percent for the selected function.

# APPENDIX D

# ASPRS ACCURACY STANDARDS FOR LARGE-SCALE MAPS

**The American Society for Photogrammetry and Remote Sensing**
**Approval by the ASPRS Professional Practicing Division, March, 1990**

These standards have been developed by the Specifications and Standards Committee of the American Society for Photogrammetry and Remote Sensing (ASPRS). It is anticipated that these ASPRS standards may form the basis for revision of the U.S. National Map Accuracy Standards for both small-scale and large-scale maps. A major feature of these ASPRS standards is that they indicate accuracy at ground scale. Thus, digital spatial data of known ground-scale accuracy can be related to the appropriate map scale for graphic presentation at a recognized standard.

These standards concern the definitions of spatial accuracy as they pertain to large-scale topographic maps prepared for special purposes or engineering applications. Emphasis is on the final spatial accuracies that can be derived from the map in terms most generally understood by the users.

### 1. Horizontal Accuracy:

Horizontal map accuracy is defined as the rms error[1] in terms of the project's planimetric survey coordinates(X,Y) for checked points as determined at full(ground) scale of the map. The rms error is the cumulative result of all errors including those introduced by the processes of ground control surveys, map compilation and final extraction of ground dimensions from the map. The limiting rms errors are the maximum permissible rms errors established by this standard. These limiting rms errors for Class 1. maps are tabulated in Table 1E(feet) and Table 1M(meters) along with typical map scales associated with the limiting errors. These limits of accuracy apply to tests made on well-defined points only[2]

*Table 1E. — Planimetric Coordinate Accuracy Requirement (Ground X or Y in feet) for Well-defined Points - Class 1. Maps*

| PLANIMETRIC (X or Y) ACCURACY[3] | |
|---|---|
| (limiting rms error, feet) | TYPICAL MAP SCALE |
| 0.05 | 1:60 |
| 0.1 | 1:120 |
| 0.2 | 1:240 |
| 0.3 | 1:360 |
| 0.4 | 1:480 |
| 0.5 | 1:600 |
| 1.0 | 1:1,200 |
| 2.0 | 1:2,400 |
| 4.0 | 1:4,800 |
| 5.0 | 1:6,000 |
| 8.0 | 1:9,600 |
| 10.0 | 1:12,000 |
| 16.7 | 1:20,000 |

*indicates the practical limit for aerial methods - for scales above this line, ground methods are normally used.

### 2. Vertical Accuracy:

Vertical map accuracy is defined as the rms error in evaluation in terms of the project's evaluation datum for well-defined points only. For Class 1. maps the limiting rms error in evaluation is set by the standard at *one-third* the indicated contour interval for well-defined points only. Spot heights shall be shown on the map within a limiting rms error of *one-sixth* of the contour interval.

[1]see Appendix A., Section A1.
[2]see Appendix A., Section A2.

*Table 1E. — Planimetric Coordinate Accuracy Requirement (Ground X or Y in feet) for Well-defined Points - Class 1. Maps*

| PLANIMETRIC (X or Y) ACCURACY[3] | |
|---|---|
| (limiting rms error, meters) | TYPICAL MAP SCALE |
| 0.0125 | 1:50 |
| 0.025 | 1:100 |
| 0.050 | 1:200 |
| 0.125 | 1:500 |
| 0.25 | 1:1,000 |
| 0.50 | 1:2,000 |
| 1.00 | 1:4,00 |
| 1.25 | 1:5,000 |
| 2.50 | 1:10,000 |
| 5.00 | 1:20,000 |

*indicates the practical limit for aerial methods - for scales above this line ground methods ore normally used.

### 3. Lower-Accuracy Maps:

Map accuracies can also be defined at lower spatial accuracy standards. Maps compiled within limiting rms errors of twice or three times the those allowed for a Class 1. map shall be designated Class 2. or Class 3. maps respectively. A map may be compiled that complies with one class of accuracy in elevation and another in plan. Multiple accuracies on the same map are allowed provided a diagram is included which clearly relates segments of the map with the appropriate map accuracy class.

### 4. Map Accuracy Test[4]:

Tests for compliance of a map sheet are optional. Testing for horizontal accuracy compliance is done by comparing the planimetric (X and Y) coordinates of well-defined ground points to the coordinates of the same points as determined by a horizontal check survey of higher accuracy. The check survey shall be designed according to the Federal Geodetic Control Committee (FGCC) [FGCC,1984] standards and specifications to achieve standard deviations equal to or less than *one-third* of the "limiting rms error" selected for the map. The distance between control points (d) used in the FGCC standard for the design of the survey shall be the horizontal ground distance across the diagonal dimension of the map sheet.

Testing for vertical accuracy compliance shall be accomplished by comparing the elevations of well-defined points as determined from the map to corresponding elevations determined by a survey of higher accuracy. For purposes of checking elevations, the map position of the ground point may be shifted in any direction by an amount equal to twice the limiting rms error in position. The vertical check survey should be designed to produce rms errors in elevation differences at check point locations no larger than *1/20th of the contour interval*. The distance (d) between bench marks used in the FGCC standard for the design of the vertical check survey shall be the horizontal ground distance across the diagonal of the map sheet. Generally, vertical control networks based on surveys conducted according to the FGCC standards for Third Order provide adequate accuracy for conducting the vertical check survey.

[3]see Appendix A., Section A3.
[4]see Appendix A., Section A4.

Discrepancies between the X, Y, or Z coordinates of the ground point, as determined from the map and by the check survey, that exceed *three* times the limiting rms error shall be interpreted as blunders and will be corrected before the map is considered to meet this standard.

The same survey datums, both horizontal and vertical, must be used for both the project and the check control surveys. Although a national survey datum is preferred, a local datum is acceptable.

A minimum of 20 check points shall be established throughout the area covered by the map and shall be distributed in a manner agreed upon by the contracting parties[5].

Maps produced according to this spatial accuracy standard shall include the following statement in the title block:

THIS MAP WAS COMPILED TO MEET THE ASPRS
STANDARD FOR CLASS 1. MAP ACCURACY

If the map was checked and found to conform to this spatial accuracy standard, the following statement shall also appear in the title block:

THIS MAP WAS CHECKED AND FOUND TO CONFORM
TO THE ASPRS
STANDARD FOR CLASS 1. MAP ACCURACY

# APPENDIX A. *EXPLANATORY COMMENTS*

## A1. Root Mean Square Error

The "root mean square" (rms) error is defined to be the square root of the average of the squared discrepancies. In this case, the discrepancies are the differences in coordinate or elevation values as derived from the map and as determined by an independent survey of higher accuracy (check survey). For example, the rms error in the X coordinate direction can be computed as:

$$rms_x = \sqrt{(D^2/n)}$$

where:

$D^2 = d_1{}^2 + d_2{}^2 + \text{--------} + d_n{}^2$

$d$ = discrepancy in the X coordinate direction
$\phantom{d} = X_{map} - X_{check}$

$n$ = total number of points checked on the map in the X coordinate direction

## A2. Well-defined Points

The term "well-defined points" pertains to features that can be sharply identified as discrete points. Points which are not well-defined (that is poorly-defined) are excluded from the map accuracy test. In the case of poorly-defined image points, these may be of features that do not have a well-defined center such as roads that intersect at shallow angles [U.S. National Map Accuracy Standards, 1941]. In the case of poorly defined ground points, these may be such features as soil boundaries or timber boundaries. As indicated in the ASPRS Standard, the selection of well-defined points is made through agreement by the contracting parties.

## A3. Relationship to U.S. National Map Accuracy Standards

Planimetric accuracy in terms of the "limiting rms error" can be related to the United States National Map Accuracy Standards (NMAS) provided the following assumptions are made:

[5] see Appendix A., Section A5.

- the discrepancies are normally distributed about a zero mean
- the standard deviations in the X and Y coordinate directions are equal
- sufficient check points are used to accurately estimate the variances

To compute the "circular map accuracy standard" (CMAS) which corresponds to the 90% circular map error defined in the NMAS [ACIC, 1962, p. 26, p. 41]:

$$CMAS = 2.146\ \sigma_x \qquad \text{or;} \qquad CMAS = 2.146\ \sigma_y$$

Given these relationships and assumptions, the limiting rms errors correspond approximately to the CMAS of 1/47th of an inch for all errors and related scales indicated in Table 1E. For the metric case indicated in Table 1M, the CMAS is 0.54 mm for all rms errors and corresponding scales. It is emphasized that for the ASPRS Standard, spatial accuracies are stated and evaluated at *full or ground scale*. The measures in terms of equivalent CMAS are only approximate and are offered only to provide a comparison to the National Map Accuracy Standard of CMAS of 1/30th inch at map scale.

## A4. Check Survey

Both the vertical and horizontal (planimetric) check surveys are designed based on the National standards of accuracy and field specifications for control surveys established by the Federal Geodetic Control Committee (FGCC). These standards and specifications [FGCC, 1984] are intended to establish procedures which produce accuracies in terms of relative errors. For horizontal surveys, the proportional accuracies for the various orders and classes of survey are stated in Table 2.1 of the FGCC document and for elevation accuracy in Table 2.2. These tables along with their explanations are reproduced here. From FGCC [1984]:

## "2.1 HORIZONTAL CONTROL NETWORK STANDARDS

When a horizontal control is classified with a particular order and class, NGS certifies that the geodetic latitude and longitude of that control point bear a relation of specific accuracy to the coordinates of all other points in the horizontal control network. This relationship is expressed as a distance accuracy, 1:a. A distance accuracy is the ratio of relative positional error of a pair of control points to the horizontal separation of those points.

TABLE 2.1 — DISTANCE ACCURACY STANDARDS

| Classification | Minimum distance accuracy |
|---|---|
| First-order.............. | 1:100,000 |
| Second-order, class I.... | 1: 50,000 |
| Second-order, class II.... | 1: 20,000 |
| Third-order, class I...... | 1: 10,000 |
| Third-order, class II..... | 1: 5,000 |

" A distance accuracy, 1:a, is computed from a minimally constrained, correctly weighted, least squares adjustment by:

$$a = d/s$$

where

a = distance accuracy denominator

s = propagated standard deviation or distance between survey points obtained from the least squares adjustment

d = distance between survey points"

## "VERTICAL CONTROL NETWORK STANDARDS

When a vertical control point is classified with a particular order and class, NGS certifies that the orthometric elevation at that point bears a relation of specific accuracy to the elevations of all other points in the vertical control network. That relation is expressed as an elevation difference accuracy, b. An elevation difference accuracy is the relative elevation error between a pair of control points that is scaled by the square root of their horizontal separation traced along existing level routes.

TABLE 2.2 — ELEVATION ACCURACY STANDARDS

| Classification | Maximum elevation difference accuracy |
|---|---|
| First-order, class I....... | 0.5 |
| First-order, class II ...... | 0.7 |
| Second-order, class I .... | 1.0 |
| Second-order, class II.... | 1.3 |
| Third-order............. | 2.0 |

" An elevation difference accuracy, b, is computed from a minimally constrained, correctly weighted, least squares adjustment by

$$b = S/\sqrt{d}$$

where

d = approximate horizontal distance in kilometers between control point positions traced along existing level routes.

S = proprogated standard deviation of elevation difference in millimeters between survey control points obtained from a least squares adjustment. Note that the units of b are (mm)/$\sqrt{(km)}$."

---

For an example of designing a check survey (selecting an order and class), assume that a survey is to be designed to check a map which is intended to possess a planimetric (horizontal) "limiting rms error" (see Table 1E. of the map standard) of *one* foot and a contour interval of *two* feet. In contrast to survey accuracies, which are stated in terms of relative horizontal distances to adjacent points, map features are intended to possess accuracies relative to all other points appearing on the map. Therefore, for purposes of the check survey, the distance between survey points (d) is taken as the diagonal distance on the ground across the area covered by the map. According to the FGCC survey standards this is the distance across which the "minimum distance accuracy" and "maximum elevation difference accuracy" is required (see Table 2.1 and 2.2 of the [FGCC, 1984] document).

For the planimetric check survey, assume that the diagonal distance on the ground covered by the map is 6000 feet. The propagated standard deviation (s) required for the check survey is one-third of the limiting rms error of one foot or 0.33 foot in this example. Returning to the equation from the FGCC [1984] document relating distance between survey points (d), standard deviation (s) and distance accuracy denominator (a):

$$a = d/s = (6000 \text{ feet})/(0.33 \text{ feet}) = 18,182$$

By referring to Table 2.1 of the FGCC document, it is clear that a control survey designed according to the standards and spec-

ifications for *second-order, class II* is required to produce the horizontal check survey for this example. If the project control survey is conducted at a standard of accuracy equal to or better than second-order, class II, the check survey can tie to the project control network in accord with FGCC standards.

For the vertical check survey, the distance (d) is also taken as a diagonal ground distance across the map to account for the fact that elevation accuracy pertains to all mapped features. The propogated standard deviation in elevation (S) is required by this standard to be equal or less than 1/20th of the contour interval of two feet;

$$S = (1/20) \text{ CI} = 0.10 \text{ feet}$$

Returning to Table 2.2 of the FGCC document, relating distance between bench marks (d in km), the standard deviation in elevation (S in mm), and the elevation difference accuracy (b);

where;
  S = 0.10 feet = 30.5 mm
  d = 6000 feet = 1.181 km

then;

$$b = s/\sqrt{d} = 28.1 \text{ mm}/\sqrt{km}$$

It is clear that a third-order survey for elevation differences is more than adequate for purposes of conducting the check survey for this map example. Other methods for conducting the check survey for elevation are acceptable provided they have demonstrated accuracy capability equal to that required by this map standard. Such departures however must be agreed upon by the contracting parties prior to conducting the survey.

## A5. Check Point Location

Due to the diversity of requirements anticipated for any large-scale special purpose or engineering map, it is not realistic to include statements that specify the spatial distribution of check points designed to assess the spatial accuracy of the map. For instance, it may be preferred to distribute the check points more densely in the vicinity of important structures or drainage features and more sparsely in areas that are of little or no interest. Of course suitable notation, such as a change in map class for the region of lesser interest, should be included accordingly on the map sheet.

For a map sheet, however, of conventional rectangular dimensions, intended to portray a uniform spatial accuracy over the entire map sheet, it may be reasonable to specify the distribution. For instance, given the minimum of twenty check points, it could be specified that at least 20% of the points be located in each quadrant of the map sheet and that these points be spaced at intervals equal to at least 10% of the map sheet diagonal.

## REFERENCES

Bureau of the Budget (1947), "United States National Map Accuracy Standards", U.S. Bureau of the Budget, June 17

ANSI (1982), "Procedures for the Development and Coordination of American National Standards," American National Standards Institute, 1430 Broadway, New York, NY 10018, Sept. 1, 1982

Federal Geodetic Control Committee (1984), "Standards and Specifications for Geodetic Control Networks", Federal Geodetic Committee, Sept.

# APPENDIX E

# PLANIMETRIC AND TOPOGRAPHIC FEATURE DEPICTION SPECIFICATIONS

This appendix contains guidance for depicting planimetric and topographic features based on the specified tar get scale. It is intended to consistently define the amount of feature density and detail required for a given scale, given the digitizing capabilities of a stereoplotter operating at that scale. Unique project-specific features not normally or routinely encoded (usually due to the extra cost thereof) must be independently identified and scheduled in a contract as a "special mapping requirement." These specifications have been developed for the nominal target scales shown in each section. They may be approximately expanded to cover the scale ranges shown. Should variations exist between these specifications and EM 1110-1-1807, EM 1110-1-1807 will govern. (These specifications were developed by Atlantic Aerial Surveys, Huntsville, AL, a member of the Management Association for Private Photogrammetric Surveyors.)

## SECTION I
## FEATURE DEPICTION SPECIFICATIONS
## NOMINAL SCALE: 50 FEET PER INCH
## TARGET SCALE RANGE:
## 20 TO 60 FT PER IN.

## E-1. TRANSPORTATION.

**A. Paved Road.** Defined by edge of pavement, excluding paved shoulder or gutter. Paved road edge has precedence over paved drive or parking lot, and the edge of pavement should remain unbroken where drives or lots intersect road.

**B. Unpaved Road.** Dirt or gravel road maintained as a thoroughfare. Unpaved roads are frequently found in rural areas or in suburban areas. Unpaved alleys are depicted as unpaved roads. Define by edge of graded surface or edge of tire wear lines, whichever is appropriate. Unpaved road edge has precedence over unpaved drive or parking lot. Where unpaved road intersects a paved surface, the edge of pavement line has precedence, including slabs or sidewalks. Also use unpaved road for unpaved runways.

**C. Railroad.** Digitize center line of all rails in use (the line will be patterned to represent two rails 5 ft apart). Show all sidings and spurs (tracks for storage, etc.).

**D. Abandoned Railroad.** Digitize center line of all abandoned railroads with tracks still intact and visible. Do not delineate old railroad grades with no tracks intact (the line will be patterned to represent two rails 5 ft apart).

**E. Bridge.** Structure erected over obstacle or depression. "Bridge" includes automotive bridges, railroad bridges, footbridges, and viaducts. Continue all depictions across bridge, including edge of paved road and guardrail, if the item continues on the bridge. Do not contour bridges.

**F. Runway.** Airport pavement used for takeoff, landing, or taxiing of airplanes. "Runway" also includes helipads. Unpaved runways shall be shown with unpaved road symbology.

**G. Retaining Wall (Major).** Fixed structure retaining earth located along thoroughfares. Digitize center line and pattern so ticks are on high side of wall. Major retaining wall has precedence over curb, fence, edge of pavement, and minor retaining wall. Snap contours to retaining walls.

**H. Trail (Vehicular).** Dirt passageway that is permanent in nature and wider than 6 ft. Trails are not maintained as well as dirt roads; field roads shall be shown as trails. All transportation features have precedence over trails.

**I. Curb.** Raised edge defining edge of pavement, parking lot islands, etc. Curbs have precedence over edge of pavement lines. Retaining walls have precedence over curbs. Contours should run unbroken along curbs (do not snap to each side).

**J. Concrete Barrier.** Short wall erected between traffic lanes. Digitize center line of barrier.

**K. Paved Shoulder.** Pavement between edge of paved road and edge of total paved surface. Curb and guardrail have precedence over shoulder. Paved shoulder has precedence over sidewalk or slab, and should be broken for paved drives and parking lots. Do not show unpaved shoulders.

**L. Paved Drive.** Define by edge of pavement. Paved drive has precedence over unpaved road or drive, sidewalk, and slab. Paved road and retaining wall have precedence over paved drive. Paved shoulder should join cleanly with paved drive.

**M. Unpaved Drive.** Paved shoulder should not stop for unpaved drive. Edge of pavement of any kind has precedence over unpaved drive. Do not cap end of drive.

**N. Pavement Change.** Delineate change of pavement only between macadam and concrete surfaces. Do not show change between old and new asphalt, road repairs, etc.

**O. Sidewalk.** Show edges of all sidewalks, public or private. Sidewalk should not continue across paved drives unless it does so visibly on photography. Paved drive, parking lot, and road have precedence over sidewalk. Sidewalk has precedence over unpaved drive or parking lot and slab. Show steps (if requested) as miscellaneous structures.

**P. Path.** Visible, permanent dirt trail less than 6 ft wide, used commonly for bikes or pedestrian traffic. Digitize center line of path. Every element has precedence over trail.

**Q. Guardrail.** Single- or double-sided box beam, corrugated steel, wooden, or cable guide rail. Guardrails are usually located in medians of roads or along road edges near hazards. Digitize center line of rail. For concrete barriers, use ornamental wall symbology.

**R. Paved Parking.** Digitize edge of pavement of parking lot and parking lot islands. Six-inch curb and retaining wall have precedence over paved parking. Paved drive should join cleanly with paved parking. Paved parking has precedence over unpaved drive or parking.

**S. Unpaved Parking.** Do not open paved shoulder for unpaved parking. Do not show islands in unpaved parking lots. Edge of pavement of any type has precedence over unpaved parking. Unpaved drive should join cleanly with unpaved parking.

**T. Parking Bumper (Special Request Only).** Temporary structure, usually concrete, used to delineate parking. Digitize edge of bumper.

**U. Paint Stripe (Special Request Only).** Digitize center line of stripes. Digitize outlines of very wide stripes and arrows, etc.

## E-2. STRUCTURES.

**A. Building.** "Building" includes residential or commercial trailers. Include covered porches, permanent overhangs, carport roofs, covered sidewalks, etc., as part of the building. Do not show common roof lines (e.g., between townhomes) or interior roof lines (e.g., dormers). All buildings are to end at the mapping contract boundary. Temporary structures are delineated as miscellaneous structures. Smokestacks are shown as buildings if freestanding.

**B. Ruin or Under Construction Building.** Delineate all visible building outlines, including foundation slabs or basement remains. Label "RUIN," "UNDER CONSTRUCTION," or "U/C," whichever is appropriate. Ruins other than buildings should be outlined as usual but labeled "RUIN" in addition to any required labels. See also "Area Under Construction."

**C. Dam.** Barrier across river, creek, or swamp to regulate or obstruct water flow. Visible beaver dams large enough to affect water flow shall be outlined also. Label "DAM."

**D. Cemetery.** Delineate cemetery boundary only if not bounded by a fence line. Show paved and unpaved drives and buildings. Do not show headstones or sidewalks. Label "CEMETERY."

**E. Tank.** Outline public utility tanks and industrial storage tanks. Show small propane tanks only if used for a business. Label "TANK," or "TANKS" if grouped together.

**F. Silo.** Cylindrical receptacle for farm product storage. Outline and label "SILO," or "SILOS" if grouped together.

**G. Fence.** Digitize center lines of all visible fences. Do not differentiate between fence and gate. If gate closes across road, pull fence across road. Do not show individual fence posts.

**H. Residential Retaining Wall (Minor)** Fixed structure retaining earth, not located along a thoroughfare. Digitize center line and pattern so ticks are on high side of wall. Minor retaining wall has precedence over curb, fence, edge of pavement, and hydrology. Major retaining wall has precedence over minor retaining wall. Snap contours to retaining walls.

**I. Ornamental Wall.** Fixed structure of concrete or brick not used for retention of earth (if constructed of wood, delineate as fence). Digitize center line of wall. Ornamental wall has precedence over fence or cemetery. If wall is used solely as a sign (as in front of a business), delineate as a postless sign.

**J. Slab.** Any miscellaneous concrete slab, such as a flagpole base or concrete around swimming pool. Also use slab for patio. If slab is imbedded in a

paved surface, outline as change of pavement. Slab has precedence over unpaved road.

**K. Pool.** Digitize interior edge of concrete around inground pools, and center line of walls in aboveground pools. Label "POOL." Also use "POOL" for aeration pools in industrial areas. Pool has precedence over slab and sidewalk symbology.

**L. Miscellaneous Post.** Pole greater than 6 ft in height, including basketball goals and unidentifiable poles. Digitize center of post.

**M. Flagpole.** Digitize center of pole. Look for slab at base.

**N. Mail Box.** Digitize center of mail box. Do not differentiate between collection boxes and delivery boxes.

**O. Telephone Booth.** Digitize center of booth or pedestal.

**P. Broadcast Antenna.** Radio or television tower. Digitize center of tower.

**Q. Satellite Dish.** Digitize center of commercial and private satellite dishes. Do not show satellite dishes on top of buildings. Broadcast antenna has precedence over satellite dish.

**R. Miscellaneous Structure.** Minor buildings (air conditioner, tool storage shed, loading dock, deck, structures within substations, etc.), Do not label.

**S. Miscellaneous Feature.** Items not classified as minor buildings, such as conveyors or crane tracks. Label if identifiable.

**T. Miscellaneous Circle.** Unidentifiable circular item, such as gas filler cap. Do not label. Digitize center of item.

**U. Miscellaneous Square.** Unidentifiable square item, such as a corrugated metal valve cover; do not label. Digitize center of item.

**V. Field Line (Special Request Only).** A change between plowed fields indicating a property line. Often apparent by a difference in crop or type of furrow. Digitize center line of rural field lines only.

**W. Golf Course.** Show outline of golf course only if not bounded by a fence. Do not digitize tees, greens, sand traps, or flags except upon special request. Show all paved and unpaved drives (cart paths) that are permanent in nature. Show all hydrology and natural features. Label "GOLF COURSE" with only enough frequency for identification.

**X. Athletic Field.** Outline field only if not depicted by fence or slab. Show permanent basketball goals, football goal posts, etc., as miscel-

laneous posts. Do not show tennis court nets or posts for tennis court nets. Do not label. Show paved or unpaved tracks as paved or unpaved drives.

**Y. Debris.** Scattered and unsorted material covering ground. Digitize outline of area and label "DEBRIS." Do not contour.

**Z. Storage.** Stacked material or piles of dirt, sand, gravel, salt, etc. Digitize outline of area and label "STORAGE." Do not contour piled areas or areas stacked so that the ground is not visible. Retaining wall symbology takes precedence over storage outline. Outline junkyards with storage line and label "JUNKYARD."

**AA. Quarry.** Mining area. No distinction is made between rock (consolidated) material mines and loose (unconsolidated) material mines. Show natural features present within quarry. Digitize quarry outline and label "QUARRY" with only enough frequency to identify feature. Contour inactive quarries only. Place spot elevations at lowest points of active quarries.

**BB. Area Under Construction.** Digitize outline of entire area under construction. Show any roads under construction as unpaved roads. Digitize buildings under construction, and any feature that has been completed (e.g., curb or completed building). Label "AREA UNDER CONSTRUCTION" or "AREA U/C." Do not show debris or storage within the area outline. Do not contour.

**CC. Pipeline.** Cross-country aboveground pipeline used for transportation of liquid, gas, or matter, usually found near industrial areas or public utilities plants. Digitize edge; label "PIPE." Do not show supporting structures. Do not show pipes that do not touch the ground, such as between buildings.

**DD. Underground Pipeline (Special Request Only).** Digitize center line of apparent underground utility pipes. Label "U/G PIPE."

**EE. Levee.** Earth wall for fluid retention, usually found along rivers or canals. Digitize outline of levee on planimetric maps only (contours define levees on topographic maps). Label "LEVEE."

**FF. Pier.** Deck supported by posts extended over water. Digitize edge of pier. Label "PIER."

**GG. Riprap.** Rocks placed along slopes to lessen erosion. Outline riprap area and label "RIPRAP." Contour general slope of riprap with dashed contours to represent nonpermanent irregular surface.

**HH. Jetty.** Structure, usually earth or concrete, extended from shore to lessen erosion. Delineate any other features such as retaining walls

or slabs. Do not label. Place spot elevations at high and low points of jetty.

# E-3. NATURAL FEATURES.

**A. River.** Navigable stream. Digitize shorelines.

**B. Lake.** A large inland body of usually fresh water. Show man-made reservoirs as lakes. Digitize shoreline. Join lake outline cleanly with river or creek line.

**C. Pond.** A body of standing water much smaller than a lake, often man-made. Digitize shoreline. Join pond outline cleanly with stream. If small pond is attached to a river or lake, include in river or lake outline.

**D. Swamp.** Area of spongy, wet ground, usually harboring vegetation. Digitize any river, lake, pond, or creek outline within the swamp. Digitize outline of swamp and place cells in the swamp area. No distinction is made between a swamp, marsh, or inundated area. Show all vegetation within the swamp area.

**E. Creek.** Nonnavigable stream. Digitize shorelines of streams wider than 5 ft, and digitize center lines of streams narrower than 5 ft. Join creeks cleanly with rivers, lakes, or ponds. Do not pull tree mass lines across double-wide creeks.

**F. Tree Mass.** Group of trees too close together to allow individual plotting. Digitize edge of tree mass by following outline along the outer edge of the tree trunks. Tree mass lines cannot cross over any double-wide linear feature (e.g., vehicular trail, creek over 5 ft wide) or any railroad line, regardless of canopy spread. Tree mass has precedence over brush.

**G. Tree.** Single tree over 8 ft tall (except upon special request). Digitize center of base of tree trunk. No distinction is made between deciduous and coniferous trees. Tree symbol does not reflect extent of tree canopy. Do not plot single trees within a tree mass outline.

**H. Tree Canopy (Special Request Only).** Digitize center of trunk and place canopy to show extent of branches.

**I. Bush.** Single bush less than 8 ft tall. Digitize center of bush. If many bushes are aligned together, use hedge row symbology. Bush symbol does not reflect width of bush. Do not show single bushes within a brush line. Do not show groups of flowers that may be interspersed with decorative bushes.

**J. Brush.** Trees under 8 ft tall, shrubs, and tall weeds thickly massed, usually found near forested areas, in unpopulated meadows or lots, or near rivers or creeks. Brush line may also be used for bushes that are too densely grouped to digitize individually. Do not outline decorative bushes or bush rows with brush. Instead, use hedge row and plot lone bushes. Tree mass has precedence over brush. Brush adjacent to a wooded area should close neatly with tree mass outline.

**K. Hedge Row.** Row of bushes close together, usually neatly maintained. Digitize center line of bush row.

# E-4. DRAINAGE STRUCTURES.

**A. Concrete Headwall.** Concrete on the end of a transverse drain or pipe culvert. Digitize the center line of thin headwalls, such as those on ditches or under driveways. Digitize outer edge of thicker and larger headwalls. Headwalls have precedence over culvert symbology.

**B. Culvert.** Pipe drain, usually located under roads or driveways. Digitize length of pipe from center of each end. Do not show culverts if cement headwalls are present.

**C. Paved Ditch.** Digitize outer edge of paved ditch. Do not show water line inside ditch. Retaining wall has precedence over paved ditch. Paved ditch has precedence over sidewalk or slab. Cap ends or join cleanly with headwalls, if present.

**D. Unpaved Ditch.** Man-made channel for drainage. On planimetric maps, digitize the center line of all apparent ditches. On topographic maps, digitize the center line of ditches wider than 5 ft or if the ditches contain water.

**E. Circular Catch Basin.** Round drainage grating. Digitize center of catch basin. Do not label.

**F. Square Catch Basin.** Small rectangular or square drainage grate. Digitize center of catch basin. Do not label.

**G. Curb Inlet.** Drainage opening beneath a curb and interrupting the gutter. Frequently curb inlets have a manhole directly above them. Digitize center of curb inlet and orient symbol along the curb. Do not interrupt curb symbology.

# E-5. SIGNS AND TRAFFIC CONTROL.

**A. Single Leg Sign.** Digitize center of signpost. Orient face of sign to correspond to its true position, if identifiable.

**B. Double Leg Sign.** Includes multileg signs and overhead signs. Digitize center of each leg. Label overhead signs "O/H."

**C. Traffic Signal Pole.** Digitize center of post. Traffic signal symbology has precedence over light pole symbology if post has a dual purpose. Do not show signals suspended over roads.

**D. Billboard.** Digitize center of each leg. Label "BB."

**E. Railroad Signal Pole.** Lights along rural tracks to guide trains or warning lights near track intersections with roads. Digitize center of post.

# E-6. UTILITIES.

**A. Power Pole.** Utility pole from which power, telephone, or cable television lines are suspended. Digitize center of pole. Power pole has precedence over light pole if the pole has a dual purpose. Traffic signal pole has precedence over power pole.

**B. Light Pole.** Pole supporting a street light. If the pole has power lines also, digitize as a power pole. Digitize the center of the light pole. Do not differentiate between street lights and parking lot lights.

**C. Yard Light.** Very short lights, usually located around sidewalks at businesses or residences. Digitize center of light.

**D. Transmission Tower.** Large structure for supporting power lines across long distances. Digitize base of tower.

**E. Substation.** High-voltage units grouped together, usually within a fence. Digitize outline if not enclosed by fence. Show large structures within substations as miscellaneous structures. Substation outline has precedence over slab, unpaved drive, and trail. Do not show individual poles, pipes, or transformers within substation boundary. Label "SUBSTATION."

**F. Runway Light.** Digitize center of visible runway and taxiway lights. Do not show reflectors.

**G. Electric Box.** Digitize center of structure.

**H. Fire Hydrant.** Digitize center of element.

**I. Manhole.** A hole through which one can enter a sewer, conduit, etc. Manholes may be located on paved or unpaved surfaces. Digitize center of manhole.

# E-7. CONTOURS.

**A. Rules for Contours (General).**

(1) Break contours for (and do not contour) man-made structures that do not conform to the ground (e.g., buildings, retaining walls, bridges, etc.). Contours should join cleanly to these features.

(2) Do not contour active quarries, areas under construction, debris piles, or storage piles. Contours should join cleanly to these features.

(3) Contours should turn back on single-line streams and should cross double-wide streams as a straight line from shore to shore.

**B. Rules for Depression Contours.** A depression is a contour that closes within the mapping limits (or obviously closes outside the mapping limits on the stereo model) such that the area enclosed by the contour is lower than the contour elevation. Depressions often occur around catch basins. If the contour turns back on a stream or ditch into a culvert or headwall, it is not a depression unless it closes on the other side of the culvert or headwall or under the road.

**C. Index Contour.** Every fifth contour shall be annotated and shall have a thicker line weight than intermediate contours. Do not break index contours for spot elevations unless absolutely necessary for legibility. Do not drop index contours. If the contours are absolutely too close to pull indexes through, such as on a cliff or in a quarry, every fifth index is to be pulled through and the others are to drop cleanly.

**D. Hidden Index Contour.** Indexes that are obstructed by dense vegetation shall be delineated as hidden index contours. The guidelines for index contours apply to hidden index contours also.

**E. Depressed Index Contour.** See B above. Follow the same guidelines as for index contours.

**F. Hidden Depressed Index Contour.** Depression index obstructed by dense vegetation. Follow the same guidelines as for index contours.

**G. Index Contour Label.** Label shall be placed on line of index contour in such a manner that the bottom of the number corresponds to the ground that is lower than the index elevation. Intermediates may be broken for index labels if necessary.

**H. Intermediate Contour.** Four intermediates exist between two index contours. Do not show any more or any less than four. Do not drop intermediate contours unless the indexes are less than 1/4 in. apart at map scale. Intermediates

should not run through spot elevations. Intermediates can be broken for other text as well.

**I. Hidden Intermediate Contour.** Intermediate contour that is obstructed by dense vegetation. Follow the same guidelines as for intermediate contours.

**J. Depressed Intermediate Contour.** See B above. Follow the same guidelines as for intermediate contours.

**K. Hidden Depressed Intermediate Contour.** Depressed intermediate contour obstructed by dense vegetation. Follow the same guidelines as for intermediate contours.

**L. Spot Elevation.** Supplemental elevation used in conjunction with contour information. Spot elevations should be placed at the following points:

(1) All road and/or railroad intersections.

(2) At each end of bridges on center line of road.

(3) At center line of roads above culverts.

(4) At the highest point of closed contour tops.

(5) At the lowest point of closed depressions, significant saddles, and quarries.

(6) At points visible through dense vegetation in obscured areas.

(7) Any necessary place such that in no place is there more than 2 in. (at map scale) between contours and/or spot elevations.

Indexes, intermediates, and tree mass patterns are the only features to be broken for spot elevation text. Spot elevations are to be rotated to be parallel to the bottom of the sheets unless otherwise requested.

**M. Water Elevation.** Elevation of surface of water. Place at or near the center of the water body itself or the water body shown on the model. Do not show water elevations on single-wide creeks or ditches.

## E-8. MANUSCRIPT DATA.

**A. Contour Limit Line.** Show line only if project has adjacent areas of planimetric and topographic detail. Contours should end exactly upon this line. Also show a contour limit line between adjacent areas where the contour interval changes.

**B. Match Line.** Place line at edge of graphic detail to allow for a butt match to adjacent sheets. Place only on edges where matching sheets exist.

**C. Model Limit Line.** Digitize edge; pull all detail cleanly to line. Do not plot model limit lines on final plots.

**D. Horizontal Control Point.** Place at coordinates and label. Show only if horizontal control is separate from vertical control.

**E. Vertical Control Point.** Place at its true position during stereocompilation and label. Show only if horizontal control is separate from vertical control.

**F. Control Point.** Point used for both horizontal and vertical control. Place at coordinates and label.

**G. Control Point Annotation.** List point number. North and east coordinate values are to be shown on horizontal points; elevations are to be shown on vertical points. Use commas.

**H. Grid Tick.** Place grid tick at grid line intersections (every 5 in. at map scale). Label outside of graphic detail such that each grid is labeled once.

**I. Grid Lines (Special Request Only).** Place lines every 5 in. at map scale at even grid coordinates. End cleanly at match lines or neat lines.

**J. Grid Annotation.** Place as appropriate. Use commas.

**K. Standard Border.** Center border around graphic detail. List project, client name, scale, contour interval, map type, sheet number and index of all sheets, month of photography, and grid north.

## SECTION II
## FEATURE DEPICTION SPECIFICATIONS
## NOMINAL SCALE: 100 FEET PER INCH
## TARGET SCALE RANGE:
## 80 TO 160 FT PER IN.

## E-9. TRANSPORTATION.

**A. Paved Road.** Defined by edge of pavement, excluding paved shoulder or gutter. Paved road edge has precedence over paved drive or parking lot, and the edge of pavement should remain unbroken where drives or lots intersect road.

**B. Unpaved Road.** Dirt or gravel road maintained as a thoroughfare. Unpaved roads are frequently found in rural areas or in suburban areas. Unpaved alleys are depicted as unpaved roads. Define by edge of graded surface or edge of tire wear lines, whichever is appropriate. Unpaved road

edge has precedence over unpaved drive or parking lot. Where unpaved road intersects a paved surface, the edge of pavement line has precedence, including slabs or sidewalks. Use unpaved road for unpaved runways.

**C. Railroad.** Digitize center line of all rails in use. Show all sidings and spurs (tracks for storage, etc.).

**D. Abandoned Railroad.** Digitize center line of all abandoned railroads with tracks still intact and visible. Do not delineate old railroad grades with no tracks intact.

**E. Bridge.** Structure erected over obstacle or depression. "Bridge" includes automotive bridges, railroad bridges, public footbridges, and viaducts. Continue all depictions across bridge, including edge of paved road and guardrail, if the item continues on the bridge. Do not contour bridges.

**F. Runway.** Airport pavement used for takeoff, landing, or taxiing of airplanes. "Runway" also includes helipads. Unpaved runways shall be shown as unpaved roads.

**G. Retaining Wall (Major).** Fixed structure retaining earth located along thoroughfares. Digitize center line and pattern so ticks are on high side of wall. Major retaining wall has precedence over fence, edge of pavement, and minor retaining wall. Snap contours to retaining walls.

**H. Trail (Vehicular).** Dirt passageway that is permanent in nature and wider than 8 ft. Trails are not maintained as well as dirt roads; field roads shall be shown as trails. All transportation features have precedence over trails.

**I. Concrete Barrier.** Short wall erected between traffic lanes. Digitize center line of barrier.

**J. Paved Drive.** Define by edge of pavement. Paved drive has precedence over unpaved road or drive, sidewalk and slab. Paved road and retaining wall have precedence over paved drive.

**K. Unpaved Drive.** Edge of pavement of any kind has precedence over unpaved drive. Do not cap end of drive.

**L. Sidewalk.** Show edges of all public sidewalks. Sidewalk should not continue across paved drives unless it does so visibly on photography. Paved drive, parking lot, and road have precedence over sidewalk. Sidewalk has precedence over unpaved drive or parking lot and slab. Do not show steps at all.

**M. Path.** Visible, permanent dirt trail less than 8 ft wide, used commonly for bikes or pedes-

trian traffic. Digitize center line of path. Every element has precedence over path.

**N. Guardrail.** Single- or double-sided box beam, corrugated steel, wooden, or cable guide rail. Guard rails are usually located in medians of roads or along road edges near hazards. Digitize center line of rail. For concrete barriers, use ornamental wall symbology.

**O. Paved Parking.** Digitize edge of pavement of parking lot and parking lot islands. Retaining wall has precedence over paved parking. Paved drive should join cleanly with paved parking. Paved parking has precedence over unpaved drive or parking.

**P. Unpaved Parking.** Do not open paved surface for unpaved parking. Do not show islands in unpaved parking lots. Edge of pavement of any type has precedence over unpaved parking. Unpaved drive should join cleanly with unpaved parking.

# E-10. STRUCTURES.

**A. Building.** "Building" includes residential or commercial trailers. Include covered porches, permanent overhangs, carport roofs, covered sidewalks, etc., as part of the building. Do not show common roof lines (e.g., between townhomes) or interior roof lines (e.g., dormers). All buildings are to end at the mapping contract boundary. Temporary structures are delineated as miscellaneous structures. Smokestacks are shown as buildings if freestanding.

**B. Ruin or Under Construction Building.** Delineate all visible building outlines, including foundation slabs or basement remains. Label "RUIN," "UNDER CONSTRUCTION," or "U/C," whichever is appropriate. Ruins other than buildings should be outlined as usual but labeled "RUIN" in addition to any required labels. See also "Area Under Construction."

**C. Dam.** Barrier across river, creek, or swamp to regulate or obstruct water flow. Visible beaver dams large enough to affect water flow shall be outlined also. Label "DAM."

**D. Cemetery.** Delineate cemetery boundary only if not bounded by a fence line. Show paved and unpaved drives and buildings. Do not show headstones or sidewalks. Label "CEMETERY."

**E. Tank.** Public utility storage tank. Digitize edge of tank. Label "TANK."

**F. Silo.** Large cylindrical receptacle for farm product storage. Label "SILO."

**G. Fence.** Digitize center lines of property line fences. Do not differentiate between fence and gate. If gate closes across road, pull fence across road. Do not show individual fence posts.

**H. Residential Retaining Wall (Minor).** Fixed structure retaining earth, not located along a thoroughfare. Digitize center line of walls over 10 ft long and pattern so ticks are on high side of wall. Minor retaining wall has precedence over fence, edge of pavement, and hydrology. Major retaining wall has precedence over minor retaining wall. Snap contours to retaining walls.

**I. Ornamental Wall.** Fixed structure of concrete or brick not used for retention of earth (if constructed of wood, delineate as fence). Digitize center line of walls over 10 ft long. Ornamental wall has precedence over fence or cemetery. If wall is used solely as a sign (as in front of a business) delineate as a postless sign.

**J. Slab (Greater Than 8 ft × 8 ft).** Any miscellaneous concrete slab, such as a flagpole base or concrete around swimming pool. Slab has precedence over unpaved road.

**K. Pool.** Digitize interior edge of concrete around inground pools. Label "POOL." Also use pool for aeration pools in industrial areas. Pool has precedence over slab and sidewalk symbology.

**L. Flagpole.** Digitize center of identifiable public flagpoles.

**M. Broadcast Antenna.** Radio or television tower. Digitize center of tower.

**N. Commercial Satellite Dish.** Digitize center of commercial satellite dishes. Do not show satellite dishes on top of buildings. Broadcast antenna has precedence over satellite dish.

**O. Miscellaneous Structure.** Minor buildings (air conditioner, tool storage shed, loading dock, deck, structures within substations, etc.). Do not label.

**P. Miscellaneous Feature.** Items not classified as minor buildings, such as conveyors or crane tracks. Label if identifiable.

**Q. Miscellaneous Circle.** Unidentifiable circular item, such as gas filler cap. Do not label. Digitize center of item.

**R. Miscellaneous Square.** Unidentifiable square item, such as a corrugated metal valve cover. Do not label. Digitize center of item.

**S. Field Line (Special Request Only).** A change between plowed fields indicating a property line. Often apparent by a difference in crop or type of furrow. Digitize center line of rural field lines only.

**T. Golf Course.** Show outline of golf course only if not bounded by a fence. Do not digitize tees, greens, sand traps, or flags except upon special request. Show all paved and unpaved drives (cart paths) that are permanent in nature. Show all hydrology and natural features. Label "GOLF COURSE" with only enough frequency for identification.

**U. Athletic Field.** Outline field only if not depicted by fence or slab. Do not show basketball goals, football goal posts, tennis court nets, or posts for tennis court nets. Do not label. Show paved or unpaved tracks as paved or unpaved drives.

**V. Debris (Greater Than 10 ft × 10 ft).** Scattered and unsorted material covering ground. Digitize outline of area and label "DEBRIS." Do not contour.

**W. Storage (Greater Than 10 ft × 10 ft).** Stacked material or piles of dirt, sand, gravel, salt, etc. Digitize outline of area and label "STORAGE." Do not contour piled areas or areas stacked so that the ground is not visible. Retaining wall symbology takes precedence over storage outline. Outline junkyards with storage line and label "JUNKYARD."

**X. Quarry.** Mining area. No distinction is made between rock (consolidated) material mines and loose (unconsolidated) material mines. Show natural features present within quarry. Digitize quarry outline and label "QUARRY" with only enough frequency to identify feature. Contour inactive quarries only. Place spot elevations at lowest points of active quarries.

**Y. Area Under Construction.** Digitize outline of entire area under construction. Show any roads under construction as unpaved roads. Digitize buildings under construction and any feature that has been completed (e.g., completed building). Label "AREA UNDER CONSTRUCTION" or "AREA U/C." Do not show debris or storage within the area outline. Do not contour.

**Z. Pipeline.** Cross-country aboveground pipeline used for transportation of liquid, gas, or matter, usually found near industrial areas or public utilities plants. Digitize edge; label "PIPE." Do not show supporting structures. Do not show pipes that do not touch ground.

**AA. Underground Pipeline (Special Request Only).** Digitize center line of apparent underground utility pipes. Label "U/G PIPE."

**BB. Levee.** Earth wall for fluid retention,

usually found along rivers or canals. Digitize outline of levee on planimetric maps only (contours define levees on topographic maps). Label "LEVEE."

**CC. Pier.** Deck supported by posts extended over water. Digitize edge of pier. Do not show private piers behind residential homes. Label "PIER."

**DD. Riprap.** Rocks placed along slopes to lessen erosion. Outline riprap area and label "RIPRAP." Contour general slope of riprap with dashed contours to represent nonpermanent irregular surface.

**EE. Jetty.** Structure, usually earth or concrete, extended from shore to lessen erosion. Delineate any other features such as retaining walls or slabs. Do not label. Place spot elevations at high and low points of jetty.

## E-11. NATURAL FEATURES.

**A. River.** Navigable stream. Digitize shorelines.

**B. Lake.** A large inland body of usually fresh water. Show man-made reservoirs as lakes. Digitize shoreline. Join lake outline cleanly with river or creek line.

**C. Pond.** A body of standing water much smaller than a lake, often man-made. Digitize shoreline. Join pond outline cleanly with stream. If small pond is attached to a river or lake, include in river or lake outline.

**D. Swamp.** Area of spongy, wet ground, usually harboring vegetation. Digitize any river, lake, pond, or creek outline within the swamp. Digitize outline of swamp and place cells in the swamp area. No distinction is made between a swamp, marsh, or inundated area. Show all vegetation within the swamp area.

**E. Creek.** Nonnavigable stream. Digitize shorelines of streams wider than 10 ft, and digitize center lines of streams narrower than 10 ft. Join creeks cleanly with rivers, lakes, or ponds. Do not pull tree mass lines across double-wide creeks.

**F. Tree Mass.** Group of trees too close together to allow individual plotting. Digitize edge of tree mass by following outline along the outer edge of the tree trunks. Tree mass lines cannot cross over any double-wide linear feature (e.g., vehicular trail, creek over 10 ft wide) or any railroad line, regardless of canopy spread.

**G. Tree.** Single tree over 10 ft tall. Digitize center of base of tree trunk. No distinction is made unless specially requested between deciduous

and coniferous trees. Tree symbol does not reflect extent of tree canopy. Do not plot single trees within a tree mass outline.

**H. Tree Canopy (Special Request Only).** Digitize center of trunk and place canopy to show extent of branches.

**I. Brush.** Trees under 10 ft tall, tall weeds, or other vegetation usually found in unpopulated meadows, near forested areas, or near rivers or creeks. Outline brush only if it is dense enough to obscure ground. Tree mass outline has precedence over brush; brush adjacent to a wooded area should close cleanly to tree mass outline.

## E-12. DRAINAGE STRUCTURES.

**A. Culvert (Over 5 ft Wide).** Pipe drain located under roads. Digitize center of each end of pipe. Do not show culverts if headwalls are present.

**B. Concrete Headwall.** Concrete on the end of a transverse drain or pipe culvert. Digitize the center lines of headwalls less than 10 ft long. Digitize outer edge of thicker and larger headwalls. Headwalls have precedence over culvert symbology.

**C. Paved Side Ditch.** Digitize outer edge of paved ditch. Do not show water line inside ditch. Retaining wall has precedence over paved ditch. Paved ditch has precedence over sidewalk or slab. Cap ends or join cleanly with headwalls, if present.

**D. Catch Basin.** Symbolize all visible catch basins as square catch basins. Digitize center.

## E-13. SIGNS AND TRAFFIC CONTROL.

**A. Billboard.** Digitize the center of each post of billboard. Label "BB."

## E-14. UTILITIES.

**A. Power Pole.** Utility pole from which power, telephone, or cable television lines are suspended. Digitize center of pole.

**B. Transmission Tower.** Large structure for supporting power lines across long distances. Digitize base of tower.

**C. Substation.** High-voltage units grouped together, usually within a fence. Digitize outline if not enclosed by fence. Show large structures

within substations as miscellaneous structures. Substation outline has precedence over slab, unpaved drive, and trail. Do not show individual poles, pipes, or transformers within substation boundary. Label "SUBSTATION."

**D. Light Pole.** Digitize center of street lights along roads. Do not show lights in parking lots or yard lights. Show lone, large light poles also (such as stadium lights or large lights at ballfields).

## E-15. CONTOURS.

**A. Index Contour.** Every fifth contour shall be annotated and shall have a thicker line weight than intermediate contours. Do not break index contours for spot elevations unless absolutely necessary for legibility. Do not drop index contours. If the contours are absolutely too close to pull indexes through, such as on a cliff or in a quarry, every fifth index is to be pulled through and the others are to drop cleanly.

**B. Hidden Index Contour.** Indexes that are obstructed by dense vegetation shall be delineated as hidden index contours. The guidelines for index contours apply to hidden index contours also.

**C. Depressed Index Contour.** See E-7B above. Follow the same guidelines as for index contours.

**D. Hidden Depressed Index Contour.** Depression index obstructed by dense vegetation. Follow the same guidelines as for index contours.

**E. Index Contour Label.** Label shall be placed on line of index contour in such a manner that the bottom of the number corresponds to the ground that is lower than the index elevation. Intermediates may be broken for index labels if necessary.

**F. Intermediate Contour.** Four intermediates exist between two index contours. Do not show any more or any less than four. Do not drop intermediate contours unless the indexes are less than 1/4 in. apart at map scale. Intermediates should not run through spot elevations. Intermediates can be broken for other text as well.

**G. Hidden Intermediate Contour.** Intermediate contour that is obstructed by dense vegetation. Follow the same guidelines as for intermediate contours.

**H. Depressed Intermediate Contour.** See E-7B above. Follow the same guidelines as for intermediate contours.

**I. Hidden Depressed Intermediate Contour.** Depressed intermediate contour obstructed by dense vegetation. Follow the same guidelines as for intermediate contours.

**J. Spot Elevation.** Supplemental elevation used in conjunction with contour information. Spot elevations should be placed at the following points:

(1) All road and/or railroad intersections.

(2) At each end of bridges on center line of road.

(3) At center line of roads above culverts.

(4) At the highest point of closed contour tops.

(5) At the lowest point of closed depressions, significant saddles, and quarries.

(6) At points visible through dense vegetation in obscured areas.

(7) Any necessary place such that in no place is there more than 2 in. (at map scale) between contours and/or spot elevations.

Indexes, intermediates, and tree mass patterns are the only features to be broken for spot elevation text. Spot elevations are to be rotated parallel to the bottom of the sheets unless otherwise requested.

**K. Water Elevation.** Elevation of surface of water. Place at or near the center of the water body itself or the water body shown on the model. Do not show water elevations on single-wide creeks or ditches.

## E-16. MANUSCRIPT DATA.

**A. Contour Limit Line.** Show line only if project has adjacent areas of planimetric and topographic detail. Contours should end exactly upon this line. Also show a contour limit line between adjacent areas where the contour interval changes.

**B. Match Line.** Place line at edge of graphic detail to allow for a butt match to adjacent sheets. Place only on edges where matching sheets exist.

**C. Model Limit Line.** Digitize edge; pull all detail cleanly to line. Do not plot model limit lines on final plots.

**D. Horizontal Control Point.** Place at coordinates and label. Show only if horizontal control is separate from vertical control.

**E. Vertical Control Point.** Place at its true position during stereocompilation and label. Show only if horizontal control is separate from vertical control.

**F. Control Point.** Point used for both horizontal and vertical control. Place at coordinates and label.

**G. Control Point Annotation.** List point number. North and east coordinate values are to be shown on horizontal points; elevations are to be shown on vertical points. Use commas.

**H. Grid Tick.** Place grid tick at grid line intersections (every 5 in. at map scale). Label outside of graphic detail such that each grid is labeled once.

**I. Grid Lines (Special Request Only).** Place lines every 5 in. at map scale at even grid coordinates. End cleanly at match lines or neat lines.

**J. Grid Annotation.** Place as appropriate. Use commas.

**K. Standard Border.** Center border around graphic detail. List project, client name, scale, contour interval, map type, sheet number and index of all sheets, month of photography, and grid north.

## SECTION III
## FEATURE DEPICTION SPECIFICATIONS
## NOMINAL SCALE: 200 FEET PER INCH
## TARGET SCALE RANGE:
## 180 TO 320 FT PER IN.

## E-17. TRANSPORTATION.

**A. Paved Road.** Defined by edge of pavement, excluding paved shoulder or gutter. Paved road edge has precedence over paved drive or parking lot, and the edge of pavement should remain unbroken where drives or lots intersect road.

**B. Unpaved Road.** Dirt or gravel road maintained as a thoroughfare. Unpaved roads are frequently found in rural areas or in suburban areas. Unpaved alleys are depicted as unpaved roads. Define by edge of graded surface or edge of tire wear lines, whichever is appropriate. Unpaved road edge has precedence over unpaved drive or parking lot. Use unpaved road symbology for unpaved runways.

**C. Railroad.** Digitize center line of all rails in use. Do not show sidings and spurs (tracks for storage, etc.).

**D. Abandoned Railroad.** Digitize center line of all abandoned railroads with tracks still intact and visible. Do not delineate old railroad grades with no tracks intact.

**E. Bridge.** Structure erected over obstacle or depression. Digitize general shape of bridge. "Bridge" includes automotive bridges, railroad bridges, and viaducts. Continue all depictions across bridge, including edge of paved road, if item continues on the bridge. Do not contour bridges.

**F. Runway.** Airport pavement used for takeoff, landing, or taxiing of airplanes. "Runway" also includes helipads. Unpaved runways shall be shown as unpaved roads.

**G. Retaining Wall (Major).** Fixed structure retaining earth located along thoroughfares. Digitize center line and pattern so ticks are on high side of wall. Major retaining wall has precedence over fence, edge of pavement, and minor retaining wall. Snap contours to retaining walls.

**H. Trail.** Visible, permanent dirt passageway greater than 200 ft long. Digitize center line of trail.

**I. Paved Drive Over 200 ft Long.** Define by edge of pavement. Paved drive has precedence over unpaved road or drive. Paved road and retaining wall have precedence over paved drive.

**J. Unpaved Drive Over 200 ft Long.** Edge of pavement of any kind has precedence over unpaved drive. Do not cap end of drive.

**K. Commercial Paved Parking Over 200 ft Long.** Digitize edge of parking lot; do not show parking lot islands. Retaining wall has precedence over paved parking. Paved drive should join cleanly with paved parking. Paved parking has precedence over unpaved drive or parking.

**L. Commercial Unpaved Parking Over 200ft Long.** Do not open paved surface for unpaved parking. Do not show islands in unpaved parking lots. Edge of pavement of any type has precedence over unpaved parking. Unpaved drive should join cleanly with unpaved parking.

**M. Guardrail Over 200 ft Long.** Digitize center line of any visible guardrails.

## E-18. STRUCTURES.

**A. Building.** "Building" includes visible lone residential or commercial trailers. Include covered porches, permanent overhangs, carport roofs, etc., as part of the building. All buildings are to end at the mapping contract boundary. Smokestacks are shown as buildings if freestanding.

**B. Trailer Park.** Digitize edge of trailer park as apparent from lot location, property lines, and other clues. Do not show trailers within trailer parks; do show buildings within parks if present. Show drives over 200 ft long. Label "Trailer Park."

**C. Ruin or Under Construction Building.** Delineate visible building outlines, including foundation slabs or basement remains. Label "RUIN," "UNDER CONSTRUCTION," or "U/C," whichever is appropriate. Ruins other than buildings should be outlined as usual but labeled "RUIN" in addition to any required labels. See also "Area Under Construction."

**D. Tank (Visible).** Public utility storage tank. Digitize edge of tank. Label "TANK."

**E. Silo (Visible).** Large cylindrical receptacle for farm product storage. Label "SILO."

**F. Dam.** Barrier across river, creek, or swamp to regulate or obstruct water flow. Label "Dam."

**G. Cemetery.** Delineate cemetery boundary only if not bounded by a fence line. Show paved and unpaved drives and buildings. Do not show headstones or sidewalks. Label "Cemetery."

**H. Fence.** Digitize center lines of visible back property line and cross-country fences.

**I. Residential Retaining Wall (Minor).** Fixed structure retaining earth, not located along a thoroughfare. Digitize center line of walls over 20 ft long and pattern so ticks are on high side of wall. Minor retaining wall has precedence over fence, edge of pavement, and hydrology. Major retaining wall has precedence over minor retaining wall. Snap contours to retaining walls.

**J. Ornamental Wall.** Fixed structure of concrete or brick not used for retention of earth. Digitize center line of walls over 20 ft long. Ornamental wall has precedence over fence or cemetery.

**K. Visible Public Pool.** Digitize interior edge of concrete around inground pools. Label "POOL." Also use pool for aeration pools in industrial areas.

**L. Broadcast Antenna.** Radio or television tower. Digitize center of tower.

**M. Miscellaneous Feature.** Items not classified as minor buildings, such as conveyors or crane tracks. Label if identifiable.

**N. Field Line (Special Request Only).** A change between plowed fields indicating a property line. Often apparent by a difference in crop or type of furrow. Digitize center line of rural field lines only.

**O. Golf Course.** Show outline of golf course only if not bounded by a fence. Do not digitize tees, greens, or sand traps except upon special request. Show all paved drives (cart paths) that are permanent in nature. Show all hydrology and natural features. Label "GOLF COURSE" with only enough frequency for identification.

**P. Athletic Field.** Outline field only if not depicted by fence. Do not label. Show paved or unpaved tracks as paved or unpaved drives.

**Q. Debris (Greater Than 20 ft × 20 ft).** Scattered and unsorted material completely obscuring ground. Digitize outline of area and label "DEBRIS." Do not contour.

**R. Storage.** Stacked material or piles of dirt, sand, gravel, salt, etc. Digitize outline of area and label "STORAGE." Do not contour piled areas or areas stacked so that the ground is not visible. Retaining wall symbology takes precedence over storage outline. Outline junkyards with storage line and label "JUNKYARD."

**S. Quarry.** Mining area. No distinction is made between rock (consolidated) material mines and loose (unconsolidated) material mines. Show natural features present within quarry. Digitize quarry outline and label "QUARRY" with only enough frequency to identify feature. Contour inactive quarries only. Place spot elevations at lowest points of active quarries.

**T. Area Under Construction.** Digitize outline of entire area under construction. Show any roads under construction as unpaved roads. Digitize buildings under construction and any feature that has been completed (e.g., completed building). Label "AREA UNDER CONSTRUCTION" or "AREA U/C." Do not show debris or storage within the area outline. Do not contour.

**U. Pipeline.** Cross-country aboveground pipeline used for transportation of liquid, gas, or matter, usually found near industrial areas or public utilities plants. Digitize center line, label "PIPE." Do not show supporting structures.

**V. Underground Pipeline.** Digitize center line of apparent underground utility pipelines. Label "U/G PIPE."

**W. Levee.** Earth wall for fluid retention, usually found along rivers or canals. Digitize outer edge of levee on planimetric maps only (contours define levees on topographic maps). Label "LEVEE."

**X. Commercial Pier.** Deck supported by posts extended over water. Digitize edge of pier. Do not show private piers. Label "PIER."

**Y. Riprap (Over 20 ft × 20 ft).** Rocks placed along slopes to lessen erosion. Outline large riprap area and label "RIPRAP." Contour general slope of riprap with dashed contours to represent nonpermanent irregular surface.

**Z. Jetty.** Structure, usually earth or con-

crete, extended from shore to lessen erosion. Delineate any other features such as retaining walls or slabs. Do not label. Place spot elevations at high and low points of jetty.

## E-19. NATURAL FEATURES.

**A. River.** Navigable stream. Digitize shorelines.

**B. Lake.** A large inland body of usually fresh water. Show man-made reservoirs as lakes. Digitize shoreline. Join lake outline cleanly with river or creek line.

**C. Pond.** A body of standing water much smaller than a lake, often man-made. Digitize shoreline. Join pond outline cleanly with stream. If small pond is attached to a river or lake, include in river or lake outline.

**D. Swamp.** Area of spongy, wet ground, usually harboring vegetation. Digitize any river, lake, pond, or creek outline within the swamp. Digitize outline of swamp and place cells in the swamp area. No distinction is made between a swamp, marsh, or inundated area. Show all vegetation within the swamp area.

**E. Creek.** Nonnavigable stream. Digitize shorelines of streams wider than 15 ft, and digitize center lines of streams narrower than 15 ft. Join creeks cleanly with rivers, lakes, or ponds. Do not pull tree mass lines across double-wide creeks.

**F. Tree Mass.** Group of trees too close together to allow individual plotting. Digitize edge of tree mass by following outline along the outer edge of the tree trunks. Tree mass lines cannot cross over any double-wide linear feature (e.g., vehicular trail, creek over 15 ft wide) or any railroad line, regardless of canopy spread.

## E-20. DRAINAGE STRUCTURES.

**A. Concrete Headwall.** Concrete on the end of a transverse drain or pipe culvert. Digitize the center of headwalls less than 20 ft long. Digitize outer edge of thicker and larger headwalls.

**B. Paved Ditch.** Digitize center line of paved ditch. Do not show water line inside ditch. Retaining wall has precedence over paved ditch. Cap ends or join cleanly with headwalls, if present.

## E-21. UTILITIES.

**A. Power Pole.** Utility pole from which power, telephone, or cable television lines are suspended. Digitize center of pole.

**B. Transmission Tower.** Large structure for supporting power lines across long distances. Digitize base of tower.

**C. Substation Greater Than 20 ft × 20 ft.** High-voltage units grouped together, usually within a fence. Digitize outline if not enclosed by fence. Show large structures within substations as miscellaneous structures. Substation outline has precedence over slab, unpaved drive, and trail. Do not show individual poles, pipes, or transformers within substation boundary. Label "SUBSTATION."

## E-22. CONTOURS.

**A. Index Contour.** Every fifth contour shall be annotated and shall have a thicker line weight than intermediate contours. Do not break index contours for spot elevations unless absolutely necessary for legibility. Do not drop index contours. If the contours are absolutely too close to pull indexes through, such as on a cliff or in a quarry, every fifth index is to be pulled through and the others are to drop cleanly.

**B. Hidden Index Contour.** Indexes that are obstructed by dense vegetation shall be delineated as hidden index contours. The guidelines for index contours apply to hidden index contours also.

**C. Depressed Index Contour.** See E-7B above. Follow the same guidelines as for index contours.

**D. Hidden Depressed Index Contour.** Depression index obstructed by dense vegetation. Follow the same guidelines as for index contours.

**E. Index Contour Label.** Label shall be placed on line of index contour in such a manner that the bottom of the number corresponds to the ground that is lower than the index elevation. Intermediates may be broken for index labels if necessary.

**F. Intermediate Contour.** Four intermediates exist between two index contours. Do not show any more or any less than four. Do not drop intermediate contours unless the indexes are less than 1/4 in. apart at map scale. Intermediates should not run through spot elevations. Intermediates can be broken for other text as well.

**G. Hidden Intermediate Contour.** Intermediate contour that is obstructed by dense vegetation. Follow the same guidelines as for intermediate contours.

**H. Depressed Intermediate Contour.** See E-7B above. Follow the same guidelines as for intermediate contours.

**I. Hidden Depressed Intermediate**

**Contour.** Depressed intermediate contour obstructed by dense vegetation. Follow the same guidelines as for intermediate contours.

**J. Spot Elevation.** Supplemental elevation used in conjunction with contour information. Spot elevations should be placed at the following points:

(1) All road and/or railroad intersections.

(2) At each end of bridges on center line of road.

(3) At center line of roads above culverts.

(4) At the highest point of closed contour tops.

(5) At the lowest point of closed depressions, significant saddles, and quarries.

(6) At points visible through dense vegetation in obscured areas.

(7) At any location necessary to provide that no more than 2 in. exist between any contour and/or spot elevation.

Indexes, intermediates, and tree mass patterns are the only features to be broken for spot elevation text. Spot elevations are to be rotated parallel to the bottom of the sheets unless otherwise requested.

**K. Water Elevation.** Elevation of surface of water. Place at or near the center of the water body itself or the water body shown on the model. Do not show water elevations on single-wide creeks or ditches.

## E-23. MANUSCRIPT DATA.

**A. Contour Limit Line.** Show line only if project has adjacent areas of planimetric and topographic detail. Contours should end exactly upon this line. Also show a contour limit line between adjacent areas where the contour interval changes.

**B. Match Line.** Place line at edge of graphic detail to allow for a butt match to adjacent sheets. Place only on edges where matching sheets exist.

**C. Model Limit Line.** Digitize edge; pull all detail cleanly to line. Do not plot model limit lines on final plots.

**D. Horizontal Control Point.** Place at coordinates and label. Show only if horizontal control is separate from vertical control.

**E. Vertical Control Point.** Place at its true position during stereocompilation and label. Show only if horizontal control is separate from vertical control.

**F. Control Point.** Point used for both horizontal and vertical control. Place at coordinates and label.

**G. Control Point Annotation.** List point number. North and east coordinate values are to be shown on horizontal points; elevations are to be shown on vertical points. Use commas.

**H. Grid Tick.** Place grid tick at grid line intersections (every 5 in. at map scale). Label outside of graphic detail such that each grid is labeled once.

**I. Grid Lines (Special Request Only).** Place lines every 5 in. at map scale at even grid coordinates. End cleanly at match lines or neat lines.

**J. Grid Annotation.** Place as appropriate. Use commas.

**K. Standard Border.** Center border around graphic detail. List project, client name, scale, contour interval, map type, sheet number and index of all sheets, month of photography, and grid north.

## SECTION IV
## FEATURE DEPICTION SPECIFICATION
## SNOMINAL SCALE: 400 FEET PER INCH
## TARGET SCALE RANGE:
## 340 TO 500 FT PER IN.

## E-24. TRANSPORTATION.

**A. Paved Road.** Defined by edge of pavement, excluding paved shoulder or gutter. Paved road edge has precedence over paved drive or parking lot, and the edge of pavement should remain unbroken where drives or lots intersect road.

**B. Unpaved Road (Visible).** Dirt or gravel road maintained as a thoroughfare. Unpaved roads are frequently found in rural areas or in suburban areas. Unpaved alleys are depicted as unpaved roads. Unpaved road edge has precedence over unpaved drive or parking lot. Use unpaved road symbology to depict unpaved runways.

**C. Railroad.** Digitize center line of visible rails in use. Do not show sidings and spurs (tracks for storage, etc.).

**D. Abandoned Railroad (Visible).** Digitize center line of all abandoned railroads with tracks still intact and visible. Do not delineate old railroad grades with no tracks intact.

**E. Bridge.** Structure erected over obstacle or depression. Digitize general shape of bridge. Do not contour.

**F. Runway.** Airport pavement used for takeoff, landing, or taxiing of airplanes. "Runway"

also includes visible helipads. Show unpaved runways with unpaved road symbology.

**G. Retaining Wall (Major).** Fixed structure retaining earth located along thoroughfares. Digitize center line and pattern so ticks are on high side of wall. Major retaining wall has precedence over fence, edge of pavement, and minor retaining wall. Snap contours to retaining walls.

**H. Paved Drive Over 400 ft Long.** Define by edge of pavement. Paved drive has precedence over unpaved road or drive. Paved road and retaining wall have precedence over paved drive.

**I. Unpaved Drive Over 400 ft Long.** Edge of pavement of any kind has precedence over unpaved drive. Do not cap end of drive.

**J. Commercial Paved Parking Over 400 ft Long.** Digitize edge of pavement of parking lot; do not show islands. Retaining wall has precedence over paved parking. Paved drive should join cleanly with paved parking. Paved parking has precedence over unpaved drive or parking.

**K. Commercial Unpaved Parking Over 400 ft Long.** Do not open paved surface for unpaved parking. Do not show islands in unpaved parking lots. Edge of pavement of any type has precedence over unpaved parking. Unpaved drive should join cleanly with unpaved parking.

## E-25. STRUCTURES.

**A. Building.** Digitize general shape of buildings over 40 ft × 40 ft. Do not show trailers at all. All buildings are to end at the mapping contract boundary. Visible smokestacks are shown as buildings if freestanding.

**B. Ruin or Under Construction Building.** Delineate all visible building outlines, including foundation slabs or basement remains. Label "RUIN," "UNDER CONSTRUCTION," or "U/C," whichever is appropriate. Ruins other than buildings should be outlined as usual but labeled "RUIN" in addition to any required labels. See also "Area Under Construction."

**C. Trailer Park.** Digitize edge of trailer park as apparent from lot location, property lines, etc. Do not show trailers within trailer parks. Show drives over 400 ft long. Label "TRAILER PARK."

**D. Dam.** Barrier across river, creek, or swamp to regulate or obstruct water flow. Label "DAM."

**E. Tank (Visible).** Public utility storage tank. Digitize edge of tank. Label "TANK."

**F. Silo (Visible).** Large cylindrical receptacle for farm product storage. Label "SILO."

**G. Cemetery.** Delineate cemetery boundary only if not bounded by a fence line. Show paved drives over 400 ft long. Label "CEMETERY."

**H. Fence.** Digitize center lines of all visible cross-country fences.

**I. Residential Retaining Wall (Minor).** Fixed structure retaining earth, not located along a thoroughfare. Digitize center line of walls over 40 ft long and pattern so ticks are on high side of wall. Retaining wall has precedence over fence, edge of pavement, and hydrology. Major retaining wall has precedence over minor retaining wall. Snap contours to retaining walls.

**J. Ornamental Wall (Visible).** Fixed structure of concrete or brick not used for retention of earth. Digitize center line of walls over 40 ft long. Ornamental wall has precedence over fence or cemetery.

**K. Broadcast Antenna.** Radio or television tower. Digitize center of tower.

**L. Miscellaneous Feature.** Items not classified as minor buildings, such as conveyors or crane tracks. Label if identifiable.

**M. Field Line (Special Request Only).** A change between plowed fields indicating a property line. Often apparent by a difference in crop or type of furrow. Digitize center line of rural field lines only.

**N. Golf Course.** Show outline of golf course only if not bounded by a fence. Do not digitize tees, greens, or sand traps except upon special request. Show all paved drives (cart paths) that are permanent in nature and over 400 ft long. Show all hydrology and natural features. Label "GOLF COURSE" with only enough frequency for identification.

**O. Athletic Field.** Outline field only if not depicted by fence. Do not label. Show paved or unpaved tracks as paved or unpaved drives.

**P. Debris (Visible).** Scattered and unsorted material completely obscuring ground. Digitize outline of area and label "DEBRIS." Do not contour.

**Q. Storage.** Stacked material or piles of dirt, sand, gravel, salt, etc., completely obscuring ground. Digitize outline of area and label "STORAGE." Retaining wall symbology takes precedence over storage outline. Outline visible junkyards and label "JUNKYARD."

**R. Quarry.** Mining area. No distinction

is made between rock (consolidated) material mines and loose (unconsolidated) material mines. Show natural features present within quarry. Digitize quarry outline and label "QUARRY" with only enough frequency to identify feature. Contour inactive quarries only. Place spot elevations at lowest points of active quarries.

**S. Area Under Construction.** Digitize outline of entire area under construction that is visible. Show any roads under construction as unpaved roads. Digitize buildings under construction, and any feature that has been completed (e.g., completed building). Label "AREA UNDER CONSTRUCTION" or "AREA U/C." Do not show debris or storage within the area outline. Do not contour.

**T. Pipeline.** Cross-country aboveground pipeline used for transportation of liquid, gas, or matter, usually found near industrial areas or public utilities plants. Digitize center line; label "PIPE." Do not show supporting structures.

**U. Underground Pipeline.** Digitize center line of apparent underground pipelines. Label "U/G PIPE."

**V. Levee.** Earth wall for fluid retention, usually found along rivers or canals. Digitize outline of top of levee visible on planimetric maps only (contours define levees on topographic maps). Label "LEVEE."

**W. Riprap (Over 40 ft 3 40 ft).** Rocks placed along slopes to lessen erosion. Outline large riprap area and label "RIPRAP." Contour general slope of riprap with dashed contours to represent nonpermanent irregular surface.

**X. Commercial Pier.** Deck supported by posts extended over water. Digitize edge of pier. Do not show private piers. Label "PIER."

**Y. Jetty.** Structure, usually earth or concrete, extended from shore to lessen erosion. Delineate any other features such as retaining walls or slabs. Do not label. Place spot elevations at high and low points of jetty.

## E-26. NATURAL FEATURES.

**A. River.** Navigable stream. Digitize shorelines.

**B. Lake.** A large inland body of usually fresh water. Show man-made reservoirs as lakes. Digitize shoreline. Join lake outline cleanly with river or creek line.

**C. Pond (Visible).** A body of standing water much smaller than a lake, often man-made. Digitize shoreline. Join pond outline cleanly with

stream. If small pond is attached to a river or lake, include in river or lake outline.

**D. Swamp.** Area of spongy, wet ground, usually harboring vegetation. Digitize any river, lake, pond, or creek outline within the swamp. Digitize outline of swamp and place cells in the swamp area. No distinction is made between a swamp, marsh, or inundated area. Show all vegetation within the swamp area.

**E. Creek (Visible).** Nonnavigable stream. Digitize center lines of streams. Join creeks cleanly with rivers, lakes, or ponds.

**F. Tree Mass.** Group of trees. Digitize edge of tree mass by following outline along the outer edge of the tree trunks. Tree mass lines cannot cross over any double-wide linear feature or any railroad line, regardless of canopy spread.

## E-27. DRAINAGE STRUCTURES.

**A. Concrete Headwall.** Concrete on the end of a transverse drain or pipe culvert. Digitize the center line of visible headwalls.

**B. Paved Ditch Over 40 ft Long.** Digitize center line of visible paved ditch. Retaining wall has precedence over paved ditch. Join cleanly with headwalls, if present.

## E-28. UTILITIES.

**A. Transmission Tower.** Large structure for supporting power lines across long distances. Digitize base of tower.

**B. Substation Greater Than 40 ft × 40 ft.** High-voltage units grouped together, usually within a fence. Digitize outline. Show large structures within substations as miscellaneous structures. Substation outline has precedence over unpaved drive. Do not show individual poles, pipes, or transformers within substation boundary. Label "SUBSTATION."

## E-29. CONTOURS.

**A. Index Contour.** Every fifth contour shall be annotated and shall have a thicker line weight than intermediate contours. Do not break index contours for spot elevations unless absolutely necessary for legibility. Do not drop index contours. If the contours are absolutely too close to pull indexes through, such as on a cliff or in a quarry, every fifth index is to be pulled through and the others are to drop cleanly.

**B. Hidden Index Contour.** Indexes that are obstructed by dense vegetation shall be delineated as hidden index contours. The guidelines for index contours apply to hidden index contours also.

**C. Depressed Index Contour.** See paragraph E-7B above. Follow the same guidelines as for index contours.

**D. Hidden Depressed Index Contour.** Depression index obstructed by dense vegetation. Follow the same guidelines as for index contours.

**E. Index Contour Label.** Label shall be placed on line of index contour in such a manner that the bottom of the number corresponds to the ground that is lower than the index elevation. Intermediates may be broken for index labels if necessary.

**F. Intermediate Contour.** Four intermediates exist between two index contours. Do not show any more or any less than four. Do not drop intermediate contours unless the indexes are less than 1/4 in. apart at map scale. Intermediates should not run through spot elevations. Intermediates can be broken for other text as well.

**G. Hidden Intermediate Contour.** Intermediate contour that is obstructed by dense vegetation. Follow the same guidelines as for intermediate contours.

**H. Depressed Intermediate Contour.** See paragraph E-7B above. Follow the same guidelines as for intermediate contours.

**I. Hidden Depressed Intermediate Contour.** Depressed intermediate contour obstructed by dense vegetation. Follow the same guidelines as for intermediate contours.

**J. Spot Elevation.** Supplemental elevation used in conjunction with contour information. Spot elevations should be placed at the following points:

(1) All road and/or railroad intersections.

(2) At top of bridges on center line of road.

(3) At center line of roads above culverts.

(4) At the highest point of closed contour tops.

(5) At the lowest point of closed depressions, significant saddles, and quarries.

(6) At points visible through dense vegetation in obscured areas.

(7) At any location necessary to provide that no more than 2 in. exist between any contour and/or spot elevation.

Indexes, intermediates, and tree mass patterns are the only features to be broken for spot elevation text. Spot elevations are to be rotated parallel to the bottom of the sheets unless otherwise requested.

**K. Water Elevation.** Elevation of surface of water. Place at or near the center of the water body itself or the water body shown on the model. Do not show water elevations on single-wide creeks or ditches.

# E-30. MANUSCRIPT DATA.

**A. Contour Limit Line.** Show line only if project has adjacent areas of planimetric and topographic detail. Contours should end exactly upon this line. Also show a contour limit line between adjacent areas where the contour interval changes.

**B. Match Line.** Place line at edge of graphic detail to allow for a butt match to adjacent sheets. Place only on edges where matching sheets exist.

**C. Model Limit Line.** Digitize edge; pull all detail cleanly to line. Do not plot model limit lines on final plots.

**D. Horizontal Control Point.** Place at coordinates and label. Show only if horizontal control is separate from vertical control.

**E. Vertical Control Point.** Place at its true position during stereocompilation and label. Show only if horizontal control is separate from vertical control.

**F. Control Point.** Point used for both horizontal and vertical control. Place at coordinates and label.

**G. Control Point Annotation.** List point number. North and east coordinate values are to be shown on horizontal points; elevations are to be shown on vertical points. Use commas.

**H. Grid Tick.** Place grid tick at grid line intersections (every 5 in. at map scale). Label outside of graphic detail such that each grid is labeled once.

**I. Grid Lines (Special Request Only).** Place lines every 5 in. at map scale at even grid coordinates. End cleanly at match lines or neat lines.

**J. Grid Annotation.** Place as appropriate. Use commas.

**K. Standard Border.** Center border around graphic detail. List project, client name, scale, contour interval, map type, sheet number and index of all sheets, month of photography, and grid north.

## APPENDIX F

# GUIDE SPECIFICATION FOR PHOTOGRAMMETRIC MAPPING AND AERIAL PHOTOGRAPHY SERVICES

## INSTRUCTIONS

1. <u>General</u>.   This guide specification is intended for use in preparing Architect—Engineer (A—E) contracts for professional photogrammetric mapping services.   These specifications are applicable to all A—E contracts used to support US Army Corps of Engineers (USACE) civil works and military construction design, construction, operations, maintenance, regulatory, and real estate activities.   This guide shall be used primarily for contracts obtained using Public Law (PL) 92—582 (Brooks Act) qualification—based selection procedures and for which unit prices in the contract schedule are negotiated. Limited exceptions to this contracting method are identified herein.   This guide supersedes and combines CE 1103, "Photogrammetric Mapping and Complementary Field Surveys," dated November 1965, and CE 1104, "Aerial Photography for Photogrammetric Mapping, Photo Maps and Mosaics," dated March 1966.

2. <u>Coverage</u>.  This guide specification contains the technical standards and/or references necessary to specify all phases of a photogrammetric mapping project.   These include aircraft operations; aerial cameras; aerial mapping film and film processing; photographic prints and film enlargements; photogrammetric rectification and stereocompilation; map planimetric feature and topographic detailing; drafting; digital mapping; generation of Computer—Aided Drafting and Design (CADD) system, Geographic Information System (GIS), Land Information System (LIS), Automated Mapping/Facility Management (AM/FM), and other spatial databases; ground survey control support; supplemental ground topographic survey densification; and contractor quality control functions.

3. <u>Applicability</u>.  The following types of A—E contract actions are supported by these instructions:

     a.   Fixed—price photogrammetric mapping and aerial photography service contracts.

     b.   Indefinite delivery type (IDT) photogrammetric mapping contracts.

     c.   A multidiscipline surveying and mapping IDT contract in which photogrammetric services are a line item supporting other surveying, mapping, hydrography, and/or other surveying services.

     d.   A work order or delivery order placed against an IDT contract.

     e.   Design and design—construct contracts that include incidental surveying and mapping services (including Title II services).   Both fixed—price and IDT design contracts are supported by these instructions.

4. <u>Contract Format</u>.  The contract format outlined in this guide follows that prescribed in Appendix B of Principal Assistant Responsible for Contracting

Instruction Letter 92-4 (PARC IL 94-4), dated 18 December 1992. PARC IL 92-4 incorporates changes to Part 14.201(a)(1) of the 1989 edition of the Engineer Federal Acquisition Regulation Supplement (EFARS). The PARC IL 92-4 contract format is designed to support PL 92-582 (Standard Form (SF) 252) qualification-based A-E procurement actions.

5. <u>Photogrammetric Line Mapping Applications</u>. This guide is intended primarily to support complete, field-to-finish type contracts written for large-scale (1 in. = 400 ft or greater) site plan mapping work, as would be used for design and subsequent contracted construction plans and specifications. Typical applications include building or structure design or relocation; river, harbor, floodplain, or reservoir project mapping; and installation master planning activities. Both planimetric feature detail and topographic data are generated or encoded using high-precision stereoscopic plotting instruments (or orthophoto scanning instruments). Specifying field-to-finish implies that all phases of the photogrammetric process, from aerial photography through final drafting, are performed by the professional contractor. In addition, the contractor is responsible for exercising complete quality control over all phases of the work.

6. <u>Supplemental Aerial Photo Products</u>. This guide may also be used to specify other associated photographic products commonly used in USACE design, planning, construction, and regulatory enforcement work. Requirements for these products would be included as supplemental line items in a professional A-E services contract intended for design mapping.

   a. <u>Air Photo Plan Drawings</u>. These are typically film-positive screened transparencies on standard drawing film format developed from enlarged aerial photos. They are often used for construction location reference drawings or navigation project condition reports. Since they do not have a consistent scale, they should not be used for detailed design.

   b. <u>Aerial Photography</u>. These include standard 9- by 9-in. aerial photographs using precision aerial mapping cameras. Such photography may be intended for subsequent line mapping compilation by either USACE hired-labor forces or another A-E contractor. Alternatively, it may be intended only for regulatory enforcement or environmental interpretative purposes, or for general reconnaissance photography of a large region. Composite paper mosaics may be constructed from this photography. Either black and white, color, or infrared photography might be specified.

   c. <u>Photographic Enlargements</u>. Aerial photo paper enlargements, either from near-vertical or oblique photography, may or may not be obtained from high-precision aerial mapping cameras. These products are normally used for display or general planning purposes.

The distinguishing factor about these supplemental items is that they are generally uncontrolled products; i.e., the photography is not converted into a base map or photograph free from scale error or relief displacement. Although these items may be included in an A-E IDT contract, they may also be procured using price competition methods, as explained in paragraph 7 below.

7. <u>Aerial Photography Procurement Using Other than A-E Forms</u>. This guide is also designed to support procurement of basic aerial photography by methods

other than A—E service contracts.  Part 36 of the EFARS prescribes that basic aerial photography may be obtained by price competition, where award is based primarily on price (i.e., low—bid), and not using professional/technical qualification—based selection criteria.  This EFARS provision strictly pertains to contracting for aerial photography and delivery of raw photographic negatives or positives to the Government.

a.  Strictly price—competitive (i.e., low—bid) procurement shall not be used if the photography is an integral part of a broader scoped contract that results in a map product, or if photogrammetric mensurations, mapping, rectifications, or any like realignment or rescaling is to be performed on the photography.  Price—competitive procurement shall also not be used if photographic spatial data are input to any type of GIS, CADD system, LIS, or any other similar database that develops vector or raster/coordinate relationships or attributes.  In all such instances, PL 92—582 qualification—based selection procedures must be used.

b.  Some USACE photographic (not photogrammetric) needs may be procured using price competition methods.  However, the following factors must be fully considered by USACE Commands in determining whether to use price competition or PL 92—582 methods:

(1)  Price—competitive (low—bid) procurement methods may be applicable to aerial photography used for photo interpretative work, such as regulatory enforcement, where the 9— by 9—in. prints can be used as is.  No subsequent mapping is intended from such photography.

(2) When aerial photography is to be compiled into line maps by a party other than the firm that flew it, a certain amount of quality control is lost over the process.  Inadequacies in the photography may not be detected until stereocompilation commences, which may occur long after the aerial photography contract has been closed out.  Likewise, photo control field surveys are best performed under the direct supervision and control of the firm responsible for compilation.  Unless there are other compelling reasons (e.g., in—house stereocompilation), full field—to—finish mapping should be performed by the same contractor using PL 92—582 procurement.  Use of low—bid procurement methods to obtain the aerial photography, and then passing such photography to another photogrammetric mapping firm for compilation, is a practice (or procurement strategy) that should be avoided if at all possible.

(3) Price—competitive procurement methods require exacting specifications and more rigorous Government quality control.  Experienced in—house personnel must be capable of assessing photographic quality, coverage, and suitability for subsequent aerotriangulation and stereocompilation.  Unless such activities are routinely performed within the USACE Command, evaluating contract performance is marginal, at best.

(4) When only small—scale, reconnaissance—type photography is required over a large area (e.g., an installation, watershed basin, or state), a price—competitive low—bid procurement action would be recommended.

(5) Air photo paper enlargements of a small, specific site may often be obtained by simple purchase order.

(6) Use of strictly price—competitive IDT contracts is not recommended.

c. USACE Commands must ultimately assess the project requirements, along with their in—house quality control capabilities, in deciding between the two forms of contracting. As a general rule of thumb, if the photographic products are to be used for construction contract plans and specifications, reproducible project condition drawings, boundary delineation or demarcation, or environmental/regulatory assessment or litigation, or will be encoded into some type of GIS, LIS, AM/FM, or CADD spatial database, the recommended method is to follow PL 92—582 qualification—based procurement methods.

8. <u>General Guide Use</u>. In adapting this guide specification to any project, specific requirements will be changed as necessary for the work contemplated. Changes will be made by deletions or insertions within this format. With appropriate adaptation, this guide form may also be tailored for direct input in the Standard Army Automated Contracting System (SAACONS). Clauses and/or provisions shown in this guide will be renumbered during SAACONS input.

9. <u>Guide Arrangement</u>. The work items listed in the Section B price schedule and Section C technical specifications are in the general order of performance on a typical photogrammetric mapping project. Scheduled line items in Section B follow the same general sequence as major paragraphs in Section C.

10. <u>Insertion of Technical Specifications</u>. Engineer Manual (EM) 1110—1—1000, Photogrammetric Mapping, should be attached to and made part of any contract for aerial photography or photogrammetric mapping services. This EM contains specifications and quality control criteria for the total (field—to—finish) execution of a photogrammetric mapping project.

a. The latest edition of the American Society for Photogrammetry and Remote Sensing's (ASPRS) Manual of Photogrammetry should also be attached by reference to any contract. This manual represents a comprehensive treatment of aerial photography and photogrammetric mapping, and should be deferred to in cases of disputes over quality of services delivered.

b. Technical specifications for photogrammetric mapping that are specific to the project (including items such as the scope of work, procedural requirements, and accuracy requirements) will be placed under Section C of the SF 252 (Block 10). The prescribed format for placing these technical specifications is contained in this guide. Project—specific technical specifications shall not contain contract administrative functions—these should be placed in more appropriate sections of the contract.

c. Technical specifications for other survey functions required in a photogrammetric mapping services contract may be developed from other Civil Works Construction Guide Specifications that are applicable to the surveying and mapping discipline(s) required.

d. Standards and other specifications should be checked for obsolescence and for dates and applicability of amendments and revisions issued subsequent to the publication of this specification. Use Engineer Pamphlet (EP) 25—1—1, Index of USACE/OCE Publications. Maximum use should be

made of existing EM's, Technical Manuals, and other recognized or current industry standards and specifications.

e. Many technical provisions in this guide have incorporated both traditional and automated stereoplotting and compilation methods. The on-going developments and refinements in automated analytical stereoplotters, digital photography, CADD, etc., require the guide user to ensure that redundant, obsolete, or inefficient procedures in this guide are continuously updated.

11. <u>Cost Estimates for Photogrammetric Mapping Services</u>. General guidance on preparing independent Government cost estimates is contained in Chapter 11 of EM 1110-1-1000. The unit of measure (lump sum/job or labor interval) shown in Section B will be highly project dependent. Given the nonlinearity of many of these services, fixed unit prices in an IDT contract may be difficult to establish. In some instances, a work order placed against an IDT contract may require adjustments for services not contemplated in the initial base contract.

13. <u>Alternate Clauses/Provisions or Options</u>. In order to distinguish between required clauses and optional clauses, required clauses are generally shown in capital letters. Optional or selective clauses are generally in lower case. In other instances, alternate clauses/provisions may be indicated by brackets "[ ]" and/or clauses preceded by a single asterisk "*". A single asterisk signifies that a clause or provision that is inapplicable to the particular section may be omitted, or that a choice of clauses may be made depending upon the technical surveying and mapping requirement. Clauses requiring insertion of descriptive material or additional project-specific specifications are indicated by underlining inside brackets (e.g., "[_____]" ). In many instances, explanatory notes are included regarding the selection of alternate clauses or provisions.

13. <u>Notes and Comments</u>. General comments and instructions used in this guide are contained in blocked asterisks. These comments and instructions should be removed from the final contract.

14. <u>Indefinite Delivery Type (IDT) Contracts and Individual Work Order Assignments</u>. Contract clauses pertaining to IDT contracts, or delivery orders thereto, are generally indicated by notes adjacent to the provision. These clauses should be deleted for fixed-price contracts. In general, sections dealing with IDT contracts are supplemented with appropriate comments pertaining to their use. Work orders against a basic IDT contract should be constructed using the general format contained in Section C of this guide. Clauses contained in the basic contract should not be repeated in work orders. Contract Section C in this guide is applicable to any type of photogrammetric mapping service contracting action.

CONTENTS

SECTION A   SOLICITATION/CONTRACT FORM

SECTION B   SERVICES AND PRICES/COSTS

SECTION C   STATEMENT OF WORK

C.1   GENERAL
C.2   LOCATION OF WORK
C.3   TECHNICAL CRITERIA AND STANDARDS
C.4   WORK TO BE PERFORMED
C.5   AIRCRAFT FLIGHT OPERATIONS AND EQUIPMENT REQUIREMENTS
C.6   AERIAL PHOTOGRAPHY SCALE AND RELATED COVERAGE PARAMETERS
C.7   AERIAL CAMERA SPECIFICATIONS
C.8   AERIAL FILM SPECIFICATIONS AND PROCESSING REQUIREMENTS
C.9   CONTACT PRINT AND DIAPOSITIVE SPECIFICATIONS
C.10  PHOTOGRAPHIC INDEX REQUIREMENTS
C.11  UNCONTROLLED PHOTOGRAPHIC ENLARGEMENTS, AIR PHOTO PLANS, AND PHOTO
      MOSAICS
C.12  CONTROLLED/RECTIFIED PHOTO PLANS AND ORTHOPHOTOGRAPHY
C.13  GROUND PHOTO CONTROL SURVEY REQUIREMENTS
C.14  STEREOCOMPILATION, DRAFTING, AND CADD SPECIFICATIONS
C.15  QUALITY CONTROL AND QUALITY ASSURANCE STANDARDS
C.16  NONTOPOGRAPHIC PHOTOGRAMMETRY SPECIFICATIONS
C.17  SUBMITTAL REQUIREMENTS
C.18  PROGRESS SCHEDULES AND WRITTEN REPORTS

SECTION D   CONTRACT ADMINISTRATION DATA

SECTION E   SPECIAL CONTRACT REQUIREMENTS

SECTION F   CONTRACT CLAUSES

SECTION G   LIST OF ATTACHMENTS

SECTION H   REPRESENTATIONS, CERTIFICATIONS, AND OTHER STATEMENTS OF OFFERERS

SECTION I   INSTRUCTIONS, CONDITIONS, AND NOTICES TO OFFERERS

## THE CONTRACT SCHEDULE

### SECTION A

### SOLICITATION/CONTRACT FORM

*************************************************************************
**NOTE:** Include here SF 252 in accordance with the instruc-
tions in Appendix B of PARC IL 92-4.
*************************************************************************

SF 252 — (Block 5):  PROJECT TITLE AND LOCATION

*************************************************************************
**NOTE:** Sample title for fixed-price contract:
*************************************************************************

PHOTOGRAMMETRIC SITE PLAN MAPPING SURVEYS IN SUPPORT OF PRELIMINARY
CONCEPT DESIGN OF FAMILY HOUSING COMPLEX ALPHA, AND RELATED INSTALLATION
MASTER PLANNING GEOGRAPHIC INFORMATION SYSTEM DATA BASE UPDATES, AT FORT
_____ , ALABAMA.

PHOTOGRAMMETRIC SITE PLAN MAPPING, SEMI-CONTROLLED AIR PHOTO PLAN DRAW-
INGS, AND AERIAL PHOTO ENLARGEMENTS FOR DREDGE DISPOSAL DESIGN, CON-
STRUCTION, AND BOUNDARY DEMARCATION, OF _____ [PROJECT],
_____ , CALIFORNIA.

*************************************************************************
**NOTE:** Sample title for indefinite delivery type
contract:
*************************************************************************

INDEFINITE DELIVERY CONTRACT FOR PROFESSIONAL PHOTOGRAMMETRIC MAPPING,
AND RELATED SURVEYING SERVICES, IN SUPPORT OF VARIOUS *[CIVIL WORKS]
[MILITARY CONSTRUCTION] PROJECTS *[IN] [ASSIGNED TO] THE
_____ DISTRICT.
*************************************************************************
**NOTE:** When other surveying services are also required as
part of a broader surveying contract, the clause shown in
EAL 90-1 shall be used.
*************************************************************************

### SECTION B

### SERVICES AND PRICES/COSTS

*************************************************************************
**NOTE:** The fee schedule for photogrammetric mapping and
related survey services should be developed in conjunction
with the preparation of the independent Government esti-
mate (IGE) along with the technical specifications.  Two
general unit of measure (U/M) methods may be used in a fee
schedule for photogrammetric mapping services:  (1) an

Hourly or Daily Rate basis or (2) a Cost per Unit Area basis.

The following tables contain sample fee schedules that may be tailored for use on most photogrammetric mapping service contracts. The guide writer should select those line items applicable to the project, or for those projects envisioned over the course of an IDT contract. Other line items may be added that are unique to the project(s). If applicable, a separate fee schedule for contract option periods should be developed and negotiated during contract negotiations and included with the contract during initial award. Unit prices (U/P) shall include direct and indirect overheads. Profit is not included on IDT contract unit prices.

Procedures for estimating line item unit prices are described in EM 1110-1-1000. Determination of these estimated unit prices must conform to the detailed analysis method, or "seven-item breakdown." The scope of each scheduled line item used in Section B must be thoroughly defined—either with the line item in Section B or at its corresponding reference in Section C of the contract. Many of the line item units of measure comprise costs from a variety of sources. These sources are combined in the IGE to arrive at the scheduled rate. For example, aircraft operation, maintenance, and labor costs are reduced to a cost per flight hour. Survey crew day rates include labor, travel, transportation, expendable materials, and numerous other items that are developed as part of the IGE.

On IDT contracts, the specification writer should strive to avoid scheduling items with little probability of being required during the contract period. Since each line item must be separately estimated and negotiated, considerable Government (and contractor) resources may be consumed in developing negotiated unit costs for unused items. For example, line items such as orthophoto map compilation or infrared photography would not be included on an IDT contract unless there is a fair degree of assurance that these items would be required on a subsequent work order.

In addition, the specification writer should attempt to include only those line items that represent a major cost activity/phase in performing photogrammetric mapping. Cost estimating emphasis and resources should be committed to major cost items such as stereocompilation, control surveys, drafting, and aerial photography, and in that order. Avoid cluttering the schedule with small and relatively insignificant (to the overall project cost) supply and material items, again minimizing the administrative costs of estimating and negotiating these items. These should be included as part of a major line item or

be contained in the firm's overhead.  Examples of normal
supply items that the guide user should avoid scheduling
are field survey books or bundles of 2- by 2-in. survey
stakes.  These items would, however, be compensated for in
the IGE.  Care must be taken in developing these schedules
with the IGE to preclude duplication of costs between line
items or overheads.  This is particularly important when
breaking out analytical stereoplotter costs with associ-
ated computer and CADD actions.  The guide user and cost
estimator must have a good working knowledge of photogram-
metric mapping production processes to properly allocate
time and costs.

The following schedules may be tailored for either A-E
fixed-price or A-E IDT contracts.  For fixed-price con-
tracts, the estimated quantities are available from the
government estimate.  For IDT contracts, a unit quantity
for each line item would be negotiated and included in the
basic contract.  Daily units of measure may be modified to
hourly or other nominal units if needed.  Lump sum or
areal units of measure are also included or may be devel-
oped for some of the services.  For non-A-E type contracts
for photography, the schedule would have to be modified
for bid submittal.  The item numbers shown are for refer-
ence in this guide only—they would be renumbered in the
final contract.
************************************************************************************

| ITEM | DESCRIPTION | QUAN | U/M | U/P | AMT |
|------|-------------|------|-----|-----|-----|
| 0500 | AIRCRAFT FLIGHT OPERATIONS: AIRCRAFT OWNERSHIP, OPERATION, AND MAINTENANCE COSTS; CAMERA; PILOT; CAMERAMAN; FUEL; LANDING FEES; ETC., BASED ON ACCUMULATED FLIGHT TIME BETWEEN CONTRACTOR'S HOME BASE/AIRFIELD TO PROJECT SITE, BETWEEN PROJECT SITES, AND/OR TEMPORARY LANDING FIELDS NEAR PROJECT SITES (IF APPLICA-BLE), OVER PROJECT SITE(S), AND RETURN TO HOME BASE/AIRFIELD. *[A MINIMUM TRANSIT TIME OF 2.5 *[_____] HOURS WILL BE AP-PLICABLE TO EACH DELIVERY ORDER, UNLESS WAIVED BY THE CONTRACTOR.]<br><br>(NOTE: Negotiated hourly rate is deter-mined primarily from field pricing support audit of firm's aircraft oper-ating costs.) | | FLIGHT HOUR | | |
| 0501 | * ADDITIONAL AIRCRAFT FLIGHT CREW COSTS: FLIGHT CREW AND CAMERAMAN LABOR AND PER DIEM ON TEMPORARY DUTY AT PROJECT SITE.<br><br>(NOTE: This line item is included only when a unique project scope, size, or location requires the aircraft and crew to temporarily locate at the project site. Normal standby time at the home base is not included in this item; it is more properly included in the firm's overhead.) | | C/DAY | | |
| 0502 | * EMERGENCY AIRCRAFT AND FLIGHT CREW STANDBY: SURCHARGE COST OF AIRCRAFT AND CREW FOR DEDICATING OPERATIONS EXCLUSIVE-LY TO GOVERNMENT-DIRECTED WORK; DURING EMERGENCY OPERATION PERIODS.<br><br>(NOTE: Include on IDT contracts as applicable. U/P is essentially firm's overhead rate for aircraft and crew while on nonflight status.) | | C/DAY | | |
| 0503 | * AIRCRAFT AND FLIGHT CREW SURCHARGE FOR *[OCONUS] [_____] TRANSIT, TRAVEL, AND RELATED NONSTANDARD FEES AND EXPENSES ASSOCIATED THEREWITH. | | JOB | L/S | |

Note: AMT = Amount; C/DAY = Crew-Day; L/S = Lump Sum; EXP = Exposure; M/DAY = Man-Day; M/HOUR = Man-Hour.

| ITEM | DESCRIPTION | QUAN | U/M | U/P | AMT |
|---|---|---|---|---|---|
| 0503 (Continued) | (NOTE: Use, as applicable, for either nonconventional or OCONUS (outside the continental United States) sites and/or projects. Fee is in addition to those routinely covered above, and could include items such as aircraft long-distance transit modifications, customs fees, fuel surcharges, OCONUS per diem, etc.) | | | | |
| 0504 | *[other requirements] | | | | |
| | AERIAL PHOTOGRAPHY: OBTAIN STEREOSCOPIC COVERAGE *[BLACK AND WHITE PANCHROMATIC] [COLOR] [_____] PHOTOGRAPHY USING HIGH-PRECISION AERIAL MAPPING CAMERA IN ACCORDANCE WITH SCALE, COVER- AGE, AND OTHER APPLICABLE TECHNICAL SPECIFICATIONS CONTAINED IN SECTION C *[AND/OR DELIVERY ORDER SCOPE], AND MAPS OR ATTACHMENTS THERETO; AND PERFORM ALL PROFESSIONAL LABORATORY FILM PROCESSING AND PREPARATION FUNCTIONS, TO INCLUDE LABOR AND MATERIALS FOR DEVELOPING, TRIMMING, CLEANING, INDEXING, LABELING, AND SHIPPING OF NEGATIVES AND POSITIVES.<br><br>AERIAL PHOTOGRAPHY SHALL BE FLOWN WITH A 6-IN. CAMERA AT AN ALTITUDE THAT RESULTS IN A NEGATIVE SCALE *[OF_____] [INDICATED IN SECTION C].<br><br>    (NOTE: For IDT contracts, add the following statement: The contractor may waive this minimum order if he is able to consume a roll of film over several projects.)<br><br>* A MINIMUM DELIVERY OF THIRTY (30) *[_____ (__)] EXPOSURES WILL APPLY TO EACH ORDER PLACED AGAINST THIS CON- TRACT, UNLESS WAIVED BY THE CONTRACTOR.<br><br>FURNISH *[ONE (1)] [_____ (__)] SET(S) OF PRELIMINARY CHECK PRINTS AND *[TWO (2)] [____ (__)] SETS OF FINAL CONTACT PRINTS FOR EACH EXPOSURE. (NOTE: Add control prints if needed.) | | | | |

| ITEM | DESCRIPTION | QUAN | U/M | U/P | AMT |
|---|---|---|---|---|---|
| (Con- tin- ued) | (NOTE:  Specify only those film types below that will be used on the project and/or IDT contract.  Detailed material and technical specifications for each film type specified must be included in Section C of the contract.) | | | | |
| 0800 | * BLACK AND WHITE PANCHROMATIC FILM | | EXP | | |
| 0801 | * COLOR AERIAL FILM | | EXP | | |
| 0802 | * COLOR INFRARED FILM (FALSE COLOR) | | EXP | | |
| 0803 | * [OTHER]  (NOTE:  Add material/ tech- nical requirements at Section C) | | EXP | | |
| 0900 | * ADDITIONAL CONTACT PRINTS (NOTE:  This item may be scheduled on IDT contracts if there is a possibility that additional contact prints (beyond the required delivery amount) may be re- quired on one or more orders.  Include a line item for each type of film sched- uled above.) | | EACH | | |
| 0901 | FILM DIAPOSITIVES: BLACK AND WHITE FILM TRANSPARENCIES COLOR FILM TRANSPARENCIES *[GLASS DIAPOSITIVES] | | EACH EACH EACH | | |
| 0902 | * OBTAIN NEAR-VERTICAL AND/OR OBLIQUE AERIAL PHOTOGRAPHY FOR *[CONTROLLED MAP- PING] [GENERAL UNCONTROLLED PHOTO ENLARGEMENT] USES, USING *[AERIAL MAPPING CAMERA] [HAND-HELD CAMERA] AND IN ACCOR- DANCE WITH SECTION C SPECIFICATIONS. | | JOB | | |
| 0903 | *[other requirements] | | | | |
| | PHOTO INDEX:  PROFESSIONAL LABOR AND MATERIALS REQUIRED TO PREPARE STANDARD PHOTO INDICES IN ACCORDANCE WITH THE TECHNICAL SPECIFICATIONS, SHEET TYPE/SIZE, SCALES, ETC., AS DESCRIBED IN SECTION C OF THE CONTRACT *[AND/OR AS MODIFIED BY DELIVERY ORDERS]; PRO- CESS/PRINT RATIOED CONTACT PRINTS; LAY OUT, INDEX, AND ORIENT FLIGHT STRIPS; AND DRAFTING AND REPRODUCTION OF INDICES. DELIVER *[ONE (1)] *[____ (__)] SET OF PHOTO INDEX MAPS PER PROJECT ON MATERIAL/FORMAT DESCRIBED IN SECTION C. | | EACH INDEX SHEET | L/S | |

| ITEM | DESCRIPTION | QUAN | U/M | U/P | AMT |
|------|-------------|------|-----|-----|-----|
| 1000 (Continued | (NOTE:  On IDT contracts, the U/M should be based on a nominal 20- by 24-in. index sheet with the negotiated U/P developed from a typical number of photos/flight strips.) | | | | |
| 1001 | LINE PHOTO INDEX MAP: DELIVER *[ONE (1)] *[____ (__)] SET OF LINE PHOTO INDEX MAPS PER PROJECT ON USGS QUAD MAP, IN FORMAT DESCRIBED IN SECTION C. | | EACH | L/S | |
| | UNCONTROLLED PHOTOGRAPHIC PRODUCTS:  FOR EACH PRODUCT LISTED BELOW, PROVIDE NECESSARY LABOR AND MATERIALS REQUIRED, TO INCLUDE THE FOLLOWING: LABORATORY FILM PROCESSING AND PREPARATION FUNCTIONS, PHOTOGRAPHIC ENLARGEMENT FUNCTIONS, TRIMMING, ORIENTATION, INDEXING, LABELING, MOUNTING, DRAFTING, REPRODUCTION, AND SHIPPING OF RESULTANT NEGATIVE AND/OR POSITIVE DRAWINGS/TRANSPARENCIES, AS APPLICABLE TO THE PRODUCT AND AS DEFINED IN SECTION C OF THE CONTRACT SCOPE OF WORK.  FURNISH [ONE (1)] *[____ (__)] SET OF EACH REQUIRED PRODUCT, MOUNTED ON *[MASONITE] [STYROFOAM] [PLYWOOD] [_____], OR ON FILMPOSITIVE TRANSPARENCIES AS SPECIFIED IN SECTION C. <br><br>(NOTE:  Specify photo mounting and framing, as applicable, or requirements for reproducible film positives or film negatives, unless covered in Section C.) <br><br>(NOTE:  Select only the following items applicable to the contract.) | | | | |
| 1100 | AIR PHOTO ENLARGEMENT, BLACK & WHITE, PER SECTION C ENLARGEMENT CRITERIA. | | *[JOB] [SQ IN] | | |
| 1101 | AIR PHOTO ENLARGEMENT, COLOR, PER SECTION C ENLARGEMENT CRITERIA. | | *[JOB] [SQ IN] | | |
| 1102 | UNCONTROLLED AIR PHOTO PLAN ENLARGEMENT, BLACK AND WHITE, FILM POSITIVE DRAWING FORMAT, PER SECTION C SPECIFICATIONS. | | *[JOB] [SQ IN] [SQ FT] | | |
| 1103 | AIR PHOTO MOSAIC, ASSEMBLED FROM UNCONTROLLED PHOTOGRAPHY. | | [JOB] | | |
| 1104 | *[other requirements] | | | | |

| ITEM | DESCRIPTION | QUAN | U/M | U/P | AMT |
|------|-------------|------|-----|-----|-----|
|  | SEMICONTROLLED AIR PHOTO PLANS, CONTROLLED AIR PHOTO PLANS, AND ORTHOPHOTO PRODUCTS:  FOR EACH PRODUCT LISTED BELOW, PROVIDE NECESSARY LABOR AND MATERIALS REQUIRED, TO INCLUDE THE FOLLOWING: LABORATORY FILM PROCESSING AND PREPARATION FUNCTIONS, PHOTOGRAPHIC ENLARGEMENT FUNCTIONS, PHOTO CONTROL RECTIFICATION, MENSURATION AND HORIZONTAL/VERTICAL ORIENTATION AND ALIGNMENT, TRIMMING, INDEXING, LABELING, MOUNTING, DRAFTING, REPRODUCTION, AND SHIPPING OF RESULTANT NEGATIVE AND/OR POSITIVE DRAWINGS/ TRANSPARENCIES, AS APPLICABLE TO THE PRODUCT AND AS DEFINED IN SECTION C OF THE CONTRACT SCOPE OF WORK.  FURNISH [ONE (1)] *[_____ (__)] SET OF EACH REQUIRED PRODUCT IN THE FORMAT SPECIFIED IN SECTION C.  (NOTE:  Specify, for each line item, sheet size, photo mounting and framing, and other applicable requirements, including requirements for reproducible film positives or film negatives. These detailed specifications may be contained in Section C.)  (NOTE:  Select only the following items applicable to the contract.) |  |  |  |  |
| 1200 | SEMICONTROLLED (TO USGS MAP BASE) AIR PHOTO PLAN ENLARGEMENT, *[BLACK & WHITE] [COLOR], ON FILM-POSITIVE DRAWING FORMAT |  | [SHEET] or [JOB] |  |  |
| 1201 | CONTROLLED/RECTIFIED AIR PHOTO PLAN ENLARGEMENT, *[BLACK & WHITE] [COLOR], ON FILM-POSITIVE DRAWING FORMAT |  | [SHEET] or [JOB] |  |  |
| 1205 | ORTHOPHOTOGRAPH, BLACK AND WHITE, FILM-POSITIVE DRAWING FORMAT. (NOTE:  Topo or feature overlay requirements would be covered by stereoplotter line items, as would ground survey control needs.) |  | JOB | L/S |  |
| 1210 | *[other requirements] |  |  |  |  |
| 1300 | REGISTERED/LICENSED LAND SURVEYOR |  | M/DAY |  |  |
| 1301 | SURVEY COMPUTER (OFFICE) |  | M/DAY |  |  |

| ITEM | DESCRIPTION | QUAN | U/M | U/P | AMT |
|------|-------------|------|-----|-----|-----|
| 1302 | [TWO] [THREE] [FOUR] [____]-MAN PHOTO CONTROL SURVEY PARTY, CONSISTING OF ALL LABOR, TRAVEL, TRANSPORTATION, SURVEY EQUIPMENT, AND MATERIALS NECESSARY TO PERFORM PHOTO CONTROL SURVEYS, INCLUDING PANELLING, QUALITY CONTROL, AND TOPOGRAPHIC DETAILING, AND OTHER FUNCTIONS SPECIFIED IN SECTION C. | | C/DAY | | |
| | (Unit rates for individual party members) | | | | |
| 1303 | SUPERVISORY SURVEY TECHNICIAN (FIELD) | | M/DAY | | |
| 1304 | SURVEYING TECHNICIAN-INSTRUMENTMAN/RECORDER | | M/DAY | | |
| 1305 | SURVEYING AID-RODMAN/CHAINMAN | | M/DAY | | |
| 1306 | STATION MONUMENTS (NOTE: Specify disc type and monument construction) | | EACH | | |
| 1307 | FIELD CLASSIFICATION, QUALITY CONTROL, AND EDIT SURVEYS: *[TWO] [____]-MAN SURVEY CREW (SUP SURV TECH + INST/REC) | | C/DAY | | |
| 1308 | FIELD QUALITY ASSURANCE MAP TESTING SURVEYS: *[TWO] [____]-MAN CREW (SUP SURV TECH + INST/REC) | | C/DAY | | |
| | STEREOCOMPILATION, DRAFTING, AND EDITING: FURNISH PROFESSIONAL LABOR, INSTRUMENTATION, AND MATERIALS REQUIRED TO ORIENT, CONTROL, AND MAP TOPOGRAPHIC AND/OR PLANIMETRIC FEATURES USING STEREOSCOPIC PLOTTING INSTRUMENTS; SCRIBE, DRAFT, EDIT FINAL DRAWINGS; AND DEVELOP DIGITAL DATABASES IN ACCORDANCE WITH THE PROJECT TECHNICAL AND ACCURACY REQUIREMENTS SPECIFIED IN SECTION C OF THE CONTRACT. | | | | |
| 1400 | MODEL SETUP AND ORIENTATION | | M/HOUR | | |
| 1401 | PLANIMETRIC FEATURE STEREOCOMPILATION | | M/HOUR | | |
| 1402 | TOPOGRAPHY STEREOCOMPILATION (NOTE: The above items may be combined) | | M/HOUR | | |
| 1403 | ANALYTICAL AEROTRIANGULATION: LABOR, MATERIALS, AND MEASUREMENT/COMPUTATION INSTRUMENTS NECESSARY TO MEASURE AND ADJUST SUPPLEMENTAL PHOTO CONTROL USING ANALYTICAL BRIDGING TECHNIQUES. | | PHOTO or PLATE MODEL | | |
| | DRAFTING MATERIALS AND LABOR: | | | | |

| ITEM | DESCRIPTION | QUAN | U/M | U/P | AMT |
|------|-------------|------|-----|-----|-----|
| 1404 | STABLE—BASED MYLAR *[F—SIZE] | | SHEET | | |
| 1405 | SCRIBECOAT MATERIAL | | SHEET | | |
| 1406 | PLANIMETRIC FEATURE PLOTTING/SCRIBING | | M/HOUR | | |
| 1407 | TOPOGRAPHY PLOTTING/SCRIBING | | M/HOUR | | |
| 1408 | CADD OPERATOR (EDITOR) | | M/HOUR | | |
| 1409 | MAP EDITING (OFFICE) | | M/HOUR | | |
| | REPRODUCTION: | | | | |
| 1410 | BLUE—LINE PRINTS *[F—SIZE] | | EACH | | |
| 1411 | FILM TRANSPARENCIES *[F—SIZE] | | EACH | | |
| 1412 | CADD—GENERATED PRINTS (PAPER/B&W)) | | EACH | | |
| 1420 | PHOTOGRAMMETRIC PROJECT MANAGER | | M/HOUR | | |
| 1430 | CHIEF PHOTOGRAMMETRIST (PRODUCTION MANAGER) | | M/HOUR | | |
| 1440 | COMPUTER USAGE:  (CADD COMPUTER CONNECT TIME CHARGES NOT INCLUDED IN OVERHEAD) | | *[MIN] [HOUR] | | |
| 1450 | *[other requirements] | | | | |
| 1600 | NONTOPOGRAPHIC PHOTOGRAMMETRY | | JOB | L/S | |
| 1601 | *[other nontopographic requirements] | | | | |

## SECTION C

## STATEMENT OF WORK

C.1  GENERAL.  THE CONTRACTOR, OPERATING AS AN INDEPENDENT CONTRACTOR AND NOT
AS AN AGENT OF THE GOVERNMENT, SHALL PROVIDE ALL LABOR, MATERIAL, AND EQUIP-
MENT NECESSARY TO PERFORM THE PROFESSIONAL PHOTOGRAMMETRIC MAPPING *[AND
RELATED SURVEYING WORK] *[FROM TIME TO TIME] DURING THE PERIOD OF SERVICE AS
STATED IN SECTION D, IN CONNECTION WITH PERFORMANCE OF PHOTOGRAMMETRIC MAPPING
AND RELATED SURVEYS AND THE PREPARATION OF SUCH MAPS AS MAY BE REQUIRED FOR
*[ADVANCE PLANNING,] [DESIGN,] [AND CONSTRUCTION] [or other function] ON
[VARIOUS PROJECTS] [specify project(s)].  THE CONTRACTOR SHALL FURNISH THE
REQUIRED PERSONNEL, EQUIPMENT, SURVEYING AND PHOTOGRAMMETRIC REDUCTION/
COMPILATION INSTRUMENTS, AIRCRAFT, AND LAND TRANSPORTATION AS NECESSARY TO
ACCOMPLISH THE REQUIRED SERVICES AND FURNISH TO THE GOVERNMENT MAPS, DIGITAL
TERRAIN DATA, REPORTS, AND OTHER DATA TOGETHER WITH SUPPORTING MATERIAL DEVEL-
OPED DURING THE FIELD DATA ACQUISITION PROCESS.  DURING THE PROSECUTION OF THE
WORK, THE CONTRACTOR SHALL PROVIDE ADEQUATE PROFESSIONAL SUPERVISION AND QUAL-
ITY CONTROL TO ASSURE THE ACCURACY, QUALITY, COMPLETENESS, AND PROGRESS OF THE
WORK.

\*\*\*\*\*\*\*\*\*\*\*\*\*\*\*\*\*\*\*\*\*\*\*\*\*\*\*\*\*\*\*\*\*\*\*\*\*\*\*\*\*\*\*\*\*\*\*\*\*\*\*\*\*\*\*\*\*\*\*\*\*\*\*\*\*\*\*\*\*\*\*\*\*\*\*
          NOTE:  The above clause is intended for use in an IDT con-
          tract for photogrammetric mapping services.  It may be
          used for fixed-price photogrammetric mapping service
          contracts by deleting appropriate IDT language and adding
          the specific project survey required.  This clause is not
          repeated on individual delivery orders.
\*\*\*\*\*\*\*\*\*\*\*\*\*\*\*\*\*\*\*\*\*\*\*\*\*\*\*\*\*\*\*\*\*\*\*\*\*\*\*\*\*\*\*\*\*\*\*\*\*\*\*\*\*\*\*\*\*\*\*\*\*\*\*\*\*\*\*\*\*\*\*\*\*\*\*

C.2.  LOCATION OF WORK.

\*\*\*\*\*\*\*\*\*\*\*\*\*\*\*\*\*\*\*\*\*\*\*\*\*\*\*\*\*\*\*\*\*\*\*\*\*\*\*\*\*\*\*\*\*\*\*\*\*\*\*\*\*\*\*\*\*\*\*\*\*\*\*\*\*\*\*\*\*\*\*\*\*\*\*
          NOTE:  Use the following clause for a fixed-scope contract
          or individual work order.
\*\*\*\*\*\*\*\*\*\*\*\*\*\*\*\*\*\*\*\*\*\*\*\*\*\*\*\*\*\*\*\*\*\*\*\*\*\*\*\*\*\*\*\*\*\*\*\*\*\*\*\*\*\*\*\*\*\*\*\*\*\*\*\*\*\*\*\*\*\*\*\*\*\*\*

     C.2.1.  PHOTOGRAMMETRIC MAPPING AND RELATED SURVEYING SERVICES WILL BE
PERFORMED AT [_____]  *[list project area, state, installation, etc.].
*[A MAP DETAILING THE WORK SITE IS ATTACHED AT SECTION G OF THIS CONTRACT.]

\*\*\*\*\*\*\*\*\*\*\*\*\*\*\*\*\*\*\*\*\*\*\*\*\*\*\*\*\*\*\*\*\*\*\*\*\*\*\*\*\*\*\*\*\*\*\*\*\*\*\*\*\*\*\*\*\*\*\*\*\*\*\*\*\*\*\*\*\*\*\*\*\*\*\*
          NOTE:  Use the following when specifying an indefinite
          delivery contract for photogrammetric mapping services.
\*\*\*\*\*\*\*\*\*\*\*\*\*\*\*\*\*\*\*\*\*\*\*\*\*\*\*\*\*\*\*\*\*\*\*\*\*\*\*\*\*\*\*\*\*\*\*\*\*\*\*\*\*\*\*\*\*\*\*\*\*\*\*\*\*\*\*\*\*\*\*\*\*\*\*

     C.2.2.  PHOTOGRAMMETRIC MAPPING AND RELATED SURVEYING SERVICES WILL BE
PERFORMED IN CONNECTION WITH PROJECTS *[LOCATED IN] [ASSIGNED TO] THE
[_____] DISTRICT.  *[THE _____ DISTRICT INCLUDES THE
GEOGRAPHICAL REGIONS WITHIN *[AND COASTAL WATERS] [AND RIVER SYSTEMS] ADJACENT
TO:]

                    _____
                    *[list states, regions, etc.]

*****************************************************************************
   NOTE:  Add also any local points—of—contact, right—of—
   entry requirements, clearing restrictions, installation
   security requirements, etc.
*****************************************************************************

C.3  <u>TECHNICAL CRITERIA AND STANDARDS</u>.  THE FOLLOWING STANDARDS ARE REFERENCED
IN THIS CONTRACT.  IN CASES OF CONFLICT BETWEEN THESE TECHNICAL SPECIFICATIONS
AND ANY REFERENCED TECHNICAL STANDARD, THESE SPECIFICATIONS SHALL HAVE
PRECEDENCE.

   C.3.1.  USACE EM 1110—1—1000, PHOTOGRAMMETRIC MAPPING.  THIS REFERENCE
IS ATTACHED TO AND MADE PART OF THIS CONTRACT.  (SEE CONTRACT SECTION G.)

   C.3.2.  USACE EM 1110—1—1002, SURVEY MARKERS AND MONUMENTATION.  *[THIS
REFERENCE IS ATTACHED TO AND MADE PART OF THIS CONTRACT.  (SEE CONTRACT
SECTION G.)]

   C.3.3.  USACE EM 1110—1—1807, STANDARDS MANUAL FOR USACE COMPUTER—AIDED
DESIGN AND DRAFTING (CADD) SYSTEMS.

   C.3.4.  MANUAL OF PHOTOGRAMMETRY, ASPRS, *[_____] EDITION.

   C.3.5.  *United States National Map Accuracy Standards, US Bureau of the
Budget, 17 June 1947.

   C.3.6.  *Reference Guide Outline:  Specifications for Aerial Surveys and
Mapping by Photogrammetric Methods for Highways, US Department of Transpor—
tation, Federal Highway Administration, Washington, DC, 1968.

   C.3.7.  ASPRS Accuracy Standards for Large—Scale Maps, ASPRS, March
1990.

   C.3.8.  *Standards and Specifications for Geodetic Control Networks,
Federal Geodetic Control Committee (FGCC), September 1984.

   C.3.9.  *[District Drafting Standards Manual]

   C.3.10.  *Flood Insurance Study—Guidelines and Specifications for Study
Contractors, Federal Emergency Management Agency (FEMA), Federal Insurance
Administration, Publication FEMA 37, March 1991.

*****************************************************************************
   NOTE:  List other reference standards that may be applica—
   ble to some phase of the work.  Reference may also be made
   to other EM's or standard criteria documents.  Such docu—
   ments need not be attached to the Contract; if attached,
   however, reference should be made to their placement in
   contract Section G.
*****************************************************************************

C.4  <u>WORK TO BE PERFORMED</u>.  PROFESSIONAL PHOTOGRAMMETRIC MAPPING AND RELATED
SURVEYING SERVICES TO BE PERFORMED UNDER THIS CONTRACT ARE DEFINED BELOW.
UNLESS OTHERWISE INDICATED IN THIS CONTRACT *[OR IN DELIVERY ORDERS THERETO],

EACH REQUIRED SERVICE SHALL INCLUDE FIELD-TO-FINISH EFFORT. ALL MAPPING WORK
WILL BE PERFORMED USING PRECISE PHOTOGRAMMETRIC DATA ACQUISITION, MENSURATION,
AND COMPILATION PROCEDURES, INCLUDING ALL QUALITY CONTROL ASSOCIATED WITH
THESE FUNCTIONS. THE WORK WILL BE ACCOMPLISHED IN STRICT ACCORDANCE WITH THE
PHOTOGRAMMETRIC MAPPING CRITERIA CONTAINED IN THE TECHNICAL REFERENCES (PARA-
GRAPH C.3 ABOVE), EXCEPT AS MODIFIED OR AMPLIFIED HEREIN.

\*\*\*\*\*\*\*\*\*\*\*\*\*\*\*\*\*\*\*\*\*\*\*\*\*\*\*\*\*\*\*\*\*\*\*\*\*\*\*\*\*\*\*\*\*\*\*\*\*\*\*\*\*\*\*\*\*\*\*\*\*\*\*\*\*\*\*\*\*\*\*\*\*\*\*\*
NOTE: The following clauses in this section of the
guide may be used for either fixed-price photogram-
metric mapping contracts, IDT work orders under a
photogrammetric mapping IDT contract, or IDT contracts
where photogrammetric mapping services are part of a
schedule of various survey disciplines.
\*\*\*\*\*\*\*\*\*\*\*\*\*\*\*\*\*\*\*\*\*\*\*\*\*\*\*\*\*\*\*\*\*\*\*\*\*\*\*\*\*\*\*\*\*\*\*\*\*\*\*\*\*\*\*\*\*\*\*\*\*\*\*\*\*\*\*\*\*\*\*\*\*\*\*\*

C.4.1. PURPOSE OF WORK. THE WORK TO BE PERFORMED UNDER THIS CONTRACT
IS TO BE USED AS BASIC SITE PLAN MAPPING INFORMATION FOR *[INSTALLATION MASTER
PLANNING] [DESIGN] [CONSTRUCTION] [OPERATION] [MAINTENANCE] [REAL ESTATE]
[REGULATORY ENFORCEMENT] [HAZARDOUS AND TOXIC WASTE SITE _____]
[_____]; INCLUDING THOSE RELATED ACTIVITIES AND/OR ENGINEERING
STUDIES COVERING SUCH PERTINENT DETAILS AS *[RESERVOIR CAPACITIES] [CHANNEL
CAPACITIES] [DAMAGE ASSESSMENT] [BENEFITS] [PROJECT LOCATION] [DESIGN OF MAIN
STRUCTURE AND APPURTENANCES] [RELOCATIONS] [LAND ACQUISITION] [LAND DEVELOP-
MENT AND MANAGEMENT] [ENCROACHMENT] [CONSTRUCTION MEASUREMENT AND PAYMENT]
[_____].

\*\*\*\*\*\*\*\*\*\*\*\*\*\*\*\*\*\*\*\*\*\*\*\*\*\*\*\*\*\*\*\*\*\*\*\*\*\*\*\*\*\*\*\*\*\*\*\*\*\*\*\*\*\*\*\*\*\*\*\*\*\*\*\*\*\*\*\*\*\*\*\*\*\*\*\*
NOTE: A brief description of the functional purpose
of the photography/mapping (in the above clause) is
absolutely essential in that the contractor can focus
his efforts and quality control toward the more criti-
cal aspects of the project. The above clause should
be written so that it explicitly describes the overall
functional purpose of the mapping effort plus any
critical design (and construction) work that will be
performed using the product. This information can be
used by the contractor to optimize flight alignment,
ground control, stereocompilation, etc., in order to
ensure coverage of critical areas.
\*\*\*\*\*\*\*\*\*\*\*\*\*\*\*\*\*\*\*\*\*\*\*\*\*\*\*\*\*\*\*\*\*\*\*\*\*\*\*\*\*\*\*\*\*\*\*\*\*\*\*\*\*\*\*\*\*\*\*\*\*\*\*\*\*\*\*\*\*\*\*\*\*\*\*\*

C.4.2. GENERAL MAPPING REQUIREMENTS. PHOTOGRAMMETRICALLY COMPILED LINE
MAPS AT A TARGET SCALE OF 1 IN. = [_____] FT ARE REQUIRED FOR THE [_____]-
ACRE SITE DELINEATED ON THE MAP ATTACHED AT SECTION G. THE MAPPING AND/OR
RELATED DIGITAL PRODUCTS SHALL MEET USACE (ASPRS) CLASS *[___] ACCURACY STAN-
DARDS AS SPECIFIED IN EM 1110-1-1000. PLANIMETRIC FEATURE DETAIL WILL BE
COMPILED BASED ON THIS HORIZONTAL MAPPING STANDARD. CONTOURS SHALL BE
DEVELOPED AT [___]-FT INCREMENTS IN ACCORDANCE WITH THE VERTICAL ACCURACY
STANDARDS. THE SITE SHALL BE FLOWN AT A PHOTO-NEGATIVE SCALE EQUAL TO OR
LARGER THAN THAT SPECIFIED IN EM 1110-1-1000 TO MEET THE REQUIRED PLANIMETRIC
AND TOPOGRAPHIC ACCURACY CRITERIA. FEATURE AND TERRAIN DATA SHALL BE
DELIVERED IN DIGITAL FORMAT.

**********************************************************************************

> NOTE:  The above clause should be used for fixed—scope
> contracts or IDT contract work orders to give a brief
> overview of the general mapping effort, the technical
> requirements of which will be described in subsequent
> paragraphs of the contract.
>
> Note that the final map compilation target scale and
> ASPRS accuracy class/standard are specifically and
> rigidly defined upfront in the scope.  These
> parameters directly define the required, or maximum
> allowable, flight altitude (and negative scales) by
> reference to the criteria in EM 1110—1—1000.
>
> IDT contracts and work orders:  Since specific project
> scopes are indefinite at the time a basic contract is
> prepared, only general technical criteria and stand—
> ards can be outlined.  Project or site—specific
> criteria, in clauses similar to the above, will be
> contained in each delivery order, along with any devia—
> tions from technical standards identified in the
> basic IDT  contract.  The clauses contained throughout
> the rest of the contract are used to develop the gen—
> eral requirements for a basic IDT contract.  Subse—
> quent delivery orders will reference these clauses,
> adding project—specific work requirements as required.
> Delivery order formats should follow the outline
> established for the basic IDT contract.

**********************************************************************************

C.4.3.  COMPLETION OF WORK.  ALL WORK MUST BE COMPLETED AND DELIVERED
NOT LATER THAN [_____].  *[Add pre/partial submittal schedules, if
applicable.]

C.5.  AIRCRAFT FLIGHT OPERATIONS AND EQUIPMENT REQUIREMENTS.

C.5.1.  AIRCRAFT AND FLIGHT CREW.  THE AIRCRAFT FURNISHED OR UTILIZED
UNDER THIS CONTRACT SHALL BE EQUIPPED WITH NAVIGATION AND PHOTOGRAPHIC INSTRU-
MENTS AND ACCESSORIES NECESSARY TO SATISFACTORILY PRODUCE THE REQUIRED PHOTO-
GRAPHY.  THE AIRCRAFT SHALL BE MAINTAINED IN OPERATIONAL CONDITION DURING THE
PERIOD OF THIS CONTRACT, AND SHALL CONFORM WITH ALL GOVERNING FEDERAL AVIATION
ADMINISTRATION AND CIVIL AERONAUTICS BOARD REGULATIONS OVER SUCH AIRCRAFT.
THE FLIGHT CREW AND CAMERAMAN SHALL HAVE HAD A MINIMUM OF 400 HOURS EXPERIENCE
IN FLYING PRECISE PHOTOGRAMMETRIC MAPPING MISSIONS.

C.5.2.  CAMERA WINDOWS AND CAMERA MOUNTING.  WHEN HIGH—ALTITUDE PHOTOG-
RAPHY IS REQUIRED, CAMERA WINDOWS MAY BE NEEDED.  CAMERA WINDOWS SHALL BE
MOUNTED IN VIBRATION—DAMPING MATERIAL TO AVOID MECHANICAL STRESS TO THE
WINDOW.  PRIOR TO PHOTOGRAPHY, ANY CAMERA WINDOW USED SHALL BE CHECKED BY THE
CALIBRATION CENTER TO ENSURE THAT IT WILL NOT ADVERSELY AFFECT LENS RESOLUTION
AND DISTORTION AND THAT IT IS SUBSTANTIALLY FREE OF VEINS, STRIATIONS, AND
OTHER INHOMOGENEITIES.  THE CAMERA ITSELF SHALL BE INSTALLED IN A MOUNTING
THAT DAMPENS THE EFFECTS OF AIRCRAFT VIBRATION.  AIRCRAFT EXHAUST GASES SHALL
BE VENTED AWAY FROM CAMERA OPENING.

*********************************************************************************
    NOTE:   The two clauses above represent minimum stand-
    ards possessed by most professional aerial mapping
    contractors, and are inherent in the quality control
    function.  Government inspection of these standards is
    neither practical nor expected.
*********************************************************************************

    C.5.3.   FLIGHT PLAN.  THE MINIMUM AREA(S) TO BE PHOTOGRAPHED ARE AS
INDICATED ON MAPS *[ATTACHED AT SECTION G] [WHICH WILL BE PROVIDED FOR EACH
PHOTOGRAPHIC DELIVERY ORDER].  GIVEN THE SPECIFIED PHOTO-NEGATIVE SCALE CRITE-
RIA HEREIN, THE CONTRACTOR SHALL DESIGN THE FLIGHT LINES FOR THE PHOTOGRAPHY
TO OBTAIN PROPER OVERLAP, SIDELAP, AND ENDLAP TO ASSURE FULL STEREOSCOPIC
PHOTOGRAPHIC COVERAGE, IN ACCORDANCE WITH THE CRITERIA DEFINED IN THIS CON-
TRACT *[OR DELIVERY ORDER THERETO].  GENERALLY, THE FLIGHT LINES SHALL BE
PARALLEL TO EACH OTHER AND TO THE LONGEST BOUNDARY LINES OF THE AREA TO BE
PHOTOGRAPHED.  FOR SINGLE STRIP PHOTOGRAPHY, THE ACTUAL FLIGHT LINE SHALL NOT
VARY FROM THE LINE PLOTTED ON THE FLIGHT MAP BY MORE THAN THE SCALE OF THE
PHOTOGRAPHY EXPRESSED IN FEET.  FOR EXAMPLE, THE ALLOWABLE TOLERANCE FOR
PHOTOGRAPHY FLOWN AT A SCALE OF 1 IN. EQUALS 1000 FT IS ABOUT 1000 FT.  THE
FLIGHT LINES SHALL *[NOT] BE SUBMITTED TO THE GOVERNMENT FOR ADVANCE APPROVAL.

*********************************************************************************
    NOTE:   Flight planning alignment and other details are
    best left to the professional contractor to design,
    given his experience in optimizing aircraft utiliza-
    tion during transit and flight operations and stereo-
    scopic coverage.  In most cases, the guide writer need
    only reference small- scale maps or drawings depicting
    the  area to be mapped, or provide geographical/grid
    coordinates defining the area/route.  During the
    initial planning discussions with the functional user,
    the outline of project limits for both aerial photog-
    raphy and mapping should be clearly defined, prefera-
    bly on the best available map.  US Geological Survey
    (USGS) quadrangle maps at scales of 1:24,000 or
    1:62,500 are particularly good for this purpose.

    Detailed flight maps will then be prepared by the
    photogrammetric contractor for his flight crew.  The
    map on which the flight lines are drawn should be the
    best available map of the project area.  Previously
    flown aerial photographs can also be used, especially
    when reflights of this photography are ordered.
    Should functional project requirements dictate a
    particular flight alignment, then the guide writer
    should incorporate that into the specifications (e.g.,
    regulatory enforcement photography being flown paral-
    lel to a shoreline).  For areas having irregular boun-
    daries or for meandering streams, block flying, that
    is, two or more parallel flight lines to cover the
    area, is preferable to many short lines designed to
    follow each irregularity of the project area.  Also,
    consideration should be given to roads and trails

adjacent to the project area.  Incorporating these
access routes into the photography frequently will
facilitate the necessary ground surveys for photo con-
trol.  Flight line design must recognize potential flight
hazards, and lines should be parallel to the ridge lines
of mountains rather than leading into them.

USACE Commands may require that proposed flight plans
be submitted to the Contracting Officer for approval.
Unless there is some unusual technical or military
operational purpose for this requirement, such
preapprovals should not be required.

************************************************************************************

C.5.4.  FLYING CONDITIONS.  PHOTOGRAPHY SHALL BE UNDERTAKEN ONLY WHEN
WELL-DEFINED IMAGES CAN BE OBTAINED.  UNLESS OTHERWISE SPECIFIED, FLYING SHALL
BE LIMITED TO THE PERIOD OF 3 HOURS AFTER LOCAL SUNRISE TO 3 HOURS BEFORE
LOCAL SUNSET.  *[PHOTOGRAPHY SHALL BE ACCOMPLISHED BETWEEN THE HOURS OF
*[_____] AND *[_____], LOCAL SOLAR TIME.] *[PHOTOGRAPHY SHALL NOT CON-
TAIN SHADOWS CAUSED BY TOPOGRAPHIC RELIEF OR SUN ANGLE OF LESS THAN *[THIRTY
(30)] [_____ (__)] DEGREES, WHENEVER SUCH SHADOWS CAN BE AVOIDED DURING
THE TIME OF YEAR THE PHOTOGRAPHY MUST BE TAKEN.]  PHOTOGRAPHY SHALL NOT BE AT-
TEMPTED WHEN THE GROUND IS OBSCURED BY HAZE, SMOKE, OR DUST, *[SNOW] OR WHEN
THE CLOUDS OR CLOUD SHADOWS WILL APPEAR ON MORE THAN *[FIVE (5)] [_____
(__)] PERCENT OF THE AREA OF ANY ONE PHOTOGRAPH.

************************************************************************************
NOTE:  The above clause should be modified based on the
project requirements.  For detailed large-scale
line mapping, obviously no obscured areas can be
tolerated, whereas for simple small-scale photo cover-
age and/or enlargements, some reasonable obscuring is
allowable.  Light snow cover may be an asset in some
instances.  Overrestriction of clear coverage require-
ments, time, or dates can significantly increase the
cost of a project.
************************************************************************************

C.5.5.  *DATE OF PHOTOGRAPHY.  PHOTOGRAPHY MUST BE FLOWN DURING THE
PERIOD [_____] IN ORDER TO ADEQUATELY DELINEATE
[_____].  *[PHOTOGRAPHY WILL BE FLOWN DURING THE PERIODS
REPRESENTED IN WORK ORDERS PLACED AGAINST THIS BASIC CONTRACT.]

************************************************************************************
NOTE:  Include any dates within which photography must
be taken, such as during minimum foliage, operational
movement, construction excavation/placement period,
certain river/reservoir stage, high/low tide, etc.
Such a clause might be required when photogrammetric
methods are used for measuring construction excavation
or placement, and photo missions are performed at
defined periods.  The above clause is applicable to
either fixed-scope contracts or IDT contract work orders.
************************************************************************************

C.5.6. AIRCRAFT UTILIZATION. TOTAL AIRCRAFT UTILIZATION TO, FROM, BETWEEN, AND OVER PROJECT SITES IS BASED ON THE PROVISIONS CONTAINED IN SECTION B. IN ESTIMATING AVAILABLE AIRCRAFT OPERATIONAL TIME, AVERAGE WEATHER AND CLOUD COVER CONDITIONS ARE ASSUMED FOR THE GIVEN SITE AND TIME OF YEAR, CONSISTENT WITH AIRCRAFT UTILIZATION RATES HISTORICALLY DEVELOPED. ADDITIONAL CREW COSTS WILL ACCRUE DURING DEPLOYMENT AT OR NEAR THE PROJECT SITE, WHERE APPLICABLE. AIRCRAFT AND FLIGHT CREW STANDBY AT THE HOME BASE SHALL BE CONSIDERED AS AN OVERHEAD EXPENSE AND SHALL HAVE BEEN PROPERLY FACTORED INTO THE UNIT RATE OF THE AIRCRAFT.

\*\*\*\*\*\*\*\*\*\*\*\*\*\*\*\*\*\*\*\*\*\*\*\*\*\*\*\*\*\*\*\*\*\*\*\*\*\*\*\*\*\*\*\*\*\*\*\*\*\*\*\*\*\*\*\*\*\*\*\*\*\*\*\*\*\*\*\*\*\*\*\*\*\*\*\*\*\*\*\*\*\*

NOTE: Aircraft hourly rates are based on long-term utilizations while performing typical project/flight missions. These rates include overhead associated with normal weather delays. These utilizations should be confirmed by field audit. If the project (or delivery order) is not typical in scope or location, then adjustment to the established rates may be warranted. Otherwise, provide detailed requirements, conditions, notification procedures, and compensation provisions for emergency dedication of an aircraft. Direct and indirect costs must be clearly identified in establishing the crew-day rate for such an item.

\*\*\*\*\*\*\*\*\*\*\*\*\*\*\*\*\*\*\*\*\*\*\*\*\*\*\*\*\*\*\*\*\*\*\*\*\*\*\*\*\*\*\*\*\*\*\*\*\*\*\*\*\*\*\*\*\*\*\*\*\*\*\*\*\*\*\*\*\*\*\*\*\*\*\*\*\*\*\*\*\*\*

C.5.7. *EMERGENCY AIRCRAFT STANDBY.

C.5.8. *OCONUS FLIGHT OPERATIONS. [Add other nonstandard photogrammetric aircraft and flight crew costs. Detail as required or if not fully defined in Section B.]

C.5.9. FLIGHT LOG. FOR EACH FLIGHT DAY, THE PILOT OR CAMERAMAN SHALL PREPARE A FLIGHT LOG CONTAINING THE DATE, PROJECT NAME, AIRCRAFT USED, AND NAMES OF CREW MEMBERS. IN ADDITION, THE FOLLOWING SHALL BE PREPARED FOR EACH FLIGHT LINE: ALTITUDE, CAMERA, MAGAZINE SERIAL NUMBER, F-STOP, SHUTTER SPEED, BEGINNING AND ENDING EXPOSURE NUMBERS AND TIMES, AND ANY OTHER COMMENTS RELATIVE TO THE FLIGHT CONDITIONS. THESE FLIGHT LOGS, OR COPIES THEREOF, MAY BE INCORPORATED INTO THE FILM REPORT (IF REQUIRED) AND WILL BE DELIVERED TO THE CONTRACTING OFFICER AS SPECIFIED IN THIS CONTRACT.

C.5.10. SUBCONTRACTED PHOTOGRAPHY. BEFORE COMMENCEMENT OF ANY AERIAL PHOTOGRAPHY UNDER THIS CONTRACT *[OR WORK ORDER] BY A SUBCONTRACTOR, THE CONTRACTOR SHALL FURNISH THE CONTRACTING OFFICER, IN WRITING, THE NAME OF SUCH SUBCONTRACTOR, TOGETHER WITH A STATEMENT AS TO THE EXTENT AND CHARACTER OF THE WORK TO BE DONE UNDER THE SUBCONTRACT, INCLUDING APPLICABLE CAMERA CERTIFICATIONS.

\*\*\*\*\*\*\*\*\*\*\*\*\*\*\*\*\*\*\*\*\*\*\*\*\*\*\*\*\*\*\*\*\*\*\*\*\*\*\*\*\*\*\*\*\*\*\*\*\*\*\*\*\*\*\*\*\*\*\*\*\*\*\*\*\*\*\*\*\*\*\*\*\*\*\*\*\*\*\*\*\*\*

NOTE: Reasonable flexibility should be provided contractors in substituting aircrafts or cameras to meet the exigencies of the operations. Ideally, potential subcontractors will have been identified during initial submittal/negotiations. In practice, unforeseen

aircraft/camera substitution is often required in order to
meet critical delivery dates.
**************************************************************************

C.6.  AERIAL PHOTOGRAPHY SCALE AND RELATED COVERAGE PARAMETERS.

C.6.1.  PHOTO-NEGATIVE SCALE AND FLIGHT ALTITUDE.  THE REQUIRED NEGATIVE
SCALE FOR THIS PROJECT *[SHALL EQUAL OR EXCEED THE CRITERIA CONTAINED IN
EM 1110-1-1000] [IS 1 IN. - *[_____] FT] [WILL BE DEFINED IN THE SCOPE
OF WORK PROVIDED WITH EACH DELIVERY ORDER], AND SHALL BE CONSISTENT WITH THE
REQUIRED MAP ACCURACY STANDARD/CLASS SPECIFIED AND THE MAXIMUM ALLOWABLE ALTI-
TUDES SPECIFIED IN EM 1110-1-1000 FOR MAINTAINING HORIZONTAL AND VERTICAL
TOLERANCES RELATIVE TO FLIGHT ALTITUDE.  THE FLIGHT HEIGHT ABOVE THE AVERAGE
ELEVATION OF THE GROUND IS DESIGNED SUCH THAT THE NEGATIVES HAVE AN AVERAGE
SCALE SUITABLE FOR ATTAINING REQUIRED PHOTOGRAMMETRIC MEASUREMENT, MAP SCALE,
CONTOUR INTERVAL, AND ACCURACY, GIVEN THE REQUIRED (FIXED) 6-IN. MAPPING
CAMERA FOCAL LENGTH, STEREOPLOTTER MODEL, AND QUALITY CONTROL CRITERIA, AS
DEFINED ELSEWHERE IN THESE SPECIFICATIONS.  *[NEGATIVES HAVING A DEPARTURE
FROM THE SPECIFIED SCALE OF MORE THAN 5 PERCENT BECAUSE OF TILT OR ANY CHANGES
IN THE FLYING HEIGHT MAY BE CAUSE FOR REJECTION OF THE WORK.]  *[DEPARTURES
FROM SPECIFIED FLIGHT HEIGHT SHALL NOT EXCEED 2 PERCENT LOW OR 5 PERCENT HIGH
FOR ALL FLIGHT HEIGHTS UP TO 12,000 FT ABOVE GROUND ELEVATION.  ABOVE
12,000 FT, DEPARTURES FROM SPECIFIED FLIGHT HEIGHT SHOULD NOT EXCEED 2 PERCENT
LOW OR 600 FT HIGH.]  ANY PROPOSED VARIATION BY THE CONTRACTOR TO CHANGE
EITHER THE CAMERA FOCAL LENGTH OR NEGATIVE SCALE CONSTITUTES A MAJOR CHANGE IN
SCOPE AND THEREFORE MUST BE EFFECTED BY FORMAL CONTRACT *[DELIVERY ORDER]
MODIFICATION.

**************************************************************************
NOTE:  No aspect of the photogrammetric mapping speci-
fication process is more critical—and subject to
abuse—than that limiting flight altitudes or negative
scales.  This is due to their direct impact on photo/
model coverage, resultant planimetric/topographic
accuracy, ground control requirements, and overall
project cost.  Since costs vary exponentially with
negative scale, even minor variations can be
significant.

EM 1110-1-1000 provides maximum flight altitudes for
the various map accuracy requirements.  The specifica-
tion writer may simply require conformance with the
criteria in this manual, or must specify a firm, fixed
negative scale that optimizes both accuracy and cost.
Use of the manual's criteria is recommended.  Any modifi-
cations to this negative scale proposed by the photogram-
metric contractor during such negotiations (or after
award) must be substantiated by appropriate revisions to
the Government estimate, or modification, as required.  No
contract should ever be awarded with indefinite "open-
ended" negative scales subject to the contractor's "expert
recommendation" or "discretion."
**************************************************************************

C.6.2.  STEREOSCOPIC COVERAGE AND OVERLAP REQUIREMENTS.  *[UNLESS OTHERWISE MODIFIED IN DELIVERY ORDERS] THE OVERLAP SHALL BE SUFFICIENT TO PROVIDE FULL STEREOSCOPIC COVERAGE OF THE AREA TO BE PHOTOGRAPHED, AS FOLLOWS:

**********************************************************************
NOTE:  Many of the following overlap and photo orienta-
tion specifications are throwbacks to older 1950's
vintage mechanical-optical train stereoplotter re-
quirements or restrictions.  Newer analytical
stereoplotters are not so sensitive to excesses in
these parameters.  However, these specifications may
optionally be retained as a form of contractor quality
control, plus assuring that, at the least, photography
is obtained that can be viewed stereoscopically by
nonanalytical devices.

USACE Commands rarely have the resources, time, or
equipment to check compliance with these orientation
requirements; therefore, clauses are given optional
enforcement/rejection provisions.  In most cases,
poorly flown photography will be rejected by the con-
tractor's internal quality control procedures and will
be reflown before compilation proceeds.
**********************************************************************

        a.  BOUNDARIES.  ALL OF THE AREA APPEARING ON THE FIRST AND LAST NEGATIVE IN EACH FLIGHT LINE EXTENDING OVER A BOUNDARY SHALL BE OUTSIDE THE BOUNDARY OF THE PROJECT AREA.  THE PRINCIPAL POINT OF TWO PHOTOGRAPHS ON BOTH ENDS OF EACH FLIGHT LINE SHALL BE TAKEN PAST THE BOUNDARY LINE OF THE PROJECT. EACH STRIP OF PHOTOGRAPHS ALONG A BOUNDARY SHALL EXTEND OVER THE BOUNDARY NOT LESS THAN *[FIFTEEN (15)] [_____ (__)] PERCENT OF THE WIDTH OF THE STRIP.

        b.  ENDLAP.  *[Unless otherwise specified in a delivery order,] the forward overlap shall be *sixty (60) percent  *[± five (5)] [± _____ (__)] percent.  Endlap of less than *[fifty-five (55)] [_____ (__)] percent in one or more negatives may be cause for rejection of the negative or negatives in which such deficiency or excess of endlap occurs.

**********************************************************************
NOTE:  A maximum endlap specification is optional—it
need not be restricted and is often deliberately in-
creased to 80 percent ± 3 percent for analytical
aerotriangulation or vertical viewing requirements.
This will impact compilation cost, however.
**********************************************************************

        c.  SIDELAP.  *[Unless otherwise specified in a delivery order,] the lateral sidelap shall average *[thirty (30)] [_____ (__)] percent *[± ten (10)] [±_____ (__)] percent.  Any negative having sidelap less than *[fifteen (15)] [_____ (__)] percent or more than *[fifty (50)] [_____ (__)] percent may be rejected.  The foregoing requirement can be varied in cases where the strip area to be mapped is slightly wider than the area that can be covered by one strip of photographs, where increase in

sidelap is required for control densification purposes, or where increase or decrease in sidelap is required to reach established ground control.

       d.  CRAB.  Absolute crab of any photograph relative to the flight line, or relative crab between any series of two or more consecutive photographs, in excess of *[10] [_____] degrees, as indicated by displacement of the principal points of the photographs, may be considered cause for rejection of the photography.  Average crab for any flight line shall not exceed *[5] [___] degrees.  For aerotriangulation, no photograph shall be crabbed in excess of five (5) degrees as measured from the line of flight.

       e.  TILT.  Negatives exposed with the optical axis of the aerial camera in a vertical position are desired.  Tilt (angular departure of the aerial camera axis from a vertical line at the instant of exposure) in any negative of more than *[four (4)] [_____ (__)] degrees, or an average of more than *[two (2)] [_____ (__)] degrees for any ten (10) consecutive frames, or an average tilt of more than *[one (1)] [_____ (__)] degree(s) for the entire project, or relative tilt between any two successive negatives exceeding *[six (6)] [_____ (__)] degrees may be cause for rejection.

       f.  TERRAIN ELEVATION VARIANCES.  When ground heights within the area of overlap vary by more than ten (10) percent of the flying height, a reasonable variation in the stated overlaps shall be permitted provided that the fore and aft overlaps do not fall below *[55] [___] percent and the lateral sidelap does not fall below *[10] [___] percent or exceed *[50] [___] percent.  In extreme terrain relief where the foregoing overlap conditions are impossible to maintain in straight and parallel flight lines, the gaps created by excessive relief may be filled by short strips flown between the main flight lines and parallel to them.

       g.  Strips running parallel to a shoreline may be repositioned to reduce the proportion of water covered, provided the coverage extends beyond the limit of any land feature by at least 10 percent of the strip width.

   C.6.3.  Where the ends of strips of photography join the ends of other strips or blocks flowing in the same general direction, there shall be an overlap of at least two stereoscopic models.  In flight lines rephotographed to obtain substitute photography for rejected photography, all negatives shall be exposed to comply with original flight specifications, including scale and overlap requirements.  The joining end negatives in the replacement strip shall have complete stereoscopic coverage of the contiguous area on the portion or portions not rejected.

   C.6.4.  *OBLIQUE PHOTOGRAPHY.

**********************************************************************************

      NOTE:  Detail herein any oblique photography and/or oblique photogrammetric mapping compilation requirements.  Camera tilts in excess of 5 degrees are classified as oblique photographs.  These photographs are used primarily for pictorial views of large areas.  They may also be used in supplementary mapping of complicated plant sites where pipelines may be obscured in vertical photographs of the plant, and as

such would be compiled on an analytical plotter.
Oblique photographs are often taken using high—quality
hand—held cameras, or using specially designed aerial
mapping camera mounts.  A high oblique aerial photo—
graph is one in which the horizon (where the earth and
sky appear to meet) is visible.  Units of measure for
oblique photography are typically on a lump sum (job)
basis, and when no controlled compilation is involved,
may be obtained by Invitation for Bids (IFB)/purchase
order procedures.  An example would be a high oblique
of an installation for a visitor information center.

**********************************************************************

C.7.  <u>AERIAL CAMERA SPECIFICATIONS</u>.

    C.7.1.  TYPE OF CAMERA.  ONLY A STANDARD 6—IN. (153mm ± 3mm) FOCAL—
LENGTH SINGLE—LENS PRECISE AERIAL MAPPING CAMERA, EQUIPPED WITH A HIGH—
RESOLUTION, DISTORTION—FREE LENS, AND WITH A BETWEEN—THE—LENS SHUTTER WITH
VARIABLE SPEED, SHALL BE USED ON THIS CONTRACT.  THE AERIAL CAMERA USED SHALL
BE OF LIKE/ SIMILAR QUALITY TO A *[Wild U. Aviogon] *[Zeiss Pleogon A] *[Jena
Lamegon Pl] *[Wild Model RC10] *[Wild RC—8], OR *[Zeiss Model RMK—A 15/23].
THE CAMERA SHALL FUNCTION PROPERLY AT THE NECESSARY ALTITUDE AND UNDER
EXPECTED CLIMATIC CONDITIONS, AND SHALL EXPOSE A  9— by 9—IN.— (228 by 228mm—)
SQUARE NEGATIVE.  THE LENS CONE SHALL BE SO CONSTRUCTED THAT THE LENS, FOCAL
PLANE AT CALIBRATED FOCAL LENGTH, FIDUCIAL MARKERS, AND MARGINAL DATA MARKERS,
COMPRISE AN INTEGRAL UNIT OR ARE OTHERWISE FIXED IN RIGID ORIENTATION WITH ONE
ANOTHER.  *WHEN EXTREMELY LARGE SCALE (LOW ALTITUDE) PHOTOGRAPHY IS BEING
FLOWN, THE CAMERA SHALL BE EQUIPPED WITH FORWARD IMAGE MOTION COMPENSATION.

    C.7.2.  CALIBRATION.  THE AERIAL CAMERA(S) FURNISHED BY THE CONTRACTOR
OR HIS DESIGNATED SUBCONTRACTORS SHALL HAVE BEEN CALIBRATED BY THE USGS WITHIN
*[THREE (3)] [_____ (__)] YEARS OF AWARD OF THIS CONTRACT.  THE CALIBRA—
TION REPORT SHALL BE PRESENTED TO THE CONTRACTING OFFICER PRIOR TO USE ON THIS
CONTRACT *[AND/OR DELIVERY ORDERS PLACED AGAINST THIS CONTRACT].  CALIBRATED
TOLERANCES SHALL BE WITHIN THE STANDARDS CONTAINED IN EM 1110—1—1000.  *[Cer—
tification shall also be provided indicating that preventative maintenance has
been performed within the last two (2) years.]

    C.7.3.  SUBSTITUTE CAMERAS.  SUBSTITUTE CAMERAS THAT DO NOT MEET THE
ABOVE SPECIFICATIONS MAY NOT BE USED ON THIS CONTRACT *[OR DELIVERY ORDERS
THERETO].

**********************************************************************

NOTE:  It is critical to maintain consistency in
aerial cameras used for detailed design line mapping
work.  Therefore, only 6—in. focal length cameras are
recommended in this guide.  Use of different cameras
with nonstandard focal lengths may affect not only the
quality of work but also the unit prices configured in
Schedule B.  The contract should not allow unlimited
flexibility to substitute cameras based on a mapping
contractor's recommendation.  If a special type of
camera is used for a particular project, then

specifications for that camera and associated costs
must be detailed herein or by modification.

Numerous camera calibration specification and
tolerance requirements are embodied in the contract by
reference to EM 1110—1—1000.  These include tolerances
for focal length, magazine platen, fiducial marks,
lens distortion, lens resolving power, filters, shut—
ters, apertures, and spectral ranges.  There is no
need to  repeat these technical specifications in this
contract.  Restrictions to like/similar camera models,
along with the requirement for USGS calibration cer—
tification, help assure that quality photography will
be obtained.
*************************************************************************************

C.8.  <u>AERIAL FILM SPECIFICATIONS AND PROCESSING REQUIREMENTS</u>.

C.8.1.  GENERAL.  FILM MATERIALS AND LABORATORY PROCESSING, DEVELOPING,
REPRODUCTION, AND PRINTING THEREOF, SHALL CONFORM WITH RECOGNIZED PROFESSIONAL
PHOTOGRAMMETRIC INDUSTRY STANDARDS AND PRACTICES, AS OUTLINED IN EM 1110—1—
1000 AND IN CHAPTER 6 OF THE ASPRS MANUAL OF PHOTOGRAMMETRY, AND OTHER
NATIONAL STANDARDS OR SPECIFICATIONS REFERENCED THEREIN.

*************************************************************************************
NOTE:  For professional service "field—finish" line
mapping contracts, it is necessary to include only
general guidance over the quality of materials and
professional photographic laboratory practices.  Since
the professional mapping firm is responsible for the
ultimate accuracy and quality of the compiled line
maps, that firm will usually strive to utilize the
highest—quality materials and related processes to
achieve that goal.  Deficiencies in materials, cover—
age gaps, obscured features, etc., will be readily
apparent during stereocompilation—in effect, the
stereocompilation phase represents a quality control
check over the initial data, both photography and
ground control.  However, when IFB contracts are used
to obtain aerial photography (no subsequent controlled
compilation), there may be far less internal quality
control.  In IFB contracts, film material and process—
ing specifications, and Government quality control/quality
assurance (QC/QA) efforts, may need to be more detailed.
*************************************************************************************

C.8.2.  TYPE OF FILM REQUIRED.  THE CONTRACTOR SHALL USE ONLY AERIAL
FILM OF A QUALITY THAT IS EQUAL OR SUPERIOR TO 4 MIL KODAK DOUBLE—X AERO—
GRAPHIC 2405 (ESTAR BASE) PANCHROMATIC FILM; KODAK PLUS—X AEROGRAPHIC 2402
(ESTER BASE); 4 MIL KODAK AEROCOLOR NEGATIVE FILM 2445 (ESTAR BASE); OR 4 MIL
KODAK AEROCHROME INFRARED FILM 2443 (ESTAR BASE), AS APPLICABLE TO THOSE TYPES
OF PHOTOGRAPHY SCHEDULED IN SECTION B.  ONLY FRESH, FINE—GRAIN, HIGH—SPEED,
DIMENSIONALLY STABLE, AND SAFETY BASE AERIAL FILM EMULSIONS SHALL BE USED.
OUTDATED FILM SHALL NOT BE USED.  *[THE THICKNESS OF THE BASE SHALL NOT BE

LESS THAN 0.1 MM AND THE DIMENSIONAL STABILITY SHALL BE SUCH THAT IN ANY NEGA-
TIVE THE LENGTH AND WIDTH BETWEEN FIDUCIALS SHALL NOT VARY BY MORE THAN
0.3 PERCENT FROM THE SAME MEASUREMENTS TAKEN ON THE CAMERA, AND THAT THE DIF-
FERENTIAL BETWEEN THESE MEASUREMENTS SHALL NOT EXCEED 0.04 PERCENT.]

**********************************************************************************

> NOTE:   Black and white panchromatic film is the most
> widely used type for aerial photography.  There is a
> greater latitude in exposure and processing of black
> and white panchromatic films than there is with color
> films.  Color aerial photography may enhance function-
> al interpretation during the plotting process.  Color
> photography requires above-average weather conditions,
> meticulous care in exposure and processing, and color-
> corrected lenses.  For these reasons, color photogra-
> phy and color prints are more expensive than panchro-
> matic.  Use of color film for detailed line mapping
> will depend on the difficulty of photo interpretation
> (by the stereoplotter operator) needed in the project
> site.  Infrared emulsions have greater sensitivity to
> red and the near infrared, which penetrate haze and
> smoke.  Thus, infrared film can be used on days that
> would be unsuitable for ordinary panchromatic films.
> It is also useful for the delineation of water and wet
> areas, and for certain types of forestry and land use
> studies.  It may be used in the detection of diseased
> plants and trees, identification and differentiation
> of a variety of freshwater and saltwater growths for
> wetland studies, and many water pollution and environ-
> mental impact studies.  A color-corrected camera lens
> is required.  The cost of obtaining infrared color is
> greater than black and white.  Infrared film would not
> be specified for detailed line mapping work.

**********************************************************************************

C.8.3.  UNEXPOSED FILM.  WHENEVER ANY PART OF AN UNEXPOSED ROLL OF FILM
REMAINS IN THE CAMERA, BEFORE SUCH FILM IS USED ON A SUBSEQUENT DAY, A MINIMUM
3-FT SECTION OF THE ROLL OF FILM SHALL BE ROLLED FORWARD, AND EXPOSED,
IMMEDIATELY PRECEDING THE BEGINNING OF PHOTOGRAPHY.

C.8.4.  QUALITY OF PHOTOGRAPHY.  THE PHOTOGRAPHIC NEGATIVES SHALL BE
TAKEN SO AS TO PREVENT APPRECIABLE IMAGE MOVEMENT AT THE INSTANT OF EXPOSURE.
THE NEGATIVES SHALL BE FREE FROM STATIC MARKS, SHALL HAVE UNIFORM COLOR TONE,
AND SHALL HAVE THE PROPER DEGREE OF CONTRAST FOR ALL DETAILS TO SHOW CLEARLY
IN THE DARK-TONE AREAS AND HIGH-LIGHT AREAS AS WELL AS IN THE HALFTONES
BETWEEN DARK AND LIGHT.  NEGATIVES HAVING EXCESSIVE CONTRAST OR NEGATIVES LOW
IN CONTRAST MAY BE REJECTED.

C.8.5.  PROCESSING OF EXPOSED FILM.  THE PROCESSING, INCLUDING DEVELOP-
MENT AND FIXATION AND WASHING AND DRYING OF ALL EXPOSED PHOTOGRAPHIC FILM,
SHALL RESULT IN NEGATIVES FREE FROM CHEMICAL OR OTHER STAINS, CONTAINING
NORMAL AND UNIFORM DENSITY, AND FINE-GRAIN QUALITY.  BEFORE, DURING, AND AFTER
PROCESSING, THE FILM SHALL NOT BE ROLLED TIGHTLY ON DRUMS OR IN ANY, WAY
STRETCHED, DISTORTED, SCRATCHED, OR MARKED, AND SHALL BE FREE FROM FINGER

MARKS, DIRT, OR BLEMISHES OF ANY KIND.  EQUIPMENT USED FOR PROCESSING SHALL BE
EITHER REWIND SPOOL—TANK OR CONTINUOUS PROCESSING MACHINE, AND MUST BE CAPABLE
OF ACHIEVING CONSISTENT NEGATIVE QUALITY SPECIFIED BELOW WITHOUT CAUSING DIS—
TORTION OF THE FILM.  DRYING OF THE FILM SHALL BE CARRIED OUT WITHOUT
AFFECTING ITS DIMENSIONAL STABILITY.

C.8.6.  THE CAMERA PANEL OF INSTRUMENTS SHOULD BE CLEARLY LEGIBLE ON ALL
PROCESSED NEGATIVES.  FAILURE OF INSTRUMENT ILLUMINATION DURING A SORTIE SHALL
BE CAUSE FOR REJECTION OF THE PHOTOGRAPHY.  ALL FIDUCIAL MARKS SHALL BE
CLEARLY VISIBLE ON EVERY NEGATIVE.

C.8.7.  FILM STRIP DOCUMENTATION AND LABELING.  AT MINIMUM, THE FOLLOW—
ING INFORMATION SHALL BE SUPPLIED AS LEADERS AT THE START AND THE END OF EACH
FILM STRIP:

a.  CONTRACT NUMBER AND/OR DELIVERY ORDER DESIGNATION, AS
APPLICABLE.

b.  FILM NUMBER.

c.  FLIGHT LINE IDENTIFICATION(S).

d.  DATES/TIMES OF PHOTOGRAPHY.

e.  EFFECTIVE NEGATIVE NUMBERS AND RUN NUMBERS.

f.  APPROXIMATE SCALE(S) OF PHOTOGRAPHY.

g.  THE CALIBRATED FOCAL LENGTH OF THE CAMERA.

h.  CONTRACTOR'S NAME.

C.8.8.  NEGATIVE NUMBERING AND ANNOTATION.  EACH NEGATIVE WILL BE
LABELED CLEARLY WITH THE IDENTIFICATION SYMBOL AND NUMBERING CONVENTION RECOM—
MENDED HEREIN.  THE NUMBERS WILL BE SEQUENTIAL WITHIN EACH FLIGHT LINE AND
SHALL BE IN THE UPPER RIGHT—HAND CORNER OF THE NEGATIVE IMAGE EDGE TO BE READ
AS ONE LOOKS NORTHERLY ALONG THE FLIGHT LINE (OR WESTERLY WHEN LINES ARE EAST—
WEST).  ALL LETTERING AND NUMBERING OF NEGATIVES SHALL BE APPROXIMATELY
1/5 IN. HIGH AND SHALL RESULT IN EASILY READ, SHARP, AND UNIFORM LETTERS AND
NUMBERS.  NUMBERING OF NEGATIVES SHALL BE CARRIED OUT USING HEAT—FOIL OR
INDELIBLE INK.  EACH NEGATIVE SHALL BE PROVIDED WITH THE FOLLOWING ANNOTATION,
WHICH SHALL ALSO APPEAR ON THE PRINTS:

a.  YEAR, MONTH, AND DAY OF FLIGHT.

b.  *[USACE PROJECT—SPECIFIC LOCATION/IDENTIFICATION NUMBER].

c.  PHOTO SCALE (RATIO).

d.  FILM ROLL NUMBER.

e.  NEGATIVE NUMBER.

THE DATE OF THE PHOTOGRAPHY SHALL BE IN THE UPPER LEFT CORNER OF EACH FRAME FOLLOWED BY *[USACE PROJECT NUMBER, AND] PHOTO SCALE RATIO.  THE FRAME NUMBER WILL BE IN THE UPPER RIGHT-HAND CORNER OF EACH FRAME WITH THE ROLL NUMBER PRINTED 2 IN. TO THE LEFT OF THE FRAME NUMBER.

C.8.9.  FILM STORAGE AND DELIVERIES.  ALL NEGATIVES AND UNCUT FILM POSITIVES SHALL BE DELIVERED TO THE CONTRACTING OFFICER ON WINDING SPOOLS IN PLASTIC OR METAL CANISTERS.  ALL EXTRA AND REJECTED NEGATIVES SHALL BE INCLUDED IN THE ROLL(S).  AT LEAST 3 FT OF CLEAR FILM SHALL BE LEFT ON OR SPLICED TO EACH END OF THE ROLL.  ALL SPLICES SHALL BE OF A PERMANENT NATURE. EXPOSED AND UNEXPOSED FILM SHALL BE HANDLED IN ACCORDANCE WITH MANUFACTURER'S RECOMMENDATIONS.  EACH CANISTER SHOULD BE LABELED WITH THE MINIMUM INFORMATION INDICATED BELOW:

    a.  NAME AND ADDRESS OF THE CONTRACTING AGENCY.

    b.  NAME OF THE PROJECT.

    c.  DESIGNATED ROLL NUMBER.

    d.  NUMBERS OF THE FIRST AND LAST NUMBERED NEGATIVES OF EACH STRIP.

    e.  DATE OF EACH STRIP.

    f.  APPROXIMATE SCALE.

    g.  FOCAL LENGTH OF LENS IN MILLIMETERS.

    h.  NAME AND ADDRESS OF THE CONTRACTOR PERFORMING THE PHOTOGRAPHY.

    i.  CONTRACT NUMBER.

C.8.10.  *FILM REPORT.  A film report shall be included with each project giving the following type of information.

    a.  Film number.

    b.  Camera type and number, lens number, and filter type and number.

    c.  Magazine number or cassette and cassette holder unit numbers.

    d.  Film type and manufacturer's emulsion number.

    e.  Lens aperture and shutter speed.

    f.  Date of photography.

    g.  Start and end time for each run in local time.

    h.  Negative numbers of all offered photography.

    i.  Indicated flying height.

j.   Computed flying height above sea level.

k.   Scale of photography.

l.   Outside air temperature.

m.   Weather conditions:  cloud, visibility, turbulence.

n.   Date of processing.

o.   Method of developing.

p.   Developer used and dilution.

q.   Time and temperature of development or film transport speed.

r.   Length of film processed.

s.   General comment on quality.

\*\*\*\*\*\*\*\*\*\*\*\*\*\*\*\*\*\*\*\*\*\*\*\*\*\*\*\*\*\*\*\*\*\*\*\*\*\*\*\*\*\*\*\*\*\*\*\*\*\*\*\*\*\*\*\*\*\*\*\*\*\*\*\*\*\*\*\*\*\*\*\*\*\*\*\*\*\*\*\*\*

**NOTE:  Requirements for submitting the above film  processing report are rare and should be required only under special circumstances.  Normally, the Flight Log submittal (Paragraph C.5.9) is adequate.**

**All film submittal and annotation/documentation requirements should be reasonable and necessary.  Many of the detailed recordation requirements listed above make sense only for large, areawide mapping projects.**
\*\*\*\*\*\*\*\*\*\*\*\*\*\*\*\*\*\*\*\*\*\*\*\*\*\*\*\*\*\*\*\*\*\*\*\*\*\*\*\*\*\*\*\*\*\*\*\*\*\*\*\*\*\*\*\*\*\*\*\*\*\*\*\*\*\*\*\*\*\*\*\*\*\*\*\*\*\*\*\*\*

C.9.   <u>CONTACT PRINT AND DIAPOSITIVE SPECIFICATIONS</u>.

C.9.1.  MATERIAL.  ALL CONTACT PRINTS SHALL BE MADE ON AN ELECTRONIC PRINTER ON *[DOUBLE-WEIGHT FIBER-BASED PAPER OR MEDIUM-WEIGHT RESIN-COATED PAPER STOCK] *[other], ON WHICH INK, PENCIL, GREASE PENCIL, AND OTHER COMMONLY EMPLOYED MARKERS CAN BE USED ON BOTH SIDES.

C.9.2.  PROCESSING AND QUALITY.  THE PROCESSING, INCLUDING EXPOSURE DEVELOPMENT, WASHING, AND DRYING, SHALL RESULT IN FINISHED PHOTOGRAPHIC PRINTS HAVING *[GLOSS] [_____] FINISH, FINE-GRAIN QUALITY, NORMAL UNIFORM DENSITY, AND SUCH COLOR TONE AND DEGREE OF CONTRAST THAT ALL PHOTOGRAPHIC DETAILS OF THE NEGATIVE FROM WHICH THEY ARE PRINTED SHOW CLEARLY IN THE DARK-TONE AREAS AND HIGH-LIGHT AREAS AS WELL AS IN THE HALFTONES BETWEEN THE DARK AND THE HIGH LIGHT.  EXCESSIVE VARIANCE IN COLOR TONE OR CONTRAST BETWEEN INDIVIDUAL PRINTS MAY BE CAUSE FOR THEIR REJECTION.  ALL PRINTS SHALL BE CLEAR AND FREE OF STAINS, BLEMISHES, UNEVEN SPOTS, AIR BELLS, LIGHT FOG OR STREAKS, CREASES, SCRATCHES, AND OTHER DEFECTS THAT WOULD INTERFERE WITH THEIR USE OR IN ANY WAY DECREASE THEIR USEFULNESS.

C.9.3.   TRIMMING.  ALL CONTACT PRINTS SHALL BE TRIMMED TO NEAT AND UNIFORM DIMENSIONAL LINES ALONG IMAGE EDGES (WITHOUT LOSS OF IMAGE) LEAVING

DISTINCTLY THE CAMERA FIDUCIAL MARKS. PRINTS LACKING FIDUCIAL MARKS SHALL BE REJECTED.

C.9.4. DELIVERIES. ALL CONTACT PRINTS SHALL BE DELIVERED TO THE CONTRACTING OFFICER IN A SMOOTH, FLAT, AND USABLE CONDITION. THE NUMBER OF CONTACT PRINTS TO BE DELIVERED FOR EACH EXPOSURE IS *[INDICATED IN SECTION B] [_____]. *[ADDITIONAL SETS OF CONTACT PRINTS MAY BE ORDERED AT THE RATES INDICATED IN SECTION B.]

C.9.5. *Preliminary Check Prints. *[Detail requirements, if any.]

C.9.6. *Marked Control Prints. *[Detail requirements, if any.]

C.9.7. DIAPOSITIVE PLATES OR TRANSPARENCIES. ALL BLACK AND WHITE DIAPOSITIVE TRANSPARENCIES USED FOR PHOTOGRAMMETRIC MEASUREMENTS, INCLUDING MAP COMPILATION, SHALL BE EQUAL OR SUPERIOR IN QUALITY TO 0.130-IN.-THICK KODAK AERIAL PLOTTING PLATES OR 0.007-IN.-THICK DUPONT DIAPOSITIVE FILM, NO. CT-7. ALL COLOR DIAPOSITIVE TRANSPARENCIES SHALL BE EQUAL OR SUPERIOR TO KODAK COLOR DIAPOSITIVE FILM, NO. 4109. DIAPOSITIVES *[WILL] [MAY] [WILL NOT] BE DELIVERED TO THE GOVERNMENT FOR INSPECTION AND/OR QUALITY ASSURANCE TESTING. *[DIAPOSITIVES DELIVERED TO THE GOVERNMENT FOR INSPECTION WILL BE RETURNED TO THE CONTRACTOR.]

**************************************************************************

**NOTE:** Diapositive film/plates are rarely delivered unless the Government plans to perform quality control/assurance tests on the models, using Government-owned stereoplotters or third-party contractors. This is an option which the Contracting Officer may wish to reserve.

**************************************************************************

C.10. PHOTOGRAPHIC INDEX REQUIREMENTS.

**************************************************************************

**NOTE:** Not all photo mapping projects require photo index maps in the traditional (but costly) style described below. For small projects with few flight lines or frames, a drafted index of photo centers plotted on a USGS quad map will often serve the same functional purpose at far less cost.

**************************************************************************

C.10.1. GENERAL. THIS ITEM SHALL CONSIST OF ONE OR MORE PHOTOGRAPHIC NEGATIVES, AS NECESSARY, AND PHOTOGRAPHIC PRINT OR PRINTS THEREOF, OF AN ASSEMBLY OF AERIAL PHOTOGRAPHS FORMING AN INDEX OF THE PROJECT AERIAL PHOTOGRAPHY. *[THIS INDEX IS REQUIRED FOR ALL DELIVERIES PLACED UNDER THIS CONTRACT.] COSTS FOR CONTACT PRINTS ARE TO BE INCLUDED IN THE OVERALL UNIT COST OF THE PHOTO INDEX(ES). *[PHOTO INDICES MAY BE COMPILED BY PLOTTING PHOTO CENTERS ON USGS QUADRANGLE MAPS *[_____], ALONG WITH DESCRIPTIVE INFORMATION SPECIFIED BELOW.]

C.10.2. ASSEMBLY. THE PHOTO INDEX SHALL INCLUDE PHOTOGRAPHIC PRINTS MADE FROM ALL NEGATIVES OF THE PHOTOGRAPHY TAKEN AND ACCEPTED FOR THE PROJECT.

THE PRINTS SHALL BE TRIMMED TO A NEAT AND UNIFORM EDGE ALONG THE PHOTOGRAPHIC
IMAGE WITHOUT REMOVING THE FIDUCIAL MARKS.  THE PHOTOGRAPHS SHALL BE OVERLAP-
MATCHED BY CONJUGATE IMAGES ON THE FLIGHT LINE WITH EACH PHOTOGRAPH IDENTIFI-
CATION NUMBER CLEARLY SHOWN.  THE PHOTOGRAPHS FOR EACH ADJACENT FLIGHT LINE
STRIP SHALL OVERLAP IN THE SAME DIRECTION.  AIRBASE LENGTHS SHALL BE AVERAGED
IN THE IMAGE MATCHING OF SUCCESSIVE PAIRS OF PHOTOGRAPHS ON FLIGHT LINES, AND
ADJOINING FLIGHT LINE ASSEMBLIES SHALL BE ADJUSTED IN LENGTH BY INCREMENTAL
MOVEMENT ALONG THE FLIGHT LINE AS NECESSARY.

C.10.3.  LABELING AND TITLING.  FOR GEOGRAPHIC ORIENTATION, APPROPRIATE
NOTATIONS SHALL APPEAR ON THE INDEX, NAMING OR OTHERWISE IDENTIFYING IMPORTANT
AND PROMINENT GEOGRAPHIC AND LAND USE FEATURES.  ALL OVERLAY LETTERING AND
NUMBERING SHALL BE DRAFTING QUALITY.  IN ADDITION, A NORTH ARROW, SHEET INDEX,
IF APPLICABLE, AND A TITLE BLOCK SHALL APPEAR ON EACH INDEX.  THE TITLE BLOCK
SHALL CONTAIN PROJECT NAME, CONTRACTOR'S NAME, CONTRACT AGENCY NAME, DATE OF
PHOTOGRAPHY, AND AVERAGE SCALE OF PHOTOGRAPHY.

C.10.4.  SCALE AND SIZE.  THE STAPLED OR TAPED ASSEMBLY OF PHOTOGRAPHY
SHALL BE PHOTO-REDUCED TO A SCALE OF ABOUT ONE-THIRD (1/3) OF THE ORIGINAL
NEGATIVE SCALE, EXCEPT THAT A LARGER PHOTO INDEX SCALE CAN BE USED IF ALL
EXPOSURES FOR ONE PROJECT FIT THE REQUIRED FORMAT ON A SINGLE SHEET.  EACH
PHOTO INDEX SHEET SHALL BE *[20 BY 24 IN.] [_____] IN SIZE.

C.10.5.  *Photographic Copying and Printing.  The photo index shall be
copied on photographic film so that prints can be made by contact or projec-
tion method.  The method used shall be the option of the contractor.  Whenever
the index cannot be copied on one (1) negative, it shall be copied on two (2)
or more negatives as necessary.

C.10.6.  PROCESSING AND QUALITY.  ALL PHOTOGRAPHIC PRINTS OF THE INDEX
SHALL COMPLY WITH THE STIPULATIONS GIVEN FOR CONTACT PRINTS IN THIS CONTRACT.

C.10.7.  DELIVERIES.  *[ONE] [_____] FILM NEGATIVE OR NEGATIVES OF THE
PHOTOGRAPHIC INDEX, *[ONE *[Continuous Tone] [specify screen size] SCREENED
MYLAR FILM POSITIVE] [AND *[TWO] [_____] PHOTOGRAPHIC PRINTS THEREOF] SHALL BE
FURNISHED TO THE CONTRACTING OFFICER *[FOR EACH DELIVERY ORDER UNDER THIS
CONTRACT].

C.11.  UNCONTROLLED PHOTOGRAPHIC ENLARGEMENTS, AIR PHOTO PLANS, AND PHOTO
MOSAICS.

*************************************************************************************

NOTE:  Uncontrolled photographic enlargements or air
photo plan drawings and photo mosaics are usually
prepared from 9- by 9-in. format film.  They may also
be prepared from film taken by any type of camera—even
by a camera held by hand out the window of an aircraft.
Photography may be near-vertical or oblique.  These
types of products are distinguished by the fact that
they are "uncontrolled"—that is, no photogrammetric
rectification is performed to remove camera nonvertical
orientation or vertical relief distortion.  The scale
of these products is therefore only approximate, and
will vary from point to point.

Due to their uncontrolled nature, such products are
used only for general feature reference or location.
Detailed design or grid coordinate points/lines should
not be superimposed on these images except for general
reference.

Uncontrolled photographic products may, at times, be
more economically procured by using standard purchase
order (IFB) methods.  They may also be included as
line items in A-E IDT contracts when such products are
required in addition to controlled line mapping of a
particular site/project.

*********************************************************************************

   C.11.1  PHOTOGRAPHIC PAPER ENLARGEMENTS.  *[BLACK AND WHITE] [COLOR]
PHOTOGRAPHIC ENLARGEMENT IS REQUIRED OF THE AREA DESIGNATED *[ON THE ATTACHED
MAP] [_____].  AERIAL PHOTOGRAPHY SHALL BE *[NEAR-VERTICAL]
[OBLIQUE] USING A *[PRECISE AERIAL MAPPING CAMERA] [HAND-HELD TYPE CAMERA].
THE PHOTOGRAPH SHALL BE MOUNTED ON A [_____ BY _____]-IN. FORMAT, MOUNTED ON
A *[PLYWOOD] [STYROFOAM] [MASONITE] [_____] BASE, CONTAINING A
[_____]- IN. TRIMMED BORDER, A [_____] FRAME WITH WALL MOUNTING HARD-
WARE.  A TITLE BLOCK SHALL BE PLACED IN THE [_____] CORNER AND CONTAIN THE
FOLLOWING DATA: *[_____].  *[_____] COPIES OF THIS PRODUCT
ARE REQUIRED.

   C.11.2.  UNCONTROLLED AIR PHOTO MAP PLAN SHEETS/DRAWINGS.  AIR PHOTO
PLAN SHEETS, AT AN APPROXIMATE SCALE OF [_____], PROJECTED ON *[F]
[____]-SIZE FILM-POSITIVE DRAWING FORMAT, ARE REQUIRED FOR THE AREA DESIGNATED
*[ON THE ATTACHED MAP] [_____].  A TOTAL OF [_____] PHOTO PLAN
SHEETS ARE REQUIRED TO COVER THE PROJECT AREA.  *THESE SHEETS SHALL BE
ORIENTED AND LAID OUT AS SHOWN ON THE ATTACHED MAP.  *A [____]-IN. OVERLAP
SHALL BE USED BETWEEN SHEETS.  NEAR-VERTICAL AERIAL PHOTOGRAPHY TAKEN AT A
SCALE OF [_____] SHALL BE ENLARGED TO THE REQUIRED DEVELOPMENT SCALE
OF THE PHOTO PLAN SHEETS.  DRAFTING AND OTHER LABELING DETAILS ARE DESCRIBED
ELSEWHERE IN THIS *[CONTRACT] [ORDER].  [____] TRANSPARENCIES ARE REQUIRED FOR
EACH SHEET.  FILM POSITIVES SHALL BE SCREENED TO [_____].

*********************************************************************************
   NOTE:  Uncontrolled air photo plan overlays are eco-
   nomical products that may be used to show planning
   developments or contemplated changes in an area.  For
   example, an air photo plan can show the planned loca-
   tion of a proposed structure, canal, highway, etc.
   They are significantly more economical to obtain than
   controlled or semicontrolled photographic products,
   such as orthophotography, and in flat areas will serve
   the same purpose.
*********************************************************************************

   C.11.3.  AERIAL MOSAICS.  AN ASSEMBLED UNCONTROLLED PHOTO MOSAIC SHALL
BE PREPARED AT AN APPROXIMATE SCALE OF [_____].  THE MOSAIC SHALL BE
ASSEMBLED FROM [_____]-SCALE PHOTOGRAPHY, AND ENLARGED/REDUCED AS
REQUIRED.  THE MOSAIC SHALL BE MOUNTED ON A [_____ BY _____]-IN. FORMAT,

MOUNTED ON A *[PAPER] [PLYWOOD] [STYROFOAM] [MASONITE] [_____] BASE,
CONTAINING A [_____]-IN. TRIMMED BORDER, A [_____] FRAME WITH WALL
MOUNTING HARDWARE. *A FILM *[POSITIVE] [NEGATIVE] OF THE FINAL MOSAIC IS ALSO
REQUIRED. MOSAIC ASSEMBLY, MOUNTING, BLENDING, AND OTHER PROCESSES SHALL
FOLLOW STANDARD PROCEDURES SET FORTH IN THE MANUAL OF PHOTOGRAMMETRY (REFER-
ENCE C.3.[___]).

\*\*\*\*\*\*\*\*\*\*\*\*\*\*\*\*\*\*\*\*\*\*\*\*\*\*\*\*\*\*\*\*\*\*\*\*\*\*\*\*\*\*\*\*\*\*\*\*\*\*\*\*\*\*\*\*\*\*\*\*\*\*\*\*\*\*\*\*\*\*\*\*\*\*\*

> NOTE: Add other specifications as required. Aerial
> mosaics are rarely used in current USACE practice.
> For most USACE purposes, a single high-altitude photo
> enlargement is more cost-effective. They are best
> negotiated on a job/lump sum basis.

\*\*\*\*\*\*\*\*\*\*\*\*\*\*\*\*\*\*\*\*\*\*\*\*\*\*\*\*\*\*\*\*\*\*\*\*\*\*\*\*\*\*\*\*\*\*\*\*\*\*\*\*\*\*\*\*\*\*\*\*\*\*\*\*\*\*\*\*\*\*\*\*\*\*\*

C.12. CONTROLLED/RECTIFIED PHOTO PLANS AND ORTHOPHOTOGRAPHY.

\*\*\*\*\*\*\*\*\*\*\*\*\*\*\*\*\*\*\*\*\*\*\*\*\*\*\*\*\*\*\*\*\*\*\*\*\*\*\*\*\*\*\*\*\*\*\*\*\*\*\*\*\*\*\*\*\*\*\*\*\*\*\*\*\*\*\*\*\*\*\*\*\*\*\*

> NOTE: The process of rectification can be generally
> defined as the projective transformation of a tilted
> photograph into one that is tilt-free and of a desired
> scale. Rectification is accomplished by graphic
> methods, by analytical computations, or optically and
> mechanically using an instrument called a rectifier.
> Orthophotographs are compiled using optical/electronic
> image scanners.
>
> The need for rectified photo plans (or orthophoto-
> graphs), as opposed to uncontrolled air photo plans,
> will depend on the functional requirements of the
> design/construction project. Most design work is
> superimposed on line maps, not photo plan enlargements
> or orthophotos. Thus, the need for expensive ortho-
> photo mapping work must be functionally justified.
>
> An uncontrolled photo plan is far more economical than
> a controlled/rectified photo, and orthophotographs are
> significantly more expensive than rectified photogra-
> phy. In relatively flat terrain, the difference
> between a rectified plan and an orthophotograph is not
> significant; however, the cost will be. Specifying
> orthophoto mapping when simple uncontrolled or recti-
> fied photography would suffice is a common problem,
> and can unnecessarily increase project costs. For
> example, orthophotos would not be necessary for river
> and harbor project condition surveys—a partially con-
> trolled air photo plan enlargement would be adequate. In
> general, an orthophotograph product should be specified
> only when design data for large-scale contract plans and
> specifications will be superimposed on the drawing.

\*\*\*\*\*\*\*\*\*\*\*\*\*\*\*\*\*\*\*\*\*\*\*\*\*\*\*\*\*\*\*\*\*\*\*\*\*\*\*\*\*\*\*\*\*\*\*\*\*\*\*\*\*\*\*\*\*\*\*\*\*\*\*\*\*\*\*\*\*\*\*\*\*\*\*

C.12.1. *[CONTROLLED/RECTIFIED] [SEMICONTROLLED] AIR PHOTO MAP PLAN
SHEETS/DRAWINGS. RECTIFIED AIR PHOTO PLAN SHEETS, AT AN SCALE OF
[_____], PROJECTED ON *[F] [___]-SIZE FILM-POSITIVE DRAWING FORMAT,

ARE REQUIRED FOR THE AREA DESIGNATED *[ON THE ATTACHED MAP] [_____].
A TOTAL OF [_____] RECTIFIED PHOTO PLAN SHEETS ARE REQUIRED TO COVER THE
PROJECT AREA. *THESE SHEETS SHALL BE ORIENTED AND LAID OUT AS SHOWN ON THE
ATTACHED MAP. *A [____]-IN. OVERLAP SHALL BE USED BETWEEN SHEETS. AERIAL
PHOTOGRAPHY TAKEN AT A SCALE OF [_____] SHALL BE *[GRAPHICALLY]
[ANALYTICALLY] RECTIFIED USING STANDARD OPTICAL-MECHANICAL RECTIFICATION
INSTRUMENTS, AND SHALL BE CONTROLLED BY PHOTO-IDENTIFIABLE *[GROUND SURVEY
CONTROL] [USGS QUAD MAP FEATURES]. FILM POSITIVES SHALL BE SCREENED TO
[_____]. DRAFTING AND OTHER LABELING DETAILS ARE DESCRIBED ELSEWHERE
IN THIS *[CONTRACT] [ORDER]. [___] TRANSPARENCIES ARE REQUIRED FOR EACH
SHEET. REFERENCE ALSO EM 1110-1-1000.

********************************************************************************

> NOTE: The rectification process requires a visual fit
> between the photograph and points identifiable either
> on a map or surveyed ground control points plotted on
> a manuscript base. When only approximate scale/
> orientation is needed, a USGS quad map (or other
> larger scale map) may be used to orient/rectify the
> photographs. Such a product might be classified as
> "semicontrolled." This method is far more economical
> than using ground surveys to control the photos, a
> controlled product. Plan sheets produced in this way
> can be printed on normal photographic paper or film
> positives for subsequent reproduction use. These can
> be combined with plots of hydrographic/stream cross
> sections, for example, on the same sheets or on over-
> lays, which can then be overlaid and the two sheets
> viewed simultaneously on a light table. The semi-
> rectified or fully rectified photo plan sheet of an
> area of flat terrain is a very good substitute for a
> planimetric line map, since it is very nearly to
> scale. However, the effects of relief displacement
> have not been removed by the rectification process.

********************************************************************************

     C.12.2.  ORTHOPHOTOGRAPHY AND ORTHOPHOTOMAPS.

********************************************************************************

> NOTE: An orthophotograph or orthophotomap is made
> from an aerial photograph by removing the effects of
> tilt, relief, lens, and other inherent distortions. Only
> when relief displacement must be removed is an orthophoto-
> graph required. Relief displacement usually need not be
> removed unless large-scale (e.g., 1 in. = 100 ft or
> larger) design drawings are involved, and the use of
> orthophotos as opposed to line maps at these design scales
> needs to be justified. The use of orthophotography for
> small-scale (e.g., 1 in. = 200 ft or smaller) general
> reference maps/charts of relativelyflat areas is a costly
> and often an unnecessary requirement—simple semicontrolled
> air photo enlargements would suffice. Orthophotography is
> often called for in specifications when there is no func-
> tional engineering or planning requirement for their use.

The guide user should strive to avoid overspecifica-
tion of photomapping products.

An orthophotomap is almost equivalent to a planimetric
line mapping, except for features having sudden, sig-
nificant elevation changes (e.g., buildings and other
like vertical structures).  Proposed designs of engi-
neering projects may be directly superimposed on the
orthophoto map to detail the understanding of work to
be accomplished, primarily for the benefit of laymen
not versed in interpreting traditional site plan map
products.  Orthophotographs are prepared from pairs of
overlapping aerial photographs using specially
designed orthoplotting instruments.  The photographs
are oriented in the instrument in the conventional
manner for standard stereo photogrammetric mapping.
The requirements for ground control or control to be
established by aerotriangulation are the same as for
photogrammetric mapping.  The instrument provides the
means of scanning the stereo model to effect correc-
tions for the varying scales caused by topographic
relief.  The tilt and other distortions are corrected
in the orientation of the stereo model.  An ortho-
photomap differs from an orthophotograph in that
planimetric and/or topographic detail is added to the
scanned photo base.
*******************************************************************************

a.  GENERAL.  [_____] SETS OF SCREENED (SCANNED) ORTHOPHOTOGRAPHS
[WITH CARTOGRAPHIC FEATURE DETAIL ADDED] [WITH TOPOGRAPHIC CONTOURS SUPERIM-
POSED] ARE REQUIRED.  THIS ITEM SHALL CONSIST OF AN ORTHOPHOTOGRAPH PHOTOGRAM-
METRICALLY AND PHOTOGRAPHICALLY COMPILED FROM ONE PHOTOGRAPH OF A STEREOSCOPIC
PAIR.  EACH ORTHOPHOTOGRAPH SHALL COMPRISE A PHOTOGRAPHIC PRINTING OF THE
PHOTOGRAPHED AREA TO THE BOUNDARIES, QUALITY, AND PRECISION SPECIFIED BY
REMOVING THE IMAGE DISPLACEMENTS CAUSED BY GROUND RELIEF AND BY TILT, AND
CONTAINING THE IMAGES OF THE GROUND SURFACE AND TOPS OF VEGETATION, BUILDINGS,
AND ALL OTHER DETAILS.

b.  MATERIALS.  ONLY FINE-GRAIN PHOTOGRAPHIC FILM ON A
DIMENSIONALLY STABLE BASE SHALL BE USED FOR EXPOSING THE INITIAL NEGATIVE OF
EACH ORTHOPHOTOGRAPH AS IT IS COMPILED.  OUTDATED FILM SHALL NOT BE USED.

c.  EQUIPMENT.  THE COMPILATION OF THE ORTHOPHOTOGRAPH SHALL BE
ACCOMPLISHED ON AN INSTRUMENT CAPABLE OF MAKING DIRECT ENLARGEMENTS UP TO FOUR
(4) DIAMETERS BETWEEN ORIGINAL NEGATIVE SCALE AND COMPILATION SCALE.  THIS
INSTRUMENT SHALL ALSO BE CAPABLE OF PRODUCING SINGLE OR DOUBLE MODEL
ORTHOPHOTOGRAPH NEGATIVES IN SIZES UP TO *[29  BY 34 IN.] [_____].

d.  CONTROL.  UNLESS OTHERWISE SPECIFIED, ALL ESSENTIAL BASIC AND
SUPPLEMENTAL CONTROL OF REQUIRED ACCURACY SHALL BE OBTAINED BY THE CONTRACTOR
FROM AVAILABLE SOURCES, OR PROJECT CONTROL SURVEYS SHALL BE MADE BY THE CON-
TRACTOR, AS NECESSARY, FOR CONTROLLING THE COMPILATION PRINTING OF THE
ORTHOPHOTOGRAPH(S).

e.  ACCURACY.  PLANIMETRIC FEATURE DETAIL SHOWN ON THE ORTHOPHOTO-
GRAPH SHALL BE ACCURATE TO THE CRITERIA SPECIFIED IN SECTION C.15 OF THIS
CONTRACT.

f.  QUALITY.  THE PHOTOGRAPHIC NEGATIVE OF THE ORTHOPHOTOGRAPH
SHALL HAVE UNIFORM COLOR TONE AND SHALL HAVE THE DEGREE OF CONTRAST TO CAUSE
ALL DETAILS TO SHOW CLEARLY IN THE DARK-TONE AREAS AND IN THE HIGH-LIGHT AREAS
AS WELL AS IN THE HALFTONES BETWEEN THE DARK AND HIGH LIGHT.  IMAGERY SHALL BE
FREE FROM DUST MARKS, SCRATCHES, OUT-OF-FOCUS IMAGERY, AND ANY OTHER INCONSIS-
TENCIES IN TONE AND DENSITY BETWEEN INDIVIDUAL ORTHOPHOTOS AND/OR ADJACENT MAP
SHEETS.  NEGATIVES HAVING EXCESSIVE CONTRAST OR NEGATIVES LOW IN CONTRAST MAY
BE REJECTED.  EXPOSURE SCAN LINES OR MATCH LINES SHALL NOT EXCEED 0.04 IN.,
AND SHALL NOT BE NOTICEABLE OR DETRACTING FROM THE PHOTOGRAPHIC DETAILS.

g.  CONTOURS.  CONTOURS AND SPOT ELEVATIONS *[WILL] [WILL NOT] BE
ADDED TO THE ORTHOPHOTOGRAPHS THROUGH THE PLOTTING SYSTEM PROVIDED IN THE
ANALYTICAL ORTHOPLOTTERS OR BY RESETTING THE ORIGINAL STEREOMODELS AND COMPIL-
ING THE CONTOURS INTO A TRANSPARENT OVERLAY REGISTERED TO THE ORTHOPHOTO-
GRAPHS.  THE OVERLAY MUST BE A STABLE POLYESTER WITH A MINIMUM THICKNESS OF
0.004 IN., REGISTERED PRECISELY WITH THE ORTHOPHOTOGRAPH BASE.  WHEN THE CON-
TOURS ARE TO BE PHOTOGRAPHICALLY COMBINED INTO THE ORTHOPHOTOGRAPH BASE, A
CHOICE MUST BE MADE BETWEEN BLACK OR WHITE LINES, BASED ON THE PREDOMINANT
TONE IN THE AREA.

h.  SCREENING.  FINAL REPRODUCIBLE SHEETS SHALL BE *[continuous-
tone] [halftone] [____] SCREENED POSITIVES ON POLYESTER BASE WITH A MINIMUM
THICKNESS OF 0.004 IN.  *SCREENING SHALL BE *[120] [____] LINES PER INCH.
*FOR COMPOSITE ORTHOPHOTO AND CONTOUR REPRODUCIBLES, ONLY THE PHOTOGRAPHIC
IMAGE SHALL BE HALFTONE SCREENED.

**********************************************************************************
NOTE:  The contours may be photographically combined
into the orthophoto map, and may be shown as either
white or black lines.  The selection is made to effect
the greatest contrast considering the predominant tone
of the work area.  Cartographic symbolization, contour
numbers, spot elevations, border, and title informa-
tion can be compiled and reproduced in the photo
laboratory.
**********************************************************************************

i.  DELIVERIES.  ALL MATERIALS, INCLUDING THE ORTHOPHOTOGRAPH
NEGATIVE(S), THE CONTROL PRINTS, AND THE DIAPOSITIVES SHALL BE FURNISHED TO
THE CONTRACTING OFFICER.

C.13.  GROUND PHOTO CONTROL SURVEY REQUIREMENTS.

C.13.1.  GENERAL.  ALL HORIZONTAL AND VERTICAL CONTROL SURVEYS REQUIRED
FOR PHOTOGRAMMETRIC MAPPING SHALL, UNLESS OTHERWISE INDICATED HEREIN, BE PER-
FORMED USING PROCEDURES AND/OR ACCURACY STANDARDS CONSISTENT WITH PROFESSIONAL
SURVEYING PRACTICES.  ALL SURVEYING AND PHOTO MAPPING WORK SHALL BE REFERENCED
TO EXISTING PROJECT CONTROL, WHICH IS ON NAD *[27] [83] (HORIZONTAL DATUM) AND
*[NGVD 29] [NAVD 88] [_____] (VERTICAL DATUM).  THE LOCAL GRID REFERENCE
SYSTEM SHALL BE *[SPCS 27 ZONE _____] [SPCS 83 ZONE_____] [UTM ZONE _____]

[ other ].  ALL GRID COORDINATES SHOWN ON MAP PRODUCTS SHALL BE EXPRESSED IN,
OR CONVERTED TO, *[US SURVEY FEET] [INTERNATIONAL FEET] [METERS].  THE CON-
TRACTOR SHALL PROVIDE SURVEY CREWS WITH PROFESSIONAL SURVEY PERSONNEL AND
EQUIPMENT CAPABLE OF PERFORMING OBSERVATIONS AND MEASUREMENTS THAT MEET THE
REQUIRED ACCURACY NEEDED FOR THE WORK.  ALL FIELD OBSERVATIONAL DATA SHALL BE
PERFORMED IN ACCORDANCE WITH STANDARD ENGINEERING SURVEY PRACTICES, *[AS
SPECIFIED IN REFERENCE *C.3.*[__]].  SURVEY DATA SHALL BE RECORDED IN BOUND
SURVEY BOOKS WHICH WILL SUBSEQUENTLY BE DELIVERED TO THE GOVERNMENT.  ALL
SURVEY WORK WILL BE PERFORMED UNDER THE SUPERVISION AND CONTROL OF A LICENSED
PROFESSIONAL LAND SURVEYOR.  *[ALL SURVEY WORK, INCLUDING OFFICE COMPUTATIONS
AND ADJUSTMENTS, IS SUBJECT TO GOVERNMENT REVIEW AND APPROVAL FOR CONFORMANCE
WITH PRESCRIBED ACCURACY STANDARDS.]

************************************************************************
          NOTE:  The above clause should reference the particu-
          lar survey procedural manual that should be followed
          in performing conventional engineering surveying,
          including note keeping and record keeping require-
          ments.  This reference may be a District manual, Techni-
          cal Manual, EM, or other recognized standard.
************************************************************************

     C.13.2.  PHOTO CONTROL SURVEYS.  SURVEYS PERFORMED TO CONTROL HORIZONTAL
OR VERTICAL LOCATIONS OF POINTS USED IN CONTROLLING STEREOSCOPIC MODELS SHALL
BE PERFORMED USING RECOGNIZED ENGINEERING AND CONSTRUCTION CONTROL SURVEY
METHODS, AS NECESSARY TO MEET THE ULTIMATE MAPPING STANDARDS REQUIRED IN PARA-
GRAPH C.15.  THIS USUALLY REQUIRES, AT MINIMUM, THIRD-ORDER PROCEDURES PER-
FORMED RELATIVE TO EXISTING NETWORK OR PROJECT CONTROL, USING STANDARD ENGI-
NEERING SURVEY TRAVERSE, DIFFERENTIAL LEVELING, GPS, OR ELECTRONIC TOTAL
STATION MEASUREMENT TECHNIQUES.

     a.  UNLESS OTHERWISE INDICATED, PHOTO CONTROL POINTS OR PANELLED
POINTS MAY BE TEMPORARILY MARKED (2- by 2-IN. STAKES, NAILS, ETC.).  THESE
TEMPORARY MARKS SHOULD REMAIN IN PLACE FOR AT LEAST THE DURATION OF THE CON-
TRACT, AND MAY BE USED FOR PERFORMING QUALITY CONTROL OR ASSURANCE SURVEYS.

     b.  EXISTING PROJECT/NETWORK CONTROL.  A TABULATION AND/OR
DESCRIPTION OF EXISTING PROJECT/NETWORK CONTROL POINTS *[IS SHOWN BELOW] [IS
SHOWN IN ATTACHMENT G] [WILL BE PROVIDED WITH EACH DELIVERY ORDER].  THE
SOURCE AGENCY, COORDINATES, DATUM, AND ESTIMATED ACCURACY OF EACH POINT IS
INDICATED ON THE DESCRIPTION.  PRIOR TO USING ANY CONTROL POINTS, THE MONU-
MENTS SHOULD BE CHECKED TO ENSURE THAT THEY HAVE NOT BEEN MOVED OR DISTURBED.

************************************************************************
          NOTE:  List each existing control station(s) or,
          alternately, refer to a map, tabulation attachment,
          and/or descriptions that would be attached at contract
          Section G.
************************************************************************

     c.  *The contractor shall perform surveys connecting existing
project control to assure that such control has sufficient relative accuracy
to control the overall project.  Should these surveys indicate deficiencies in
the existing control, the contractor shall advise the Contracting Officer, and

appropriate modification may be made to the contract to perform resurveys of the existing network.

 d. All horizontal and vertical control points will be occupied as a station within a closed traverse or closed level loop. If it is not possible to occupy an individual control point or photo target, thus requiring spur shots, all angles shall be read at least three times and averaged, and all distances measured twice and averaged.

\*\*\*\*\*\*\*\*\*\*\*\*\*\*\*\*\*\*\*\*\*\*\*\*\*\*\*\*\*\*\*\*\*\*\*\*\*\*\*\*\*\*\*\*\*\*\*\*\*\*\*\*\*\*\*\*\*\*\*\*\*\*\*\*\*\*\*\*\*\*\*\*\*\*\*\*\*\*\*\*\*\*\*

 NOTE: The following clauses would be used only when permanent project control monuments need to be established for future design or construction work, when existing control is found to be deficient, when existing project control is distant from the project site necessitating extensive traversing or leveling work, or when there is no existing project control. Procedural methods for horizontal or vertical control extension should follow either USACE Command standards or FGCC criteria, which should be referenced/attached to the contract, and specifically noted for each type of work. FGCC standards are intended for national geodetic network densification and would normally be used only if no other local standards are available.

 Therefore, there is no need to reiterate basic surveying techniques, procedures, methods, standards, etc., in the contract. Few USACE mapping or construction projects require X-Y or Z relative accuracies in excess of those obtainable by Third-order methods/standards. Specifying higher levels of accuracy must be thoroughly justified relative to the impact on relative mapping accuracies and other factors. Refer also to the guidance contained in EM 1110-1-1000.

\*\*\*\*\*\*\*\*\*\*\*\*\*\*\*\*\*\*\*\*\*\*\*\*\*\*\*\*\*\*\*\*\*\*\*\*\*\*\*\*\*\*\*\*\*\*\*\*\*\*\*\*\*\*\*\*\*\*\*\*\*\*\*\*\*\*\*\*\*\*\*\*\*\*\*\*\*\*\*\*\*\*\*

 C.13.3. *New station monumentation, marking, and other control requirements. Permanently monumented control stations shall be surveyed as at the locations shown in the attachment in Section G. *[Note specific locations where permanent control points are required.] A total of [___] horizontal points and [___] vertical points are required.

 C.13.4. *Horizontal accuracy requirements. New or permanent control monuments/stations shall be established to a *[Third] [_____]-order, Class *[I] [___] relative accuracy classification, or 1 part in *[10,000] [_____]. *Supplemental control stations shall be established to a *[Third] [_____]-order, Class *[II] [___] relative accuracy classification, or 1 part in *[5,000] [_____]. See Reference C.3.*[___].

 C.13.5. *Vertical accuracy requirements. New or permanent vertical control shall be performed to *[Third] [_____]-order standards. See Reference C.3.*[___].

a.  *All stations shall be monumented in accordance with EM 1110-1-1002, Survey Markers and Monumentation.  Monumentation for this project shall be Type *[_____] for horizontal and Type *[_____] for vertical per EM 1110-1-1002 criteria.  *[Monumentation shall be defined to include the required reference marks and azimuth marks required by EM 1110-1-1002.]

**************************************************************************
NOTE:  Deviations from EM 1110-1-1002 should be indicated as required.  USACE project control rarely requires supplemental reference/azimuth marks—the optional specification clauses below should be tailored accordingly.
**************************************************************************

b.  *At each station, angle and distance measurements shall be made between a network station and reference marks/azimuth marks established in accordance with the requirements set forth in EM 1110-1-1002.  All observations shall be recorded in a standard field book.

(1)  *For reference marks, two (2) directional positions are required (reject limit $\pm$10- second arc) and with steel taping performed to the nearest $\pm$0.01 ft.

(2)  *Four directional positions are required to azimuth marks. The reject limit for a 1-second theodolite is $\pm$5 seconds.  Azimuth mark landmarks shall be easily defined/described natural features or structures of sufficient distance to maintain a *[$\pm$ ___]-second angular accuracy.  *[_____-order astronomic azimuths shall be observed to azimuth marks.]

(3)  *A compass reading shall be taken at each station to reference monuments and azimuth marks.

C.13.6.  *Station Description and Recovery Requirements.

a.  *Station descriptions and/or recovery notes shall be written in accordance with the instructions contained in EM 1110-1-1002.  [Form *[_____] shall be used for these descriptions.]  Descriptions shall be *[written] [typed].

b.  *Descriptions *[are] [are not] required for *[existing] [and/or newly established] stations.

c.  *Recovery notes *[are] [are not] required for existing stations.

d.  *A project control sketch *[is] [is not] required.

C.13.7.  PREMARKED PHOTO CONTROL TARGETS.  UNLESS OTHERWISE SPECIFIED HEREIN *[OR IN DELIVERY ORDER INSTRUCTIONS], ALL GROUND CONTROL USED AS PHOTOGRAPHIC CONTROL POINTS UNDER THIS CONTRACT WILL BE PREMARKED PRIOR TO OBTAINING AERIAL PHOTOGRAPHY.  TARGETS SHALL BE OF ADEQUATE SIZE AND PROVIDE GOOD PHOTOGRAPHIC CONTRAST SO THEY WILL BE CLEARLY DISTINCT IN STEREOSCOPIC MODELS. PANELS WILL BE MADE USING COLORED FABRIC (UNBLEACHED MUSLIN), PLASTIC, OR IN SOME INSTANCES, PAINT ON ROADS.  THE COLOR TO BE USED SHOULD BE IN SHARP CONTRAST TO THE BACKGROUND AREA, I.E., BLACK ON A WHITE BACKGROUND, ETC.  PANELS

ARE IN THE FORM OF CROSSES, T'S, V'S, OR Y'S. THE LONG DIMENSION OF THE PANEL
SHOULD BE A MINIMUM OF 0.015 OF THE NEGATIVE SCALE IN FEET. FOR PHOTOGRAPHS
AT A SCALE OF 1 IN. - 500 FT, THIS WOULD BE 7.5 FT. THE MINIMUM WIDTH SHOULD
BE 0.01 OF THE PHOTO SCALE IN INCHES. LARGER TARGETS WILL BE MORE EASILY
VISIBLE, WHILE ANYTHING SMALLER MAY NOT BE SEEN ON THE PHOTOGRAPHS. THE CON-
TROL POINT IS LOCATED DIRECTLY UNDER THE CENTER OF THE CROSS OR THE INTERSEC-
TION OF THE LINES OF THE T OR V, AND MAY BE MARKED IN A TEMPORARY MANNER. THE
PANELS SHOULD BE SECURED TO THE GROUND.

\*\*\*\*\*\*\*\*\*\*\*\*\*\*\*\*\*\*\*\*\*\*\*\*\*\*\*\*\*\*\*\*\*\*\*\*\*\*\*\*\*\*\*\*\*\*\*\*\*\*\*\*\*\*\*\*\*\*\*\*\*\*\*\*\*\*\*\*\*\*\*\*

> NOTE: The location of the photo control points on the
> photography should be selected by the contractor,
> either by designation of an area in which a specific
> control point should be obtained or by actually iden-
> tifying the point on the photograph. The former
> method is to be preferred since the surveyor should be
> required to make the most reliable selection in the
> field. For small mapping projects, or where good
> judgment and economy dictate, photo control should be
> obtained for each of the stereo models to be used
> in the mapping. An ideal situation requires at least
> three horizontal and four vertical photo control
> points for each stereo model. Refer also to EM 1110-
> 1-1000.

\*\*\*\*\*\*\*\*\*\*\*\*\*\*\*\*\*\*\*\*\*\*\*\*\*\*\*\*\*\*\*\*\*\*\*\*\*\*\*\*\*\*\*\*\*\*\*\*\*\*\*\*\*\*\*\*\*\*\*\*\*\*\*\*\*\*\*\*\*\*\*\*

C.13.8. *Full Photo Model Control. The contractor shall establish a
minimum of *[three (3)] [_____ (__)] horizontal and *[four (4)] [_____
(__)] vertical control points for each stereoscopic model by field survey
methods. The horizontal points shall be as far apart as feasible within each
model. Each point shall be an image of an existing object or be a finite
photographic pattern that is clearly identifiable both on the ground and on
the photographs, or be the photographic target. The vertical points shall be
spaced for optimum use of the model, preferably in or near each corner of the
model. The accuracy of all supplemental control surveys shall be the same as
that stipulated for all control surveys required under this contract. Where
pretargeting is to be utilized, sufficient targets must be established so that
each model contains the specified number of control points, even though the
starting point of flight lines may shift from the intended position.

\*\*\*\*\*\*\*\*\*\*\*\*\*\*\*\*\*\*\*\*\*\*\*\*\*\*\*\*\*\*\*\*\*\*\*\*\*\*\*\*\*\*\*\*\*\*\*\*\*\*\*\*\*\*\*\*\*\*\*\*\*\*\*\*\*\*\*\*\*\*\*\*

> NOTE: The above clause is used in instances when
> analytical aerotriangulation extension methods are not
> used. Aerotriangulation is a method of extending and
> increasing the density of photo control. It may be
> performed using a precision type stereoplotting in-
> strument; when so performed it is called "bridg-
> ing" or "stereotriangulation." Aerotriangulation also
> may be accomplished by mathematical computational
> routines, called "analytical phototriangulation."
> Aerotriangulation is used most successfully on large
> projects, on jobs where existing basic control is
> found at each end of a mapping area, or when the
> requirements of the job do not include the

establishment of ground control points within the mapping
area.  When two or more adjacent flight lines are
involved, a block system of aerotriangulation is used.
Analytical aerotriangulation bridging techniques are
especially applicable to small-scale mapping work
covering relatively large areas.  For large-scale site
plan mapping of relatively small areas (i.e., only one
or two models may be involved), which are intended
for detailed design, use of analytical aerotriangu-
lation bridging techniques should be limited; suffi-
cient ground photo control should be set to cover each
model within the project.  As with all phases of
mapping work, the decision to use full ground photo
control or aerotriangulation bridging is a function of
the project requirements and resources available.  See
also guidance contained in EM 1110-1-1000.
**********************************************************************

C.13.9.  CONTROL PHOTOGRAPHS.  ALL HORIZONTAL AND VERTICAL CONTROL
POINTS INCLUDING SUPPLEMENTAL CONTROL POINTS SHALL BE MARKED AND LABELED WITH
APPROPRIATE POINT IDENTIFICATION NUMBERS.  ALL CONTROL POINTS NOT PREMARKED
SHALL BE NEATLY PIN-PRICKED AND CLEARLY IDENTIFIED AND BRIEFLY DESCRIBED ON
THE BACK OF THE PHOTOGRAPH.  *[COORDINATES AND BRIEF DESCRIPTIONS OF MARKED
CONTROL POINTS SHALL BE WRITTEN ON THE BACK OF EACH PHOTO.]  (FULL STATION
DESCRIPTIONS WILL BE WRITTEN FOR NEWLY SET, PERMANENTLY MONUMENTED POINTS.)
THE MARKED-UP CONTROL PRINTS *[WILL] [WILL NOT] BE DELIVERED TO THE
GOVERNMENT.

C.13.10.  FIELD TOPOGRAPHIC SURVEY DENSIFICATION.  CONSISTENT WITH THE
PLANIMETRIC FEATURE, TOPOGRAPHIC, AND UTILITY DETAILING REQUIREMENTS CONTAINED
IN PARAGRAPH C.14, ADDITIONAL DETAIL SURVEYS BY *[PLANE TABLE] [TOTAL STATION]
METHODS SHALL BE PERFORMED AS NECESSARY TO ASSURE MAPPING COVERAGE.

**********************************************************************
        NOTE:  Add here any requirements for highway/stream
        sections, overbank surveys, hydrographic surveys,
        FEMA/Flood Insurance Study sections, etc.
**********************************************************************

C.13.11.  FIELD CLASSIFICATION AND MAP EDIT SURVEYS.  FIELD CLASSIFI-
CATION, INSPECTION, AND/OR EDIT SURVEYS *[WILL] [WILL NOT] BE PERFORMED *[ON
THIS PROJECT] [AS REQUIRED IN THE SCOPE OF DELIVERY ORDERS].  A *[TWO]
[_____]-MAN SURVEY CREW WILL PERFORM SURVEYS NECESSARY TO CLASSIFY CULTURAL
FEATURES, CLARIFY OBSCURED DETAIL; ADD TO OR CORRECT INCOMPLETE, CRITICAL
FEATURE, OR TOPOGRAPHIC DETAIL BY CONVENTIONAL FIELD SURVEY METHODS; AND PER-
FORM MAP STANDARD INTERNAL QUALITY CONTROL TESTING AS REQUIRED BY THE
CONTRACTOR.

**********************************************************************
        NOTE:  Field inspection of manuscripts is often neces-
        sary in order to fill in details required by the
        specifications that may have been obscured on the
        aerial photography or are too small to be recognized
        on the photographs.  The project's functional

requirement will dictate the need for and scope of subsequent field classification/edit surveys. For map scales of 1:2,400 and smaller, the field edit takes the form of classification of data. This might include names of landmark buildings, highways, trails, cemeteries, identification of major features, and similar general data. Occasionally, classification surveys can be made before the maps are compiled, and it is desirable to use enlarged photographs for this purpose. For maps of larger scales, particularly 1 in. - 60 ft and larger, the field edit becomes an essential part of the mapping process. Since large-scale maps are used for the design of engineering projects, complete map details are essential. In urban areas, parked cars may hide manholes and catch basins; invert elevations or other underground utility data may be required; utility poles and outlets should be checked and identified; property corners and the names of owners should be provided; and trees and bushes and such other details as may be needed by the map user should be identified. For this purpose, prints of the manuscript map should be used in the field. The field notations must be neat and legible. Field classification work may entail use of a plane table, total station, level, etc., to perform the work. Typically, a fully equipped two-man survey crew can perform this work.
************************************************************************

C.13.12. *FINAL MAP QUALITY ASSURANCE TEST SURVEYS. THE CONTRACTOR WILL FIELD A *[TWO] [_____]-MAN SURVEY CREW TO PERFORM QUALITY ASSURANCE TESTS IN ACCORDANCE WITH THE CRITERIA CONTAINED IN SECTION C.15 OF THIS CONTRACT. THESE TEST SURVEYS *[MAY] [SHALL] BE CONDUCTED WITH A GOVERNMENT REPRESENTATIVE PRESENT.

C.14. STEREOCOMPILATION, DRAFTING, AND CADD SPECIFICATIONS.

C.14.1. ANALYTICAL AEROTRIANGULATION SPECIFICATIONS. WHEN AUTHORIZED WITHIN THIS CONTRACT *[AND/OR DELIVERY ORDER], THE X-, Y-, AND Z-COORDINATES FOR SUPPLEMENTAL PHOTO CONTROL POINTS MAY BE DERIVED USING FULLY ANALYTICAL, SIMULTANEOUS BLOCK AEROTRIANGULATION ADJUSTMENT METHODS. INDUSTRY-STANDARD ADJUSTMENT SOFTWARE, OR THAT SUPPLIED WITH ANALYTICAL PLOTTERS, MUST BE USED TO PERFORM THE COMPUTATIONS. USE OF DIFFERENT ALTITUDE PHOTOGRAPHY IS NOT ALLOWED—THE PHOTOGRAPHY SPECIFIED IN PARAGRAPH C.6 SHALL BE USED TO PERFORM ALL MEASUREMENTS.

a. EQUIPMENT. THE PHOTOGRAMMETRIC MENSURATION INSTRUMENTS SHALL HAVE SUFFICIENT ACCURACY AND UTILITY FOR MEASURING THE X AND Y PHOTOGRAPHIC COORDINATES OF THE FIDUCIAL OR OTHER PHOTOGRAPHIC REFERENCE MARKS, TARGETS, PHOTOGRAPHIC IMAGES, AND ARTIFICIALLY MARKED POINTS TO ACHIEVE THE REQUIRED ACCURACIES.

b. GROUND AND SUPPLEMENTAL CONTROL REQUIREMENTS AND EXTENSION LIMITS. THE CONTRACTOR SHALL BE RESPONSIBLE FOR DETERMINING THE OPTIMUM LOCATION, QUALITY, AND ACCURACY OF ALL GROUND SURVEYED CONTROL POINTS USED FOR

CONTROLLING THE AEROTRIANGULATION ADJUSTMENT.  UNLESS OTHERWISE SPECIFIED,
THERE SHALL BE AT LEAST ONE (1) GROUND VERTICAL CONTROL POINT FOR EVERY *[TWO
(2)] [_____ (__)] STEREOSCOPIC MODELS AND ONE (1) GROUND HORIZONTAL
CONTROL POINT FOR EVERY *[FOUR (4)] [_____ (__)] STEREOSCOPIC MODELS.
AT LEAST SIX PHOTO CONTROL POINTS MUST APPEAR ON EACH STEREO MODEL.  SUPPLE-
MENTAL POINTS INCLUDE A POINT NEAR THE PRINCIPAL POINT OF EACH PHOTO WITH THE
OTHER FOUR (4) POINTS LOCATED NEAR EACH CORNER OF THE MODEL, PREFERABLY IN THE
OVERLAP AREA BETWEEN ADJACENT MODELS AND STRIPS.  A GROUND CONTROL POINT MAY
BE SUBSTITUTED FOR A SUPPLEMENTARY CONTROL POINT IF IT IS LOCATED IN THE SAME
GENERAL AREA OF ONE OF SIX (6) POSITIONS DESCRIBED HEREIN.  UNLESS OTHERWISE
DIRECTED, ALL SUPPLEMENTAL CONTROL POINTS WILL BE PHYSICALLY DRILLED (PUGGED)
ON THE AERIAL PHOTO.

        c.   RESULTANT ACCURACY OF AEROTRIANGULATION ADJUSTMENT.   FOR
CLASS 1 MAPS, THE ROOT MEAN SQUARE (RMS) ERROR FOR THE X-, Y-, AND Z-
COORDINATES OF ALL SUPPLEMENTAL CONTROL POINTS DETERMINED BY ANALYTICAL
AEROTRIANGULATION SHALL NOT BE IN ERROR BY MORE THAN *[1:10,000] [_____] IN
HORIZONTAL POSITION (X AND Y) AND *[1:8,000] [_____ (__)] IN ELEVATION (Z), WHEN
EXPRESSED AS A RATIO FRACTION OF THE FLYING HEIGHT.  THESE ADJUSTMENT STATIS-
TICS MUST BE CLEARLY IDENTIFIED ON THE ADJUSTMENT SOFTWARE OUTPUT THAT SHALL
BE DELIVERED TO THE GOVERNMENT *[PRIOR TO COMMENCEMENT OF STEREOPLOTTING].   A
SHORT WRITTEN REPORT *[SUBMITTED TO THE CONTRACTING OFFICER PRIOR TO COMPILA-
TION] EXPLAINING ANY ANALYTICAL CONTROL PROBLEMS ENCOUNTERED SHALL ACCOMPANY
THIS PRINTOUT.  AEROTRIANGULATION ACCURACY CRITERIA FOR OTHER MAP CLASSES ARE
CONTAINED IN EM 1110-1-1000.

        d.   CONTROL PRINTS.  THE IMAGE OF ALL GROUND CONTROL AND SUPPLE-
MENTAL CONTROL POINTS SHALL BE APPROPRIATELY MARKED AND IDENTIFIED ON A SET OF
CONTACT PRINTS.   THE IDENTIFYING NUMBER FOR EACH SUPPLEMENTAL CONTROL POINT
SHALL BE RELATED TO THE PHOTOGRAPH ON WHICH IT APPEARS.

        e.   DELIVERIES.  ALL MATERIALS, INCLUDING THE X-Y-Z COORDINATE
LISTING OF SUPPLEMENTAL CONTROL POINTS, FINAL ADJUSTMENT COMPUTATIONS WITH
ERROR OF CLOSURE, CONTROL PRINTS *[THE MARKED/DRILLED DIAPOSITIVES], AND ANY

ROLLS—FILM NEGATIVES USED BY THE CONTRACTOR, SHALL BE PROVIDED TO THE GOVERNMENT.

C.14.2.  STEREOPLOTTER SPECIFICATIONS.  TOPOGRAPHIC AND/OR PLANIMETRIC FEATURE LINE MAPS ARE TO BE DEVELOPED/GENERATED ON AN ANALYTICAL STEREOPLOTTER OF SIMILAR OR EQUAL DESIGN TO THAT OF A *[Wild_____,] *[Zeiss_____,] *[Kern_____,] [specify plotter/model].  THE PLOTTER MUST BE CAPABLE OF AUTOMATICALLY PERFORMING/ADJUSTING INTERIOR, RELATIVE, AND ABSOLUTE ORIENTA-TIONS, AND OUTPUT STATISTICAL DATA THEREOF, AND GENERATING DIGITAL DATA OF OBSERVED TOPOGRAPHIC/FEATURE INFORMATION INTO SPATIAL LAYERS DIRECTLY COM-PATIBLE WITH TWO—DIMENSIONAL/THREE—DIMENSIONAL DESIGN FILE CRITERIA (STANDARDS MANUAL FOR USACE COMPUTER—AIDED DESIGN AND DRAFTING (CADD) SYSTEMS EM 1110-1-1807 (REFERENCE C.3.[___])).  *[PREVIOUS GENERATION OPTICAL—MECHANICAL TRAIN STEREOPLOTTERS, OF SIMILAR OR EQUAL DESIGN TO A *[Wild A—10], MAY BE USED WHEN UPGRADED OR MODIFIED FOR DIRECT DIGITAL DATA OUTPUT.]  *Stereoplotter opera-tors should have demonstrated experience on the machine and in the type of terrain being compiled.

\*\*\*\*\*\*\*\*\*\*\*\*\*\*\*\*\*\*\*\*\*\*\*\*\*\*\*\*\*\*\*\*\*\*\*\*\*\*\*\*\*\*\*\*\*\*\*\*\*\*\*\*\*\*\*\*\*\*\*\*\*\*\*\*\*\*\*\*\*\*\*\*\*\*
NOTE:  All map compilation under this guide is intend-ed to be performed using high—accuracy analytical stereoplotters.  With provision, an older analog, opticaltrain, "first—order" type stereoplotter may be substituted.  Under some circumstances, such as small-scale mapping, use of analog plotters may be allowed.  Direct digital output is a requirement unless except-ed.  Production levels, and thus unit costs in Sec-tion B, will be a function of the plotter used; there-fore, unit prices should be based on a specific instrument or instruments.  Since the guide user will specify photo—negative scale, final mapping target scale, and the type of stereoplotter to be used for each project/ order, there should be no conflict over plotter capabilities, C—factors, etc.
\*\*\*\*\*\*\*\*\*\*\*\*\*\*\*\*\*\*\*\*\*\*\*\*\*\*\*\*\*\*\*\*\*\*\*\*\*\*\*\*\*\*\*\*\*\*\*\*\*\*\*\*\*\*\*\*\*\*\*\*\*\*\*\*\*\*\*\*\*\*\*\*\*\*

C.14.3.  MAP COMPILATION SCALE.  THE CONTRACTOR SHALL FURNISH TO THE CONTRACTING OFFICER STEREOPLOTTER—DERIVED *[MANUSCRIPTS] [AND/OR FINISHED MAPS] AT A SCALE OF 1 IN. = *[_____] FT, OR AS INDICATED IN SECTION H ATTACHMENTS.

C.14.4.  MANUSCRIPT PLOTTING MEDIA.  *[MANUSCRIPTS DRAFTED DIRECTLY FROM THE STEREOPLOTTER SHALL BE PLOTTED IN *[PENCIL] [INK] [BALLPOINT PEN] ON *[PAPER] [HIGH—GRADE, STABLE BASE MYLAR NOT LESS THAN 0.004—IN. IN THICKNESS] ON STANDARD *[F] [__]—SIZE SHEETS.]

\*\*\*\*\*\*\*\*\*\*\*\*\*\*\*\*\*\*\*\*\*\*\*\*\*\*\*\*\*\*\*\*\*\*\*\*\*\*\*\*\*\*\*\*\*\*\*\*\*\*\*\*\*\*\*\*\*\*\*\*\*\*\*\*\*\*\*\*\*\*\*\*\*\*
NOTE:  The manuscript map is the initial medium in the preparation of the final map.  In some instances, it is the final product delivered to the map user.  In order to preserve the accuracy standards of the photogrammetric process, the manuscript (the original) map must be drawn on a stable base material (polyester sheets, Dupont Mylar, or equal are recommended).

Experience indicates that the manuscript sheets should
be cut from the manufacturer's rolls and allowed to
"season" in the atmosphere of the map compilation
area.  For analytical plotters, a variety of map
preparation phases exist.  The manuscript phase may be
generated after stereocompilation, with preliminary
editing and drafting performed on a CADD work station
independent of the stereoplotter.
****************************************************************************

C.14.5.  MODEL SETUP AND ORIENTATION DATA.  ANALYTICAL PLOTTER ORIENTA-
TION PARAMETERS AND STATISTICAL OUTPUTS FOR EACH MODEL SETUP SHALL BE SUB-
MITTED WITH EACH PROJECT.  THESE SHEETS SHALL BE FULLY ANNOTATED BY DATE,
TIME, OPERATOR NAME, COMPILATION DATES/TIMES, PHOTO NUMBERS, AND OTHER DATA
THAT CONFIRM THAT THE MAPPING WAS COMPILED FROM THE REQUIRED NEGATIVE SCALE.
****************************************************************************

NOTE:  Receipt of these computer printouts is a par-
tial QA check that the work was compiled from the
required negative scale using established photo con-
trol.  It is not necessarily a 100 percent assurance
against a contractor using bootleg higher-altitude
photography and/or USGS quad maps for control, a far
too common practice in the past when photogrammetric
mapping was obtained by other than competitively
negotiated A-E contracting methods.
****************************************************************************

C.14.6.  PLANIMETRIC FEATURE DATA DETAILING.  THE MAPS SHALL CONTAIN ALL
THE PLANIMETRIC FEATURES VISIBLE OR IDENTIFIABLE ON OR INTERPRETABLE FROM THE
AERIAL PHOTOGRAPHS, AND COMPATIBLE WITH TYPE OF PROJECT INVOLVED (I.E.,
MILITARY MASTER PLANNING, DETAILED SITE PLAN MAPPING, ETC.)  THESE SHALL
INCLUDE, BUT NOT BE LIMITED TO, BUILDINGS, ROADS, FARM LANES, TRAILS, DRIVE-
WAYS, SIDEWALKS, CATCH BASINS, RIVERS, SHORELINES, DITCHES, DRAINAGE LINES,
EROSION AREAS, PONDS, MARSHES, LAKES, RESERVOIRS, RAILROADS, FENCE LINES,
POWER POLES, PIPELINES, WOODED AREAS, TIMBER LINES, TREE CLUMPS, ORCHARDS,
VINEYARDS, INDIVIDUAL TREES THAT CAN BE RECOGNIZED AS SUCH, BRIDGES, CULVERTS,
PIERS, SPILLWAYS, TUNNELS, DAMS, ROCK OUTCROPS, QUARRIES, RECREATION AREAS,
CEMETERIES, *[_____], ETC.  *[LEVEL OF DETAIL REQUIRED FOR EACH
PROJECT WILL BE PROVIDED IN DETAILED SPECIFICATIONS FOR THE WORK ORDER.]
REFER ALSO TO EM 1110-1-1000.

a.  *Features such as quarries, gravel pits, log piles, coal
piles, sand piles, slag piles, open pit mines, etc., shall be shown by symbols
identified in USGS Photogrammetric Compilation Symbols -- Chapter 3F1,
Preliminary Edition, March 1981, unless otherwise specified.

b.  *Surface utility data.  Locate and identify all utilities such
as culverts (pipes or box drains); water systems including valves and meters;
catch basins; manholes (storm, sanitary, telephone, gas, and electric); meter/
valve boxes; overhead electrical pole location and type; low wire elevations;
towers; and transformers.  Except in urban or heavy industrial areas, locate
only main trunk aerial and surface lines; identify size and capacities and
measure invert elevations as applicable to project.  Obtain ground photographs

critical for this portion of the work, and the func-
tional need for each item must be carefully considered
—in particular, underground utility surveys.  The
amount of ground detail required may also determine
whether photogrammetric methods are cost-effective, or
if the full project should be mapped using ground
survey methods (plane table, total station, etc.).
*********************************************************************

C.14.7.   TOPOGRAPHIC DATA DETAILING.  THE MAP SHALL CONTAIN ALL REPRE-
SENTABLE AND SPECIFIED TOPOGRAPHIC FEATURES VISIBLE OR IDENTIFIABLE ON OR
INTERPRETABLE FROM THE AERIAL PHOTOGRAPHY.  TOPOGRAPHIC DATA MAY BE GENERATED
BY *[CONTOUR TRACING] OR *[DIGITAL TERRAIN MODELING] TECHNIQUES.

a.  CONTOUR TRACKING/TRACING.  *[THE CONTOUR INTERVAL FOR THIS
PROJECT IS _____ FT.]  EACH CONTOUR SHALL BE DRAWN SHARP AND CLEAR AS A
SOLID LINE, EXCEPT THROUGH DENSELY WOODED AREAS WHERE THE GROUND CANNOT BE
SEEN AND WHERE IT IS OBSCURED BY AN OVERHANGING BLUFF OR LEDGE.  IN SUCH
GROUND HIDDEN PLACES, THE CONTOURS SHALL BE SHOWN AS DASHED (BROKEN) LINES.
EVERY *[FIFTH] [_____] CONTOUR (INDEX CONTOUR) SHALL BE ACCENTUATED AS A
HEAVIER LINE THAN THE INTERMEDIATE FOUR AND SHALL BE NUMBERED ACCORDING TO ITS
ACTUAL ELEVATION ABOVE MEAN SEA LEVEL.  WHENEVER INDEX CONTOURS ARE CLOSER
THAN ONE-QUARTER (1/4) INCH, AND THE GROUND SLOPE IS UNIFORM, THE INTERMEDIATE
FOUR MAY BE OMITTED.

(1)  *[HALF-INTERVAL CONTOURS SHALL BE ADDED IN ALL SIZEABLE
FLAT AREAS WHERE GENERAL SLOPES ARE 1 PERCENT OR LESS.]  LABELING OR NUMBERING
OF CONTOURS SHALL BE PLACED SO THAT THE ELEVATION IS READILY DISCERNABLE.
LABELING OF INTERMEDIATE CONTOURS MAY BE REQUIRED IN AREAS OF LOW RELIEF.

(2)  THE TURNING POINTS OF CONTOURS THAT DEFINE DRAINAGE
CHANNELS, DITCHES, RAPIDS, FALLS, DAMS, SWAMPS, SLOUGHS, ETC., SHALL BE CON-
SISTENT IN DEPICTING THE CORRECT ALIGNMENT OF THE CHANNEL AND IN REFLECTING
THE CONTINUATION OF THE DRAINAGE.

(3)  PARTICULAR CARE MUST BE TAKEN TO SHOW THE OUTLINE OF
SHORELINES OR OTHER WATER LIMITS AT THE TIME PHOTOGRAPHY IS TAKEN.  WHERE THE
WATER DEMARKATION LINE CANNOT BE DEFINITELY ESTABLISHED, THE APPROXIMATE
POSITION SHALL BE SHOWN BY A BROKEN LINE SO AS TO INDICATE THE CONTINUITY OF
DRAINAGE.

b.  DIGITAL TERRAIN MODEL (DTM) GENERATION.  DIGITAL ELEVATION
MODELS (DEM) SHALL BE GENERATED ON A PRESET GRID INTERVAL OF *[_____] FT C/C,
AS TRACKED AUTOMATICALLY IN THE ANALYTICAL PLOTTER, OR ON A NETWORK OF RANDOM
POINTS SUPPLEMENTED WITH BREAK-LINE POINTS TO PROPERLY ESTABLISH THE
HYPGOMETRY OF THE TERRAIN.  INTERMEDIATE BREAKS, HIGHS, LOWS, ETC., ARE ADDED
INDEPENDENTLY.  CONTOURS WILL BE GENERATED OFF-LINE USING STANDARD DTM/CADD
SOFTWARE.

***********************************************************************
NOTE:  With the automated scanning features on analyti-
cal plotters, systematic DTM/DEM topographic genera-
tion may prove more efficient than conventional trac-
ing of individual contours.  Contours can later be

generated from triangulated irregular network (TIN)
models created from the DTM/DEM.
*****************************************************************************

    c.  SPOT ELEVATIONS.  SPOT ELEVATIONS DETERMINED PHOTOGRAM—
METRICALLY SHALL BE SHOWN ON THE MAPS IN PROPER POSITION AT WATER LEVEL ON THE
SHORELINE OF LAKES, RESERVOIRS, PONDS, AND THE LIKE; ON HILLTOPS; IN SADDLES;
AT THE BOTTOM OF DEPRESSIONS; AT INTERSECTIONS AND ALONG CENTER LINES OF WELL
TRAVELED ROADS; AT PRINCIPAL STREETS IN CITIES, RAILROADS, LEVEES, AND HIGH—
WAYS; AT TOPS AND BOTTOMS OF VERTICAL WALLS AND OTHER STRUCTURES; AND AT
CENTER LINE OF END OF BRIDGES.  IN AREAS WHERE THE CONTOURS ARE MORE THAN *[3]
[_____] IN. APART AT MAP SCALE, SPOT ELEVATIONS SHALL ALSO BE SHOWN AND THE
HORIZONTAL DISTANCE BETWEEN THE CONTOURS AND SUCH SPOT ELEVATIONS OR BETWEEN
THE SPOT ELEVATIONS SHALL NOT EXCEED *[2] [_____] IN. AT SCALE OF DELIV—
ERED MAPS.  SPOT ELEVATIONS SHALL BE MEASURED TO THE [_____]—ON 1—FT CONTOUR
DRAWINGS THEY SHALL BE SHOWN TO THE 0.1—FT LEVEL.

    d.  *WHEN THE CONTRACT STIPULATES THE DELINEATION OF SPECIFIED
FEATURES (PLANIMETRY AND CONTOURS) REGARDLESS OF WHETHER SUCH FEATURES ARE
VISIBLE FROM OR OBSCURED ON THE AERIAL PHOTOGRAPHY AND ON STEREOSCOPIC MODELS
FORMED THEREFROM, THE CONTRACTOR SHALL COMPLETE COMPILATION OF THE REQUIRED
MAPS BY FIELD SURVEYS ON THE GROUND.

    e.  DASHED CONTOURS.  WHEN THE GROUND IS OBSCURED BY VEGETATION TO
THE DEGREE THAT STANDARD ACCURACY IS NOT OBTAINABLE, *[CONTOURS SHALL BE SHOWN
BY DASHED LINES] [FIELD SURVEY TOPOGRAPHIC DENSIFICATION SHALL BE PERFORMED]
[_____] .

   C.14.8.  MANUSCRIPT DRAFTING.  ALL DRAFTING ON THE MANUSCRIPTS SHALL BE
SUFFICIENTLY NEAT AND COMPLETE AS TO ELIMINATE OR MINIMIZE ERRORS OF MISINTER—
PRETATION ON THE PART OF THE SCRIBER AND/OR DRAFTSMAN PREPARING THE FINISHED
LINE MAPS.  MANUSCRIPT DRAFTING SHALL BE SUFFICIENTLY DARK AND ADEQUATELY
EDITED SO AS TO AFFORD GOOD AND USABLE PRINTS, IF REQUIRED.  EITHER PENCIL OR
INK MAY BE USED.

*****************************************************************************
    NOTE:  The above requirement may not be applicable to
    analytical plotters where the manuscript is effective—
    ly the digital database and is displayed on a work—
    station monitor.  Manuscript copies may be used for
    performing quality control/assurance surveys.
*****************************************************************************

   C.14.9.  COMPILATION HISTORY.  A COMPILATION HISTORY (MODEL DIAGRAM OR
MODEL SETUP SHEET) SHALL BE PREPARED FOR EACH STEREOSCOPIC MODEL USED TO
ACCOMPLISH THE MAPPING.  HISTORY SHALL INCLUDE BUT NOT BE LIMITED TO THE FINAL
PHOTOGRAPHIC FIT TO X—, Y—, AND Z—COORDINATES OF GROUND AND SUPPLEMENTAL CON—
TROL POINTS AND ANY OTHER PROBLEMS ENCOUNTERED IN THE MODEL ORIENTATION AND
COMPILATION PROCESS.  HISTORY SHALL ALSO INCLUDE THE PROJECT NAME, FLIGHT
DATE, PHOTO SCALE, MAP SCALE, STEREOPLOTTER USED, AND THE OPERATOR NAME.

*****************************************************************************
    NOTE:  With the completion of the map compilation by
    the plotter operator, a thorough review and edit shall

be made before final drafting. This element of quali-
ty control is designed to check for discernible errors
(unusual topographic features can be checked by exam-
ining the contact prints stereoscopically); to ensure
that the manuscript map (or workstation viewed database)
is conventional and consistent in expression; that the
user's specifications have been followed (designated
mapping limits, symbols, amount and type of details
shown, names, format and content); that ties have been
made and referenced to adjacent sheets; that control
has been labeled; and that the manuscript (or digital
database) is complete with respect to content and
appearance.
**********************************************************************

C.14.10.  FINAL SITE PLAN MAPS AND/OR DIGITAL DATA BASE CONTENTS.

a.  COORDINATE GRID.  UNLESS OTHERWISE SPECIFIED, GRID TICKS OF
THE APPLICABLE STATE PLANE COORDINATE SYSTEM (SPCS) *[UNIVERSAL TRANSVERSE
MERCATOR (UTM) SHALL BE PROPERLY ANNOTATED AT THE TOP AND RIGHT OF EACH
MANUSCRIPT SHEET.  SPACING OF THE GRID TICKS SHALL BE APPROXIMATELY FIVE
(5) IN.  *[THE SPCS TO BE USED FOR THIS PROJECT IS _____.]
*[Specify SPCS/UTM and local zone, if applicable.]

b.  CONTROL.  ALL HORIZONTAL AND VERTICAL GROUND CONTROL AND ALL
SUPPLEMENTAL CONTROL DETERMINED BY EITHER FIELD OR AEROTRIANGULATION METHODS
SHALL BE SHOWN ON THE MAP/MANUSCRIPT.  *[All control points should be plotted
to an accuracy of $\pm 0.005$ mm.]

c.  SHEET LAYOUT AND MATCH LINES.  THE *[CONTRACTOR SHALL DESIGN]
[GOVERNMENT WILL PROVIDE] THE SHEET LAYOUT THAT PROVIDES OPTIMUM COVERAGE OF
THE PROJECT.  MATCH LINES SHALL BE PROVIDED AND PROPERLY LABELED SO THAT EACH
SHEET MAY BE JOINED ACCURATELY TO ADJACENT SHEETS.  (SEE *[DISTRICT] DRAFTING
STANDARDS SPECIFIED IN SECTION *[C.3.____] OF THIS CONTRACT.)

d.  SYMBOLS AND NAMES.  THE SYMBOLS TO BE USED FOR MAJOR PLANI-
METRIC AND TOPOGRAPHIC FEATURES SHALL BE IN ACCORDANCE WITH SYMBOLS PROVIDED
IN REFERENCE *[C.3.____].  THE NAMES OF CITIES, TOWNS, VILLAGES, RIVERS,
STREAMS, ROADS, STREETS, HIGHWAYS, AND OTHER FEATURES OF IMPORTANCE SHALL BE
OBTAINED BY THE CONTRACTOR.  ALL NAMES AND NUMBERS SHALL BE LEGIBLE AND CLEAR
IN MEANING AND SHALL NOT INTERFERE WITH MAP FEATURES.  NAMES OF TOWNS, RIVERS,
STREAMS, ETC., WILL GENERALLY BE THOSE APPEARING ON THE EXISTING USGS, DEFENSE
MAPPING AGENCY (DMA), OR STATE HIGHWAY PUBLISHED MAPS.  *[THE US BOARD OF
GEOGRAPHICAL NAMES MAY ALSO BE CONSULTED.]

e.  TITLE AND SHEET INDEX.  A TITLE SHALL BE PLACED ON EACH MAP
MANUSCRIPT TO THE SIZE AND ARRANGEMENT DIRECTED BY THE CONTRACTING OFFICER,
AND SHALL INCLUDE THE NAME OF THE CONTRACTING AGENCY, THE PROJECT NAME, THE
DATE OF PHOTOGRAPHY USED, THE STRIP AND PHOTOGRAPH NUMBERS, THE MAP SCALE, THE
DATE OF THE MAPPING, MANUSCRIPT NUMBER, AND THE NAME OF THE CONTRACTOR.  IF
MORE THAN ONE (1) MANUSCRIPT/MAP SHEET IS PREPARED, A SMALL-SCALE SHEET INDEX
SHALL BE DRAWN ON EACH MANUSCRIPT/MAP SHEET SHOWING THE POSITION AND THE RELA-
TIONSHIP OF ALL MAP SHEETS TO EACH OTHER.  THE TITLE BLOCK CONTENTS *[AND
SHEET INDEX REQUIREMENTS] FOR FINISHED MAPS WILL BE FURNISHED BY THE

CONTRACTING OFFICER.  *THE CONTRACTOR'S NAME/ADDRESS, CONTRACT/DELIVERY ORDER
NUMBER, AND LOGO WILL BE PLACED ON EACH MAP SHEET.  *[Add applicable
professional certification requirements.]

      f.  VERTICAL DATUM.  UNLESS OTHERWISE SPECIFIED, ELEVATIONS ARE
BASED ON NGVD 29.

      C.14.11.  FINAL PLOTTING MEDIA.  THE FINISHED LINE MAPS SHALL BE
*[SCRIBED AND PHOTOGRAPHICALLY PRINTED IN FILM POSITIVE FORMAT] [DRAFTED IN
INK] [ELECTROSTATICALLY PRINTED FROM THE CADD DATABASE] ON STANDARD *[F] [__]-
SIZE [___ - BY ___-IN.] DIMENSIONALLY STABLE, STATIC-FREE POLYESTER DRAFTING
FILM (E.G., MYLAR), OF AT LEAST 0.004-IN. THICKNESS.  *FILM POSITIVE DRAWINGS
MADE FROM SCRIBESHEETS SHALL BE SCREENED AT *[_____].  *THE MAP BORDER WILL
NOT EXCEED [___ BY ___] IN. AND THE SHEET WILL BE ORIENTED NORTH-SOUTH, UNLESS
OTHERWISE SPECIFIED.  LOCATIONS OF TITLE BLOCKS, REVISION BLOCKS, BORDER
DETAIL, LINE WEIGHTS, ETC., ARE CONTAINED IN REFERENCE *[C.3.__].  *[MASTER
BORDERED FORMAT SHEETS WILL BE PROVIDED BY THE GOVERNMENT FOR CONTRACTOR
REPRODUCTION.]

      C.14.12.  DRAFTING AND SCRIBING QUALITY.  THE PROFESSIONAL STANDARDS OF
DRAFTSMANSHIP AND SCRIBING SHALL BE MAINTAINED THROUGHOUT THE MAPPING PROCESS.
ALL SYMBOLS, LINES, LETTERS, AND NUMBERS SHALL BE CLEAR AND LEGIBLE AND
CONFORM WITH THE *[DISTRICT] DRAFTING STANDARDS SPECIFIED IN REFERENCE
*[C.3.___].

      C.14.13.  MAP EDITING.  ALL MAP PRODUCTS WILL BE REVIEWED BY AN EXPERI-
ENCED EDITOR DURING APPLICABLE STAGES OF PRODUCTION.

*******************************************************************************
      NOTE:  The amount of time required for office map
      editing and review will vary with the project type,
      scope, and topographic/planimetric feature complexity.
      Not all projects require extensive editing.  This line
      item is separate from field classification surveys or
      field edit work, which may also be required after
      initial manuscript compilation.
*******************************************************************************

      C.14.14.  DIGITAL DATA DESIGN FILE SUBMITTALS.

      a.  PRODUCTS.  DIGITAL DATA PRODUCTS TO BE FURNISHED BY THE CON-
TRACTOR SHALL INCLUDE, BUT NOT BE LIMITED TO, TOPOGRAPHIC DRAWINGS, CROSS
SECTIONS, PROFILES, AND DIGITAL ELEVATION/TERRAIN MODELS.

      b.  ACCURACIES.  THE HORIZONTAL AND VERTICAL ACCURACIES FOR
DIGITAL PRODUCTS SHALL BE AS STIPULATED IN SECTION C.15 OF THIS CONTRACT.

      c.  FORMAT.  THE COMPLETED DRAWINGS, DIGITAL FILES, ETC., SHALL BE
FULLY OPERATIONAL, BY TRANSLATION OR OTHER PROCESS, ON THE *[INTERGRAPH]
[AUTOCAD] [_____] OPERATING SYSTEM UTILIZED BY THE
[_____] DISTRICT AT THE TIME THE DRAWINGS ARE DELIVERED.  PRESENT
OPERATING SYSTEM IS *[INTERGRAPH IGDS 8.8.2, VMS 5.0] [AUTOCAD VERSION 10]
[_____].  (SEE ALSO USACE CADD STANDARDS, REFERENCE *[C.3.____].)

*[THE MAPPING DATABASE WILL BE COMPATIBLE WITH USGS DIGITAL LINE GRAPH, LEVEL 3 FORMAT.]

********************************************************************************
        NOTE:  Add any specific layer or file requirements,
        such as contour string limits, unique layer re-
        quirements, and data translation or transfer stan-
        dards.  Add project-specific deviations from the Corps
        CADD standards (EM 1110-1-1807).  Include also any
        requirements for file translation or transfer
        with/between specific GIS, LIS, AM/FM systems.
********************************************************************************

        d.  ALL DESIGN FILES, INCLUDING DRAWINGS AND/OR MODELS, SHALL BE
FURNISHED ON *[9-TRACK MAGNETIC TAPE CERTIFIED AS 1600 OR 6250 BPI] [MAGNETIC
DISK] [other].  HIGH-DENSITY 5-1/4" OR 3-1/2 IN. FLOPPY DISKETTES FORMATTED
FOR MS-DOS MAY BE USED.  THE CONTRACTOR SHALL FURNISH A COPY OF THE CELL
LIBRARY USED IN PREPARING THESE DRAWINGS AND COMPILATION HISTORY AS DESCRIBED
ABOVE.  ALL DATA SHALL BECOME THE PROPERTY OF THE GOVERNMENT UPON SUBMITTAL.

        C.14.15.  DELIVERIES.  ALL COMPLETED MANUSCRIPTS, MAPS, AND ANY REPRO-
DUCTIONS THEREOF, DIAPOSITIVES, MODEL DIAGRAMS, COMPILATION HISTORIES, AND
DIGITAL DATA SHALL BE DELIVERED TO THE CONTRACTING OFFICER IN ACCORDANCE WITH
WORK ORDER REQUIREMENTS.

C.15.  QUALITY CONTROL AND QUALITY ASSURANCE STANDARDS.

        C.15.1.  CONTRACTOR QUALITY CONTROL.

        a.  GENERAL.  ALL PHOTOGRAMMETRIC MAPPING DATA SUBMITTED UNDER
THIS CONTRACT SHALL CONFORM TO THE ACCURACY STANDARDS OUTLINED IN EM 1110-1-
1000 UNLESS MODIFIED OR SUPPLEMENTED BELOW.  THE CONTRACTOR SHALL BE RESPON-
SIBLE FOR INTERNAL QUALITY CONTROL FUNCTIONS INVOLVED WITH FIELD SURVEYING,
PHOTOGRAPHY AND LABORATORY PROCESSING, STEREOCOMPILATION, DRAFTING, FIELD
CHECKING, AND EDITING OF THE PHOTOGRAMMETRICALLY MADE MEASUREMENTS AND
COMPILED MAPS TO ASCERTAIN THEIR COMPLETENESS AND ACCURACY.  ALSO, THE CON-
TRACTOR SHALL MAKE THE ADDITIONS AND CORRECTIONS NECESSARY TO COMPLETE THE
MAPS AND PHOTOGRAMMETRICALLY MADE MEASUREMENTS.

        b.  MATERIALS.  ALL MATERIALS, SUPPLIES, OR ARTICLES REQUIRED FOR
WORK THAT ARE NOT COVERED HEREIN, OR BY WORK ORDER SPECIFICATIONS, SHALL BE
STANDARD PRODUCTS OF REPUTABLE MANUFACTURERS AND ENTIRELY SUITABLE FOR THE
INTENDED PURPOSE.  UNLESS OTHERWISE SPECIFIED, THEY SHALL BE NEW, UNUSED, AND
SUBJECT TO THE APPROVAL OF THE CONTRACTING OFFICER.

********************************************************************************
        NOTE:  One of the following map accuracy standards
        shall be specified by the guide user and the others
        deleted.  Alternatively, the standards set forth in EM
        1110-1-1000 may be used and simply referenced in this
        contract.  The ASPRS standard is recommended for USACE
        large-scale mapping work.
********************************************************************************

C.15.2. *NATIONAL MAP ACCURACY STANDARDS (LARGE-SCALE MAPS). Unless specified otherwise, all photogrammetric mapping will meet the following horizontal and vertical accuracy requirements for scales of 40, 50, 100, 200, and 400 ft to 1-in.

a. Contours. Not more than 10 percent of the elevations tested shall be in error more than one-half contour interval. In checking elevations taken from the map, the apparent vertical error may be decreased by assuming a horizontal displacement of 1/30 in.

b. Planimetric features. Not more than 10 percent of well-defined points or features tested shall be in error by more than one-thirtieth (1/30) of an inch, measured at the map/manuscript publication scale. Well-defined features are those that may be plotted within 1/100 in. at the map/manuscript scale.

C.15.3. *DEPARTMENT OF TRANSPORTATION REFERENCE GUIDE OUTLINE ACCURACY SPECIFICATIONS (LARGE-SCALE MAPPING). Unless specified otherwise, all photogrammetric mapping will meet the following horizontal and vertical accuracy requirements for scales of 40, 50, 100, 200, and 400 ft to 1 in.

a. Contours. Ninety percent of the elevations determined from the solid-line contours of the topographic maps shall have an accuracy with respect to true elevation of one-half (1/2) contour interval or better and the remaining 10 percent of such elevations shall not be in error by more than one contour interval.

b. Coordinate grid lines. The plotted position of each plane coordinate grid line shall not vary by more than one-hundredth (1/100) of an inch from true grid value on each map manuscript.

c. Horizontal control. Each horizontal control point shall be plotted on the map manuscript within the coordinate grid in which it should lie to an accuracy of one-hundredth (1/100) of an inch of its true position as expressed by the plane coordinates computed for the point.

d. Planimetric features. Ninety percent of all planimetric features that are well-defined on the photographs shall be plotted so that their position on the finished maps shall be accurate to within at least 1/40 in. of their true coordinate position, as determined by the test surveys. None of the features tested shall be misplaced on the finished maps by more than 1/20 in. from their true coordinate position.

e. Special requirements. When stipulated in the contract or delivery order scope of work, all specified features shall be delineated on the maps, regardless of whether they can be seen on the aerial photographs and on stereoscopic models formed therefrom. The contractor shall complete compilation by conventional field surveys on the ground so as to comply with all accuracy and completeness stipulations.

f. Spot elevations. Ninety percent of all spot elevations placed on the maps shall have an accuracy of at least one-fourth the contour interval, and the remaining 10 percent shall not be in error by more than one-half the contour interval.

C.15.4.  *ASPRS ACCURACY STANDARDS FOR LARGE-SCALE MAPS.

a.  Vertical accuracy.  Vertical map accuracy is defined as the 1-sigma (RMS) error in elevation in terms of the project's evaluation datum for well-defined points only.  The limiting RMS error shall be one-third (1/3) the contour interval for well-defined points and one-sixth the indicated contour interval for spot heights placed on the map/manuscript.  The map position of the ground point may be shifted in any direction by an amount equal to twice the limiting RMS error in position (defined below).  Statistical tests shall be made in accordance with ASPRS procedures.

b.  Horizontal accuracy.  Horizontal map accuracy is defined as the 1-sigma RMS error in terms of the project's planimetric survey coordinates (x-y) for checked well-defined points as determined by full (ground) scale of the map/manuscript.  The limiting RMS errors in x or y (feet) for each scale (in feet/inch) are as follows:

| Error ft | Scale ft/in. |
|---|---|
| 0.2 | 20 |
| 0.3 | 30 |
| 0.4 | 40 |
| 0.5 | 50 |
| 1.0 | 100 |
| 2.0 | 200 |
| 4.0 | 400 |

c.  Blunders.  Discrepancies between the x-, y-, or z-coordinates of the ground point, as determined from the map by the check survey, that exceed three (3) times the limiting RMS error shall be interpreted as blunders and will be corrected.

C.15.5.  *FEMA FLOOD INSURANCE STUDY ACCURACY REQUIREMENTS.  For photogrammetric surveys performed in support of FEMA flood insurance studies, the following standards shall be met.  Detailed specifications and quality control standards are found in Appendix 4 of Reference C.3.*[__].

a.  Contours.  The contour interval shall be 4 ft.  Ninety percent of the elevations determined from the solid-line contours of the topographic maps shall have an accuracy with respect to true elevation of one-half (1/2) contour interval or better and the remaining 10 percent of such elevations shall not be in error by more than one contour interval.

b.  Coordinate grid lines (if used).  The plotted position of each plane coordinate grid line shall not vary by more than 1/100 in. from true grid value on each map.

c.  Horizontal control.  Each horizontal control point shall be plotted on the map manuscript within the coordinate grid in which it should lie to an accuracy of 1/100 in. of its true position as expressed by the plane coordinates computed for the point.  Should noncoordinate control procedures be utilized, the same accuracy shall pertain to the plotting of any type of control points.

**********************************************************************************
            NOTE:  For FEMA work, horizontal photo control may be
            adequately effected by scaling coordinates from USGS
            1:24,000-scale quad maps, provided no degradation to
            the critical vertical component results.  Absolute
            accuracy required in the vertical is ±0.5 ft.
**********************************************************************************

        d.  Planimetric features.  Ninety percent of all planimetric fea-
tures that are well-defined on the photographs shall be plotted so that their
position on the maps shall be accurate to within at least 0.025 in. of their
true coordinate position.  None of the features shall be misplaced on the maps
by more than 1/20 in. from their true coordinate position.  When map produc-
tion is accomplished without benefit of a grid coordinate system, then the
accuracy shall be interpreted as the distance between any two well-defined
points.

        C.15.6.  USACE PHOTOGRAMMETRIC MAPPING ACCURACY STANDARDS.  UNLESS
SPECIFIED OTHERWISE, ALL PHOTOGRAMMETRIC MAPPING WILL MEET THE HORIZONTAL AND
VERTICAL ACCURACY REQUIREMENTS SPECIFIED FOR CLASS *[___] MAPPING, IN CHAPTER
2 OF EM 1110-1-1000.

        C.15.7.  *SMALL-SCALE ACCURACY REQUIREMENTS.  FOR LINE MAPS OF SCALES
SMALLER THAN 1 IN. PER 400 FT (1:4,800), THE UNITED STATES NATIONAL MAP
ACCURACY STANDARDS (REFERENCE C.3.[__]) SHALL BE FOLLOWED.

        C.15.8.  METHODS FOR EVALUATING MAP ACCURACY.  ALL MAPS COMPILED SHALL
BE SUBJECT TO MAP TESTING BY THE GOVERNMENT, BY INDEPENDENT THIRD-PARTY
FORCES, OR BY CONTRACTOR FORCES WORKING UNDER DIRECT GOVERNMENT REVIEW, TO
ENSURE THAT THEY COMPLY WITH THE APPLICABLE ACCURACY REQUIREMENTS LISTED
ABOVE.  THE MAP TEST RESULTS WILL BE STATISTICALLY EVALUATED RELATIVE TO THE
DEFINED ACCURACY CRITERIA, AND PASS/FAIL DETERMINATION MADE ACCORDINGLY.  THE
DECISION OF WHETHER OR NOT TO PERFORM RIGID MAP TESTING ON ANY PROJECT,
DELIVERY ORDER, OR PORTION OF A PROJECT RESTS WITH THE CONTRACTING OFFICER.
IN ALL CASES, THE CONTRACTOR WILL BE ADVISED IN WRITING WHEN SUCH ACTION WILL
BE TAKEN.

**********************************************************************************
            NOTE:  For fixed-scope contracts, indicate herein the
            degree of formal map testing contemplated, and by
            whom.  If performed by contractor survey forces, then
            adequate field survey time must be allocated in Sec-
            tion B.  On IDT contracts, formal map accuracy tests
            are optional for each delivery order.  The need for
            map tests is a function of the ultimate or intended
            use of the maps.  For large-scale site plan mapping,
            being intended for detailed foundation design, map
            testing is critical, as well as for maps containing
            critical utility and drainage detail.  However, map
            testing would not be as necessary for general, smaller
            scale map products on which no design effort is
            foreseen.  Master plan mapping might fall in this catego-
            ry.  The availability of Government survey resources
            to perform the  testing must also be considered.  If

contractor forces are needed to perform the tests, then a Government representative must be present to select test points and review the actual field observations. A separate A-E contractor may also be selected to perform such work. Given the resources involved in performing map testing, the costs of such efforts must not be disproportionate to the overall photogrammetric mapping effort—the benefits of photogrammetric mapping over conventional plane table or total station survey methods might be eliminated.
*******************************************************************************

a. OFFICE AND FIELD CHECKS. THE PARTY RESPONSIBLE FOR MAP TESTING MAY, DURING THE COURSE OF THE PROJECT, INSPECT MAP COMPILATION IN THE CONTRACTOR'S FACILITY BY COMPARISON WITH AERIAL PHOTOGRAPHS. HOWEVER, THE FINAL MAP COMPILATION SHALL BE CHECKED BY FIELD INSPECTION AND A HORIZONTAL AND VERTICAL ACCURACY CHECK BY CONVENTIONAL FIELD SURVEY CHECKS, USING TRAVERSE, TRIANGULATION, AND DIFFERENTIAL LEVELING METHODS TO TEST SELECTED POINTS OR FEATURES ON THE COMPLETED DRAWINGS.

b. TEST PROFILES FOR TOPOGRAPHY. IN ORDER TO CHECK FOR COMPLIANCE WITH THE VERTICAL CONTOUR ACCURACY REQUIREMENTS, TEST PROFILE TRAVERSES SHALL BE MADE IN THE FIELD. PROFILES TO CHECK CONTOURS AND SPOT ELEVATIONS SHOULD BE AT LEAST FIVE (5) IN. LONG AT THE MAP SCALE, AND SHOULD CROSS AT LEAST TEN (10) CONTOUR LINES. PROFILES SHOULD START AND CLOSE UPON MAP FEATURES OR PREVIOUSLY ESTABLISHED CONTROL POINTS. IN FLAT AREAS AND AT PRINCIPAL ROAD AND RAIL INTERSECTIONS, SPOT ELEVATIONS SHALL BE CHECKED. IN GENERAL, ONE PROFILE *[PER MAP SHEET] [PER *[3] [_____] STEREO MODELS] IS SUFFICIENT.

c. SPOT ELEVATION TESTS. TESTING FOR VERTICAL ACCURACY MAY ALSO BE PERFORMED BY COMPARING THE ELEVATIONS AT WELL-DEFINED POINTS AS DETERMINED FROM THE MAP TO CORRESPONDING ELEVATIONS DETERMINED BY A SURVEY OF HIGHER ACCURACY. A MINIMUM OF 20 POINTS SHALL BE CHECKED AND SHALL BE DISTRIBUTED THROUGHOUT THE SHEET, OR CONCENTRATED IN CRITICAL AREAS.

d. TEST POINTS FOR PLANIMETRIC FEATURES. THE ACCURACY OF THE PLANIMETRIC MAP FEATURE COMPILATION SHALL BE TESTED BY COMPARING THE GROUND COORDINATES (X AND Y) OF AT LEAST 20 POINTS (WELL-DEFINED MAP FEATURES) PER TEST PER MAP SHEET, AS DETERMINED FROM MEASUREMENTS ON THE MAP AT PUBLICATION SCALE, TO THOSE FOR THE SAME POINTS, AS PROVIDED BY A CHECK SURVEY OF HIGHER ACCURACY. THE CHECK SURVEY SHALL HAVE AN ORDER OF ACCURACY EQUAL TO OR EXCEEDING THAT SPECIFIED FOR ESTABLISHING THE MAPPING CONTROL. MAPS WILL ALSO BE EXAMINED FOR ERRORS AND/OR OMISSIONS IN DEFINING FEATURES, STRUCTURES, UTILITIES, AND OTHER NOMENCLATURE, OR FOR TOTAL GAPS IN COMPILATION/COVERAGE. THE MINIMUM OF 20 POINTS SHALL BE DISTRIBUTED THROUGHOUT THE SHEET OR CONCENTRATED IN CRITICAL AREAS.

e. SELECTION OF WELL-DEFINED TEST POINTS. THE TERM "WELL-DEFINED MAP FEATURES" PERTAINS TO FEATURES THAT CAN BE SHARPLY DEFINED AS DISCRETE POINTS. POINTS THAT ARE NOT WELL-DEFINED ARE EXCLUDED FROM THE ACCURACY TEST. THE SELECTION OF WELL-DEFINED POINTS SHALL BE MADE THROUGH AGREEMENT BETWEEN THE CONTRACTING OFFICER AND THE CONTRACTOR. GENERALLY, IT MAY BE MORE DESIRABLE TO DISTRIBUTE THE POINTS MORE DENSELY IN THE VICINITY OF IMPORTANT

STRUCTURES OR DRAINAGE FEATURES AND MORE SPARSELY IN AREAS THAT ARE OF LESSER
INTEREST.  FURTHER DEFINITIONS AND REQUIREMENTS FOR SELECTION OF WELL—DEFINED
PHOTO/MAP POINTS ARE FOUND IN THE REFERENCE STANDARD USED.  THE LOCATIONS AND
NUMBERS OF MAP TEST POINTS AND/OR TEST PROFILES SHALL BE MUTUALLY AGREED TO BY
THE CONTRACTOR AND CONTRACTING OFFICER'S REPRESENTATIVE (COR).

   C.15.9.  CORRECTION OF UNSATISFACTORY WORK.  FAILURE TO MEET MAP TEST
CRITERIA WILL REQUIRE RECOMPILATION OF THE PROJECT AT THE CONTRACTOR'S
EXPENSE.  WHEN A SERIES OF SHEETS ARE INVOLVED IN A MAPPING PROJECT, THE
EXISTENCE OF ERRORS (I.E., MAP TEST FAILURE) ON ANY INDIVIDUAL SHEET WILL
CONSTITUTE PRIMA FACIE EVIDENCE OF DEFICIENCIES THROUGHOUT THE PROJECT (I.E.,
ALL OTHER SHEETS ARE ASSUMED TO HAVE SIMILAR DEFICIENCIES), AND FIELD MAP
TESTING WILL CEASE.  AFTER CORRECTION OF THE WORK, THE CONTRACTOR WILL BE
RESPONSIBLE FOR PAYMENT OF MAP TESTING REQUIRED ON THE CORRECTED DRAWINGS.
WHEN SUCH EFFORTS ARE PERFORMED BY GOVERNMENT SURVEY FORCES, THESE COSTS WILL
BE DEDUCTED FROM CONTRACT/DELIVERY ORDER PAYMENT ESTIMATES.

**************************************************************************

NOTE:  The purpose of the above clause is to preclude
the Government from performing contractor quality
control functions to the extent that the map testing
effort becomes a field classification/edit function.
However, the Government COR must exercise reasonable
judgment in assessing map test results, given the fact
that no map is perfect and minor errors or omissions
can be expected.  For this reason, the specification
writer must clearly define critical parameters in the
scope of work in order for the contractor to ensure
quality control is performed in these areas.  For
instance, if top of curb elevations are important,
these should be emphasized in the scope.  Conveying
such information is best accomplished by clearly
noting the intended functional/project use of the maps
in the scope (e.g., foundation design, spillway
design, runway construction, general installation
masterplanning, etc.).  With such information, the
contractor can concentrate his resources on the more
critical feature elements and not spend undue time on
feature detail superfluous to the design/construction
effort.

**************************************************************************

C.16.  NONTOPOGRAPHIC PHOTOGRAMMETRY SPECIFICATIONS.

**************************************************************************

NOTE:  Specifications for close—range photogrammetric
measurements on structures or mechanical devices
should be developed from or referenced to the Manual
of Photogrammetry.

**************************************************************************

C.17.  <u>SUBMITTAL REQUIREMENTS</u>.

C.17.1.  SUBMITTAL SCHEDULE.  THE COMPLETED WORK, MAPS, AND REPORTS SHALL BE DELIVERED WITHIN *[___ DAYS AFTER NOTICE TO PROCEED IS ISSUED] *[BY calendar date].

```
**
 NOTE: Include a more detailed submittal schedule
 breakdown if applicable to project. Note any prelimi-
 nary, priority, or partial delivery requirements, with
 reference to specific Section B line items.
**
```

C.17.2.  PACKAGING AND MARKING.  PACKAGING OF COMPLETED WORK SHALL BE ACCOMPLISHED SUCH THAT THE MATERIALS WILL BE PROTECTED FROM HANDLING DAMAGE. EACH PACKAGE SHALL CONTAIN A TRANSMITTAL LETTER OR SHIPPING FORM, IN DUPLI-CATE, LISTING THE MATERIALS BEING TRANSMITTED, BEING PROPERLY NUMBERED, DATED, AND SIGNED.  SHIPPING LABELS SHALL BE MARKED AS FOLLOWS:

U.S. ARMY ENGINEER DISTRICT, _____
    ATTN: _____
                   *[include office symbol and name]
    CONTRACT NO. _____
    *[DELIVERY ORDER NO. _____]
    [STREET/PO BOX] _____
                  *[complete local mailing address]

*HAND-CARRIED SUBMISSIONS SHALL BE PACKAGED AND MARKED AS ABOVE, AND DELIVERED TO THE FOLLOWING OFFICE ADDRESS:

_____

*[insert office/room number as required]

```
**
 NOTE: In this section, also reference any unique data
 transmittal/submittal requirements for digital data,
 if applicable.
**
```

C.18.  <u>PROGRESS SCHEDULES AND WRITTEN REPORTS</u>.

C.18.1.  *PREWORK CONFERENCE.

```
**
 NOTE: Detail any requirements for a prework confer-
 ence after contract award, including requirements for
 preparing written reports for such conferences.
**
```

## SECTION D

### CONTRACT ADMINISTRATION DATA

## SECTION E

### SPECIAL CONTRACT REQUIREMENTS

## SECTION F

### CONTRACT CLAUSES

**********************************************************************************
**NOTE:  See instructions in Appendix B of PARC IL 92—4.**
**********************************************************************************

## SECTION G

### LIST OF ATTACHMENTS

G.1.  U.S. ARMY CORPS OF ENGINEERS EM 1110-1-1000, PHOTOGRAMMETRIC MAPPING.
THIS REFERENCE IS ATTACHED TO AND MADE PART OF THIS CONTRACT.

**********************************************************************************
> **NOTE:  List any other attachments called for in con-
> tract Section C or in other contract sections.  This
> may include such items as:**
>
> a.  **Marked—up project sketches/drawings.**
>
> b.  **Station/Monument descriptions or Recovery Notes.**
>
> c.  **Drafting standards.**
>
> d.  **CADD standards.**
**********************************************************************************

## SECTION H

## REPRESENTATIONS, CERTIFICATIONS, AND OTHER STATEMENTS OF OFFERERS

## SECTION I

## INSTRUCTIONS, CONDITIONS, AND NOTICES TO OFFERERS

\*\*\*\*\*\*\*\*\*\*\*\*\*\*\*\*\*\*\*\*\*\*\*\*\*\*\*\*\*\*\*\*\*\*\*\*\*\*\*\*\*\*\*\*\*\*\*\*\*\*\*\*\*\*\*\*\*\*\*\*\*\*\*\*\*\*\*\*\*\*\*\*\*\*\*\*\*\*\*

**NOTE:** See PARC IL 92-4 for guidance in preparing these clauses/provisions.

\*\*\*\*\*\*\*\*\*\*\*\*\*\*\*\*\*\*\*\*\*\*\*\*\*\*\*\*\*\*\*\*\*\*\*\*\*\*\*\*\*\*\*\*\*\*\*\*\*\*\*\*\*\*\*\*\*\*\*\*\*\*\*\*\*\*\*\*\*\*\*\*\*\*\*\*\*\*\*

# INDEX

Absolute orientation 97

Accuracy standards 5-6, 162; aerotriangulation 21, 23, 60-64, 188, 191; ASPRS standards 5, 6-9, 244-246, 318-319; compliance 6, 9-11, 24; coverage 25-26, 33, 289; digital terrain mapping 20, 25; DOT map standards 5, 10-11; FGCC standards 55; ground control 59; guide specifications 318-319; highways 10; large-scale maps 5, 6-9, 244-246, 318-319; mosaics 82; National Cartographic Standards 11; orthophotographs 21-25; photo plans 82; position accuracy 86; project planning 105-106; stereoplotters 60-61, 69-70, 95, 97; surveys 10, 55; target scales 5; tolerable errors 191; USACE standards 6, 11-25, 66, 76, 79; USNMAS standards 5, 9-10, 11

Accuracy testing 7-9, 11, 18-30

Adjustment; definition 162

Aerial cameras 31, 34-36, 174, 177, 291; C-factor 20, 21, 69-70, 163, 183; calibration 35-36, 42-47, 65, 131, 291; camera log 42, 48; focal length 35, 174, 242; guide specifications 291; lens distortion 35, 165; light filters 35, 174-175; mounting 35; substitute cameras 36; vacuum supply 31, 174

Aerial film *see* Photographic film

Aerial mosaics *see* Mosaics

Aerial photography 127, 129; aircraft 31-32, 173-174, 284, 287; cost estimation 132-133, 198, 199, 204, 206, 211, 214; crab 23, 34, 163, 180, 290; drift 179-180; errors 191; flight altitude 22, 164, 183, 209; flight conditions 32, 132, 175-176; flight crew 30, 129, 285; flight inconsistencies 34, 179-180; flight lines 32, 82, 164; flight log 33, 296; flight maps 126, 127, 285; flight plan 164, 285-286; flight specifications 31-34; fogging 164-165; geometry 87-90, 91-93; guide specifications 274-277, 287, 288; labor rates 206; production scheduling 234-235; radiant energy 170-172; tilt 23, 90, 168, 180, 290; weather conditions 32, 132, 175-176, 286; *see also* Aerial cameras; Photographic film

Aerotriangulation 28-29, 57-64, 100-102, 130, 162, 307-308; accuracy standards 21, 23, 60-64, 188, 191; C-factor 20, 21, 69-70, 163, 183; cost estimation 207; deliverables 64; end lap 33-34, 164, 178, 289; equipment 194; errors 191; fully analytical aerotriangulation 102; guide specifications 279; preliminary sequential aerotriangulation 61-62; production scheduling 235; semianalytical aerotriangulation 62, 64, 101-102; simultaneous bundle adjustment 62;

time requirements 207; *see also* Ground control

Air base 162

Aircraft 31-32, 173-174; guide specifications 284, 287

Analog photogrammetric solution 94

Analog stereoplotters 181

Analytical photogrammetric solution 94

Analytical stereoplotters 96, 162, 181, 289

Annotation 41, 82, 102, 294

Antihalation layer 172-173

Antivignette filter 162, 175

Architect-Engineer contracts; cost estimating 2, 169-170, 193-243; guide specifications 2, 264-325

Area expansion factor 196

Area mapping; testing 30

ASPRS (American Society for Photogrammetry and Remote Sensing) standards 5, 6-9, 10, 244-246, 319

Average scale; calculation 88

Azimuth 162

Base map 65

Basic control survey 51-52, 162-163

Benchmark 163

Between-the-lens shutter 163

Black and white film 39, 293

Block control 58, 59

Bridges; depiction specifications 247, 253, 257, 260

Bridging *see* Aerotriangulation

Bridging distance 59

Budgetary cost estimating 195-196

Buildings; depiction specifications 248, 253, 257, 260

C-factor ratios 20, 21, 69-70, 163, 182-183

Cadastral data 10, 30, 163

Cadastral maps 10, 163, 180, 182

CADD system 71, 78

Calibration; aerial cameras 35-36, 42-47, 65, 131, 291

Calibration plate 163

Camera axis 163

Camera filters 35, 174-175

Camera lenses 35, 174

Camera log 42, 48

Camera platen 35

Camera shutter 35

Camera station 163

Cameras; aerial *see* Aerial cameras

Cameras; terrestrial photogrammetry 94

Cartography 163

Checkpoints 8

CI *see* Contour interval

Civil works; surveying and mapping requirements 14-16

**Date Due**

| | | | |
|---|---|---|---|
| OCT 1 2 2000 | | | |
| MAR 3 1 2005 | | | |
| | | | |
| | | | |
| | | | |
| | | | |
| | | | |
| | | | |
| | | | |
| | | | |
| | | | |
| | | | |
| | | | |
| | | | |
| | | | |
| | | | |